MICHELANGELO
ARCHITECT

MICHELANGELO
ARCHITECT

By Giulio Carlo Argan and Bruno Contardi

Translated from the Italian by Marion L. Grayson

HARRY N. ABRAMS, INC., PUBLISHERS

Giulio Carlo Argan wrote the introduction, chapter essays, and epilogue.
Bruno Contardi provided the history, chronology, and documentation for the
relevant works in individual entries following each chapter essay.

Editor, English-language edition: Marion L. Grayson
Designer, English-language edition: Maria Miller
Photographs by Gabriele Basilico

Library of Congress Cataloging-in-Publication Data

Argan, Giulio Carlo.
 [Michelangelo architetto. English]
 Michelangelo architect / Giulio Carlo Argan, Bruno Contardi;
translated from the Italian by Marion L. Grayson.
 p. cm.
 Includes bibliographical references and index.
 ISBN 0–8109–3638–0
 1. Michelangelo Buonarroti, 1475–1564—Criticism and
interpretation. 2. Architecture, Renaissance—Italy. I. Contardi,
Bruno. II. Title.
NA1123.B9A8713 1993
720′.92—dc20 92–38117
 CIP

Published in 1993 by Harry N. Abrams, Incorporated, New York
A Times Mirror Company

Printed and bound in Italy

Table of Contents

MICHELANGELO AS ARCHITECT

"It is healthier, both in war and in sport, to know how to lose a great deal than to gain a little." Poems, 244

When Michelangelo began his architectural career under the patronage of Pope Leo X, he was already thought of as a "god." He had stunned the world with the Sistine Ceiling completed four years earlier, and he had even designed architecture there in the figurative sense—not as a simulation of real architecture opening up to a celestial vision but as a means of defining pictorial space and light. Then he was called on by the pope to change the architecture of his imagination into reality, although, at that moment, it was only to design a façade to house a collection of statues. Thus it can be said that he arrived at architecture through painting and sculpture, aiming for a supreme coexistence or synthesis of the three arts.

Michelangelo often said that painting and sculpture were his arts and he was not practiced in architecture. He did not say this out of modesty, a virtue which in truth he did not have, but perhaps to distance himself, intellectual aristocrat that he was, from those who were professional architects by trade—just as he said, while creating poetry, that he was not a writer. Or he may have thought that architecture ranked a bit above the other two arts because it did not involve manual labor. The architect invented, designed, directed, and controlled, but did not actually execute the work himself. Michelangelo's own approach to architecture was in fact one of creating forms rather than of preordaining construction. A great builder he was not, and more than once he created plans without construction in mind.

For at least the first half of his long career, his stated goal was the synthesis of the arts in which the techniques specific to each were surpassed, thereby making art a liberal activity measured by the same standard as other liberal disciplines. But architecture for Michelangelo was not synthesis nor one of its various factors. It was the final step in the process of achieving the extinction of representation and its differentiated techniques, and the result of successive renunciations which would be followed, finally, by total renunciation even of the plan. The Church of Santa Maria degli Angeli in Rome, the last architectural work, was neither a plan nor a construction but only an idea or gesture.

Early humanism, with Leon Battista Alberti, had expressed a theory of the arts, giving them a common mathematical rationale by which their convergence and union could be obtained within a single concept. Michelangelo had believed himself to be the heir and custodian of that high culture, and his ideal masters were Brunelleschi, Donatello, and Masaccio. Neoplatonism, which Lorenzo the Magnificent had made the philosophy of his court, was rooted in humanism, and the young Michelangelo had been formed in this Medicean intellectual milieu. But that culture seemed to him to have gone astray over time, with artists continuing to theorize the synthesis of the arts while conceiving it eclectically as a sum. One cause—perhaps the greatest—of this deviated course was, or so he thought it to be, Leonardo da Vinci, with his skepticism about religious truth, his indifference to Classical antiquity and history, and his experimentalism and analysis of real phenomena.

The incompatibility between phenomenalism and spiritual transcendence had been the origin of the old argument between Leonardo and Botticelli. The still-young Leonardo left Florence for Milan, and Botticelli, nearly at the end of his worldly career, fell into a crisis of delirious asceticism, rejecting every idea of progress and cursing the newborn century. From this point on, an uncompromising anti-Leonardoism, signs of which are in all of Michelangelo's work, affected not only the culture of Florence but also the future path and destiny of art in the world. The disagreements were over which was the dominant art, painting or sculpture, and also over the nature of the relationship of the arts to science or to poetry. There were serious differences too in ideas of ancient and modern, of the world and God, and of horizontally extended cognitive research versus the vertical ascent of the spirit. By defining art as research and analysis by which to discover reality, Leonardo had undoubtedly freed it from the obligation to imitate institutionalized nature and, by this time, canonical antiquity, but was his progressist view therefore more modern than the rigid, apparently almost reactionary one of Michelangelo? Or was it not a reprise at the end of the century of the divergence which, at the beginning of it, had opposed the new historicism and classicism of Florentine humanism to the open modernism and "techniqueism" of Late Gothic internationalism? What effects did that impartial revival of emphasis on technique and mechanics have on the arts? Had the specific techniques of art entered into the controversy as well? The "malady" of *The Last Supper*, which would soon alarm Vasari, had not yet begun, but Leonardo's technical innovation in mural painting in the Palazzo Vecchio's Salon dei Cinquecento had ended in disaster, his success in sculpture was dubious, and his architecture remained a hypothesis, with which, if ever he knew it, Michelangelo could only have disagreed. In retrospect, even Leonardo's intention to make the arts a sensitive, penetrating tool of scientific research was not observed, and the new science was developed and set forth as a cultural hegemony with quite contrary methods, instruments, and aims. Leonardo's approach to creating and inventing was completely different, and what he proposed was the revival, reform, and updating of an old culture rather than the foundation of a new one.

Incontestably, Leonardo extended the field of knowledge and the human capacity for knowing beyond all limits. He thought of nature as always in a state of becoming and therefore as movement—a kinetic "fury" really, which was all at once cosmological, physiological, and psychological. And he proposed cognition of the world as object and subject by way of penetrating analysis rather than by mirrored representation. But in extending its limits to infinity, he reinforced the naturalistic concept of art. His phenomenalistic, analytical naturalism was, in the ideology of the Renaissance, the laic parallel to and the analytical-experimental complement of the dogmatic, historicist naturalism of Raphael.

Seemingly conservative but in reality audaciously advanced, Michelangelo was the opposite of Leonardo in thought. His synthesis of the arts was neither a fusion of similar elements nor a compendium of the universal, but rather the product of a dialectical process. He was quite aware that synthesis was the unification of the arts, but it was also the isolation of art within a system no more unitary than the culture. He saw poetry and probably music integrated with the autonomous yet intercommunicative domains of art, but he no longer associated them with other disciplines, especially science. To remove the fundamental principle of imitation meant to negate the value of representation as a cognitive act. Certainly, Leonardo had already negated this value, but by pointing towards other, more penetrating processes for knowing. Michelangelo did not accept the dogma of art-mimesis, because it made art the effect of a cause and thereby gave it a logical, dual structure which his ontological monism rejected. Besides, if nature was the creation and image of God, there was a much greater reason not to imitate it; the relationship of mortals to God ought to be one of love and aspiration, which is inductive and not deductive.

In Michelangelo's life, the obligations of his work and the events of his existence were inextricably bound together. As a consequence, it is not at all strange that, at the time the responsibility was given to him for the building of Saint Peter's, with the anxiety about failure which could have been perdition, he had not had other thoughts. Yet his renunciation of representation was conscious and quite deliberate, as he declared in his poems and letters. The commission coincided with, and was explained by, the most critical stage of what was called his "conversion," when the chronic intellectual tension had turned into religious calling. It seemed to him then that the "making of so many puppets" was a kind of *ignava ratio*, a thinking of the divine as similar to the human. What else were nature and image except a third term of mediation, almost an allegorical fiction, interposed between the subject and object of the love relationship? His soul converted and already offered to God with death near, he did not speak in metaphors, yet in passing from the mimetic imagery of representation to the metaphysics of architecture he did not disappear completely into abstraction. His images, increasingly concerned with conveying messages, would be made more intense and solicitously nonrelative, like gems in a costly setting. Even God was seen with the eyes; would to God that he were all eyes in order to see Him better. Sight will be given back to the eyes of the dead at the time of the Last Judgment, so that they may see Him; and the visibility of the Church had a theological rationale.

To think of art as aspiration and expectation meant thinking of it as constitutionally incomplete or not perfect, because the complete essence of the Divine was not revealed to the living. Up until death, existence was incomplete or not perfect, and although art always had real value, the value was that which was incomplete and imperfect in the world. But were not man-made products of this world finished and complete? In the economic field, as well as in the crafts, that was the technique of every production, and perfection was the connotation of value. To be precise, however, art had been disconnected from the crafts, and thus wasn't its true worth perhaps that of being "not finished"—just as existence was not finished? Not-

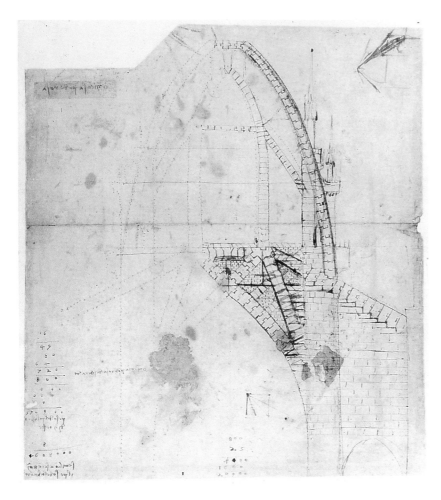

1. *Leonardo da Vinci. Study of tribune gallery for Cathedral of Milan. Biblioteca Ambrosiana, Milan, Cod. Atlantico, f. 310v-b*

finished meant never being self-satisfied, always being in a state of uncertainty about the exact outcome, and therefore always seeking anxiously to surpass oneself through continuous self-criticism. This was Mannerism, an artistic risk-taking not guaranteed *a priori* by the logic of nature and the authority of history, just as existence was lived without knowing what, in the end, its destiny would be.

Michelangelo's *livre de chevet* was *The Imitation of Christ*, but Christ was not imitable. Therefore, art would not be truly religious unless it were the imitation of the inimitable, which was fatally destined to failure. He no longer imitated nature and history, as it was logical to do so long as nature and history were models of perfection, but what if instead they themselves were problematic? They were in fact for Leonardo, who, avid for knowledge, admitted the impossibility of knowing everything. But what was accepted by Leonardo as methodological doubt became for Michelangelo sacred mystery, and all that was known about the mystery was the struggle it required to try to penetrate it. Having rejected with his conversion every relationship with the objective world, his art, in order to continue to be imitation, could only imitate itself and become, more than representation, the tracing of its own concept. Transposed from the sphere of cognition to that of moral philosophy, imitation became submission, and the merit of submission depended on its difficulty—that is, on the value of the rebellion which had been subjugated. For this reason, the presence of suppressed, overcome impulses was necessary. His architecture was full of repented extravagances, and probably it was the contrast between guilt and redemption which pleased him, as Vasari said, in the work of young Pontormo.

It is well known, given the authoritative example of Michelangelo, that all Mannerism was anticlassical; the intrinsic greatness of antiquity was not contested but rather the legitimacy of its generalized interpretation. The term "classical" came later at the end of the sixteenth century, but the classical interpretation of the antique, in which art by emulation made it a precept, was a precedent already at the beginning of the century. This was the product of the ideology and program of *renovatio urbis Romae*, the renewal of the city of Rome, which descended from early Florentine humanism, precisely from the time in which the architect Alberti was close to Pope Nicholas V. Rome would be redeemed from chronic decay in order to conform to that excellence which had been recognized at the end of the schism in the Western Church. The research, study, and restoration of the old, and the planning of the new, were all connected activities. But in order to arrive at a norm for planning, it was necessary to balance and standardize the measurements derived from both the physical evidence and the literary sources of Vitruvius and Pliny, drawing from them laws that were imaginary but which corresponded to an idea of the antique as essentially rational. In sum, it was the art of a culture to which, providentially, the yet-unrevealed God had given nature as an image and model of true rationality. The internal forces of construction obeyed the natural law of gravity, therefore the external forms were to reflect and make manifest the logic of that equi-

librium. In this way, architecture, although not reproducing a likeness of nature, remained within the orbit of mimesis and thus of the classical concept of art as balance, order, and proportion.

For Bramante and Raphael also, the rationale of the classical concept of the antique was related to their program of *renovatio* presented to Pope Leo X and reported on by Baldassare Castiglione. This vast program of recovery and reform involved the employment of a category of architects who would work on a common stylistic and typological basis according to Raphael's principle of variety within uniformity. Michelangelo's concept of the antique was something quite different. To his way of thinking, history was not master and patron, and it did not exonerate the artist from the responsibility of acting in the present. Through Bertoldo di Giovanni, his only master in sculpture, he had been drawn close to Donatello, the first anticlassical "antiqueist." An erudite artisan and philologist as well, Donatello extracted fragments from the antique and embedded them in a modern context, demonstrating that they could maintain a pictorial force equal to that of the Florentine vernacular. At least in the beginning, the antique for Michelangelo was a question of text more than of norms, as witnessed in the youthful episode of his *Sleeping Cupid* altered without his involvement and sold as an authentic antique work. As his biographer Condivi wrote, no one suffered more from this than he did. He did not shun iconic recourse, but he disavowed stylistic imitation based on typology. When he cited the antique, which was more pronounced in his architecture, it was to show that he tended more towards the strange than to the rational. His emotion is well-known in response to having seen the *Laocoön* immediately upon its excavation in Rome, an experience which certainly could not have convinced him of the cathartic harmony of the Classical.

His relationship with Giuliano da Sangallo, which was very important with respect to his approach to architecture, could only have encouraged him to a nearly linguistic study of the lexicon of the antique. But he worked in Florence within an architectural complex that was still Brunelleschian, and Brunelleschi, who put the flowery language of the Late Gothic outside the law, had fixed instead a sober repertory of architectonic icons redesigned from the antique, which the Florentine artisans then delineated in clear forms of *pietra dura*. Clearly this divergence in establishing a new lexicon according to an iconological criterion rather than a typological one set Michelangelo in opposition to the classicism of the Rome school. Typological morphology corresponded with a modular or proportional composition and was therefore syntactic, while iconological morphology corresponded with a composition dependent on the intrinsic force of each of the elements and was therefore rhythmic. Bramante had turned to the geometric logic of Ciceronian rhetoric, but the architecture of Michelangelo was made up of tensions and extensions, highs and lows, in the same manner as his poetry, which was all lexicon and rhythm.

The rhythmic flow arose from the exertions and relaxations of the human body, which an art tied to the dynamic of existence could not leave out of

3. Michelangelo. Study of bay for façade
of San Lorenzo, Florence. Casa Buonarroti,
Florence, A 100 (C. 506)

4. Michelangelo. Horizontal section of
capital, and section of marble block for
capital. Casa Buonarroti, Florence,
A 78 (C. 509)

5. Funerary monument of Giuliano de'
Medici, detail of throne. New Sacristy,
San Lorenzo, Florence

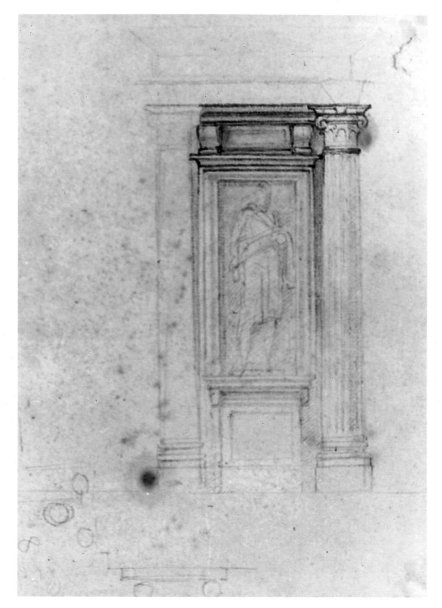

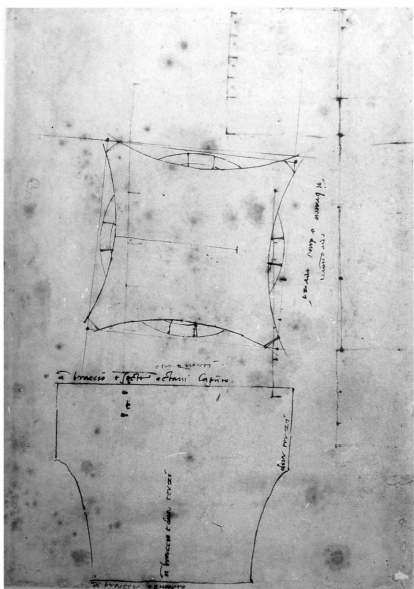

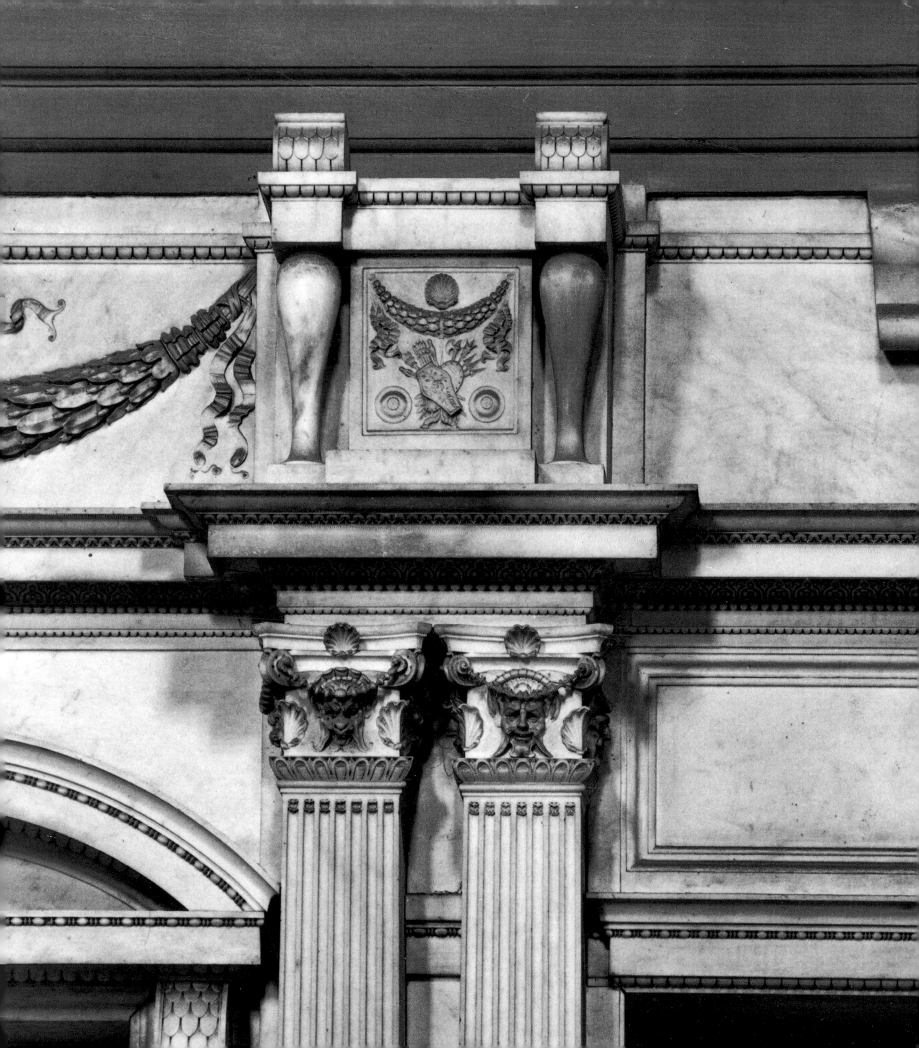

6. *Sarcophagus of Lorenzo de' Medici,
detail of ornamental decoration on end of
bier. New Sacristy, San Lorenzo, Florence*

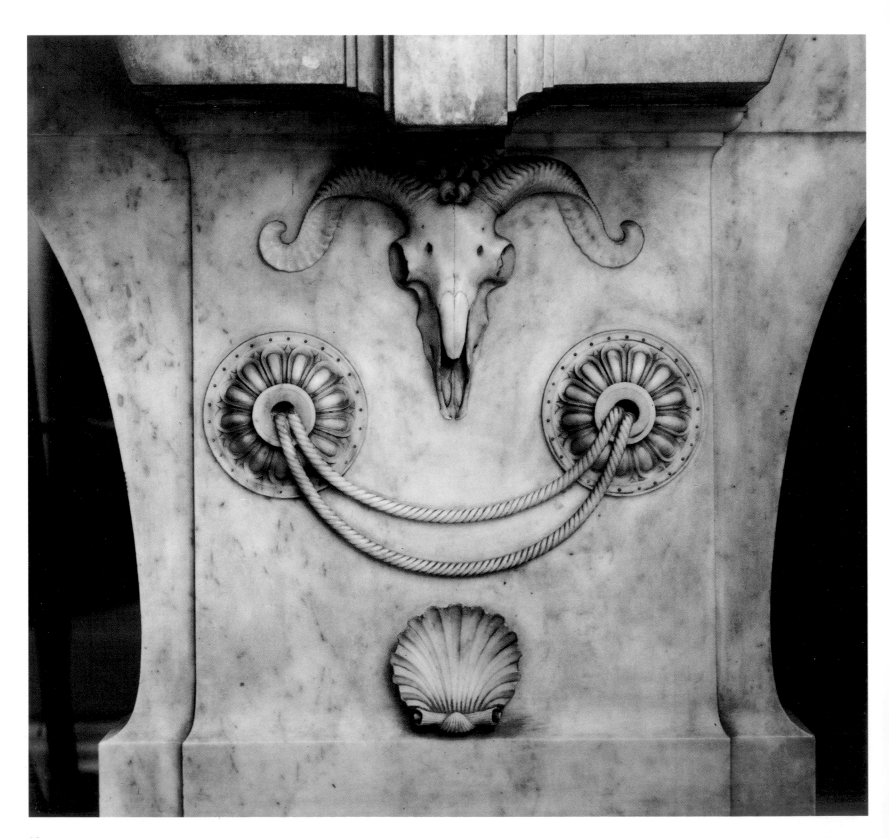

consideration. Michelangelo clearly stated that the elements of architecture were like the parts of a man, and one could not be a good architect without knowing anatomy, but for him the human body was a generator of force, not a model of symmetry and proportion. Ackerman stated it very well that Michelangelo had a concept of the body which was somewhat more organic than rational. His anatomical research was essentially involved with the physical implements of volition and not, as Leonardo's, with the agents of sensibility. But that volition did not achieve its goal; at the peak of endeavor, it suddenly dropped and tension was followed by collapse, which could be death. What anatomy was for Michelangelo can be seen with paradigmatic clarity in the young male nudes of the Sistine Ceiling—a gymnastic rhythm of seated figures and a gesturing without any aim except to make evident the forces in action—about which scholars never tire of debating their significance and symbolic meaning. Whatever they were, they had an architectonic purpose as a living picture frame for the effractic, enigmatic, metaphoric stories of the Old Testament. These nudes were nothing if not manifestly illogical, because the message they would have conveyed on earth was certainly not logical.

All of Michelangelo's work, but especially his architecture, can be categorized as theoretical "illogic," and not just due to the absence of normal cause-and-effect relationships. The "not-logical" and even the "illogical" were dimensions of the imaginary opened up to the consciousness by neoplatonism and therefore intentional. The antique was in fact valued for being idea without any correspondent reality. Botticelli had redone from literary sources alone *The Calumny* by Apelles, for which no pictorial record existed, just because it was a memory which, by cyclical resurgence, turned into imagination through an entirely inductive process. Already Castiglione had insinuated, ironically, that the platonists reasoned by contradiction, and Francesco Berni was the first to say that no thought was born in the mind of Michelangelo which was not platonic. Nearly one hundred years ago, the great German philosopher Georg Simmel (1858–1918) dedicated to Michelangelo a memorable, all-but-forgotten essay which begins: "In the depths of our spiritual essence seems to dwell a dualism which prevents us from understanding the world, whose image penetrates our soul as a unity and decomposes there incessantly into pairs of opposites" (Simmel, Ital. trans. 1985). Michelangelo's thinking was not logic but eros—a pulsating vertical oscillation between opposite poles which ultimately coincided. One was all, and death was life. Even the fundamental duality of sexual and spiritual love was translated into unity in the end. I cannot say by what means (certainly not Ficino), but Michelangelo acquired the more authentically religious platonism of Nicholas of Cusa (1410–1464) and his concepts of the *docta ignorantia*, the *coincidentia oppositorum*, and death and resurrection. There is no sonnet or madrigal of the artist's *Poems* whose conceptual dynamic was not manifested as a coincidence of opposites. The same was true in his artistic representation, for which the generating mechanism of the forms was foreshortening—that is, the unifying and harmonizing of the points of maximum projection and maximum recession. Foreshortening finished by canceling out the very perspective view which gave it life and, as a consequence, the presumed logic of space-nature, just as the vertical dialectic of opposites annihilated logic-syntax in syntactic rhetorical discourse.

Nicholas of Cusa's thinking agreed on at least one point with the theses of early humanism—that of the greatness of the masters of antiquity. With the gift of art, Providence had compensated for humanity's innocent ignorance of the true God. But that which is dead is not reborn by its own virtue; it can only rise again by Divine Will. If Christ had not been truly dead, he could not have been resurrected, said Nicholas. If the art of antiquity had not been truly dead, it could not have been transmuted and resurrected as Christian. As Antonio Manetti related, Brunelleschi believed along with other early humanists that Providence had elected Florence to be the heir to the greatness of Roman antiquity. It was said that antique wisdom had not arisen from the earth, but perhaps had descended from Heaven. There was not, however, an interrupted continuity with which it would be possible to link up. Modern was the opposite of the antique, therefore respect for the antique had to be defined, yet antiquities were few in Florence, and the structure of the city was modern, which ruled out the possibility of a restoration. Alberti was the first to plan restorations of the antique while working for Pope Nicholas V. The city of Rome was to resurrect, even in its urban order, the antiquity which had once been at its center. From Alberti came the ideology of *renovatio*, its primary method of monumental restoration, and its utopia of a modern architecture reborn from the antique. With the goal of serving the rebirth of Rome, he wrote his treatise on architecture and thus became the new Vitruvius.

For Michelangelo, antiquity and modernity were opposites that ultimately coincided. In order to be sure of being modern, Leonardo had superseded the antique; in fact, his modern was made after nature and not achieved through history. The modern of Michelangelo was all history and nothing of nature. He rejected the generalized interpretation and literary precepts of the antique, but he responded passionately to its texts. True or false, the anecdotes of his early youth are indicative; imitation of the antique inevitably resulted in a copy or a counterfeit. Yet his statue of *Bacchus*, as well as that of *David*, the symbol of the Florentine spirit, presupposed lost and therefore incorporeal antique models for the ideal image, or concept, which the excellent artist saw circumscribed in the marble and then gave substance and visible form. Thus one can speak of two "images"—one abstract and the other concrete and visible, but this subtending rendered more intense the manifest charging of the work with antique contents made real. These images were two "contraries" which became one, with the invisible concept admirably reinforcing the visible form. Even to a greater degree in his architecture than in his representation, the observed appearance mediated the relationship between a physicality and a spirituality that were equally exalted.

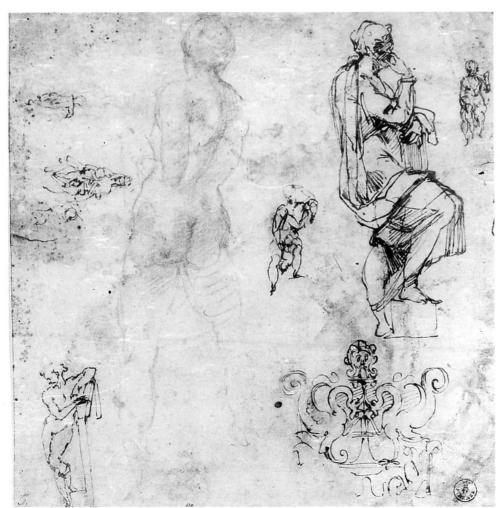

This is not to say that Michelangelo had studied in a profound way the architectural heritage of antiquity. In fact, he occupied himself very little with it before being called to do architecture in Florence. Even then, it can be reduced to a beginner's attempt, schematic and second-hand, with regard to the measurements of some principal morphemes from the lexicon of the antique: columns, capitals, bases, and moldings. He studied particularly the complex bases and cornices composed of a succession of small elements—upright and reverse ogee, ovolo, astragal, clamshell, and concave moldings—which simulated compressions and tensions, contractions and releases, giving an appearance of elasticity to the construction. These elements were used to create proportion and balance in the classical interpretation, but, in the anticlassical interpretation of Michelangelo, the contractions and releases had, in the larger context of the construction, a dynamic function like that of foreshortening in figural representation. And they produced in the same way a stronger impact on visual perception. As a result, Michelangelo, surely the most conceptual of architects, was also the most immediately communicative. Architecture would no longer be a representation for contemplation but an almost traumatic experience which passed through the eyes directly to the consciousness and urged one to action.

The reason for the extreme clarity of the formal icons was the deliberate alteration, or sometimes breaking, of the usual syntactical orders and connections, but this certainly did not cause the enormous power which, strange to many, characterized the architecture of Michelangelo. The detachment between the values was often minimal; nevertheless, the leap was qualitative with no disparity between the distinct and the contradictory. As in his painting, there was the same detachment between two close chromatic values, in terms of quality, as there was between black and white.

The principle of the merger of opposites was valued at all levels of magnitude—corporeal and spiritual, life and death, and (in the words of Simmel) fixed and becoming, and existence and destiny. Political and religious were included too, because architecture was an art of government

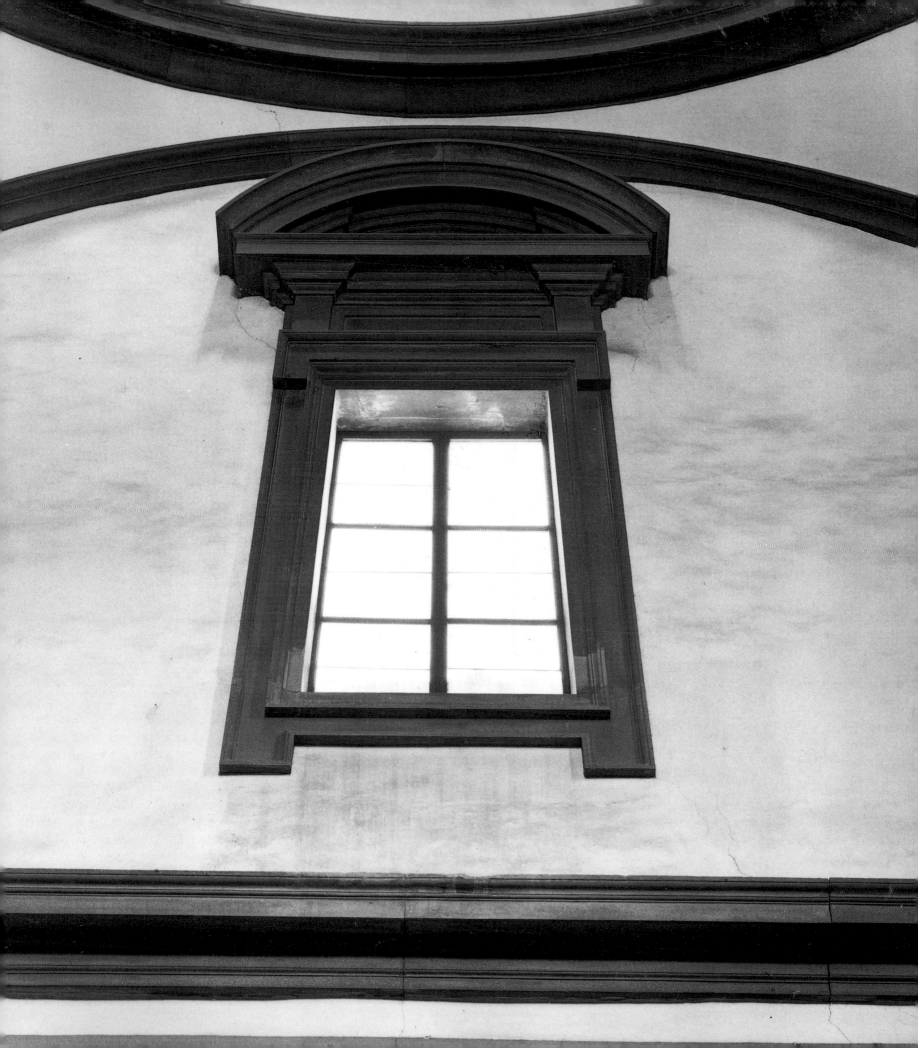

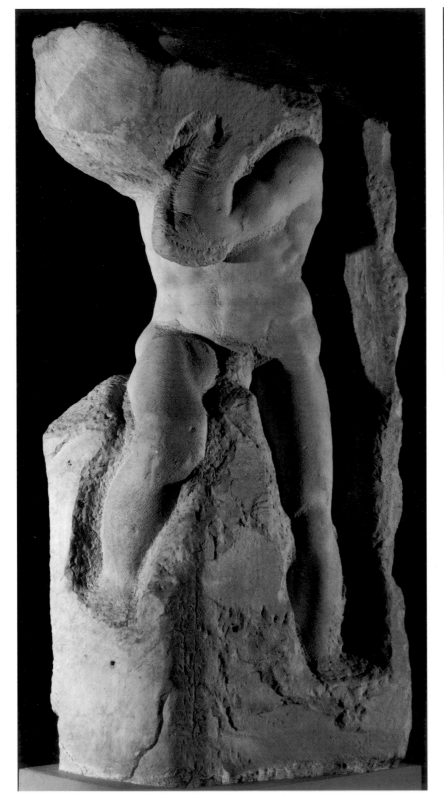

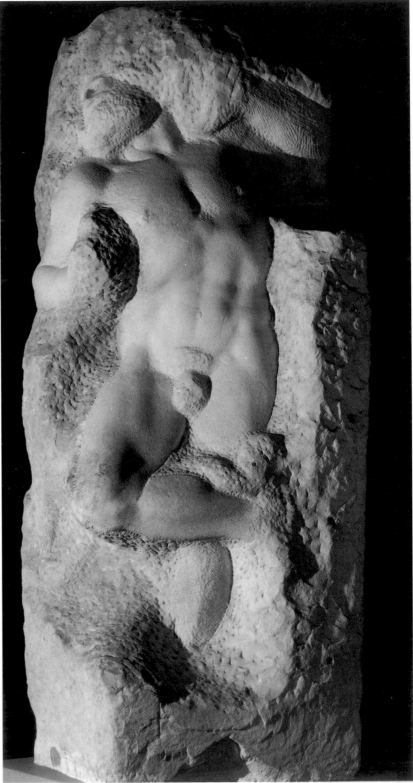

related to current conditions. The fundamental politics of architecture really began with Michelangelo, and with it the obligation to signify, to communicate, and to influence the consciousness. Humanistic belief had established a concept and a praxis of lay religiosity which the Church, after its initial diffidence, realized that it could not do without. For Michelangelo, the difference between laic and ecclesiastic was the same as that between the bourgeois culture of Florence and the Roman Curia, a binomial which the two Medici popes reduced but deliberately maintained, and which Michelangelo reflected in his work. When the civil ideology of early humanism died with the Republic, the defense of "true" Christianity was identified with the defense of the historical patrimony and the charismatic investiture of Rome.

There was an important relationship of affinity and antithesis between Michelangelo's architectural works in Florence and those in Rome. The dialectic of the laic and the religious connected and also divided them at the time of the *furor* of politico-religious crises, as seen in the involuntary, or even unconscious, syntony of the Florentine fortifications with *The Last Judgment* of the Sistine Chapel. In spite of the great dimensional differences, there were certain structural similarities between the Laurentian Library and the Capitoline complex, both laic works, and the New Sacristy and the new Saint Peter's, both religious works—laic religion and professional religion ran along binary parallels. More than structural similarities, the works had common iconic roots; the New Sacristy and Saint Peter's both had square plans and, instead of sedate cappings, domes which ascended directly from their bases, sublimating their materials in luminous spheres. The image of the laic Laurentian Library was recreated and transformed in the Capitoline piazza, not only in the symmetry of design but also in the difference of the levels.

More evident in the architecture, which lacked the mediation of figural representation, was the rapid diagram of coinciding opposites, still in the morphemes of the lexicon of the antique, which took on sculptural body in construction. But architecture clearly inverted the process of making art by means of subtraction, by the fact that these antique morphemes passed from the iconic state to that of form. Simmel explained that all of Michelangelo's visualized thought endured a conflict between the kingdom of earthly realities and that of otherworldly ones. The tragedy of his thought, which in architecture had no escape into figurative allegory, was that it was depended upon yet a third kingdom, which was beyond life.

For the humanists, reason was the highest of the virtues, but it had its contrary, folly. Alberti spoke of this in his *Momus*, Erasmus of Rotterdam in his *Encomium*, and Hieronymous Bosch and Pieter Bruegel in their paintings. Even the dignified reason of antiquity had its counterpart in the *grottesco*, which the followers of Raphael practiced as the complement of figural narrative. Michelangelo touched on it in a rather grim manner in the Tomb of Julius II, and again with an unaccustomed, final lightheartedness in the Porta Pia. But he only touched on it as an indulgence in experiment. All

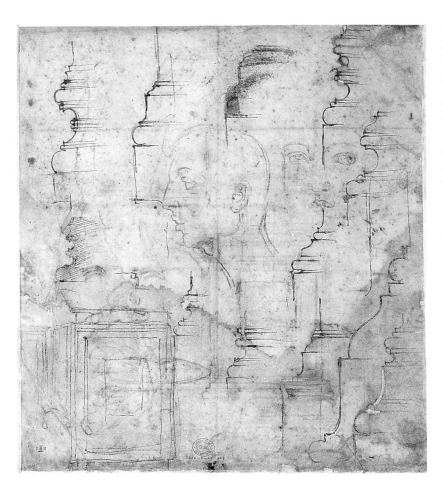

of his life had in fact been a tormented research of the irrational as eros, and of the illogical as religious and moral belief—and aesthetic also, naturally. Platonically speaking, beauty and goodness were one, and feeling, intellect and faith lived in the same tension. The exigency of rigorous illogic had given life to his poetry—the meter, the rhyme, and, even more so, the logic and the syntax.

In the life of Michelangelo, it is easy to distinguish the periods when he spoke many arts or only one, but he spoke poetry from his youth to his old age. He himself inserted it *de facto* into the category of the arts, although it was soon afterwards ratified academically by Benedetto Varchi. He spoke of not being a writer and also of not being an architect, because he entertained the same antipathy for professional writers that he had for professional architects. Thus it would have been difficult for him to give permission for the publication of his poems to Luigi del Riccio (who never carried it through), if he had not been sure of their quality. He was jealous of his fame as an artist, and he knew that professional writers such as Aretino would not have held back their sarcasm with regard to his literary efforts. The *Poems* were published and became known only in the seventeenth century from the very poor volume edited by the artist's nephew, and no one, up until the most recent scholars (Robert Clements, Walter Binni, Glauce Cambon), understood their meaning or value. They were praised however by Francesco Berni, a poet and contemporary of Michelangelo, and they did not escape the attention of two poets of our own time, Eugenio Montale and Giuseppe Ungaretti. But the assessment of the poetry, from Ugo Foscolo to Benedetto Croce, was distorted by the inevitable comparison with the painting and sculpture, and therefore it was spoken of as dilettantism and literary diversion. But the problem was and is not the level of quality nor the analogy between poetic and pictorial images. Poetry made up part of Michelangelo's system of the arts as a function of structural research and verification. It represented in that system the parole, or name, whose value, though implied, was an essential, constituent part of the image.

Michelangelo was closely observant of the canonic rules of poetry involving the different types of compositions, the meter, and the rhyme. Clearly, he understood intuitively that if the compositional laws superseded syntactic logic, it would create a discourse which was not logical, not dual, and not deductive, but instead was linear, inductive, and erotic. Love—be it sexual, intellectual, or mystical—was the driving principle in all of Michelangelo's poetry. And what could platonic love be otherwise if not a *coincidentia oppositorum*, a unity of contraries and differences? "*Di te me veggo e di lontan mi chiamo / per appressarm'al ciel dond'io derivo / e per le spezie all'esca a te arrivo / come pesce per fil tirato all'amo* (Near you I see me and from afar I call to myself / in order to draw nearer to Heaven whence I come / and for the spices of the bait to you I arrive / like a fish pulled by a hook and line)." Logico-syntactical discourse gives value to words by their relationship and proportion, which mitigates the specificity of meaning and reduces, if not annihilates, the tonal singularity. In sum, the discourse of prose is like

14. *(above) Michelangelo. Plan of properties between Borgo and Piazza San Lorenzo, Florence, related to project for Laurentian Library. Casa Buonarroti, Florence, A 81 (C. 543)*

15. *(below) Michelangelo. Sketches for newel-post of staircase in vestibule of Laurentian Library, and study of hand. Casa Buonarroti, Florence, A 37v (C. 226v)*

chiaroscuro in which all rises or falls in gradations of quantity. But Michelangelo's merging of opposites was pure illogic, and the discourse constructed according to that diagram had other tempos. He broke up the rational order of subject-verb-predicate by shifting the terms in a way that loosened up their relationships and accentuated their singularity. Here is a case in point: *"Ogni ira, ogni miseria, e ogni forza / chi d'amor s'arma vince ogni fortuna* (Every anger, every misery, and every violence / who by love is armed conquers every fortune)." In this case, the deferred placement of the subject and verb acquired for them a salient prominence, which was manifested also in the phonetic reinforcement—*"amor s'arma."* Drawing attention to itself, this phonetic bond fell, anxiously awaited, at the end of a crescendo—*"ira, miseria, forza"*—and was followed by a summary and conclusive term—*"fortuna."* The intensity of tone which certain words took on was similar to the violent clarity of light striking the emergent forms in a painting or sculpture and, like these, they presupposed an uneven context of foreshortenings and contractions, sometimes to zero, of every graduated passage. In the restored frescoes of the Sistine Ceiling, it is clearly seen that the foreshortenings, so celebrated for their powerful plasticity, had instead a coloristic result. With his changeable-color technique (shading of one color with a contrasting hue), the passage from light to shadow was in effect a passage from one chromatic tone to another.

Michelangelo wrote many times that sensory perception should be surpassed but not repressed. To render it more intense meant to give it more of humanity, which better allowed for the capturing of hidden signs of the presence of the Divine in the world. He prayed for God to make of his "whole body only an eye," greedy for every marvel of creation. *"Po' c'a distinguer molto / dalla mie chiara stella / da bello a bel fur fatti gli occhi miei* (Because to distinguish much / by my bright star / from beauty to beauty my eyes were made)." Even concepts were physically perceived as being brighter than real objects, and ordinary colors were bearers of semantic meaning: *"El bianco bianco, el ner più che funebre / s'esser può, el giallo po' più leonino, / che scala fa dall'una all'altra vebre. / Pur tocchi sopra e sotto el suo confino, / e 'l giallo e 'l nero e 'l bianco non circundi* (The white white, the black more than funereal / can be, the yellow a little more leonine, / which scale makes one vibrate from the other. / Pure touches above and below its border, / and the yellow and the black and the white not encircled)." How close this is to Rimbaud's *Voyelles!* The very speed of pulsation between opposite and distinct terms led to a phonetic intensification paralleling the intensified opticality in his representational and architectural work. Here are a few examples from among many possibilities: *"Di fior sopra ' crin d'or d'una grillanda* (Of flowers over the golden locks, of a garland)"; *"Poi ch'i' fui preso alla pristina strada / di ritornare indarno s'argomenta* (After I set out on the ancient road / turning back was tried in vain)"; *"Tu sa' ch'io so, signor mie, che tu sai / . . . / e sai ch'io so che tu sa' ch'i' son desso* (You know that I know, my lord, that you know / . . . / and you know that I know that you know that I am he)"; *"Non so se s'è la desiata luce* (I do not know if there is the desired light)"; and, finally, *"Del*

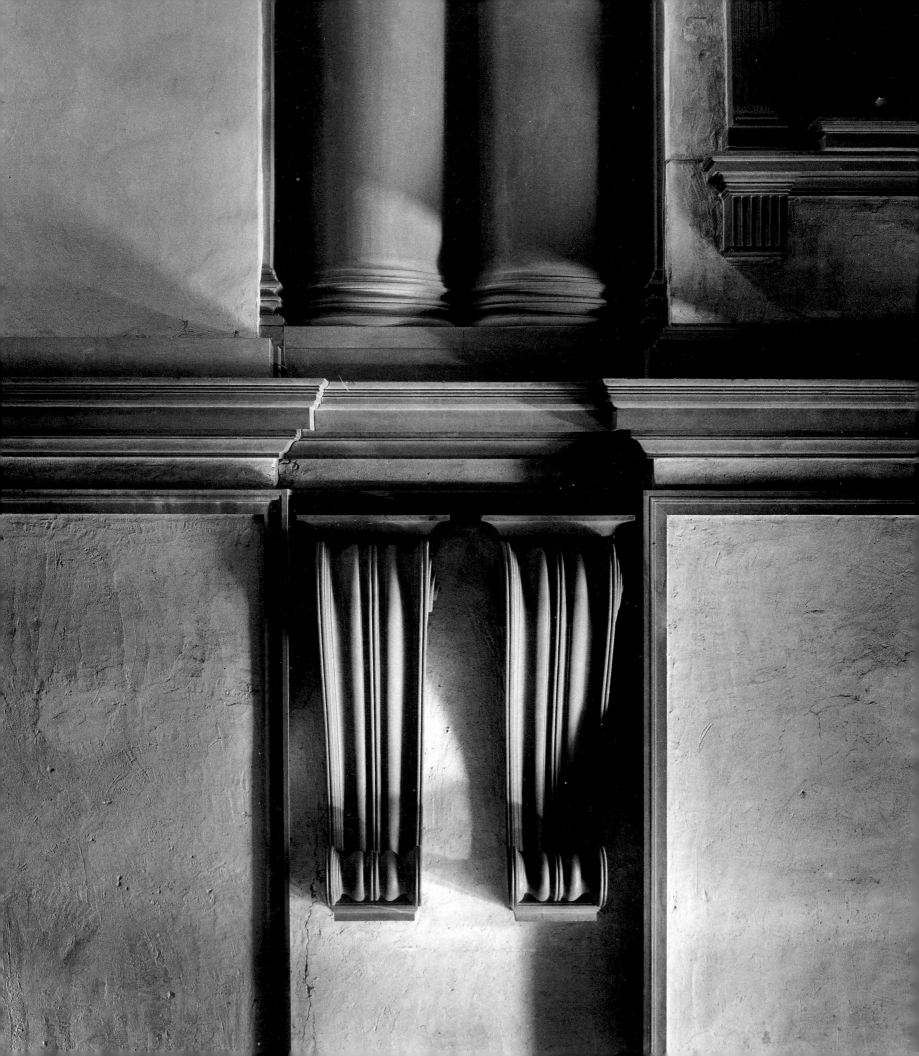

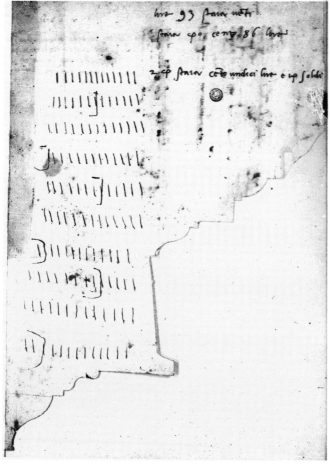

16. *(opposite) Laurentian Library, vestibule, detail of volute brackets under paired columns. San Lorenzo, Florence*

17, 18. *Michelangelo. Architectural profile of door leading from vestibule to reading room of Laurentian Library, and account records. Archivio Buonarroti, Florence, XIII, ff. 127r-v (C. 539r-v)*

pages following:

19. *Tomb of Julius II, detail of upside-down volute. San Pietro in Vincoli, Rome*

20. *Laurentian Library, vestibule, detail of volute brackets under paired columns. San Lorenzo, Florence*

fuoco allor di fuor / che m'arde or drento (Of the fire then outside / which warms me now inside)." The vocality of the verse was perhaps greater in the early poetry, when he looked with approval on the fanatic grandeur of the late, prophetic, desperately ascetic Botticelli. Michelangelo's work with the chisel and burin, simultaneously refined and coarse, is reflected in the physical body of the words, incised, sharpened and moved from one place to another, yet in the end glowing like precious stones. In observing how the work of the written word was carried out with artisanlike skill by means of subtraction, a good case can be made for the abuse of apocopes, apostrophes, and syncopes.

Michelangelo's architecture was very close to his poetry and not just due to the fact that both were metaphysical arts beyond mimesis. In both, he worked with an institutionalized lexicon—of antique architectural icons and of words, all endowed with their semantic sense and purpose. The artist preserved these in his elaborations of them, while at the same time giving them a significance different from the usual one. In the poetry, the meaning of the words changed when, taken out of the usual syntactic context, they were embedded in the poetic one. The same thing occurred with the antique architectural morphology by which the scholars of the Rome school endeavored to fix exact typologies and constant measures. The form of the volute bracket interested Michelangelo as one of the great variables, and he derived satisfaction from that tight concentration of forces flowing outward in the long stroke from the smaller scroll and slowly rewinding into the larger one. He used it, deliberately extrapolated, in the chapel for Leo X in Castel Sant'Angelo (fig. 64), in the Laurentian Library vestibule (fig. 16), and on the final version of the Tomb of Julius II (fig. 19). He valued it for the absence of every functional reason—for its perfect gratuitousness. Was that perhaps why the tragic exertions of the statues were made to bear the weights?

Any mention, however timid, of the definitive ornamental character of Michelangelo's architecture risks being met with derision. After all, it is supposed to be muscular, powerful, titanic, and demiurgical. Instead, it ended in decoration just as the Psalms end in glory. Moreover, it was charged with forces which concluded in a demonstrated futility, just as the struggles of the bound and dying slaves and prisoners were futile. The fact is that he did not accept the classical distinction between construction and decoration, in which the second was to the first as the first was to real space. Instead, for Michelangelo the relationship between the dynamism of load-bearing forces and that of the visible elements was not one of deduction; it was either one of continuity or one of rupture. Vasari was not entirely wrong when he said of the Medici chapel in San Lorenzo that it was "very different from that which by measure, order and rule, men made according to common use and according to Vitruvius and antiquity," and that therefore it had "broken the ties and bonds" of the common operating procedures of the architects, both antique and modern. The great innovation was "the order of the ornamentation," and, naturally, it was a very beautiful thing but not

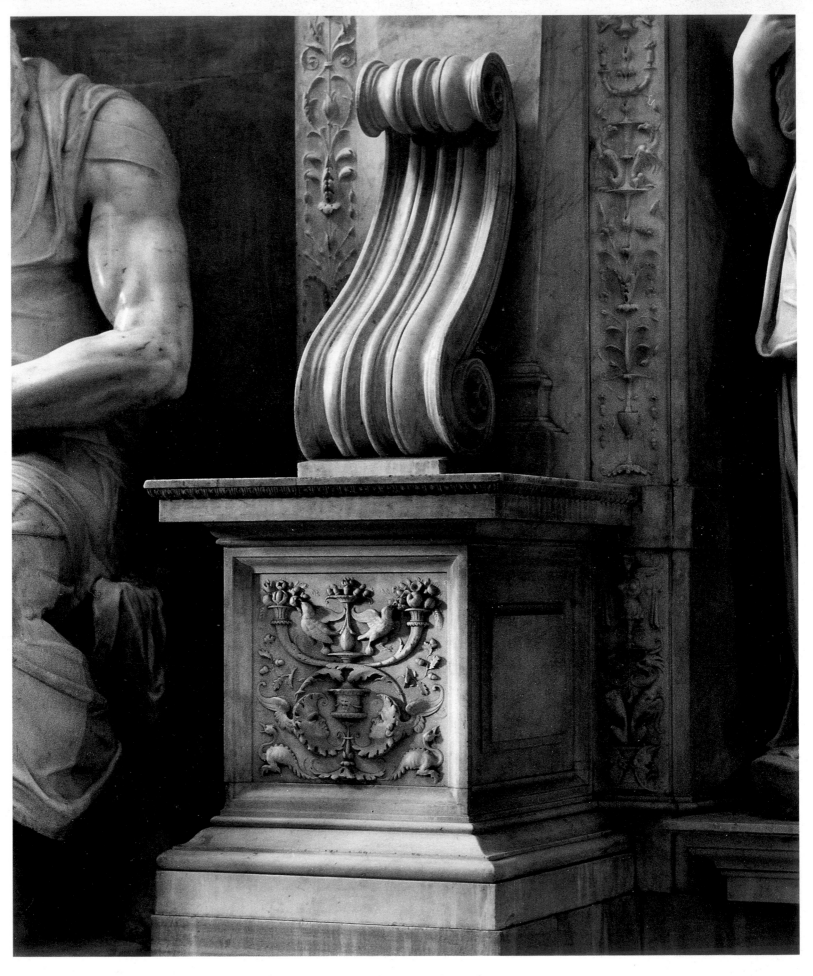

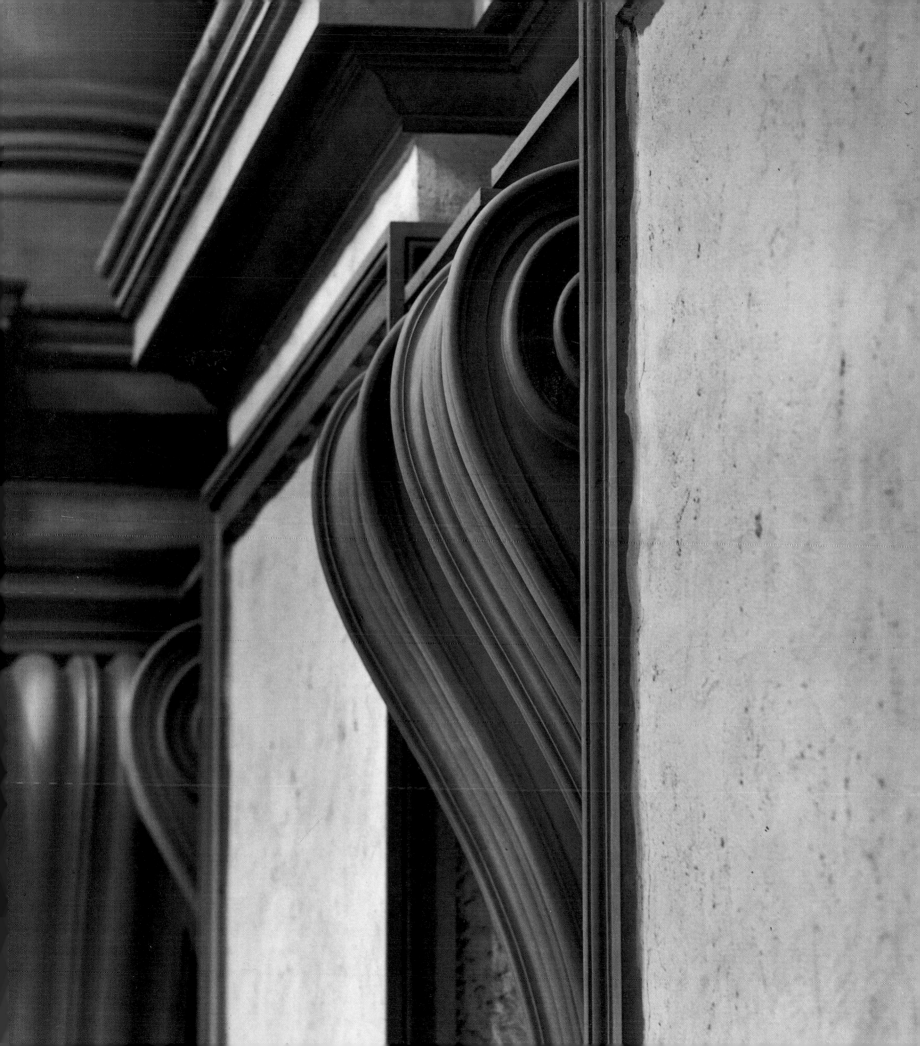

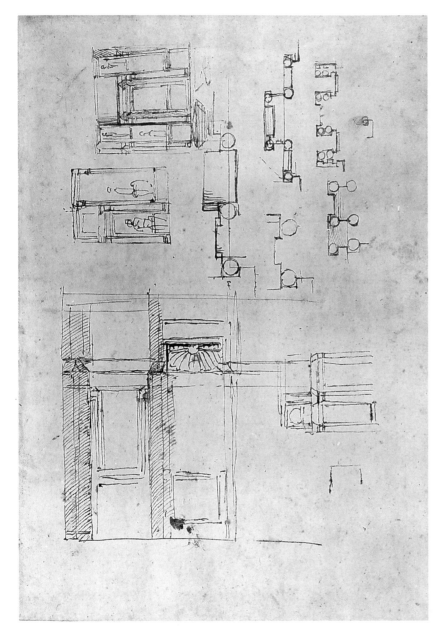

advisable for those who did not have the genius of the "god." This biographer seems to have understood intuitively that through all of Michelangelo's gratuitous decoration ran a physical and spiritual current—an impulse of predetermined renunciation and offering, an enjoyed and suffered experience of the world, which was given back with the purity of a visual litany to the First Maker.

It would be vain to look for a conceptual dilemma in the contrasting pairs which fill up the *Poems* nearly to tedium: life-death, love-hate, spiritual-material, compassion-cruelty, redemption-sin, and so on. These had a remote Petrarchan origin, but they contained nothing of reality; they were names used as icons for concepts. Or, to paraphrase Berni, they were not words but things—"thingified" words. For the same reason, it would be of no use to cede a static rationale to the elements of his architecture. The large volute brackets on the Tomb of Julius II supported nothing; they were arabesques which preserved only in the profile, or curve, the potential for freeing the compressed forces in their static mechanisms. Michelangelo was aware that the architecture of his time had an antique lexicon which could be converted into modern, and this was his intention, at least up until there was resolved in his mind another, greater antinomy between representation-cognition and action-will. The crucial moment was the invention of the Florentine bastions, the imaginary result of whose furiously charged geometries was not construction but the actions of the combatants. The language was not just architecture opened out to all different views as in the Piazza del Campidoglio, nor its contrary sign, all strongly centralized as in the new Saint Peter's. Certainly, his architecture was composition using predefined formal icons, just as his poetry was created by using preexisting words, yet a work of art would not have been whole unless it were also parole. The blow struck on the knee of *Moses* (fig. 33) was more silly story than legend, but everything was asked of this statue made up entirely of large geometric angularities, except that it speak, and yet, strangely, one feels that this powerful image calls the parole, the name. In fact, his work cannot be understood unless attention is paid to the presence of, or the weighing upon by, the parole and its evident or implied symbiosis with visible forms. Michelangelo's importance to the history of epigraphy has been perceived, and Petrucci (1986) also discerningly saw as inscription the blind epigraphs which were a frequent element of great significance in the architecture. For example, the blind windows, a contradiction in themselves, were not there for symmetry with the open windows; what they signified was not the opening towards physical space but its revocation. In the same way, the paired columns of the Laurentian Library vestibule (fig. 138) were "nominally" columns with bases, capitals, and entases, but they were not "functionally" that, because, embedded in the wall, they were the opposite of columns.

To the problem of the parole was connected that of the langue, which Michelangelo did not, however, put in terms of discourse but of Florentineness. At the beginning of the sixteenth century, the question of language, or

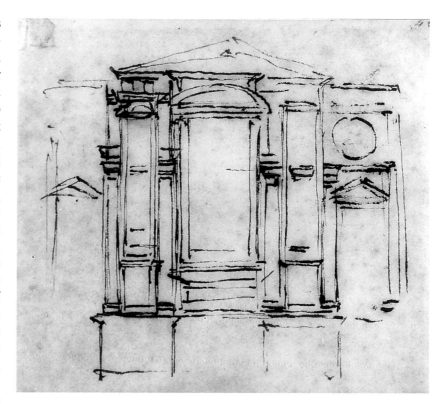

22. (above) Michelangelo. Study for tombs of Medici popes in choir of San Lorenzo, Florence. Casa Buonarroti, Florence, A 46r (C. 277r)

23. (below) Michelangelo. Sketch for Medici tombs. Casa Buonarroti, Florence, A 93r (C. 275r)

tongue, was at the center of the cultural debate, and, with Machiavelli's participation, it also had a political aspect. It seemed necessary to institutionalize an Italian language in order to establish a minimum of cohesion between the discordant Italian city governments at a time when the danger from intervention by foreign powers was increasing. Was status to be given to the political priorities of the apostolic authority of the Rome Curia, or to the brilliant cultural supremacy of the Florentine Medici? With transparent political aims, Lorenzo the Magnificent had sent Botticelli to Rome in 1481 for the purpose of illustrating the neoplatonic interpretation of the Old Testament on the walls of the Sistine Chapel, which Sixtus IV had made the vertex of the liturgy and the ecclesiastical hierarchy. About thirty years later, Michelangelo continued the Biblical-platonic discourse on the Sistine ceiling (figs. 35, 36) with a *visio intellectualis*, which was, in a real sense, the idea of the vision that was held by Florentine culture beginning with Dante. While Michelangelo's worship of Dante is well-known and patent in his poems, Leonardo was said by Vasari to have mocked him. Michelangelo deplored especially, as Botticelli had before him, Leonardo's choice of Milanese technology over the Florentine erudition expressed in the platonic theology of Ficino. He deplored also Leonardo's minimal interest in the problem of the Italian vernacular. Moreover, he saw in him the cause of the deviation of the artistic culture away from strict humanistic historicism, and he believed also that he was the source of the eclecticism which characterized the skillful but mundane Florentine artistic profession in the early sixteenth century. Returning to Florence to complete the façade of the Church of San Lorenzo, in celebration of the importance to Medici rule of finally having its pope, Michelangelo undoubtedly proposed to remedy that deviation from true humanistic culture. In the New Sacristy and the Laurentian Library, he focused on the problem of a dialectic rather than eclectic unity of the arts, because that was the lineage of Florentine culture. And then, in desperation, he witnessed the collapse of the culture with the fall of the Republic in 1530. From then on, the relationship between art and language no longer had meaning for him, and he made of his art a finalized moral act.

It was natural, given his mentality expanded by understanding the identity of differences, for him to see in the defense of Rome from Lutheran aggression the continuation of the unsuccessful defense of Florence from imperial aggression. All of his Rome architecture was manifestly pragmatic and political, not just in the sense of the commission received and carried out but in his autonomous participation and responsibility with respect to the politico-religious struggle. Paul III did not undervalue the importance of this cultural alliance, and he entrusted to the intellectually honest Michelangelo the solemn affirmation of the doctrinal principle of the Visible Church.

"Painting and sculpting no longer bring tranquility to / the soul, turned towards that Divine love," wrote the artist in his old age. By this time, he had detached himself from figural representation, because the figure was some-

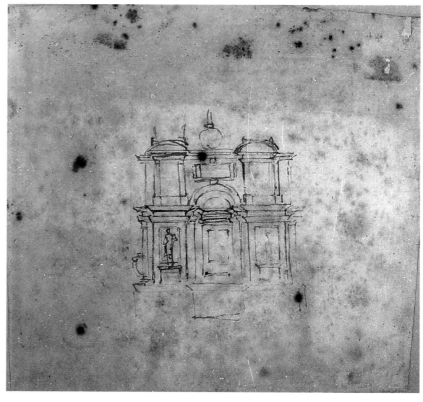

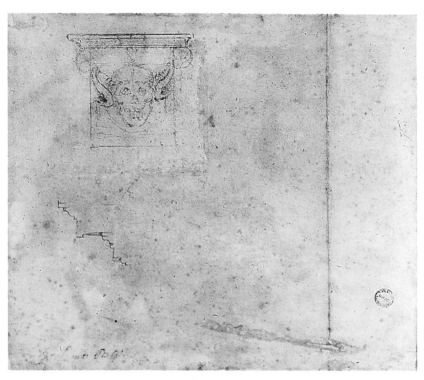

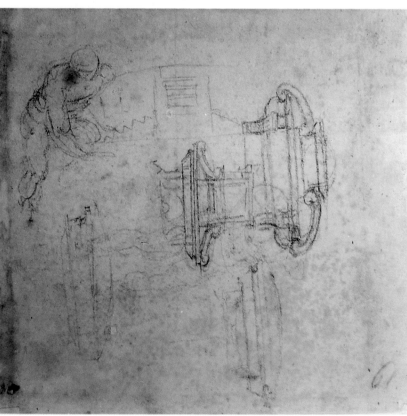

thing intrinsically complete, and to surpass its limits would be to destroy its physical perfection. The *non-finito*, or "not-finished" of Michelangelo had nothing in common with the sketchy rendering contrasted by Vasari with the "finished" manner. He made his art an act of being instead of a way of knowing, and therefore it was constitutionally not finished, like existence. In sculpture, the not-finished was ascertained in the transition by slow gradations from polished forms to coarse workings, which transformed the stone into a material trembling with light—not physical light, direct or raking, but illumination from within that dissolved and regenerated the material. In painting, the not-finished was not a sudden transcendence of an accurate, precise rendering technique, but a deliberate disordering of the images by which perspective was rejected as the space of action. The compositional dissociation and crowding together of the frightened by-standers in the two frescoes of the Pauline Chapel were clear cases of the not-finished *historia* (figs. 313, 314).

As for architecture, it is known that he finished almost nothing of what he began, which proceeded from external circumstances, of course, but also because he continued with planning even when construction had already been halted. Bruno Zevi (Portoghesi-Zevi 1964) wrote some very beautiful pages on the architectural not-finished of Michelangelo, which consisted in substance of a withdrawal from the classicizing equilibrium of weights and corresponding proportions. Proportion was replaced by rhythm, always not finished, and all of Michelangelo's architecture was rhythmic not propor-tional. The drawings, which demonstrate his nervous method of planning, are impetuous inventions which the rapid drawing technique did not take time to transcribe fully. Cases in point are the plans for the Florentine bastions, as well as the designs for San Giovanni dei Fiorentini in Rome (figs. 405–407), which were agitated rethinkings done in fear that his ideas would be travestied by those who executed them. Vasari said that, in order to prevent this, Michelangelo made use of certain binding "verifications," for which there would have been no need had there been a regular stated or quoted plan of execution. Beyond any casual empiricism, he dedicated himself to the difficult mathematical calculations necessary to provide a solution for the problem of superimposing two equally hemispheric "caps" on the dome of Saint Peter's. Why else would he have given Vasari a meticulous description of that research, unless it were to show that his planning was a process of mathematics and not of construction technique? While racking his brain over that squaring of the circle, he wrote to Vasari that, if he were not successful in raising this dome before he died, it would be a sin and a disgrace which would defer the salvation of his soul. The planning was in sum a desperate intellectual and religious effort, but it is difficult to see how it could have been of use for the disposition of the workshop. It is possible that he suffered from senile mania and phobia, of course, but the circumstances suggest that he had never had a studio equipped to make what one calls an executional plan. In any case, he never completed a plan which could easily be carried out by a workman. This was

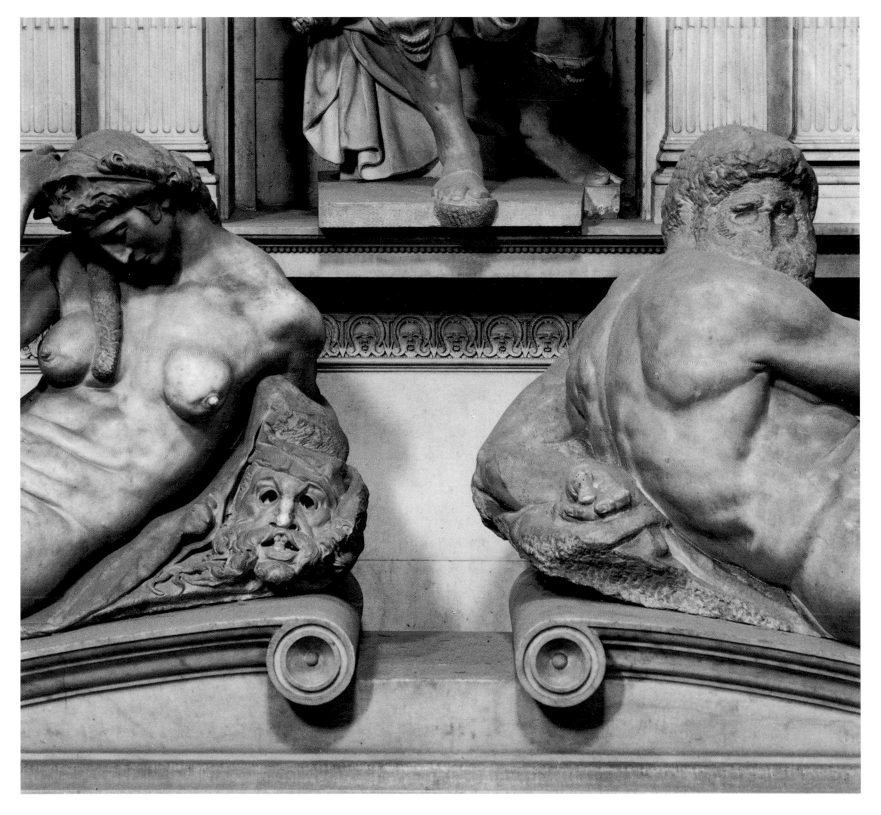

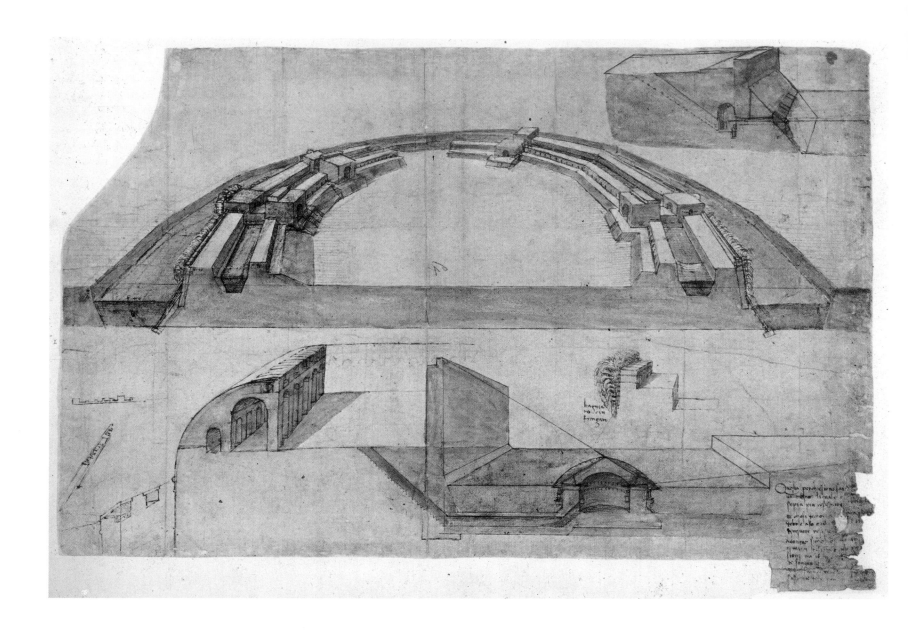

not due to any uncertainty about technique in an art which was not properly his. It came instead from his concept of art as something purely intellectual or spiritual, and from the necessity therefore to disconnect it, little by little, from every conventional, workaday involvement.

The "not-finished" was not a result of interruption or suspension caused by external circumstances or even by intervention from internal agitation. It was something intimately tied to the concept, or even to the destiny, of Michelangelo's architecture. It was seen in the sculpture (and really to the limit in the architecture) of the New Sacristy in the decomposition of the funerary monument on the walls (figs. 121, 122)—the movement from an earthly spatiality invaded by the allegorical statues of time to the spatiality of the beyond and the empyrean, and the reciprocal integration of not-finished statues of a not-finished time with those, finished, of the dead dukes. The architectonic not-finished is exemplified also in the slight, scarcely strident proportional discrepancy in the perspective of the reading room, and the disturbing enigma of the columns and the staircase of the vestibule in the Laurentian Library (fig. 148). Not-finished too was the multidirectionality of the Piazza del Campidoglio (fig. 319) and, especially, the treatment of the wall surface in the new Saint Peter's (figs. 396, 397), a continuous turning between inside and outside as in sculpture, from salient to profound, from front to back, and vice versa. There was no longer a counterpoised logic between those opposed values but an anxious avoidance of the firm opposition of external and internal as they would normally exist. The plan of the new Saint Peter's (see fig. 384) was all extension and retraction of those enormous, articulated pilasters towards the inside and the outside, although not for the purpose of creating wall divisions. A statue was never seen in its entirety, frontally or from the back, and yet in the frontal view, the nonvisible back was imagined or perceived by intuition. Michelangelo praised the very different plan of Bramante, all balance and formal clarity, but it had been created to give the appearance of a secure institution. Secure no more, the Church had become endangered and in need of being defended with zealous strength, yet with a heart full of concerned love. The intention was the same, but the concept was different.

Michelangelo, through his close friend Vittoria Colonna, was tied to the moral rigidity and asceticism of the Catholic reformists, who condemned the practices of the Roman Church but nevertheless defended its doctrinal integrity. Was it possible for the Church in its struggle over the contested "real truths" to feign a certitude of fifty years earlier and conceal the actual tensions and anxieties? Michelangelo created in that solemn work of Saint Peter's an alternation of opposing thrusts and contrary concepts, of rising up and falling back, that characterized his love poems. Through the existence of the courageous and ardent faithful, the existence of the Church was neither finished nor unfinished, but not finished.

Scholarly interest in the "not-finished" has turned attention away from the problem of the "not-begun," when in fact Michelangelo began almost nothing in his architectural career. The New Sacristy repeated in terms of volume the Old Sacristy by Brunelleschi, and the Laurentian Library rose on the preexisting body of the Convent of San Lorenzo. On two of the three Capitoline palaces, he only changed the façades, and the new third palace mirrored the one it faced. The Farnese Palace was three-quarters built and the fabric of Saint Peter's was already well-advanced. The ruins of the Baths of Diocletian were there and, left as they were, they became a Christian church. Michelangelo apparently was not interested in erecting monuments but in intervening with force in existing ones and changing their meaning, often with only a few energizing features. This was neither chance nor choice but a factor of his way of being an artist in a world where all was changing. In a similar manner, he did not exalt, investigate, or interpret the human figure in his painting and sculpture, but took it instead as a handed-down icon, an image almost without meaning, for "re-signifying" or "re-semanticizing."

No claim can be made that any of the architectural works done to impact strongly on a particular situation lived beyond and eternalized the artist. Saint Peter's, as Michelangelo conceived it, was the image of the threatened and defended unity of the Christian world. Then Carlo Maderno transformed it at the height of the Counter Reformation, when ceremony counted for more than the Eucharistic rite and the space of the congregation was separated from that of the religious hierarchy. A little less than a decade later, Gianlorenzo Bernini modified and transformed its spaces again, because, with the missionary work of the New World, the Christian ecumene had a quite different radius and horizon. And the re-signification of the antique given by Michelangelo to the Church of Santa Maria degli Angeli was re-signified again in the eighteenth century by Vanvitelli, because it did not fit the neoclassical ideal. For Michelangelo, the antique was *so-sein*, a reality ineluctably dead, which only a thaumaturgical gesture could resurrect, changing pagan into Christian. For the neoclassicists it was an ideology, albeit expressed in a rather confused way by Vanvitelli. The *templum Virginis*, which for Michelangelo was a re-signification of the pagan *idolum*, was seen by Vanvitelli in relation to the new ideology as an image of compromise.

Not-finished meant also that an image was not dealt with as a finished thing in a finite space. The architecture of Michelangelo was intolerant of its own objectival limits, yet it was not harmonized with its surroundings. Too much has been said about Michelangelo the "urbanist." In the accepted meaning of that term, he was not an urbanist but the contrary. Nevertheless he was acutely conscious, as no one else before him, of the historical and ideological value of the two cities in which he worked on architecture—Florence as David, and Rome as Moses.

In Florence, while working on the church and convent of San Lorenzo, he said nothing about his concept of the city, yet when it was threatened by siege, he thought about and took on the responsibility for its defensive armament. Although he did not do it intentionally, the enterprise of the Florentine fortifications became the final act of his anti-Leonardoism. Leonardo, without doubt a great master of military and fortification arts,

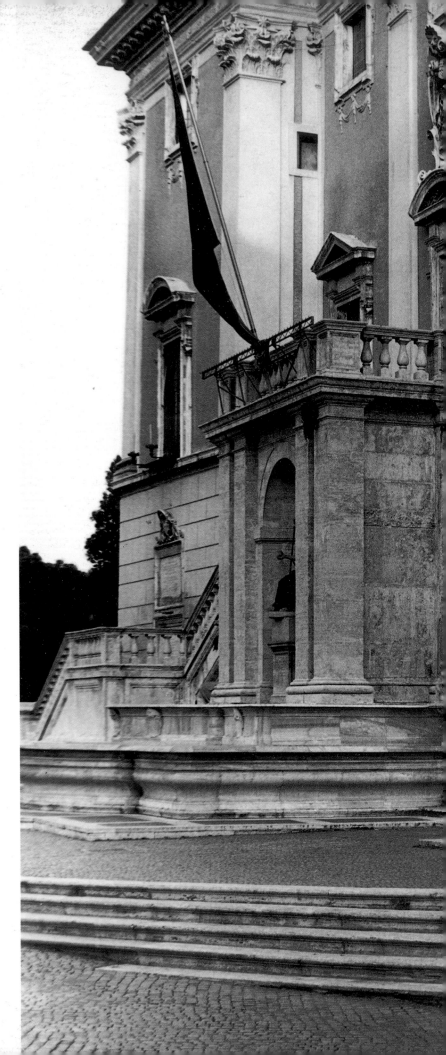

thought of war as a furious but well-organized mechanism. The problem was the same, but, with technical progress and the widespread use of artillery weapons, the strategies and tactics of offense and defense had changed, affecting also the form and function of the city walls. While the fortifications of Leonardo (fig. 27) were non-heroic, sophisticated equipment of war, Michelangelo's (figs. 158, 159) were an expression of the political passion, or *furor*, of the city and the Republic in danger, which, conscious of its weakness, compensated for it with the "courage and anger" of its fighting citizens. Florence was David who would strike down Goliath, and the fortifications were conceived and designed by the artist as the armor of a fighting city.

In 1534, with Florence still wracked by internal turmoil, Michelangelo left that city and became deeply involved with the problems of Rome, which had suffered the same fate three years earlier. His conception of this city and its ideological and historical significance was also not necessarily urbanistic. He was never concerned with who the people were, how they lived, or even what their needs might have been. In his mind, Rome was not a grid of houses and streets but a constellation of places which had been consecrated by ancient pagan and Christian history, and this sacred quality of place supported the authority of the pontiff. But Protestantism had contested the truth of its historico-ideological value and was seeking to break the nexus which tied the past to the present.

For Michelangelo, Rome was antiquity, but the ideal solution to its problems was not antiquity, which was a problem in itself and therefore tied to the problematic character of existence. Existence meant having an awareness of one's own being in the present, as well as an awareness of oneself in confrontation with the past. Michelangelo was far more than just an instrument of the action of Paul III against the Reformation. No other intellectual before him had been made a participant in so much power and invested with so much responsibility. In the construction of the new Saint Peter's, he was given the authority to demolish everything that had already been discussed at great length, approved, and in part executed. That church was a hot spot of conflict on the moral and doctrinal level, and defining its form was the equivalent of enunciating a dogma of faith. It is hard to believe that the scholars themselves were not aware that, in the conceptual debate of the time, only the ideas of Erasmus of Rotterdam were equal in profundity to those of Michelangelo. These were expressed not only in the project for the new Saint Peter's but also in that for its complementary, the Piazza del Campidoglio.

This complementary relationship between laic and apostolic poles was part of the political scheme of Pope Paul III, who made the decision to renovate the Capitoline area. But it was Michelangelo who defined and made manifest the ideological contents of the piazza design in relation to the new Saint Peter's, even before he knew that he would be called on to define the theological content and form of that church edifice. Already in the design of Antonio da Sangallo the Younger being carried out, the church

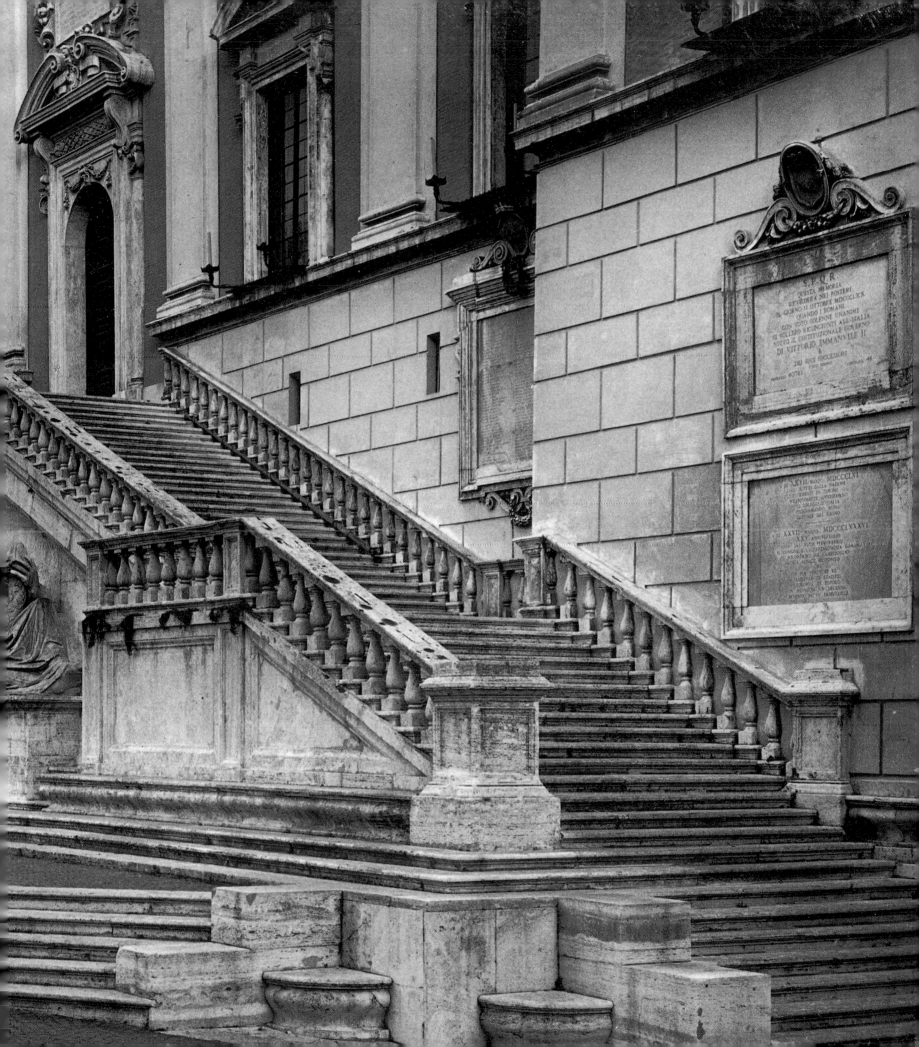

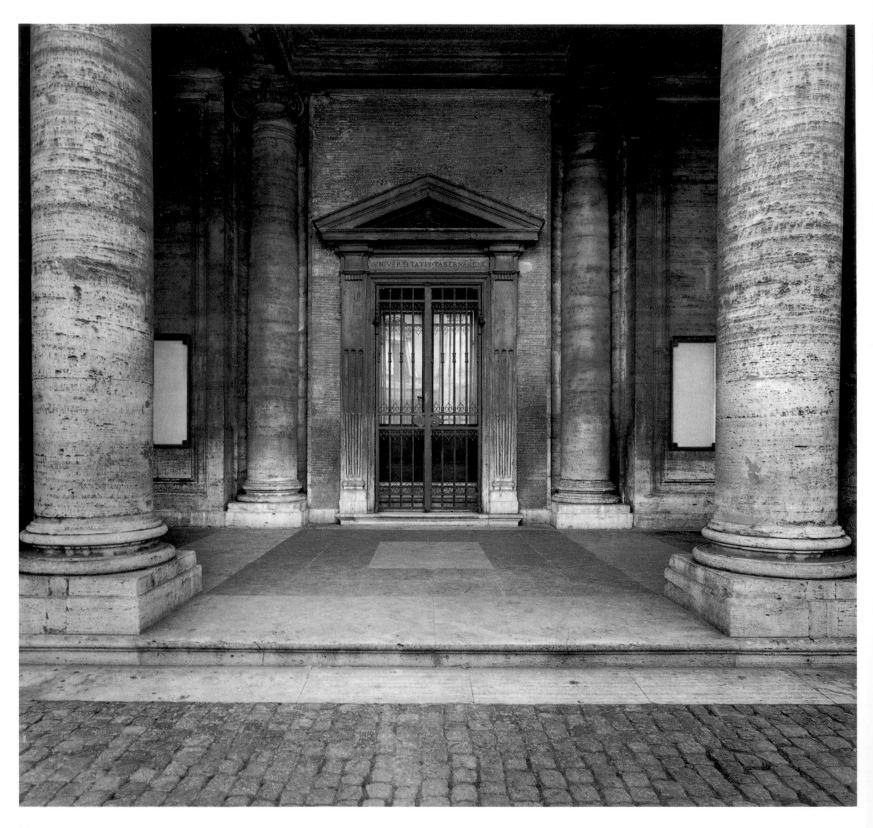

structure was a closed form with a system of mounting, converging forces, and it was precisely this tendency towards height that Michelangelo intensified when he succeeded Sangallo as head of the Works of Saint Peter's. That he viewed the double powers of the pope as an absorption of differences is demonstrated by the fact that he conceived the Campidoglio as an open structure made of diverging perspectives, deviating planes and differing levels. More an echo than an analogy, the centralized plan of Saint Peter's was a development on a grand scale of the New Sacristy, just as the open scheme of the Piazza del Campidoglio recalled the laic Laurentian Library, thus the same conjunction of religious and laical powers created in Florence was now made manifest in Rome. The unification of the two lines of papal power was expressed equally by Michelangelo in the re-signification performed at the private palace and court of Paul III Farnese by imposing there an entablature which, whether tiara or crown, was nevertheless an external sign of royalty (fig. 339).

To the very last, Michelangelo continued to define every concept by contradiction with another. The agitated designs for the Church of San Giovanni dei Fiorentini would appear far too dynamic, were it not taken into consideration that the reference, by contrast, was the massive round fort of Castel Sant'Angelo opposite it on the bank of the Tiber. In comparison with that antique Imperial mausoleum, the Christian church was full of violent and repressed tensions. It was impossible to work in Rome without confronting and in some way resolving the difficulty of the coexistence of the antique and the modern. With the advance of Counter Reformation moralism, the antique was no longer the model of perfection, and architecture was done in Latin, just as the mass was done in Latin. The elderly Michelangelo did not refuse to build a modern church out of the *tepidarium* of the Baths of Diocletian (fig. 419) just out of respect for the antique context, but also because the survival of those ancient walls was the will of Providence. The presence of the antique, in sum, gave witness to the greater glory of God. On the other hand, the antique was easily recreated in the modern with full freedom of license—just two steps away from the intact and rebuilt Baths, Michelangelo invented the Porta Pia (fig. 415), almost a joke done in "dog Latin." As Ackerman acutely observed, the theme of the city gate was in vogue, as proved by Sebastiano Serlio's remarkable book. The Porta Pia was like a backdrop for a scene of the *commedia*, because the modern city was like a theater (which would later be the *idée fixe* of Bernini). The worldly city had its elegance, of course, but nothing of the courtly.

To his contemporaries Michelangelo appeared to be the master of the irregularity that was allowed to genius. It is understandable that he was detested by the speculators of the "Sangallo Sect" ejected from the Works of Saint Peter's, because, as Michelangelo said, it was only a factory for them to make money. But even among the genuine professionals, his architecture aroused only perplexity and more or less veiled dissension. Pirro Ligorio, the erudite scholar of the antique called to work on Saint Peter's with Vignola, preferred to resign his position rather than give substance to the "broken orders" of Michelangelo. While Vignola did not actually resign, he talked of doing so two years before Michelangelo died. Whether catechism, code of behavior, or just a reference manual, Vignola's *Regola delli cinque ordini* (*The Rule of the Five Orders*) was surely written to protect architects from the temptations of unregulated creative genius. In the time of the Counter Reformation, the antique was less important as a source of authenticity than as a discipline which ought to be obeyed. In his final years, Michelangelo, who had never really deepened his knowledge of the architecture of antiquity, actually studied it in the texts, in the scholarly designs of Giuliano da Sangallo, and also in the central-plan Late Antique architecture of Santa Costanza, Santo Stefano Rotondo, and the Lateran Baptistry, which fascinated him because he saw in them the passage, or conversion, from the pagan to the Christian. Vignola, erudite and otherwise pedantic but always the true professional, was not fond of the direct study of antique texts. Although now and then it was necessary to give an order to a capital, the political importance of which grew every day, a good prose was much more useful than a poem. This would be seen twenty years later, when Domenico Fontana redesigned Rome for Sixtus V.

Michelangelo as an architect did not create a "school," but others were obliged to take sides for or against his position. In Rome the moderates prevailed and in Florence the eccentrics, but the dissent was only superficial. The classical rule was no longer a dogma of faith but an aid to planning, which not only admitted but favored the exception. Even for Vignola himself, as seen in the Villa Farnese at Caprarola, the rule which was promulgated did not impede inventive freedom. As it is known, when the moderates saw that they were not able to repress the new, they assimilated it in some way. One observant and modest supporter of Michelangelo, with some permissible extravagance, was Giacomo del Duca, who worked on the Porta Pia. But Vignola, Giacomo della Porta, and Carlo Maderno converted Michelangelo's architectonic poetics into a decorous and demure parochial sermon in the belief that the very form of churches ought to act to persuade the viewer, if not to sublime truth then at least to correct religious deportment. Della Porta transformed the dome of Saint Peter's, which Michelangelo had rendered hemispheric, by raising its sesto to lift the eyes heavenward. Maderno subverted the centrality of the original plan, grafting onto it a nave destined for the homage of the faithful to the pope as he was carried in on the Bishop's Chair. With that anterior lengthening of the arm of the cross, the colonnaded porch no longer had the meaning nor, in that climate of post-Tridentine devotionality, the implicit recollection of the Pantheon. Maderno respectfully kept the façade low, however, so as not to offend what was left of the symbolic authority of the set-back dome. But it was a backdrop which presupposed a piazza, necessary anyway for the worship of the crowds which could not be accommodated on the interior of the church. Bernini actually designed the piazza, but Maderno had unintentionally already given the church a "coupling" with the city, which was certainly not predicted in preceding plans. The shape of the city was

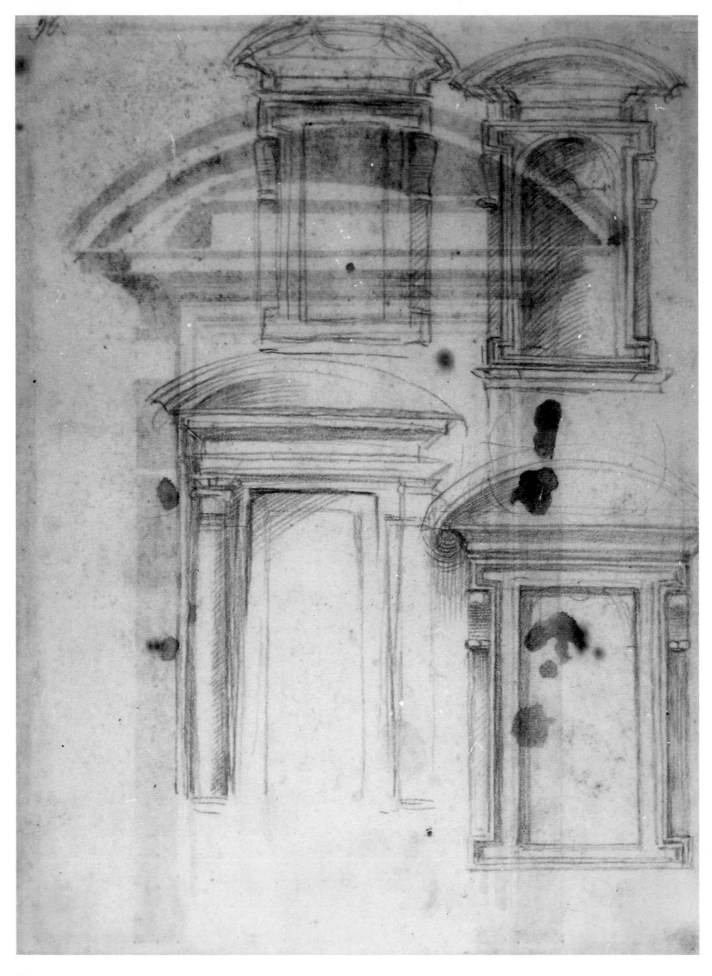

changing rapidly due to social interests connected with the politics of the Counter Reformation. The new urban planning allowed for broad development of general construction and required able workers who would cause no serious problems.

In interpreting Michelangelo's architectural heritage, Rome and Florence again differed; the approach of the Rome circle was deferential but reductive and moderating, while that of the Florentines was sophistic and eccentric. The very respectful attitude of Cosimo I de' Medici and the friendship of Vasari had brought Michelangelo in his old age back in close contact with Florence and Medici patronage, but it fell to the refined architect Bartolomeo Ammanati to interpret the ideas of the master in that city at least twice from rather summary documents. He carried out from a clay model the "ovate" staircase of the Laurentian Library, but with a more courtly elegance by making it of marble instead of walnut, as it was in Michelangelo's concept. Although it is not known how precise the suggestions were for the Santa Trinità bridge, brought to Florence from Rome by Vasari, very probably there was a basic concept by Michelangelo to which Ammanati added his own refinements of the assonance between the pylons and the flow of the current and the sensitive correspondence between arches, roadway level, and surrounding hills, all of which were clearly in the elegant taste of Grand Duke Cosimo's court.

Vasari was an intimate of Michelangelo, and the biography he wrote from firsthand sources has the value of authentic testimony. In painting, he imitated verbosely the design of the master's compositions but with far too much drama. In the greatest of his architectural works, the Uffizi with its two façades confronting each other across empty space, he showed that he had captured the innovative aspect of the Campidoglio in terms of the symmetry of the two palaces acting as the walls of a piazza. It was really Vasari who orchestrated the Michelangelo scholarship in the Academy of Florence founded by him in 1563 with Vincenzo Borghini. But it was also Vasari, the Mannerist, who paved the way for the fatal decline of art after Michelangelo *il divino*. Of what use would geniuses be, if, from heaven, they did not protect the mediocre?

In the work of Michelangelo, there was a weak link with Venice. The corona of light sources at the base of the dome in San Marco is perhaps reflected in the large windows of the drum of Saint Peter's. Frightened by the siege, Michelangelo had escaped from Florence in 1529 and gone to Venice. It is not known if he encountered Sansovino, there since 1527, who was very close to Titian and desirous of impressing his warm, palpitating light on architecture. He succeeded in doing this in his façade design for the Library of San Marco, of 1537, modeled in high relief. Michelangelo could not have seen the actual structure by Sansovino, but certainly the comparison is remarkable between it and the planned front for the Conservators' Palace on the Campidoglio only a few years later, in spite of the fact that Michelangelo's design was sharper, the distinctions more pronounced, and the light striking the giant order of pilasters more intense. Even Michelan-

gelo, according to how much they pleased him, took his ideas where he found them.

The most eccentric of Michelangelo's Florentine followers, albeit indirectly, was Bernardo Buontalenti, who was really formed by what Ligorio called the breaking of the orders. For the Medici Casino, he redesigned with sagacious, critical intelligence the "kneeling" window which Michelangelo had made for the Medici Palace in Florence. And elsewhere, he even cut the lunette of the window pediment in half and turned the two sections outward (fig. 513). Vasari was not completely wrong to fear that the Michelangelesque taste in decoration would end in pure folly. But, thanks to that folly, Buontalenti overcame the pious scruples of Michelangelo, coordinated architecture with the garden, ennobled the crafts of goldsmithing and *pietre dure*, and made a science of gaiety, or, as Nicholas of Cusa would have said, of *garrula ratio*. Was not Michelangelo the first to believe that the domain of the arts was the irrational?

But this was not what scandalized the Florence Academy founded in Michelangelo's name and on an interpretation completely in terms of supreme beauty, which Benedetto Varchi also gave to his poetry. The dispute was not over the austere versus the fantastic, now equally permissible in Florence, but over the design as the idea of art which took precedence over the technical execution. Michelangelo, in his own work, had declared the value of artistic thought and its absolute disciplinary autonomy, without the guarantee of either mathematics or history.

When the dialectical game of "the rule versus the imagination" was ended, Michelangelo was seen not as a miracle but as a problem. His approach to representation was debated at the beginning of the new century between Annibale Carracci and Caravaggio, and, at the middle, his architecture was interpreted in opposite terms by Bernini and Francesco Borromini. During the same years when Descartes was defining the characteristics and limits of ratiocination, Bernini defined those of the imagination by its verisimilitude (distinct from chimeric fantasy, which he attributed to Borromini) in the opening out or the contracting of the human mind, searching for ever wider horizons or ever steeper ascents. Both artists moved away from Michelangelo, with Bernini opening up Saint Peter's to *urbi et orbi*, and Borromini making a foolhardy intellectual exercise out of a faith already lost.

With his architecture, free of allegorizing representation, Michelangelo posed the question not of perfection in art but of its intrinsic, irreducible problematicity. This was his legacy to the modern world. He spent his life in search of a perfection which was from the dead art of antiquity, and finally he resolved it—but negatively. The antique no longer had the power to orient the modern, and the neoclassicists evoked it only to make it a philosophy. He demonstrated especially in his architecture that he was not a giant nor a demiurge but a profoundly distressed artist. Having sadly dismissed the protective past, he could see that Leonardo was not the cause of what was happening in the art world. He was frightened by this.

Chapter One

BEFORE
ARCHITECTURE

"There is no harm equal to time lost." Poems, 51

For Michelangelo, having bound together his reason for being with the aims of art, as much due to the pain of existing as to the uncertainty of knowing, there was no separation between the crises of his life and those of his art. Vasari's biography of him, as of no one else, has a very different tone, as if the way of being an artist and making art had changed with this "god." Anticipating the Romantics, Michelangelo dedicated and also sacrificed his life to art. As Merleau-Ponty said of Cézanne, he made that life in order to make that art. Moreover, because he wished his art to be invested directly with a true and inalienable authority (from 1505 on, he worked almost exclusively for the popes), the crises of his work were not only the crises of his life but those of his historical time as well. He lived frantically the tragedy of Florence and the collapse of its humanistic ideology, and then the religious anxiety of the threatened Church. The first of these experiences led him to cease as unprofitable his purely intellectual search for unification of the arts within a superior concept of Art, and thus to move from ideation to action. The other caused him to reject the classical alibi of idealizing and cathartic mimesis, first renouncing sculpture and painting in favor of architecture and then, in the presence of death, even architecture, almost as if to demonstrate the impotence of human actions in confrontation with the Divine.

There was, in the early years, another crisis—that of his relations with authoritative power in the abrupt and unmotivated interruption of the ambitious project of the Tomb of Julius II, envisioned by him at that time as a total work of art (No. 1). This affair then dragged on for a mortifying forty years, during which Michelangelo saw the progressive reduction of the project and the painful, to his eyes almost ridiculous, final result in the Church of San Pietro in Vincoli. Although it seemed to him, and in a certain sense was, the wreck of an ideal of monumentality, the important fact remained that, even "patched up and redone," the tomb was "nevertheless the most noble one to be found in Rome and perhaps anywhere" (Condivi). For us, it was the manifesto of Mannerism in architecture.

Certainly Julius II did not call a halt to an enterprise undertaken for his own glory because of a whim or as a superstitious gesture to ward off evil. Probably, it was the power of the institution that prevailed over a personal ambition considered inopportune. For Michelangelo it was the ruin of his *Gesamtkunstwerk*, which explains his rage, his flight from the Rome Curia back to the intellectual refinement of Florence, and then, after his obligatory return, his desire for vindication in the Sistine Ceiling. All of this can be read in the authorized biographies by Vasari and Condivi, who also recount the long, humiliating dispute with the heirs over the funerary monument of Pope Julius II.

The radical refutation of Leonardo da Vinci was the greatest objective in Michelangelo's mind. In the hierarchy of the arts, Leonardo had given first place to painting as more ductile and sensitive in registering the movements of a reality constantly in the state of becoming. Michelangelo's preference was for sculpture, because of its reductive method of creation in which the

image was "freed" through the destruction of the material. The Tomb of Julius II was to have been the triumph of sculpture, just as Leonardo's *The Last Supper*, in the refectory of Santa Maria delle Grazie in Milan, had been the triumph of painting. Located in the choir of the new Saint Peter's, the tomb monument would have reduced the architecture to negative space around its sculptural mass, which explains the hostility of Bramante. Moreover, the architecture of the monument was not actually designed but rather grew out of the displacement of the sculpture, which was the generator of its salient dynamic and, assuredly, the root of the relationship which Michelangelo saw between architectonic elements and parts of the body with their movements. This was the conceptual assumption that the monument would have demonstrated, along with an emphatic elegy to the pontiff as patron and arbiter of all, including the arts.

All of Michelangelo's work developed as the uneven but coherent forward progression of an idea that never retraced beaten paths. When the tomb project was interrupted, seemingly with little hope of resumption, the path of that idea continued elsewhere—precisely, in the painting of the Sistine Ceiling. But the matter of the tomb was not closed. The executors of the pope's will demanded the completion of the work, and it went forward between postponements and reductions until the enervating struggle ended, sadly, in the tomb of San Pietro in Vincoli, the most disconcerting of Michelangelo's works.

Having defined the problem of the union of the arts elsewhere, Michelangelo, in resuming work on the tomb, would have sought to avoid routine in changing the design for it. All of his work implied a continuous, rigorous self-criticism and self-improvement, even though self-criticism was the opposite of traditional practice in the arts. In spite of papal "absolution" and his increasing successes, that monumental tomb, for so many years suspended, resumed, and postponed, was, by the time of the maturity of the artist, an indelible defeat that remained on his conscience—or rather in his unconscious—like an inferiority or guilt complex. Perhaps this failure helped to convince him that art was totally, constitutionally, incomplete and imperfect, and that its real truth consisted of this existential condition which had to be sublimated in religious life. That the experience of painting the Sistine Ceiling had distanced him from the full volumetric aspect of his first design is demonstrated by the second one of 1513, in which the tomb is backed against the wall and orchestrated with a choir of statues on an expanded background surface. It may well have been this design which inspired Leo X with the idea to have Michelangelo design the unfinished façade of the Church of San Lorenzo in Florence, constructed by Brunelleschi for Cosimo de' Medici il Vecchio (fig. 96). It was believed that a structure of longitudinal perspective could only have a façade based on a bisected plane, and, wanting to give it prominence, the pope pictured the San Lorenzo façade as an exhibition of sculpture. For that reason, he gave the commission to Michelangelo, even though the artist had done little or no architecture. In spite of his inexperience, however, Michelangelo gave true

architectural consistency to that frontal plane in the development of his design. Thus, in the course of departing from sculpture and passing through painting, he became an architect.

The tangled, not wholly edifying maneuvers around the façade of San Lorenzo (No. 7) have confused things to such a degree that it is difficult to explain why, outside the pretext of the Lombard war, the Medici ultimately rejected this showy glorification of the family. It is clear that Michelangelo had asked to have sole responsibility for the project, which may be explained both by his overwhelming ambition and by his relationship, not sympathetically reciprocated, with the Florentine artistic community. Sansovino, its most important representative along with Andrea del Sarto, did not hide his resentment. After all, Michelangelo had strongly praised Pontormo, thereby contrasting him, without actually saying it, with the reigning eclectic artistic professionalism.

I agree with Ackerman that the church façade conceived as a rigorously perspective organism was a problem left unresolved by Brunelleschi—at San Lorenzo as at Santo Spirito. Clearly, the simple "halving," exemplified by Cronaca's façade at San Salvatore al Monte, concluded the volume of the building but created no impact on the surrounding space. Giuliano da Sangallo, the single influence on Michelangelo in the phase of his approach to architecture, had given the bisected plane true plasticity in his own proposal for the San Lorenzo façade through the proportional squaring and the projection of the cornices (figs. 182–184). And this was the point of departure for Michelangelo, but, in comparing the three stages of his planning (figs. 98–100), it is obvious that his aim was to translate the graphic proportional squaring into consistent sculptural elements, even at the cost of forcing an implicit equilibrium. In this way, he departed little by little from the Sangallo solution. Baccio d'Agnolo, Michelangelo's last assistant and subordinate collaborator, was obliged to draw attention to this divergence from the geometric laws of proportionality in his translation of the master's final design into the wood model (fig. 101), which Michelangelo then criticized as "a childish thing." Unable to accept this exhortation to moderation, Michelangelo moved even further in the direction of a solution that reduced to a minimum the mediation of the wall plane between the anthropomorphic plasticity of the statues and the geometry of the structure.

From the drawings of the first two designs (figs. 98, 99) is seen the proposal to preserve the Sangallo scheme but to redesign it with different energy, changing the proportions of the squares and the strength of equilibriums achieved with regard to the load-bearing forces. We now know with maximum probability the design for the façade developed by Raphael, which Leo X initially intended to have carried out at San Lorenzo (fig. 97). This façade, which had its own volumetric autonomy, was an external architecture placed in front of the internal, whereas Michelangelo's design counterposed a façade conceived as a *schiacciato* relief that stood out very little from the wall plane, a motif derived from Donatello. The elements

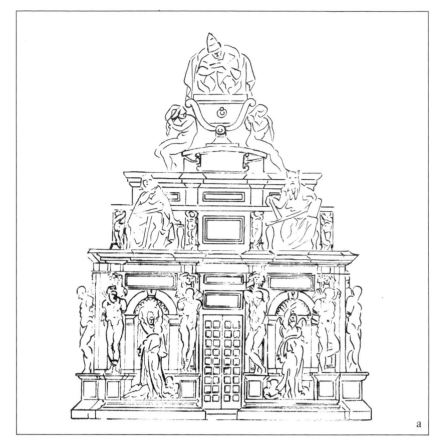

a

corresponding to the three interior nave aisles were volumes which projected and then receded, and weighing upon them with their iconic semanticism were the pediments, triangular at the center and rounded at the sides.

In his third, definitive drawing (fig. 100), from which the wood model was derived, Michelangelo dared finally to liberate the façade from all obvious correlations with the interior by creating a rectangular, sculpted screen divided into three registers by strongly projecting cornices. In the drawing, although eliminated in the model, an articulated cornice runs longitudinally across the mezzanine, establishing on that intermediate level an equilibrium between weight and thrust. The relationship with the volume of the church structure was still there but pushed to the ends, where two short cornices extended onto the sides and ordered the perspective of the walls. It was again a foreshortening on the perpendicular, as so often seen in his sculpture and painting. The layout of the whole Medici area had been planned originally according to a system of Leonardo's, and Michelangelo wanted to oppose to this rational space a façade which would have an authoritative impact on the piazza in front of it, although certainly not for urbanistic reasons.

Returning to the matter of the Tomb of Julius II, it continued to torment the artist through litigation, phases of work on it, and fits of remorse lasting another thirty years (No. 5). When it came to an end with the final, ambiguous version installed in San Pietro in Vincoli, it was the admission of a suffered defeat for Michelangelo. Subsequently, he applied himself to the frescoes of the Pauline Chapel, a supreme moment of his religious calling, and to the planning of the Piazza del Campidoglio on the Capitoline Hill, which made manifest the clear stand he had taken with regard to the problem of the antique. Since the first design for the Tomb of Julius II was conceived nearly thirty years earlier, much had changed—the concept of art and the vital interests of the artist, to begin with, and also the political aims of the papacy, as well as the position and doctrinal authority of the Church of Rome.

Tolnay (1954) made the most reliable reconstructions of the four designs that preceded the final, executed monument described by Condivi on the artist's authority as "patched up and redone." The first design of 1505 (fig. 31a) was a pyramid of three large steps with groups of statues on each level, surmounted by the bier of the pope. The second of 1513 (fig. 31b) followed immediately after the painting of the Sistine Ceiling, and the experience of that composition was reflected in the design (cf. fig. 36). Backed against the wall, it consisted of only two steps topped with a disproportionately tall pediment equal in height to the sum of the other two levels. This approximated the disproportion seen in the Sistine ceiling fresco between the heavy thrones of the prophets and sibyls and the thin pilasters which extended across the ceiling as archivolts. The third design of 1516 (fig. 31c), done in the same year as his first ideas for the façade of San Lorenzo, had fewer statues, a reduction imposed by circumstances but resulting in a greater emphasis placed on the architectural elements. The tomb now consisted of

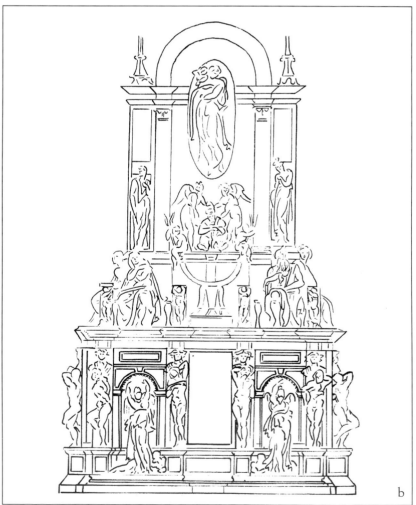

b

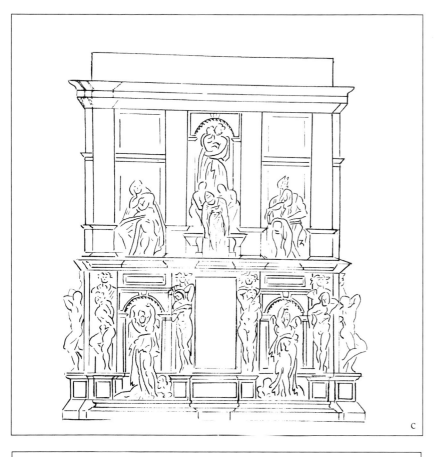

c

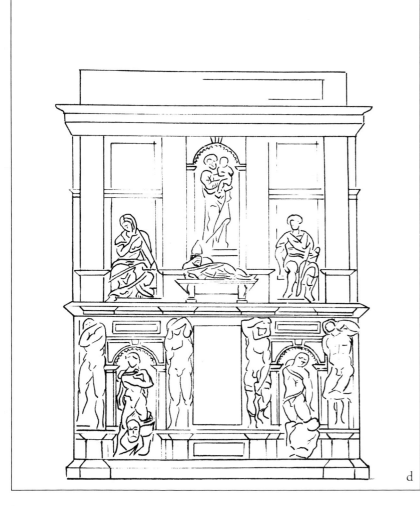

d

only two levels, the first still replete with sculpted figures but the second more articulated by pilasters, panels, and cornices. The statuary groupings of the first level formed a solid base, and from the physical gestures of these figures arose the upward thrust, full of energy, which carried to the top level. There, the statue of a standing Virgin was enclosed in a narrow niche with the figure of the pope displayed below. Here in embryo was already the relationship between the statues and the wall system of the New Sacristy. The succeeding design of 1532 (fig. 31d) differed only slightly, but by this time a location for the tomb in the new Saint Peter's had been given up. From this humbled last design was then derived the final solution of 1545 (fig. 32), in which none of the statues already executed for the tomb still figured, except *Moses*. Also gone were the doors to the burial chamber alluding to the dark enigma of the beyond as a necessary transition for resurrection. The disappearance of this entrance into an imaginary interior space negated the tectonic structure of the monument, leaving it nothing more than a surface articulated, modeled, and exposed to light.

There was a reason; the large statue of *Moses* (fig. 33), sculpted around 1515, had been moved from the middle level to the first in the location of the previous doors. Moses represented the Law and therefore the Church and its charismatic authority. In view of the religious conflict of the times, this theme was undoubtedly more important than one of death and resurrection taken from neoplatonism. In comparison with so large a protagonist as the *Moses*, the other statues made a poor appearance; therefore, through lucid and penetrating self-criticism, Michelangelo decided to downgrade them to a chorus. In essence, he reduced them to the status of emblematic figures, just as he had the architectural elements: the great coiled, upside-down volutes capriciously symbolizing useless, nonexistent thrust; the capital-caryatid figures, simulacrums too of nonexistent forces; and the elongated pilasters on the top level suggesting funerary stelae. Next to the imperious *Moses* of ancient times, the orant figures were like acolytes in submission to a great priest. *Leah* and *Rachel*, as executed by Michelangelo in 1542, now served in the unaccustomed role of assistants, thus personifying the servile devotion preached by the Church.

It is all too clear that the artist was going through a rending personal crisis. The emblematic iconism of the architecture and the figures was essentially a preparation for the ultimate renunciation of every object or resemblance of the world. In these same years, he wrote: "The fables of the world have taken from me / the time given for contemplating God"; and again, "What use is it to want to make so many puppets, / if it brought me to the end, like one / who crossed the ocean and then was drowned in snots?"

In that bitter document of his defeat, and indirectly in his art, Michelangelo was not unaware of the implicit anticlassical polemic. The words were still those of the antique lexicon, but the discourse was dialectic, perhaps even sophistic, yet in no way rhetorical. Today we see the tomb as a manifesto of Mannerism, almost provocatory, designed with the harsh manner of the rule enunciated and then transgressed in an ironic amplifica-

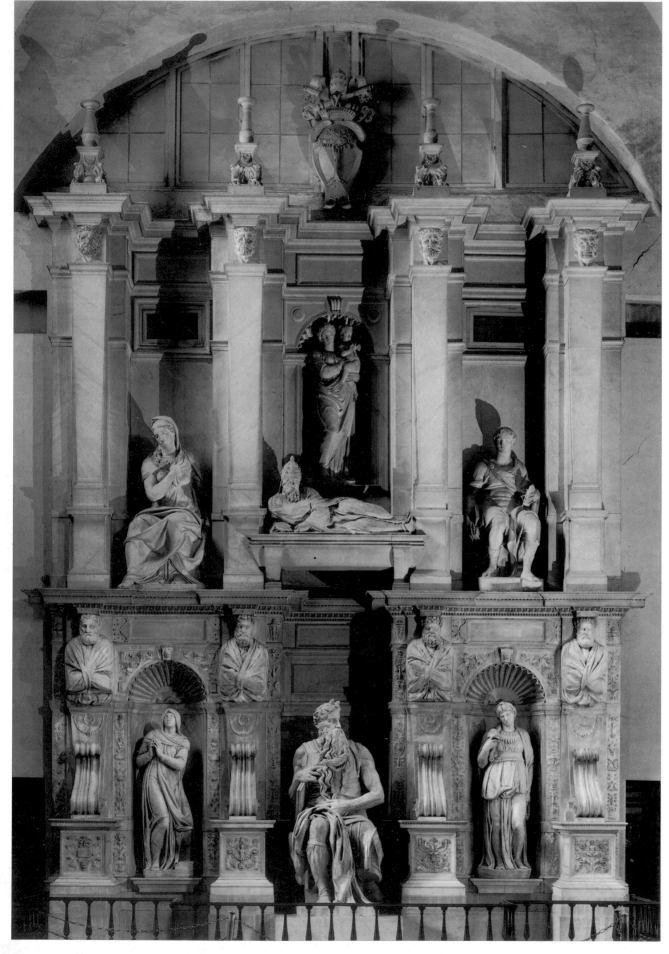

32. *Tomb of Julius II. San Pietro in Vincoli, Rome*

33. *(opposite)* Moses, *Tomb of Julius II. San Pietro in Vincoli, Rome*

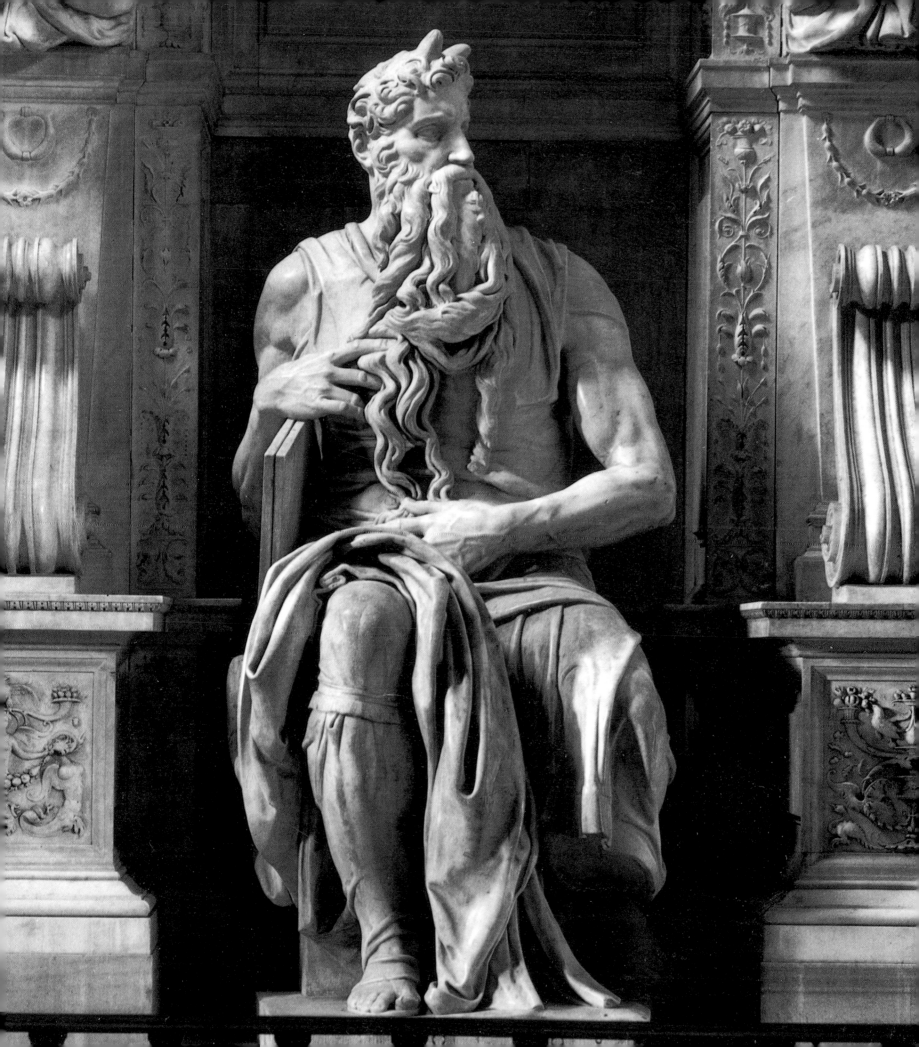

tion of the statement. The sought-for proportional irregularity exacerbated the chiaroscuro in an intense range of grays from the pure white of the marble to the darks of the deep recesses. The long history of the tomb was told also by the odd setting for the magnificent statue of Moses, and this self-quotation forced the comparison—"thus I was, so I am." Having once believed sculpture to be the most powerful of the three arts, he was at the point of abandoning it as an experience now exhausted.

In the executed monument, he strongly emphasized the disconnection; the very large space taken up by the figure of Moses with its right-angle body movements made the two orants appear even smaller. These two minor figures were more than Biblical, they were Early Christian, dressed in Classical garments but posed in prayer as believers. They receded into the architecture as the figure of Moses emerged from it, and the rayed shells of their niches formed with subtle ambiguity aureoles and nimbi. In the overall design, there was a contradictory, double tendency to draw near and pull away, and these oscillating movements were related to the disproportionate whole, with the second level too tall with respect to the first.

The keys to the disproportion of the monument were the large volutes on plinths, supporting the slender pilaster-stelae in the same way that the heavy thrones of the Sistine Ceiling supported the slender archivolts. Almost playfully, these volutes rhymed with the twisted beard of Moses, which in turn was repeated like an echo in the beards of the capital-caryatids. There was in the whole work a continuous transition, almost a strange metamorphosis, between sculpture and architecture, which was owed not so much to the hypothetical analogy of the parts of the human body and the elements of architecture as to the ironic metamorphosis of human icons into architectural ones. In sum, it was really here with this tomb, ambitiously initiated but bitterly ended, that Michelangelo's distancing from figural representation began. It had been an important experience, but Michelangelo valued each experience only in how much had been overcome.

Thus it is not strange that this unruly and discontented architecture, commemorated in one of his poetic passages, signified a sharp turn in the history of Michelangelo's ideas about art. In documenting a bitter failure that was both personal and related to the politics of the patron, he made his very dissatisfaction the connotation of the true value of the work, and of art in general, thus signifying the end of his concept of art as the conscious perfection it was believed to be in the Renaissance. Self-criticism was part of his planning process, but in this case self-criticism led to the dissociation, or the deconstruction, of the logico-static system and the conversion to a sad awareness of the incompleteness—the constitutional *non-finito*—of all art.

The tomb in San Pietro in Vincoli was not the hasty settlement of an old debt with the petulant nephews of the defunct pope. Julius II had become "endeared" to Michelangelo litigiously, and the majestic *Moses* is clearly an evocative image of him. His imperious spirit had been assonant with the artist's own youthful ambition to create a total work of art, yet, in the end, not only was Julius's glory obscured but the very majesty of the Law was

disputed. No longer an era of authoritarian action, it had become a time of worried, humble prayer. The figure of Moses was a metaphor, with the believers who formed his chorus absorbed and assimilated into the abstract pathos of the architecture. In the Pauline Chapel decoration of about the same period, the theme of one of its two frescoes was the conversion of Saul, a representation also more symbolic than historical, considering that the youthful Biblical convert was given the white beard of the pope (fig. 313). Saul was depicted being struck by a blinding ray of light streaming from the sky, while the bewildered bystanders scattered this way and that in a bright light without rays. For the elected, conversion was revelation; for the crowd, it was confusion. But the mission of the Church and the pope was precisely to clarify, gather together, illuminate, orient, and redeem the crowd.

The contextuality of compositional contraction and dissociation was to become the first rule of the irregular rhythm of Michelangelo's architecture. Obviously, this was not possible in a solid, shaded construct but only in passages of color and light. On the Tomb of Julius II in San Pietro in Vincoli, the shading was in fact extreme and rapidly escalated in foreshortening between those parts emerging into the light and those receding into deep shadow. And the internal source was the rotation of the large volute brackets on the first level. The structure of the tomb recalled that of the imaginary, painted architecture of the Sistine Ceiling, where, for the first time, Michelangelo had expressed in color and light his idea of architecture (No. 3). He did not create simulated architecture there but rather "painted architecture," meaning real architecture created by means of painting. It was an exchange of technique completely legitimate for an artist who believed that art had worth beyond all technical specificities. According to his concept, art was not the coexistence nor the summation but the synthesis of the three arts. And synthesis presupposed an intellectual process consisting of the dialectical overcoming of specific differences.

In obedience to Julius II, who wanted the painted ceiling of the chapel of Sixtus IV to be the summit, or apex, of the Church, Michelangelo had to interrupt his work on the tomb. He had been engaged in achieving a specific objective—that of making the mausoleum of this pope, the protector of the arts, a total work of art. The suspension of the project cut short the course of his idea, and if that idea were thought about and expressed elsewhere, then he would no longer be able to continue work on the tomb without repeating himself. To his mind, self-criticism was rethinking, not repetition, therefore the research begun with the tomb continued on in the painting of the Sistine Ceiling and went even beyond.

To do painting was imposed upon him by this pope, just as another pope would later impose upon him to do architecture. In his concept of art, painting was inferior to sculpture but necessary as a first step. The most imitative of the arts, it represented as well as exhausted the initial phase of perception and imitation. On the Sistine Ceiling, painting imitated marble and bronze sculpture, architecture, and even itself, because the scenes at the top were direct illustrations of Biblical narrative.

36. *Sistine Chapel, ceiling after restoration:*
Creation of Eve, Creation of Adam,
Separation of the Waters, *and* Creation
of the Sun, Moon and Plants; *prophets*
Ezekiel, Cumaean Sibyl, Daniel, *and*
Persian Sibyl; *and (in spandrels) kings*
Roboam, Asa, Jesse, *and* Salmon. *Vatican
Palaces, Rome*

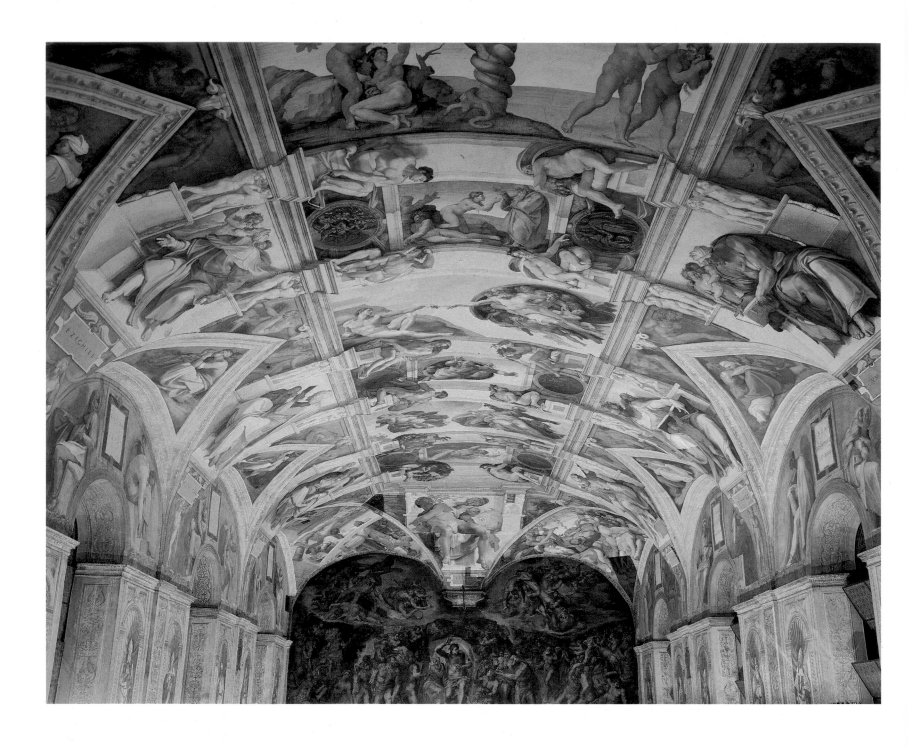

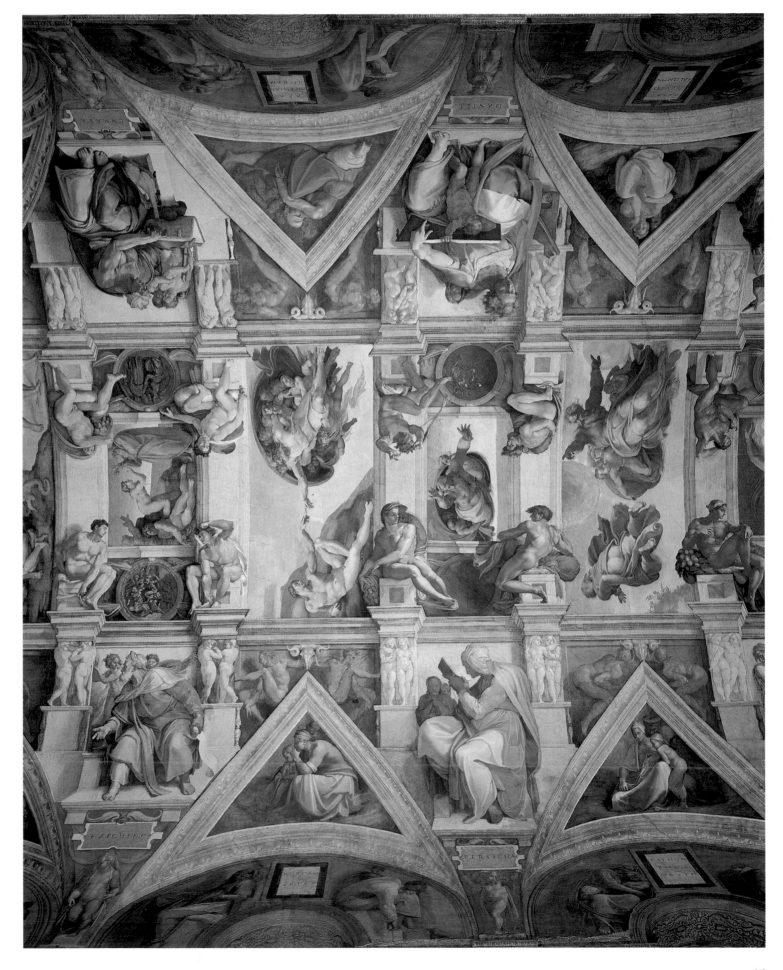

Scholars have tenaciously sought, but have not been able to prove, any formal correlation whatsoever between the architecture of the chapel itself and that painted on its ceiling. It was certainly not a "*sfondato,*" an imaginary space beyond the real space, as in the Baroque era; nor was there an opening up to the physical sky or to the empyrean. The ceiling remained physically a curved masonry surface, but, in this chapel of such noble grace, it became a screen visualizing the aspiration of mortals (in this case, the high clergy) to the contemplation of the Divine. Precursors of the Christian sacerdotes, the prophet and sibyl figures—for whom the essence of the Divine was a mystery—clearly exhibited, if nothing else, the tension of hermeneutic endeavor.

The results of the recent restoration of the Sistine frescoes have surprised those scholars used to interpreting Michelangelo almost exclusively in terms of powerful plasticity. A clear, firm, and brilliant color palette has appeared, made up of dissonant chords yet superior to all the hues of sensation and sentiment, without gradations of shading and tonal effusions, very resolute and yet impetuous. This coloration grew out of strong intellectual stimulation, rather than optical impressionability; for Michelangelo, who was said to have calipers in his eyes, optical perception was a function of the intellect. There was only one possible historical source for this type of color without rays or reflections—the great Botticelli and his ecstasies of clear, shining splendor. He was, at the end of the fifteenth century, the most neoplatonic of the Florentine artists. He thought of color in terms of pure quality, and therefore he was biased against Leonardo, for whom color, veiled and shaded, was pure quantity. Recollections and even quotations of Botticelli are frequent, especially in the first figural representations of the Sistine Ceiling, both in the color and in the ideological relationship of the Old Testament to the New. The Biblical vision on the ceiling was related to the parallel stories of Moses and Christ painted earlier by Botticelli on the wall of the chapel.

Whatever the chromatic range on the ceiling, the idea of light was necessarily implied. Because the representation was, in the theoretical sense of the term, a "vision," the light which pervaded it could not be natural light having a source, an incidence, or an oscillation. For the neoplatonists, space and light were a single entity—not objective and physical but purely conceptual. Architectonic form, intrinsically perspectival, visualized space and light as a unity, thus the architecture of the Sistine Ceiling was a division and structure of the space as a source of light, understood not as natural but as intellectual light. With the restoration of the ceiling frescoes, the painted architecture turned out to be a very brilliant white—not physically illuminated, but functioning as the light itself which gave tonality to all the colors, like a tuning fork. As a result, all of the colors were maintained at a maximum level of clarity and related to each other by contrasts as distinct as a relationship of opposites.

Because the lighting of the painted architecture was nonnatural and in no way illusionistic, it was illogical. A "vision" was also structurally illogical in

the intellectual and religious sense of the concept provided by Dante and Petrarch. This had been animatedly discussed at the Council of 1439 in Florence (Ley 15th c.), and it was expressed in art in the *visio beata* of Fra Angelico and the *visio intellectualis* of Botticelli. The vision, which was not knowledge but the urge of the soul to know, was laical spirituality of a very clear Florentine stamp. And Michelangelo, as Botticelli before him, wanted an explicit sign of "Florentineness" on that summit of ecclesiastical doctrine in the Sistine Chapel. It was architecturally illogical that, by a stroke, the massive thrones of the prophets and sibyls were transformed into thin pilasters which became archivolts following, luminously, the curve of the ceiling. These were projections to infinity—verticals which, prolonged without end, became curves. As Nicholas of Cusa had declared in *De docta ignorantia*, an infinite straight line was a curve. And Nicholas certainly was, although indirectly, a source of neoplatonism for Michelangelo.

This architecture made by painting on the Sistine Ceiling showed that the artist was totally interested in the image and not in architectonic construction. Space was not an objective reality in which the work of art was situated. Rather, it was an image within an image, which was its intrinsic, innate principle of order. The Sistine representation was not the preliminary condition for a vision, it was the vision itself. It was also the ultimate and victorious affirmation of anti-Leonardoism, which, in disputing religious skepticism especially, was properly located in this charismatic place at the apex of Christian doctrine. According to Leonardo, there was no such thing as a vision, only an infinite view; for Michelangelo, there was no view, only a vision. Without doubt, the vision was the very essence of his religiosity. On the Sistine Ceiling, for example, he wanted to depict prophets and sibyls instead of the twelve apostles requested by Julius II, because the reality of religious faith was not based on testimonial proofs but on inspired intuitions. As usual, he became a "victim" in the course of carrying out this enormous work, although it had not been asked of him. He himself had wanted and planned it for the prestige of the Florentine platonic theology, but also as an antidote to the boundless, sometimes excessive, naturalism of Leonardo.

In Leonardo's *The Last Supper*, still celebrated as an innovation of spirit and technique, the artist's main motive was to depict the psychological diversity of the twelve apostles who represented every kind of temperament. Although the cause was the same—the announcement of the upcoming betrayal of Christ—the gestures and physiognomic reactions were all different. Having made many analytical studies from life, Leonardo had deduced from this extensive casuistry a "psychological" typology. His deductive process was infinitely more subtle and penetrating than the architectural typologism of Bramante or the physiognomic one of Raphael, but it was not structurally different. Michelangelo went in the opposite direction; moving from the more or less canonic icons for prophets and sibyls, he exalted and idealized them according to their messages as individualized images of meditation, ecstasy, and intuition about religious truth,

page following:

37. *Sistine Chapel, detail of painted architecture. Vatican Palaces, Rome*

which was not manifest but revealed through arcane signs or ancient writings. The placement of the large prophet figures at the base of the Biblical scenes was an expression of the anxious tension and tormented search of the texts for Divine Truth, which constituted the substance of religious life.

Having made painting a means of analytic research, of slow and complex unfolding, Leonardo obviously could not employ a rapid and resolute technique such as the *buon fresco* of truly Florentine tradition. A technologist by vocation, he therefore invented his own technique of oil painting on the wall, which allowed for glazing and shading, changing one's mind and retouching. Unfortunately, the surfaces deteriorated rapidly, as Michelangelo had seen with his own eyes in the ruin of Leonardo's *The Battle of Anghiari* in the Council Hall of Florence. But the technical wonder of the Sistine was not an aspect of petty rivalry—the problem of technique was imbued with an importance for Leonardo the technologist that it simply did not have for Michelangelo the ideologist.

Michelangelo probably did not know the architectural drawings of Leonardo, in which a concordance was sought between the mechanics of architectural structures and those of natural and cosmic forces, but he would not have been interested in a transition from architectural to universal equilibrium. His own architecture avoided every fusion or harmony with the environment. He had first been a stranger to, and then turned hostile toward, even that hint of Leonardoism brought from Milan to the Rome school of architecture by Bramante. The painting of the Sistine Ceiling procured fame for Michelangelo as the unequalled master of perspective foreshortening, in which the volumetric reduction through contraction of body parts and condensation of motor energy produced tension in anticipation of great expansion and release. With foreshortening, the figures were not situated in space but took possession of it. It was also a method of visualization conforming to the idea of the coincidence of opposites in the approach of the farthest points of reference to the nearest ones. Nowhere on the ceiling of the Sistine were the foreshortened figures expressive of actual physical activity; they were limited to posed movements as seen in the motionless gymnastics of the *ignudi*. They were, therefore, the agents of a structural rhythm very similar to those of Michelangelo's poetry, where the foreshortening occurs not only in the phrases but also in the metrics and even the phonetics of the words. Michelangelo had read Dante, and he knew that, in their phonetic reality, words were not the enunciation of concepts but the concept itself. Thus, to make his architecture, he did not draw on the forces of nature but on the intrinsic capacity for tension in the structures. Because foreshortening was a structure of the vision, and the "vision" of the Sistine had an architectural structure, it could be said that this was not only the precedent but the origin and the matrix for the architecture of Michelangelo.

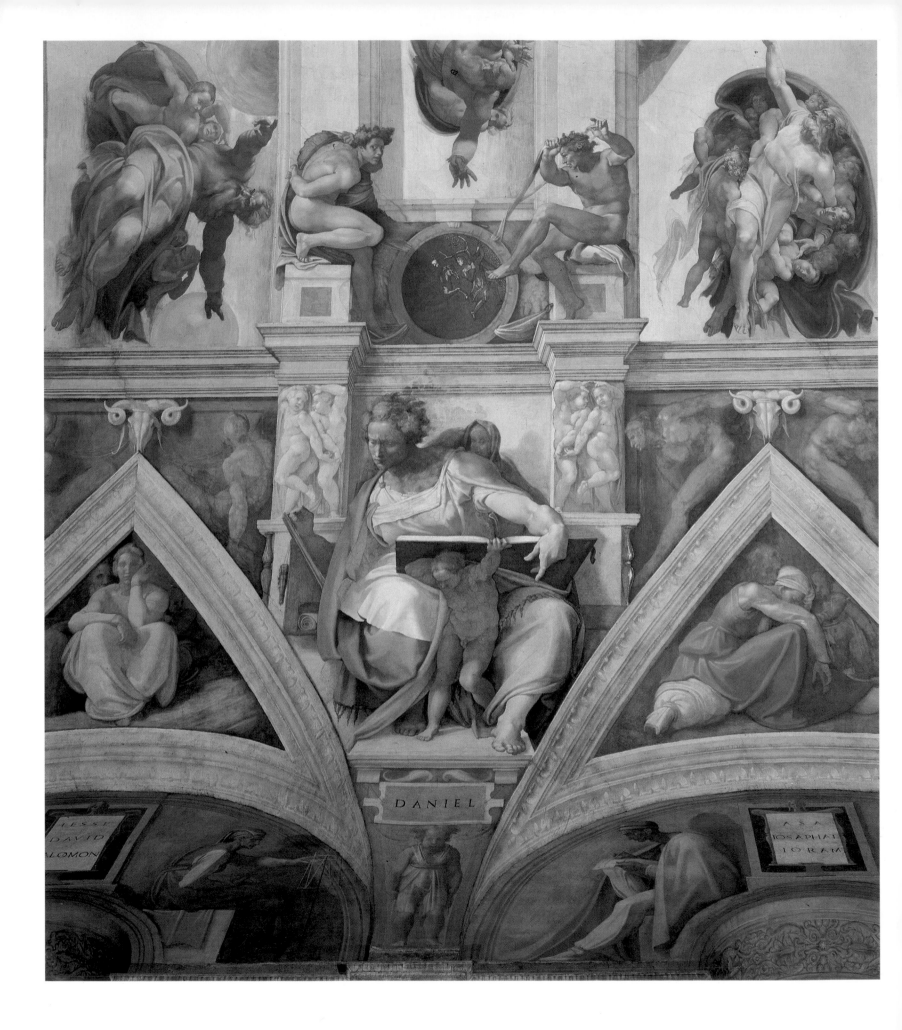

DANIEL

As recorded by Condivi and Vasari, Michelangelo was called to Rome by Julius II as soon as this pope was elected to the Throne of Peter (October 31, 1503). Condivi wrote that "many months passed before Julius came to a decision about how he would make use of him," but Vasari connected Michelangelo's coming to Rome directly with the project for the pontiff's tomb. This chronology of events has been doubted since the eighteenth century, however, and Michelangelo himself, in a letter to Giovanni Fattucci at the end of December 1523, reconstructed the story of his commission differently: "When [Julius II] sent for me in Florence, which I believe was the second year of his pontificate, I had undertaken to paint half of the Council Hall of Florence, for which I had three thousand ducats, and the cartoon had already been done, as it was known all over Florence. And for the twelve Apostles that I still had to do in Santa Maria del Fiore [Cathedral of Florence], there was one roughed out for it, as it was also seen, and I had already brought in most of the marble" (DXCIV). In another version of this letter, he wrote: "In the first years of Pope Julius, I believe that it was the second year that I went to be with him, after many designs for his tomb, one of them pleased him, over which we made the deal (el merchato), and I undertook to make it for ten thousands ducats, and transporting of the marble there one thousand ducats, [which] he had paid to me, I think by Salviati in Florence, and he sent me for the marble. I went, bringing the marble and men to Rome, and I began to work on the frame and the figures, for which there were already some men who worked there; and, at the end of eight or nine months, the pope changed his mind and did not want to continue it" (DXCV).

Thus, it was in the second year (November 1504–October 1505) of the Della Rovere pontificate that Michelangelo was called to Rome. During his first stay there from 1496 to 1500, he had been the guest for more than a year of Cardinal Riario, a cousin of the future Julius II, an arrangement possibly owed to Giuliano da Sangallo, who was active in the Rome court (Vasari). Because Mi-

chelangelo was present in Florence on February 28, 1505 to collect payment on the cartoon of the *Battle of Cascina* for the Council Hall, the tomb commission has been dated by scholars to March of that year. But it could have been anticipated for a few months, considering that the artist was already at work on it in April. No doubt a contract was drawn up, although it has not been preserved, which stipulated the amount of compensation (10,000 ducats) and a period of five years to complete the work.

In April 1505, Michelangelo left for Carrara to select the marble for the tomb, which proves that the design must have been sufficiently determined by that time. On November 12, he contracted for the transport of thirty-four *carrate* of marble, including "two pieces that are 15 *carrate*," from the port of Avenza to Rome. On December 10, a contract with Guido d'Antonio di Biagio and Matteo di Cucarello called for the extraction of the last sixty *carrate*, comprising four "large stones"—two of eight *carrate* and two of five *carrate*—with the remainder each weighing two *carrate* or less. The *carrata*, at the beginning of the sixteenth century, was equal to about 850 kilograms, according to the research of Klapisch-Zuber (1969).

In January 1506, Michelangelo was in Rome, where the blocks ordered from Carrara arrived little by little. At the same time, the workshop necessary for the execution of the entire project was prepared. But, on April 17, the day before the laying of the cornerstone for the new Saint Peter's, the artist fled Rome, irritated at not having been received by the pontiff, who was supposed to reimburse him for the cost of a shipment of marble which had arrived from Carrara. Accusing Julius II of wanting to postpone the project indefinitely, Michelangelo, and Condivi and Vasari as well, connected the setting aside of the tomb project by the pope with the intrigue of Bramante, who convinced Julius to give preference over the work on the tomb to the construction of the Vatican church. In this first decisive phase, a great part of which had been spent in preparation, a little over a year was wasted on what would become, in the artist's mind, the "tragedy" of the tomb.

Very little of the work carried out in 1506 is still extant and consists mainly of the decorative reliefs at the base of the niche for *Rachel* on the tomb monument in San Pietro in Vincoli. (For an improbable hypothesis of a collaboration with Antonello Gagini, see Kruft 1975.) Due to the lack also of the original contract and any drawings unequivocally connected to Michelangelo's initial concept, the essential sources for the reconstruction of the first design—which, as already mentioned, was sufficiently delineated to allow for the required amount of marble to be ordered—are the descriptions by Condivi and Vasari. All of the different hypothetical reconstructions are based on the data provided by them.

Condivi recorded: "This sepulcher would have had four faces, two of eighteen *braccia* which formed the flanks, and two of twelve *braccia* for the ends, so that it came out to be a square and a half. All around the outside were niches wherein statues were placed, and between niche and niche were herms, against which, supported on projecting pedestals that came up from the ground, were other statues bound like prisoners; these represented the liberal arts, likewise painting, sculpture and architecture, each one with its attributes so that it could easily be recognized for what it was; signifying by these that all of the virtues were prisoners of death along with Pope Julius, the likes of whom they would never find again to protect and nourish them as he had. Above these ran a cornice that encircled the whole work, on which level were four large statues, one of which, that of Moses, is seen in San Pietro ad Vincula, and this will be spoken about in its place. Thus ascending the work from there, it ended in a flat surface upon which were two angels who supported a sarcophagus; one of them appeared to laugh, as if rejoicing that the soul of the pope was received among the blessed spirits, and the other to weep, as if mourning that the world was deprived of such a man. The sepulcher was entered by one of the ends, that is, by the one which was on the side of the above, into a small chamber in the guise of a little temple, in the middle of which was a marble casket, where the

body of the pope would be entombed; everything was worked with marvelous artistry. In sum, there were over forty statues on the whole work, not counting the narrative mezzo-rilievos made of bronze, all concerned with actual events, and where it was possible to see the deeds of such a great pontiff."

Vasari wrote: "Because it would show the greatest magnificence, he directed that it would stand alone, so that it could be seen from all four faces, which had two sides measuring twelve *braccia* and the other two eighteen *braccia*, so that the proportion was a square and a half. It had a row of niches all around the outside, which were interspersed with herms clothed from the waist up, who held up the first cornice with their heads, and each herm had tied to it a nude prisoner in a strange and bizarre pose with his feet placed on a projecting base. These prisoners were all the provinces subjected by this pontiff and made obedient to the Apostolic Church, and other different statues, completely bound, were all the virtues and the applied arts, which were shown to be subordinate to death, no less than the pontiff himself, who so honorably had made use of them.

"On the corners of the first cornice were four large figures: Active and Contemplative Life, and Saint Paul and Moses. The work rose above the cornice in diminishing steps with a decoration of narrative scenes in bronze, and with other figures and putti and ornaments as well; and on top, finally, were two figures, one of which was Caelus, laughing, who held on his shoulders a sarcophagus together with Cybele, goddess of Earth, who seemed to be sorrowing as she recalled that the world was deprived of all virtue by the death of this man; and Caelus seemed to be laughing because his soul had passed to celestial glory. It was arranged so that one entered and exited by the ends of the framework between the niches; and the interior, to be used as a temple, was in oval form, which had in the middle the casket where the dead body of that pope was to be placed; and, finally, there were in this entire work forty marble statues, not including the other narratives, putti and ornamentation, and the

38. *Reconstruction of 1505 design for Tomb of Julius II (Panofsky 1937): (a) side; (b) front; (c) horizontal section of base; and (d) ground plan*

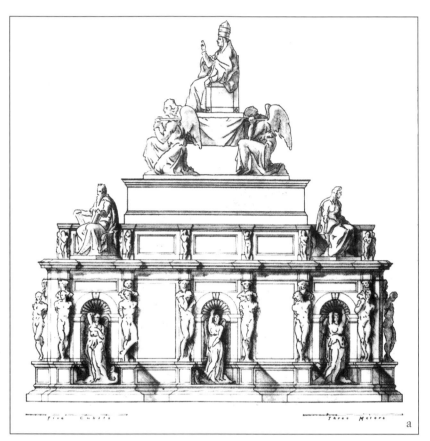

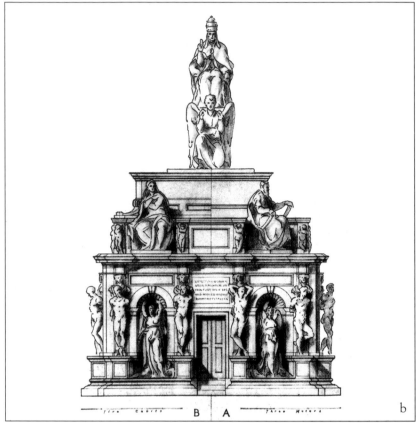

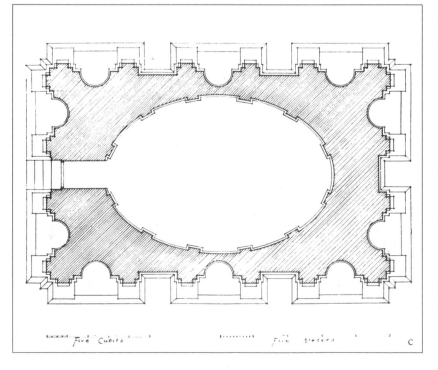

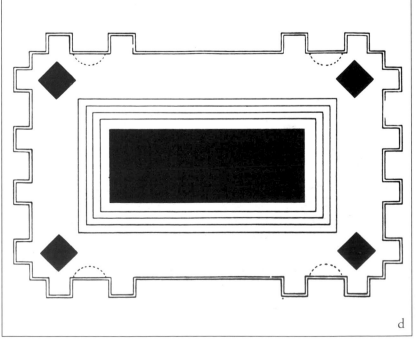

39. Reconstruction of 1505 design for
Tomb of Julius II (Weinberger 1967):
(a) side; (b) front; and (c) ground plan
and horizontal section of base

40. (below right) Reconstruction of 1505
design for Tomb of Julius II (Hartt 1969)

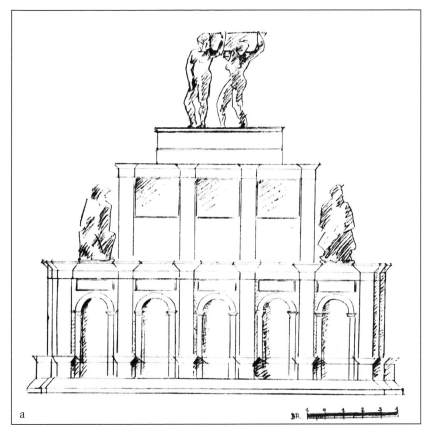

a

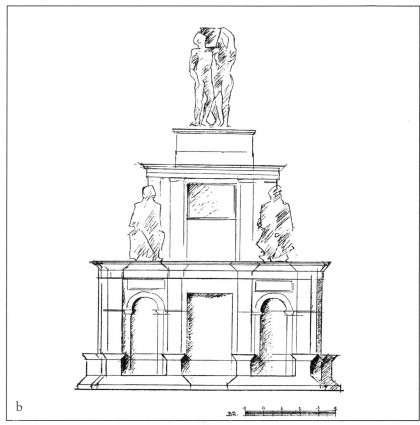

b

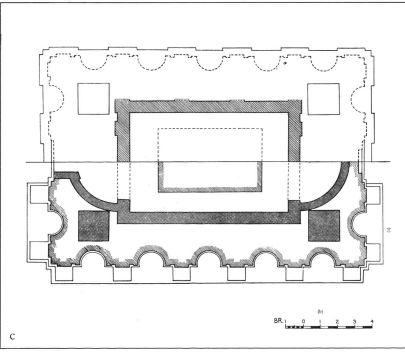

c

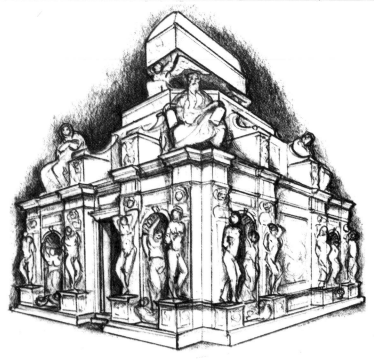

41. *Reconstruction of 1505 design for Tomb of Julius II (Frommel 1977): (a) side; and (b) front view and ground plan*

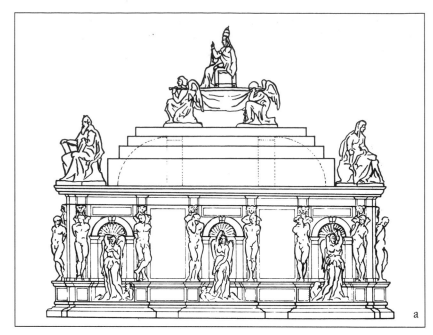

a

cornices and other parts of the architectural work [were] all carved."

On the basis of both testimonies, the first design for the Tomb of Julius II was projected as an autonomous organism in rectangular form, with the sides having a ratio of 2:3 and measuring 7 × 10.5 meters. Populated with statues, the levels of the monument diminished in circumference towards the top. The lower zone was articulated with niches containing sculpture, which were flanked by herm figures. These herms supported a cornice, a middle zone with four large statues, and a third and top level destined for the actual glorification of the pontiff. On the inside of the structure, in a space accessible through one or two openings, was the casket in which the actual body of the pope was to repose.

Many hypothetical reconstructions of the 1505 tomb project have been offered and even graphically rendered by such scholars as Panofsky (1937; fig. 38), Tolnay (1954; fig. 31a), Weinberger (1967; fig. 39), Hartt (1969; fig. 40), Einem (1973), and Frommel (1977; fig. 41). The scholars' interpretations differed considerably on the relationship between the first and the other two levels, and on the crowning of the top level. Where one assumed a sarcophagus held up by two angels, another put the body of Julius II in place of the sarcophagus, and yet another took Vasari's term *bara* (bier or sarcophagus) to mean *sella*, the litter on which the seated pope is carried. They also differed on the number of entrances into and the shape of the interior space. For example, it was assumed to be elliptical by Panofsky (1937), while Frommel (1977) thought it was more likely rectangular with a semicircle on the short side opposite a single entrance.

Extremely few drawings have been securely connected to the first design for the tomb, aside from some sheets related to the principal figures, such as the Musée Condé study for *Saint Paul*, one of the four statues above the first cornice (fig. 42). Nearly all scholars agree, however, on some sketches of fantastic decorations in the British Museum and the Uffizi (figs. 7, 43), proposed in the *Corpus* as referring to the

tomb. Of decisive importance, however, is the current discussion about a drawing now in Berlin (Staatliche Museen, Print Dept., 15305 [C. 55r]), considered since its first publication (Schmarsow 1884) to be very close to the tomb design of 1513. Several copies are connected with it, in particular one by Jacomo Rocchetti (fig. 71) also in Berlin, and another of the lower zone in the Uffizi (fig. 72), possibly by Aristotile or, more likely, Giovanni Battista da Sangallo (Degenhart 1955), but recently attributed to Michelangelo himself by Hirst (1989). The hypothesis has been advanced (Hartt 1971, and *Corpus*) that, instead of referring to the project of 1513, this sheet in Berlin and its related copies could document an alternative solution to the spatially autonomous tomb of the 1505 project. In addition, a sheet in the Metropolitan Museum, New York (fig. 73), originally published by Hirst (1976) as a preliminary study for the design of 1513, was reconsidered by him in 1989 to be a variant of the 1505 design, although the *Corpus* did not agree with the conclusion. Granted, the lower zone of the tomb in the Berlin drawing is very close to the description given in the two biographies, and on its verso are sketches stylistically attributable to 1504–5, which makes the hypothesis philologically proposable. But the suggestion is at odds with what has been verified in the past few years about the original site for the funerary monument, which makes improbable an initial design choice between an isolated organism and a wall tomb.

The most fertile path of research on Michelangelo's first design for the tomb seems to be that of comparing the data and the hypotheses formulated on the tomb against what is known about the contemporaneous plans of Bramante for the new Saint Peter's. Absolutely not believable is Condivi's statement that Julius II, indifferent to the problem, had given Michelangelo the responsibility of selecting the place in the Vatican church "where it would be convenient to locate" the tomb. The site of the tomb and the reconstruction of Saint Peter's, instituted by Julius II, are inseparably bound, as Argan (1964) and Einem

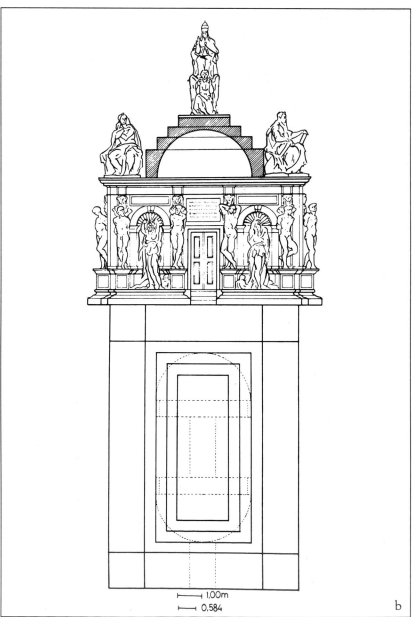

⊢——⊣ 1,00m

⊢——⊣ 0,584

b

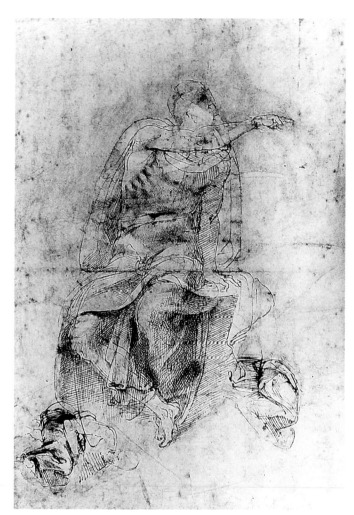

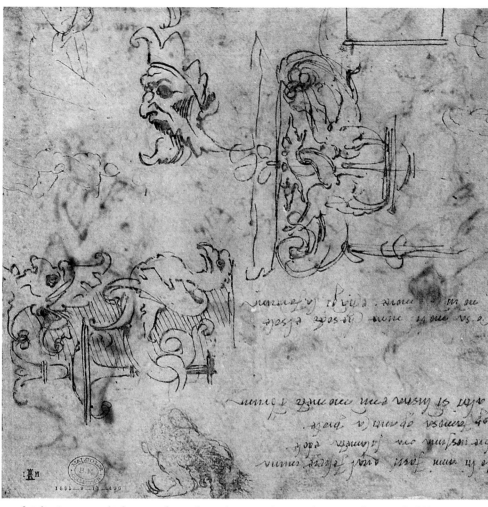

(1951) already presumed in proposing that the tomb was to have been placed under the central dome of the church. Having dated to August 1505 the large ground plan of Bramante (fig. 44), inscribed on the verso by Antonio da Sangallo the Younger as the "plan of Saint Peter's by the hand of Bramante that was not made," Metternich (1963) hypothesized the placement of Julius's tomb in the southwest chapel of the quincunx, which he calculated to measure eighty *palmi* in diameter. The pope's refusal to accept the idea of not having the tomb of the First Apostle coincide with the center of the dome, as it was in Bramante's 1505 plan (documented by Egidio da Viterbo in his *Historia viginti Saeculorum*), and the subsequent reduction in the size of the chapel in the final plan of early 1506, would have made it impossible to

carry out the construction of Julius's tomb there, according to Metternich. (For further considerations, see Metternich 1975.)

More convincing, and I believe conclusive, is the hypothesis of Frommel. In his studies of 1976 and 1977, he reviewed the events of the construction of the new Saint Peter's under Julius II and of Michelangelo's first design for the tomb, proposing for the latter (in the wake of Tolnay 1954 and 1963) a placement in the Julia chapel (see fig. 45)— that is, in the choir arm of the new church, which would then have functioned as a funerary chapel in the same manner as the old choir housing the tombs of Sixtus IV, uncle of the pontiff, and his family. Frommel calculated that only 12,250 ducats were spent on the construction of Saint Peter's in the first

year, little more than what Julius's tomb monument would have cost under the March 1505 contract. Considering the scarcity of funds in 1506, it is not surprising that the pope decided to give precedence to the building construction. He did not however actually reject the project for the tomb, as it appeared from Michelangelo's letter, but only set it aside temporarily, as demonstrated by the shipment of a block of marble for the statue of the pontiff in June 1508. Frommel's proposal of 1977, far too detailed to summarize, convincingly explained the analogies often noted between the Tomb of Sixtus IV by Antonio del Pollaiuolo, rendered in bronze, which anticipated the theme of the lamentation of the Arts abandoned by their protector, as seen in Michelangelo's design for the Tomb of Julius II.

A recapitulation of all the iconological interpretations of the tomb is not possible, but two names stand out—Panofsky (1937) and Tolnay (1954). In the wake of Vasari's claim that, "by the beauty, proudness, and grand ornament and richness of the statues, [the tomb] surpassed every antique and imperial sepulcher," the influence of the antique on the design of the tomb has frequently been mentioned. The following sources in particular have been recognized: the sarcophagus of Villa Montalto-Negroni-Massimo, now in the Vatican Museums collection (Panofsky); the tripartite Mausoleum of Hadrian; models of funerary pyres passed down on medals and coins of the Classical period and interpreted as imperial tombs (Frazer 1975); and, above all, the Mausoleum of Halicarnassus, the object of numerous

44. *(above) Bramante. Plan of Saint Peter's, Rome. Uffizi, Florence, Drawings and Prints Dept., A 1*

45. *(below left) Antonio di Pellegrino (attrib.). Plan of Saint Peter's, Rome. Uffizi, Florence, Drawings and Prints Dept., A 3r (position of Tomb of Julius II in 1506 project superimposed in black, according to Frommel 1977)*

46. *(below right) Antonio da Sangallo the Younger. Plan of choir of Saint Peter's after Bramante's plan. Uffizi, Florence, Drawings and Prints Dept., A 44r*

reconstructions based on Pliny's description by architects of the early sixteenth century (see fig. 48; Frommel 1977).

Several derivations from Michelangelo's first design for the Tomb of Julius II have been suggested: in particular, the design by Andrea Sansovino for the Tomb of Leo X (Victoria and Albert Museum, London; Tolnay 1951); the sheet recently attributed to Raphael in close relation to the design of the sepulchral monument for Francesco Gonzaga (fig. 49), who died in March 1519 (Oberhuber-Burns 1984, following Frommel 1977); the Tomb of Baldassare Castiglione in Santa Maria delle Grazie, Mantua, on the design of Giulio Romano (Burns-Pagliara 1989); and the designs by Antonio da Sangallo, Giovanni Francesco da Sangallo, and Baccio Bandinelli for the tombs of Leo X and Clement VII (Frommel 1977).

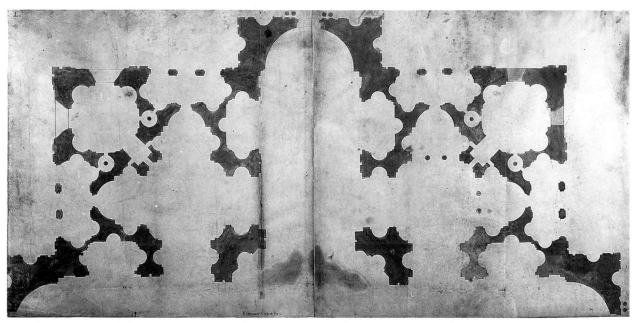

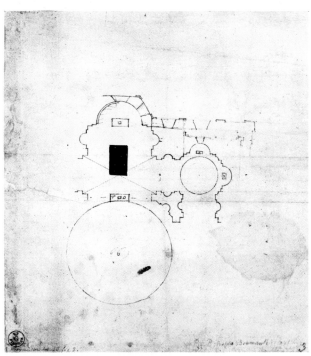

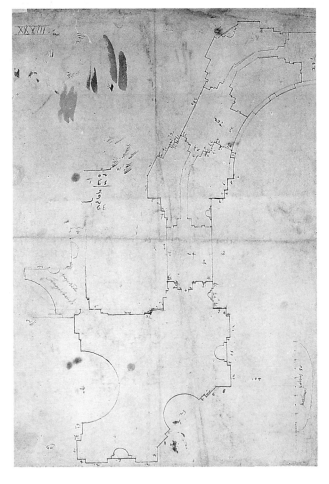

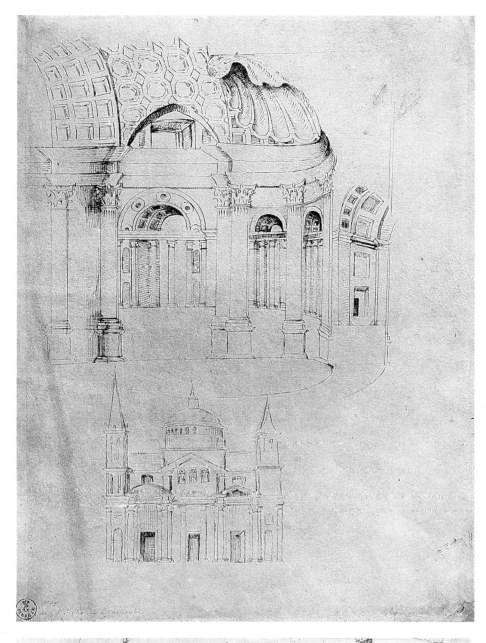

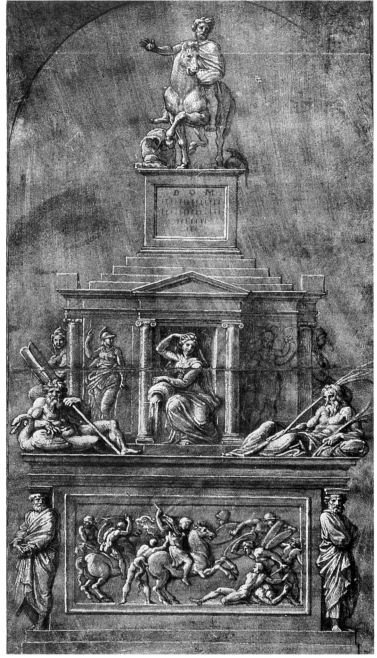

47. (above left) Anonymous, 1st half 16th c. Choir of Saint Peter's, Rome, perhaps after Bramante's wood model. Uffizi, Florence, Drawings and Prints Dept., A 5r

48. (below left) Antonio da Sangallo the Younger. Reconstruction drawing of Mausoleum of Halicarnassus (Turkey). Uffizi, Florence, Drawings and Prints Dept., A 1037

49. (right) Raphael. Design for Tomb of Marchese Francesco Gonzaga. The Louvre, Paris, Dept. of Drawings, 1420v

STUDIES FOR THE COMPLETION OF THE DRUM OF THE DOME OF SANTA MARIA DEL FIORE, FLORENCE, 1507 AND 1516

When the lantern of the dome was finished in 1471, the work of completing the Cathedral (Santa Maria del Fiore) in Florence proceeded with the covering of the exterior of the whole drum and the top part of the nave with facings of polished marble. But the large section of the drum just below the dome, destined to hold a gallery or loggia, remained unfinished, as seen in paintings of the late fifteenth century. According to documents published by Marchini (1977), a meeting of architects and ordinary citizens was called in July 1507 for the purpose of discussing the completion of the drum. It was decided to invite Michelangelo (then in Bologna) and Andrea Sansovino (perhaps in Rome) each to submit, by the end of August, a plan, model, or drawing for the work. Architects in Florence were also invited to enter the competition. According to Marchini, Michelangelo sent his design to a Florentine carpenter to execute a wood model, identified with one labeled as no. 143 and preserved in the Museo dell'Opera of the Cathedral (fig. 51). Also preserved are: no. 142, by Cronaca, Giuliano da Sangallo, and Baccio d'Agnolo (fig. 52); no. 139, attributed to Andrea Sansovino; no. 137, by an anonymous Florentine woodcarver; and no. 141, a damaged model related to the fifteenth-century phase. Model no. 143 differed from the others in not having a loggia. Instead, a row of white marble rectangles framed in green was added above the two existing rows of square panels and surmounted by a wide entablature supported on Ionic-style pilasters in high sculptural relief. The reason why Michelangelo's design was rejected is not known, but it has been noted (Marchini 1977, and *Corpus*) that the model, perhaps due to a misunderstanding on the part of the woodcarver who translated the drawing sent from Rome, did not take into account the "toothing" left in the Quattrocento building phase for the purpose of anchoring the new construction.

In 1513, Baccio d'Agnolo, the master of the Cathedral Works, approved a design differing only slightly from the one he, Cronaca and Sangallo had presented together in 1507. A 1514 order exists for materials necessary to construct the gallery on one face of the octagonal drum (the only one completed), which was unveiled in June 1515 (fig. 50). Pedretti (1978) demonstrated the relationship between the design executed by Baccio and a concept of Leonardo da Vinci in a comparison of the gallery with a drawing by Leonardo in the Codex Atlanticus (fig. 54). In effect, the addition of the shadowed openwork of the loggia created a delicate transition, atmospheric and almost "sfumato," between the drum and the great dome. Nevertheless, Michelangelo strongly criticized Baccio's solution in 1516, calling it a "cricket cage" and saying "that great machine required something better, and done of a different design with art and grace," in place of the gallery, which was "too small in comparison with such a great machine" (Vasari). To his mind, the gallery served to emphasize a break at the place where there should have been a sturdy, essential connection with the dome to mark the beginning of the powerful curvature of its ribs, as he had proposed in his design of 1507. According to Vasari, Michelangelo then created another model, which D'Ossat (1966) identified with no. 144 in the Museo dell'Opera (fig. 53). Marchini (1977) agreed with D'Ossat's identification, but Ackerman (1986) rejected it. This model proposed abolishing the gallery and substituting for it a large entablature supported on corner pilasters and having only two tiers instead of the three shown in model no. 143. In the frieze area were windows to an inside passageway, and the whole section was designed to rest on the fifteenth-century supports.

Related to the 1516 proposal are two splendid sheets of drawings, recto and verso, (figs. 55, 56 and 57, 58) accepted as authentic since Geymüller (1904). The *Corpus* related the first to the 1507 model, but on both the number of marble panels was reduced to two, one on either side of the oculus, outlined by slender fillets. Saalman (1977) saw as a derivation from an idea of Michelangelo a design by a Venetian artist (Uffizi, Drawings and Prints Dept., A 7999r; *Disegni* 1977), having pairs of freestanding columns in lieu of the pilasters, a proposal as unconvincingly made by Tolnay.

52. (above left) Cronaca, Giuliano da Sangallo and Baccio d'Agnolo. Wood model for drum of Santa Maria del Fiore. Museo dell'Opera of the Cathedral, Florence, no. 142

53. (below left) Michelangelo (attrib.). Wood model for drum of Santa Maria del Fiore. Museo dell'Opera of the Cathedral, Florence, no. 144

54. (right) Leonardo da Vinci. Architectural sketches. Biblioteca Ambrosiana, Milan, Cod. Atlantico, f. 114r–b

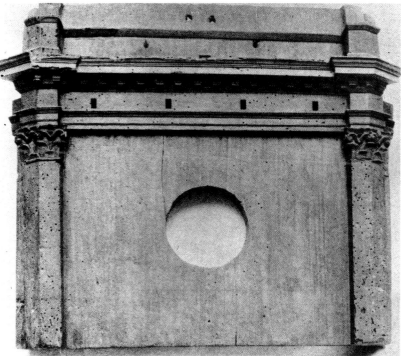

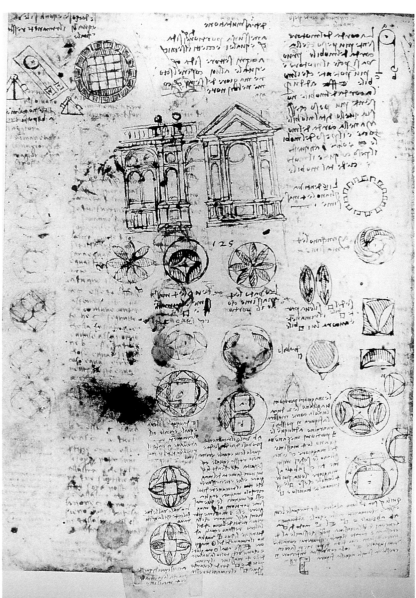

55. *Michelangelo. Study for drum of dome of Santa Maria del Fiore, Florence. Casa Buonarroti, Florence, A 50r (C. 491r)*

56. *Michelangelo. Study for drum of dome of Santa Maria del Fiore, Florence. Casa Buonarroti, Florence, A 50v (C. 491v)*

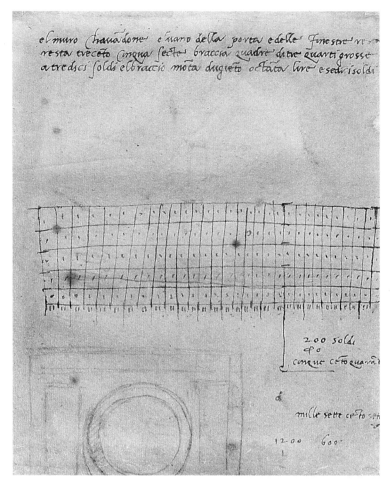

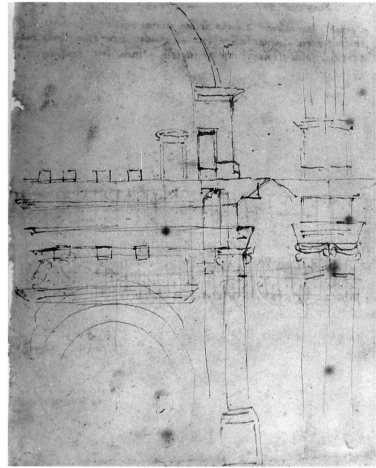

55. *Michelangelo. Study for drum of dome of Santa Maria del Fiore, Florence. Casa Buonarroti, Florence, A 50r (C. 491r)*

56. *Michelangelo. Study for drum of dome of Santa Maria del Fiore, Florence. Casa Buonarroti, Florence, A 50v (C. 491v)*

57. *Michelangelo. Study for drum of dome of Santa Maria del Fiore, Florence. Casa Buonarroti, Florence, A 66r (C. 492r)*

58. *Michelangelo. Study for drum of dome of Santa Maria del Fiore, Florence. Casa Buonarroti, Florence, A 66v (C. 492v)*

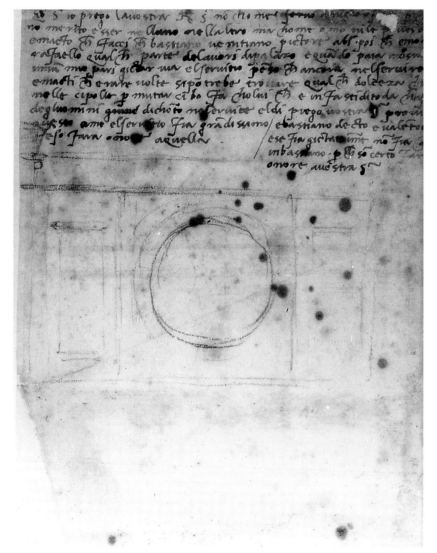

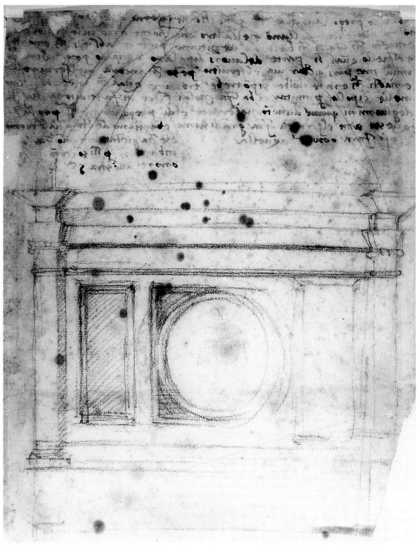

PAINTED ARCHITECTURAL
DIVISIONS ON THE CEILING
OF THE SISTINE CHAPEL,
ROME, 1508–12

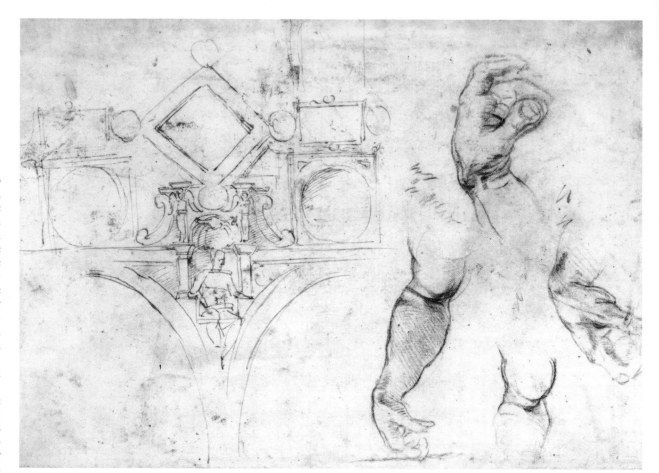

The Sistine Chapel, where the group of persons comprising the Pontifical Chapel assembled, according to the analysis of its function by Shearman (1986), was built by Sixtus IV between 1477 and 1481 on the site of the large medieval chapel of the Vatican Palace and perhaps utilizing part of its elevation (Pagliara 1990). The walls were decorated between 1481 and 1483 by four Umbrian and Tuscan masters: Perugino, Ghirlandaio, Botticelli, and Cosimo Rosselli, in collaboration with Pinturicchio, Luca Signorelli, Bartolomeo della Gatta, Piero di Cosimo, and Fra Diamante. (For recent iconological interpretations of the frescoes, see Calvesi 1980 and Shearman 1986.) The ceiling was painted with gold stars on a blue background by Pier Matteo d'Amelia. The preparatory drawing for it, once owned by Antonio da Sangallo the Younger and now in the Uffizi, was published by Steinmann (1905), but differences between the drawing and the ceiling have been pointed out by Shearman (1986). The fifteenth-century decoration would have been badly damaged by work carried out between the spring and October 18 of 1504 to arrest the alarming cracking at the center of the vaulted ceiling. Large iron chains were installed to hold together the side walls at the top and bottom, and the resulting holes were repaired with bricks. This damage, more than the desire to separate the sacristy from the congregation (Wilde 1978), seems to have been the primary reason for the intervention in the ceiling decoration just twenty-five years after it was painted by Pier Matteo d'Amelia.

The first evidence for Michelangelo's connection with the new decoration is in a letter to the artist from Pietro Rosselli, written from Rome on May 10, 1506. In it, Rosselli quoted Bramante's objections to Julius II's announcement that he was sending Giuliano da Sangallo to Florence with the hope of convincing Michelangelo to return to Rome: "Holy Father, it will be of no use, because I have had much experience with Michelangnolo, and he has said to me many times over that he did not want to undertake the chapel and that you wanted to give this commission to him,

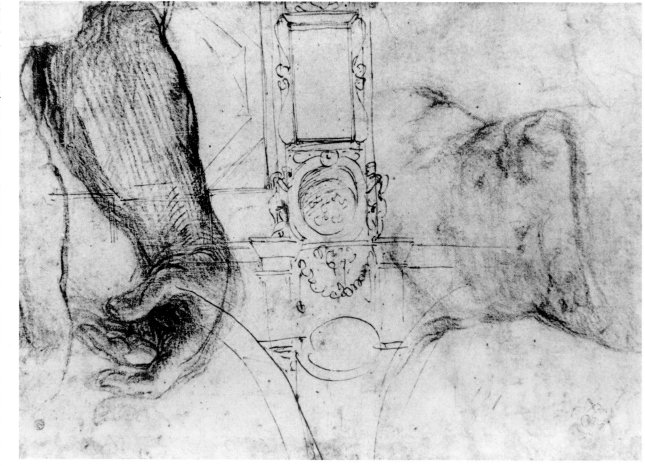

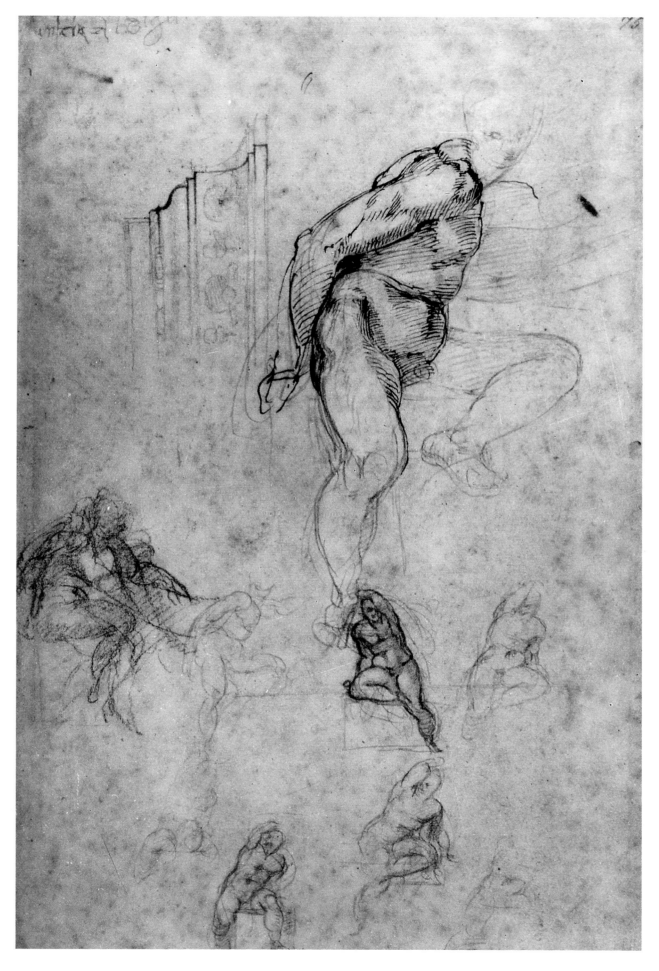

59. *(opposite above) Michelangelo. Study for decoration scheme of ceiling of Sistine Chapel, Rome. British Museum, London, 1859–6–25–567r (C. 119r)*

60. *(opposite below) Michelangelo. Study for decoration scheme of ceiling of Sistine Chapel, Rome. The Detroit Institute of Art, 27.2r (C. 120r)*

61. *Michelangelo. Studies of cornice, and male nudes for ceiling of Sistine Chapel, Rome. Casa Buonarroti, Florence, F 75r (C. 145r)*

[and] that therefore you did not want otherwise to undertake the tomb and not the painting." Bramante continued: "Holy father, I believe he lacks the courage for it, because he has not done too many figures, and especially the figures are high up and foreshortened, and that is very different from painting on the ground" (x). According to this, the commission to have Michelangelo paint the Sistine Ceiling—or at least Julius's idea for it—can be dated before April 1506, even though the actual work did not begin until May 1508. On May 10, 1508, Michelangelo received from Cardinal Alidori a downpayment of five hundred ducats on the agreed total of three thousand ducats. Between May 11 and July 27, Rosselli, the master of Works, put up the scaffolding and applied the *arriccio*, or rough undercoat of plaster, to the ceiling. During the summer, Michelangelo was still waiting for the assistants recruited in Florence.

Different hypotheses have been advanced for the chronology of the work on the ceiling fresco, but all converge in the belief that, on the basis of Condivi, the work proceeded from the entrance towards the wall of the *Last Judgment*. The most credible reconstruction prior to the last restoration of the frescoes was that of Tolnay (1945), who proposed four distinct phases: by September

1509, the three scenes of Noah, five prophets and sibyls, and eight *ignudi*, plus the related spandrels and double spandrels; by August 1510, the scenes of *The Creation of Eve* and *The Fall*, with their related sibyls, prophets, *ignudi*, and spandrel scenes; between January and August 1511, the rest of the ceiling; and, from October 1511 to October 1512, the wall lunettes above the windows. The question has now been resolved definitively, in my opinion, by Mancinelli (1982 and 1986), who discovered the holes that housed the *sorgozzoni* which braced the scaffolding, a system devised by Michelangelo himself after Bramante, the architect for the Vatican Palace, had proposed a solution which proved to be impractical. Based on stylistic and technical analyses as well as the documentation (especially the diaries of the pontifical master of ceremonies, Paride de Grassi), Mancinelli confirmed the hypothesis of Wilde (1978) in recognizing only two phases: the first, comprised of that part of the ceiling and related lunettes up to the *Creation of Eve*, which was unveiled in August 1511; and the second, comprising the other half of the ceiling and its related lunettes, unveiled on All Saints Eve, October 31, 1512. (For a much less convincing solution to the problem of the scaffolding, see Hartt 1982.)

The conception of the complex fresco cycle occupied Michelangelo probably up to December 1507, while the artist was still in Bologna supervising the casting of a large bronze statue of Julius II. In a letter of December 1523, he recalled: "[Julius] decided that I would paint the ceiling of the Sixtus with only a few figures, on which I agreed to three thousand ducats for all my expenses. But after I had made certain drawings, it seemed to me to have a poor appearance, therefore, he gave me a different commission [to paint] as far down as the scenes below, and that I could make on the ceiling what I wished, going up about as far. And so I agreed" (DXCV). In another version of the same letter, he wrote: "He sent for me to paint the ceiling of the Sixtus, and we agreed on three thousand ducats; and the first design of said work was the twelve Apostles in the

lunettes, and the rest a certain compartmentalization filled with decorations, as was the custom" (DXCIV).

His first design for the ceiling is documented in a drawing in the British Museum (fig. 59) showing the triangular impost area occupied by a male figure (perhaps an apostle) seated on a throne topped with a shell niche and flanked with pilasters. Above this is a rhombus with circles at each vertex, one of which is inserted into the top of the throne. On either side of the rhombus are horizontal rectangles set above squares inscribed with circles and below vertical rectangles which, by implication, continue across the arch of the vault. As Tolnay (1945) emphasized, each element of the decorative system—throne, circle, rectangle, and rhombus—is found alone or in combination in decorations preceding or contemporary with the Sistine Ceiling (for example, the choir of Santa Maria del Popolo painted by Pinturicchio), but in none of these is found the interpenetration of elements characteristic of the London drawing.

In the Detroit drawing (fig. 60), the thrones are restricted to the triangular imposts with the rest of the space developed as veritable painted architecture consisting of: an articulated entablature supported by wide pilasters; large framed octagons at the center of the ceiling, probably thought of as containing painted scenes; and wide dividing strips with putti holding up oval medallions attached to rectangles decorated with scrollwork, also perhaps imagined as painted with figures. Many elements of the final architectural program of the ceiling were already present: the large cornice, the alternation of large and small scenic fields, and the system of short pilasters supported on the spandrel frames which acted as bases for the *ignudi* who held the medallions. Thus, after having developed in the London drawing the theme given to him by the patron, of twelve enthroned apostles (locating them not in the lunettes over the windows but in the triangular impost areas of the ceiling) and a geometric decoration in the central area, Michelangelo rejected that design as having "a poor appearance" and developed the design shown in the Detroit drawing. Realizing the impossibility of avoiding emphasis on the verticality of the architectural structure in extending the axes of the fifteenth-century wall pilasters upward in the painted decoration, the artist next examined the possibility of organizing the vault area rhythmically in panels isolated by an entablature, thus progressing logically, through the substitution of the rectangle for the rhombus, to the schematic design on the verso of the London sheet (fig. 62).

As shown in the Casa Buonarroti drawing (fig. 61), he had originally thought of a decoration with shell and acorn motifs all along the entablature, alluding to the arms of the Della Rovere family and analogous to the motif used by Giuliano da Sangallo on the capitals of the loggia built for Julius II at Castel Sant'Angelo. In the final ceiling design, this decorative motif was restricted to the frames that outline the spandrels, and the cornice became a powerful entablature inspired probably by the Palatine Septizonium (Tolnay 1945), which was studied intensively by architects of the early sixteenth century (see fig. 63; Borsi 1985).

The importance of this architectural "divisioning" of the vault surface was stressed in the description, perhaps referring back to an observation made by Aretino in a letter to Fausto da Cangiano (Pertile-Camesasca 1960), cited by Condivi: "A cornice . . . encircles the whole work, leaving the middle of the ceiling from one end to the other as open sky." Vasari noted more precisely: "In the division he has not used the rules of foreshortening, nor is there a fixed view, but the division has been more accommodated to the figures than the figures to the division." This clearly characterizes the painted architecture as not illusionistic—that is, not presented from a single point of view (as easily seen in looking at the ceiling as a whole), and not understood therefore to be a cornice beyond which the sky was opened up. As noted by Wilde (1978), Michelangelo resolved the arrangement of the Sistine decoration in a different way than that described in May 1506 by Bramante, according to his experience

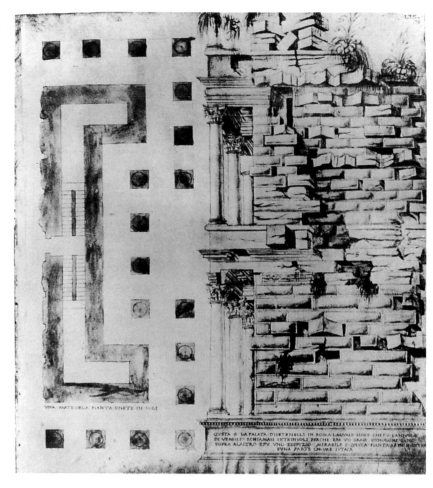

with the illusionistic ceilings of Melozzo and Mantegna: "The figures are high up and foreshortened, and that is quite different from painting on the ground." Rather than using foreshortening as a way of introducing figures into a space created from the single point of view of the spectator, Michelangelo made it the means of getting away from that naturalistic-perspectival condition. For the same reason, the shadows do not correspond to a single source of natural illumination but change as if there were different light sources. The complex architectural scheme, comprising the smaller Biblical scenes each framed by a double fillet of simulated marble and the larger ones opened onto the curvature of the arch, actually denied the possibility of understanding the figural compositions as framed paintings or pseudo tapestries (Tolnay). The attempt by Schiavo (1949 and 1953) to deduce from the painted architecture an architectural plan superimposed by Michelangelo on the real configuration of the ceiling was therefore not only unproductive but contradictory. It was the same as attempting to deduce from the painted bronze medallions Michelangelo's activity as a sculptor. As pointed out by Argan, the painted architecture of the ceiling had a purely effractic value and entered equally with the figures into a *visio intellectualis*, understood in the neoplatonic sense. The recent restoration of the fresco and the restitution of a more reliable philological text provided evidence of the figurative value of the painted architectural structure, interpreted as a classical *temenos* by Finch (1990) and associated by Frommel (1990) with Bramantesque examples.

AEDICULA FOR THE CHAPEL OF SAINTS COSMAS AND DAMIAN, CASTEL SANT'ANGELO, ROME, c. 1514

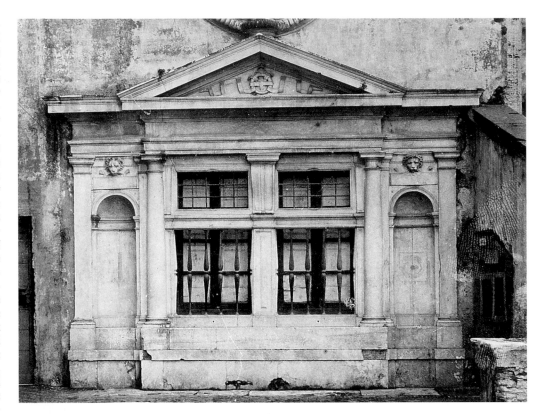

64. *(above) Chapel of Saints Cosmas and Damian, detail of aedicula in courtyard before restoration of early 20th c. Castel Sant'Angelo, Rome*

65. *(below) Chapel of Saints Cosmas and Damian, detail of aedicula in courtyard after restoration of early 20th c. Castel Sant'Angelo, Rome*

The chapel adjacent to the fifteenth-century papal apartment in Castel Sant'Angelo was reconstructed in the first years of the pontificate of Leo X. An account recording that "the work of the wall made in Castel Santo Agnolo by master Antonio da Sangallo [was] finished . . . on November 10, 1514" (Frey 1911, and Giovannoni 1959, with differences) also refers, in addition to the creation of the courtyard on the east side of the apartment (Contardi 1984), to a "door . . . which goes into the new chapel, of voussoirs" as well as to the "foundation for the chapel which was first made 47 *palmi* long by 15 high by 4 deep [and] afterward made 31 *palmi* long, 18 high, from the level of the courtyard, and 4 deep." The construction under the first Medici pope is further attested to by his coat of arms at the center of the chapel ceiling and by the arms of the chamberlain of the castle at the time, Raphael Petrucci, on tiles and corbels, which allows the work to be dated before 1517 (Mazzucato 1985, example U). Confirmation exists as well in a letter of Leo X referring to the chapel as "newly constructed" (Pagliucchi 1906–9). Tafuri (1984a) has connected a study by Antonio da Sangallo the Younger with the project (fig. 66).

The marble aedicula on the south wall of the court of honor frames a large Guelph Cross window illuminating the chapel interior from the side. Sculpted in the triangular pediment is the emblem of Leo X, a ring with three plumes (fig. 64), which dates the aedicula to his pontificate also. The attribution to Michelangelo was based on a drawing in the Lille notebook (fig. 67) attributed by Geymüller (1885) to the Sangallos, Bastiano, called Aristotile (who was Michelangelo's aide on the Sistine Ceiling) and Giovanni Battista, called Gobbo. Under the sketch (which has measurements quite different from those recorded at the beginning of this century), is inscribed: "This in castle of Rome by the hand of Michelangelo in travertine." A copy after this sheet (Commune Library, Siena, S.IV, 1, f. 12v), inscribed "In Castle of the Blessed: Michelangelo," appears in the notebook used by Oreste Biringucci to collect illustrative materials for his *Tratto degli edifici e delle fabbriche nobili del mondo così antiche, come*

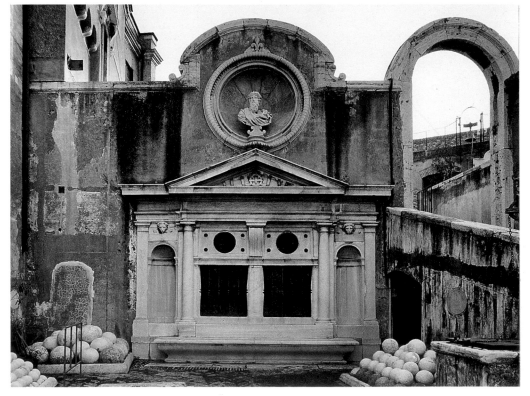

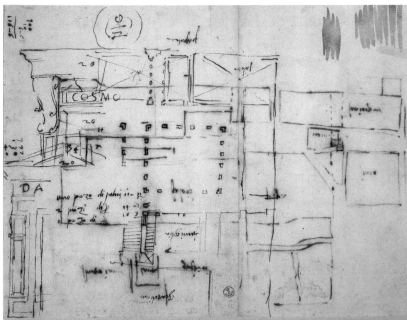

66. (above left) Antonio da Sangallo the Younger. Study for Chapel of Saints Cosmas and Damian, and study for Medici palace with two courtyards. Uffizi, Florence, Drawings and Prints Dept., A 1259v

68. (right) Anonymous, 16th c. Copy of Raphael da Montelupo's design in fig. 67 (bottom of sheet). Private Coll. (Uffizi negative 126259)

67. (below left) Raphael da Montelupo. Study for modifying aedicula of Chapel of Saints Cosmas and Damian. Musée des Beaux-Arts, Lille, Wicar Coll., f. 733

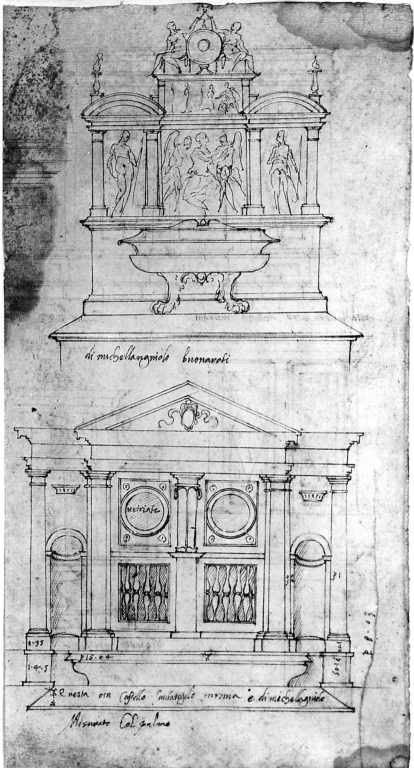

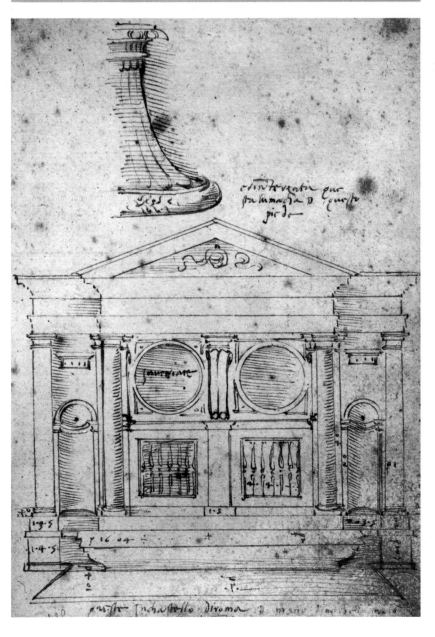

69. *(above) Michelangelo. Study for bipartite window. Casa Buonarroti, Florence, A 58 (C. 594r)*

70. *(below) Michelangelo. Plan, perhaps for aedicula of Chapel of Saints Cosmas and Damian. Archivio Buonarroti, Florence, II, III, f. 30v (C. 493v)*

moderne. Seemingly derived from the Lille drawing or its prototype are two other works, one attributed to Giorgio Vasari the Younger and inscribed "This is in Castello S. Agnolo designed by Michelangelo" (Uffizi, Drawings and Prints Dept., A 4686), and an anonymous sketch (fig. 68) inscribed: "And remains in Castel Sant'Agnolo in Rome and by Michelangelo," published by Gaudioso (1976).

The attribution to Michelangelo, a sixteenth-century tradition witnessed by these inscribed drawings, has never been challenged (Ackerman 1961). Gaudioso (1976ª) related the considerable differences between the Lille drawing and the actual work (for instance, the medium is marble not "travertine") to the enlargement and modernization of the pontifical quarters under Paul III between 1543 and 1548. The apartment was augmented by one floor, elevating the Pauline salon and the so-called Library. The court of honor was also altered as a result, and another monumental aedicula in travertine was constructed on the north side. Probably to create some form of correspondence between the two short walls, which became the scenographic backdrop of the court of honor, the Farnese architect (almost certainly Raphael da Montelupo, who received payments as architect of the castle between July and December 1544) had planned to rebuild or alter the existing aedicula by Michelangelo. The only change, however, was the addition above the pediment of the large tondo niche topped with the Farnese lily, which holds a bust sculpted by Guglielmo della Porta (fig. 65). Gaudioso's hypothesis received confirmation by Nesselrath (1983), who identified the second hand in the Lille notebook (close to Aristotile da Sangallo, who was present in the Farnese workshop at Castel Sant'Angelo) as that of Raphael da Montelupo, author of the drawing of the aedicula in fig. 67.

On the basis of a drawing of the aedicula preserved in Florence and mistakenly thought to be autograph (fig. 68), Mariano Borgatti had some unjustified additions made to the structure in the early 1900s, including the panels with circular openings installed in the upper sections of the window and

the bench incorporated into the foundation (fig. 65). In the 1988 restoration of the aedicula directed by me, the panels were removed, but it was not possible to take out the bench without damage to the aedicula. On this occasion also, it became clear from details of the construction that photographs from the end of the nineteenth century showed the aedicula quite probably as it was constructed originally (fig. 64). As a result, we find ourselves confronting Michelangelo's first architectonic design, datable between 1514 and 1516. Ackerman (1961) has noted some aspects of the aedicula design, such as the projection of the central zone, the provision of a pediment, the lateral bays surmounted by rectangular tablets, and the large volute bracket at the center of the window, which recall Michelangelo's slightly later projects, especially that for the façade of San Lorenzo. Also, the slender bronze "balusters" over the windows, certainly original, closely resemble similar elements on the painted thrones of the prophets on the Sistine Ceiling.

No drawings have been securely related to the design of the aedicula as it was first executed, but scholars have proposed to identify some preparatory sketches. Stylistically related, but without direct connections, is a drawing in Christ Church, Oxford (0992, previously DD 24v [C. 280v]), hypothesized by Tolnay, however, as a study for a Medici funerary monument in Santa Maria Maggiore. Much discussed is the autograph drawing by Michelangelo in the Uffizi (Drawings and Prints Dept., F 18724v [C. 317v]) published by Ferri-Jacobsen (1905), who, among others, related it to the aedicula.

Tolnay (in the *Corpus*) suggested that the Casa Buonarroti drawing of a bipartite window (fig. 69) was an early study for the central zone of the aedicula, an idea anticipated by Gaudioso (1976), but its resemblance to three windows generally attributed to Baccio d'Agnolo on the third floor of the Cocchi-Serristori Palace, Florence, suggests a date for it after 1516 in Michelangelo's Florentine period. Tolnay's proposal (1980) that the drawing in fig. 70 is related to the aedicula project is problematic but possible. Excluded is fig. 506, as advanced by Schiavo (1953).

TOMB OF JULIUS II,
SUCCESSIVE DESIGNS, 1513–42

Following the death of Pope Julius II on February 13, 1513, there was a good relationship between his heir, Francesco Maria della Rovere, duke of Urbino, and his successor to the pontifical throne, Leo X. The executors of Julius's will, Leonardo Grosso della Rovere, cardinal of Agen, and Lorenzo Pucci, apostolic bursar and later cardinal of Santi Quattro, reopened the file on the tomb, interrupted in 1506, probably to carry out the desires of the defunct pontiff (Pastor). On May 6, 1513, a contract was drawn up by which Michelangelo, in exchange for 16,500 ducats (6,500 more than the original price in 1505), would execute the funerary monument within a period of seven years, according to a "design, model, or form of said tomb." He further agreed to their stipulation that "he could not take other work, at least not important and on that account could impede the making of and work on said tomb." The contract also gave the precise configuration of the monument: "A structure which is seen from three faces, and the fourth face joined to the wall and not seen. The face in front—that is, the end of this structure—to be twenty *palmi* wide and fourteen high, and the two other faces that go to the wall, where the fourth face is attached, have to be thirty-five *palmi* long and the same fourteen high; and on each of these three faces go two niches, which rest on a base that goes around said structure and with their decoration of pilasters, an architrave, frieze and cornice, as seen by a small wood model. In each of the said six niches go two figures, about a *palmo* larger than lifesize, which are twelve figures; and in front of each of those pilasters placed between each niche goes a figure of the same size, which are twelve pilasters, coming out to be twelve figures. And on the top level of said structure comes a casket with four feet, as seen by the model, in which will be the said Pope Julius, and at the head will be two figures on either side who hold him up, and at the foot on either side two others, which come out to be five figures at the casket, all five larger than life, nearly twice lifesize. Around said casket comes six pedestals, on which come six figures of the same size, all six seated; then, on the same level

where these six figures are, above that face of the tomb which attaches to the wall, emerges a shrine (*capelletta*) which goes up about thirty-five *palmi*, in which go five figures larger than all the others, because they are farther from the eye. Also three scenes go there, either of marble or of bronze, as it will please the above-mentioned parties, on each face of the said tomb between one niche and the next, as seen in the model" (Milanesi 1875).

In substance, the monument was no longer freestanding, as in the design of 1505, but backed to the wall and also reduced in volume. Anticipated was a lower level formed by three sides—the front end fourteen by twenty *palmi* (312 × 446 cms.) and the two sides fourteen by thirty-five *palmi* (312 × 781 cms.)—each one containing two niches flanked by two pilasters, with a total of twelve statues, two in each of the six niches, plus twelve figures against the twelve pilasters. Above this level was the statue of Julius II in a casket surrounded by four more figures and six statues seated on pedestals, probably above each of the six niches. On the same level as these eleven statues was a "little chapel," or shrine, thirty-five *palmi* (781 cms.) high, in which another five figures were placed. This was a total of forty statues, to which were added nine bas-reliefs of bronze or marble with "scenes," three on each side, and twelve herm-pilasters. In December 1523, Michelangelo recalled in a letter to Giovanni Fattucci that this was a matter of "making a larger work than the design which I first made" (DXCIV), and the price had consequently gone up (see reconstructions in figs. 31b, 74, 76, and 80a).

The description in the contract of 1513 conforms well, except for the measurements, with a drawing of the tomb in Berlin (Staatliche Museen, Print Dept., 15305r [C. 55r]) and its copy by Jacomo Rocchetti also in Berlin (fig. 71), as well as a sketch of the lower zone in the Uffizi (fig. 72). The latter was attributed by Degenhart (1955) to Giovanni Battista da Sangallo, but Hirst (1989) reattributed it to Michelangelo himself. From these drawings showing only the front view, we see: on the lower level, two niches holding two statues each

(one standing and the other reclining), and four pilasters with four figures (two figures on the pilasters immediately adjacent on the sides can also be seen in profile); on the top level, four seated statues, two frontal and two in profile (the other two on the long sides are not depicted), the pontiff on a bier being held up by two winged figures, and at his feet two genies holding torches; and in the "shrine," the Virgin and Child and two more standing figures (another two can be imagined on the hidden sides). The only differences here are the lack of pedestals under the seated statues and the lack of a proportional increase in size of the statues towards the top, "because they are farther from the eye."

Unanimously connected with the 1513 project was the execution of the two *Slaves* in the Louvre (figs. 81, 82), because of the similarity with the figures described in the contract "in front of each of those pilasters, placed between each niche." In a letter of May 1518, Michelangelo in fact recalled: "While I was in Rome the first year of Pope Leo, master Luca da Cortona the painter came there. . . . He came to my house on the Macello de' Corvi . . . and found me working on a standing marble figure, four *braccia* tall, which has its hands in back" (CCLXXXV), apparently the *Rebellious Slave* (fig. 82). The identification, although unanimously accepted, is contradictory to the measurements for these figures given in the contract of May 1513 as "a *palmo* larger than lifesize," corresponding more or less to 180–200 centimeters, while the Louvre *Slaves* are respectively 229 and 215 centimeters in height. The Berlin drawing (notwithstanding the ingenious explanation by Joannides 1981) has often been noted as not having the same proportions indicated by the measurements in the May contract, which established the ratio of 1:2.5 between the height of the lower zone (fourteen *palmi*) and that of the shrine (thirty-five *palmi*). The conclusion is therefore that the Berlin sheet referred not to the measurements of May 6 but to those given two months later in an agreement of July 9, 1513. In this document, Antonio da Pontassieve was to provide, for a payment of 450 ducats, "made and finished, the framework and the carving for . . .

the face which is in front—that is, a façade about thirty *palmi* wide and seventeen high, according to the design." By assuming the height of the lower zone of the tomb in the Berlin drawing to represent, instead of the fourteen *palmi* of May, the seventeen *palmi* of July, and maintaining the shrine height at thirty-five *palmi*, the resulting ratio is 1:2. Consequently, the "prisoners" actually measure about ten *palmi*, which corresponds to the heights of the Louvre *Slaves* (for reconstruction, see fig. 75.)

In view of the description given in the 1513 contract for the tomb, the proposal of the Metropolitan Museum drawing (fig. 73) as a variation of the 1513 solution is too farfetched (as is the idea that it represents an autograph preliminary study for the design of 1505). The appearance of the base, with columns in place of the "prisoners," and the graphic style suggest that this drawing may be an alternative design to Michelangelo's, datable perhaps to the twenty years of his contractual noncompliance, when different artists—probably even Sansovino—came forward to present to the Della Rovere heirs their ideas for a speedy resolution to the tomb. Perhaps acceptable is the proposal of Joannides (1982) that the bronze statuette of a *Slave* in the Poldi Pezzoli Museum (fig. 84) was directly derived from the model of the tomb presented by Michelangelo in 1513, as was the drawing for a "slave" in Paris (fig. 83).

Often noted as an example of Michelangelo's urge to "re-create" was his substitution for the freestanding tomb monument in the manner of a Classical mausoleum, of a compromise between it and the Christian tradition of the wall tomb. This change corresponded to the mutation of the funerary monument from an exaltation of the figure of the Roman pontiff to a kind of glorification of the power of the Della Rovere family. From the point of view of the history of the forms, without doubt Michelangelo moved away from the synthesis of the arts sought programmatically in 1505 to a dynamically charged relationship between sculpture and architecture, which was necessary for him to complete the experience of the Sistine Ceiling. Also, Tolnay (1945) has noted the reemergence here of a "Gothic impulse."

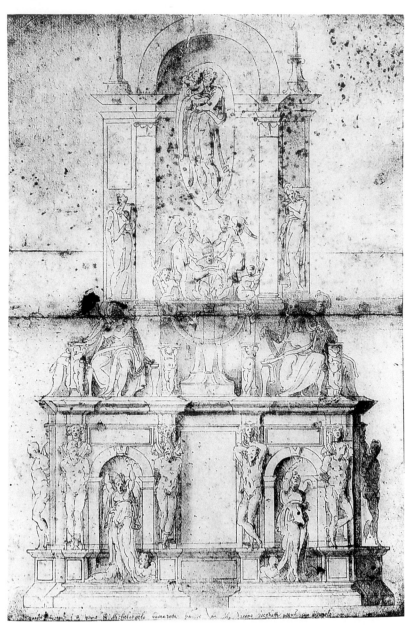

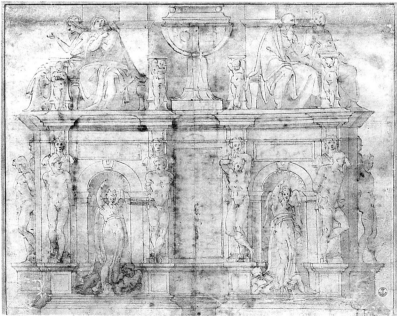

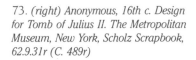

71. *(above left) Jacomo Rocchetti. Copy of Michelangelo's 1513 design for Tomb of Julius II. Staatliche Museen, Berlin-Dahlem, Print Dept.*

72. *(below left) Michelangelo (attrib.). Lower zone of 1513 design for Tomb of Julius II. Uffizi, Florence, Drawings and Prints Dept., E 608r*

73. *(right) Anonymous, 16th c. Design for Tomb of Julius II. The Metropolitan Museum, New York, Scholz Scrapbook, 62.9.31r (C. 489r)*

74. *(opposite) Reconstruction of Michelangelo's 1513 design for Tomb of Julius II (Panofsky 1937): (a) side; (b) front; (c) ground plan; and (d) horizontal section of base*

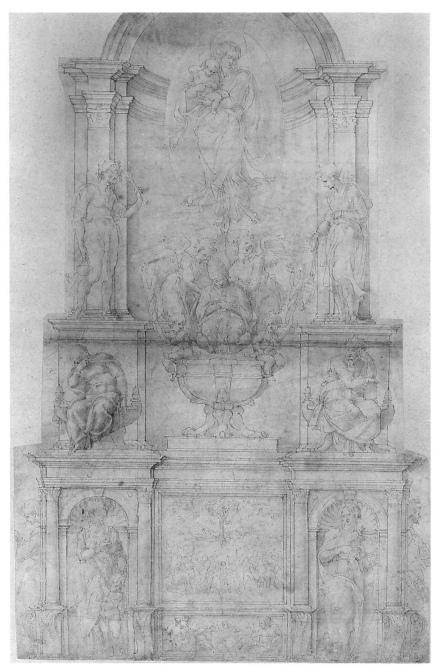

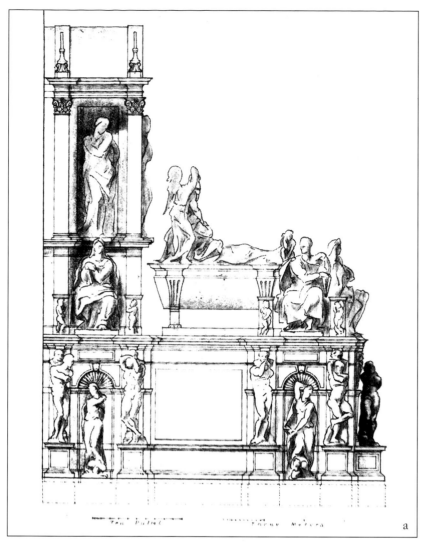

a

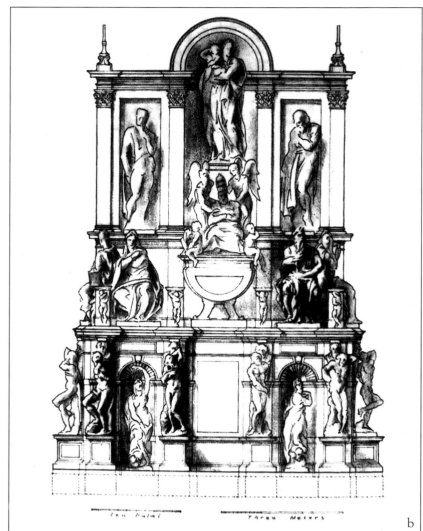

b

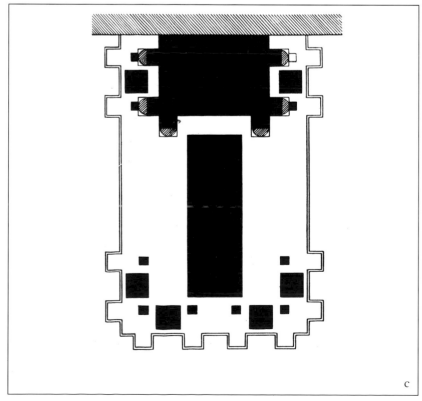

c

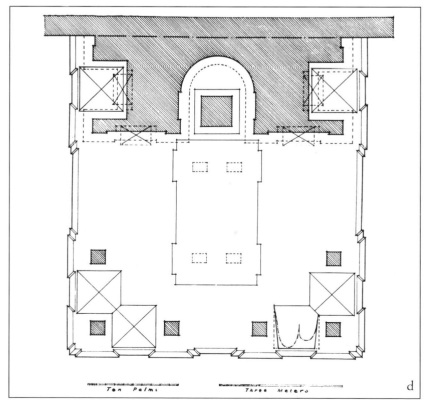

d

69

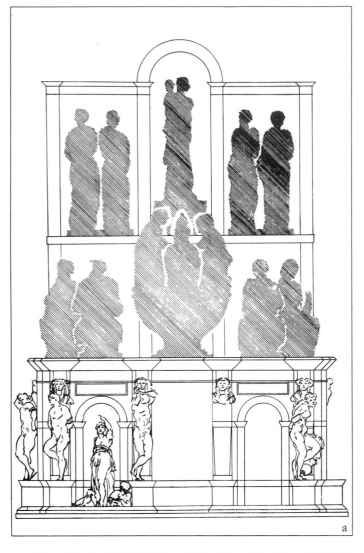

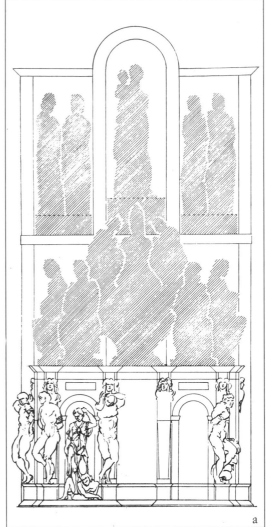

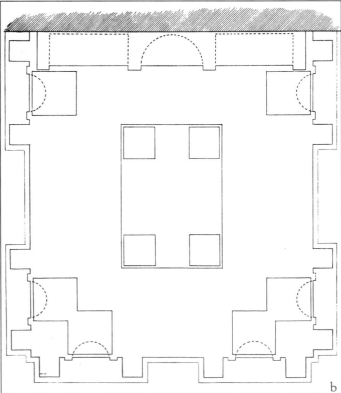

75. *(left above, below) Reconstruction of Michelangelo's second design of 1513 for Tomb of Julius II (Weinberger 1967): (a) front; and (b) ground plan*

76. *(right above, below) Reconstruction of Michelangelo's first design of 1513 for Tomb of Julius II (Weinberger 1967): (a) front; and (b) ground plan*

Between 1513 and 1515, the work proceeded in a sufficiently expeditious way due to the collaboration of assistants, who prepared the marble blocks. Besides Antonio da Pontassieve mentioned above, Rinieri, Bernardino di Pier Basso, and "a Lombard" were also hired in August 1514 (CXIII). Soon after completing the two *Slaves* in the Louvre and perhaps another two elsewhere (Weinberger 1967), Michelangelo began the *Moses*, one of the six seated figures above the lower zone, which is slightly taller (235 cms.) than the *Slaves*, as specified in the May 1513 contract. On June 16, 1515, in a letter to his brother Buonarroto, he spoke of having "bought perhaps twenty thousands of copper to cast certain figures," probably the bas-reliefs in bronze [alloy of copper and tin] planned for the tomb. He also confided: "I need to make a great effort, this summer, to finish this work quickly, because I estimate then to have to be in the service of the pope" (CXXVIII), perhaps the first hint of his involvement with the sculptural decoration of San Lorenzo in Florence.

In the last months of 1515, however, the relations between Leo X and Francesco Maria della Rovere worsened, owing to the latter's refusal to help the pontiff in his war in Lombardy against the French, with whom the duke was secretly allied. By the usual political machinations, the pontiff, after he was defeated by Francis I, met with the French king in Bologna in December 1515 and succeeded in obtaining the dukedom of Urbino for his nephew Lorenzo de' Medici. Thus ousted from his position by Leo X, Francesco Maria fled to Mantua in March 1516 and was never reconciled with the pontiff. The work on the tomb was, of course, affected by the changed political conditions, and Michelangelo began actively to solicit the commission for the façade of San Lorenzo. On April 21, 1516, the cardinal of Agen asked Michelangelo to allow the new duchess of Urbino, on a visit in Rome, to see "your work on the sepulcher" (CXLV), which shows that his house on the Macel de' Corvi was still an active shop. A few months later in July, a new contract was drawn up for the tomb in a considerably reduced configura-

tion. "The model is about eleven Florentine *braccia* wide on the front face; on this width is placed at the ground level a base with four socles or four pedestals with their cornices all around on which come four figures cut of marble, each of three and one-half *braccia*, and behind said figures on each pedestal goes its pilaster; the height up to the first cornice going from the base is six *braccia*. And between the two pilasters with their pedestals is placed a niche, the space of which is four and one-half *braccia* high; and the same for the other side are two more pilasters with a similar niche put between them, which comes out to be two niches on the front face below the first cornice, in each of which comes a figure similar to those mentioned above. Then between one niche and the other remains an empty space two and one-half *braccia* high up to the first cornice, in which goes a scene in bronze. And the said work will be built coming out from the wall an amount which is [the] width of one of said niches, which are on the front face; and on the flanks which go to the wall, that is, on the ends, go two niches similar to those on the front with their pedestals and their figures of similar size, which comes to be twelve figures below the first cornice and a scene, as said; and above the first cornice, over the pilasters with the niches between them below, come more pedestals with their decoration, [and] up there half columns which go up to the top cornice, that is, they go eight *braccia* high, about from the first to the second cornice which is its completion. And on one side between the two columns comes a certain empty space, in which goes a seated figure three and one-half Florentine *braccia* high seated; the same thing goes between the other two columns on the other side. And between the heads of said figures and the top cornice remains an empty space of about three *braccia* for each side, in which goes a scene of bronze for each space, which comes to be three scenes on the front face. And between the two seated figures in front remains an empty space, which comes above the space of the scene in the middle below, in which comes a certain alcove (*trebunetta*) in which goes the figure of the deceased,

that is, of Pope Julius, between two other figures; and a Virgin above of marble, about four *braccia* tall; and above the niches on the ends, or actually on the return face of the part below, comes the return face of the part above; on each of the two goes a seated figure in between two columns, with a scene above similar to those on the front" (Milanesi 1875; for reconstructions see figs. 31c, 77, and 80b.)

Two drawings are of fundamental importance for the reconstruction of the design, which was reduced in the number of statues from more than forty to only twenty, and in volumetric bulk with the flanking ends, or return faces, becoming almost turned-back cuffs. The first, in the British Museum (fig. 85), depicts the lower part "of the front face of the sepulcher [measuring] six *braccia* high from the ground to the first cornice and eleven *braccia* wide from one corner to the other." On the verso of this drawing (fig. 86) are sketches of the marble blocks for the funerary monument, some of which, according to the autograph inscription of Michelangelo, were already finished. The second sheet in the Casa Buonarroti (fig. 87) was first recognized by Wilde (1954) as a side view of the top zone of the Tomb of Julius II according to the 1516 design, modified by the substitution of pilasters for the half columns described in the July contract. On the top part of the page is a fragment of an autograph "record" dated January 25, 1516 (1517 in modern style). Certainly related also are sketches of the pilaster-herms (fig. 189) done in connection, significantly, with the first ideas for San Lorenzo, and some studies for the statues of "prisoners" and the bronze bas-reliefs (fig. 83). Wilde (1954 and 1978) recognized the importance and the completeness of the design of 1516, which remained contractually valid at least up until 1532. Michelangelo's interest had turned again to the relationship between sculpture and architecture, which was resolved to such an extent in comparison with the 1513 design that Wilde believed there was a specific intention on the sculptor's part to substitute for the earlier design another he had developed in the meantime. The clause in the con-

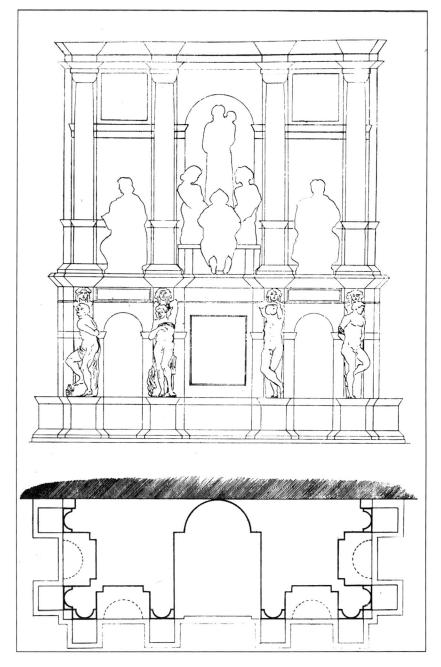

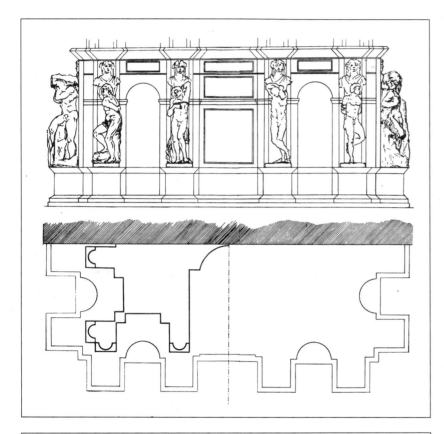

78. *(above) Reconstruction of elevation and ground plan of Michelangelo's 1519 design for Tomb of Julius II (Weinberger 1967)*

79. *(below) Reconstruction of elevation and ground plan of Michelangelo's 1532 design for Tomb of Julius II (Weinberger 1967)*

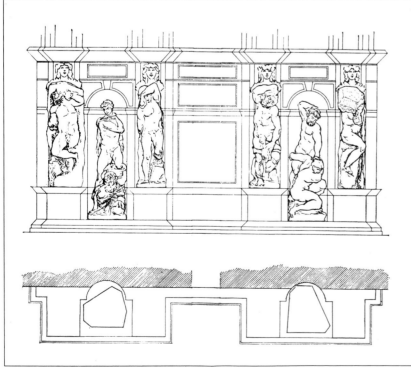

tract with Julius's executors forbidding him to accept other binding commissions so extensive as to require pontifical permission, as well as the fact that he was busy with quarrying marble for the tomb at Carrara and Pietrasanta, kept Michelangelo from full involvement in the project for the façade of San Lorenzo. But the first suspicions about it had already emerged at the time he left Rome. Leonardo Sellaio, who remained in the city to take care of Michelangelo's affairs, wrote to him in Florence on August 9, 1516: "And I pray you, remain in the good hope that you will finish this work in order to make liars of those who say that you have gone away from it and it will not be finished" (CXLVIII). Whatever limits were imposed on the artist by his activity for San Lorenzo, the work on the tomb did go forward, because, on December 5, 1517, Sellaio wrote from Rome to Michelangelo in Florence: "Yesterday I was with the cardinal, and he kept me for more than an hour, and I said to him that all the marbles were at the dock, and that you estimate at any rate within two years, if no problems arise, to have the work completed or nearly so" (CCXLIX). The sculpted works begun in 1513 were therefore already in Rome, and, in a letter of February 5, 1518, Sellaio, who was in charge of the shop on the Macel de' Corvi, wrote that he was worried "by the jealousy over those figures" (CCLV), apparently two of the *Slaves* and the *Moses* at least in a rough-cut state. On October 23, 1518, Cardinal Leonardo Grosso della Rovere wrote to Michelangelo: "With eagerness we look forward to seeing the two figures at the time you have promised them" (CCCLVII). The same day, Sellaio wrote: "The cardinal trusts no one and believes no one who speaks against you, because he is a very great man, and he himself makes a joke of it. But you need to make liars of them with deeds, because I have promised at least one figure at the new time" (CCCLVIII).

Obviously the insinuations by someone who sought to procure the commission himself to execute the tomb, given the stalemate at which Michelangelo's work seemed to have arrived, made an impression on the patron, because, scarcely two months later on December

18, Sellaio wrote again to the sculptor: "The cardinal . . . told me that a great master has been to visit him and told him that you were not working on and will never finish his work, and that I had lied to him" (CCCLXXX). The stalemate was perhaps admitted by Michelangelo in a letter of December 21, 1518, in which he wrote in reference to the work on the tomb: "I am very upset over not being able to do what I would like" (CCCLXXXII). The work progressed to some degree, nevertheless, and Sellaio wrote on February 13, 1519: "[The cardinal of Agen] was very satisfied with you; and he told me that Jacopo Salviati told him that you had in any case made 4 figures, about which he was very happy" (CDIX). This was not just a matter of unfounded promises or assurances. In much later correspondence, Michelangelo recalled that Francesco Pallavicini, the personal assistant of Cardinal Leonardo Grosso della Rovere, while on a visit to Florence in May 1519, had seen "the marbles and rough-cut figures" for the tomb in the sculptor's studio on the Via Mozza.

While contested on stylistic grounds by many scholars, the four figures promised for the summer of 1519 have been identified with the four *Slaves* given in 1564 to Grand Duke Cosimo I by Michelangelo's nephew, then installed later in the grotto of the Boboli gardens, and finally brought to the Galleria dell'Accademia (figs. 10, 11). This allows recognition of a final modification to the design of 1516, which would have to be dated in 1518–19, considering that the London drawing (fig. 85) is datable a little after February 1518. Apparently sketched by Michelangelo in response to a letter around that time from Sellaio, it clearly shows herm-pilasters that are incompatible with the *Slaves* in the Accademia. Accepting this modification, as hypothesized by Wilde (1954), allows the dating to the years immediately following 1519 of the conception of the *Victory* in the Palazzo Vecchio (fig. 88), certainly executed for the Tomb of Julius II. (Already in 1505 and 1513, Victories had been planned for it, even nude ones.) According to this hypothesis, based on the acceptance of an early date also for the London sketch of

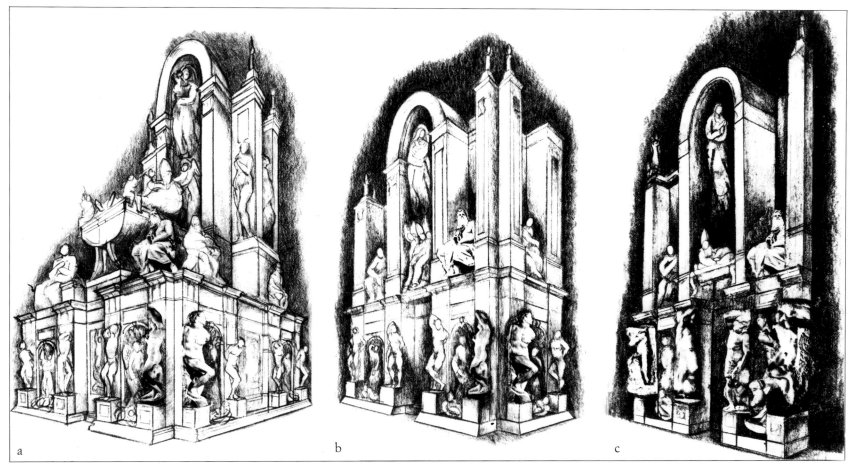

80. *Reconstruction of successive designs by Michelangelo for Tomb of Julius II (Hartt 1969): (a) 1513 project; (b) 1516 project; and (c) 1532 project*

a b c

the torso for *Victory* (fig. 89), the statue was conceived for the left niche on the lower level and a corresponding group of two figures would have been in the right niche. A date for the actual execution of the *Victory* in the same years as the statues for the Medici chapel—more stylistically congruous—does not cause any contradiction with this hypothesis, if one considers that the 1516 contract was not actually modified until 1532.

A prolonged period of work on the tomb is confirmed by what is known about external events, as well as by Michelangelo himself, who often recalled in later years that he never ceased working on the tomb—sometimes even in secret. With the death of the cardinal of Agen in September 1520, one of the protagonists of the tomb event was gone. Moreover, with the death of Leo X and the election to the throne in January 1522 of the Dutch pope Hadrian VI,

Francesco Maria della Rovere regained the dukedom of Urbino and, contemporaneously, papal interest in the work on the Medici chapel in San Lorenzo declined. Upon expiration of the contractual terms fixed in 1513 and 1516, the Della Rovere family wanted to proceed legally against Michelangelo for failing to carry out his obligations. In April 1523, the sculptor wrote to Giovanni Fattucci: "You know that in Rome the pope has been advised about this tomb of Julius, and that they have made an actual move to make him sign and proceed against me and to ask me for what I have been paid over and above said work, and damages and interest; and you know the pope said: 'That would be done, if Michelangelo does not want to make the tomb.' Therefore, I must make it, if I don't want something bad to happen; as you see, it is ordained. And if, as you told me, Cardinal de' Medici now

again wants me to make the tombs in San Lorenzo, you see that I cannot, if he does not free me from this thing in Rome; and if he frees me, I promise him to work for him without any recompense for all the time that I live. I am not asking for freedom in order not to make Julius's tomb, because I would gladly do it, but to serve him; and if he does not want to free me, and because he wants something by my hand in said tombs, I will do my best, while I work on the tomb of Julius, to take time to do something that pleases him" (DLXXI).

At the end of the year, the Medici cardinal became Pope Clement VII, but the Della Rovere lawsuit continued. On June 14, 1525, Michelangelo signed over the power of attorney to Giovanni Fattucci for the purpose of handling on his behalf "the lawsuit or dispute he had in opposition with the illustrious lord Bartolomeo della Rovere and those other

heirs or executors of the will of the favorably remembered Pope Julius II, in the presence of the reverend father lord Cornelio della Volta, hearer of claims for the apostolic palace, on and over the non-observance of the agreed-upon contract between himself on one side, and of good memory Leonardo, Cardinal of Agen, and Lorenzo, Bishop of Palestrina, holy Roman Church cardinal, executors of said will, over the work or making of the tomb of said lord Julius pope" (Milanesi 1875). That summer an alternative and less onerous proposal was made for the completion of the tomb. Michelangelo wrote to Fattucci on September 4: "The making of said tomb of Julius on the wall, like that of Pius, satisfies me, and, in any case, it is much curtailed" (DCCXIII); and again on October 24: "I am satisfied to make the tomb like that of Pius in [old] Saint Peter's, as you have written me, and I

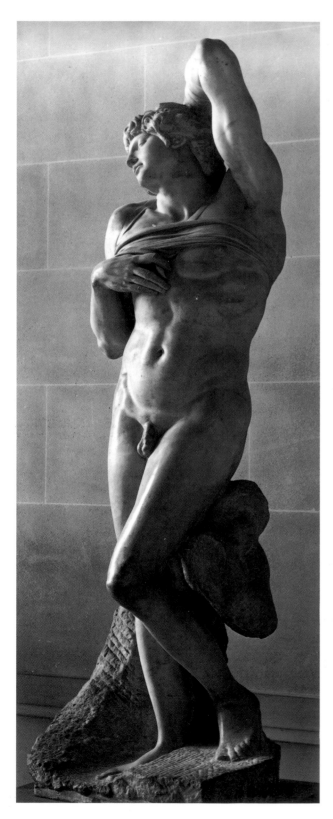

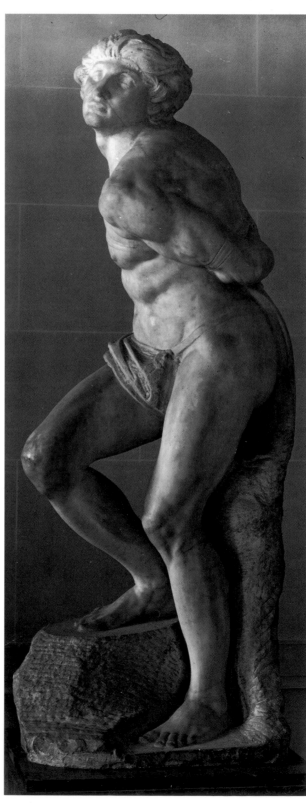

will have it made little by little, between other things" (DCCXIX). The negotiations for the new contract, subject to the approval of a final design submitted by Michelangelo, which Fattucci requested on October 30 (DCCXXI), hinged particularly on the terms of delivery. Fattucci wrote to him: "[The heirs] wanted a short time and you wanted a long one" (DCCXXXI).

On October 16, 1526, the new design arrived in Rome (DCCLIX), but its reception was not enthusiastic, because, on November 1, Michelangelo commented: "This is the bad attitude which the relatives of Julius have towards me, and not without reason. . . . I wanted to get out of this chore more than to live" (DCCLX). The historical events—the Sack of Rome, the siege of Florence, and the return of the Medici—did not allow for an immediate resolution, however, and the matter of the tomb reemerged in the correspondence only in April 1531. At that time, Sebastiano del Piombo wrote from Rome to Michelangelo about having encountered Girolamo Genga, an artist in the court of Urbino: "[He] told me that he will be a good messenger to make the Duke be satisfied with you about the work of Pope Julius, which shows him to have this work very much at heart. I replied to him that the work was in a very good state, but that eight thousand ducats were lacking, and that there was no man who would respond with these eight thousand ducats; and he answered me that the Duke would provide it himself except that His Lordship hesitated about losing the money and the work and seemed to be very angry. But after much talk, he said: 'Couldn't he cut this thing off in some way that would satisfy both sides?' I replied to him that it would be necessary to talk with you." Sebastiano added in the letter that the heirs, in his opinion, "would be satisfied with everything, because they expect certain appearances more than the actual truth" (DCCCXIII).

With the renewed possibility for the completion of the work, lengthy negotiations were opened, during which Michelangelo offered: "[I will give] designs and models and whatever is wanted, and, with the marbles which were

83. *Michelangelo. Drawing for Slave.*
Ecole des Beaux-Arts, Paris, 197r (C. 62r)

84. *Anonymous copy after Michelangelo's*
Slave. Museo Poldi Pezzoli, Milan

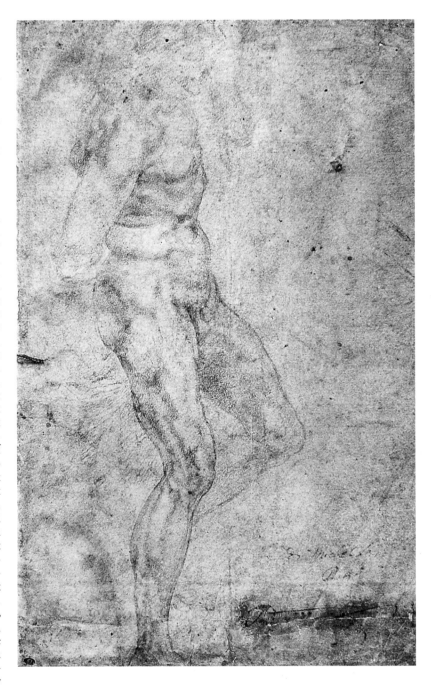

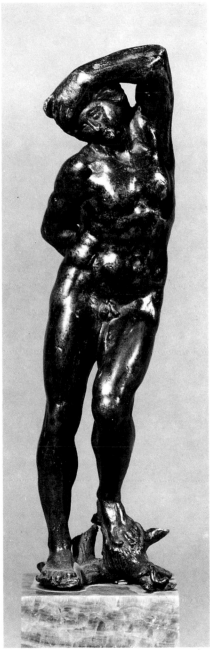

worked, adding up to an amount of two thousand ducats, I believe that it would make a beautiful tomb" (DCCCXXIV). Sebastiano del Piombo confirmed the evaluation of how much had already been executed by Michelangelo, which was actually a great deal (DCCCXX, DCCCXXV). Confronted then with the completion of the 1516 design requiring another eight thousand ducats, the duke of Urbino, in November 1531, specified his preference for the alternative offer to make the "reduced [work] for the amount of money" already received by Michelangelo (DCCCXXXIII). A new contract was then drawn up in which it was agreed that the sculptor would present a "new model or actual design of said tomb at his convenience, in the composition of which will be, and given as promised to give, six marble statues begun and not finished in Rome or actually existing in Florence, by his hand and work completed here in Rome, and, in the same way, everything else belonging to said sepulcher" (Milanesi 1875). The contract dated April 29, 1532, which obligated him to complete the tomb within three years, did not specify where the funerary monument would be placed, but a letter from Giovanni Maria della Porta to the duke of Urbino mentions that "not being able to put it in Saint Peter's, as it cannot be, it seemed very suitable to everyone that it should be put in San Pietro in Vincula, as the family's own church, which still has the name of Sixtus, and the church built by Julius. . . . For the People it would be good in a place much frequented, but, according to Michelangelo, there isn't enough space or light there for the design" (Gotti 1875). Scholars have made various proposals for the identification of the six statues, finished or rough-cut, existing in Rome or in Florence, which were to have been placed on the monument (see reconstructions, figs. 79, 80c). Unanimously accepted is the *Moses*, with two different groups proposed to accompany it— either the two Louvre *Slaves* and the *Virgin*, *Prophet*, and *Sibyl* rough-cut much later, or, according to Tolnay, the four Accademia *Slaves* and the *Victory*.

At the end of the three years, Michelangelo was already involved with the

85. (left) Michelangelo. Sketch for architecture of lower zone of Tomb of Julius II according to 1516 contract. British Museum, London, 1859–5–14–824r (C. 57r)

86. (above right) Michelangelo. Sketch of marble blocks for lower zone of Tomb of Julius II according to 1516 contract. British Museum, London, 1859–5–14–824v (C. 57v)

87. (below right) Michelangelo. Side view of top zone of Tomb of Julius II according to 1516 design. Casa Buonarroti, Florence, A 69r (C. 58r)

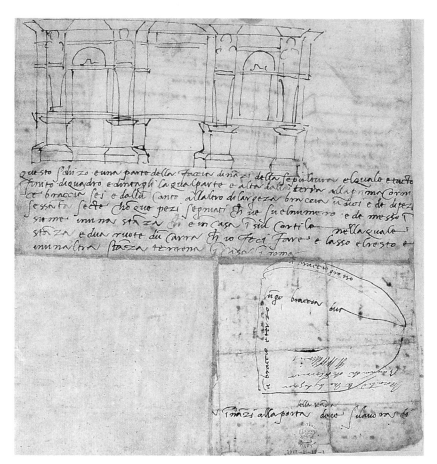

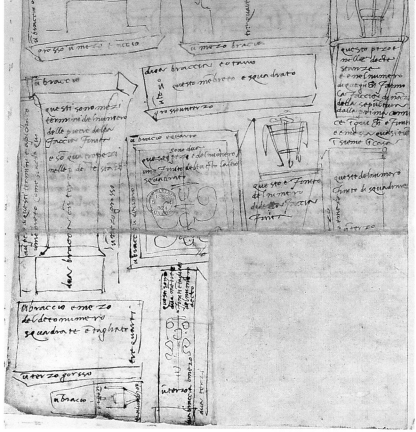

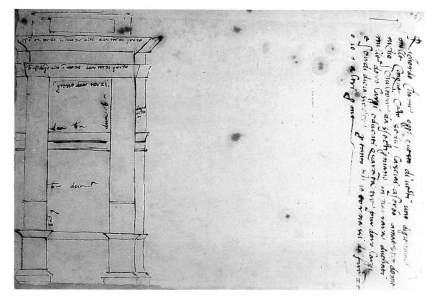

Last Judgment commissioned by Paul III. With a *motu proprio* of November 17, 1536, the pontiff released Michelangelo from the obligation he had assumed with the Della Rovere family, and in October 1538 Francesco Maria della Rovere died. In a letter of September 7, 1539 to Michelangelo, Guidobaldo della Rovere, the successor to the dukedom of Urbino, confirmed his hope that, at the end of the work on the *Last Judgment*, "[the artist] will then bring everything to conclusion on said tomb, redoubling [his] effort and haste in order to compensate for lost time" (CMLXX). The expectation was destined to be frustrated, however. When the *Last Judgment* was completed, a letter from Cardinal Antonio Parisani to Duke Guidobaldo on November 23, 1541 informed him that, because the pontiff had commissioned Michelangelo to paint the Pauline Chapel, "it will not be possible for him to work on the tomb,

because he is old and resolved, having finished said chapel (if he lives that long), not to do any more work, and it will take three or four years on it, and it will be necessary to provide in some other way there." Nor were the statues already completed sufficient. Parisani continued: "Our Lord judges that, if a worthy public decoration of said Chapel is desired, then, with respect to the new design of the tomb, these could not be used. . . . [Therefore, the provision is necessary that] the six statues, which were to have been made by the hand of the aforesaid Michelangelo, will be made by the hand of another master with his model and design, while an effort will be made to see if these six statues could not have something either made or rough-cut by his hand" (Gaye 1839–40).

On February 27, 1542, Michelangelo signed a contract with Raphael da Montelupo for a payment of four hundred

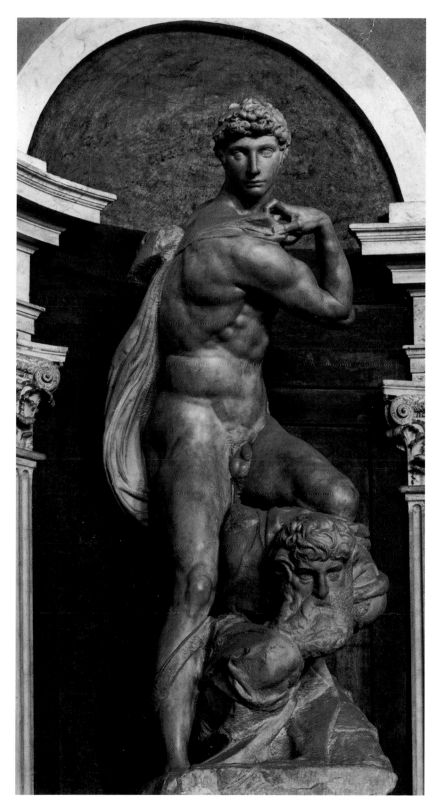

88. *Michelangelo.* Victory.
Palazzo Vecchio, Florence

ducats to finish, in eighteen months, "three figures of marble larger than life-size, rough-cut by my hand." In the event that Michelangelo successfully finished two of these, the *Active Life* and the *Contemplative Life*, the amount of payment would then be reduced (Milanesi 1875). A few days later, on March 6, 1542, in consideration of the desire expressed to him by Paul III to use Michelangelo "in painting and decorating his chapel, newly built in that apostolic Palace," Guidobaldo wrote to the artist: "[I agree] to place on the tomb of the holy memory of Pope Julius, my uncle, the three statues entirely worked and finished by your hand, including in this number that of the Moses, with the satisfaction close to final perfection of the work according to the last meetings, as you told me that voluntarily and promptly you had offered to want to do, and the other three statues in the middle which you will have done by the hand of another good and praised master, with your design, therefore, and assisting with your personal help" (CMLXXXIX). On May 16, 1542, Michelangelo turned over to Francesco called Urbino and Giovanni de' Marchesi "all the work of the body of said tomb from that which up to the present was done above, as by a design made and agreed to," with the whole work to be terminated in eight months for a compensation of seven hundred ducats (Milanesi 1875). In a petition submitted to Paul III on July 20, 1542, Michelangelo observed that, of the "three figures . . . nearly ready, . . . the two Prisoners were made when the work was designed as much larger, where there were very many figures, which then in the . . . contract [of 1532] was cut down and narrowed, for which reason they did not agree with this design, nor were they in any way possible to keep." Having "begun the two statues which were from the group of Moses, that is, the Active Life and the Contemplative Life," he requested "permission to be able to give the work on the other two statues which remained to be finished to said Raphaello da Montelupo." With Paul III's consent, the fifth and final contract was arrived at on August 20, 1542, in which the tomb would have, besides the *Moses* entirely finished by the hand of Michelangelo, five other statues, a "Virgin with the Child in her arms, which is already completely finished, a Sibyl, a Prophet, an Active Life, and a Contemplative Life, rough-cut and nearly finished by the hand of said Michelangelo," which would be completed by Raphael da Montelupo. At the end of 1544, the architectural framework was completed, and Raphael da Montelupo installed the statues on the top level in January 1545, followed by *Moses*, *Rachel* and *Leah* in February. With the settlement of the account for the funerary monument by Bernardo Bini on May 14, 1548, the drama of the tomb was concluded.

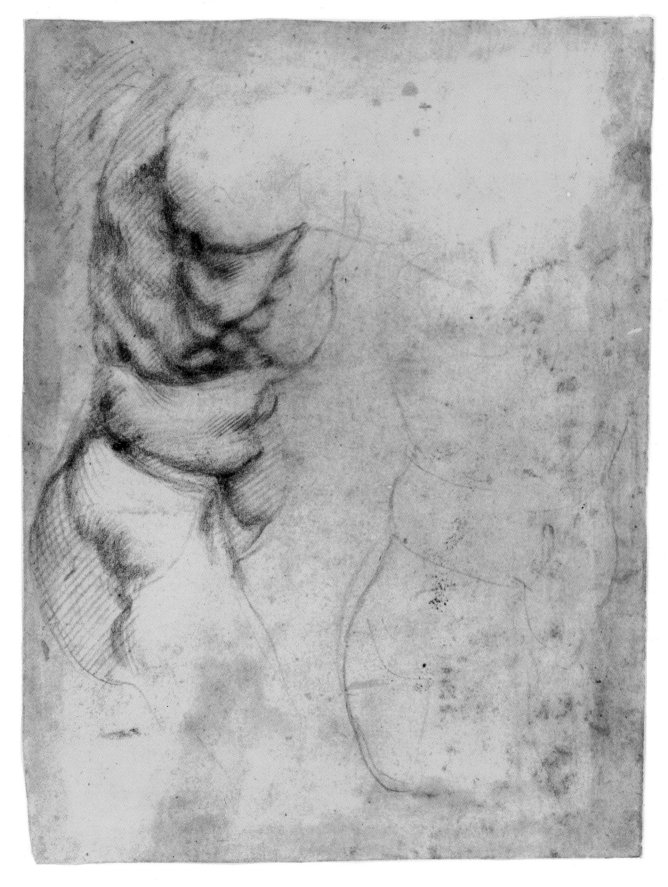

89. *Michelangelo. Sketches for torso of*
Victory. *British Museum, London, 1859–*
6–25–563 (C. 67r)

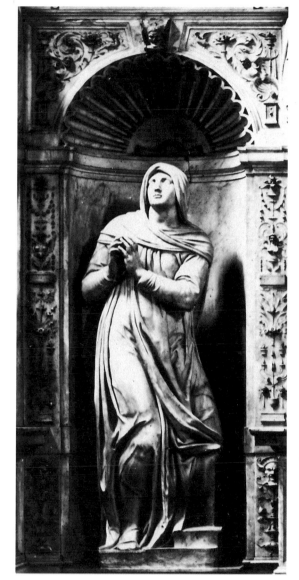

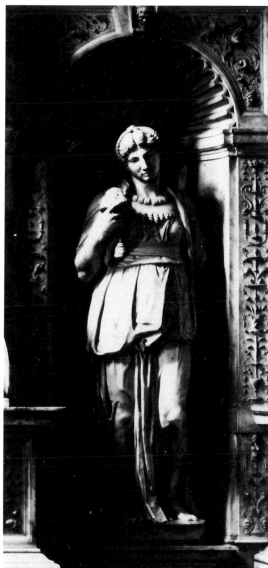

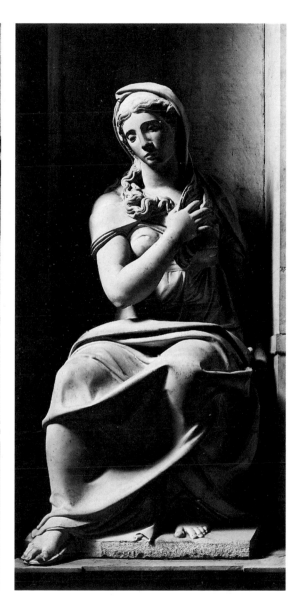

90. *Michelangelo and Raphael da Montelupo.* Rachel (Active Life), *Tomb of Julius II. San Pietro in Vincoli, Rome*

91. *Michelangelo and Raphael da Montelupo.* Leah (Contemplative Life), *Tomb of Julius II. San Pietro in Vincoli, Rome*

92. *Raphael da Montelupo.* Sibyl, *Tomb of Julius II. San Pietro in Vincoli, Rome*

79

FLORENCE, 1516-34

"Pure touches below and above its border and the yellow and the black and the white not encircled." Poems, 35

The façade of San Lorenzo

L eo X was a better politician as a patron of the arts than he was as pope. After the Sistine Ceiling, Michelangelo was the most admired artist in Italy, and it was natural that Leo was not pleased to see him work for the posthumous glory of his papal predecessor. But why did he have him do architecture, and not in Rome but in Florence? Michelangelo was not a docile man, so why did he accept? He had not done any architecture except the extemporaneous design for the small courtyard façade of the Chapel of Saints Cosmas and Damian for Leo X in Castel Sant'Angelo, which was more of a pastime (No.4). In Rome, after Bramante's death in 1514, the construction of Saint Peter's had gone forward under Raphael, the new *magister operis*, and his assistants Giocondo and Giuliano da Sangallo. For him, the church was to have been the triumph of Renaissance ideology: "I want to discover the beautiful forms of ancient edifices, even if I know it will be a flight of Icarus." Leo X had intended to assign Raphael to the completion of the façade of San Lorenzo, the Medici family church, but he changed his mind, commissioning Michelangelo instead and sending him to Florence in 1516. Why?

The election of Giovanni de' Medici, son of Lorenzo the Magnificent, as Pope Leo X had been the triumph of Medici family ambition, and it had put an end to the culturally motivated tensions existing between Rome and Florence for over half a century. Rome by tradition and Florence by election, each wanted to be heir to Roman antiquity. Florentine humanism through Alberti provided a pragmatic and historical motive for the recovery of antiquity in Rome, and it became the track and guide for the reclamation of the city, then desperate and regressive but, with the end of the schism in the Western Church and the return of the pope, destined to assume new apostolic authority and great political importance. In Florentine neoplatonic thought of the late Quattrocento, antiquity was more of an ideal than a historical reality, and it was no more localizable in Rome than in Greece. As a culture dead for centuries, it could not be reborn naturally but only resurrected in Christianized form. But Florence, a relatively modern city, had no need to be reconstructed, while Rome did.

With the coincidence of his election to the pontifical throne in Rome and the restoration of Medici rule in Florence, Leo X wanted both cities to carry the sign of the double power of his family in two monumental works of high prestige, but each with a different meaning—the new Saint Peter's in Rome and the completed Church of San Lorenzo in Florence, the latter a masterpiece built by Brunelleschi for Cosimo de' Medici il Vecchio but left without a façade (fig. 96). The Florentine project was connected with the planned renewal of the whole urban area and the construction of a new Medici palace.

The continuing problem with regard to the façade of a church of rigid perspective structure was whether it should be a simple bisected plane on which was projected, in the same number of proportional divisions, the

spaces of the interior, or an architectural organism with its own spatiality, as seen in Alberti's façade for the Church of Sant'Andrea in Mantua. Giuliano da Sangallo had already devoted long study to the problem, and his solution was clearly the point of departure for Michelangelo, when, not having had any real experience with architectural construction, he was given the responsibility for the façade of San Lorenzo (No. 7).

Although carefully reconstructed by Millon, the history of that enterprise prior to the granting of the commission to Michelangelo remains uncertain. There was some type of competition for which "designs were made by Baccio d'Agnolo, Antonio da Sangallo, Andrea and Iacopo Sansovino, and the gracious Raphael of Urbino." The pope apparently favored Raphael's design, and he actually took the artist with him to Florence in August 1515, so that preparations could be made on the spot. Tafuri and Frommel have identified a copy after Raphael's design attributed to Aristotile da Sangallo (fig. 97), in which the façade was in the form of a "narthex" with true depth and plasticity. This was undoubtedly the final solution to the problem at that moment, and it is not clear why, after having chosen it, Leo X then discarded it. The condition of providing a great deal of space for sculpture had been met, which was the pope's intent from the start, so that the façade would have its own value beyond that of merely completing the church structure. Probably, the perfect balance of architecture and sculpture in Raphael's design did not satisfy him, and, desiring a stronger prevalence of sculpture, he thought of assigning the enterprise to the greatest sculptor of the time, who happened also to be a Florentine.

Michelangelo's behavior was contradictory, or at least ambiguous, although certainly not for the first time. He had not participated in the competition, but he seems to have worked on his own to obtain this important commission from Leo X, who, for his part, could not have asked for a better turn of events. Suppressing qualms about the completion of the Tomb of Julius II, Michelangelo went to Florence as the head of the San Lorenzo façade project (complaining, naturally, wrote Condivi). One can't say how much the pope's decision was influenced by the desire to give the façade of the Medici church a frankly Florentine character, but certainly this commission was for Michelangelo an opportunity for revenge with respect to the arrogant Florentine artistic school. He returned to Florence to continue a work by Brunelleschi, one of the three major protagonists of that early artistic humanism from which, it seemed to him and earlier to Botticelli, modern Florentines were becoming more and more removed. There was a direct challenge from Jacopo Sansovino, who, as a Florentine sculptor, wanted a part in the essentially sculptural enterprise, but plainly Michelangelo was unable to form an alliance with the Florentine school, which was professionally and culturally excellent but eclectic. In fact, the tandem efforts of Sansovino and Andrea del Sarto, as director of the project, had achieved a brilliant success with a provisional façade for Santa Maria del Fiore created on the occasion of the pope's visit the previous year. Following the established theme of the celebration, this had been conceived as a harmonious convergence of the three arts—architecture, sculpture and painting. Was this not perhaps a qualification or even an experimental demonstration for the façade of San Lorenzo?

The motive is not clear for the pope's ultimate rejection also, in March 1520, of Michelangelo's design for the façade. Perhaps it was the cost in an economically difficult time, or pressure from the artist's enemies, or the fear, not completely unjustified, of a result that might fall short of expectations. The artist himself accepted the recision of the contract without much of a reaction, and his initial enthusiasm, which had led him to promise the pope a work never before seen, had evidently waned. Perhaps he had never achieved a strong creative inspiration, owing to the preordained relationship of the architecture and the sculpture on that planar façade, leaving no problem to be solved. He had moved at first without urgency along the same track as Giuliano da Sangallo (figs. 182–184), who had studiously sought in his designs to evoke on the frontal plane the perspective spatiality of the interior while giving plastic consistency to the façade, not only by its divisions but also by the evident forces of weight and thrust of the elements, especially the moldings. The compressed shapes of the upright and reverse ogee, square, and astragal moldings at the bottoms of the columns and pilasters, and the collars at the tops, were elastic, nearly hidden, "springs" for the composition. Michelangelo had in fact studied these in sketches after the Coner Codex drawings of Classical columns and cornices by an artist from Sangallo's circle (No. 6; figs. 161–176).

The planning process for the façade advanced through numerous designs and was concluded in the preserved wood model (fig. 101). Having rejected the idea of reducing the frontal plane to a backdrop decorated with statues and reliefs, Michelangelo sought immediately to increase its intrinsic plasticity—that is, its truly architectural character. He solved this in the end by giving the façade two strong returns, or "cuffs," wrapped around onto the side walls, which joined it solidly with the perspective body of the church while maintaining it as an absolutely autonomous sculptural and architectural organism. These returns were perspective escapes on the perpendicular, two foreshortenings to zero—nearly a *sottosquadro*—derived from the technique of *schiacciato* relief. It is obvious from the drawings that Michelangelo was hesitant at first about not representing the different levels of the nave interior in the contour of the façade, but finally he reduced the shape to a simple rectangular plane surmounted by a triangular pediment, more emblematic than tectonic. Yet some type of relationship between the façade and the interior was necessary, and these flanking returns established the connection, not just by allusion but also sculpturally, thus making the façade a true showcase for statues by giving it a strong plastic density. It should be noted also that the return faces ended abruptly on the brick side walls with a transition that was the parallel of the passage from finished to not-finished in his sculpture.

The definitive image of the façade matured through a tormented process documented in the drawings, the most important of which are in the Casa

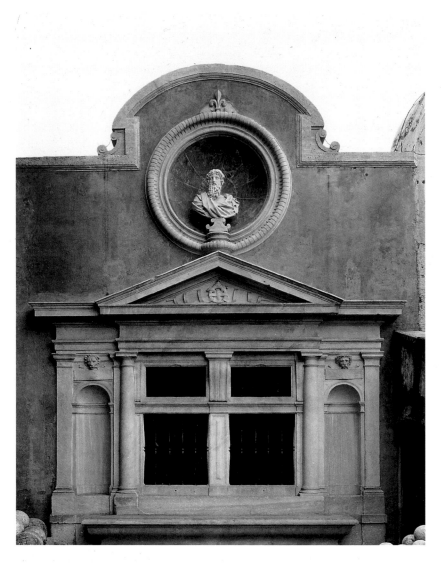

Buonarroti (figs. 98–100), and the final document appears to be the wood model mentioned above. The identification of this as the one completed by Baccio d'Agnolo in February 1517, and quickly disavowed by Michelangelo as a "childish thing," has recently been questioned by some scholars, however. The reason given is that, at such an early date, Michelangelo was unlikely to have already rejected the connection between the façade contour and the nave divisions still to be seen in figs. 98–99. Nothing at all can be deduced about the lost clay model made by Michelangelo in Carrara, but there is an obvious relationship between the extant wood model and the design shown in fig. 100, which is generally considered to have been Michelangelo's final one. In comparison with this design, the model was clearly a critique and a "correction" with the intention of reordering, at least in part, the harmony of the proportions, which Michelangelo had deliberately transgressed. The biggest change was the greater development of the façade in width and its consequent reduction in height. The matter of rebalancing is so strong in the model that some scholars have proposed that it was the work of a woodcarver of a more classical tendency, an improbable but not impossible hypothesis.

Beyond the simplification of the façade contour to a simple rectangle, the main innovation of Michelangelo's design was, according to Ackerman, the tall band forming a mezzanine between the first and third levels. In the wood model, this was only a "long pause," while in Michelangelo's final design it was a strong element with a double cornice two-thirds of the way up emphasizing the height. The third level no longer weighed upon the first but possessed its own thrust. And it was precisely this static autonomy of the levels and this nascent thrust of the walls that would create the dominant theme soon afterwards in the new Medici chapel inside the church. Never too proud to boast, Michelangelo sent a message to the Medici pope and cardinal in May 1517, saying that he would create on this façade "of architecture and sculpture the mirror of all Italy," if they would come to a decision on whether or not to make it. Naturally, he wanted to be the only one to make it, and the patrons agreed, assuring him that he was free to do whatever he wished and would not have to "respect either Biagio or anyone else." There is nothing to indicate what kind of sculpture would have been on the façade. Judging from the divisions, one can conjecture that there would have been freestanding statues on the ground level and in the niches on the top level, and bas-reliefs on the mezzanine and in the tondos of the top level, perhaps in bronze as he had simulated them in the Sistine Ceiling fresco. Thus, while it would have had true depth and projection, the bottom level of the façade would have created a very static condition.

Even before giving up on the project for the façade, Pope Leo and Cardinal Giulio had decided to have built inside San Lorenzo, in a symmetric relationship with the existing one, a new sacristy to function as a Medici family funerary chapel. For Michelangelo, it was the opportunity which allowed him to define in three dimensions, without the expedient of illusory simulation, the problem of the integration of the three arts.

94. *Chapel of Saints Cosmas and Damian,
aedicula (current state). Castel Sant'Angelo,
Rome*

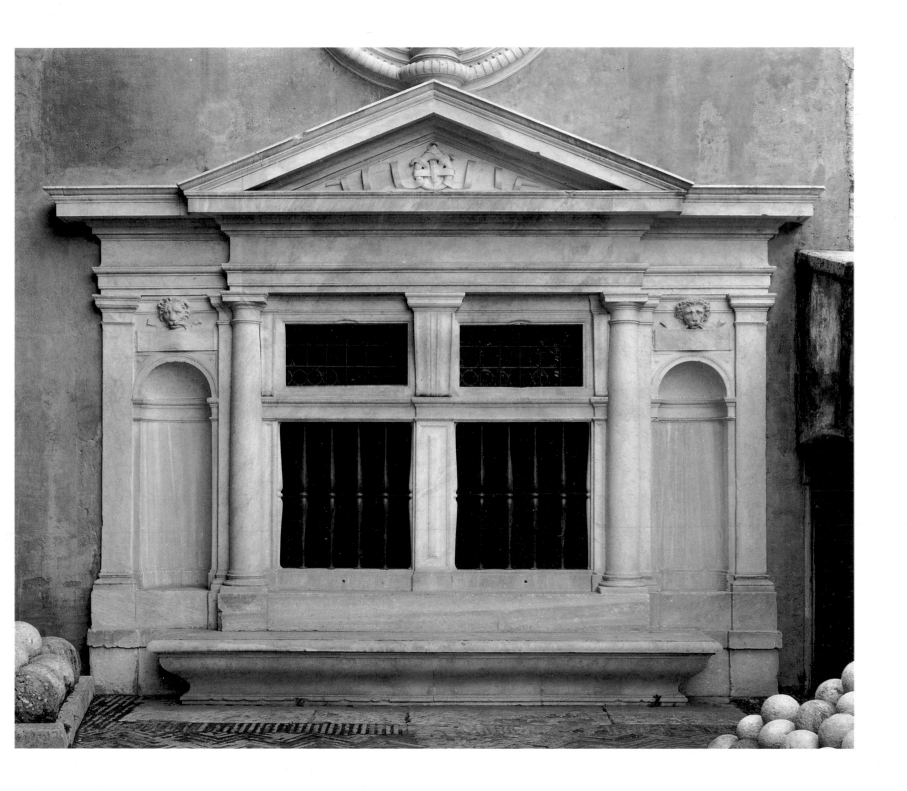

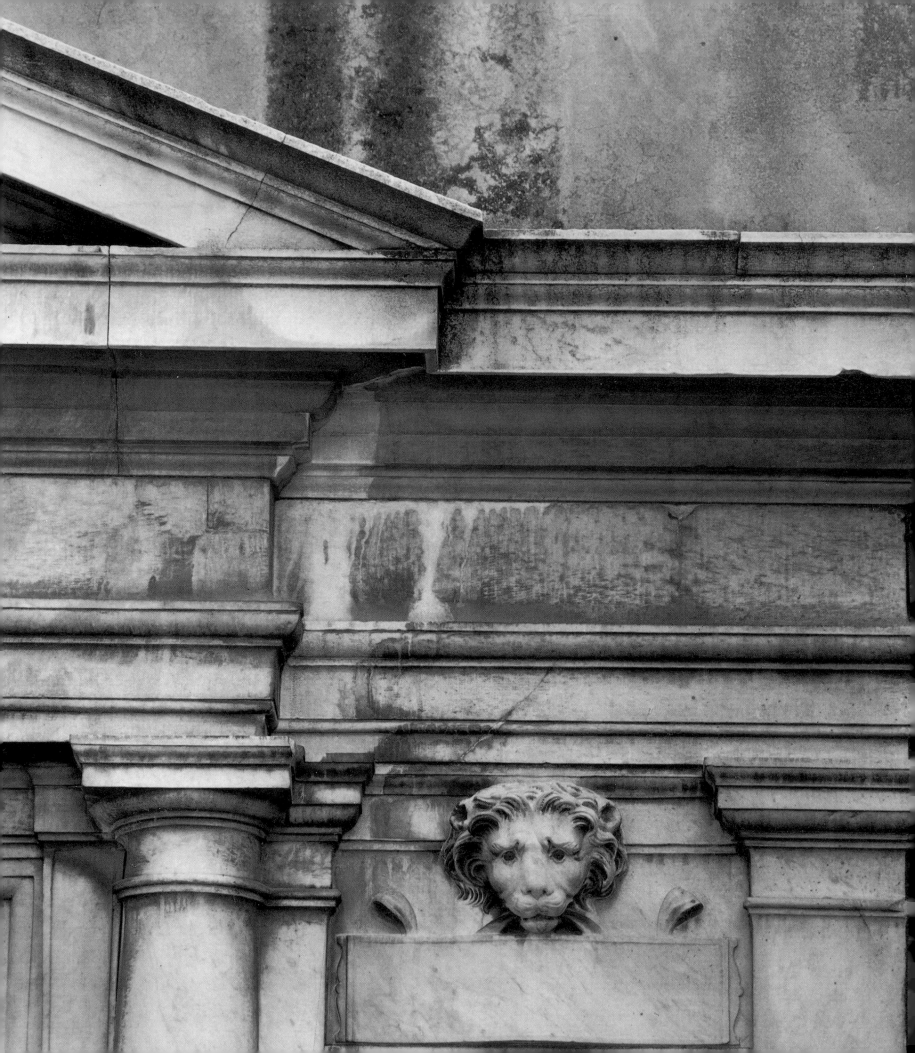

95. *Chapel of Saints Cosmas and Damian,*
detail of aedicula. Castel Sant'Angelo, Rome

The "kneeling" window

But first, something should be said about Michelangelo's design for the so-called kneeling window (No. 8), which was repeated three times on the ground level of the Medici Palace at the ends, where two corner loggias had been enclosed (figs. 103, 104). It was a modest and casual service which the difficult artist would not have rendered even to his great patrons had he not been interested in the almost linguistic study of the window as an iconic constant transformed into greater significance. He respected the palace architect Michelozzo, the great humanist collaborator of Donatello and the major Latinist in art in the fifteenth century. The sharp contrast between the rustic "bark" of the ashlar walls and Michelozzo's light, delicate bipartite windows, of a deliberately archaizing elegance, surely pleased Michelangelo as a refinement of that scholar, to whom he gave homage by near quotation in the pediments of his own windows. On the ground floor of the palace at each end were emphatic downward thrusts owing to the force of the radiating-voussoir arches. Once opening into the airy spaces of loggias, they were now closed, and the windows breaking through them supplied an overt thrust, which lightened the weight of the palace walls. Had not Alberti said that the palaces of rulers should unite grace with strength?

The two strongly projecting volute brackets coming up from the ground under the windowsill implied, but only simulated, load-bearing capacity. They were made to appear to sustain great weights, but instead the architecture was dominated by the weightless transparency of the reticulated iron grille, which mediated with geometric precision the passage of external light into the dark void. These grilles were elegant works of refined artisanry, and this esteem for the skill of the artisan was a trait typical of humanistic liberality on the part of the artist. Recourse to that subordinate but intelligent collaboration with the artisan became a constant in Michelangelo's architecture. The checkered reticulum was a necessary protective measure, of course, but its geometry provided an almost metaphysical diaphragm between two spatialities of opposite sign—the window frame which receded under the arch to create perspective and lead into the void, and the window opening which projected outward as if pushed from the inside. The typological anomaly did not escape Vasari, who baptized it the "kneeling" window with a Tuscan humor that would not have displeased the master. The large volutes were the knees and the small ones at the top the shoulders, with the pediment signifying the head of the "kneeler." Even architecture has its humor. While Michelangelo did not actually believe in architecture-mimesis, he sometimes took delight in certain consonances, like rhyme, between the human figure and architecture. What interested him about the window, or other such recurring forms, was not typology but iconology. It was not a scheme liable to reasoned variations, but an icon which was transformed by rhythm. The contrast between Michelangelo and the Rome school was, substantially, a contrast between typology and iconology as two different processes of planning.

In classical typological syntax, window jambs mediated between empty and filled space, and between sill and pediment, but Michelangelo reduced them here to weak, barely perceptible projections. The rhyme between the large and small volute brackets was strongly marked, yet the relationship was one of assonance, not of proportions. The strength of these brackets, which were in fact only ornamental arabesques, was completely emblematic. The ornamentation was an act of homage, and these windows were a symbolic "device" of the Medici court. Even the pediment, in its resemblance to a *felucca*, or cocked hat, was ceremonial—a correct Latin eulogy for the august patrons, yet strangely incoherent in having its full massive weight resting on the frail weft of the iron grille instead of supported on the window jambs. The structure of the window-icon was not logical but startling. With the large volute brackets at the bottom on the level of the passersby and the small ones at the top under the pediment, it was more or less a deconstruction of the classical structural type. Perhaps it was not by chance that the first anticlassical declaration was made in Florence on the Medici Palace and in the same context with the most "antiqueist" of the scholars of fifteenth-century Florentine humanism. There was undoubtedly a tie between Florentinism and anticlassicism.

Michelangelo's interest in this *ex tempore* architecture, composed metrically and rhymed like a sonnet or madrigal with the customary play of opposites, went beyond that of a subtle and already virtually Mannerist linguistic analysis. Implied in it was a particular appreciation for the work of Michelozzo, upon which a thoughtless alteration had been inflicted by the enclosure of the two ground-floor loggias, and the need to give back to it its meaning, which, of course, could not be the original one. In sum, Michelangelo found himself confronted for the first time with the need to "re-signify" an existing context, and the fact that he was able to use only a minimal means—the model of a window—rendered the enterprise more difficult and therefore more exciting. Michelangelo resolved it by deconstructing the plastic organism while preserving the iconic image. The aedicula broke out from the walled-in arch, the lower brackets grew up out of the ground, the triangular pediment repeated and thus raised the horizontal of the window-sill, and the metallic reticulum of the grille agreed with and provided a variation on the luminous vibrations of the regular rectangles of rusticated ashlar. To conclude, this window model was nothing other than an experimental trial in which were announced some of what would become the great themes of Michelangelo the architect.

The New Sacristy, San Lorenzo

It does not appear that the artist was bothered by the sudden decision of the Medici pope and cardinal to abandon, or at least suspend, the project for the façade of San Lorenzo. After all, the idea which fascinated him in those ranks of statues and reliefs was followed up soon afterward in the sculpting of the slaves and prisoners for the Tomb of Julius II. Nor does it appear that Leo X found it so important any longer to have that showy affirmation of the

96. (above) Church of San Lorenzo,
Florence, façade

97. (below) Aristotile da Sangallo (attrib.).
Copy of Raphael's design for façade of San
Lorenzo. Uffizi, Florence, Drawings and
Prints Dept., A 2048

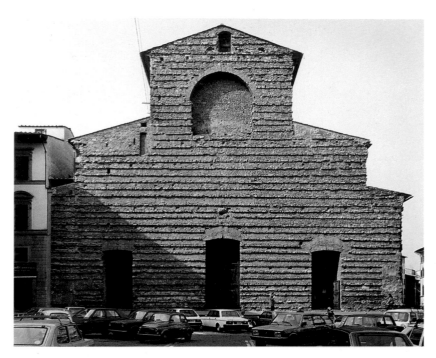

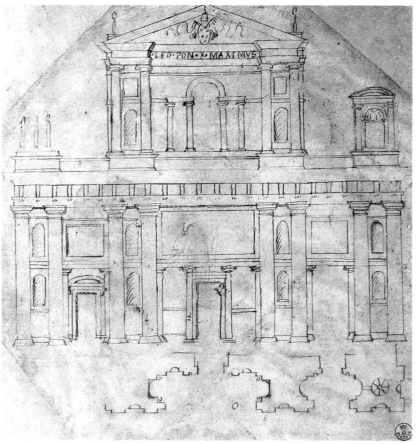

power of the family. The first return of the Medici to power in 1512 had come about with the help of foreigners, and no one could have been deceived about an autonomy of Florentine politics. Also, other events had taken place in the intervening years which had rendered more opportune the celebration of civil virtue rather than the signifying of authority. Giovanni was the pope and the prestige of the family was at its height, yet the future of the Medici restoration remained uncertain. Giuliano, duke of Nemours, died young in 1516, and Lorenzo, duke of Urbino, even younger in 1519. Moreover, the Republican ideology was not yet dead, and the Medici were driven out again in 1527, although they returned, ingloriously, only three years later. In San Lorenzo, instead of a monument to restored rule, a funerary monument would arise. For Michelangelo, the New Sacristy (No. 11) would be the first planned and constructed architectural project, although it was not without certain preexisting constraints. The symmetry and volumetric parity with the original sacristy were *a priori* conditions, and he admired the great master with whom he was confronted. He himself "wanted to make [the new sacristy] in imitation of the old one, by Filippo Brunelleschi." Thus, he undoubtedly began work on the first level still thinking of constructing this new Medici chapel as a space only in which to accommodate the tombs of the young dukes. He quickly diverged from that concept and proceeded with one in which the architecture, the statues, and the sarcophagi with the four allegorical figures became a single entity, a figural-architectural unity to which was added a strong "painterly" component through the use of different-colored materials and the luster of gilding. The Old Sacristy of Brunelleschi was a space integral with the body of the church destined for liturgical uses, saturated with cosmological doctrine, and endowed with true charismatic holiness, but naturally it lacked any funerary character. On the other hand, the New Sacristy would be a sepulchral chapel to accompany like visual "music" the idealized transition of the Medici rulers from the time of life to the time of history and from there to eternity. Brunelleschi had taken the straight line and the curve as symbolic forms of the identity of being and thinking, which Michelangelo maintained while transforming them into symbols of transcendence. The humanistic ideology, of which Brunelleschi was a pioneer, had evolved, or mutated, in platonic meaning. The ideal was no longer the intrinsic harmony of mathematical truth but the "beauty which leads the living from the earth to heaven." The location of the tombs, where the transition from earth to heaven occurred, was a place dedicated to beauty.

The modular calculation of the "musical" proportions of the walls on a cubic basis for the Old Sacristy was in relation to the uniform, invariable diffusion of light created by the slow turning of the radiating ribs of the dome (fig. 106). There were no reflections, either direct or indirect, but rather an immobile saturation. The light did not fill the space; it was space itself. Michelangelo had said that Brunelleschi's lantern could be "varied but not bettered." Also, he did not reject the metaphysical abstraction—too attractive to him as philosophical thought made architectonic image, but he

98. *(above) Michelangelo. Preliminary design for façade of San Lorenzo. Casa Buonarroti, Florence, A 91r (C. 499r)*

99. *(below) Michelangelo. Second design for façade of San Lorenzo. Casa Buonarroti, Florence, A 47r (C. 500r)*

changed the dominant horizontality to verticality. Vasari correctly observed that the key to Michelangelo's system was also the lantern, obviously an act of homage to Brunelleschi in recalling both the small dome of the Old Sacristy and the large one of the Cathedral of Florence. The design of the Old Sacristy lantern was unusual—a grooved and twisted conical spire which caused a kind of rotation of the natural light as it penetrated the interior from along the small external columns and was taken up in the wide turn of the radiating ribs.

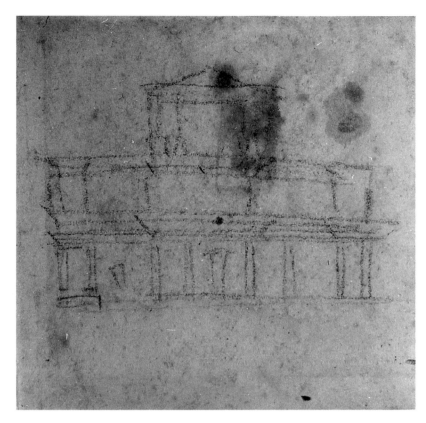

Michelangelo conceived his lantern for the New Sacristy also as a collector and diffuser of the light (fig. 108). At the summit on the exterior, he placed a reflective copper ball with seventy-two facets commissioned from the goldsmith Piloto. This faceted ball, a symbol of perspective illusion from the time of Paolo Uccello, demonstrated that the humanistic tradition, which seemed elsewhere to have broken up and dispersed, still persisted in Florentine artisanry. The natural light, captured and absorbed by the conical cap of the lantern, fell and accumulated on the large volute brackets, then gathered with the force of an architectonic element on the projections of the cornice. From there it descended along the shafts of the small columns, penetrating the interior through the glazed windows or dispersing on the exterior in vibrating waves along the scaly cap of the dome.

On the inside, the dome was a void filled with white light (fig. 107). All of the articulation and modeling of the interior space were functions of that empty, luminous hemisphere, but with an ascending movement as opposed to the static nonmateriality of the Brunelleschian cube. The coffers of Michelangelo's dome interior, a textual quotation from the Pantheon, curved the perspective view, dematerializing and geometrizing the light which entered through the lantern (fig. 109). Tangent to but barely grazing the circular opening of the dome in the top register of the chapel were four large arches drawn in gray on the pure white wall planes. Contained within these were windows narrowed slightly in width towards the top to give a sense of perspective (fig. 111), as if the thrusts of the strong tensions from the first two levels of the chapel were finally demolished there. Between the arches, the curved triangles of the pendentives acted in similar fashion to sublimate the thrusts of the strong corner elements (fig. 115). Everything on this top level was inscribed in dark outlines of *pietra serena* on the whiteness of the plaster, the two-color scheme taken from Brunelleschi but rendered irrational and absurd by Michelangelo's geometry. How otherwise can one explain the theoretical paradox of windows in perspective, narrowing towards the top, inside arches that were horizons? As in the Old Sacristy, the pendentives were decorated with tondi (fig. 113). Brunelleschi conceived his as "eyes" opened onto scenic views, and Donatello had filled them with narrative representations of an incisive, edifying Latinness. For Michelangelo, the tondi were pure abstractions, circles outlining light, but also empty and therefore symbols of absence—the luminous, unforlorn absence of the young rulers for whom the eulogy had just been pronounced below. Through this pure beauty was accomplished the separation of the spirit

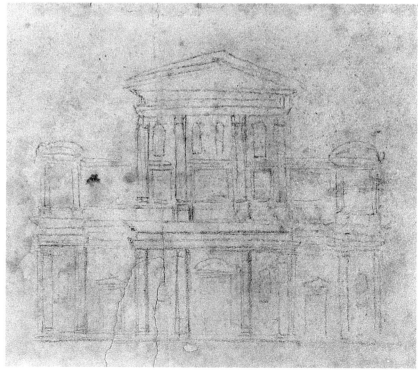

100. (above) Michelangelo. Final design for façade of San Lorenzo. Casa Buonarroti, Florence, A 43r (C. 501r)

101. (below) Wood model for façade of San Lorenzo. Casa Buonarroti, Florence

from the mortal remains. The overall spatial concept of the Old Sacristy was decisively overturned in the New by the insertion of a mediating mezzanine level between the floor level and the top level. This transformed the dominant horizontality into verticality and also created a break between terrestrial space, where the allegorical statues personified the time of life, and the nonworldly space, which was pure abstraction. The intermediate level was deliberately ambiguous, with windows opening into the outside world but enclosed in dark mournful frames, powerful arches suspended over but detached from the figures below, and an interminable, unbroken band of pure white between dark cornices, which created more of a sense of leave-taking than of connection (fig. 116). The detachment would have been total except for the nonproportional relationship between the windows and the rectangular niches in the lateral wall zones, as well as between the arches in the central zones (figs. 121, 122). Along with their austere pilasters, the funereal icons of the windows on the second level repeated in height and depth the contours of the white aediculae below, which were exalted hymns to the dead (fig. 118).

The ambiguity was raised to the peak of the sublime on the first level, where the transition by degrees from earthly life, to memory, to history, and then to the final dissolution of human physicality into eternal light was experienced firsthand by the viewers. The artist seemed to ignore the fact that his architecture existed in natural space and had an exterior. The idea did not impact on him, quite obviously, that architecture was a constructed volume whose interior had a practical use. The Medici chapel was completely independent of its exterior, which he himself had materially constructed; it was instead a void in which the architectural elements and the sculpted figures stood out, imposing upon the viewers their luminous presence. That end-beginning space was not the space of life, it was already beyond life. Resorting for once to allegory, which he did not like, Michelangelo represented the reclining figures on the sarcophagi as the Times of Day, surviving icons who were themselves on the point of separation from their tombs.

Here on this first level was posed imperiously the problem of the relationship between the nonnatural forms from the architectural lexicon and the human forms of the sculpted figures, and immediately one sees that the artist had discarded every reference to the real world. The Times of Day were conceptualized images, and the statues of the dukes were not faithful portraits but humanistic *elogia*. These figures were no more connected to the reality of the human body than a Corinthian capital was to the vegetal reality of an acanthus bush.

Michelangelo wanted formal distinctions and also connections between the statuary and architectural zones, and only later, in the existential flow of his planning process, was a relationship possible by the coincidence of the differences rather than by affinity or analogy. The thinking of Michelangelo moved with the rhythm of existence by reflection on repressed memories of overcome anxieties. Therefore it is not strange that, in the concept of the

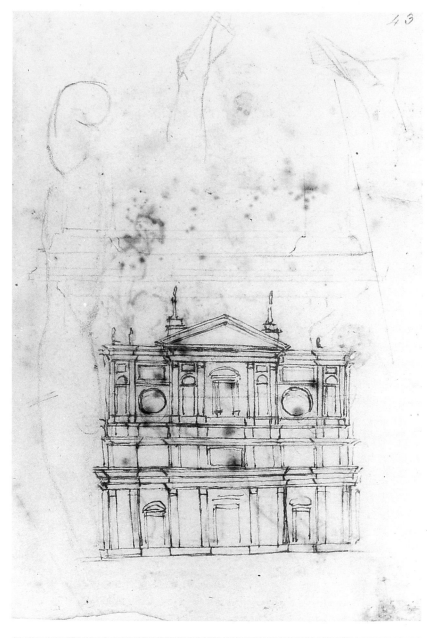

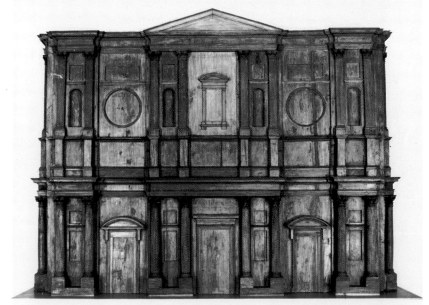

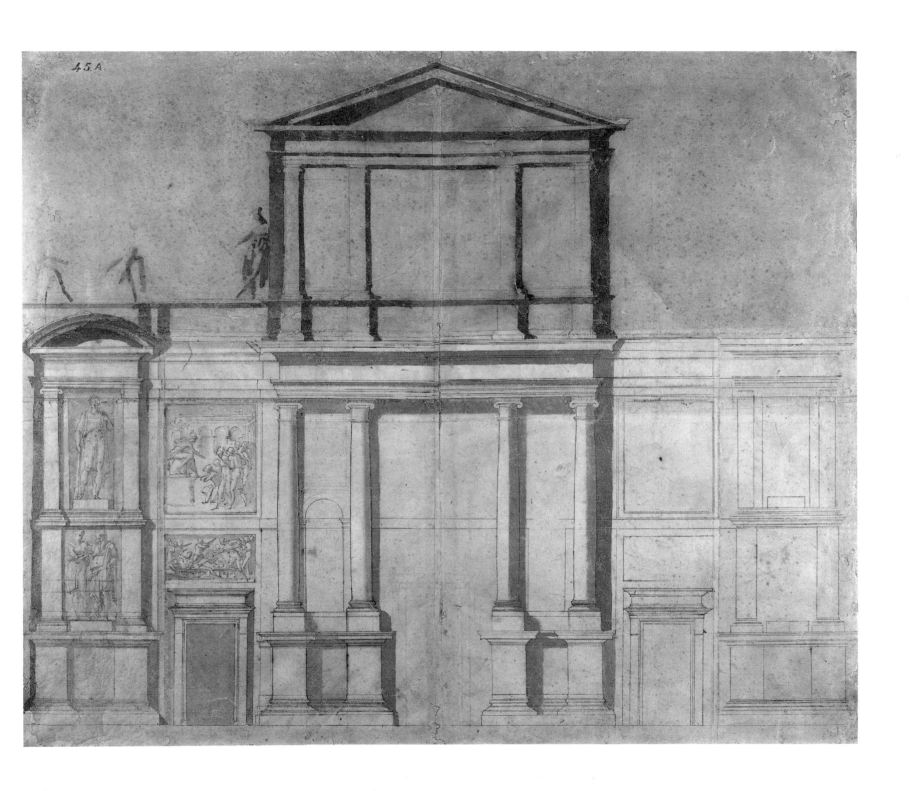

102. *Michelangelo. Design for façade of San Lorenzo. Casa Buonarroti, Florence, A 45r (C. 497r)*

45.A.

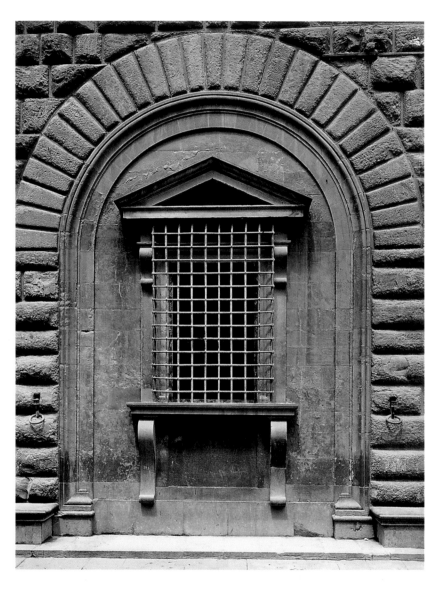

Medici chapel, there were, briefly, developmental repercussions from the postponed work on the Tomb of Julius II. From the beginning, the artist thought of giving the Medici tombs the same form as the papal tomb in its first design, backing them against each other to create a pyramid dominating the small space directly below the nonnatural light of the dome. The architecture would have been an accompaniment in low tones, which echoed solemnly the comprehensible song of the two tombs. In that form, it would have been, as it was perhaps first intended by the patrons, a dedicated sacristy. The humanistic and laic religiosity of Michelangelo went beyond this; the civic memory of the dukes was sublimated in the sacredness of place by a process of election which was completely visible, displayed, and edifying. He made a unity of the walls and the tombs, and then placed the altar niche, which repeated in a minor key the main central space, on the median axis with liturgical correctness.

Instead of being derived from a preconceived idea, this space was born out of the coincidence of opposites—in this case, the thickness of the walls with the rarefied central void under the dome. The thickness of the walls was suggested by the niches of the ducal statues, but these two narrow, sharply-defined voids did not receive the statues. They appeared to push them outward, causing them to emerge from the niches into the light. To continue this coincidence of opposites further, the real space of the real world existed within the thickness of the walls, while the void was the space of "true" life—that of election after death. Did he not treat many times in his *Poems* this Manneristic conceptual antinomy of life-death, death-life?

The tradition and custom for monumental tombs was that of figures contained in an architectural framework. Michelangelo broke that tradition, deconstructing the analogical and associative unity into unity by contradiction. The statues of the dukes formed triangles with the allegorical figures below them, which set up continuities, repetitions, and responses between their body movements (fig. 124). But they belonged to different spaces, with the ducal statues existing within the thickness of the wall above and the allegories out in the central void below. For Michelangelo, space was also time, therefore the statues of the Times of Day were unstable atop the curved covers of the sarcophagi, necessitating body movements that sought to maintain the balance they were in danger of losing. They had and displayed the connotation of the ephemeral, and it could not be otherwise for allegorical images, which were momentary, illusory configurations of concepts. For the moment, however, they occupied space on the floor level, designating as earthly that space where the living moved and from which the elective process began—a process not limited to celebrated personages alone. The architectural articulation of the walls tied their dark depths to the light of the central void, and thus through an animated dialectic, the relationship between architecture and sculpture was achieved (figs. 120–123). Ackerman emphasized the determinant importance of the verticals of *pietra serena* dividing the architecture of the chapel from the architecture of the tombs. They were distinct entities between which existed a relationship of dialecti-

cal tension. This relationship was limited to the first register, of course, because there were no figures above; human semblances remained on earth, at a distance. The architecture of the chapel, in order to give space to the monuments, was concentrated and condensed at its four corners (fig. 115), where the strongly framed doors and aediculae projected beyond the Brunelleschian architectural framework. The contrast between maximum recession and maximum projection came from the antithesis of the deep, dark doorway and the tall white aedicula, or blind window, which surmounted it.

These aediculae, which should have been contained within the architecture, projected out from it and constrained the capitals of the adjacent pilasters (fig. 125). Rather than making an architectural surrounding for the space, they penetrated that space with arrogance. Embodying both window and niche, they should have receded in graduated levels of depth, but instead they were embedded with force in each other, interpenetrating one another. In juxtaposition, the repressed violence of these window-niches formed a contrast with the smaller, more delicate ones in different materials appearing at the same level in the tomb panels. This transition from compressed spatiality to reduced or interrupted structures would become a recurring motif in Michelangelo's architectonic composition and indicated his breaking away from the restful natural view.

The aediculae were images in the form of windows whose brackets below and pediments above arrogantly violated the architectural boundaries of the wall pilasters with a license that could not have been more offensive to the classical rule. Because the brackets supporting their sills were integral with the jambs of the doorways emerging out of the dark depth below, the aediculae too appeared to thrust forward out of the depths into the full light. Moreover, they were in effect two blind windows interpenetrating and interchanging one with the other without an exit, and this closure was just as irrevocable as the death signified by the slender festoons which adorned them (fig. 127).

In the two spaces of the ducal tombs were similar blind window-niches flanking the deep central niches and separated from them by pilasters. Slightly set back with respect to the large aediculae above the doors, they appeared by contrast farther away, thus emphasizing the forward thrust of the statues on the same level. The separation of the tomb wall from the sarcophagi and allegorical figures in the open space in front of it was indicated but then quickly contraindicated through the luminous, almost golden grain of the materials. The difference in spatial levels was modulated also in terms of color, quality of material, and different reaction to light through the network of elements made up of dark, grayish *pietra serena*. Never before had an architect used light—generally only a regulatory means of visibility—as his material for modeling.

The two spatial registers—architectural framework and architecture of the tombs—intervened and interacted but were not identified with each other, which was the primary cause of the strong manifestation of the not-finished in the architectonic fabric. The "finished" with which it was contrasted in this case was the original premise of exact mathematics in the Brunelleschian structure. In the wall elevation of the Old Sacristy, the bottom register was a square and the top one a semicircle, with both registers equal in height and their sum equal to the diameter of the circle. In the New Sacristy, the semicircular arch form was also the key to everything, but, springing from the base of the middle register, it concluded nothing. It was a factor of suspension in some ambiguous way, which mediated between the constructed plasticity of the first level and the pure linearity of the top level. This was not a space which had been conceived in the mind and then made a visual reality, as in the manner of Brunelleschi; it was an architecture which was happening and becoming, thus existing in space and time and therefore constitutionally not-finished. The not-finished aspect included the flagrant infraction of the boundary between the aedicula and the dark doorway below it and the fusion of the two into a single structural element, as well as the perspective narrowing of the large windows in the arches of the upper level (which will return many years later with an analogous meaning in the Sforza Chapel). The allegorical statues too were not-finished, both in their forms and in their presentation as images which, having barely appeared, were already on the point of disappearing. They were also not-finished technically, almost as if the sculptor had interrupted his work for some reason, and this gave another sign of the ephemeral temporality of their presence (see fig. 26). By contrast, the figures of the dukes were technically finished, yet there was a sense of the not-finished in the fact that, while the two statues were symmetrically analogous, each had a different meaning. One of the dukes was deeply contemplative (by which name he came to be called), as if absorbed in the memory of the past, while the other duke seemed to have just been aroused from the short sleep of the dead. In these statues, as in the architecture of the chapel itself, the precise, nearly punctilious delineation of the images concealed the state of uncertainty and the alternate movement of the spirit of those young dukes who had aspired to something and were aware of not having been able to attain it while alive.

This sense of "time lost" is the recurrent motif in the enchanting imagery of the chapel. The literal indefiniteness of the antique lexicon in the aediculae, the volutes, and the capitals was deliberate. It would have been so easy to cite from the available visual models or from Vitruvius; why reinvent them with a kind of amused, philological pedantry? There was no lack of antique models for the sarcophagi, yet Michelangelo created his as if they were antiquities, while at the same time depriving them of every resemblance to real antique sarcophagi (fig. 6). He needed the curved lids in order to pose the statues as if they were sliding off, and he wanted the two large scrolls to intone solemnly from below the "voluble" theme which will be repeated many times on different scales. The interpretation of these extracts *all'antica* was somewhat relaxed in the detailed decoration of the sarcophagus legs with "scales" surrounded by colored inlay, but it increased again in the frieze above with its gilded balusters, swags, scrolls, and

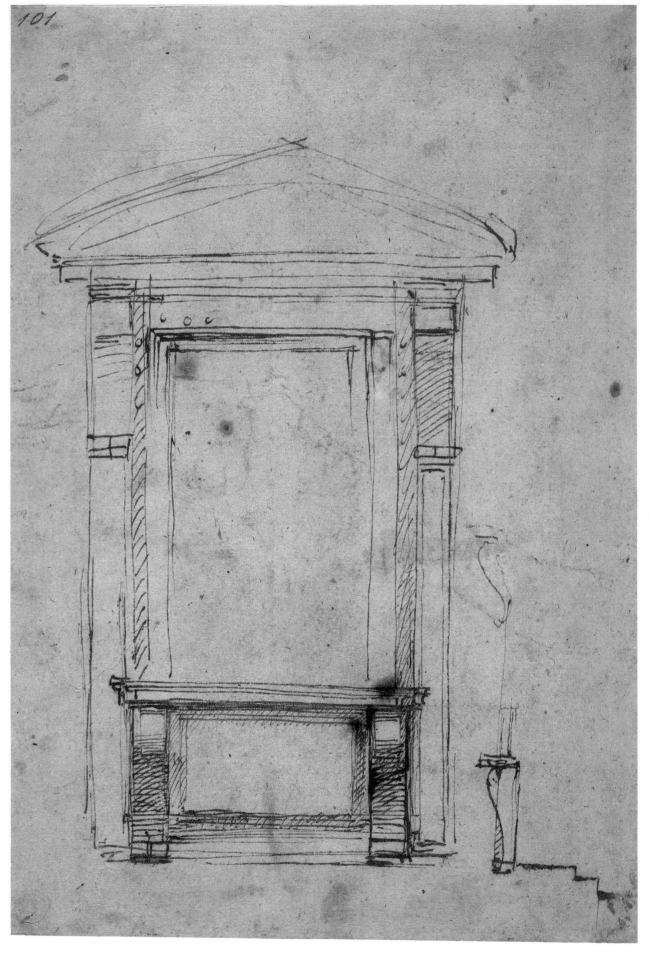

104. *Michelangelo. Study for "kneeling" window of Medici Palace. Casa Buonarroti, Florence A 101r (C. 495r)*

105. *(opposite) Michelangelo. Decoration for coffers of dome interior of New Sacristy. Casa Buonarroti, Florence A 127r (C. 206r)*

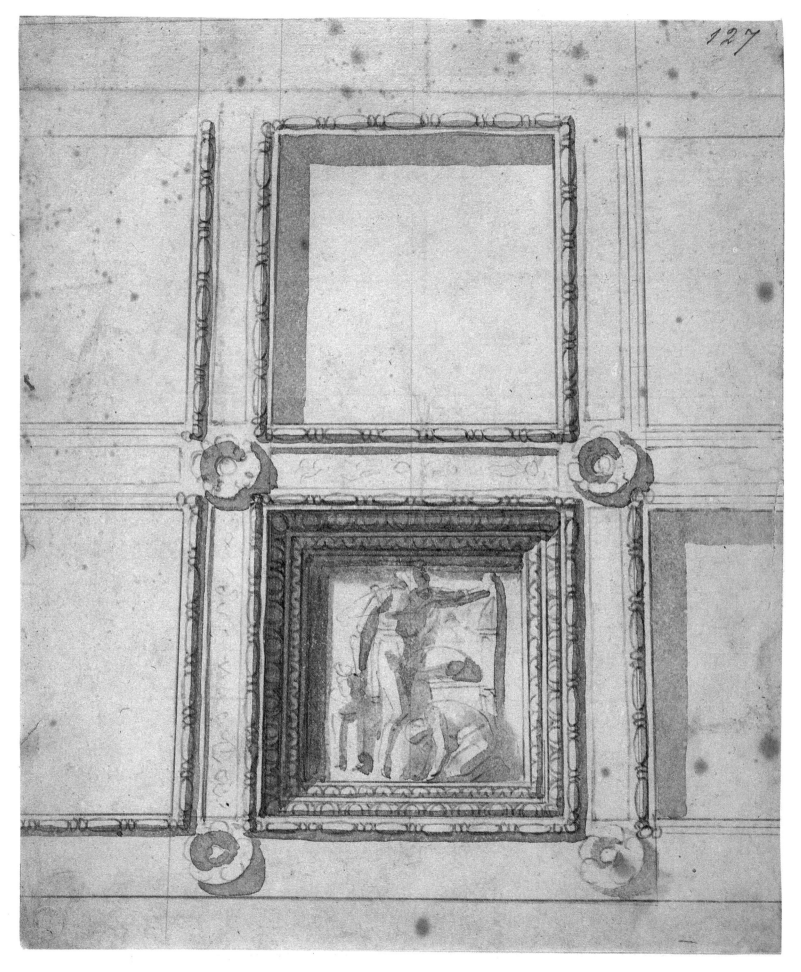

106. *(above) Old Sacristy, interior of dome. San Lorenzo, Florence*

107. *(below) New Sacristy, detail of interior of dome. San Lorenzo, Florence*

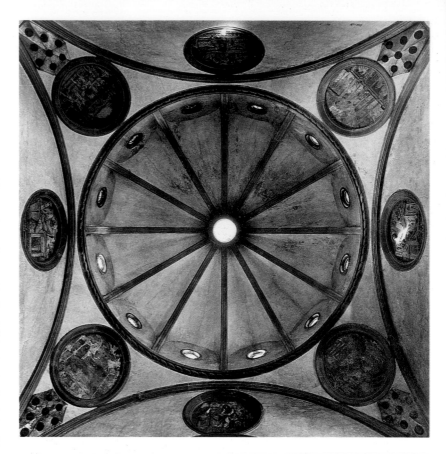

funerary amphorae (fig. 5). The aim was probably an evocation in that location of the strongly impure, often vernacular "antiqueism" of Donatello. But Michelangelo also deliberately sought, in what is surely the most poetic of his architectonic works and the one closest to the metrical-lexical structure of his poems, that symphonic double register of slow rhythm gradually rising to the highest notes.

Vasari, as always, understood this, and he rendered an enthusiastic yet cautious opinion of the chapel, where he was certain that Michelangelo's desired intention was to make an imitation of the old sacristy "but with a different order of ornamentation." Nothing could be said from the point of view of the construction, but represented there was "a decoration composed in a more varied and newer way than the old and modern masters had been able to work at any time." In sum, this was quite different "from that which men made by measure, order, and rule according to common use, and according to Vitruvius and antiquity. . . . [This] freedom gave great spirit," although not much skill to his imitators. The greatness of Michelangelo was not disputed, but he was responsibile for having authorized "the new fantasies [which] were now seen, closer to the grotesque than to reason and rule." In sum, "he broke the ties and bonds" of architectural normality with respect to a culturally and technically powerful professionalism which wanted from antiquity only a safe concept to apply in making modern architecture. In fact, with regard to the classical static-plastic syllogism, the architecture of Michelangelo was pure decoration, no longer adjectival but substantive, endowed with a power of transcendence which went beyond the logic of a uniform, generalized, and ordered classical interpretation of the antique.

The Laurentian Library

Moving from the Medici chapel to the Laurentian Library, Vasari continued: "Then, he showed it even better, and wanted to have the same thing recognized in the library of San Lorenzo, in the same place, in the beautiful distribution of the windows, in the divisioning of the ceiling, [and] in the marvelous entrance into that vestibule." But certainly it was not just a question of ornamentation in this project, which began first with a search for and selection of a site for its construction (No. 12). Portoghesi (Portoghesi-Zevi 1964) observed that "the Laurentian library is the most intense and the most complete among the architectural works of Michelangelo; [and of prime importance], there was anticipated [in it] all of the presuppositions of the *non-finito*, as awareness of the constitutional incompleteness of existence, as rejection of the authority of the finished form, and as emphasis on the formative act more than on the final result."

After his election in 1523 as the second Medici pope, Clement VII, the former Cardinal Giulio, followed attentively the developments in San Lorenzo through an agent, Giovanni Francesco Fattucci. The first act of his statesmanship in the confrontations with the city was to guarantee its cultural prestige by making the projected library as illustrious as the

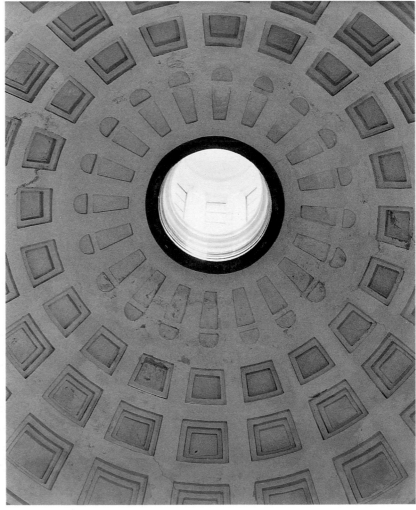

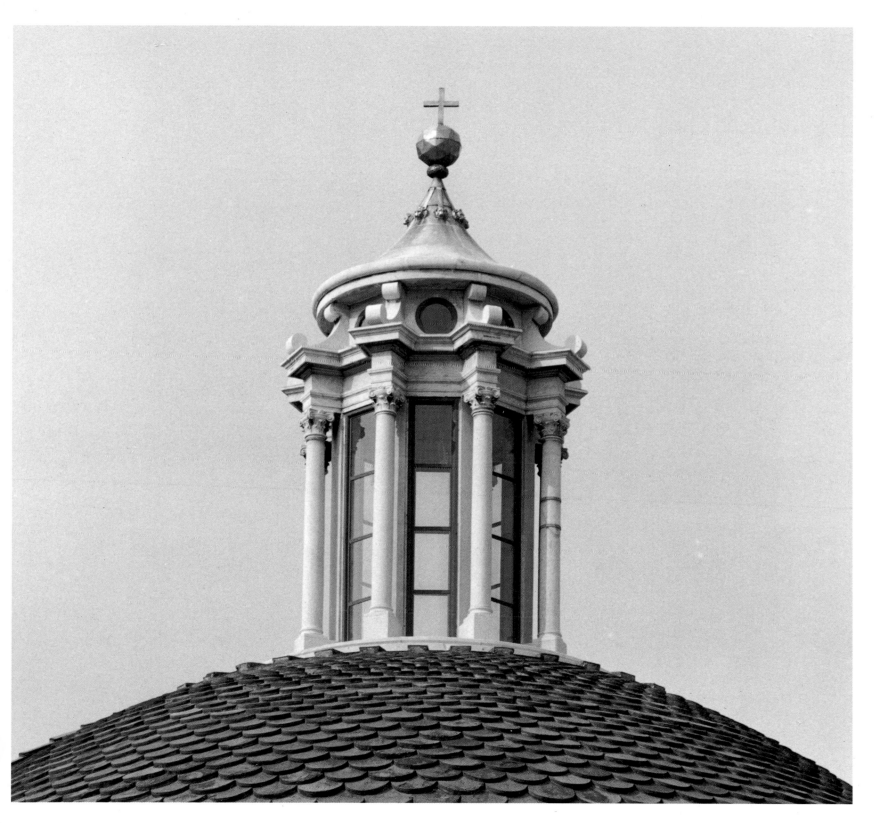

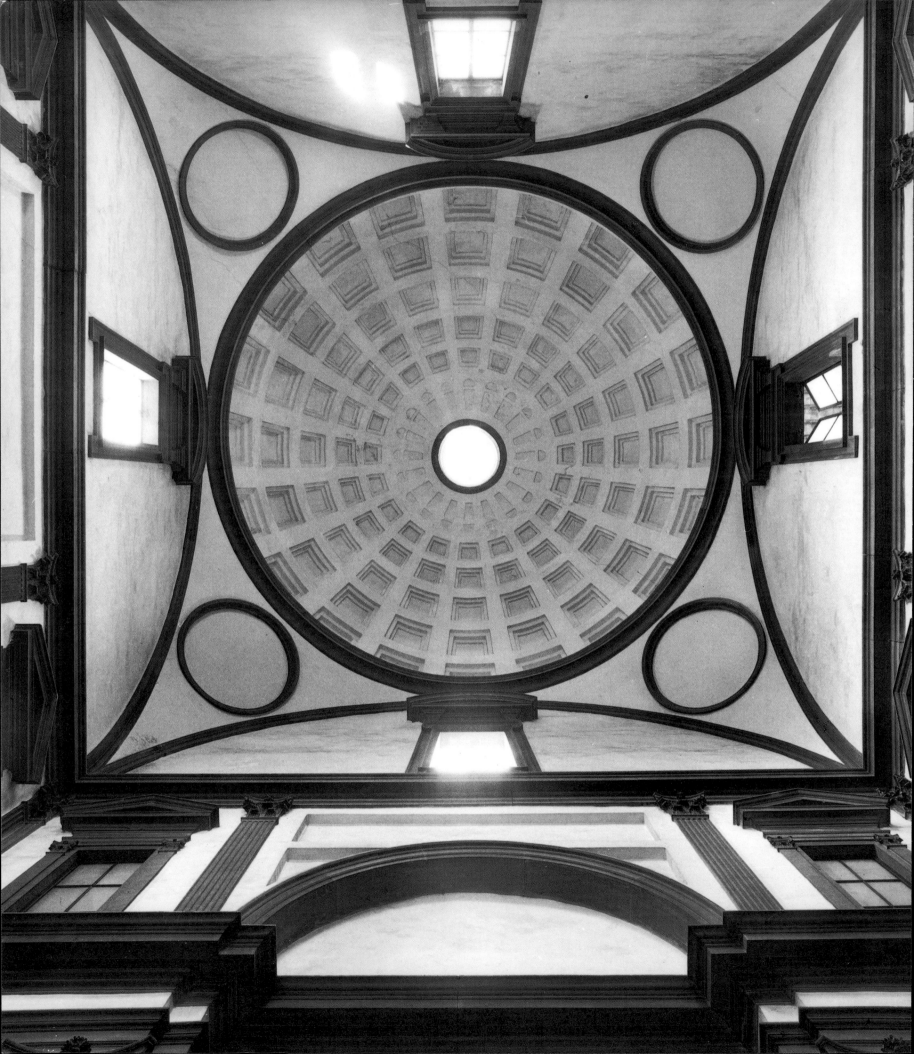

109. *(opposite) New Sacristy, interior of dome. San Lorenzo, Florence*

110. *New Sacristy, relationship between apsidal niche and central space. San Lorenzo, Florence*

pages following:

111. *New Sacristy, pendentives and lunettes with trapezoidal window. San Lorenzo, Florence*

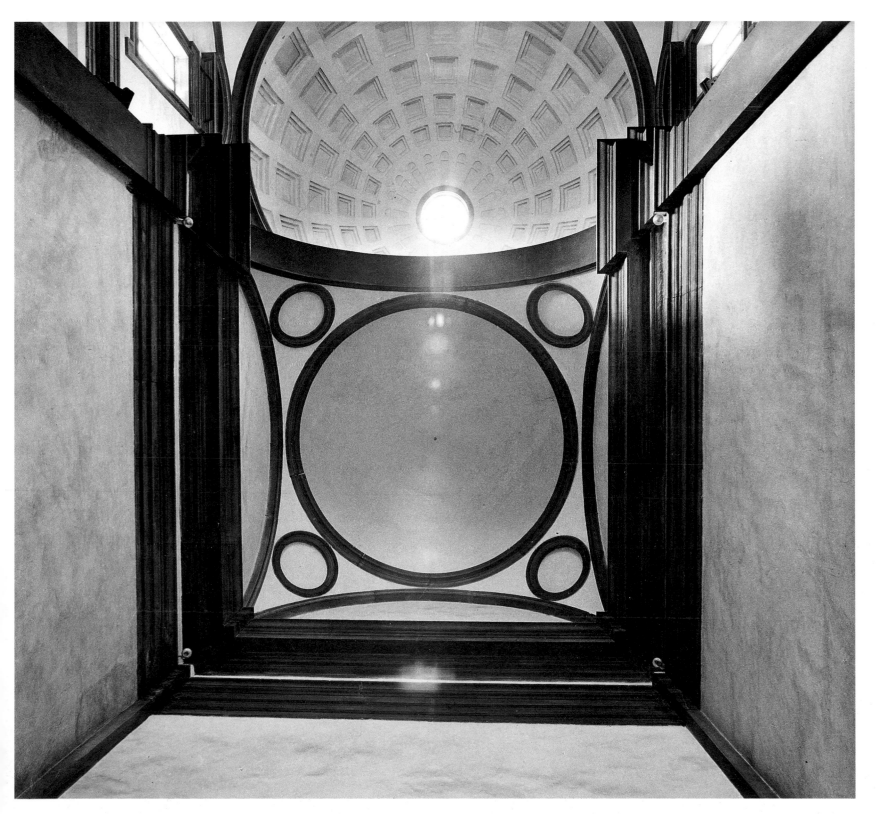

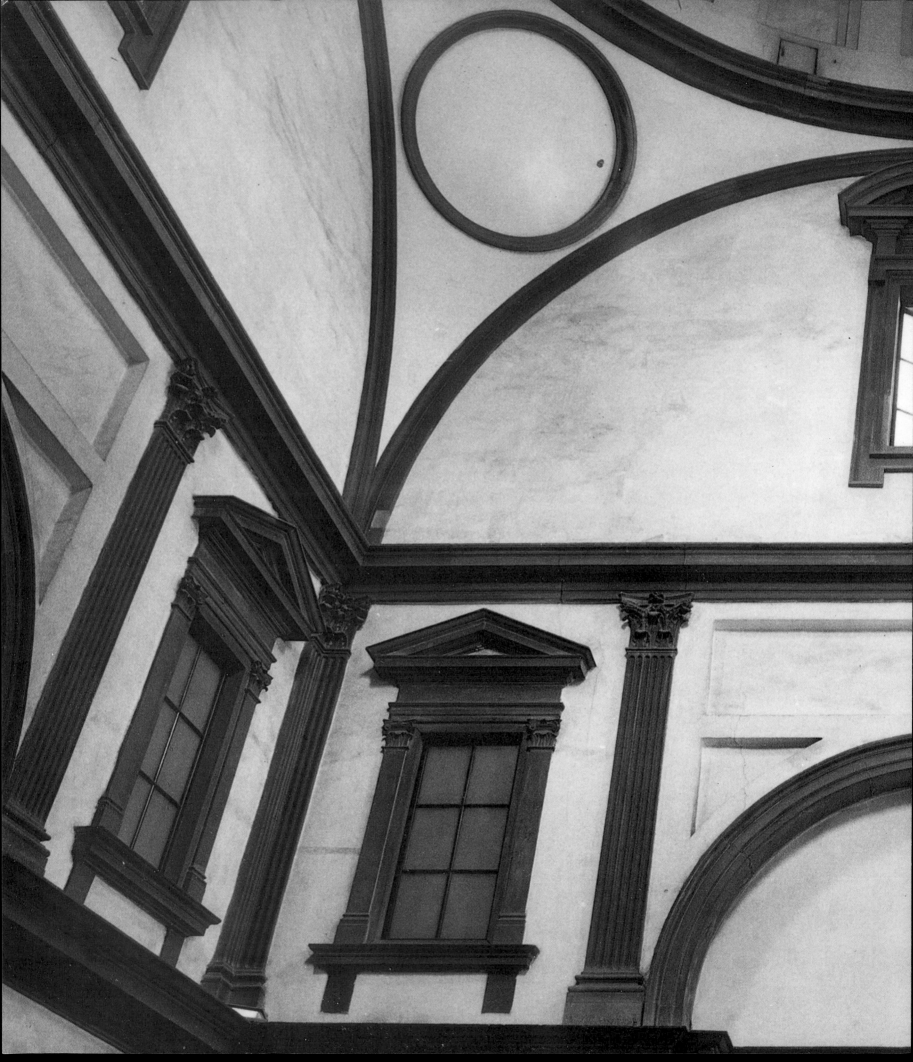

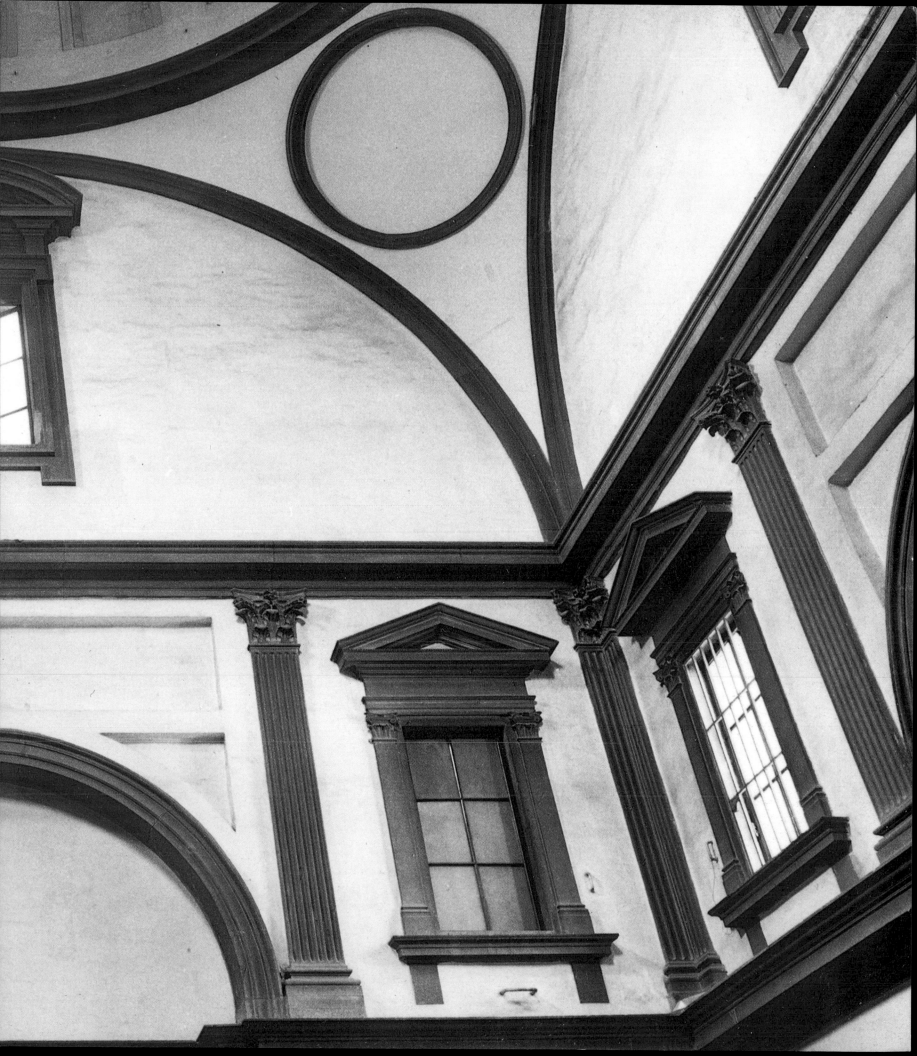

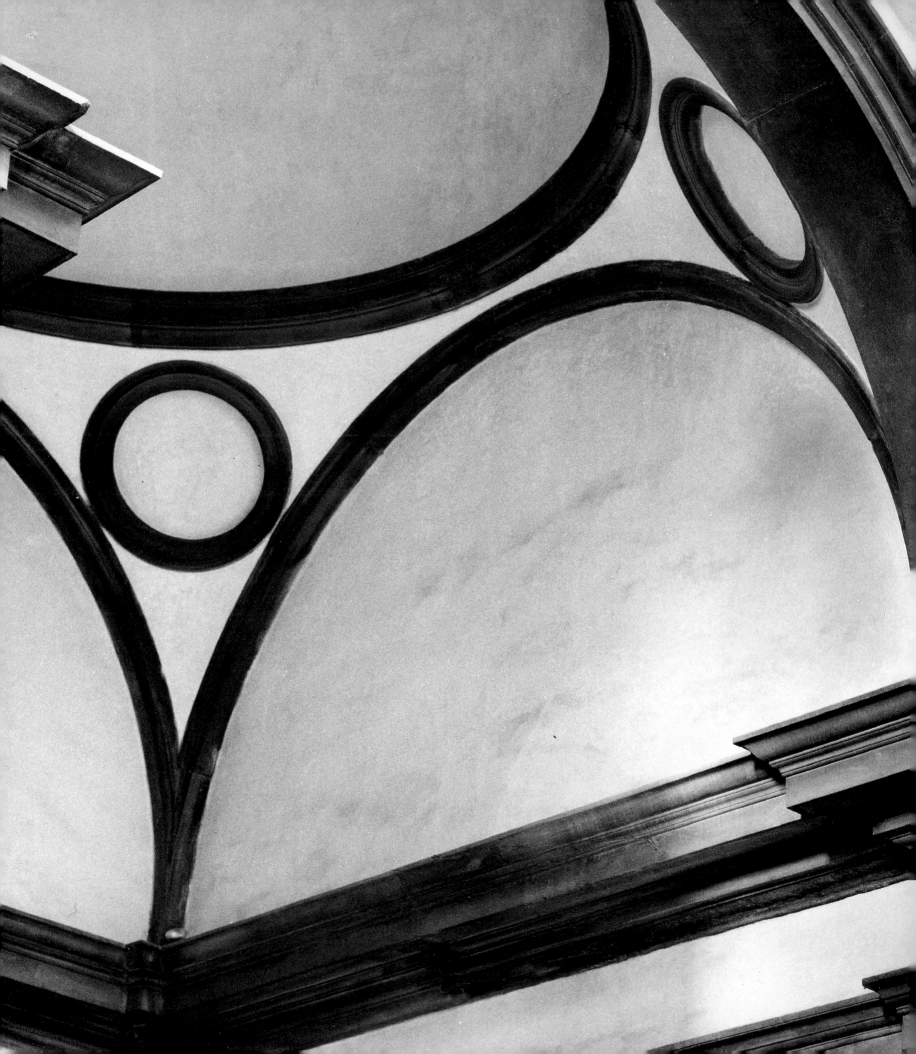

112. (opposite) New Sacristy, detail of vault of altar apse. San Lorenzo, Florence

113. New Sacristy, detail of dome pendentive with blind oculus. San Lorenzo, Florence

pages following:

114. New Sacristy, north wall from first cornice to dome. San Lorenzo, Florence

115. New Sacristy, detail of corner. San Lorenzo, Florence

116. New Sacristy, east wall above funerary monument of Giuliano de' Medici, duke of Nemours. San Lorenzo, Florence

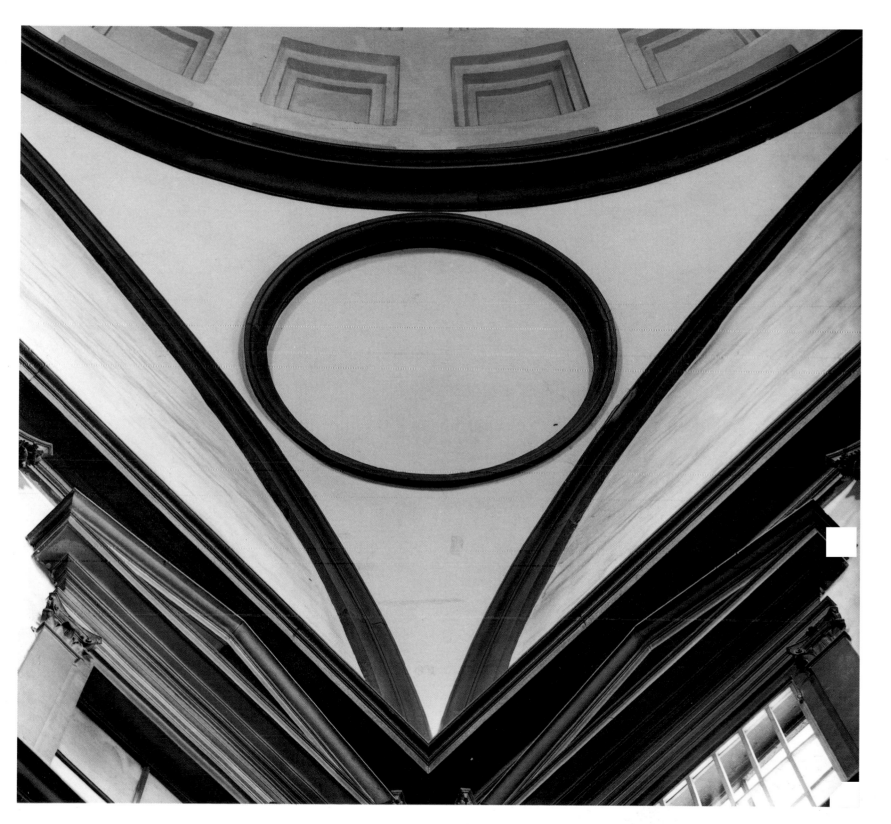

101

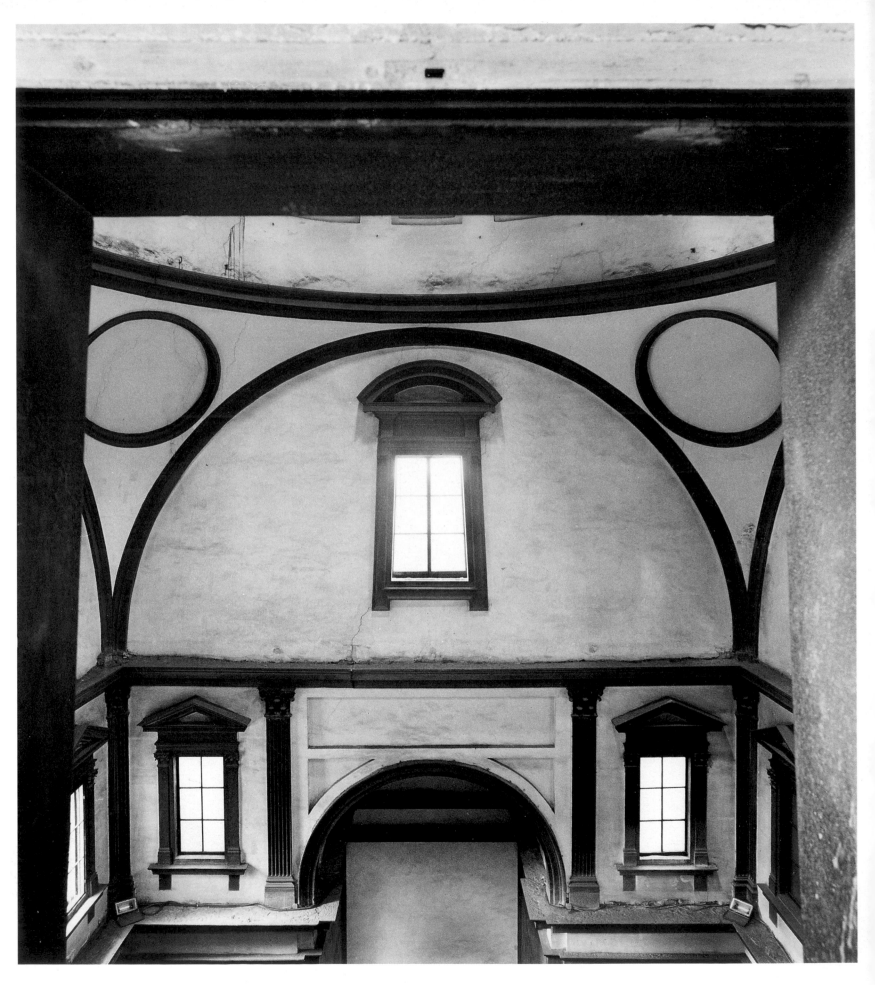

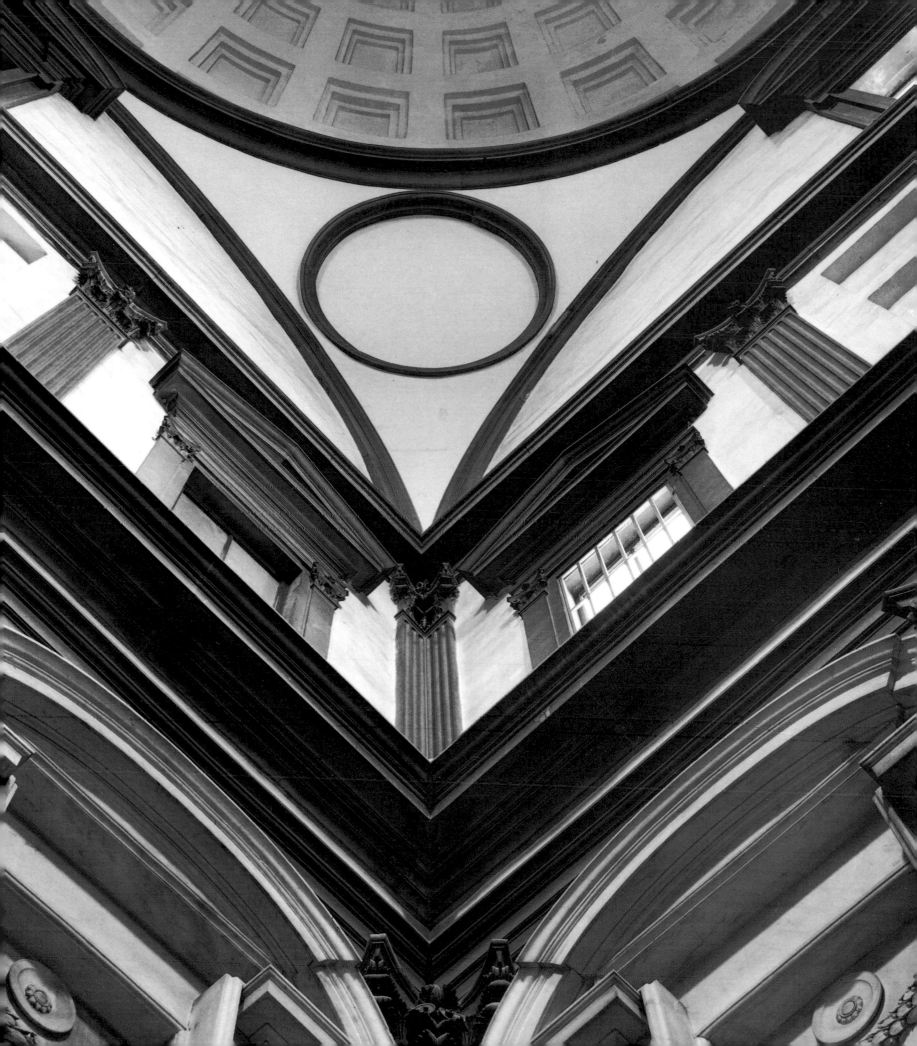

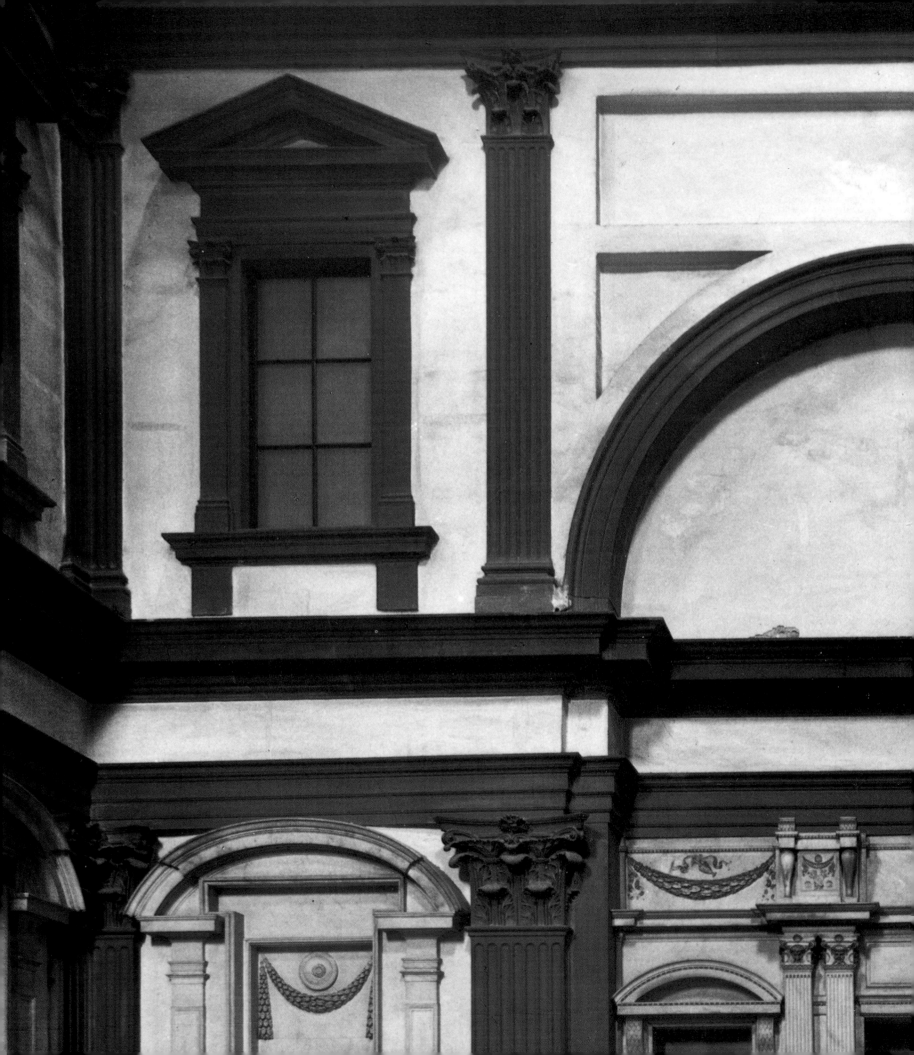

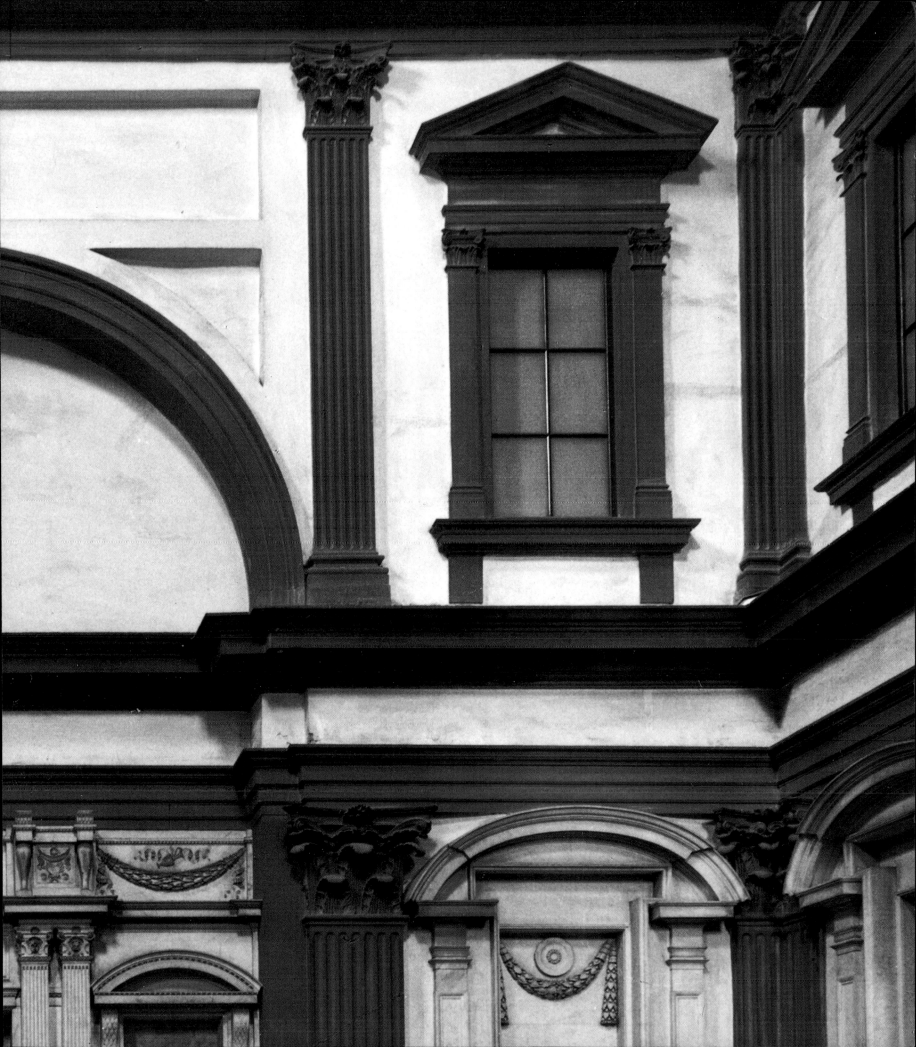

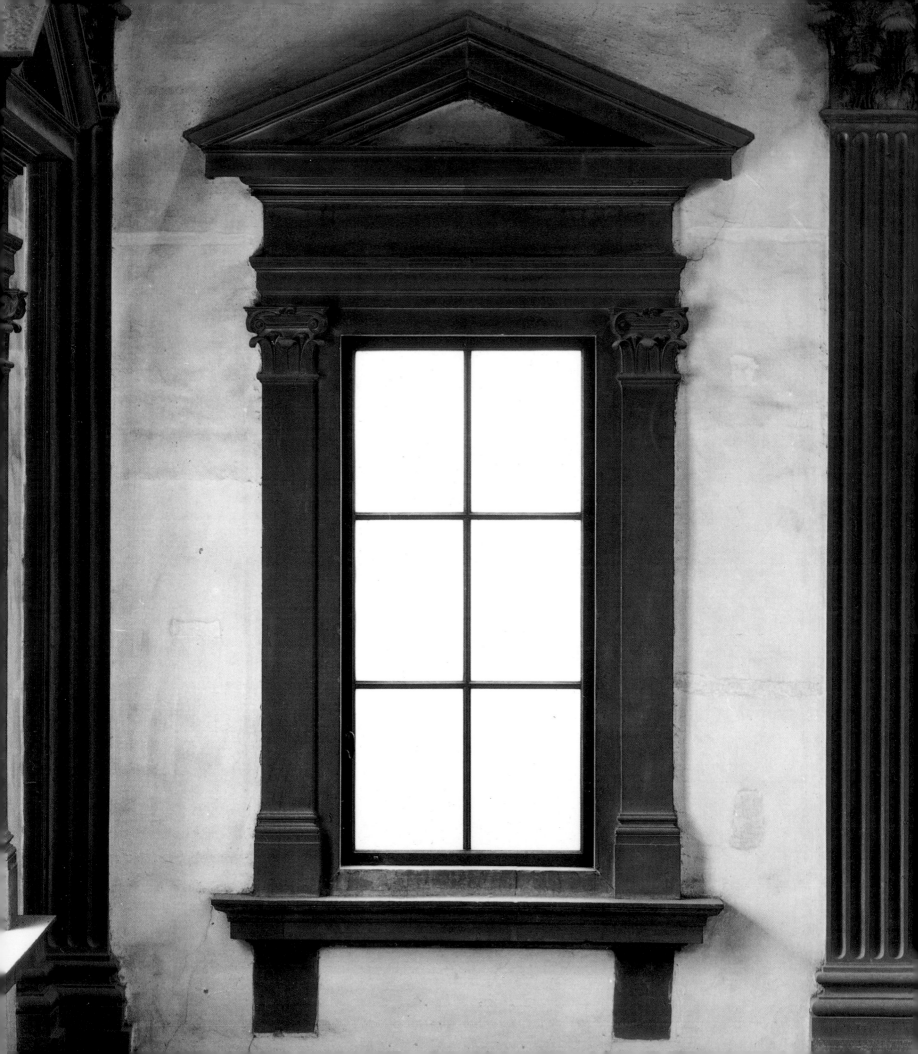

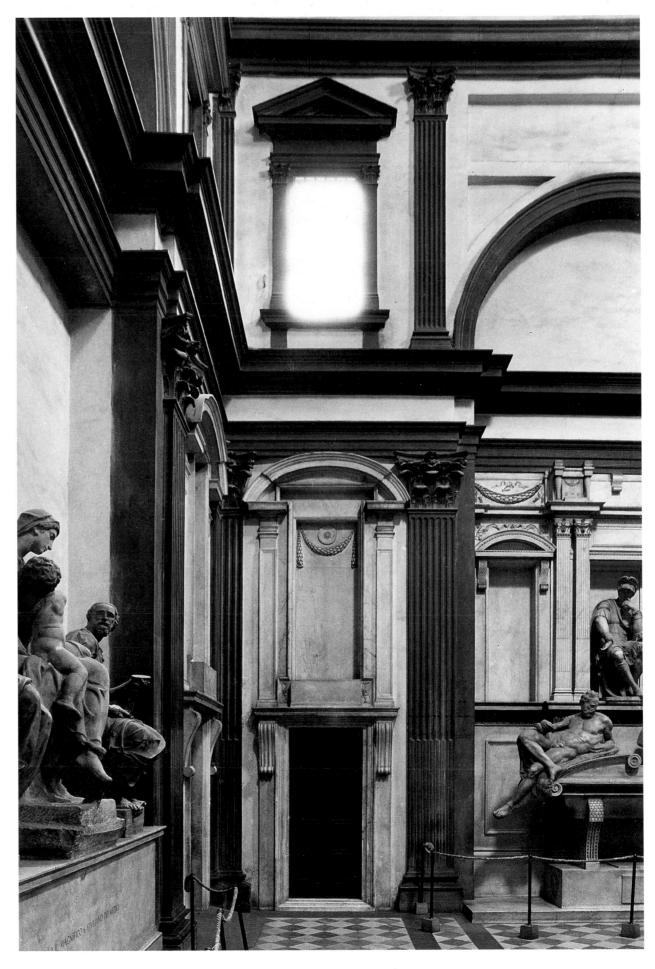

117. *(opposite) New Sacristy, window-aedicula. San Lorenzo, Florence*

118. *New Sacristy, west wall, tripartite elevation: door, aedicula, and window. San Lorenzo, Florence*

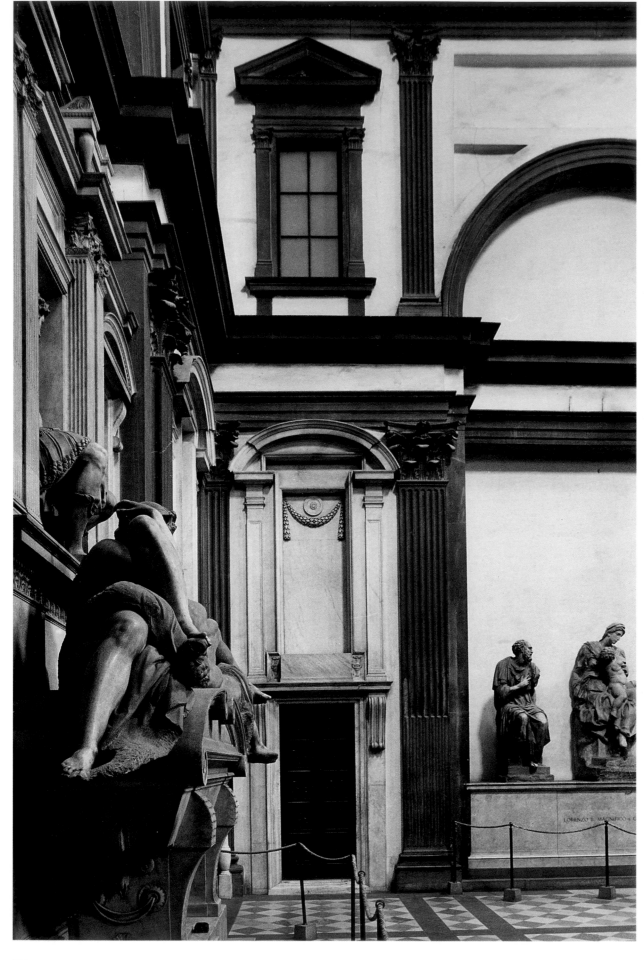

119. *New Sacristy, south wall, tripartite elevation. San Lorenzo, Florence*

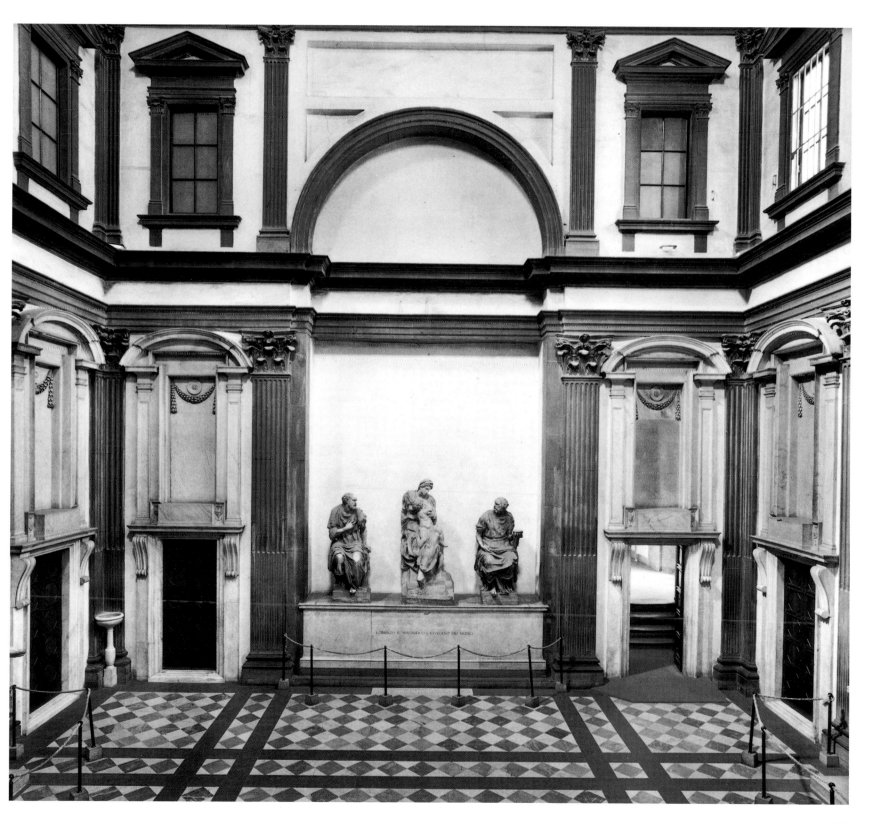

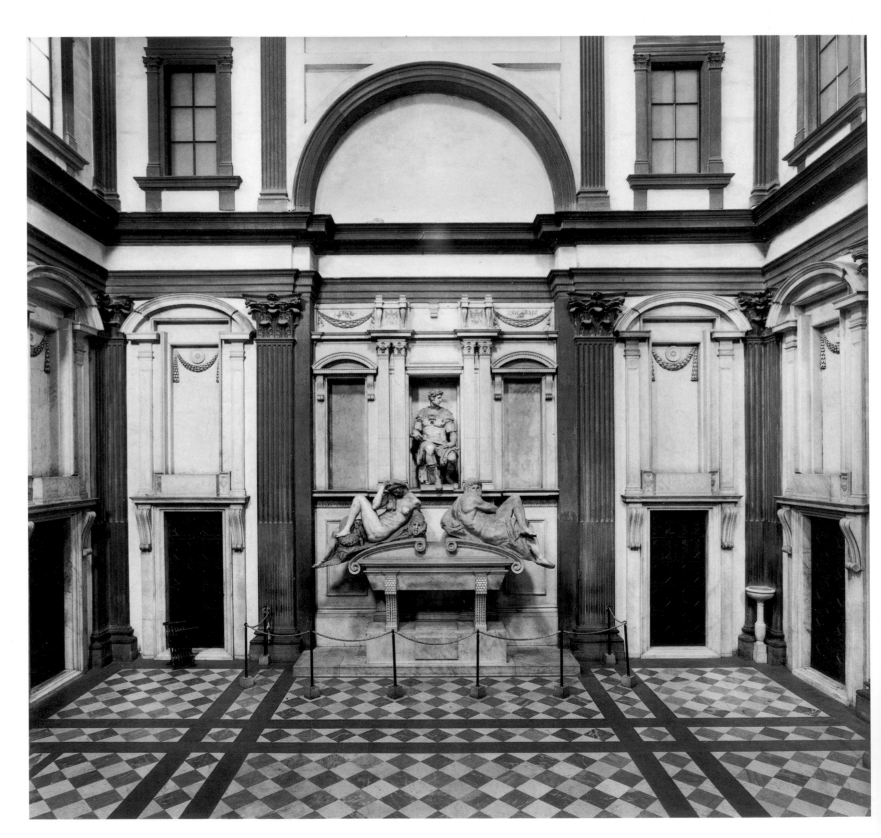

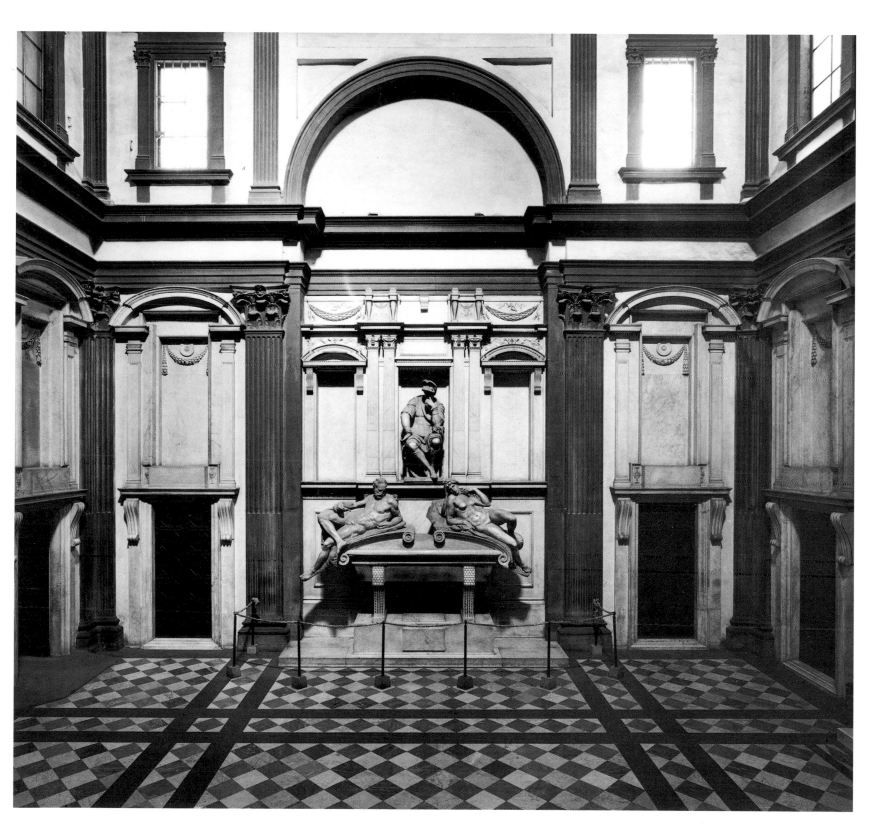

123. *New Sacristy, north wall with altar apse. San Lorenzo, Florence*

124. *(opposite) New Sacristy, funerary monument of Lorenzo de' Medici, duke of Urbino. San Lorenzo, Florence*

pages following:

125. *New Sacristy, detail of corner pilasters. San Lorenzo, Florence*

126. *New Sacristy, detail of* pietra serena *capital. San Lorenzo, Florence*

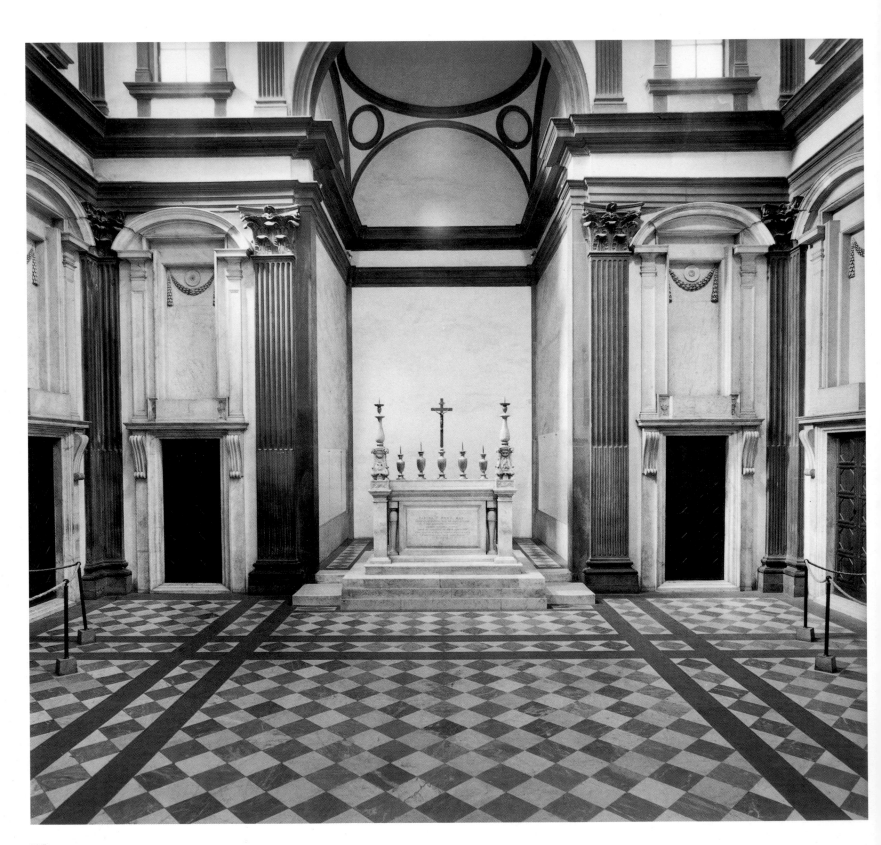

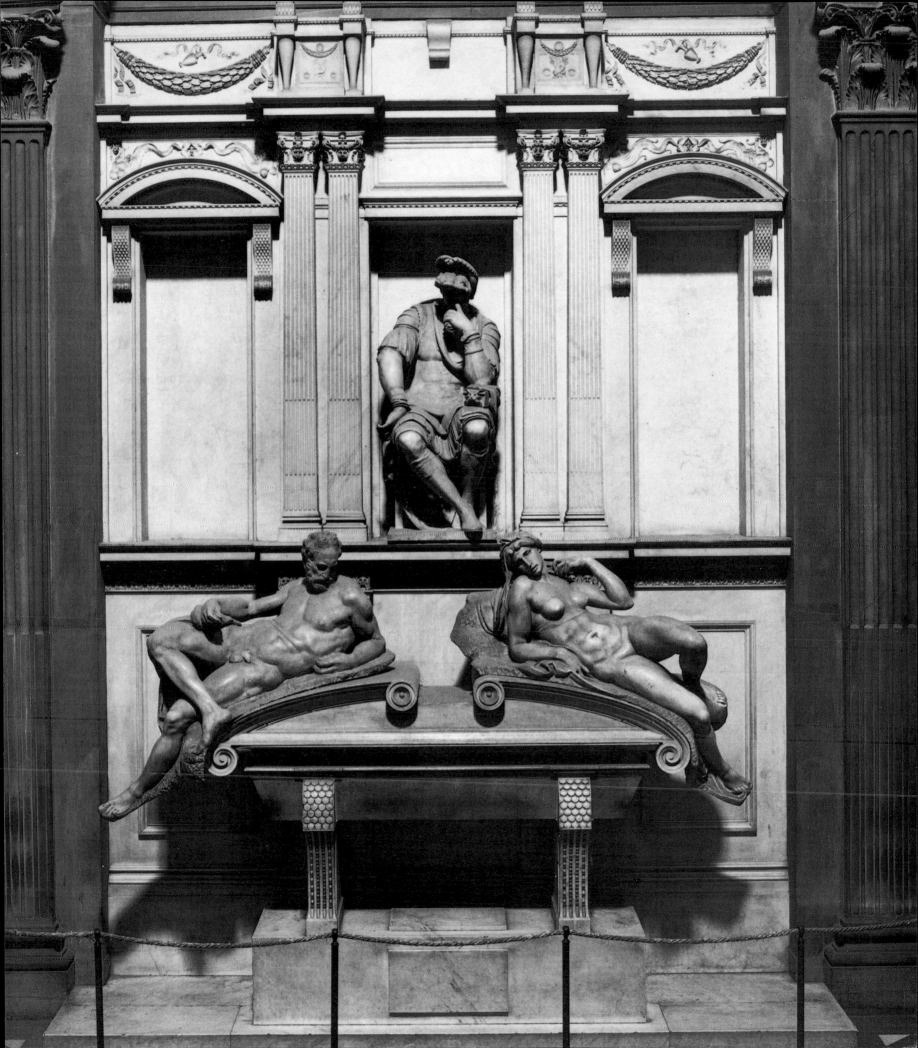

127. *New Sacristy, north wall, door to washroom. San Lorenzo, Florence*

128. *Michelozzo Michelozzi. Library of San Marco, interior. Convent of San Marco, Florence*

Apostolic Library of the Vatican. In it would be united and made accessible all of the precious Latin and Greek codexes collected by his forebears, Cosimo il Vecchio and Lorenzo the Magnificent—the very texts upon which the secular culture of Florentine humanism had been founded. It was, said Tolnay, the first library of secular formation, although by this he did not mean nonreligious. The Lutheran protest was just at its beginning, and Clement did not foresee its grave danger, even though intolerance of corruption in the Church had spread everywhere, especially in Florence where the preaching and martyrdom of Fra Girolamo Savonarola still burned in the collective memory. Also in contention were problems of doctrine. At the Council of 1439, Florence was at the center of the debates between Greek and Western theology. Through Nicholas of Cusa and Marsilio Ficino, the Florentine religious culture had been given a neoplatonic orientation which distinguished it from the official scholastic tradition. But Lutheran reformist doctrine was also tendentially platonic in its references to Saint Paul and Saint Augustine. Florentine neoplatonism—that is, the Ficinian theology which Lorenzo the Magnificent had protected—was in truth laic but it constituted a strong doctrinal defense. Michelangelo was formed in that orbit, and no one could have interpreted its beliefs better than he. His greatest innovation, however, was really the desire to make the new library both an environment for and the visible form of the Florentine culture.

There was, of course, a precedent and an authoritative typological premise for the library. Not to follow it meant to dissent from it—and Michelangelo dissented. In the mid-fifteenth century, by the order of Cosimo il Vecchio, Michelozzo had built the library for the Dominican Convent of San Marco (fig. 128), of strict Thomist observance, making it a basilica-form structure with three nave aisles, because the completely ecclesiastical essence of the studies carried out there was obvious. Michelangelo was clearly desirous of visualizing in the form of the Laurentian Library a laic culture which would be on a par with the religious. Wanting it to be an "eloquent" architecture, but not one which enunciated an abstract concept, he conceived this visible place of scholarly life in the form of a large parallelepipedal void—a long perspective space without action—isolated above the convent so that it would have total exposure to the natural light (figs. 129, 130). But building the library on top of the sleeping quarters of the religious brothers presented some technical difficulties with regard to reinforcing the load-bearing walls and making the new walled volume as light as possible. Therefore, he thought of the walls of the room simply as drawings inscribed on the white intonacos with thin reliefs of gray stone. That was the architectonic theory; the carpenters would have thought of making the space habitable and comfortable with the large reading desks. But the space of study should really be connected with the space of life in order to maintain the true laical spirit, and that animated space of life was the library's multilevel vestibule where the future and the past coexisted. It was a space unto itself, as emotive as the other space was abstract and almost completely filled by a grand staircase clearly symbolic of opposing existential states of rising and descending.

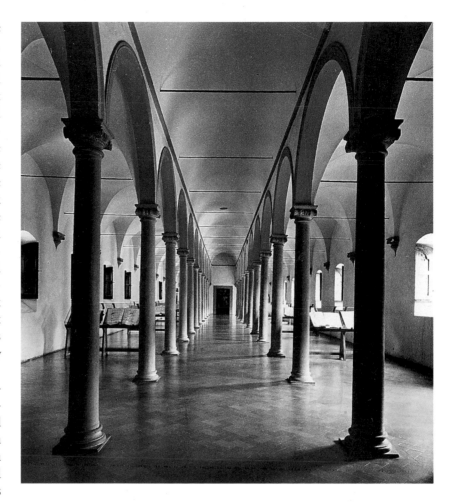

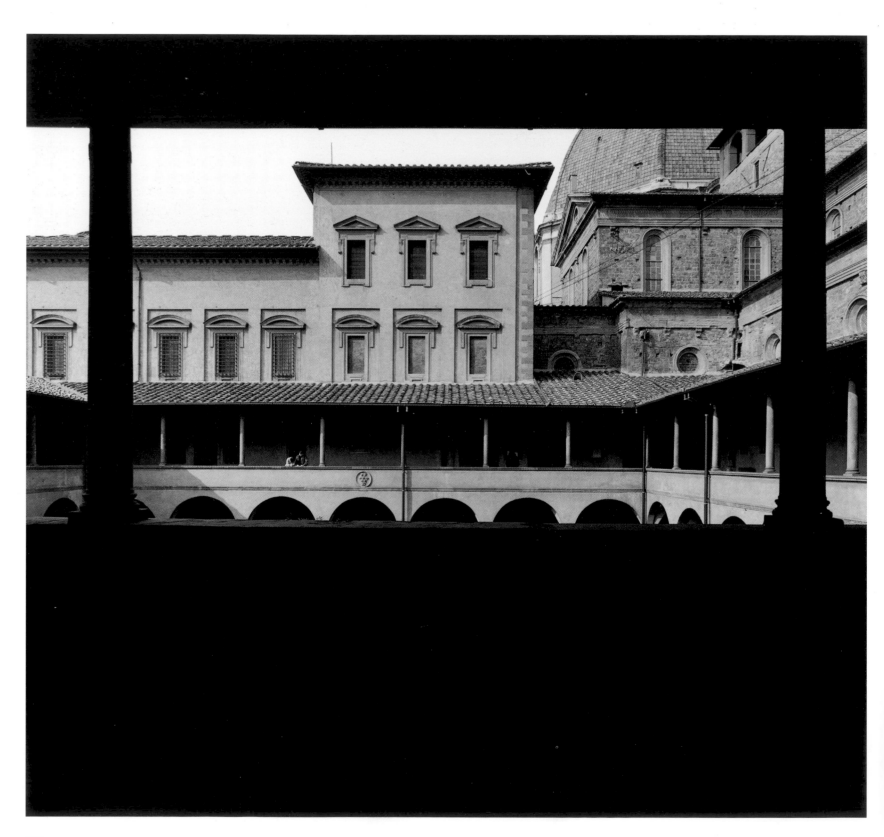

130. *(above) Laurentian Library, exterior view of east wall before 1903 restoration (Foto Brogi 8434). San Lorenzo, Florence*

131. *(below) Laurentian Library, exterior of reading room windows. San Lorenzo, Florence*

In reconstituting the history of the construction of the library, Rudolf Wittkower demonstrated that this absolute metaphysical perfection of design was the fruit of a long and profound process of rethinking and self-criticism. When Michelangelo left Florence in 1534, he was still agonizing over the definitive form of the vestibule and its staircase. The desks, ceiling, floor, and glazed windows of the reading room would also be executed later, but they had been planned for at the same time as the architecture. They were not accessories, however, and even this entered into the ideology of Michelangelo; they were the products of an artisanry certainly considered subordinate by this great aristocrat of a liberal culture, but which was coordinated with the intellectual work of the artist. As already said with regard to the Medici chapel, he saw the crafts as a genuine component of the Florentine artistic culture. While feigning modesty, he knew that he was as great an intellectual as Botticelli before him. He despised the eclectic affectation of the trendy professors of art, but he idealized the manual labor of his own work, and therefore he respected the respectful artisans, the heirs of an ancient and noble tradition.

The library in its original design was to have had several annexes to the main space. The preserved plan of one, destined for the protection of the most precious codexes, shows a massive, fortified triangle like a bastion (fig. 155). With the humanistic Florentine culture threatened along with the Republic, there was nothing accidental about the mental association of the library and the fortifications for Florence in that difficult situation. The chronological proximity and, to some degree, the same coincidence of opposites explained the complementary relationship between the library and the bastions.

Already of a contrary sign were the two related, contiguous spaces of the large reading room of completely linear design and the small vestibule with its elements standing out like tensed muscles. Even the levels were different, with the floor lower and the ceiling higher in the vestibule than in the reading room. Their spatial orientations were in opposition as well—the reading room all length (fig. 132) and the vestibule all height (fig. 137). The contrast of the two axes was already anticipated in the New Sacristy, but in the library it was repeated on a larger scale with a very different resonance.

In the reading room, the light entered from two opposing banks of windows which mirrored and annulled each other as light sources, translating instantly the physical substance of the light into metaphysical geometry written in black on white (fig. 134). In the vestibule, the light fell from above, caressing the columns that emerged from the darkness of the wall and going mad on the rolled-up volutes of the brackets (fig. 144). There was, however, no symbolic intent here. Michelangelo did not accept the double nature of reality and symbol, yet he was aware that the more visually intense the image was made, the clearer its symbolic meaning would be. Already evident in this conjunction of mental abstraction and strong emotive force was what would become the characterizing constant of his architectural oeuvre—instead of the illustrious eloquence of a monument *aere perennius*,

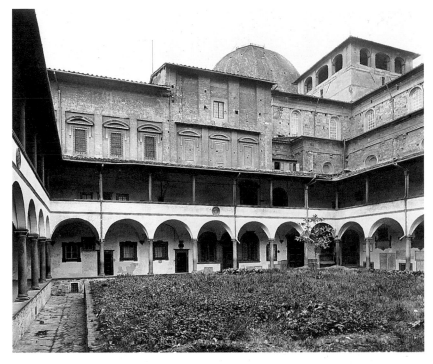

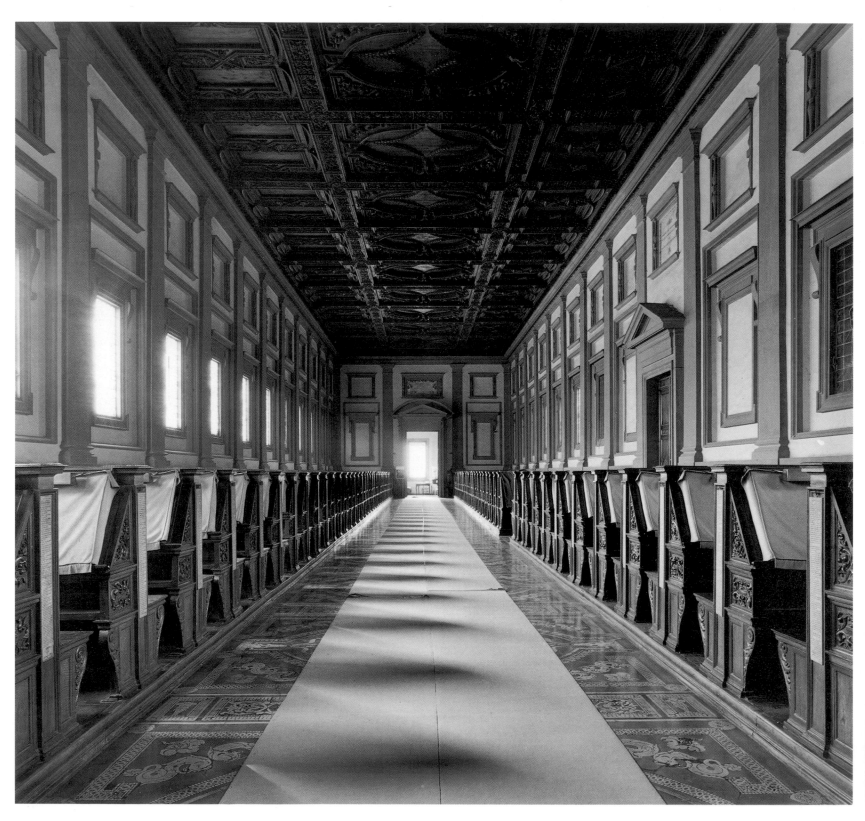

pages following:

133. *Laurentian Library, reading room, east wall. San Lorenzo, Florence*

it had become the involved action of the edifice upon those who entered it. As Portoghesi (1964) said, the formative act was more important than the formal result, therefore the structure did not communicate a message of solid grandeur but rather one of the anxious movement of a thinking mind. Perhaps this was the reason why Michelangelo planned more than he constructed; and that planning without end resulted in the not-finished aspect of his architecture. In reflecting on this continuous process of planning, one realizes that large and small were only relative differences in his way of thinking. The vestibule staircase leading up to the door of the reading room (figs. 152, 153) provided a kind of initiation—a passage from the dramatic dimension of existence to the higher, serene one of study. In fact, Michelangelo meditated at length on that relationship, first placing stairs on the back wall, then on the side walls, and finally deciding to weld both options into one grand staircase, which, like a leading actor, dominated the whole vestibule. Thus a utilitarian element of practicality in construction became a principal force, concentrating in itself and its own implicit movement the meanings of the other elements. In the final concept for the vestibule, which was provided only many years later, Michelangelo accentuated the meaning of epilogue and moral in the architectonic discourse in charging the design with the agitated memory of his dramatic, lived experience.

His letter to Vasari about the still unbuilt staircase, dated September 28, 1555, could be interpreted in a psychoanalytical way. He had only a vague recollection of the matter of the library, and if he could have remembered his original concept, the request would not have been necessary. As it was, it came back to his mind like a dream by means of that strange "ovate (*aovata*)" stair tread. Yet he went on to describe it with precision as an elastic configuration, seeming to be mobile in its central part yet rigid in the lateral ramps, which were interrupted in a fantasy by two large volutes without arriving at the top of the staircase (fig. 150). How can one not perceive the deliberate irony in this maliciously pedantic conjunction? Without doubt the central ramp with its large curves and curls at the edges was reserved for the ruler and the austere side ramps for his acolytes. In the Medici court, philosophy no longer reigned, as in the time of the Magnificent, but ceremony—no longer Botticelli, but Bronzino. In the past, Michelangelo had made numerous drawings for the vestibule stairs (figs. 157, 254, 257, 259, 260), working out the different meanings it could have in relation to the reading room. This discourse on the relationship between life and thought, suspended in Florence, was taken up again in Rome in the double-ramped staircase of the Senator's Palace (figs. 320, 321). Here again, he alluded vaguely to the tie between power and the common people as a final homage to, almost a commemoration of, the Republican ideology. That the main ramp of the Laurentian vestibule staircase was somehow in contrast with the linear purity of the reading room and, more dramatically, with the "column-prisoners" of the vestibule wall, was felt from the very earliest designs, just as the relationship between the highly luminous reading room

and the "frowning" vestibule bespoke the anxiety of an equilibrium on the point of being shattered. Returning after many years and many sorrows to that project of the distant past, he could only verify bitterly the correctness of that foreboding. This was confirmed when, with the excuse of having to complete the dome of Saint Peter's in order to save his soul, he had not given in, while really wanting to do so, to the urgings of that enlightened despot Cosimo de' Medici I, who wanted him back in Florence.

The secret motivation for all of Michelangelo's thought was self-criticism, and without it he would have been unable to surpass himself. Every new work contained a judgment on the preceding ones, therefore the process of his art was constitutionally reductive. In the final version of the Laurentian staircase constructed by Bartolomeo Ammanati, the object of Michelangelo's self-criticism had been the library, in particular the vestibule space, which in its turn had been a critique of the reading room. This was another example of the not-finished, although ideological rather than technical, in the architecture of Michelangelo.

The vestibule had three levels (fig. 137): the lowest, simple and unadorned without any sign except the vain play of forces in the volutes; the second, which began at the same level as the floor of the reading room, was undoubtedly the most sculptural of all his architecture with its paired, embedded columns and large blind windows; and the top level, above the ceiling level of the reading room, was the light source, almost like a cupola. It was Ackerman who explained the perfect "antilogic" of these pairs of embedded columns, which at the same time strongly affirmed and strongly denied their reason for being, just as the windows next to them declaimed by their frames, then quickly denied in being blind, their normal purpose.

Comparisons between the abstract figurativeness of the column-prisoners, without any sign of life except the tenuous swelling of the entases on their shafts, and the tragic statues of the dying slaves are by now commonplace and unexceptional. Were they figures which suffering had exalted, apart from their physical exertion, in the geometry of the cylindrical shafts? Or were they geometric forms charged with the pathos of human figures under stress? In either case, because the form itself was both sculptural and architectural, the sought-for synthesis was accomplished fact.

The volute brackets below them guaranteed and redoubled the absolute functional inanity of these double columns. Clearly these were not load-bearing elements, but rather they capriciously dispersed in arabesque every illusionistic static effect. They were the very distinct signs of that illogic which Michelangelo believed to be appropriate for poetic construction—the structurally asyntactic. In similar fashion, the icon of the volute, with that inverted rotation of the curves, was repeated on a larger scale on the staircase with the two volutes which ended the rigid rise of the lateral ramps in nothingness. Yet there was nothing strange in having that severity end by a stroke in pure extravagance. The curvilinear central ramp was like a dense, boiling flow towards the edges, where it was contained by two large

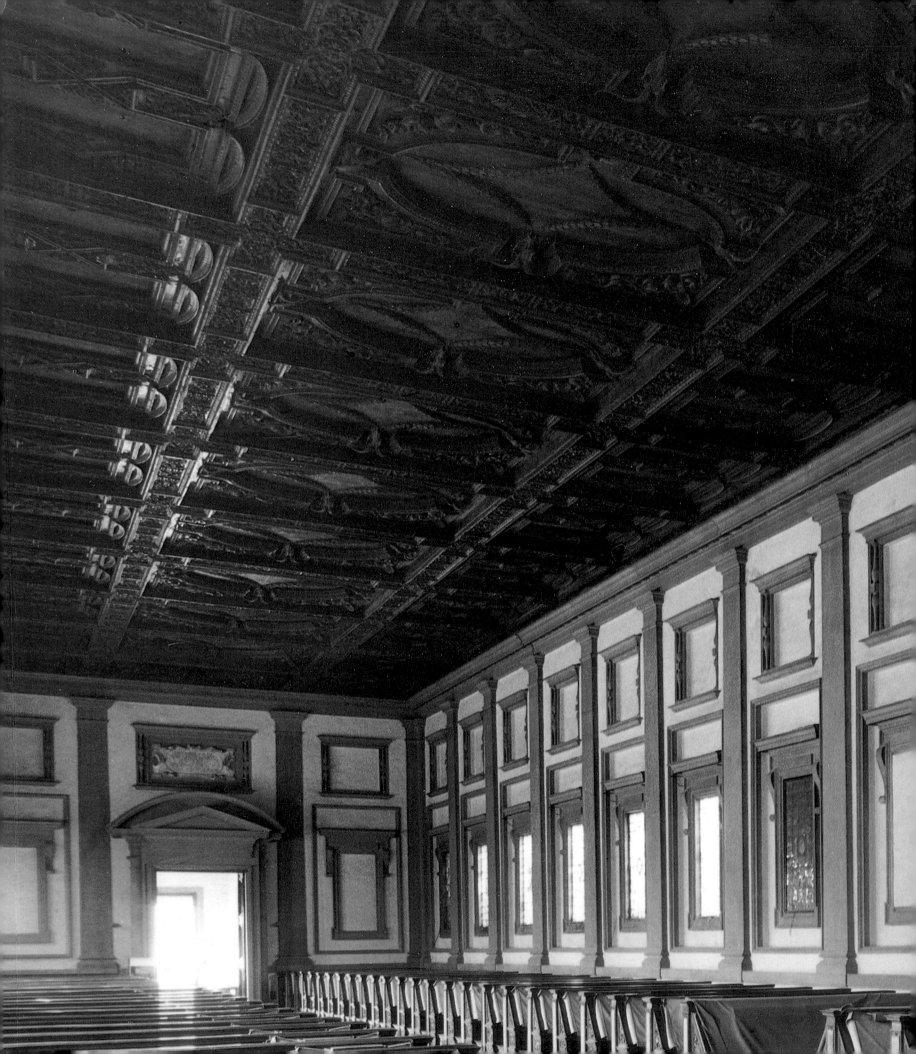

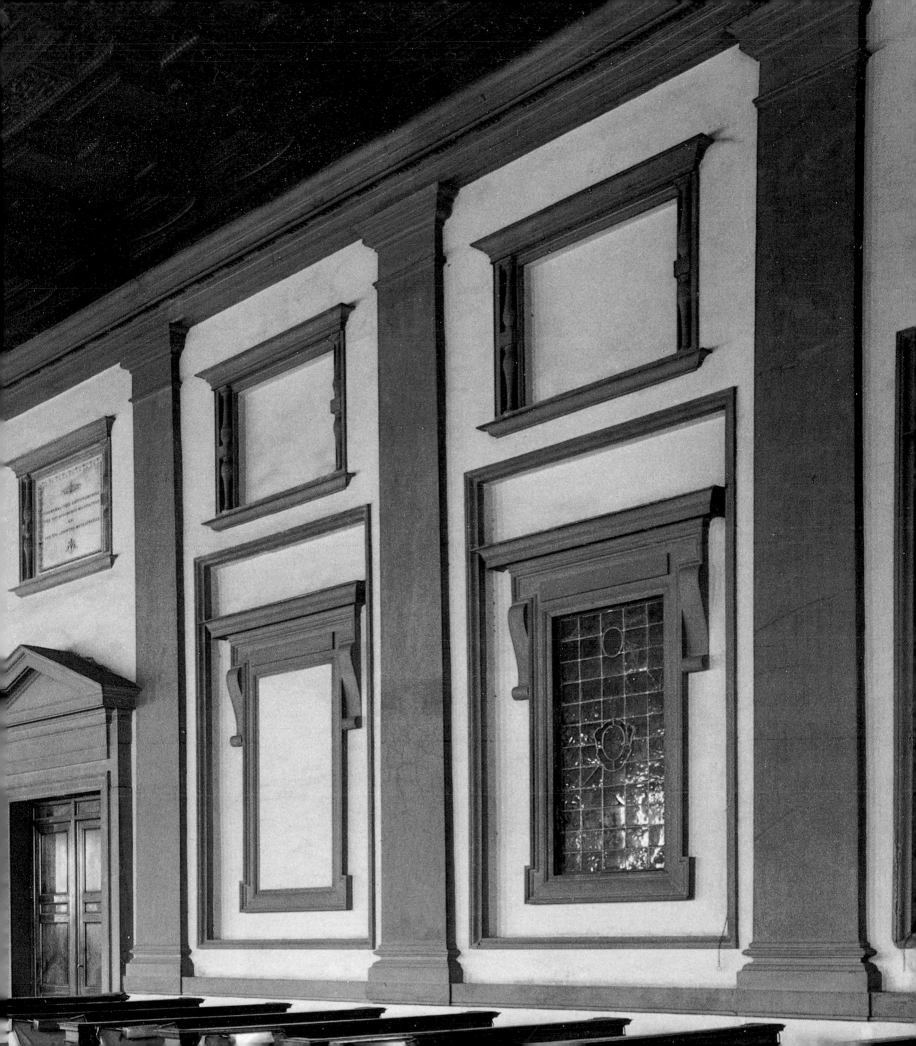

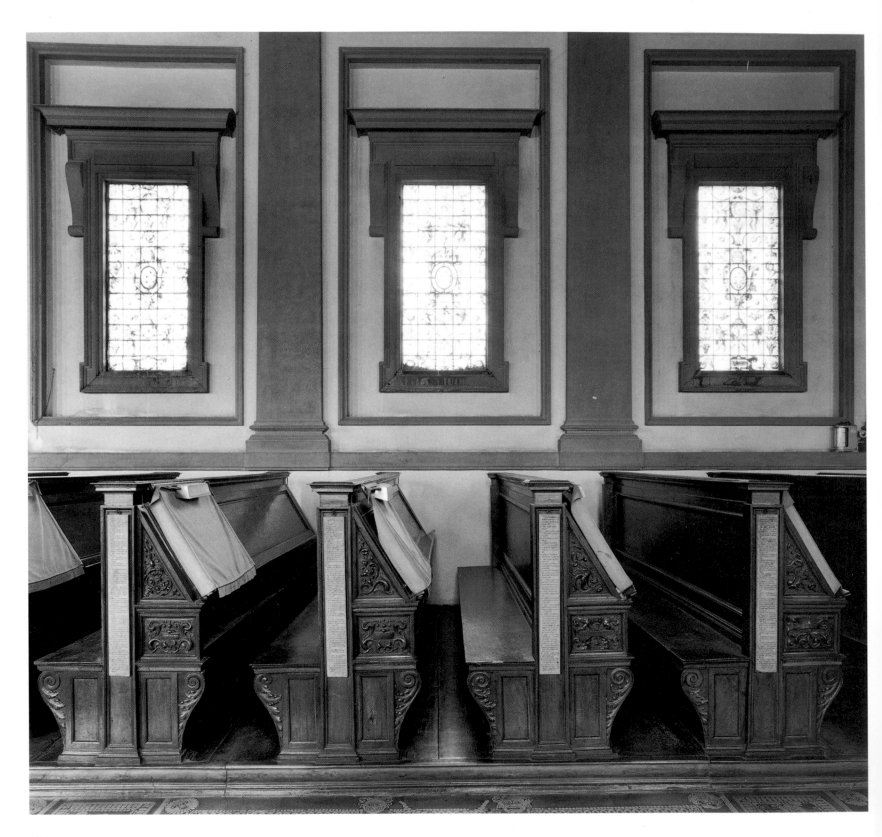

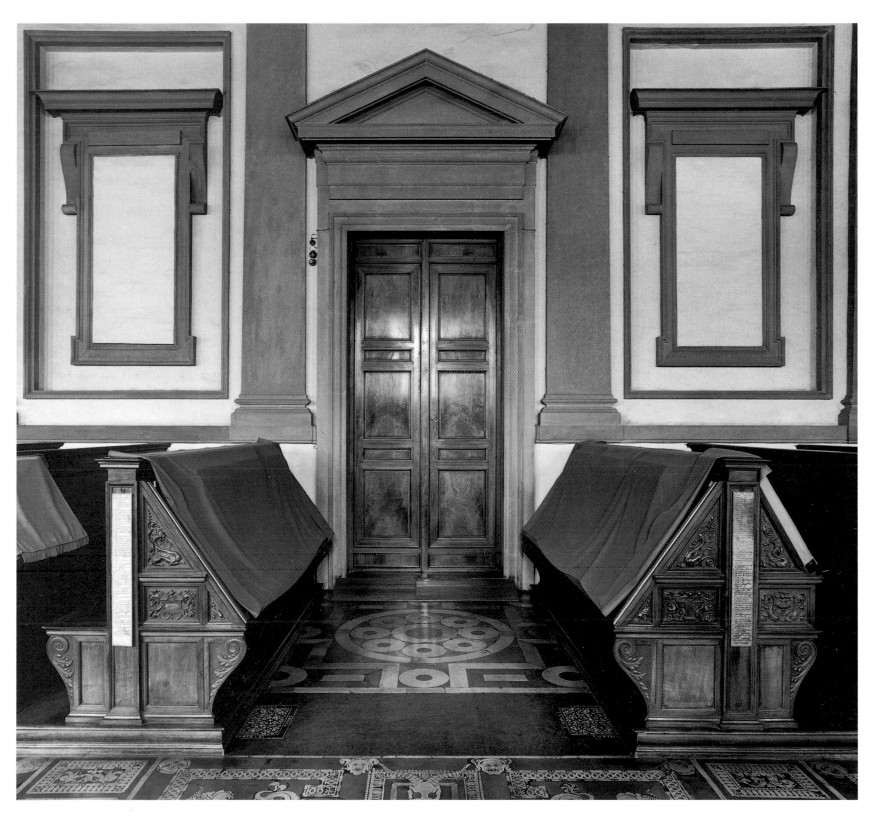

136. *Laurentian Library, reading room, door to vestibule. San Lorenzo, Florence*

137. *Laurentian Library, vestibule, north wall. San Lorenzo, Florence*

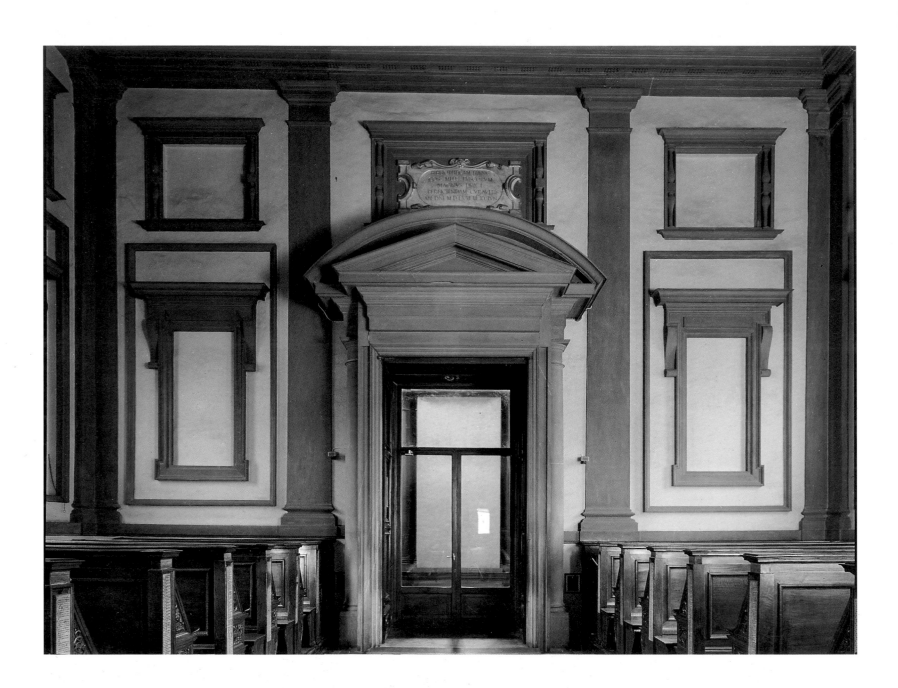

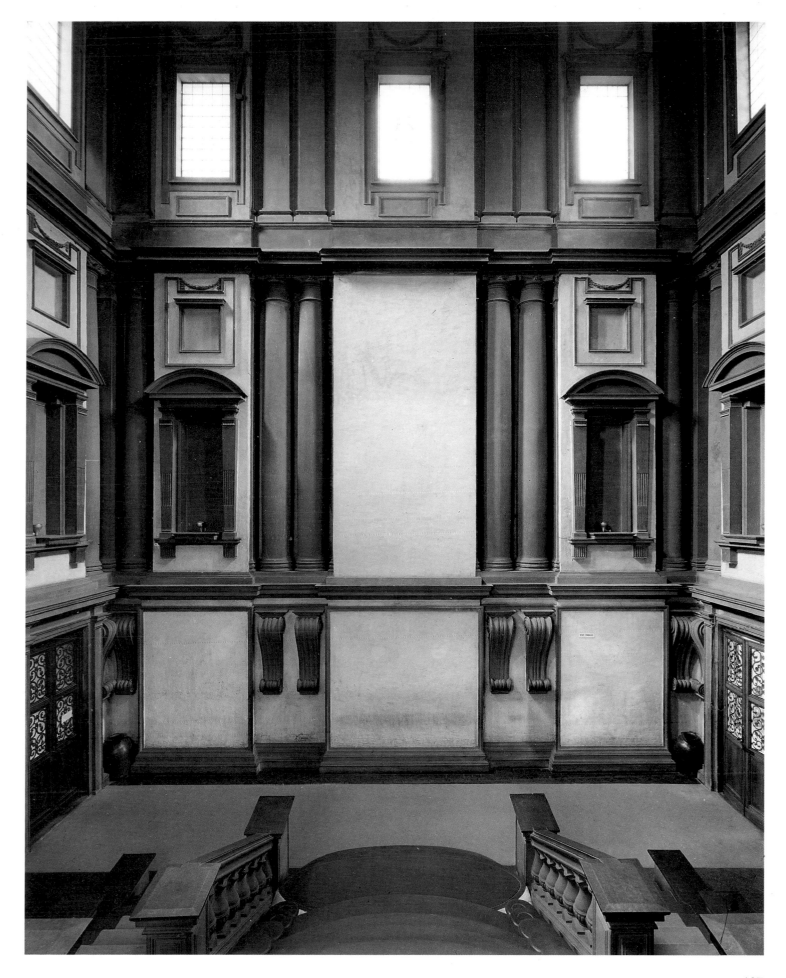

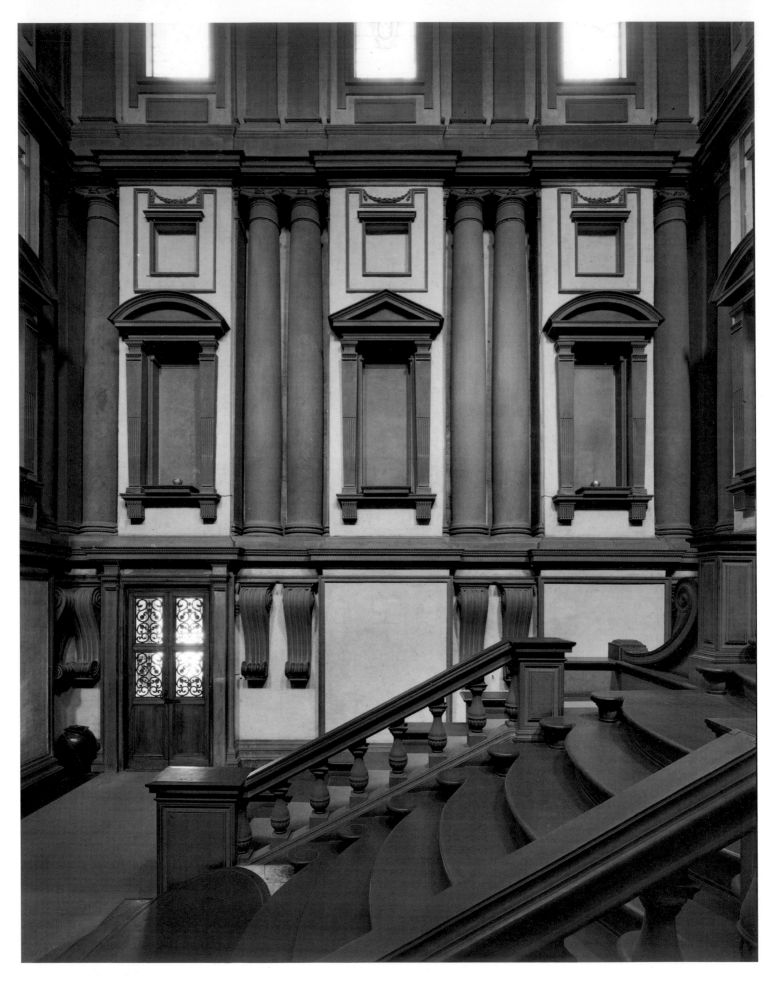

138. *(opposite) Laurentian Library, vestibule, east wall. San Lorenzo, Florence*

139. *Laurentian Library, vestibule, west wall. San Lorenzo, Florence*

pages following:

140. *Laurentian Library, vestibule, detail of aedicula. San Lorenzo, Florence*

141. *Laurentian Library, vestibule, detail of corner (ceiling restored early 20th c.). San Lorenzo, Florence*

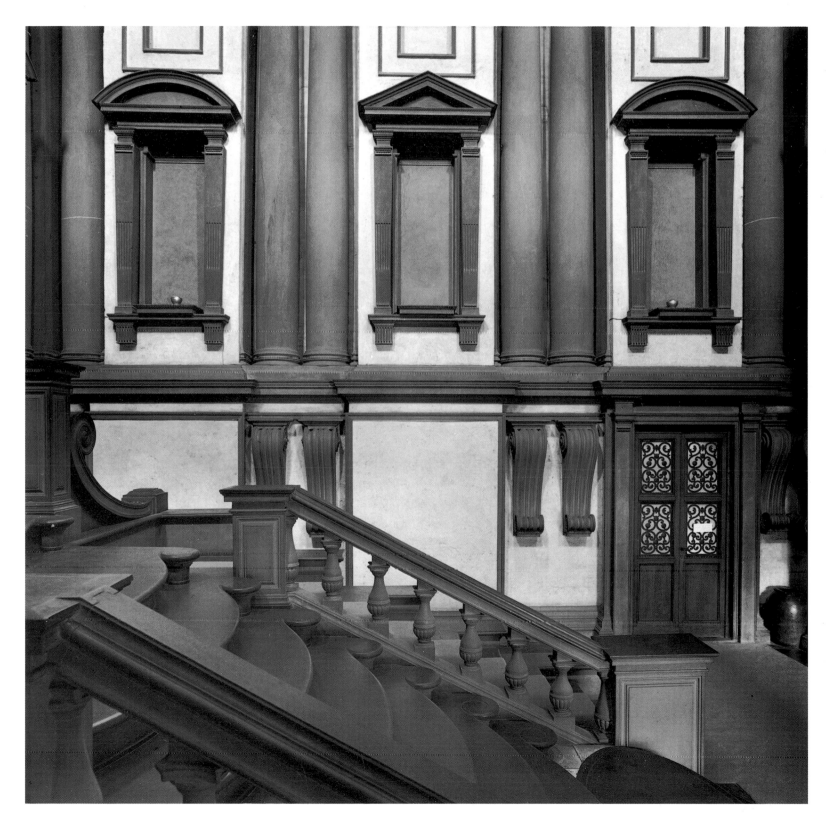

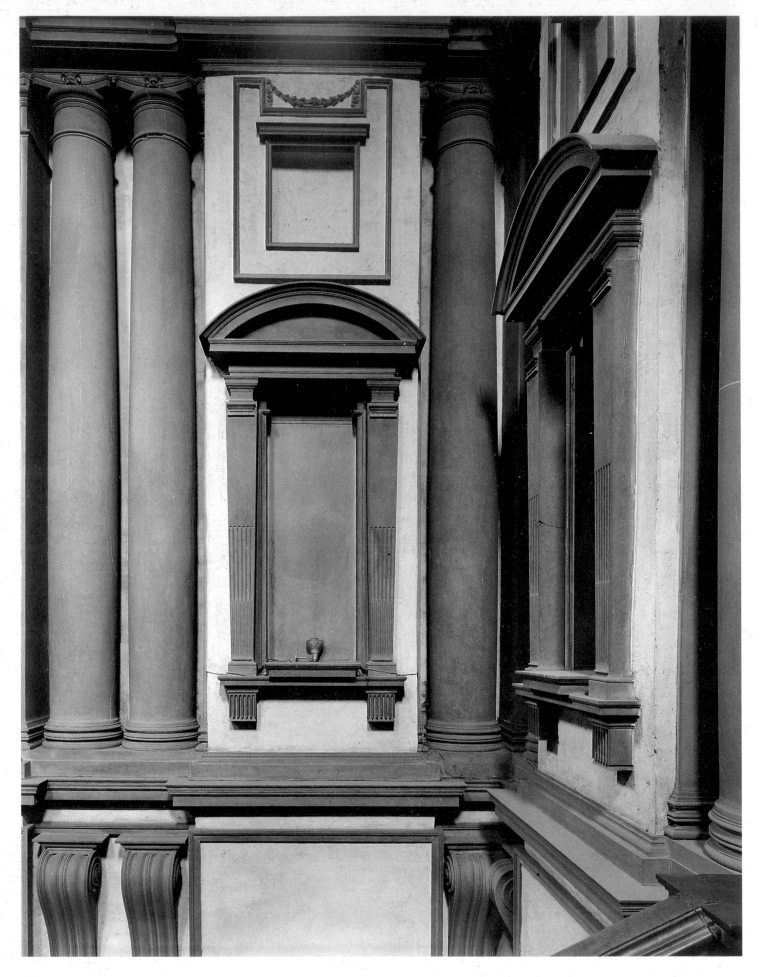

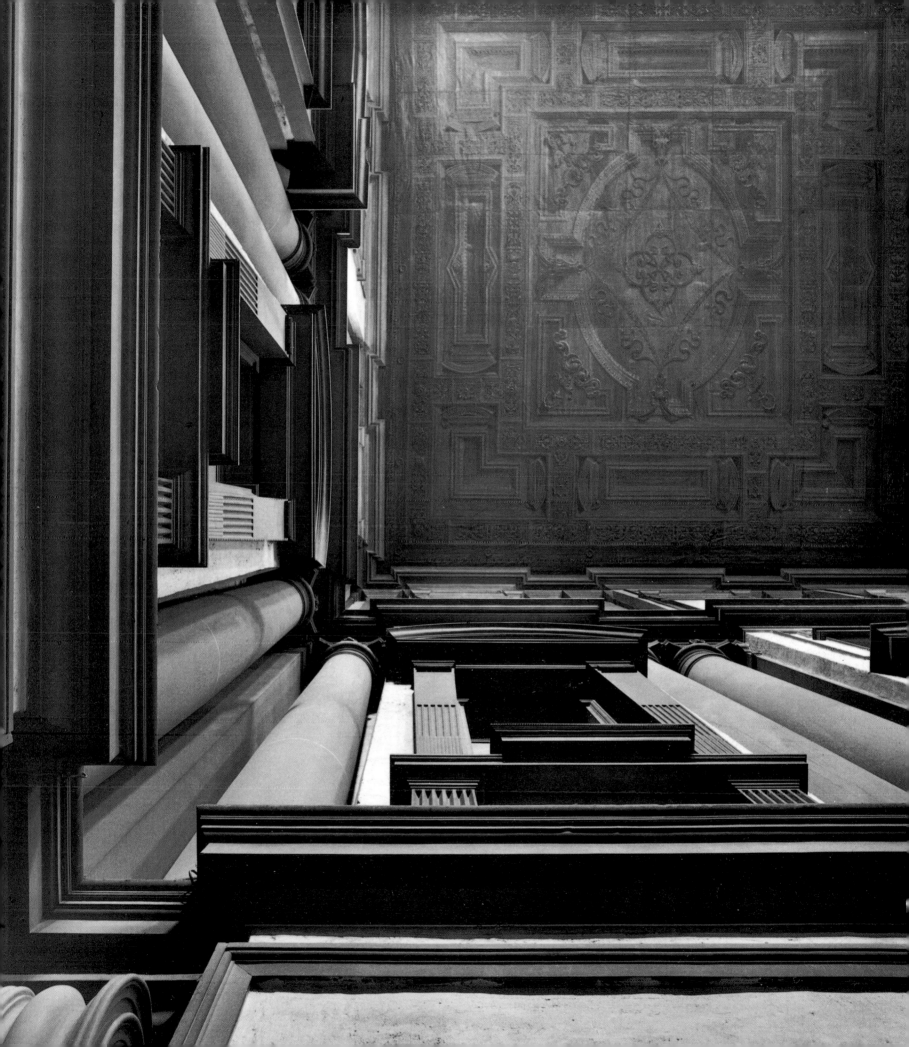

142. *Laurentian Library, vestibule, detail of capitals of paired columns. San Lorenzo, Florence*

143. *(opposite) Laurentian Library, vestibule, east wall with entrance door, aediculae, and rectangular niches. San Lorenzo, Florence*

pages following:

144. *Laurentian Library, vestibule, detail of corner. San Lorenzo, Florence*

145. *Laurentian Library, vestibule, conjunction of volute brackets in corner. San Lorenzo, Florence*

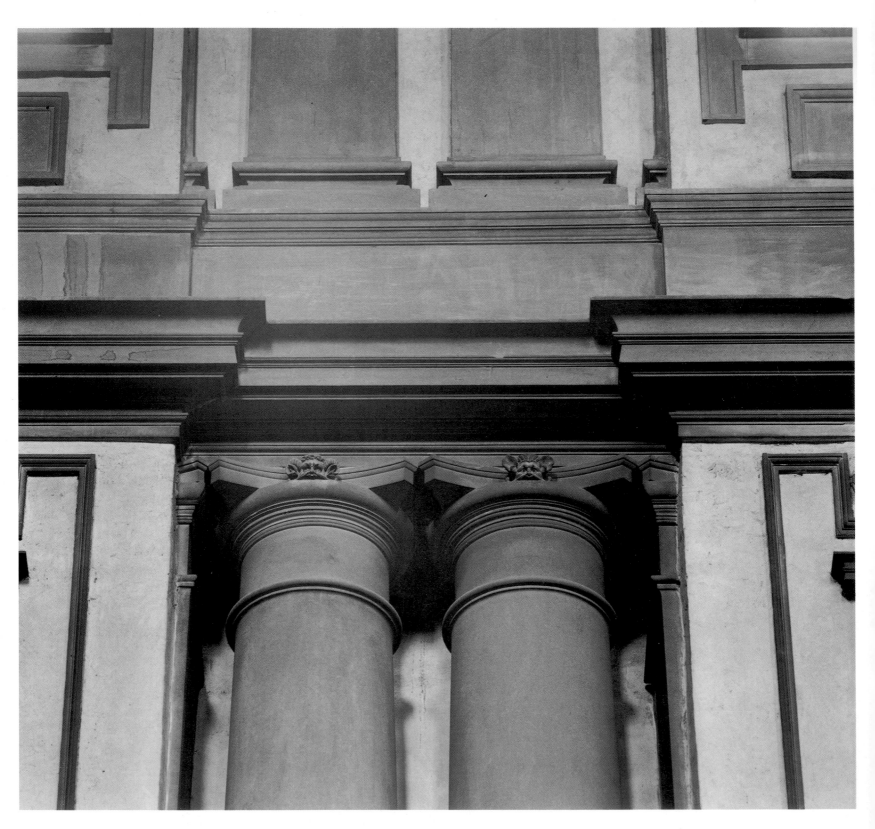

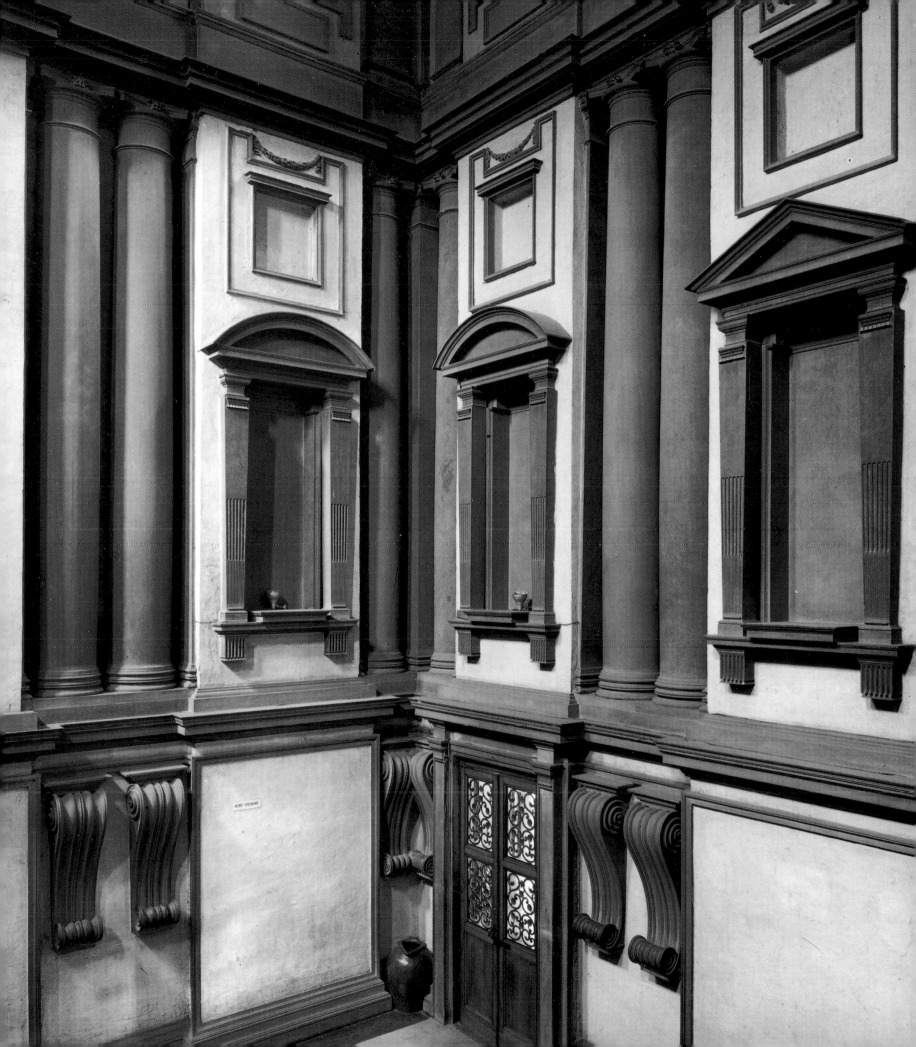

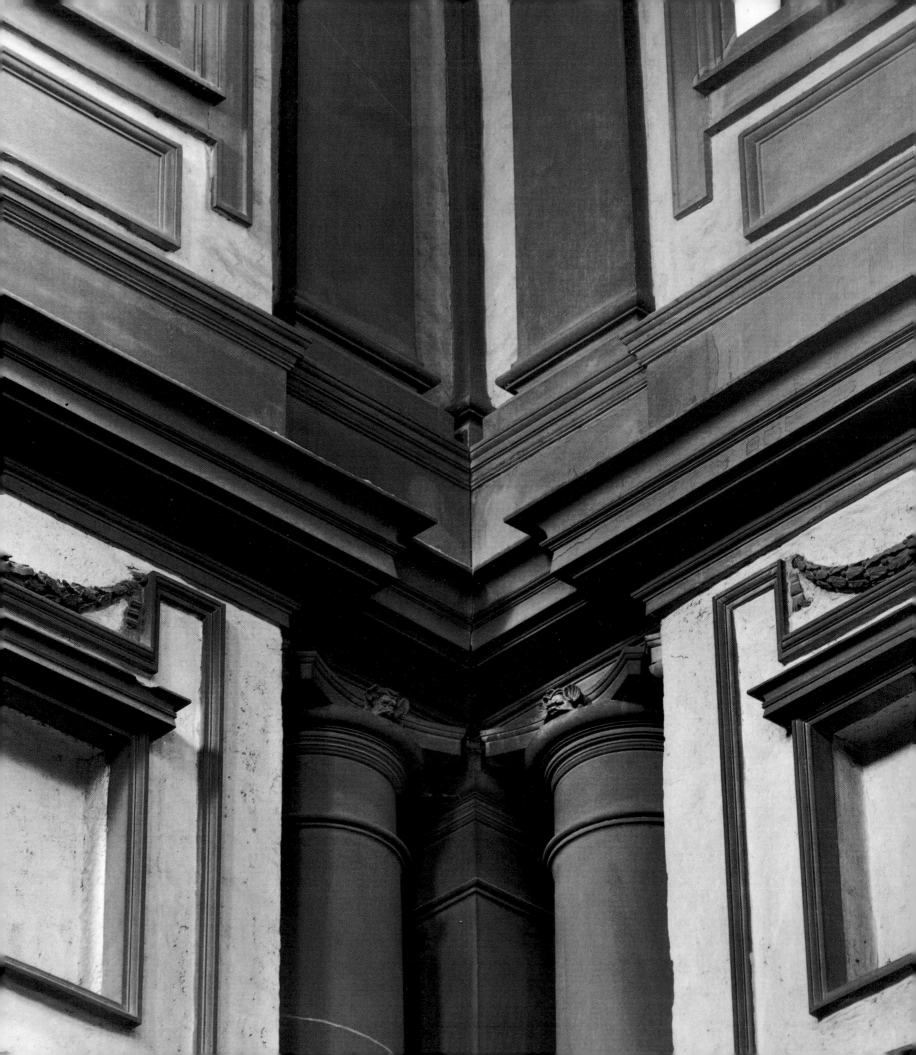

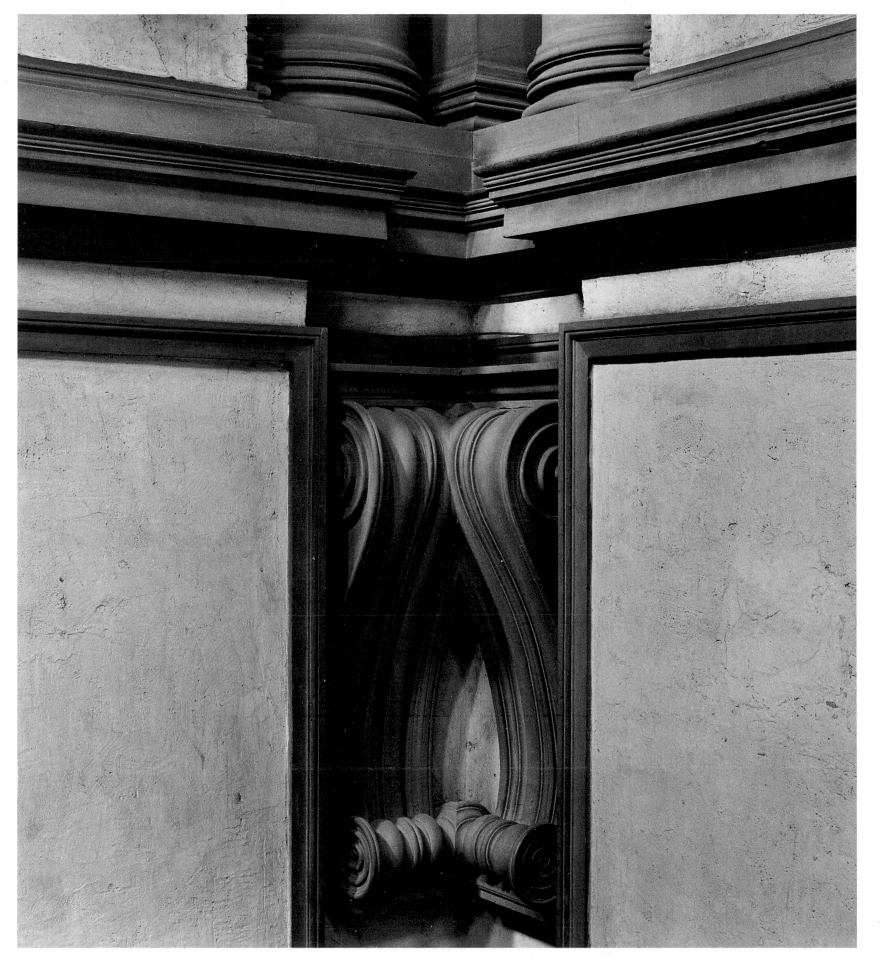

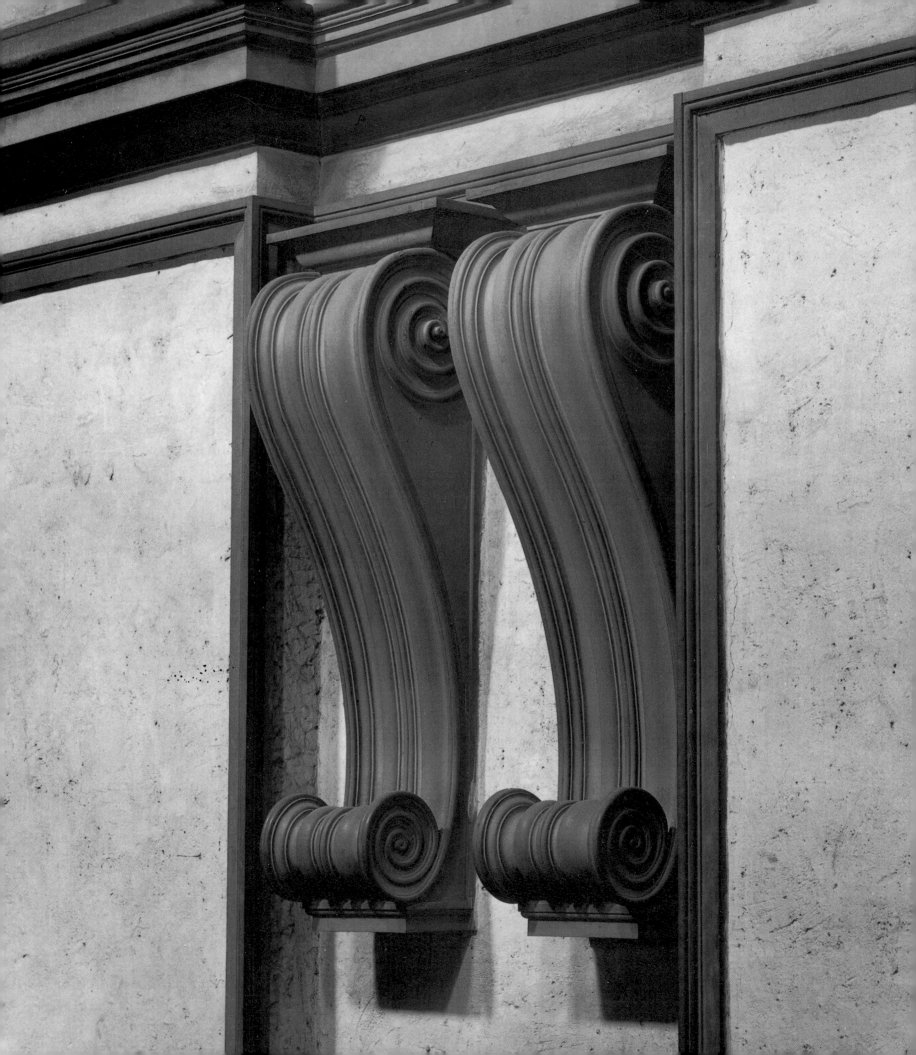

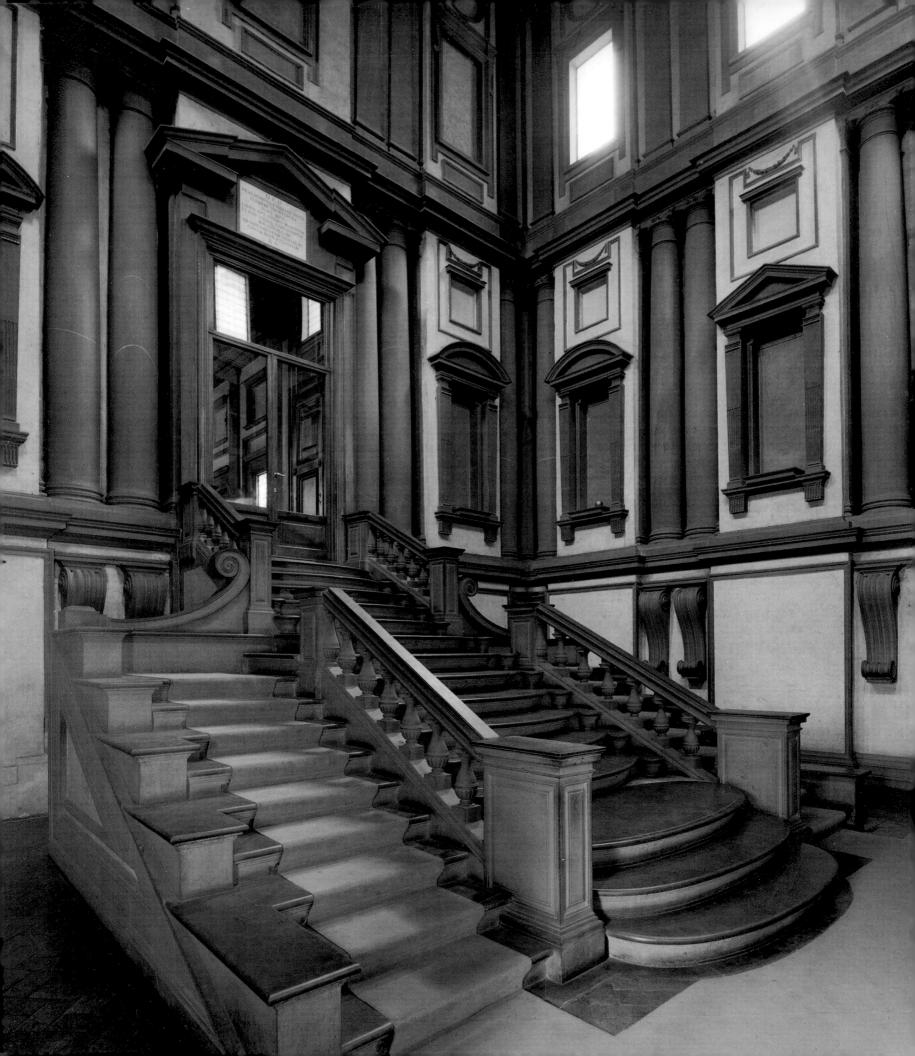

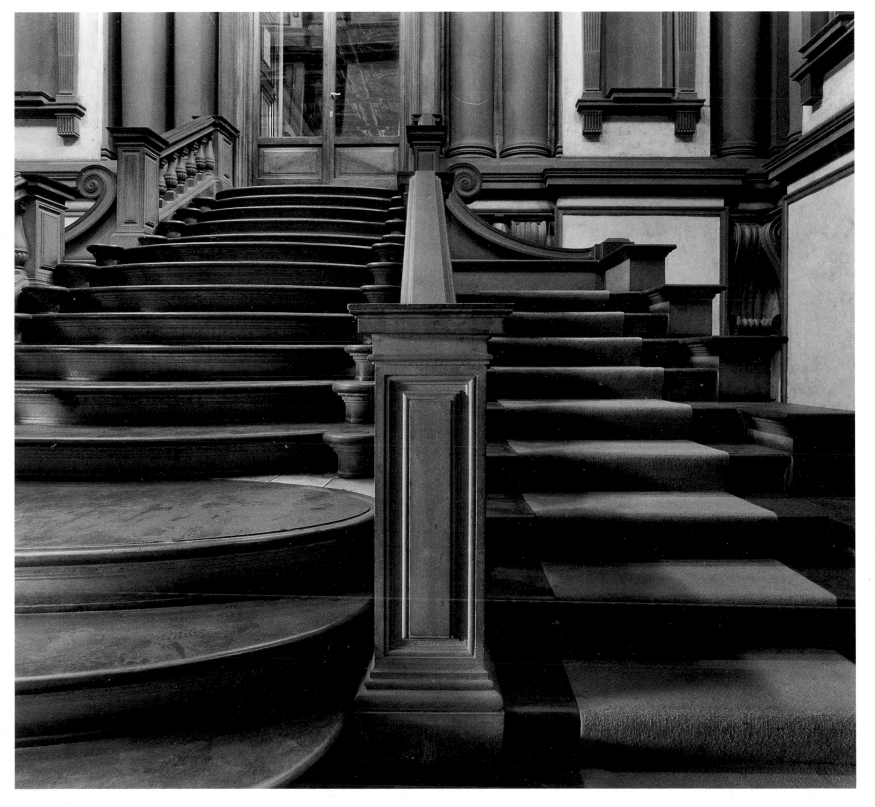

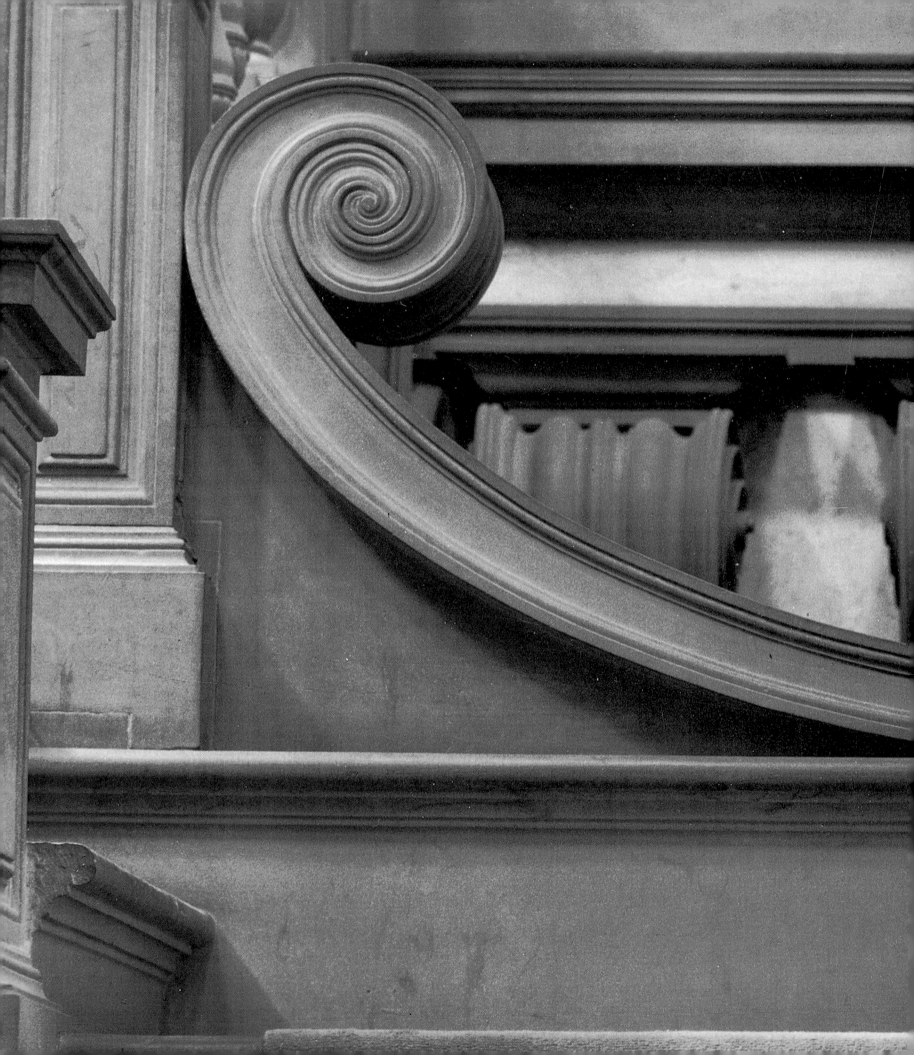

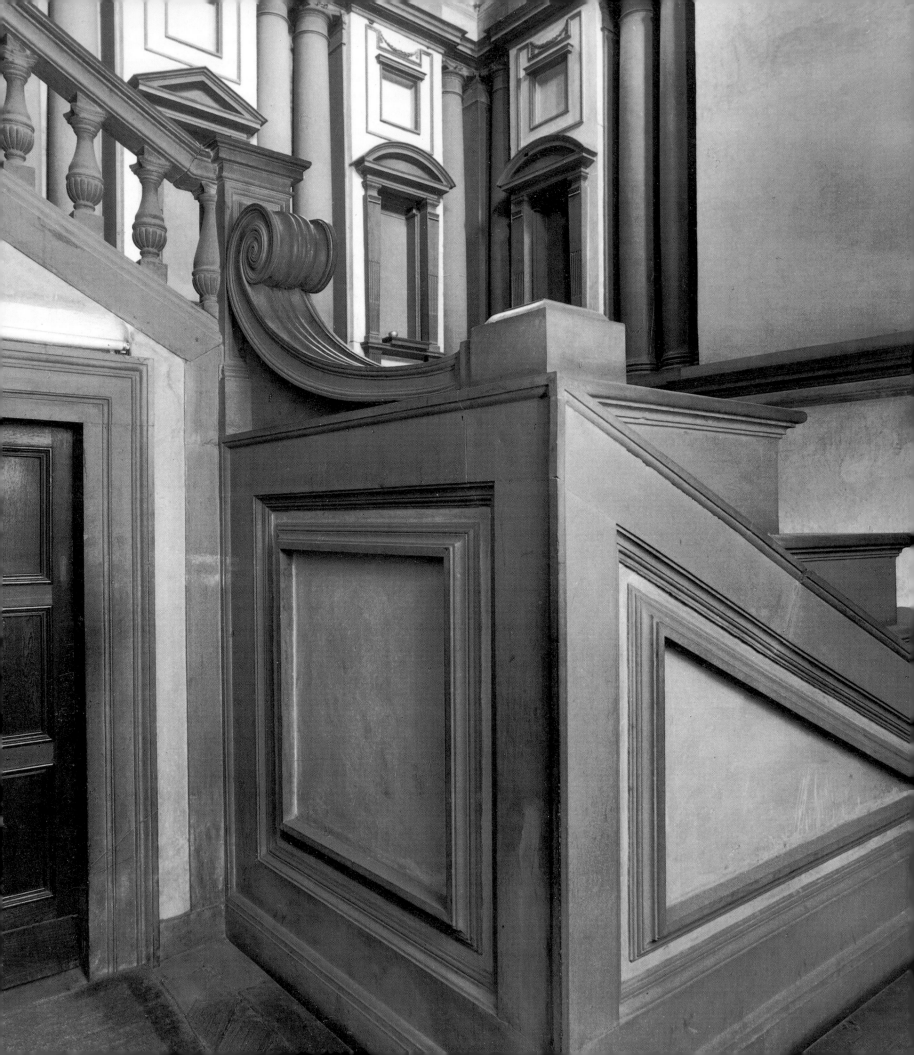

151. *Laurentian Library, vestibule staircase, detail of juncture of side ramp with main ramp. San Lorenzo, Florence*

152. *Laurentian Library, vestibule staircase, detail of main ramp. San Lorenzo, Florence*

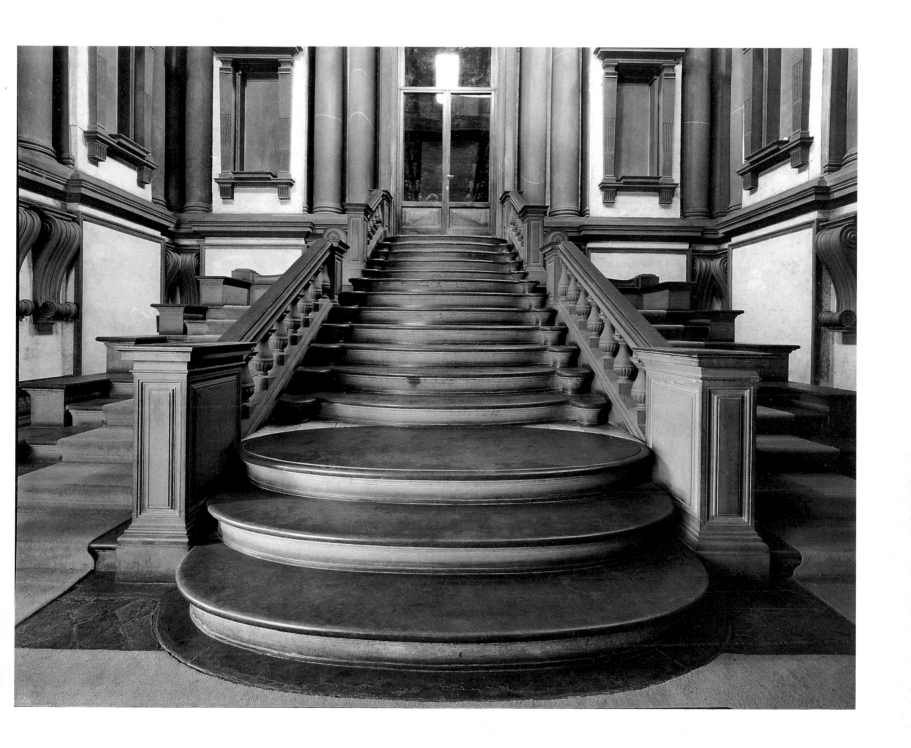

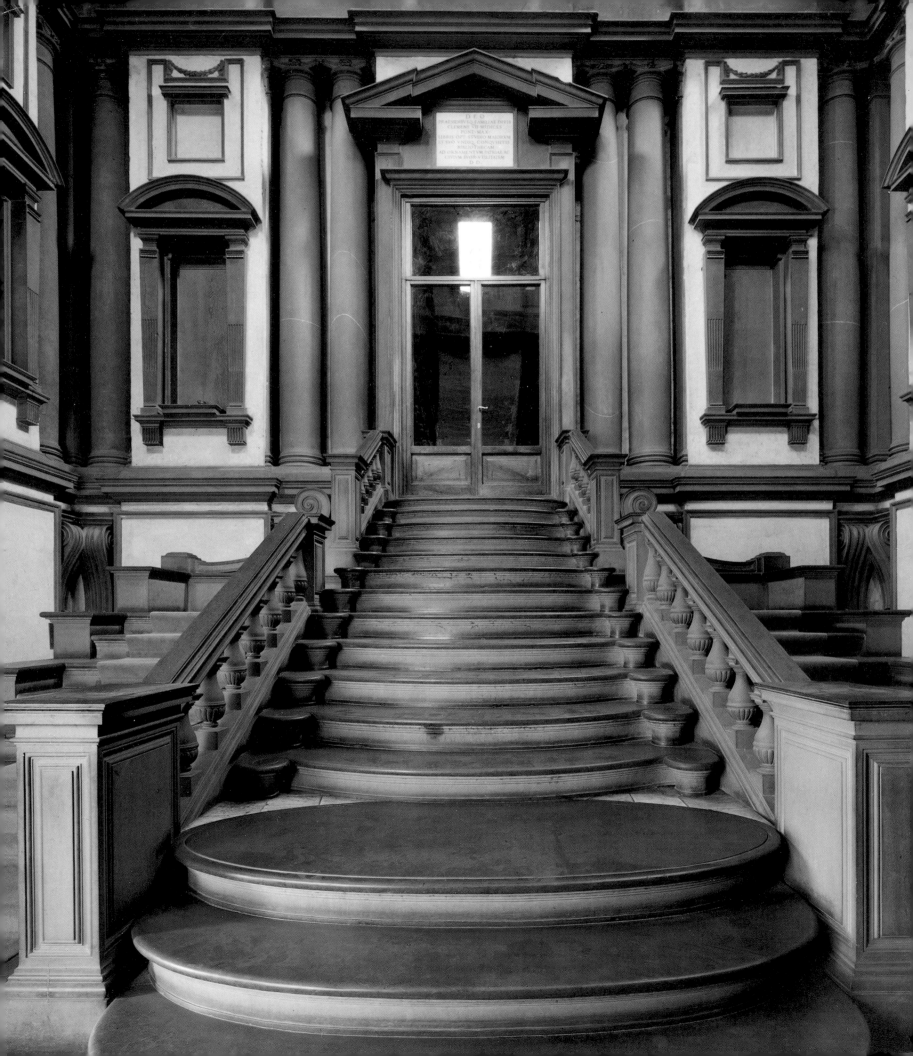

balustrades and welded to the rigid side ramps of the opposite sign. This ironic "nod" to the hierarchy of rulers and their courtiers demonstrated the way in which Michelangelo designed his architecture in relation to its use and users. The reading room was strictly functional—filled with bright light falling directly on the lecterns of the scholars from tall windows above the desks, which were not just furniture but architecture themselves (fig. 134). Michelangelo had wanted the vestibule steps made of wood like the desks, but Ammanati made them of stone for courtly elegance. Michelangelo preferred humility.

The fortifications for Florence

Michelangelo knew that the culture to whom the Laurentian Library was dedicated would be finished before the library itself was completed. A Republican because he was a platonist, he came to the defense of the Republic as one of the Nine of the Militia, the board directing military operations in Florence, and, in 1529, as the commissioner general of fortifications. He made military architecture out of a kind of patriotic fervor and not because he was interested in the techniques of fortification, however. Although by this time there was no actual polemical intent, his designs for the bastions were a last antagonistic gesture towards Leonardo da Vinci, for whom the modern fortification was an architecture based more on the dynamic than on the static (see fig. 27). For Michelangelo, the military problem was incorporated with the political. From the moment the Medici fell, he knew that they would return with the aid of imperial arms, and he began to think about a defense. What he really wanted to arm to defend itself was the Florentine culture which had been restored with the regime of the Republic. The problem posed with regard to Florence was that the city not only be armed but also capable of moving from defensive to offensive action "with strength and anger," like his *David* placed at the entrance to the palace of the Signoria. He would be disappointed, of course, because the political situation was muddy, the city officials Niccolò Capponi and Francesco Carducci were quick to negotiate, and the military head Malatesta Baglioni was corrupt.

The twenty-eight designs for bastions preserved in the Casa Buonarroti appear incredibly *ex tempore*, charged with heated fury and bursting with energy (No.15). But they were only planimetric drawings and never considered as preparatory studies with a view to future construction. Michelangelo knew that they would never be built, because there was neither the time nor the desire, but the designs were not pure fantasy. The relationship between the wall enclosures and the surrounding terrain was studied with extreme precision, and they were also up-to-date with respect to new strategies and tactics for a siege which employed field artillery. For the first time, Michelangelo's idea of the city appeared as the larger term of a binomial expression whose lesser term was the surrounding terrain. No longer was this terrain a peaceful countryside, it was a potential field of battle. No longer an extended horizon of distant hills and nearby cultivated fields, it was completely disrupted ground—broken, ridged, furrowed—with sheltered zones and uncovered areas, strong points and weak points. Naturally, nothing perspectival could construct and order that space, measured as it was by the forces and trajectories of the cannons. The direction and force of impact of the projectiles alone determined the thickness of the fortification. There was no longer, as in Leonardo's work, a bellicose *furor* identified with the cosmic *furor*, which had as a mediating term the mechanistic *furor* of the machines of war. What fascinated Michelangelo was not the naturalness but the violent unnaturalness of the action of war.

The designs for the fortifications were only partial plans and did not constitute the preliminary planning phase of construction. It is futile to fantasize about the elevations of these designs, because Michelangelo's fortifications began and ended with the ground plans. They were not projections of construction but virtualities, which contained a potential force beyond every calculation, like explosive charges. It would be an error, however, to consider them as a kind of intellectual adventure undertaken in a state of patriotic excitement and therefore substantially isolated from the mainstream of his architectural work. They were not an exception. Thirty years later, he would create the same kind of planimetric designs for the Church of San Giovanni dei Fiorentini (No. 28). These involved not only the same impulse and tension but also the same certainty that they would not be constructed, and therefore the same desire to make the plan itself as powerful as an edifice. In his concept of architecture, the plans were more than the initiation of a project; they were the proof that the value of the architecture was not in the completion of the work. What was more notfinished than a ground plan for which the elevation was not provided?

The contemporaneity of the Laurentian Library and the fortifications was not at all surprising. Like the library, the bastions were conceived in relation to human function and behavior. The life of the scholars in the library was quiet, contemplative, and absorbed, although not without inner turmoil due to the contacts with everyday life. The life of the soldiers in the bastions was frenzied, impulsive, and completely active, although not without skillful and sometimes playful elegance. Frequently, the angled, split walls ended in arabesques—scrolly, curly ears that were like the volute brackets in the Laurentian Library vestibule (figs. 158, 159). What Étienne Boullée will later call "eloquence" was clearly not sufficient for Michelangelo, who wanted a more violent emotive quality in his work. In following the peaceful discourse of the library with the vehement one of the bastions, he was convinced, in sum, that the making of architecture was not representation but action. He experimented therefore with a new kind of relationship—one of more immediate contact between the work of art and its consumers, and out of his discovery grew his disenchantment with monumental representation. Always an extremist, he experimented soon afterward, in *The Last Judgment* of the Sistine Chapel and in the two frescoes of the Pauline Chapel, with nonrepresentative figuration, or occurring action. That this action was more deterring than beatifying was a further sign of his transposition of art

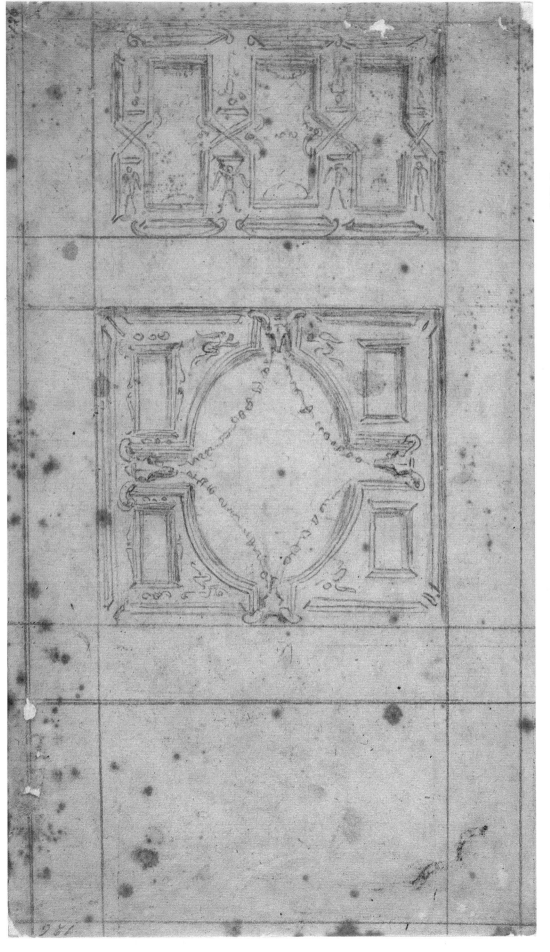

154. *Michelangelo. Study for decoration of central and lateral ceiling coffers for reading room of Laurentian Library. Casa Buonarroti, Florence, A 126 (C. 542)*

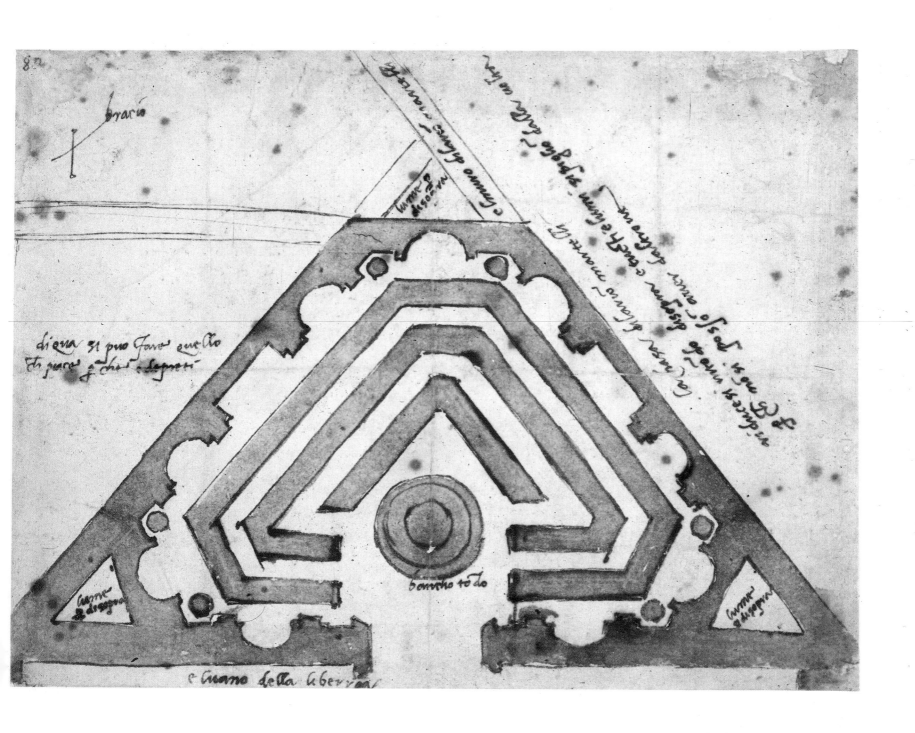

155. *Michelangelo. Plan for secret library in Laurentian Library. Casa Buonarroti, Florence, A 80 (C. 560r)*

147

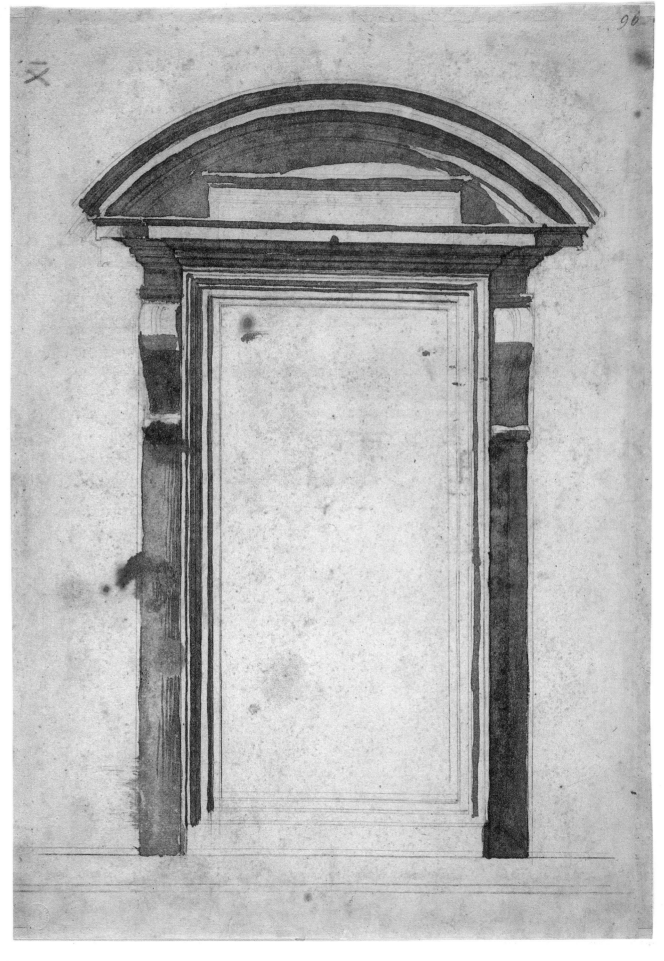

156. *Michelangelo. Study for door from vestibule to reading room of Laurentian Library. Casa Buonarroti, Florence, A 96r (C. 551r)*

157. *(opposite) Michelangelo. Designs for vestibule staircase of Laurentian Library, profiles of column bases, and figure studies. Casa Buonarroti, Florence, A 92r (C. 525r)*

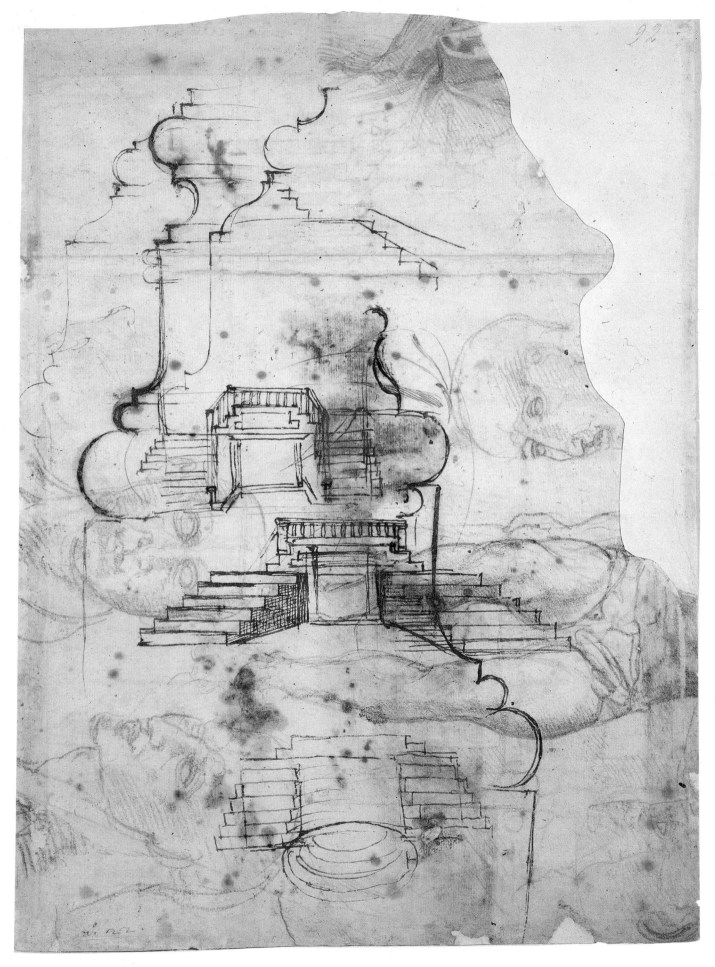

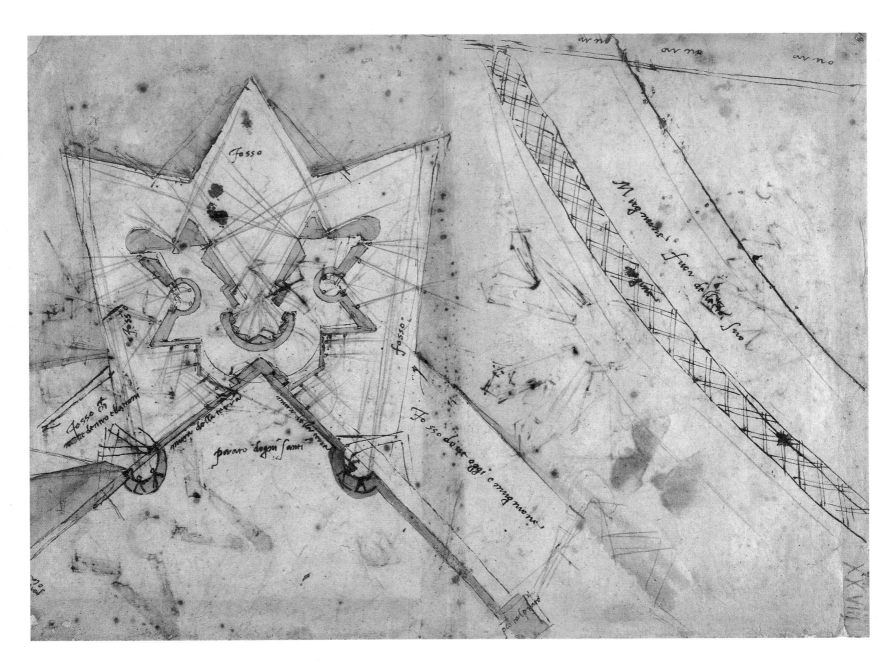

from the sphere of representation to that of action. At this point, in fact, figural representation had become only a metaphor and, as such, was being eliminated. This concept of architecture-action was also the origin of the design for Saint Peter's. Instead of the church-Church exhorting, instructing, and leading believers towards salvation, it would actually, physically act to save them, which would be a powerful argument in the doctrinal battle against Lutheranism. The image which Michelangelo immediately associated with the architecture of war was not so much that of a war "machine" but that of "armor" for the combatants. In addition to its effective power, it would have a deterrent aspect in the same way as ancient helmets decorated with ferocious animal heads. From there the passage was easy to those forms of almost deceiving beauty alluding to the elegance of swordsmanship, which was connected with fighting. Knowledge of the twenty-eight designs for bastions was never lost, and the great military architect to Louis XIV, Sébastien Le Prestre Vauban, regarded them with interest. Yet, up until about ten years ago, they were considered the product of an occasional service at the margins of art. Whether or not the designs were made to be executed, modern scholars have discovered in them a very important,

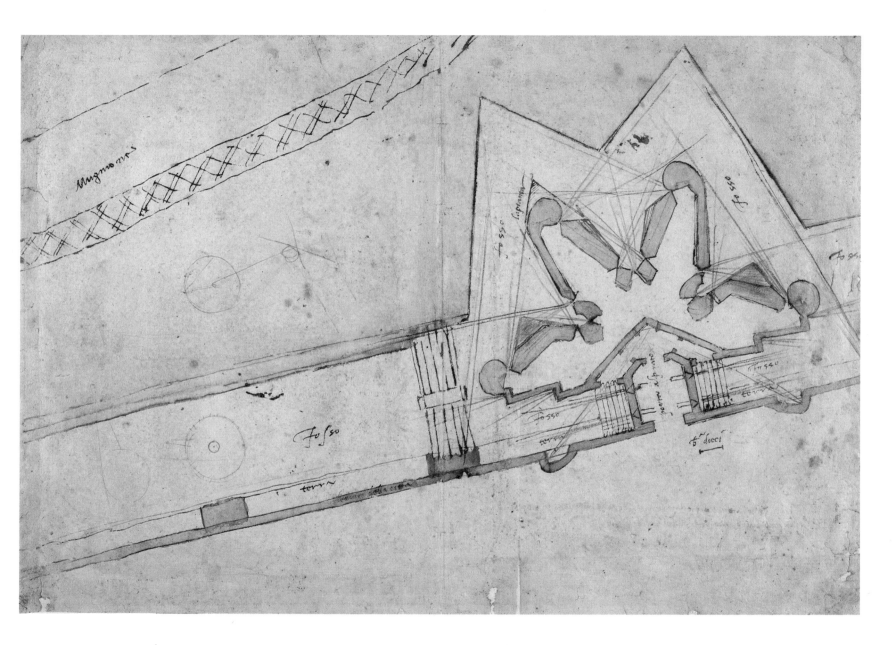

decisive moment in the history of Michelangelo's architectonic oeuvre. Zevi (1964) described it in a very beautiful essay as "the most original moment, taut and subversive, of the architectonic creativity" of the master. Wittkower identified it as the generator of what would become, in Rome, his architectural dynamism, a characteristic which was especially evident in the designs for San Giovanni dei Fiorentini. Ackerman recognized in the plans for the fortifications the first appearance of an architecture made not to signify, celebrate, and magnify certain religious and political values, but to do something—to act. Thus scholars are by now unanimous in recognizing the enormous importance of that incursion into the field of military strategy, which was in the long run more important to the history of art than it was to the history of fortifications. But was this, as Zevi thought, an advanced, almost foolhardy position from which Michelangelo would later retreat? Certainly, this was the first example of an architecture of action and gesture, which was totally nonlinguistic, and it was also the first where no thought of the antique entered into it in any way. Without that drastic experience, the artist probably would not have been able to clarify the manner of posing the problem of the antique in an anticlassical sense. Without doubt these drawings were the sign of a profound crisis and a point of no return. Michelangelo knew very well that the essence of the humanis-

160. *Santa Trinità bridge, Florence*
(restored 1955), by Bartolomeo Ammanati
using Michelangelo's ideas

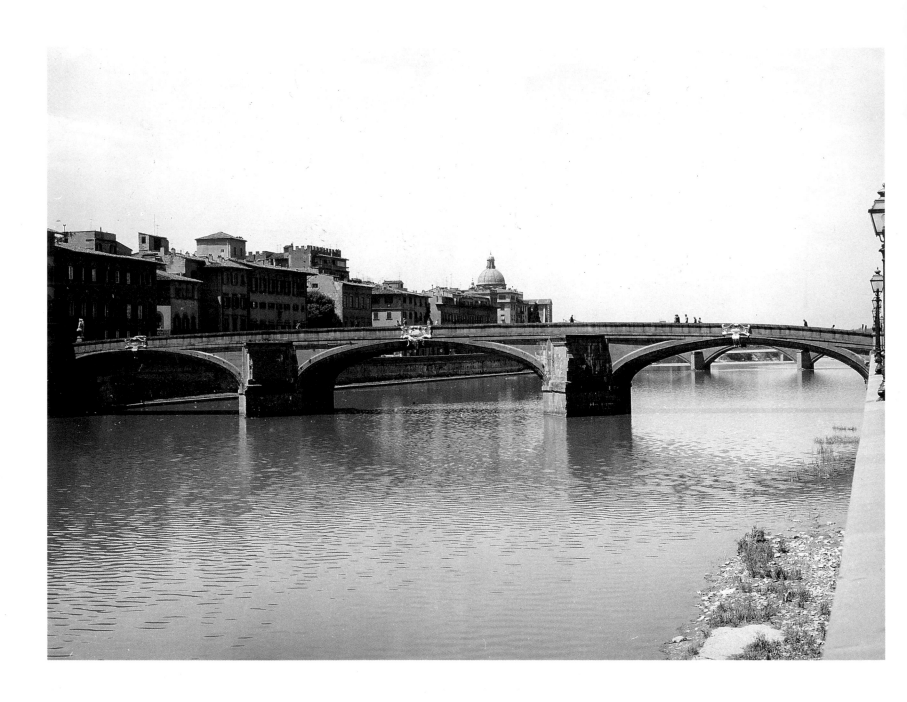

tic culture to which he had felt connected had already vanished, even before Alessandro de' Medici annulled it. From that moment on, he lived the experience of an art which lacked any relationship with the antique, an infraction which put him in opposition to the attempt by the classicists to propose and impose an antiqueism which was no longer historical but only a literary precept.

The crisis of a great artist is always a reaction against himself. With these plans of the bastions, Michelangelo renounced even the three-dimensional body of architecture, reducing it to an impetuous outline of charged vectors of force. What were the effects of this experience? The architectonic image of the bastion as a point of concentration of force in a walled enclosure was not new. Francesco di Giorgio Martini had already anticipated that evolution of the rampart. The antique too was obviously out of the picture. Michelangelo wanted the fortifications to be not just modern but surprising—perfectly functional but with a marked psychological component. A complex combination of strength and elegance produced the intense movement of the planimetric schemes: projections and recessions, broken lines, pincers, half-moons, and large ears. Military architecture was the opposite of civil architecture, of course, but evident in Michelangelo's plans was the determination to avoid all forms of static equilibrium. The contours of the foundations were all acute angles and deep cleavages, diagonals and curves strained like bows. Zevi suggested as a criterion for interpretation "to concentrate attention on the cavities rather than on the walled structures." The men and the cannons were located in those cavities, and it was there that the dynamic of war was generated, increased, and turned into action, with the thrusts going in all different directions towards the outside. The walls acted as oblique screens for diminishing the impact of incoming shots, and sturdy ramparts stood between the two opposing forces. Naturally, the space did not have a perspective dimension; the dynamic of the action defined it. Giving no thought to the statics, the monumentality, or the beauty, he calculated the force of the structure not its stability. The obligation to fortify Florence was for Michelangelo a fundamental experience, which erased from his thoughts every concern for the representative monumentality of the unshakable stability of certain institutional values. Architecture was no longer an institution, and it no longer had a language or a code. Like all art, it was image, and that image signified and communicated, acting empathetically on those who were there to experience it. Its own constitutional incompleteness unified it with the world in a relationship of common existence. The bastions certainly did not imitate natural reality; if anything, they ravaged it.

Even after he left Florence, he did not stop thinking about the city, which was as warlike as it was learned. For example, he was asked for and gave his ideas about the reconstruction of the damaged Arno bridge of Santa Trinità (No. 17). Earlier, he had also provided ideas for the building of a new Rialto bridge in Venice (No. 16) and the repair of the Santa Maria bridge in Rome (No. 22). The theme and form of the bridge interested him as an important and useful architectural object, and, in joining the two opposed banks, it implied the idea of the river as an urban generator. The Tiber would play its part too in the visual connection between Saint Peter's, Castel Sant'Angelo, and San Giovanni dei Fiorentini.

The Santa Trinità bridge in Florence was constructed by Bartolomeo Ammanati, but Cosimo I de' Medici wanted Michelangelo's feelings on the matter. The artist in fact gave it a great deal of thought, according to Vasari, and then made some designs, which are generally believed to have been quite detailed. This was in 1560, when Michelangelo was no longer actively involved in constructing but nevertheless continued to think about architecture. Ammanati was an artist of refined inventiveness, and the bridge of Santa Trinità (fig. 160), built between 1567 and 1571, was written by his hand—but was it written or transcribed? The innovation in the bridge design consisted of the large piers cut at an acute angle, which split the flow of the current like the prow of a ship, a form which descended directly in its implicit dynamic from the designs for the fortifications. The almost violent connection between the piers and the river was deliberately slowed, widened and spread out in the arches of the bridge, whose relaxed, yet not weakened, curvatures bonded with the horizon of the Florentine hills. Although Ammanati sweetened this relationship in his transcription, it had very probably been conceived by Michelangelo. There was an entirely different tone of feeling, but it was the same type of relationship with the natural environment as that seen in the bastions.

The designs for the Church of San Giovanni dei Fiorentini in Rome would demonstrate also the same graphic violence as the designs of the bastions, and the margin of virtuality left for future builders was identical (figs. 405–407). From the same period were the designs for the Sforza Chapel in the Church of Santa Maria Maggiore in Rome, which Michelangelo intended from the beginning to entrust to Tiberio Calcagni for execution (No. 29). Thematically quite different, the Sforza Chapel was nonetheless structurally very close to the Santa Trinità bridge. Its side walls were gently curved inward with the wide curve restricted at the extremes. It was the same curve as that of the bridge arch, and to this relaxed curve were contrasted the pilasters which, like the piers of the bridge, were thrust audaciously along the diagonals of the chapel (fig. 408). In this case also, the origin was the break with all institutionalized architectural languages. The designs for the fortifications had been that breaking point, that gesture of moral violence, which brought to a close the intellectual relationship with Florence, where humanistic ideology was dead, and opened the final period of Michelangelo's career in Rome.

DRAWINGS AFTER THE CONER CODEX AND OTHER STUDIES OF CLASSICAL ARCHITECTURE, 1515/17

161. *(above) Michelangelo. Studies of Roman monuments after Coner Codex. Casa Buonarroti, Florence, A 8 (C. 512r)*

162. *(center) Michelangelo. Studies of architectural elements. Casa Buonarroti, Florence, A 5r (C. 514r)*

163. *(below) Michelangelo. Profile of base. Casa Buonarroti, Florence, A 5v (C. 514v)*

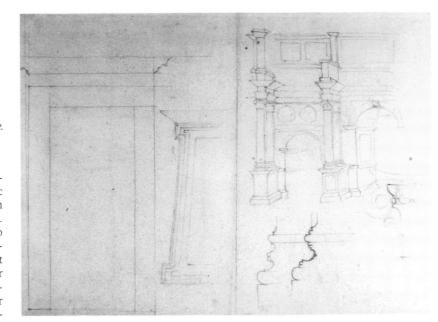

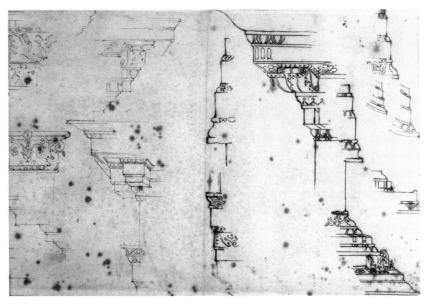

A group of drawings divided between the Casa Buonarroti (figs. 161–163, 169–174) and the British Museum (figs. 164–168), done in sanguine chalk and quite similar in size (276 to 289 mm. × 215 to 218 mm., or 424 to 433 mm. for double sheets), was first recognized by Ashby (1904) as somewhat freely-translated copies after those in the so-called Coner Codex (Soane's Museum, London). Named for the previous owner Andreas Coner, a German priest, the Codex is a notebook of drawings, later bound as an album (Nesselrath 1986), executed by Bernardo della Volpaia around 1515 (Buddensieg 1975). Frey (1909–11) doubted that the sketches were done from the Codex drawings, believing instead that they had an older prototype in common. The derivation of the sketches from the Codex has now been widely accepted, and, although doubted previously by some scholars, so is the attribution of the sheets to Michelangelo himself. The *Corpus*, however, proposed them to be by a pupil under his direction and with his occasional intervention (Düssler 1959). Conclusive evidence for the attribution to Michelangelo is that one of the British Museum drawings includes, along with the copy after the Codex, sketches for the façade of San Lorenzo and an autograph inscription (fig. 165). This allows the group of drawings to be dated between 1515, when the Codex sheets were executed, and 1517, the latest date when Michelangelo's planning for the façade was being done, thus placing his study of Bernardo's notebook in the same time frame as his first architectural commission. The good relationship between Michelangelo and the Volpaia family is attested to in his letters, which would explain the short lapse of time between Bernardo's execution of the notebook drawings and Michelangelo's copies done after them. Although the Michelangelo sheets show no evidence of sewing, the possibility cannot be ruled out that he intended to compose them into a notebook also (Hirst 1988).

Except for one British Museum sheet (fig. 177) much too divergent in size (134 × 212 mm.) to group with the others and having no direct relation to the Codex (Wilde 1953), these drawings after Volpaia's are the only known graphic documents of Michelangelo's interest in the study of Classical architecture. There is indirect evidence, however, to suggest that there were other such studies. For example, Condivi records that the young Michelangelo had asked for but was denied permission by his master Domenico Ghirlandaio to copy after a book of drawings, possibly the Escurial Codex containing sketches of Classical architecture as hypothesized by Egger (1906). As Nesselrath (1986) has pointed out, however, it is impossible to know if the hypothesis is correct. Of more substance is the fact that Pietro Bembo, in his book written before 1516, mentioned the example of Michelangelo and Raphael, who had drawn from Classical buildings in order to attain the perfection of antiquity to which he also aspired in his Latin literary models. In the 1520s, according to a contemporary witness, a group of artists and writers composed of Michelangelo, Pietro Vettori, Antonio degl'Alberti, Averardo Serristori, Giovanni Francesco da Sangallo, and Lorenzo Cresci, "saw and examined a large part of the writings of Vitruvius," although, "due to different mishaps . . . [this remained] an incomplete study" (see Spini in Acidini 1980). Vitruvian studies are attested to also in a letter of December 7, 1532 from Giovanni Norchiati, chaplain of San Lorenzo in Florence, to Michelangelo: "Since the time that you left here, I have worked hard on Vitruvius, and I am already in the seventh book, six of which are entirely translated, and still studied; but I need to have you near, so as to see again with your own eyes certain things of the antique" (DCCCXCVI). Nor was the Vitruvian treatise the only other source for his study of antique monuments. Hersey (1989) identified the Vitruvian-like molding profiles in Michelangelo's drawing for the Medici chapel (fig. 178) as derivations from the work of Francesco di Giorgio Martini.

For the drawings and their corresponding Coner Codex works, see Ashby (1904), Wilde (1953), Barocchi (1962), Lotz (1967), and Agosti-Farinella (1987).

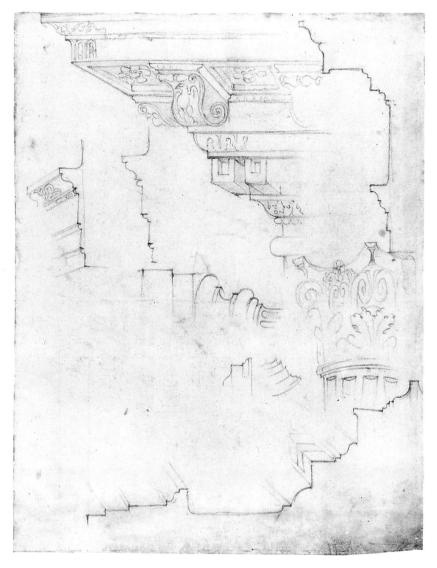

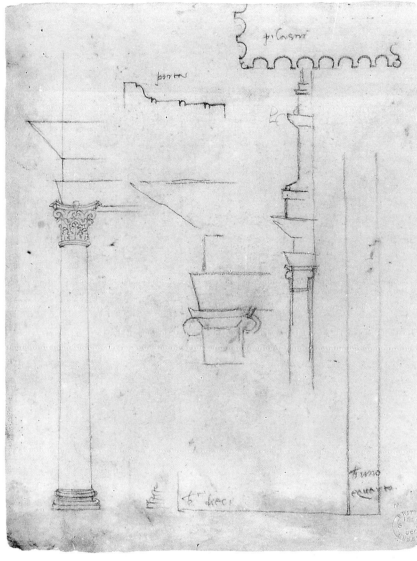

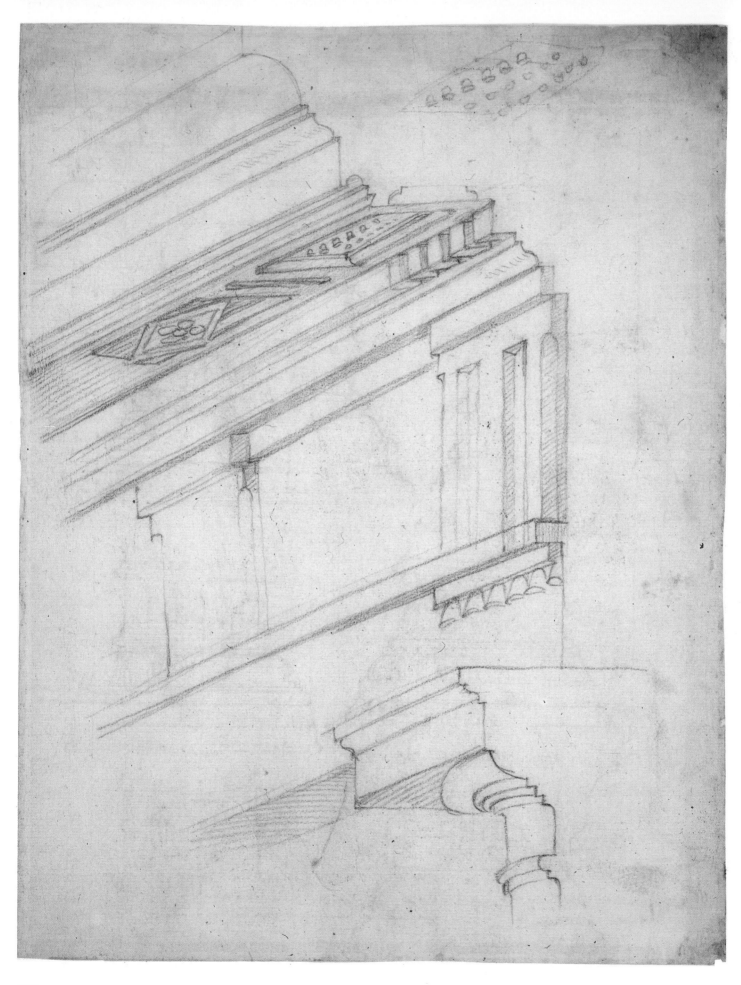

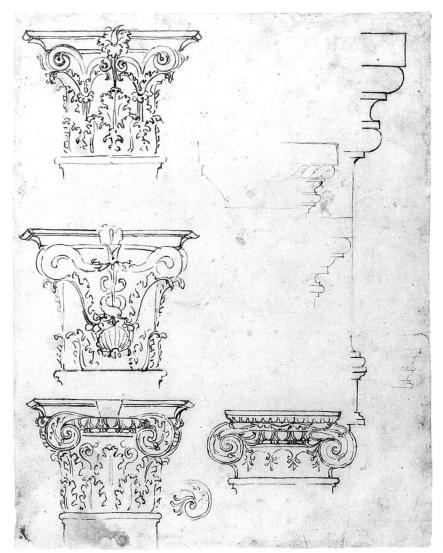

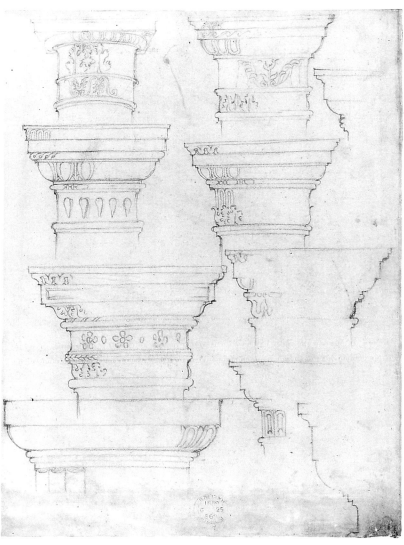

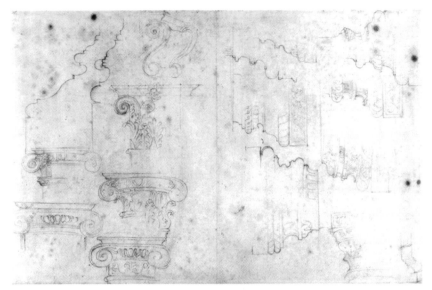

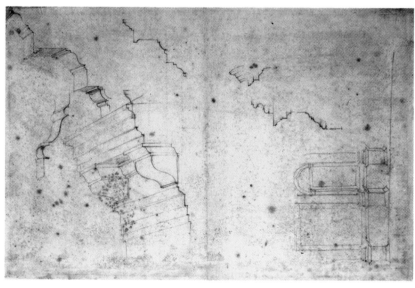

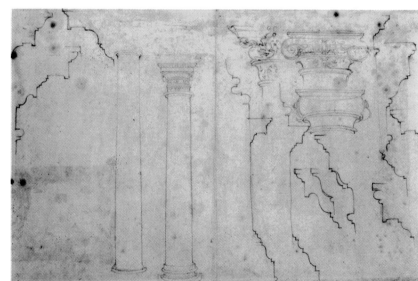

173. *(above) Michelangelo. Studies of Roman monuments after Coner Codex. Casa Buonarroti, Florence, A 4r (C. 519r)*

174. *(below) Michelangelo. Studies of Roman monuments after Coner Codex. Casa Buonarroti, Florence, A 4v (C. 519v)*

175. *(above) Michelangelo. Studies of Roman monuments after Coner Codex. Casa Buonarroti, Florence, A 3r (C. 520r)*

176. *(below) Michelangelo. Studies of Roman monuments after Coner Codex. Casa Buonarroti, Florence, A 3v (C. 520v)*

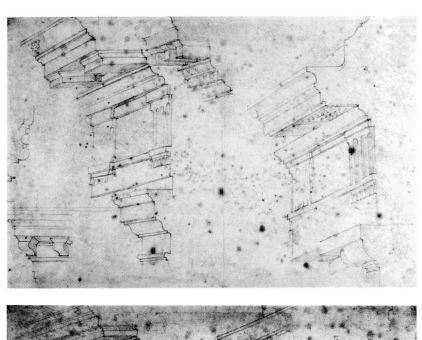

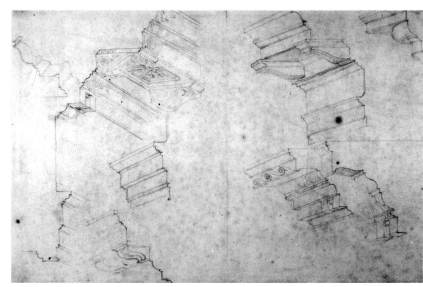

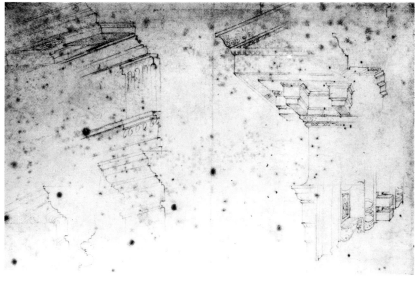

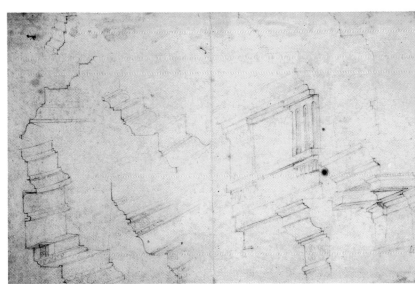

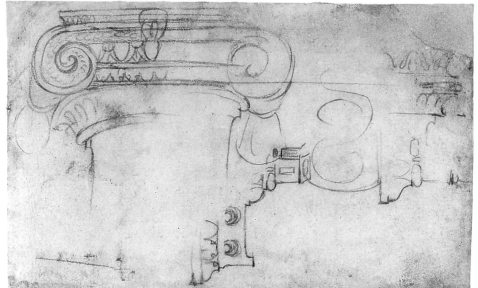

177. *Michelangelo. Study of capital, cornice, and base. British Museum, London, 1859–6–25–549 (C. 513r)*

178. *Michelangelo. Study of column base moldings. Casa Buonarroti, Florence, A 10r (C. 201r)*

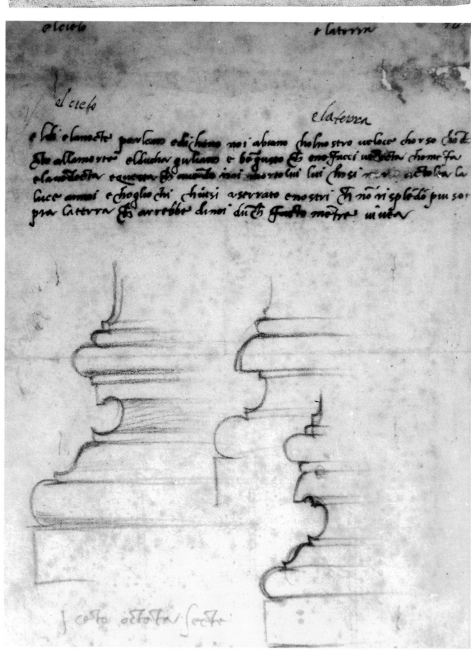

160

DESIGN FOR THE FAÇADE
OF SAN LORENZO, 1516–20

179. *Leonardo da Vinci. Studies for new Medici palace in Florence. Biblioteca Ambrosiana, Milan, Cod. Atlantico, f. 315r-b*

After the work of Brunelleschi and his "continuers" under Cosimo de' Medici il Vecchio and Piero de' Medici, the Church of San Lorenzo in Florence was complete at the end of the fifteenth century, except for its façade wall left with plain, rough masonry inside and out, as it still exists on the exterior today (fig. 96; Hyman 1977 and Battisti 1981). A drawing of the Quattrocento church is preserved in the Archivio di Stato, Venice (see Burns 1979, Olivato 1980, and Foscari-Tafuri 1983). The restoration of Medici rule in Florence in 1512 and the election of Giovanni de' Medici as pope in 1513 brought attention to the problem of the completion of the church as a symbol both of family patronage and of their reappropriation of civic power. From sketches on a sheet in the Codex Atlanticus, Pedretti (1978) identified a projected plan by Leonardo da Vinci, then in the service of Giuliano de' Medici, brother of the pope, to renovate the area in front of the church and to construct a new Medici palace to face the existing one on Via Larga (fig. 179). The work was commissioned, according to Pedretti, by Lorenzo de' Medici, a nephew of the pope and the governor of Florence at that time, for whom Leonardo also worked on a plan for the stables near San Marco in 1515–16 (fig. 180). This project would have constituted a Florentine parallel to the scheme for a Medici complex on the Piazza Navona in Rome (Bentivoglio 1972, Frommel 1973, and Mariani 1983), for which Tafuri (1984a) identified, we believe correctly, a plan in the Uffizi by Antonio da Sangallo the Younger, dated 1515–16, for connecting two Medici palaces and the Sapienza by way of a large rectangular piazza (fig. 181).

The decision to complete San Lorenzo with a modern façade seems to have been confirmed during the visit of Leo X to Florence in November–December 1515, perhaps as a result of the impression made on him by the temporary structures erected for the occasion of his triumphal entry into the city, among them a provisional façade for Santa Maria del Fiore (for the entry, see Shearman 1975). The different, partly contradictory stories told by Vasari and Condivi about the first involve-ment of Michelangelo in the façade project were probably owed to the artist himself, who was sufficiently reticent in his old age about Florentine events of those years to have translated them in the final analysis into a failure. Vasari (1568) related: "For the architecture, many artists competed in Rome at [the request of] the pope, and made de-signs—Baccio d'Agnolo, Antonio da Sangallo, Andrea and Jacopo Sansovino, [and] the gracious Raphael da Urbino, who was then brought to Florence as a consequence, on the arrival of the pope. Whence Michelangelo resolved to make a model, and did not want anyone but himself superior and the leader of the architecture in this matter. But this not wanting assistance was the reason that neither he nor the others worked, and those despairing masters were sent back to their usual activities, and Michelan-gelo went to Carrara with a commission for which he was paid one thousand ducats by Jacopo Salviati." The biogra-phy seems to distinguish two phases for the project. In the first, Michelangelo was given only the sculptural decora-tion for a façade to be designed by some-one else following a competition for the architecture. Possibly, he was even to have shared the work with other sculp-tors, considering the strongly polemical letter of Jacopo Sansovino of June 30, 1517 (CCXXXI). In the second phase, Michelangelo assumed full control of the entire project. Scholars have doubted the reality of a competition such as that described by Vasari, al-though, at least in the case of Raphael, we find independent testimony in a let-ter of December 7, 1547 to Duke Cosi-mo I from Baccio Bandinelli, who recalled that Michelangelo and Raphael had been called from Rome during the Florentine visit of Leo X for the matter of the façade of San Lorenzo (Bottari 1754–73). We know also from a notar-ial act that Raphael was absent from Rome on November 8, 1515 (Golzio 1936). Tafuri (1984b) has, to my mind, correctly identified a copy, perhaps by Aristotile da Sangallo, of Raphael's de-sign for the façade of San Lorenzo (fig. 97), a hypothesis accepted by Frommel (1986) but disagreed with by Elam (1984). No façade designs by the other

architects named by Vasari are known, but there are five drawings in the Uffizi (on three sheets) by Giuliano da Sangallo which were certainly done for the San Lorenzo project: fig. 182, dated 1516; fig. 183, probably earlier but adapted for San Lorenzo according to a later inscription; fig. 184; and Uffizi, Florence, Drawings and Prints Dept., A 281, dated 1516, and A 278. On this basis, Tafuri (1984b) proposed that Giuliano became involved in the events of the façade project just before his death on October 20, 1516. Borsi (1985) believed, however, that Giuliano entered the original competition, and, when Leo X showed his preference for Raphael's design over Giuliano's, Michelangelo then took the matter in hand. This would leave unexplained Vasari's silence on Giuliano's participation in the competition, which is odd in view of the fact that the Uffizi sheets came from the historiographer's own collection. Nor does this account for the date of 1516 affixed to the drawings, if the victor Raphael was brought to Florence by Leo X already in November-December 1515, as Vasari wrote. Probably, there was a different succession of events, along the lines of Tafuri's proposal, in which Raphael's idea was accepted and Michelangelo was simultaneously involved as the sculptor in November 1515. Giuliano then entered the picture in 1516, and by August 1516 Michelangelo had decided to ask for the commission as architect himself, in competition with Raphael, having allied himself on this matter, as we will see, with Baccio d'Agnolo.

From our careful review of the documents, it appears certain that Michelangelo was involved at a very early date in the project, but only for the decoration. Already on June 16, 1515, he wrote to his brother: "I need to make a great effort, this summer, to finish this work quickly [on the Tomb of Julius II], because I estimate then to have to be in the service of the pope" (CXXVIII). In an August letter, he complained: "I do not have time to write very much" (CXXXV). On July 8–10, 1516, a new contract was drawn up with the executors of Julius's will, by which, in addition to a smaller overall configuration for the tomb, he

obtained an extension of time on the commission from seven to nine years and permission "to work either in Rome, or outside." In August 1516, on his way to Carrara, he stayed at length in Florence, where he received a letter sent to him on August 26 from Iacopo d'Antonino di Maffiolo, an excavator of marble in Carrara, who offered his services to "the very excellent master, Michelangelo the Florentine, sculptor of the Apostolic Seat" (CLIII). This would support a conclusion that an important pontifical commission was already in hand or in the course of being defined. From a conscientious examination of the letters dated between October and December 1516, the most reliable source for the activities having a bearing on the façade project, a sufficiently clear course of events emerged, in spite of being obscured by silences and reticence, although all is still not fully understood. In a letter of October 7 to Baccio d'Agnolo, who promptly turned it over to Michelangelo, Domenico Buoninsegni, secretary to Cardinal Giulio de' Medici, wrote: "I spoke to the Cardinal about the matter of the façade, which he spoke about with the pope, and he will be content to agree with you and with Michelangelo about giving it to you to make." He urged, nevertheless, that the two artists come to meet with the pope at Montefiascone "before he returns to the court at Rome, which will be one or two days before All Saints. And I say this because *the friend whom you know, or other friends of his, would not interfere in [the matter]; because of said friend not being here, [things] would be better concluded here* [author's italics], all of which I discussed with the Cardinal, and it seems that he went to meet with Our Lordship, as said. And as to the money for the assignment of the matter, you know that it will not be lacking, because a good sum has already been set aside for it, which is not touched and saved for that. And also I said that you could take the marble over by yourself and all were satisfied. And therefore make everything understood to Michelangelo quickly, and settle it and answer immediately. *And if you come, find some excuse, so that it does not appear that you came for this matter, and no one can guess your business*

[author's italics]" (CLXII). So much secrecy and the emphasis on the favorable absence of a "friend" or "friends" of the "friend," who could impede the progress of the commission for the façade, lead to the supposition that the commission was already promised to, or at least still interested, someone who boasted powerful friends at the papal court.

In a letter to Michelangelo of November 3, Buoninsegni regretted that the encounter at Montefiascone had not taken place, but he gave reassuring news that, on the word of Cardinal Giulio, the money was not lacking, the pope was well disposed toward the situation, and it was just a matter of the sculptor coming to Rome: "[Or] if there is a problem about coming, as you indicate, [then at least Baccio should come to the court, and] above all do it quickly" (CLXIV). On November 6, Baccio wrote to Michelangelo urging that he accompany him to Rome to see the pope (CLXVII), but the sculptor apparently refused again. Finally, in a letter to Michelangelo, which is very important in revealing the nature of the intrigue and especially the identity of the individual to whose injury it was being played out, Buoninsegni showed his vexation: "You know that when we were in Florence, you and Baccio spoke to me about that business of the façade, and you two agitated and made a great story [*fantasia di torla*] about it, and you sought for me to work so that this thing would be effected; and you told me that first I should speak about it with the Cardinal. Wherefore, as soon as I arrived at Monte Fiasconi, I began to talk to him about it, and, without hesitation he went himself to the Pope and came back to tell me that I should write to you, both you and Baccio, who should come to see him in order to settle everything on the design and thus to agree between you on other terms, which cannot possibly be done except in the presence of the parties." After a recapitulation of the frequent letter exchanges about the façade commission, the good offices interposed with the cardinal, and the assurances in two consecutive letters from Michelangelo about his upcoming trip to Rome, Buoninsegni ended on a threatening note: "And now from this your last [let-

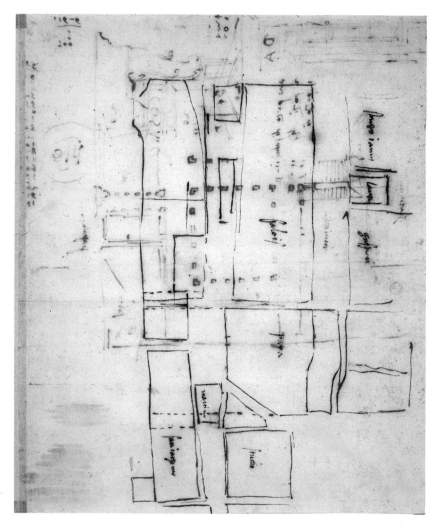

181. *Antonio da Sangallo the Younger. Study for renovation of Medici area in Rome between Piazza Navona and Piazza dei Caprettari. Uffizi, Florence, Drawings and Prints Dept., A 1259r*

ter], I see that you are resolved never to come, and I am also resolved no longer to meddle in such matters, for which I don't know what I could benefit except shame and some kind of reproach. . . . And, as for having the suspicion that, coming, you would be deceived, . . . I know very well that up to now I remain the deceived, and much more by Baccio than by you. . . . I tell you that I will not bother myself anymore with this business nor will I write anymore to you about it, neither to you nor to Baccio, unless I am specifically asked to do so by those who are superior to me and could ask me. And I tell you again that, *when it is a matter of you two lamenting that this honorable and useful work was given to outsiders and outside of the nation* [author's italics], I will say again that you others were the cause of it, with the false and abstract fantasies which you made" (CLXXIII). Who could the non-Florentine (*fuori della nazione*) be, whose assignment of the "honorable and useful work" thus aroused the protest by Michelangelo and Baccio to Buoninsegni? The single non-Florentine named by Vasari among the competitors for the architectural commission was Raphael "of Urbino." Shortly before or at the same time of the letter in which he refused to come to Rome, fearing to be "deceived," Michelangelo must have written to Leonardo Sellaio, his studio supervisor in Rome, to ask for news about the building of Saint Peter's after the death of Giuliano da Sangallo and about Raphael, because Sellaio replied on November 22: "Raphael, it is said, requested an assistant and he was given Antonio da Sangallo, with the means to provide for him" (CLXXIV).

Baccio d'Agnolo, in commenting on Buoninsegni's letter of November 26, asserted to Michelangelo: "He wrote to me many times to go by myself, when you could not come, but I wrote to him that I did not in any way want to go without you, because the design was seen not to be resolved yet, and I did not believe that they would want to resolve it without you; thus, because of this, it seemed to me that to go would be to waste time and be deceived, *because I know with whom it was to be done. . . . You know that I had to oppose the cardinal of*

Bibiena and mister Giovan Batista da l'Aquila, and I know that when they saw me alone and without you, I could do nothing [author's italics]" (CLXXVII).

The resistance of those with whom "it was to be done" came therefore from the circle of Cardinal Bibiena and Giovanni Battista Branconio, two powerful individuals on the side of Raphael by whom both Michelangelo and Baccio feared being deceived. (This was the same period as the rivalry between Raphael and Sebastiano del Piombo.) Adding in the testimonies of Vasari and Baccio Bandinelli, the conclusion emerges that Raphael boasted some claim on, or at least an interest in, the planned Florentine project from November 1515 up to the autumn of 1516, and that Michelangelo, with the good offices of Buoninsegni, undermined the Urbino native. Only by hypothesizing such a turn of events can a logical explanation be found for the delays and indecisions of Michelangelo and Baccio, which Millon (1988) attributed solely to the uncertainty over the design for the façade.

In December 1516, Michelangelo finally returned to Rome and obtained the commission. He wrote in his records: "On the fifth day of December 1516, I went from Carrara to Rome to Pope Leo, who sent for me on account of the façade of San Lorenzo. . . . On the sixth or seventh, I went up again to Carrara with a verbal agreement from the pope. . . . Received 1,000 ducats on account" (*Ricordi* XCVII; see also *Carteggio* CLXXXV, CLXXXVII). From the letters, however, Millon (1988) dated the Rome trip to December 15–22, 1516.

Before December 30, the excavators began work on the footings for the façade, which led to the discovery of the foundation of the old porch and the subsequent decision to rebuild it (CLXXXVI). In a letter of February 2, 1517 (CXCV), Buoninsegni described the wood model, on which Baccio had been working from Michelangelo's drawing since January 1 (CLXXXVI), as having a façade with ten statues on three different levels: on the bottom, four standing figures from left to right of Saints Paul, Peter, John the Baptist and Lawrence; on the middle register, four seated statues of the Evangelists Mark, Matthew, John

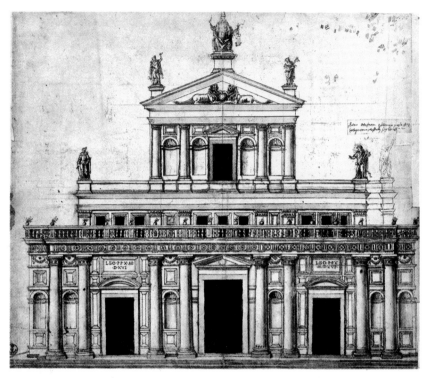

and Luke, in the same order; and on the top, the Medici patron saints Damian, on the left, and Cosmas. Very soon the misunderstandings began between Baccio and Michelangelo, who complained to Buoninsegni in a letter of January 28 that Baccio's model did not follow his design. The secretary replied on February 14 that he had spoken with the cardinal, who confirmed that the ideas of Michelangelo ought to be respected "entirely and by everyone" and that the artist should not worry too much about Baccio or the others (CXCIX).

Baccio's model (fig. 101), nearly ready by mid-February (CCII) and completed before March 7 (CCV), was criticized by Michelangelo in a letter of March 20 as such "a childish thing" that he was persuaded to have another one made by Francesco di Giovanni, "of clay according to the design, [even if] it will be necessary, in the end, that I make it by myself" (CCXII). A small clay model by Michelangelo was ready on May 2, by which time he was rid of Baccio d'Agnolo, according to his letter to Buoninsegni of that date (CCXXI). In this, he confirmed his availability to carry out both the sculpture and the architecture

of the façade, and he agreed to finish the work in six years at a price of 35,000 ducats (10,000 more than his estimate given the previous December). In a letter of May 9, Buoninsegni requested a new wood model on behalf of the pope and asked the artist to begin the foundations for the façade (CCXXIII). In July, Michelangelo wrote to his father that he would be in Florence during all of August to execute the requested model (CCXXXV), but in fact he did not leave Carrara until August 20 (*Ricordi* XV).

Prevented by a long illness from working in September-October 1517, Michelangelo finally sent the wood model "with the figures in wax" (CDLVIII) to Rome during the third week of December (CCLII). On January 19, 1518, he signed the contract in Rome for the façade, which put an end to the negotiations and defined precisely the constituent elements of the work (Milanesi 1875). In 1518–19, Michelangelo was engaged in the extraction of the marble at Pietrasanta, whose quarries were to provide the necessary stone by the express wish of the patrons.

On March 10, 1520, Michelangelo recorded: "Now Pope Leo, perhaps to

make the above-mentioned façade of San Lorenzo more quickly than the arrangement which he made with me, and therefore still thinking of me, freed me from the agreement" (*Ricordi* XCVIII). The recision of the contract with regard to the furnishing of the marble by Michelangelo did not mean, however, the rejection of the façade on the part of the Medici pontiff. The activities of the workshop and the arrival of the material from Pietrasanta continued for a considerable period, even though Michelangelo was involved full time with the commission for the New Sacristy of San Lorenzo from September 1519 on. This project had taken precedence in the mind of Leo X, probably because of the unexpected death in May 1519 of Lorenzo, the duke of Urbino (Ackerman 1986), more than due to the diminishing of funds by the costs of the war in Lombardy (Vasari 1568). It has also been proposed that the contract recision was motivated by dissension between the incorruptible Michelangelo and Buoninsegni, whom Vasari mentions as having wanted to turn illicit profits from the supplying of the marble (Ramsden 1963).

We have sure information, in fact, that the work for the façade went forward at least until April 1521, the date when the first column cut at Pietrasanta arrived in Florence. In his biographies of Giovanni da Montorsoli and Nicolò Tribolo, Vasari (1568) informs us that Clement VII intended to revive the project, and it was probably only the death of this second Medici pope in 1534 which ended all possibility for the completion of the façade.

The various creative phases are recorded in a sufficiently large series of drawings, either autograph or copies after lost originals, among them sketches for the cutting of the marble blocks for the façade (figs. 198–210) first identified by Tolnay (1954). The wood model, previously kept in the vestibule of the Laurentian Library, is now preserved in the Casa Buonarroti (fig. 101). Definitive for the dating of the different stages of the planning process was the study and comparison by Ackerman (1961) of this wood model, the contract of January 1518, and the drawings of the

blocks for extraction at Pietrasanta, which were delineated in such a precise way as to allow for the reconstruction of the final design (fig. 197). The substantial homogeneity of these three different sources guarantees that the final solution adopted by the artist and fixed in the contract is reflected faithfully enough in the extant wood model. The authenticity thus asserted for this model has never been questioned since Ackerman (1961), and the date has been established between the end of 1517 and the early months of 1518. We know that, at least in the seventeenth century, the wood model was accompanied by another, much smaller one with wax figures, perhaps similar to if not identical with the one sent by Michelangelo to Rome in December 1517, therefore it may be deduced that the façade design was scaled down in the number of levels between 1516 and the end of 1517.

A group of drawings, none autograph but bearing the inscription: "The first design that Michelangelo made for the façade of San Lorenzo," aid in establishing a chronology relevant to the planning stages: fig. 185 attributed by Nesselrath (1983) to Raphael da Montelupo; Staatliche Graphische Sammlung, Monaco, no. 33256, attributed by Tolnay (1972) to Giovanni Battista or Aristotile da Sangallo; Biblioteca Estense, Modena, ms. Campori, App. 1755 = a.Z.2.2., traditionally attributed to Giovanni Antonio Dosio but identified by Nesselrath (1986) as a copy by Raphael da Montelupo; The Rugby School, Rugby, notebook drawing attributed by Geymüller (1901) to Aristotile da Sangallo but by Nesselrath (1983) to Raphael da Montelupo; and Biblioteca Comunale, Siena, S.IV.1, f. 145, by Oreste Biringucci. These show a configuration with the main entrance flanked by a giant order of paired columns on high pedestals with the bays at either end, barely arrested from becoming aediculae, crowned by segmental-arched pediments. On the top level of the façade, limited to the central nave area, pilasters also supported on high pedestals continued the giant order vertically to end in a triangular pediment. The rich sculptural decoration was to have consisted of bas-reliefs above the

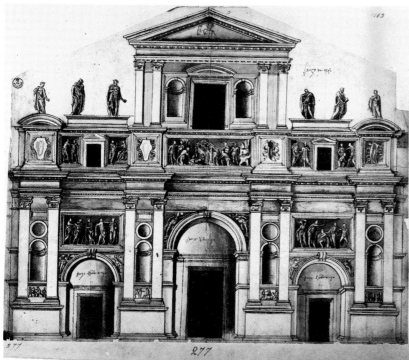

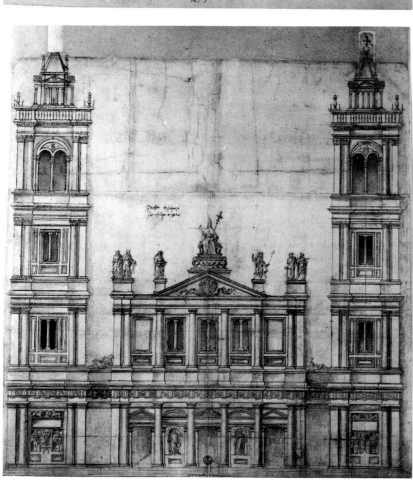

183. *Giuliano da Sangallo. Design for façade of religious edifice, perhaps Santa Maria di Loreto, then adapted for façade of San Lorenzo. Uffizi, Florence, Drawings and Prints Dept., A 277*

184. *Giuliano da Sangallo. Design for façade of San Lorenzo. Uffizi, Florence, Drawings and Prints Dept., A 280*

185. *Raphael da Montelupo. Copy of Michelangelo's "first design" for façade of San Lorenzo. Musée des Beaux-Arts, Lille, Wicar Coll., f. 790*

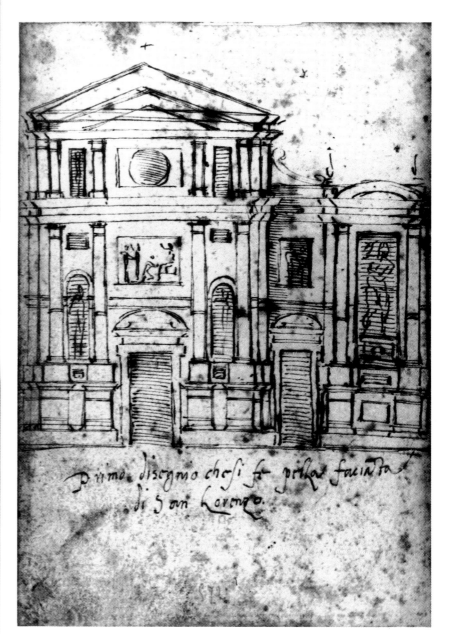

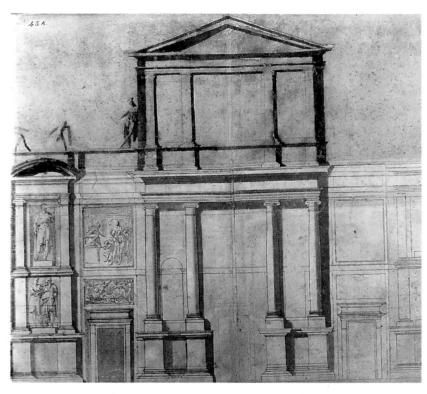

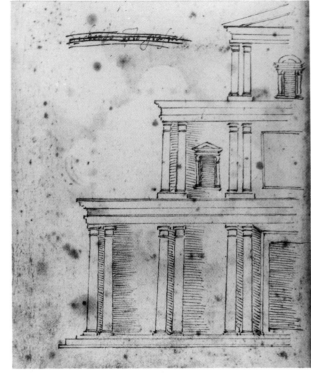

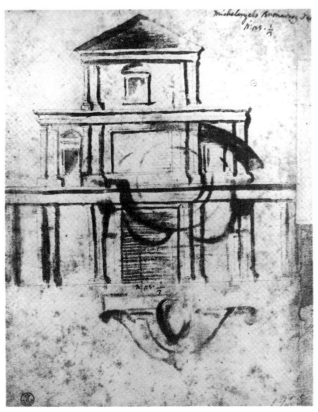

doors, two statues in niches between the pairs of columns at either side of the door, two more statues in the "aediculae," and perhaps freestanding statues crowning the attic level above the aediculae.

A large sheet in the Casa Buonarroti (figs. 102/186) appears to be, if not the original of the drawings mentioned above (although with small but important variations), at least a contemporary solution or perhaps a preparatory study for the "first design." Originally considered autograph, this attribution was refuted but then returned, first by Hirst (1972) followed by Joannides (1978), and then Millon (1988). The *Corpus* agreed only so far as the figural parts, with Tolnay proposing Baccio d'Agnolo for the architecture. The very way of constructing the design, composed of six sheets joined together, and the changes which occurred in the course of execution, as noted by Millon (1988), give evidence for the experimental nature of the solution defined here.

As for the chronology, the "first design" has been nearly unanimously dated before February 2, 1517, because

it doesn't accommodate the ten statues described in Buoninsegni's letter of that date. If this letter reflected intervening agreements made with Leo X in December 1516, which is probable, then a date as early as October-November 1516 could be considered. Tolnay (1972) proposed identifying as a preliminary idea for San Lorenzo a light sketch on a sheet in the Casa Buonarroti (A 41v [C. 496v]), and this is supported by two related copies (figs. 187, 188) which show a façade of three levels narrowing in width toward the top, with six pairs of columns at the bottom, four at the middle, and two at the top. The levels also diminish in height towards the top. The proposal was accepted by Joannides (1978), Ackerman (1986), and Millon (1988), with Millon dating the design to the spring or summer of 1516, although perhaps this is too early for Michelangelo to have thought about the architecture of the façade.

The "second design," documented by two Casa Buonarroti drawings (figs. 99, 189), shows a façade still having three levels but with the lateral aediculae on the middle level instead of the bottom.

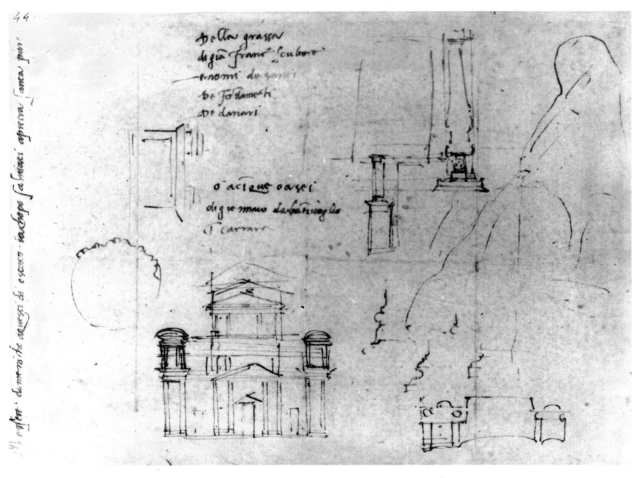

There are ten niches—four each on the bottom and middle levels, and two on the top, as described in the letter of February 2, 1517, which suggests a date between December 1516, when the agreements were reached, and the first months of 1517. The autograph inscriptions seen in fig. 189 have been dated to the period of January-March 1517 (*Corpus*), therefore this design would have been the basis for the wood model worked on by Baccio in January-February 1517. Perhaps related to the "second design" (Hirst 1983 and Millon 1988) is the Casa Buonarroti sheet (fig. 190), which has traditionally been identified however as a study for the Medici chapel.

A principal turning point in the planning for San Lorenzo, emphasized by Ackerman (1961), was the rejection of a slab façade—that is, the facing of the existing wall plane with a veneer of bricks, as seen in the preliminary design (fig. 98) and in the "first" and "second" designs. Favor was then shown for a "narthex" scheme, already previewed in the designs by Giuliano da Sangallo which provided the alternative of a façade "with a porch" (fig. 184) or "without porch" (fig. 183). Raphael, from what we know by the copy of his design (fig. 97), presented a solution of double, nonconnecting "forceps" vestibules. Michelangelo was able to get away from the triangular configuration, which had conditioned the project up to that point and restricted his freedom in the articulation of the façade, by choosing an organism autonomous from the existing wall plane—a freestanding three-dimensional structure, as shown in fig. 191. Obviously, the footings begun for a veneered façade were not sufficient for a completely autonomous structure, and it was probably because of this that Michelangelo delayed in proceeding with the foundation for his façade (Ackerman 1961). This work, initiated only upon insistence from Rome in July 1517 after completion of the clay model, was perhaps studied in a Casa Buonarroti drawing (fig. 192) having on its recto, significantly, a design for a façade with a porch. For this same reason perhaps, the cost of the project was raised from 25,000 to 35,000 ducats, as announced

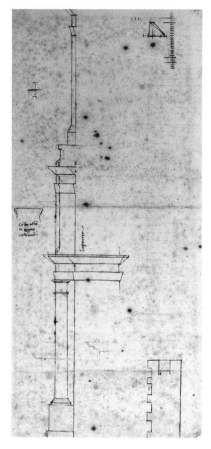

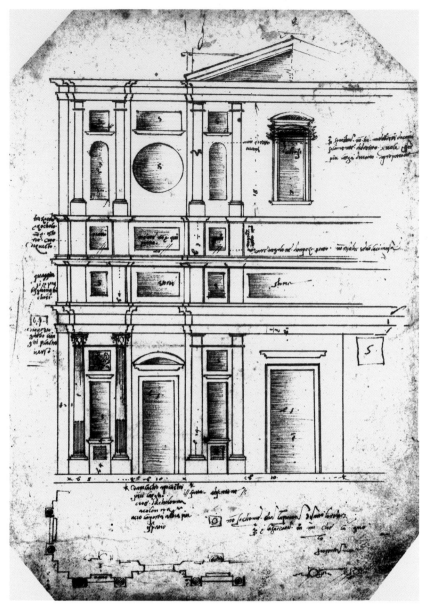

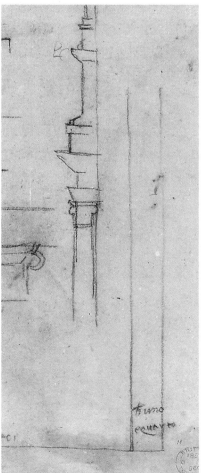

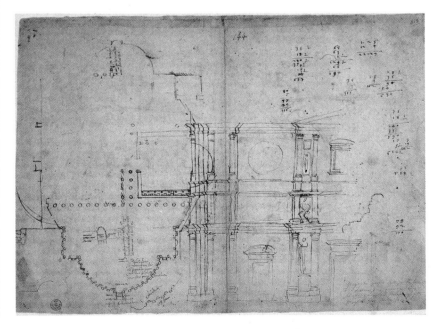

193. *(above left) Michelangelo. Study of section of façade of San Lorenzo. Casa Buonarroti, Florence, A 51r (C. 504r)*

194. *(below left) Michelangelo. Study of section of façade of San Lorenzo, detail of fig. 165. British Museum, London, 1859–6–25–560/2v (C. 511v)*

195. *(above right) Giovanni Battista da Sangallo (attrib.). Copy of Michelangelo study for façade of San Lorenzo ("final design"). Biblioteca Trivulziana, Milan, Bianconi Coll., IV, f. 35a*

196. *(below right) Antonio da Sangallo the Younger. Copy of Michelangelo study for "final design" of façade of San Lorenzo. Uffizi, Florence, Drawings and Prints Dept., A 790*

197. *(opposite above) Reconstruction of Michelangelo's design for façade of San Lorenzo based on cited sketches and 1518 contract (Ackerman 1986): (1) statue, 5* braccia *high; (2) sculpted relief panel; (3) bronze seated statue, 4 1/2* braccia *high; (4) pilasters; (5) niches; (6) statue, 5 1/2* braccia *high; (7) sculpted relief panel with seated lifesize figures; (8) sculpted relief panel with seated lifesize or larger figures; (8') sculpted relief panel, 8* braccia *long, with lifesize or larger figures; (8") sculpted relief panel, 9* braccia *long, with lifesize or larger figures; and (9) sculpted relief tondo with lifesize figures.*

198. *(opposite below) Michelangelo. Sketches of marble blocks for façade of San Lorenzo (Ackerman 1961): top, six bases for statues on bottom level; bottom, six pedestals and twelve bases for columns on bottom level; and twelve small pieces not identified. Archivio Buonarroti, Florence, I, 128, f. 243r*

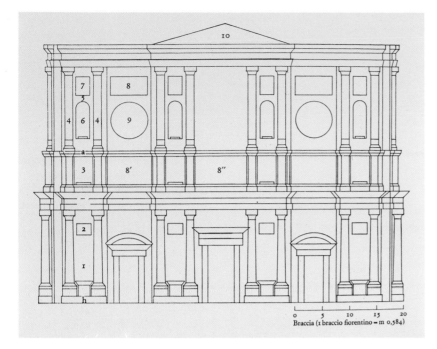

Braccia (1 braccio fiorentino = m 0,584)

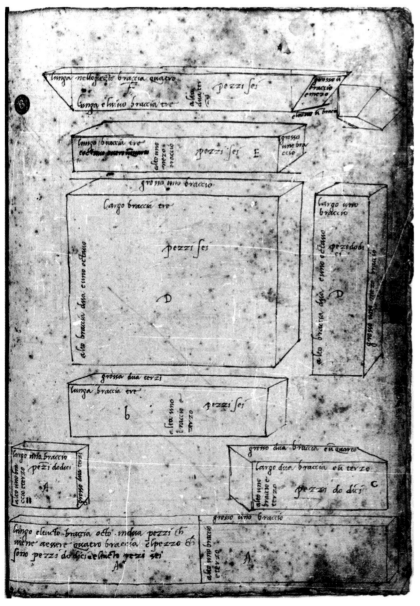

in the sculptor's letter of May 1517, and the wood model by Baccio was definitively rejected. The final design, the development of which began in February and went through successive models in clay and wood, was concluded in the autumn of 1517. This marked a clear break, not only in the planning process for San Lorenzo but also in the maturation of Michelangelo himself. By rejecting the option of a simple architectonic framework in which to insert some statues, he was able to announce in May that his façade would be "of architecture and sculpture, the mirror of all Italy" (CCXXI).

Probably the earliest drawing of the "final design" is a sheet in the Casa Buonarroti (fig. 100) considered to be entirely autograph. Here, the façade was articulated with tiers of the same height projecting forward at the ends and in the center, which was crowned by a triangular pediment, but receding in the areas of the side-aisle entrances. This projection-recession format was emphasized in a succeeding version, a lost Michelangelo design a little later than that in fig. 100, which was recorded in several copies showing on the bottom level projecting pairs of columns with concave niches between them meant to house statues. The copies include: fig. 195, attributed by Tolnay (1972) to Giovanni Battista da Sangallo; Staatliche Graphische Sammlung, Monaco, 33258, by Aristotile da Sangallo; and The Louvre, Paris, 134v, attributed to Baccio Bandinelli.

The following step conceptually—although not necessarily later in date considering Michelangelo's ideational practice—was a solution known from two copies in the Uffizi, one by Antonio da Sangallo the Younger (fig. 196) and the other by an anonymous sixteenth-century artist (Drawings and Prints Dept., A 205), in which the paired columns are tied together at the bottom with a continuous plinth supporting individual pedestals from which the column shafts spring. Some autograph drawings of sections—figs. 165/194 and fig. 193—document a succeeding phase showing a progressive reduction in height by halving, in which double becomes single in the wood model. With the latter, the decorative aspects

were better defined in another, much smaller model with wax figures, still extant in the seventeenth century but now lost. This terminated the complex planning process by Michelangelo except for some details—"rethinkings" actually of the space between the columns in the center section, which was widened to hold a large central relief. By consequence the recessive zones of the side-aisle entrances were restricted, as determined from the sketches executed in view of cutting the stone needed for the work and recorded in Ackerman's reconstruction drawing (fig. 197).

Two important aspects remain unclear and probably were left undefined by the artist—the manner in which the surface of the existing fifteenth-century façade would have been treated (on the previously mentioned Monaco copy by Aristotile da Sangallo, this artist noted: "I do not know how it is on the inside in this design"), as well as the system of illumination for the interior of the church. No doubt these and other problems, anticipated but not definitively resolved, would have been confronted as soon as the work went forward, in Michelangelo's way of planning.

After the adjournment of the façade project, probably due to a sum of incidental reasons rather than by the deliberate choice of the patrons, the façade of San Lorenzo came up twice more in Michelangelo's architectural career. The first time was in the winter of 1524, when he contemplated the possibility of placing the Laurentian Library (No. 12) on the piazza in front of the church, a scheme which seems to have been rejected out of "considerations with regard to the façade of San Lorenzo" (DCXXVIII). Then, while working inside the church on the Tribune of the Relics (No. 13) between 1525 and 1531, he made a plan which connected the tribune on the inside of the entrance wall with an "outside pulpit niche" on the façade of the church (fig. 280), but this was not carried out. Between Michelangelo's enthusiastic announcement on May 2, 1517 regarding the façade of San Lorenzo and the hasty conclusion of his work on the Tribune of the Relics, as if in fulfillment of an obligation in order to acquire his freedom, all of the Florentine experience was exhausted.

199. *Michelangelo. Sketches of marble blocks for façade of San Lorenzo (Ackerman 1961): top, six unidentified pieces; left, ten posts to back columns on bottom level; bottom, six cornices to be placed probably above statues on bottom level. Archivio Buonarroti, Florence, I, 128, f. 243v*

200. *Michelangelo. Sketches of marble blocks for façade of San Lorenzo: base, shaft and capital of columns on bottom level. Archivio Buonarroti, Florence, I, 129, f. 244*

201. *Michelangelo. Sketches of marble blocks for façade of San Lorenzo, entablature of bottom level. Archivio Buonarroti, Florence, I, 130, f. 245r*

202. *Michelangelo. Sketches of marble blocks for façade of San Lorenzo (Ackerman 1961): top, six cornices for mezzanine and twelve bases for pilasters of third level; bottom, twelve pilasters for mezzanine with pedestal for each pair, and eight posts. Archivio Buonarroti, Florence, I, 134–135, ff. 250v-251r*

203. *Michelangelo. Sketches of marble blocks for the façade of San Lorenzo (Ackerman 1961): architraves for bottom level over side bays and the ends. Archivio Buonarroti, Florence, I, 136, f. 252*

204. *Michelangelo. Sketches of marble blocks for one of two curved pediments for side portals, with chord of nine* braccia *and pediment in single piece for façade of San Lorenzo. Archivio Buonarroti, Florence, I, 137, f. 253r*

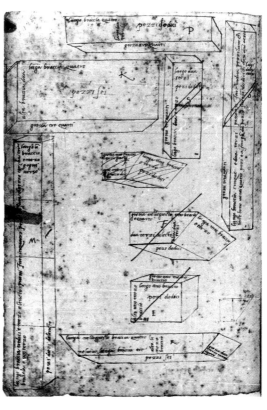

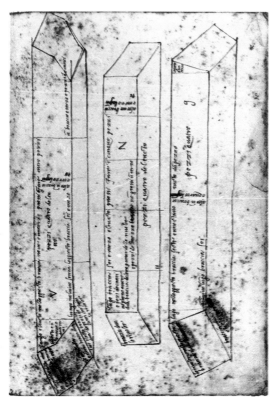

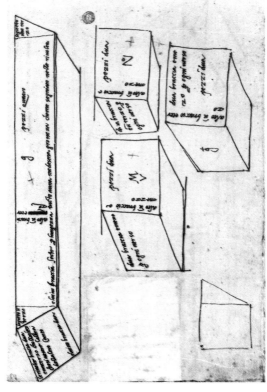

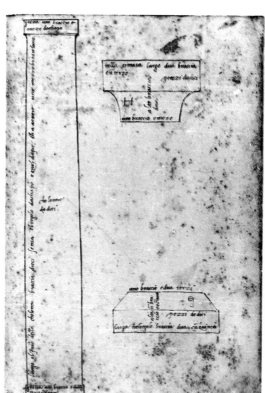

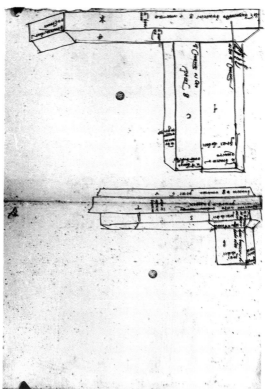

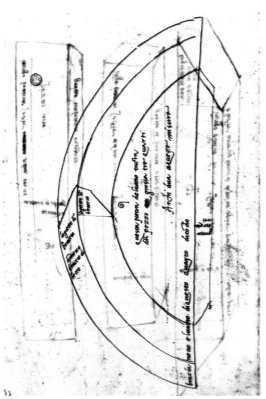

205. *Michelangelo. Sketches of marble blocks for central portal entablature for façade of San Lorenzo. Archivio Buonarroti, Florence, I, 137, f. 253v*

206. *Michelangelo. Sketch of marble block for supports of central portal, and cross section of same, for façade of San Lorenzo. Archivio Buonarroti, Florence, I, 138, f. 254*

207. *Michelangelo. Sketch of marble blocks for supports of side portals, and architrave (canceled) for façade of San Lorenzo. Archivio Buonarroti, Florence, I, 139, f. 255*

208. *Michelangelo. Sketch of marble blocks for façade of San Lorenzo (Ackerman (1961): two elements of cornice for uncertain location. Archivio Buonarroti, Florence, I, 145, f. 261v*

209. *Michelangelo. Sketch of marble blocks for façade of San Lorenzo (Ackerman 1961): complete series of elements for bottom level (side bays and ends). Archivio Buonarroti, Florence, I, 144–145, ff. 260v-261r*

210. *Michelangelo. Sketches of marble blocks for façade of San Lorenzo (Ackerman 1961): top, parts of entablature for side bays; below, five slabs not identified. Archivio Buonarroti, Florence, I, 155, f. 276*

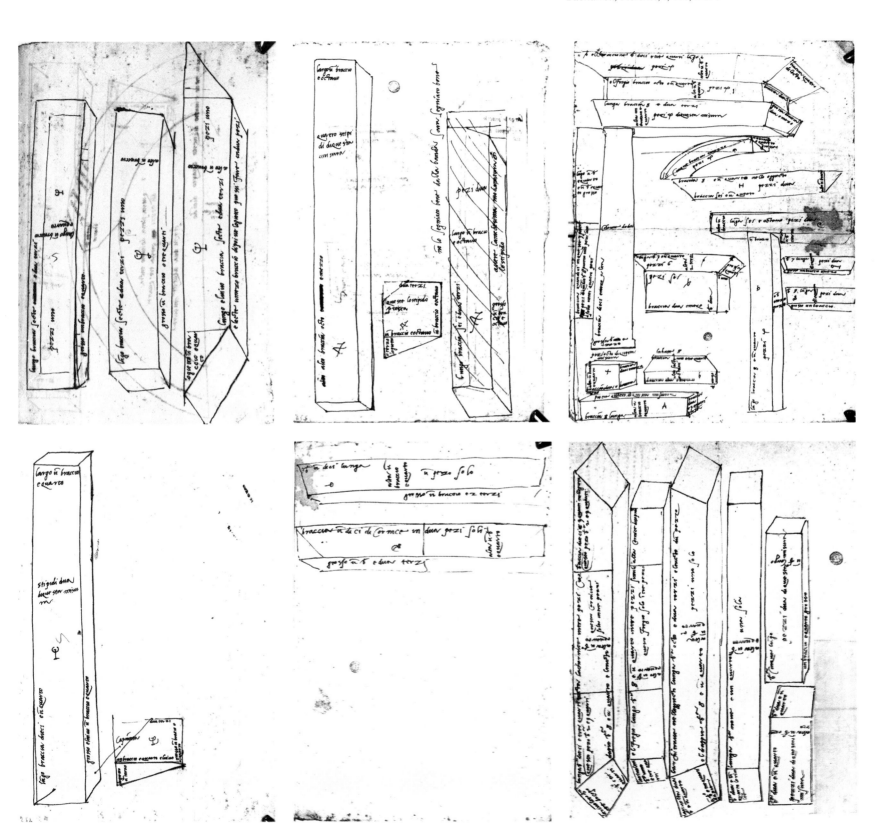

211. *Anonymous, 16th c. Drawing of "kneeling" window of Medici Palace, Florence. Uffizi, Florence, Drawings and Prints Dept., A 1916r*

212. *Michelangelo. Two plans and elevation for half-octagon structure. British Museum, London, 1859–6–25–546 (C. 521r)*

213. *Michelangelo. Architectural sketches for half-octagon structure. Ashmolean Museum, Oxford, Parker 312r (C. 522r)*

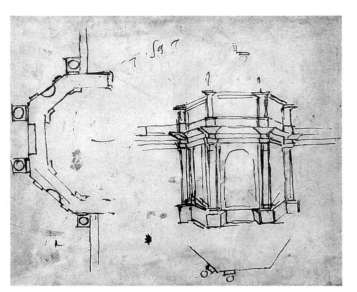

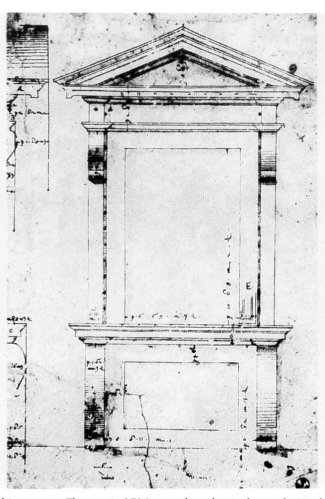

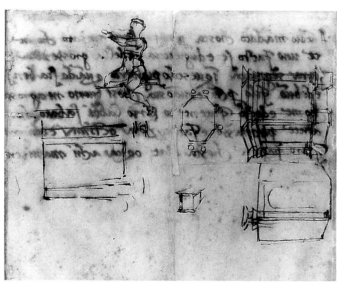

Upon his return to Florence in 1516, Michelangelo "made for the Medici palace a model of the kneeling [*inginocchiate*] windows for those rooms which were on the corner" (Vasari), obtained by enclosing the loggia at the corner of Via Larga and Via de' Gori of the fifteenth-century residence built by Michelozzo (fig. 103). The rooms (identified by Frey 1907) were then decorated with ornaments in stucco and paintings by Giovanni da Udine (but completed by Vasari himself in 1537). Vasari wrote also that Michelangelo had designed window blinds executed in copper fretwork by the goldsmith Giovanni di Baldassare called Piloto (no longer extant).

From the interior design, Marchini (1976) attributed two more windows to Michelangelo at the right end of the palace—one in the arch on the façade

and another in that on the Via de' Ginori side near the juncture with the garden wall. The detailed drawing in fig. 104 was very close to the final design except for the indecision about a round-arched or a triangular pediment. Differences between this and the executed window —elimination of the flanking pilasters, alignment of the top and bottom volutes on the same axes, and elevation of the sill with the consequent elongation of the brackets below it—are too extensive and important to suppose, as does the *Corpus*, that the workmen made these changes during execution, especially if we assume that there had been a full-scale model for it. The sketch in fig. 211 seems to have been done after the window itself, rather than as a model for the stone cutter, as Tolnay (1975) proposed.

A ground plan and elevation of a half-octagon structure, perhaps a pulpit (fig. 212), was first attributed to Michelangelo by Wilde (1953). The pulpit appears also on a sheet of five sketches (fig. 213), which Wilde dated to the summer of 1518 from a letter fragment on it in Michelangelo's hand regarding a matter discussed in other dated letters. In spite of Kurz's objection (1953) that such a structure was liturgically anachronistic, Morselli (1981) proposed that the studies for the pulpit were related to the redecoration of the Florence Cathedral. There are no factors for accepting or rejecting this hypothesis, nor is it docu-

mented in any way. It is known that, a few days after being made the architect for Saint Peter's, Michelangelo claimed that he had "had a similar commission for Santa Maria delle Fiore in Florence" (letter of February 26, 1547 from Giovanni Arberino and Antonio de' Massimi to Monsignor Filippo Archinto; Saalman 1978), but Saalman interpreted from this that the artist could have been head of the Cathedral Works during the siege of Florence in 1529.

DESIGN FOR A PALACE, 1518–20

214. (above) Michelangelo. Plan for private residence. Casa Buonarroti, Florence, A 117r (C. 586r)

215. (below) Michelangelo. Plan for private residence. Casa Buonarroti, Florence, A 118r (C. 587r)

Preserved in the Casa Buonarroti are two sheets by Michelangelo, each with the plan of a two-story palace. In one (fig. 214), the ground floor has a shop on either side of the door which opens into a center hall. Directly behind the shops are two pairs of rooms on either side of, but not connecting with, a passage leading to double staircases. Beyond these is a courtyard with a well, and on either side of this are two more pairs of rooms, each including a kitchen. The plan of the second floor, appearing at the bottom left of the sheet, comprises the staircases and two large rooms directly above the shops. Framing the floor plans is a large detail of a door outlined in pencil, above which is inscribed "*laltopascio*." The other sheet (fig. 215) shows a fairly similar plan, with the left side indicating the rooms on the ground floor (*disocto*) and the right side those on the second level (*disupra*). It varies in having the stairs directly behind the shops, as seen at the left, and the courtyard, or garden, the same width as the vestibule at the entrance. On the versos of both sheets, which may once have been joined, are pencil sketches which, if identified as the plan and elevation of the lantern of the dome of Saint Peter's, can be dated to 1546–47 (figs. 235, 237). To these sheets, which are clearly related to each other, has been added a third (fig. 216; Thode 1908–13), which, although less detailed, depicts a similar palace plan.

Due to the inscription "*laltopascio*" in fig. 214, Geymüller (1904) identified this plan as one for the palace of Ugolino Grifoni, master general of the Hospice of Altopascio, a hypothesis accepted with caution by Thode (1908–13), Düssler (1959), Ackerman (1961), and Barocchi (1962), who have nevertheless noted the resemblance in the disposition of the rooms and the enclosed garden to the Grifoni Palace. Subsequently called the Budini-Gattai, this palace was begun in 1557 and constructed on a plan by Bartolomeo Ammanati (for the palace, see Lisci 1972 and Bucci-Bencini 1974; for Ammanati's designs, see Vodoz 1941 and Fossi 1970).

Tolnay (1966) disagreed with this identification and believed that the three drawings were related instead to the enlargement of the Casa Buonarroti in view of the marriage of Michelangelo's nephew Leonardo, which was documented in the letters from around 1546–49. He connected to the drawings a fourth one in the Buonarroti Archive (fig. 218) having on its recto a letter from Domenico di Terranova dated April 27, 1518, which he proposed to be the first plan to unite two of the three houses owned by Michelangelo on the Via Ghibellina. According to Tolnay, the fact that it was the artist's own property would explain the connection between drawings otherwise far apart chronologically.

Recently, Wallace (1989) convincingly argued that the drawings in figs. 235 and 237 were related to the design of the lantern for the New Sacristy in San Lorenzo, rather than the lantern for Saint Peter's, and could therefore be dated to the 1520s. Accepting this hypothesis, the project for the palace would then date not too long after 1518, the *terminus post quem* of the Archive drawing (fig. 218). As already noted by Ackerman (1961), a date in the early 1520s would agree better stylistically with the ductus of the drawing of the door with a triangular pediment present on the sheet in fig. 214.

While Ugolino Grifoni acquired the property for his palace only in 1549 (Barocchi 1962), the possibility remains, even if not completely proven, that Michelangelo's plans are indeed related to it. The *Corpus* gives the ingenious explanation for the notation "*laltopascio*" that, because the inscription is tied closely to the large detail of the door, this could mean a later reuse of the sheet, a proposal just as difficult to prove.

There is evidence of at least two cases in which Michelangelo was asked to work on projects for palaces. On February 8, 1525, after having broached the subject in a letter to the artist of January 28, Giovanni Francesco Fattuci asked for "a few designs" for the cardinal of Santi Quattro, who wished to make in Rome "the façade of his palace, and he thought of making it of ashlar [*bozi*] up to the first row of windows" (DCLXXXVI, DCLXXXIX). About a year later, on February 4, 1526, Pietro Rosselli wrote from

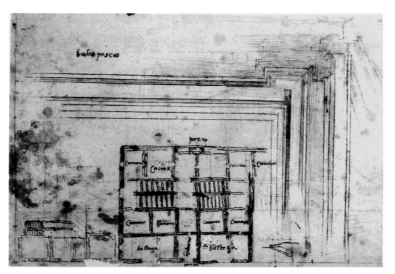

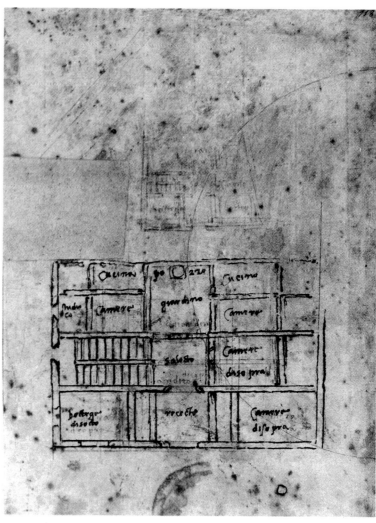

216. *(above left) Michelangelo. Plan for private residence. Casa Buonarroti, Florence, A 33 (C. 585r)*

217. *(below left) Michelangelo. Plan for private residence, perhaps a villa. Casa Buonarroti, Florence, A 119r (C. 588r)*

218. *(right) Michelangelo. Plan for private residence. Archivio Buonarroti, Florence, XI, f. 722v (C. 584r)*

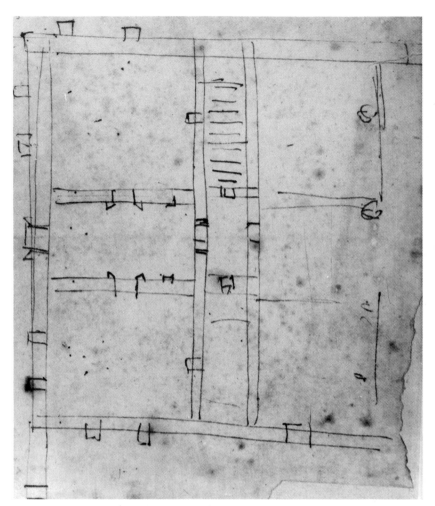

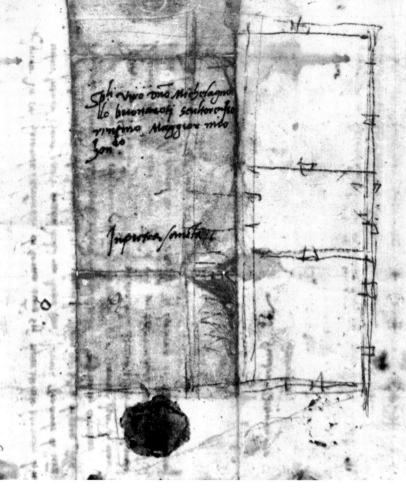

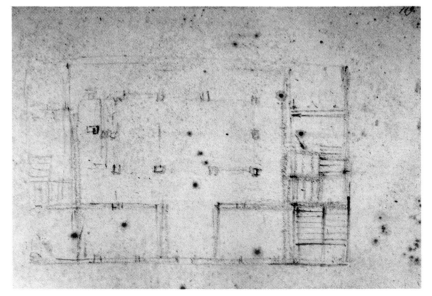

Rome to Michelangelo that Giuliano Leni had shown the cardinal of Santi Quattro "a sketch or actual design of said façade, and he said that Michelangelo Buuonaruuoti had made it." Rosselli described the drawing: "The design is like that of the house where Raphael of Urbino lived opposite Hadrian, with those raised blocks of tufa or stone according to the Rome custom, which is stones of tufa, and over the stone blocks a giant order, and above the columns of said giant order the architrave and frieze and cornice." There are no reasons to either accept or refute Leni's story about which Rosselli expressed his skepticism, albeit in a not disinterested way. Leni intended to take the building commission away from Domenico Rosselli, Pietro's son, about which the father wrote: "I worked hard for more than six years to bring [him] this project" (DCCXXXVIII).

A letter of April 1532 (DCCCLVI) indicated that Michelangelo was also involved in the planning of the Florentine palace for Bartolomeo Valori. Probably in that case as well, the artist furnished only some advice and perhaps some sketches. A fourth sheet in the Casa Buonarroti (fig. 217) is certainly a plan for a private residence. Thode (1908–13) and Düssler (1959) interpreted this as a country villa, but the *Corpus* and Tolnay (1966) related it to a project for Michelangelo's studio on the Via Mozza in Florence.

The "memoir" of Giovanni Battista Figiovanni, published by Corti-Parronchi (1964), allows the precise dating of the birth of the idea to create in the Church of San Lorenzo, Florence, a new sacristy with the functions of a funerary chapel for the Medici family (for its functions, see Ettlinger 1978). Figiovanni, who became administrator of the Medici undertaking, recalled: "Having returned to the government of [Florence] immediately after the death of Duke Lorenzo his nephew in the year 1519 . . . the month of June, the Very Reverend mister Giulio de' Medici [announced, together with his cousin Pope Leo X]: '[We are] of a mind to make an expenditure of about 50,000 ducats on San Lorenzo, the library, and the sacristy in company with the one already [made] and it will be called the chapel, where [there will be] many tombs for burying the dead ancestors who are in storage: Lorenzo and Iuliano our fathers and Iuliano and Lorenzo brother to [Leo] and nephew.'" [Duke Giuliano was Giulio's cousin, and Duke Lorenzo his cousin once removed.]

On September 3, 1519, Cardinal Giulio acquired, for one hundred twenty gold ducats, a house owned by Francesco Nelli "for making said new sacristy" (Elam 1979; for location, see Saalman 1985), and a contract was drawn up on October 3 with Francesco Lucchesino (Elam 1979) to furnish the *pietra serena* (gray sandstone). Figiovanni recorded also that "the two foremost master builders of Florence" agreed on the "starting date of November 4, 1519" for the construction, beginning with "tearing down the two houses of the Nelli family and the walls of the church in the area where the sacristy would be made."

In spite of much evidence accumulated in recent years, scholars are still divided on the question of whether Michelangelo built the structure from the ground up, as Wilde (1955) strongly maintained and Figiovanni's memoir and the documents rediscovered by Elam (1979) seem to prove, or whether he had continued the work on a preexisting building or plan. The latter, favored in most of the current literature, is supported by Saalman (1985). Those in

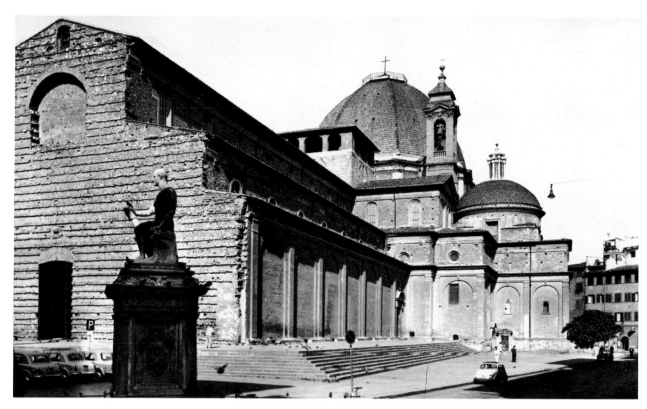

favor of the first hypothesis, which we believe is more convincing, cite as proof, besides the documentation mentioned above and the archaeological data reported by Dal Poggetto (1979), a contemporary view of the church by Leonardo da Vinci (previously noted by Wilde 1955) and a ground plan of San Lorenzo (fig. 220), dated by Burns (1979) to 1490–1510, by Olivato (1980) to the last years of the fifteenth century, and by Foscari-Tafuri (1983), who attributed it to Sansovino, to 1510–15. Neither of these documents shows construction adjacent to the north transept of the church.

Some factors exist in favor of Michelangelo's continuation of a preordained plan, in particular the lack of correspondences between the existing New Sacristy (interior and exterior) and a ground plan of San Lorenzo by Giuliano da Sangallo in his Siena Notebook (Biblioteca Comunale, S.IV.1, f. 21v), which redoubled symmetrically the Old Sacristy within the corpus of the building, mirroring identically the Brunelleschi construction. According to Borsi

(1985), however, the Sangallo plan should perhaps not be read as a representation of the existing church but as an attempt to interpret Brunelleschi's original design, which had been badly executed by his "successors."

In spite of the acceptance of Saalman's proposal (1985), which tended towards the identification of a preceding plan for the project by Guilio da Sangallo datable to the years 1478–92, the fact that Michelangelo played a role in the planning of the entire elevation of the Medici chapel is by now indisputable. On March 1, 1520, we know that construction was already in progress on the walls, and on June 9, the city government gave the Chapter of San Lorenzo permission "to be able to take XXIIII *braccia* of the alleyway or actual street which is behind the church of San Lorenzo to make the sacristy." Plans preserved in the Archivio Buonarroti, Florence (figs. 221 and 222; and I, 211r [C. 179r]) are recognized as first designs for the New Sacristy. In fig. 221, Michelangelo extended to all four walls the tripartite division used by Brunelleschi

only on the side of the choir in the Old Sacristy, and he located the four Medici tombs in the narrower zones of the side walls, two on each wall, inserting them between strongly projecting pilasters. Lightly and hesitantly indicated as an afterthought on the already delineated plan was also the idea of opening out apses in the wider zones of the side walls, but this was not feasible—an "unrealizable fantasy" (Ackerman 1968)—because of preexisting urban structures. In delineating the choir apse, Michelangelo strongly inflected the curvature of the lateral walls, transforming the fifteenth-century prototype into a trilobed organism. The difference in comparison with Brunelleschi's choir is evident from a sheet with two small sketches, drawn one above the other, of the plans of the two apses (fig. 222). Referring to the ground plan in fig. 221, four pairs of columns, probably meant to flank doorways, are seen in the narrow bays without tombs on the choir wall. The character of this plan as a study is confirmed by the presence, on the side with the main entrance, of a

220. *(left) Jacopo Sansovino (attrib.). Plan of San Lorenzo. Archivio di Stato, Venice, Misc. Mappe 1285*

221. *(above right) Michelangelo. Plan for New Sacristy. Archivio Buonarroti, Florence, I, 77, f. 210v (C. 178v)*

222. *(below right) Michelangelo and assistant. Plan for choir in New Sacristy with plan of choir of Old Sacristy above it. Archivio Buonarroti, Florence, I, 77, f. 211v (C. 179v)*

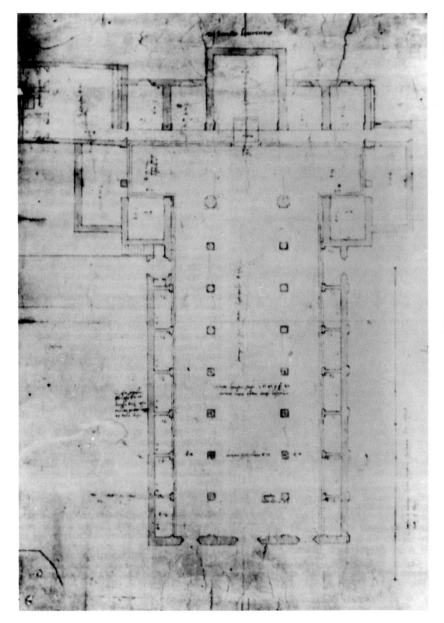

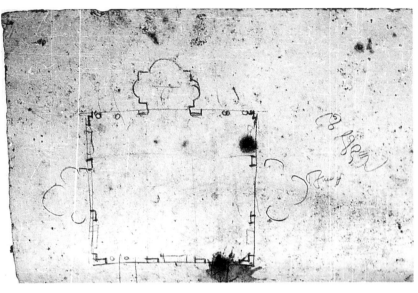

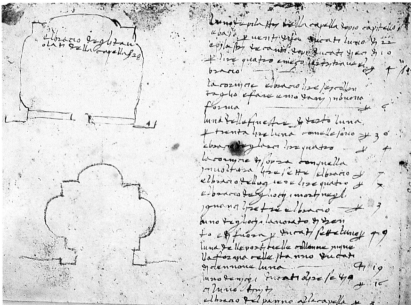

fifth funerary monument larger than the others. Rather than the tomb of Cardinal Giulio, an idea not presented until December 1520, this could be read as an alternative solution for the four tombs, which would have had to be very developed in height if placed in the narrow bays. In other words, it could be interpreted as a matter of providing only three tombs in the chapel, with the third a double one for the "Magnificents," the fathers of the patrons. These would occupy the three larger central wall zones with the fourth reserved for the choir apse. A very early dating for the two sheets is confirmed by an account record appearing on the sheet in fig. 222, which Wilde (1955) was the first to interpret correctly as an estimate of expenses for an exact reproduction of the Old Sacristy.

In addition to the two solutions studied in fig. 221—four tombs in the narrow bays, or three tombs in the wider ones, another arrangement was advanced. On November 28, 1520, Giulio de' Medici wrote to Michelangelo that he had received "the design or sketch of the chapel [showing the idea] of putting the IIII tombs in the middle of the chapel," but he objected: "[There is] a difficulty, because I don't know if it would be possible, in IIII *braccia* of space . . . by width, for each side, to contain said tombs with the decorations and then to put forth eight *braccia* for each side of the chapel" (CDLXXXIII). Michelangelo's new proposal recalled the tomb at the center of the Old Sacristy, "the stone slab of about four *braccia* for each side," cited in a fragment of a letter perhaps from November 1520 (CDLXXXII). As Wilde (1955) demonstrated, ideas for wall tombs and for a funerary monument at the center of the chapel proceeded at the same time in Michelangelo's mind as alternative possibilities. On December 28, 1520, through Domenico Buoninsegni, Cardinal Giulio proposed to include his own tomb in the new chapel and described the arrangement: "In the overall scheme of the tombs, [there would be] at the center an arch which would open through, which would come out to be an arch on each face, and the passages of these arches would intersect in the middle and be passed under,"

and the sarcophagus would be placed on the floor at the center of this four-sided arch (CDLXXXIX). The artist studied all of the options in a series of drawings (figs. 223–232), and in some cases designs for wall monuments and for freestanding tombs in the manner of an "*arcus quadrifrons*" appear on the same sheet (figs. 225, 226).

By April 1521, however, faced with the difficulty of placing freestanding tombs in the very small space of the chapel, Michelangelo had chosen the most natural solution of putting tombs in the three wide bays, with those of the dukes facing each other across the chapel and the double one for the Magnificents on the entrance wall. At this point in time, Michelangelo was already in Carrara to extract the marble for the tombs, which presupposes, if not a precise and detailed design, at least a final decision on the number and sizes of the funerary monuments by this date. On April 20, the artist received a letter from Stefano Lunetti, whom he had left in Florence to oversee construction, informing him of the state of the work. Already in place was "the base of the side with the entrance . . . of the chapel." The cornice and the pilasters in *pietra serena* were also finished, but he was waiting to install them until the return of Michelangelo, who could then judge "with [his] eyes what still remained and was needed for the complete setting up and raising of them." Everything took place in a climate of reticence in confrontations with the patrons, as would have been the norm in Michelangelo's workshops, along with the lack of understanding among the different co-workers (DVII). Only a few days later, Giovanni Francesco Fattucci informed the artist that "the architraves are nearly all placed" (DX). The installation of the network of *pietra serena* pilasters and architraves framing the tombs would have undoubtedly brought with it the definition of the internal spatiality of the chapel and the conclusive decision on the actual height and width of the tombs themselves. On this basis, the drawing in fig. 233 was dated to March-April 1521 by Joannides (1972), who saw it as the autograph, definitive solution for the tomb of the Medici dukes,

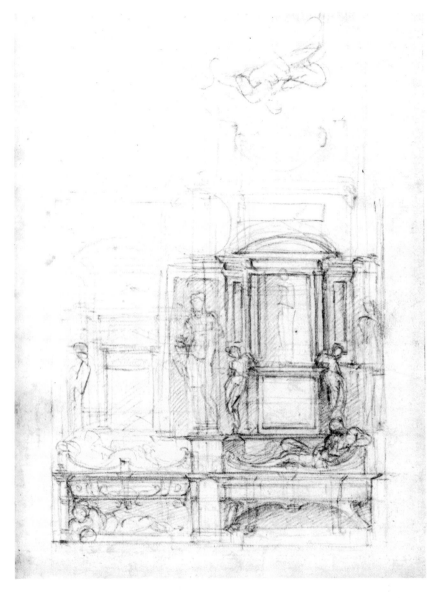

but the *Corpus* and Perrig (1981) identified it as an old copy after Michelangelo's final design. Wallace (1987a) confirmed the dating by Joannides and proposed it as a presentation drawing, not necessarily by the master, and therefore probably by the hand of Michelangelo's assistant Tommaso Lunetti. The related drawing in fig. 234 is generally accepted as a copy after the final solution for the tomb of the Magnificents, but Joannides (1972) saw it also as autograph. Wallace (1987), on the other hand, proposed Giovanni Angelo da

Montorsoli as the author of the drawing and dated it around 1531, the year in which work resumed after the siege of Florence.

After a slow period during the pontificate of Hadrian VI and a Rome stay by Michelangelo immediately following the election of Cardinal Giulio de' Medici as Pope Clement VII in late 1523, the work on the chapel architecture must have gone forward rather quickly. At the end of January or the first few days of February 1525, the artist announced to Clement that "the lantern

224. *(left) Michelangelo. Designs for freestanding tomb, double tomb, and single sarcophagus for New Sacristy. British Museum, London, 1859–5–14–822v (C. 180v)*

225. *(above right) Michelangelo. Sketches for* arcus quadrifons *tomb, wall tomb, and freestanding tomb. Casa Buonarroti, Florence, A 49r (C. 182r)*

226. *(below right) Michelangelo. Two sketches of wall tomb, and two sketches for tomb as* arcus quadrifons *for New Sacristy. Casa Buonarroti, Florence, A 88r (C. 181r)*

opposite:

227. *(above left) Michelangelo. Designs for tomb monuments in New Sacristy. Casa Buonarroti, Florence, A 71r (C. 183r)*

228. *(below left) Michelangelo. Studies of tombs for New Sacristy. British Museum, London, 1859–6–25–545r (C. 184r)*

229. *(above right) Michelangelo. Sketch for wall tomb for New Sacristy. British Museum, London, 1859–5–14–823r (C. 185r)*

230. *(below right) Michelangelo. Sketch for double wall tomb. British Museum, London, 1859–6–25–543r (C. 189r)*

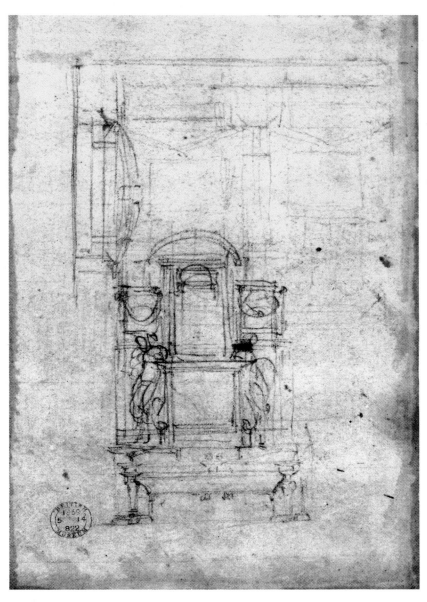

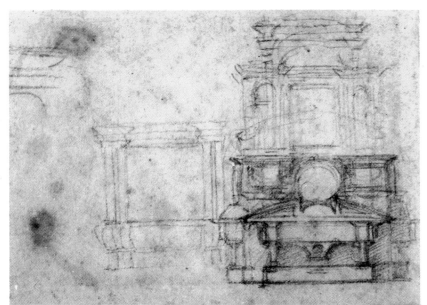

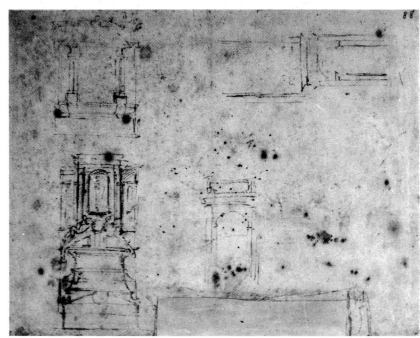

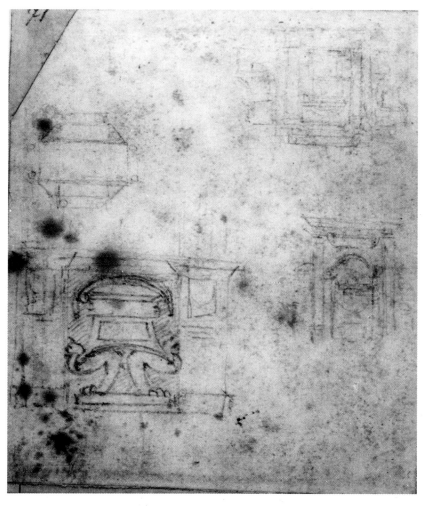

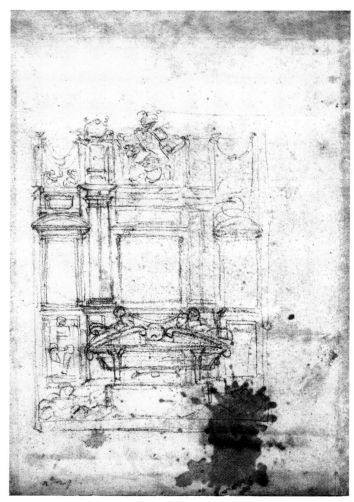

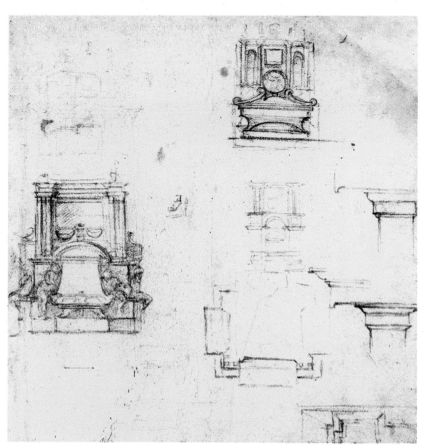

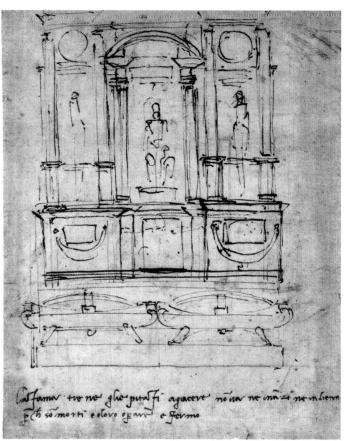

Chi fama tuo nie ghu pinsti fi agiacere non va ne inazi ne inbieno
p ch so morti e elovo ogani e fermo

231. *Michelangelo. Autograph inscription with sketches of two urns for New Sacristy and male nude figure. British Museum, London, 1859–5–14–823v (C. 185v)*

232. *Michelangelo. Sketch for double tomb of the Magnificents. British Museum, London, 1859–6–25–543v (C. 189v)*

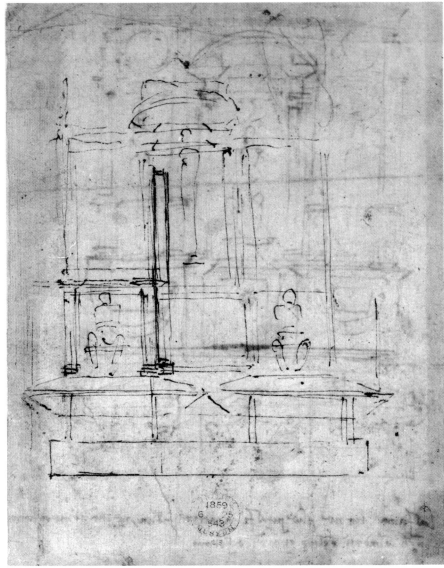

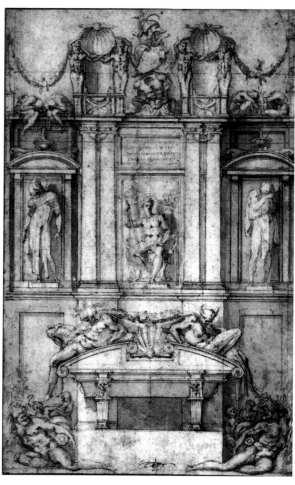

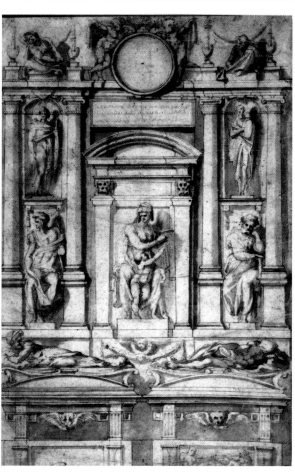

here of the chapel . . . Stefano has finished by putting it on and unveiling it, and it is universally pleasing to everyone. . . . I had the ball made about a *braccio* high, and, to make it different from the other one, I thought of making it faceted, which I believe will have grace" (DCLXXXVII, DCLXXXVIII; Milanesi 1875 and Thode 1902–12 dated the letters in 1524). The copper ball (see fig. 108) was executed by Giovanni di Baldassare called Piloto to whom payments were made between April 1524 to May 1526 (published by Gronau 1911). Three drawings have been proposed as studies for the lantern: fig. 236 (Tolnay 1948); and figs. 235 and 237 (Wallace 1989). For the problem of illumination from above, see Frommel (1967).

Work on the funerary monuments, the doors, and the windows progressed rather slowly, between delays in marble shipments, difficulties with stonecutters, defects in materials, and the indecisions of Michelangelo, who seemed still inclined to change some details of the tombs. While in April 1524 he was sure of being able to build the architectural framework of the two ducal tombs within a year (DCXXVIII), in June 1526, only the first one had been built (DCCLII).

In late January or early February 1524, he requested from Rome "the receipt of the plasters" (DCXIV), and after the scaffold was installed in February, he had "one of the panels on the ceiling [prepared], so that those who have to make it of stucco will see how it has to be (*Ricordi* CXVI, CXVII). Not until April 1526, however, did he request the assistance of Giovanni da Udine to execute in stucco his designs for the ceiling coffers (DCCXLVII). An autograph drawing for this figural decoration, different from what was actually executed, is shown in fig. 105. Although Giovanni promised to come to Florence in September 1526 (DCCLVI), he was not able to begin work until October 1532. With the decoration nearly completed, the project was then suspended in August 1533. Giovanni's stucco decoration has disappeared and is known only from Vasari's description as "the most beautiful foliage, rosettes, and other ornaments of stucco and gold, [and] on the

flat edges which make the ribs of the ceiling and those which come across, enclosing the panels, . . . foliage, birds, masks, and figures which are not seen from the ground level, because of the height of the location, although they are very beautiful." A triumph of pure elegance, "which glittered like a mirror" (Vasari), they were in agreement with the refined, abstract vegetal decoration of the thrones, the tragic masks of the capitals (see fig. 5; attributed by Popp 1922 to Silvio Cosini da Fiesole), and the frieze of *grottesche* which once ran below the thrones (removed in 1556, when the Sacristy was replastered).

Autograph sketches of architectural details for the New Sacristy include: fig. 238, a study for the "perspective" windows in the lunettes below the dome, one of the most celebrated and original inventions in the chapel; fig. 240, studies for the thrones atop the double pilasters flanking the ducal tombs, whose high backs were eliminated during execution, probably because the *pietra serena* cornice was placed lower than originally planned; fig. 239, splendid studies for the pilaster bases; and two sheets of studies for masks (British Museum, London, 1859–6–25–557r [C. 236r]; and Windsor Castle, 12762r [C. 236*bis*-r], with some reservations by Tolnay).

After the interruption owed first to the Sack of Rome and then to the siege of Florence, during which Michelangelo stood openly against the Medici, the work began again only in 1531. The artist subsequently built and completed the second tomb, but he left the monument for the Magnificents unfinished at the time of his departure for Rome in 1533. The statues for it, left incomplete in the chapel (which opened in 1545), were finally finished by Tribolo and Raphael da Montelupo in 1559, and, with slabs of marble remaining in Michelangelo's Florence studio, the sarcophagus for the Magnificents was constructed against the entrance wall and used as a base for the statues.

The tombs of the Medici popes

Returning to an early problem, the matter of tombs for the Medici popes, Giovanni Fattucci advised Michelangelo in

235. *(left) Michelangelo. Two studies for lantern of New Sacristy, and sketches for door. Casa Buonarroti, Florence, A 118v (C. 587v)*

236. *(above right) Michelangelo. Study for plan of lantern of New Sacristy. Casa Buonarroti, Florence, A 70r (C. 207r)*

237. *(below right) Michelangelo. Plan for lantern of New Sacristy (semicircle from joining two sheets). Casa Buonarroti, Florence, right sheet: A 117v (C. 586), and left sheet: A 118r (C. 587r)*

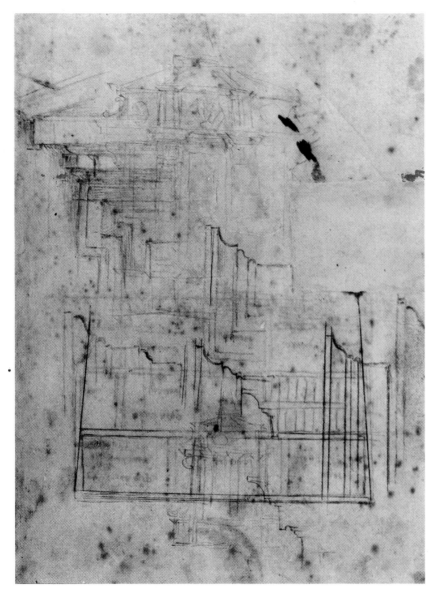

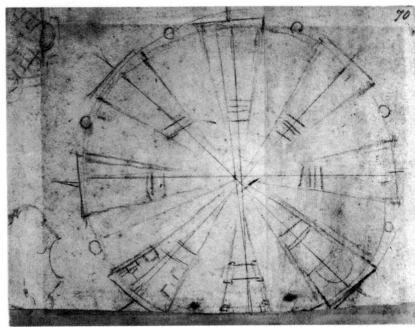

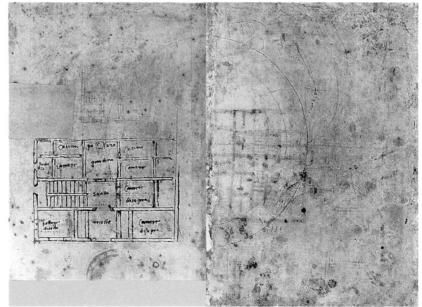

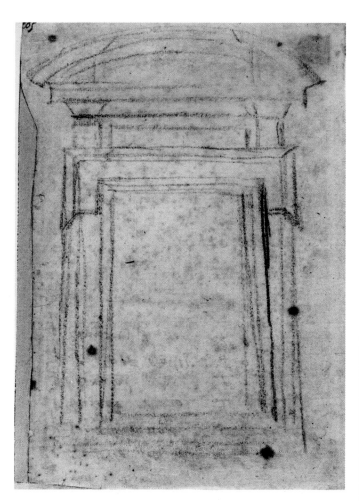

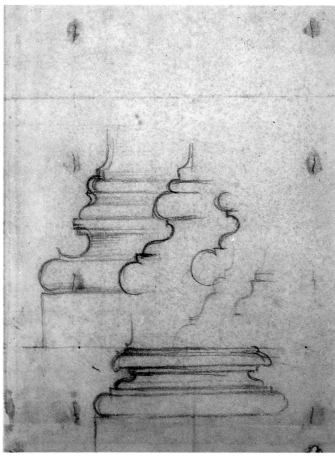

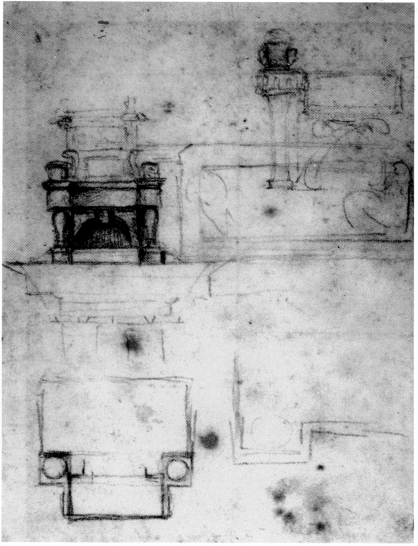

238. *Michelangelo. Study for "perspective" window of New Sacristy. Casa Buonarroti, Florence, A 105r (C. 205r)*

239. *Michelangelo. Study for base of pilasters for New Sacristy. Casa Buonarroti, Florence, A 9r (C. 202r)*

240. *Michelangelo. Two ground plans and two views of thrones. Casa Buonarroti, Florence, A 72 (C. 199r)*

a letter of May 23, 1524 that, at the suggestion of Jacopo Salviati, Clement VII intended to place in the new chapel, "if there was room," in addition to the tombs of the two young dukes and the two Magnificents, "two caskets" for himself and his defunct cousin Leo X (DCXL). A few days later on May 29, "a little sketch" was requested from the artist, who was to take into account that "the most honorable place should be reserved for the popes" (DCXLI). Instead of sending the requested design, Michelangelo apparently proposed placing the papal tombs in another location, because Fattucci responded on June 7 that

"the idea about the tombs . . . pleases Our Lordship, only he was doubtful about the light of that washroom where the stair is." Fattucci himself thought that this "seemed a small place for two popes," in spite of Michelangelo's idea to enlarge the space with "some coffers," probably only illusionistically (DCXLIII). On June 25, the date on which the receipt of a design for the tombs was acknowledged, Fattucci emphasized that, while Clement was "very pleased," it was a question of "making them very beautiful" without sparing the expense, because "he feared that those of the dukes will be more beautiful than those

241. *(above) Michelangelo (attrib.). Design for papal tomb. Formerly, Kupferstichkabinett, Dresden, C 49r (C. 276r)*

242. *(below) Michelangelo. Design for papal tomb. Ashmolean Museum, Oxford, Parker 307r (C. 187r)*

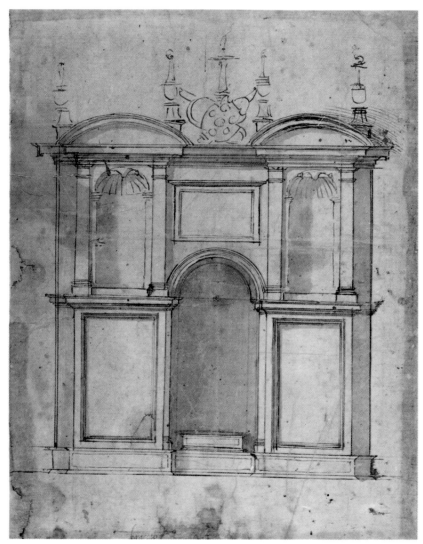

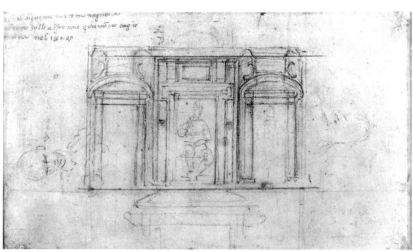

of the popes." This was in reference to Michelangelo's idea of locating the tombs in the place he had proposed prior to June 7, because he was asked to estimate the cost of the "house which deprived the washroom of light," in order to acquire it and tear it down (DCXLVI). Independently of the decision about the specific location, authorization was given on July 9 to extract the marble for the papal tombs (DCXLVIII), which was done between July 21 and August 13, 1524 (DCLIV, DCLVIII), even though the first doubts were already being expressed by the pope. In the July 21 letter, his scribe wrote to Michelangelo: "[He] wishes that you would think if in the church, in the choir or elsewhere, there was an honorable and larger site. . . . Although that of the washrooms does not displease him, he worried whether it was not a small place for the popes" (DCLIV). Other plans must have been developed, because, on April 12, 1525, Fattucci forwarded the designs "for the tomb of the Pope," together with those for the Laurentian Library (DCXCV). Further solicitations were made in October (DCCXVII) and November 1525 (DCCXXVII), and in June 1526, a final proposal appeared from Rome. In view of the difficulty of installing the tombs in the two washrooms and the impossibility of finding a suitable place elsewhere in the church, "it would be possible to tear down Santo Giovannino [degli Scolopi] as far as the alley, and to make a round temple and put both of the tombs there," at an estimated cost for the pontiff of around 50,000 ducats (DCCL). Still mentioned as late as September 1526, the enterprise was put to an end by the events surrounding the Sack of Rome of 1527. After the death of Clement VII in 1534, the commission to execute the tombs of the two Medici popes was given to Alfonso Lombardi, who had a model with wax figures made "after some sketches by Michelagnolo Buonarroti" (Vasari) for monuments to be placed in the Church of Santa Maria Maggiore in Rome. Lombardo was succeeded in 1536 by Baccio Bandinelli, and finally the tombs were erected by Antonio da Sangallo the Younger in the choir of Santa Maria sopra Minerva in Rome.

Much discussed has been the identification of the "washroom where the stair is," in which Michelangelo had thought of placing the pontifical tombs. In all probability, it was the small space to the left of the choir inside the New Sacristy (see fig. 127), where a sixteenth-century ground plan first published by Tolnay in 1948 (The Metropolitan Museum, New York) shows a stair that no longer exists. Ackerman (1961) pointed out that the hypothesis of Popp (1927), according to which the washroom might be identified with one in a similar location in the Old Sacristy, was contradicted by the proposal of June 1525 to tear down a house which took away the external light, whereas the Brunelleschi sacristy was backed by a garden. By June 1526, "two washrooms" were specified, one for each monument, therefore the idea must have been to utilize both spaces flanking the choir in the Medici chapel (cf. fig. 123; see Dal Poggetto 1979).

Several drawings, not all autograph, have been related to the planning of the Medici papal tombs. One in Dresden (fig. 241), discussed as autograph, was proposed by Popp (1927) as the first design for the monument to be placed in the "washroom." Wilde (1953) refuted this on the basis that the Medici arms did not have the added pontifical insignias, but this objection is negated by the letter of June 6, 1526, which stated that Clement "did not want there the arms of the Pope but those of the House with the liveries" (DCCL). Clement would make a similar request with regard to the arms to be placed on the Tribune of the Relics in San Lorenzo. Ackerman's objection (1961) to identifying fig. 241 as the first design was on the grounds that the monument as shown would not have fit the small space inside the Medici chapel (but the measurements were disputed by Frey 1951). Without doubt related to the papal tombs are two drawings representing a tomb with three zones, having in the center a statue of a pontiff in the act of blessing (figs. 242, 243), although neither of these was accepted as autograph by the *Corpus*. Popp (1927) identified a drawing of a funerary monument in the Casa Buonarroti (A 128r [C. 279r]) as a design for the papal

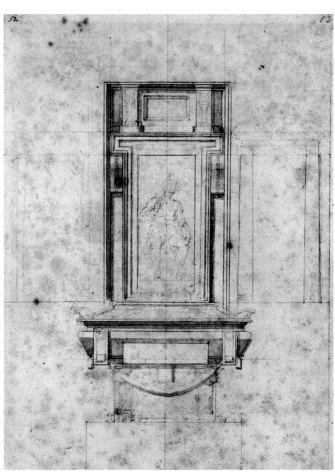

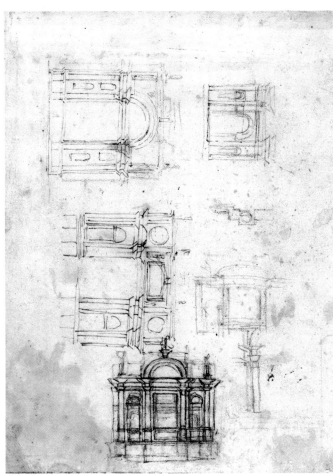

243. Michelangelo. Alcove for tomb monument of a pontiff. Casa Buonarroti, Florence, A 52 (C. 188r)

244. Michelangelo. Studies for monument in form of triumphal arch, probably for tomb of Medici popes in San Lorenzo. British Museum, London, 1895–6–25–559r (C. 272r)

245. Michelangelo. Design for monumental wall tomb, perhaps for Medici popes (above), and studies for walls of reading room or vestibule of Laurentian Library. British Museum, London, 1895–9–15–507r (C. 192r)

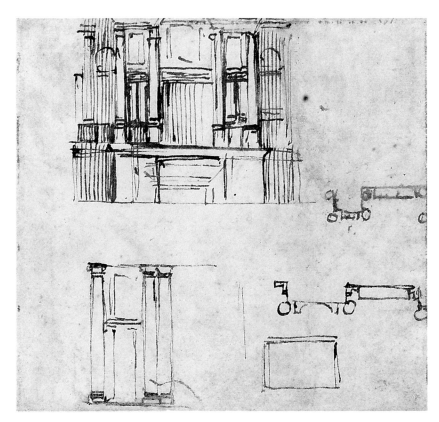

tombs to be located in the choir of San Lorenzo, for which a preparatory sketch, also in Casa Buonarroti (A 116 [C. 190]), was considered completely autograph by Hirst (1989). Other related drawings are: fig. 22; figs. 21 and 245, identified by the *Corpus* however as referring to the tomb of the Magnificents; and Archivio Buonarroti V, 38, f. 213v (C. 278v). All of these are close in style to the Laurentian Library and should therefore be dated c. 1526 (Ackerman 1961). Dal Poggetto (1979) has connected several full-scale elevation drawings for the apse of the Medici chapel, rediscovered by him, with the papal tombs destined for the choir area (New Sacristy, Florence, nos. 97, 110, 134, 135).

As for the designs prepared in 1534 by Alfonso Lombardi with a view to locating the papal tombs in Santa Maria Maggiore (copied from those of Michelangelo, according to Vasari), the *Corpus* identified two drawings in Christ Church, Oxford (0992v, previously DD 24 [C. 280v]; and 0993r, previously DD 26 [C. 282r]), which Shaw (1976) related instead to the design for the tombs to be placed in the Medici chapel.

185

According to the "memoir" of Giovanni Battista Figiovanni, Cardinal Giulio de' Medici communicated to him in June 1519, in the name also of his cousin Pope Leo X, the intention to construct in San Lorenzo, the Medici family church, "the library and the sacristy" (Corti-Parronchi 1964). Although the idea to create both was conceived by the patrons at that time, and work began on the New Sacristy (No.11) almost immediately, the construction of the library, in which to place the rich collection of books begun by Cosimo de' Medici il Vecchio and added to notably by Lorenzo de' Medici the Magnificent, became concrete only after Giulio was himself elected pontiff on November 19, 1523, assuming the name of Clement VII. Following a brief visit in Rome around December 10, Michelangelo submitted a first design for the library, which arrived in Rome on December 30 (DXCVI). On January 2, 1524, Giovanni Fattucci requested on behalf of the pontiff "another design" providing the "measure of both libraries, that is, of the Latin and of the Greek," because the preceding plan had not given the length of the section reserved for the Greek works. He also warned Michelangelo to take care "because, at the entrance to the library, it seems that there has to be a little light" (DC).

Subsequent to a letter in which Michelangelo admitted not knowing "where he wanted to make [the library]" (DCII), a plan of the Monastery of San Lorenzo arrived in Rome on January 21, which rendered graphically the placement of the library inside the Laurentian complex. On January 30, the Rome correspondent informed the artist that, while Pope Clement "was addressing himself to making that one which is on the south side," he had expressed his wish not to intervene too much in the rooms below, which belonged to the religious, in the building of the footings. Also, he stated his preference for a vaulted ceiling for the purpose of preventing fires, and he asked for a plan of the lower level in order to consider the eventual work to be carried out in the cloister areas (DCX). On February 9, Fattucci wrote: "[Because the previous plan showed] that seven rooms above would

be ruined and below another seven would be harmed, . . . [thus] half the convent would be broken up, [the pope proposed] that the library go up on the piazza towards the Santo Lorenzo quarter," in which case, he wanted assurance that "those who removed the priests or other tenants from the shops and houses which would be taken for the library, and for the shops going below there, [would] indemnify the priests for their loss" (DCXIV). Evidence that this proposal was seriously considered exists in the form of two records of it by Figiovanni and a plan by Michelangelo indicating the real properties surrounding the Piazza San Lorenzo (fig. 14). On March 10, two more plans arrived in Rome, following which Fattucci communicated that the pontiff was favorable to the one which anticipated placing the library "on the side of the piazza," with measurements of ninety-six braccia long and six braccia high from the entrance level and having a coffered ceiling. And he again requested a vaulted ceiling for the spaces below. Also, "at the back of the library, . . . [the pontiff] has designated two small studies on either side of the window which faces the library entrance. And in these studies he wishes to place certain very secret books, and he wants to employ these again on either side of the door" (DCXVIII). On March 22, the site selection for the library was confirmed, even though it was admitted that the exposure would not be optimal: "It will not be good in either the summer or the winter" (DCXXIV). After Michelangelo claimed, rather incredibly, that the intervening correspondence had gone astray, Fattucci finally wrote this on April 3: "Our Lordship says that you can make the library where you want it, that is above the rooms on the side of the old sacristy, and your consideration with respect to the façade of San Lorenzo pleased him very much." The little studies (studioli) "of six braccia each" were still anticipated to go two "at the back of the library [with] a window in between . . . and two others with the door in between" (DCXXVIII).

Several drawings have been proposed as studies for the location of the library, which was the main object of the correspondence between the papal court and

Michelangelo from January through April 1524. The sketch in fig. 247 has been connected with the library location "on the south side," which was accepted by the pontiff in the letter of January 30 and subsequently rejected due to the excessive work necessary in the convent areas. This ground plan shows the library orientation as it would actually be carried out, but disposed on the south instead of the west side of the main cloister and resulting in the obstruction of the smaller cloister. The drawing in fig. 248 shows a different solution in which the body of the reading room was placed parallel to the church. As Wilde (1953) demonstrated, these two drawings were made on the same sheet of paper, which was only later cut into two pieces, therefore the alternative plans are contemporaneous and, in all probability, datable to January 1524.

There is no graphic evidence for the initial concept which featured a separate arrangement for the Latin and the Greek sections in the library, but Joannides (1981) proposed that the elevation drawing in fig. 249, previously interpreted as an early design for the interior of the reading room, was related instead to the idea of locating the library on the Piazza San Lorenzo. In my opinion, this solution, which the correspondence places around February 9 (DCXIV), was rejected only on April 3 (DCXXVIII) at Michelangelo's explicit request, evidently because it would interfere with the project for the façade of the church. Ackerman (1961) believed however that the definitive solution was proposed on March 10.

With the location for the library finalized (see fig. 246), the problem of the footings was under consideration by April 13 (DCXXXIII). From the letters, it is clear that Michelangelo intended to increase the thickness of the existing walls by more than one Florentine braccio (DCXXXVI), consequently "breaking everything from the first floor up . . . to make stone pilasters on the inside and outside of the rooms" (DCXXXVII). But Fattucci persisted in the notion that, because it was not necessary "to support anything but the roof," there was no need to do the difficult and costly work

of demolitions and footings. With the advice of Baccio Bigio, the final structural solution was worked out between May and June, in which the load-bearing walls would be replaced by external buttresses having corresponding interior pilasters (studied in fig. 253). This method of construction imposed heavy limitations on the development of the reading room interior, however. Unable to conceive it strictly in terms of wall articulation, Michelangelo resolved the problem by a rhythmic alternation of windows and pilasters, whose scansion was determined by the preordained system of statics. Following pontifical approval of the new system on July 9 (DCXLVIII), the artist sent some estimated costs, which were accepted on August 2 (DCLV). This opened the way to construction, which did not provide at first for the crociera, or groin-vaulted ceiling, although the architect was asked to allow for the possibility of adding it later. While the actual execution was supervised by Baccio Bigio so that Michelangelo could "with more leisure attend to the figures" for the New Sacristy (DCLXIV), the sculptor remained in complete charge of the project, as the pope specified in authorizing the work arrangement.

The reinforcement of the existing structures began in October and continued through the entire winter of 1524–25. Figiovanni, who had criticized the location of the library in a letter to Clement VII, saying that they were making "the library in a pigeon roost" (DCLXIV, DCLXVI), asked the artist in early October for information about the method of vaulting for the rooms below the reading room (DCLXVII), and on November 6, he was told that "some of those strong stone pilasters have been built" (DCLXXIII). In January 1525 payments were made for work on the demolition and the footings (Gronau 1911), and in February the stone arrived "for a window of the library" (Ricordi CLX). In April, the long walls were under construction, and, April 12, Clement approved "the designs of the windows . . . inside and outside, and also those niches inside over the windows" (DCXCV).

To the drawings already connected with architectural details for the win-

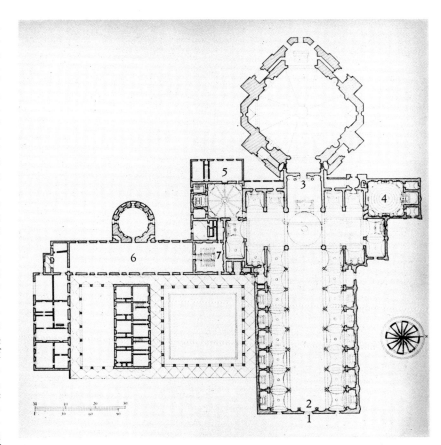

246. *Plan of San Lorenzo complex: (1) façade; (2) Tribune of the Relics; (3) choir; (4) New Sacristy; (5) Old Sacristy; and (6) reading room, and (7) vestibule of Laurentian Library. From Portoghesi-Zevi 1964.*

dows and the pilasters of the reading room, Dal Poggetto (1979) added two elevation drawings showing extraordinary *exempla* of the internal and external windows (figs. 250, 251). These were drawn by Michelangelo in actual size for the carpenter to execute wood models to be used in carrying out the designs in stone.

In a letter of April 12, 1525, Michelangelo's proposal was accepted to make, in place of the two staircases proposed and accepted a year earlier by the pope (DCXXXVI, dated April 29, 1524), only one "which would occupy and take up the whole vestibule." In addition, the pope "said that he did not want the chapel at the end of the library, but he wanted instead a secret library to hold certain books more precious than the others." Not until November 10, 1525 did some "designs for the little library" arrive in Rome, which the pontiff accepted and "wanted made there . . . as designed" (DCCXXVII). Also, he assigned Giovanni Spina to acquire the adjacent house owned by Ilarione Martelli to be demolished in part to allow for the library construction.

On April 3, 1526, following Michelangelo's request for the "resolution of the little library, so that he could make the mezzanine level between the vestibule and the library," Clement responded by remarking that, "when the little [library] was done, what he wanted done then was for the vestibule to be finished" (DCCXLV). The cessation of the work as a result of the events of 1527–30, however, condemned to the "not-finished" Michelangelo's extraordinary design, which would have placed the concluding episode of the long reading room—that is, the secret library—in a formal relationship with the strong "prologue" of the vestibule. (The interpretation of this by Wittkower 1934 in an "expressionistic" vein was subsequently argued against by Sinding-Larsen 1978.)

Wittkower (1934) was the first to identify with reason the sketch at the top left of the drawing in fig. 254, of a rectangular space surmounted with an oval dome supported on corner pilasters and two side pilasters, as the "chapel" to be located off the reading room. He con-

nected it with "the one added at the end of the library," mentioned by Fattucci in the letter of August 2, 1524 (DCLV) and specifically rejected by the pope in April 1525. Tolnay (1935) proposed fig. 510 as the elevation for the ground plan in fig. 254, but Wilde (1953) considered this drawing to be related to the idea to locate the tomb of the Medici popes in the choir of San Lorenzo. Unanimously accepted as relating to the rare-books rooms are two splendid sheets in the Casa Buonarroti (figs. 255, 256), variants of a small room of triangular shape with niches and corner columns, whose walls have no outside opening and the only light comes from the top through circular openings. The dating of these two sheets, with fig. 256 constituting the more developed version, can be placed between April and November 1525. This range could well be narrowed, however, if the *terminus ante quem* was considered to be August 1525, the date referred to in the first record of payment noted on the verso of fig. 255. Just previous to November 29, 1525, Michelangelo had written to Rome about being "resolved to make the vestibule," but on that date Clement conveyed his objection to the artist's design because the "windows over the roof with those glass oculi in the ceiling, something new and beautiful," would be very difficult to maintain, and, he added, "it would be necessary to marshal two Jesuit brothers who would do nothing else but clean off the dust" (DCCXXVIII). On December 23, Clement sent the message that "raising the wall by two *braccia* to make the windows," as Michelangelo had proposed, was a question of verifying "if the weight will be supported and [if it will] do damage to the building" (DCCXXXII). On January 20, 1526, Piloto, writing to Michelangelo from Venice, said that he intended "to begin to build the vestibule" (DCCXXXV). Wittkower (1934), who reproduced the old Brogi photographs made prior to the complete restoration of the façade of the vestibule in 1903, noted that the wall addition of about one meter in height was still quite visible at that time.

For the planning of the vestibule, a series of studies can be dated from the

187

247. (above left) Michelangelo. Plan of Monastery of San Lorenzo with proposed location of Laurentian Library. Casa Buonarroti, Florence, A 10v (C. 201v)

248. (above right) Michelangelo. Plan of Monastery of San Lorenzo with proposed location of Laurentian Library. Casa Buonarroti, Florence, A 9v (C. 202v)

249. (below) Michelangelo. View of Laurentian Library in proposed location on side of Piazza San Lorenzo. Casa Buonarroti, Florence, A 42r (C. 541r)

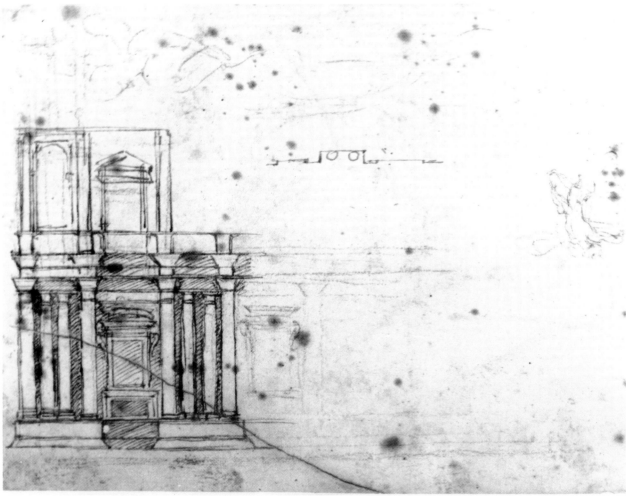

250a. *Michelangelo. Wall drawing with example of window for interior of reading room of Laurentian Library. New Sacristy, San Lorenzo, Florence, no. 137.*

250b. *Tracing of fig. 250a from Dal Poggetto (1979)*

251a. *Michelangelo. Wall drawing with example of window for exterior of reading room of Laurentian Library. New Sacristy, San Lorenzo, Florence, no. 112.*

251b. *Tracing of fig. 251a from Dal Poggetto (1979)*

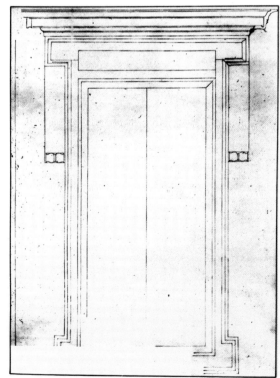

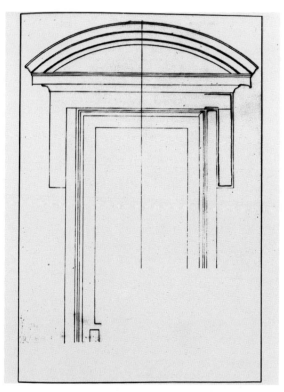

frequent correspondence between the artist and his patron. Clement VII had accepted the idea of double flights of stairs at the end of April 1524, therefore the following sheets can be dated to the intervening twelve months up to April 1525: fig. 257, an arrangement providing the simplest solution of stairs placed against the east and west walls leading up to a landing on the south wall outside the reading room; figs. 258 and 259, presenting variants of the design for the west wall, of a design very similar to that of the reading room, but, as Ackerman noted, predicting obvious problems due to the excessive height of the lower wall zone, which rose about six *braccia* from the ground; and fig. 254 (bottom of sheet), a design dividing the nearly three-meter rise of the stairs into more sections, perhaps to provide more space for architectural divisioning on the east and west walls and thereby reduce the height of the bottom wall zone. Here the side ramps terminate in separate landings with four steps up to a common central landing and three more steps from there up to the reading room entrance. The difficulty of achieving a unified treatment of the four walls while maintaining two separate flights of stairs must have been viewed as insurmountable, because, in April 1525, Michelangelo proposed a single staircase occupying the whole central space of the vestibule. This freed up the side walls completely, as is seen in successive studies on one sheet, recto and verso (figs. 157, 260), which may even have preceded the letter of April 3 due to their very experimental character.

Michelangelo then concentrated on the solution to another pressing problem. Maintaining the overall height of the vestibule with a vaulted ceiling equal to that of the reading room with a flat ceiling would result in the main (second) level of the vestibule being sufficiently lower in height as to involve a difference of modulation (at this time, Michelangelo also studied the rarebooks room, which posed a similar difficulty). A wall view without stairs on the side walls (fig. 261; verso in fig. 263) shows pairs of embedded columns and pilasters flanking niches projecting outward in the form of aediculae, with

circular windows above to provide illumination. Fig. 262 represents a study for the bottom zone of the vestibule close to that in fig. 261, also with the embedded columns and still considering a vaulted ceiling, as seen in the light sketch visible under the main drawing by turning the sheet ninety degrees clockwise. This drawing is nearer the final solution, however, because it depicts the volute brackets and the framed panels below the aediculae.

Michelangelo's proposal to eliminate the uppermost level of the vestibule and move the oculi to the ceiling, clearly to allow for a greater development in height of the second level, was rejected in November 1525 by Clement VII, and the artist accepted the counterproposal to raise the body of the vestibule by two *braccia*, thus interrupting the external integrity of the building. The choice of a flat ceiling instead of the more cumbersome vaulted one allowed for maximum elevation of the vestibule, but, in January 1526, when the footings were begun, this was still only partially defined. The three drawings in figs. 264–266, which are certainly related to the window design for the top level of the vestibule, can therefore be dated either between December 1525 and the early months of 1526—or even later to 1532–33, if one agrees with Wilde (1953) that the sketch of a hand present on the verso of fig. 266 refers to a group, *Venus and Cupid*, by Bartolomeo Bettini (see fig. 15). Acceptance of the later date, of course, would provide evidence that none of the four walls of the vestibule were completed at the time of Michelangelo's departure for Rome in 1533 (Ackerman 1961).

In mid-1526, the design for the entrance door to the reading room, approved on April 17, 1526 (DCCXLVII), was most certainly defined, and figs. 267–269 and 275 have been identified as preliminary studies for it. At least five columns for the vestibule had been constructed, and Michelangelo had given assurance that he would complete the aediculae in four months (DCCLII). The reading room was nearly finished (and even roofed according to Gronau 1911), except for the ceiling, floor, wood furnishings, and window glazing.

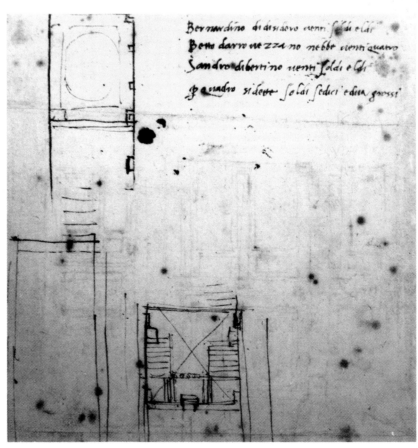

252. *Michelangelo. Plan with proposed location of Laurentian Library. British Museum, London, 1946–7–13–33v (C. 561v)*

253. *Michelangelo. Construction plan with pilasters for Laurentian Library. Archivio Buonarroti, Florence, I, 160, f. 286 (c. 545r)*

254. *Michelangelo. Plan for "chapel" at rear of reading room, and plan of vestibule for Laurentian Library. Casa Buonarroti, Florence, A 89v (C. 524v)*

opposite:

255. *(above left) Michelangelo. Two plans for "little library," and partial view of wall for Laurentian Library. Casa Buonarroti, Florence, A 79r (C. 559r)*

256. *(center left) Michelangelo. Plan of "secret library" for Laurentian Library. Casa Buonarroti, Florence, A 80 (C. 560r)*

257. *(below left) Michelangelo. Ground plan of vestibule for Laurentian Library. Archivio Buonarroti, Florence, I, 80, f. 219 (C. 523r)*

258. *(above right) Michelangelo. Elevation and ground plan of vestibule for Laurentian Library. Teylers Museum, Haarlem, A 33a-v (C. 218v)*

259. *(below right) Michelangelo. Elevation of staircase and ground plan of vestibule, and elevation of reading room for Laurentian Library. Teylers Museum, Haarlem, A 33b-v (C. 219v)*

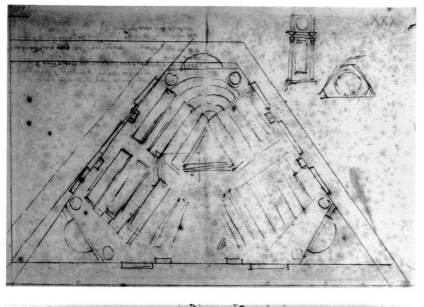

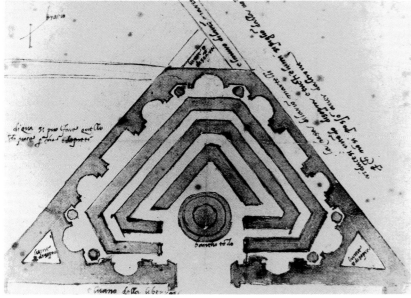

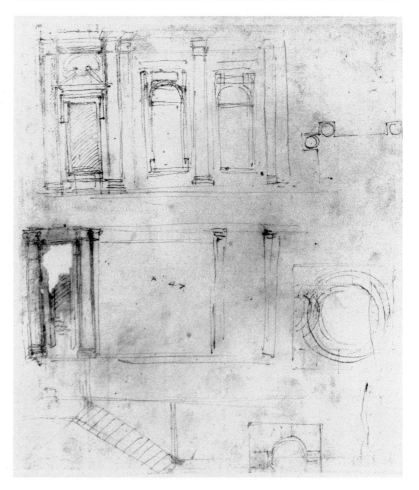

260. *(left) Michelangelo. Design for vestibule stairs of Laurentian Library; profiles of column bases; figure studies; and sketch of niche. Casa Buonarroti, Florence, A 92v (C. 525v)*

261. *(right) Michelangelo. Study of vestibule wall for Laurentian Library. Casa Buonarroti, Florence, A 48r (C. 527r)*

opposite:

262. *(above left) Michelangelo. Study for lower zone of vestibule wall for Laurentian Library. British Museum, London, 1895–9–15–508r (C. 528r)*

263. *(below left) Michelangelo. Study for vestibule wall for Laurentian Library. Casa Buonarroti, Florence, A 48v (C. 527v)*

264. *(above right) Michelangelo. Study of window flanked by columns or paired pilasters for top level of vestibule for Laurentian Library. Casa Buonarroti, Florence, A 39r (C. 553r)*

265. *(below right) Michelangelo. Design of window for top level of vestibule for Laurentian Library. Casa Buonarroti, Florence, A 39v (C. 553v)*

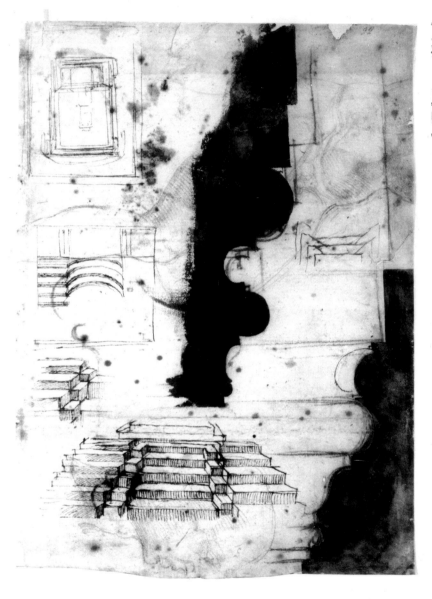

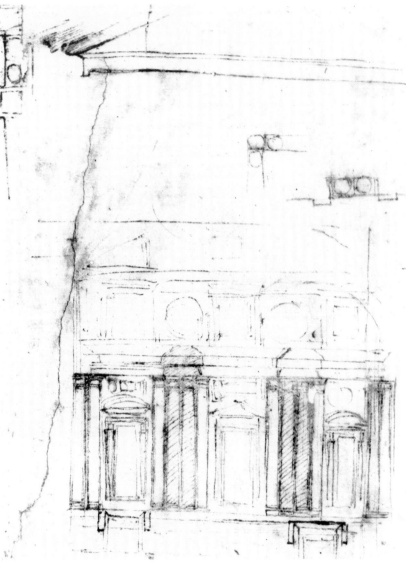

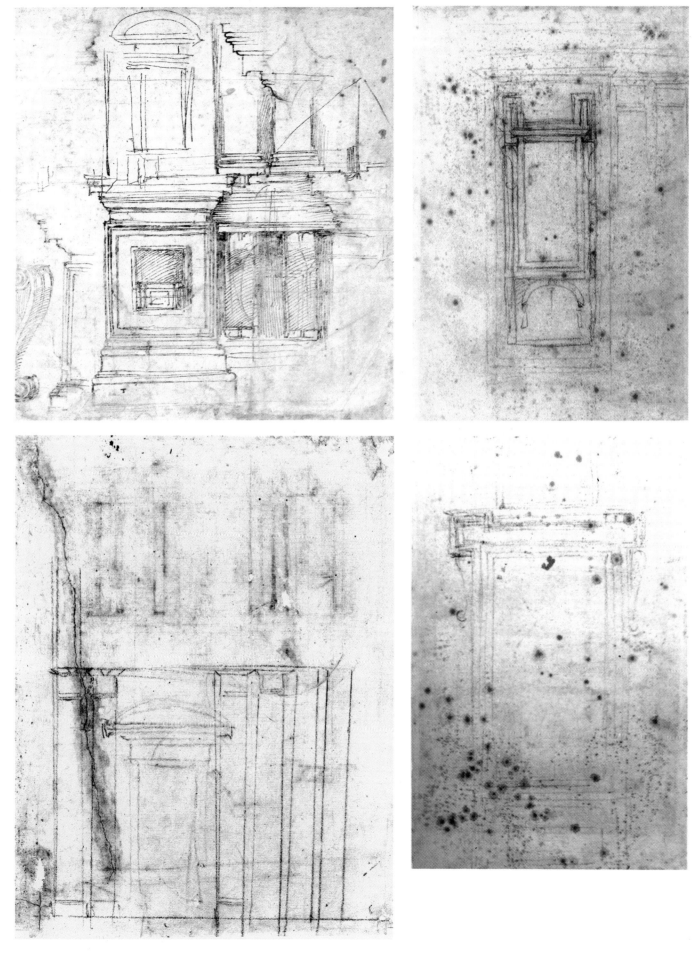

266. *Michelangelo. Design of window for top level of vestibule for Laurentian Library. Casa Buonarroti, Florence, A 37r (C. 226r)*

267. *Michelangelo. Study for door between reading room and vestibule for Laurentian Library. British Museum, London, 1859–6–25–550r (C. 554r)*

268. *Michelangelo. Studies for door between reading room and vestibule, and for exterior window of reading room for Laurentian Library. British Museum, London, 1859–6–25–550v (C. 554v)*

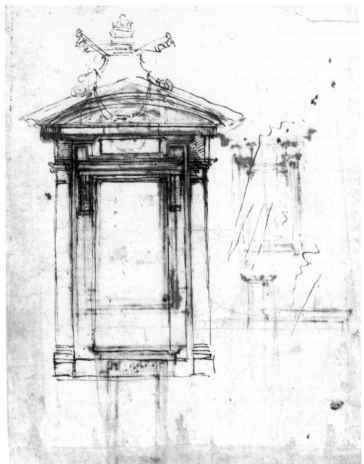

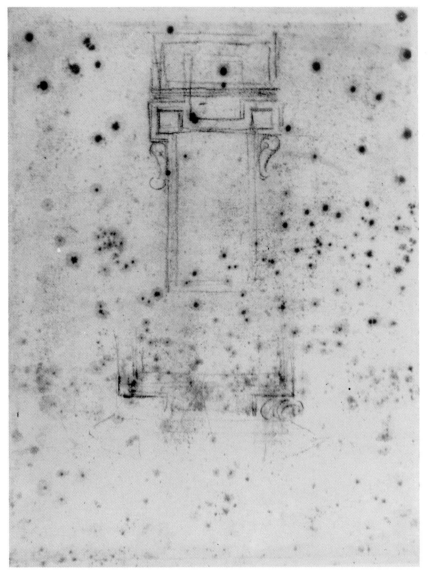

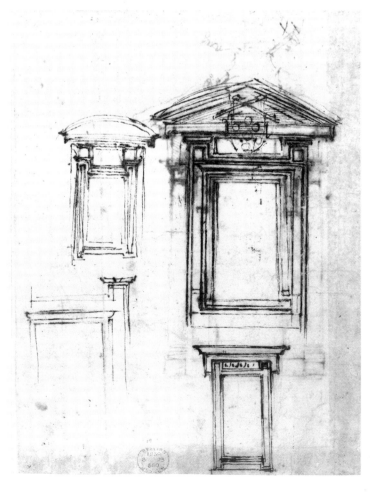

269. *Michelangelo. Study for door between reading room and vestibule for Laurentian Library. Casa Buonarroti, Florence, A 111 (C. 555r)*

270. *Circle of Michelangelo. Design for door from cloister into vestibule for Laurentian Library. Casa Buonarroti, Florence, A 95 (C. 549r)*

On July 17, 1526, Fattucci informed Michelangelo that the pontiff "did not wish for now to spend so much on the library, and wanted the monthly expenses reduced by two-thirds" (DCCLVI). On October 16, he communicated that, as "for the ceiling of the library, for now nothing should be done" (DCCLIX), although the artist was assured that "the cause was not the wish of, but the occupations and stresses with which His Holiness was and is involved" (DCCLXI). Progress on the library construction had definitely slowed by November 4, 1526, and the pope's "stresses," which had been of an economic nature in 1526, soon became political, first with the Sack of Rome in 1527 and then with the succeeding problems of the Florentine Republic.

Shortly before leaving Florence for Rome, Michelangelo commissioned the woodcarvers Battista del Cinque and Ciapino in August 1533 to make the reading desks. These had already been designed by August 1524 "not simply as furniture but as necessary elements integrated with the architecture." (Portoghesi-Zevi 1964). Autograph designs for the desks are preserved: fig. 271; fig. 511; and Buonarroti Archive, Florence, XIII, f. 79v (C. 557v). According to Figiovanni's memoir, in September 1534, shortly before the death of Clement VII, six carpenters were at work on the construction of the desks and another six were cutting the panels for the ceiling, the design of which had been confirmed by April 1526. A drawing for the ceiling panels, certainly autograph and very close to the final solution, is shown in fig. 272. Perhaps a bit earlier in date, according to Tolnay (1935), is the sketch for the ceiling in fig. 273. Executed by Battista del Tasso and Antonio di Marco di Giano called Caroto (Vasari 1568), the ceiling was completed after 1537, because it bears the insignia of Cosimo I de' Medici. The flooring in the reading room was made between 1549 and 1554 by Santi Buglioni after the design by Tribolo, who then "had the whole ceiling rebuilt and installed above" (Vasari). The window panes bear dates of 1558 and 1568.

The status of the library, probably around 1535–40, is recorded in

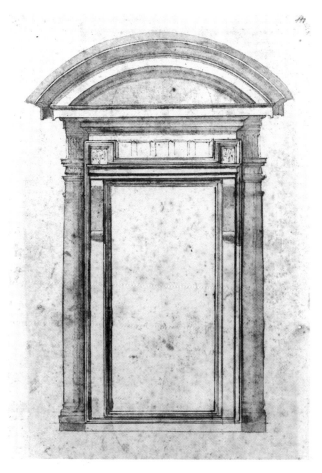

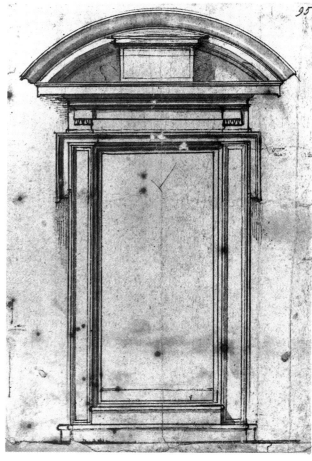

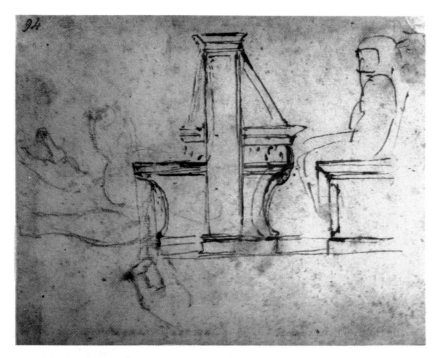

sketches in the Lille Notebook, attributed in recent times to Raphael da Montelupo and Aristotile da Sangallo (Nesselrath 1983), which were then copied by Oreste Vannocci Biringucci in his Notebook preserved in the Biblioteca Comunale, Siena (S.IV.1). Of particular interest in these is the fact that the vestibule is shown complete except for the top level still in rough stone. On August 30, 1533, Michelangelo had hired five stonecarvers to execute the cornices for the doors, as well as the

large staircase according to a clay model described in the contract. One of the doors was certainly that to the reading room, a drawing for which (fig. 274) bears the autograph inscription "to Cechone" (Francesco d'Andrea Luccherini), one of the five stonecarvers. The other door from the cloister into the vestibule—for which a design probably by an assistant is shown in fig. 270—was executed in a different manner only in 1687. For whatever reason, the staircase was not executed in Michelangelo's

absence, and Vasari (1568) recalled that "in the time of Paul III," Tribolo, on the charge of Duke Cosimo, went to Rome and tried, unsuccessfully, to persuade the artist to return to Florence in order to finish the New Sacristy and the Laurentian Library. Vasari wrote: "[Tribolo then] asked . . . about the stair of the library of San Lorenzo, for which Michelangnolo had had many stones cut, and there was no model for it nor sure note of the form, and although there were traces on the ground in the brick flooring and different clay sketches, the actual and final resolution had not been found." Michelangelo, assuming an almost agitated attitude, "responded only by saying that he didn't remember about it." Not having been able to figure out "either the measurements, or anything else," Tribolo finally abandoned the project a little before 1550, "having set up four large steps" (Vasari 1568; for Tribolo's attempt, see Wittkower 1934). When Vasari himself later sought clarifications on behalf of Duke Cosimo, the elderly master responded on September 26, 1555, no less evasively but giving a more concrete idea: "About the stairs for the library, . . . believe me that if I could remember myself how I planned it, then I would not have made [you] ask. A certain stair comes back to my mind as in a dream, but I don't believe that it was what I thought of back then, because I remember it as something awkward. Still, I will write it here: which is, that you should take a quantity of ovate boxes of a depth of one *palmo* each, but not of the same length and width; and the largest and first you should place on the ground as far away from the wall with the door as needed, according to whether you want the staircase to be gentle or steep, and you should put on top of this another one, which is that much less on each side; and in putting it on the first one below, you should advance it forward by how much space you want on the flat surface for the feet to step on; then one after the other continue going up, diminishing and narrowing them towards the door, with the reduction of the last step to the same width as the door. And this part of the staircase should have two wings, on one side and the other, which

should have the same steps, but not ovate. Of this, the middle serves for His Lordship; from the middle up of said staircase, and the sides of said wings should go back to the wall; from the middle down to the pavement, the staircase should be completely detached from the wall about three *palmi*, so that the lower zone of the vestibule was not occupied anywhere, and all the faces are left free. I am writing this in a ridiculous way, but I know very well that you will discover something of its intention" (cited in Vasari 1568). An autograph draft of this letter (MCCXIII; fig. 509), comprising only the last part and varying slightly from Vasari's text, has on it a quick sketch related to the 1555 concept of the staircase (Panofsky 1922).

Three years later, on December 16, 1558, having been asked for advice by Bartolomeo Ammanati "about a certain stair which was to be made in the library of S. Lorenzo," Michelangelo prepared "a bit of a small clay model, as it seems to me that it could be made" (MCCLXXX). The model was sent to Florence on January 13, 1559, accompanied by a letter in which Michelangelo explained: "I have only been able to make the design, remembering that what I had planned there previously was isolated and unattached except at the door of the library. Try to keep the top levels the same way, and the stairs on either side of the main one I do not want to have balusters on the outside like the main stair, but for every two steps a seat, as it is indicated." As for the material of which to make the steps, it would be best if "they were made of wood, that is, of a beautiful walnut, which would be better than of stone and more in keeping with the desks, the ceiling, and the door" (MCCLXXXIV). In giving the go-ahead on February 22, 1559 for the work to be supervised by Ammanati, however, Duke Cosimo ordered "that the stair be made of stone, and not of wood" (Gaye 1839–40). The library, nearly complete, was opened to the public in June 1571. The ceiling inside and the exterior of the vestibule, having been left in an unfinished state, were products of a complete restoration, arbitrary and pedestrian, done in the early years of the twentieth century.

273. (above left) Michelangelo. Design for ceiling of reading room for Laurentian Library. Ashmolean Museum, Oxford, Parker 308v (C. 191v)

274. (below left) Michelangelo. Profiles of jambs, lintel, and molding for door between reading room and vestibule for Laurentian Library. Casa Buonarroti, Florence, A 53r (C. 534r)

275. (right) Michelangelo (attrib.). Study for door between reading room and vestibule for Laurentian Library. Casa Buonarroti, Florence, A 98 (C. 550r)

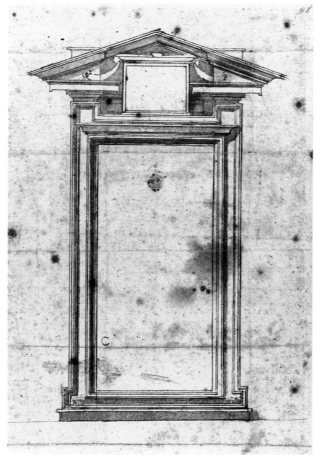

TRIBUNE OF THE RELICS, SAN LORENZO, 1525–33

276. *Michelangelo. Plan of choir of San Lorenzo with baldachin for relics over altar. Casa Buonarroti, Florence, A 76r (C. 285r)*

277. *Michelangelo. Front and side views of tribune gallery over entrance to San Lorenzo, and study of corbel for it. Casa Buonarroti, Florence, A 76v (C. 285v)*

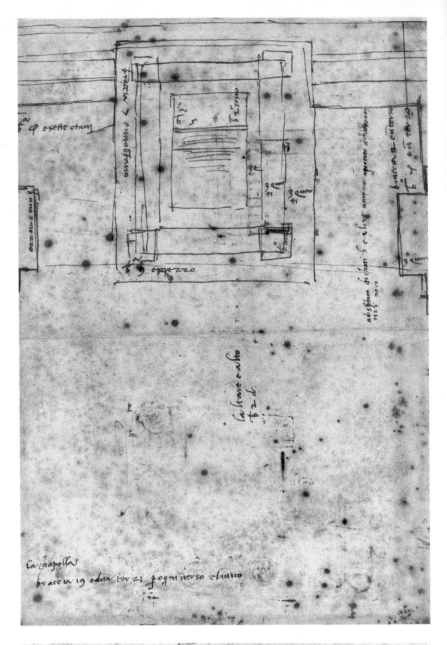

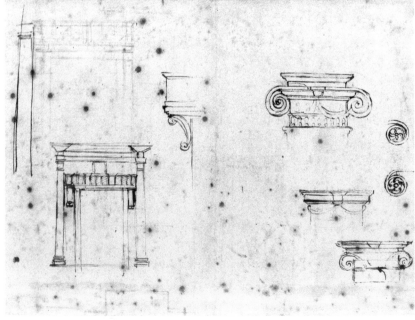

On October 14, 1525, Giovanni Francesco Fattucci notified Michelangelo that Clement VII wanted him to think about "a baldachin over the altar of San Lorenzo, atop four columns . . . [in order] to put inside there all of our urns, which belonged to Lorenzo the magnificent, the elder, and inside them . . . to put many beautiful relics [in a way that] it is possible to walk around, so that said relics can be shown to the people" (for Lorenzo's urns, see Heikamp 1975). Towards this aim, the pontiff had already asked Fattucci to "look for four porphyry columns, [two of which had been located] of eastern granite, very beautiful, at Tre Fontane." Fattucci added: "[The pope would be satisfied] to give the work on it to whomever you would think . . . and the money will be paid to you over there, and perhaps Our Lordship will pay it" (DCCXVII).

Two more entreaties were sent, on October 30 (DCCXXI) and again on November 10, when Fattucci reported that Clement VII wanted to start the work that winter, having found the columns, and also "wanted the entablature made of bronze . . . with a core of iron" (DCCXXVII). At last, Michelangelo proposed three different possibilities for placement of the baldachin: the first, "above the middle door" [of the main entrance to the church], was excluded by the pope because "it would please him very much if you could accommodate it lower": the second, "over the door of the new sacristy," was still under consideration ("still directed to him"), but it was a question of "making the place where the urns with the relics would stand, which Our Lordship wanted to put there"; and the third, "over the main altar [requiring] a ladder"—evidently preferred by the pope (DCCXXVIII).

On February 4, 1526, Michelangelo submitted designs referring to the third and favored solution, which, as Fattucci reported four days later, "pleased [the pontiff] enormously, but he did not want the view of the chapel blocked, [which] he wanted to have painted, God willing" (DCCXXXIX). The pope therefore suggested a structure less visually encumbering, with only two columns and backed to the wall.

On February 23, the worries of the pope were repeated that the baldachin placed over the altar "would take away the view" of the choir, which he wanted to have painted in fresco by Michelangelo himself, but a model was nevertheless requested for it (DCCXLI). In all probability Michelangelo delayed in carrying out the numerous tasks because, on April 3, Fattucci finally wrote, in the name of His Holiness: "About the baldachin, he is satisfied for you to make the model in the correct manner. Make it whenever you want, and when you don't have so much to do, and then give your opinion about the columns, so that they can be extracted at Porto, where they say that there is the quantity which anyone might require" (DCCXLV). The project was cut short by the Sack of Colonna on September 20, 1526 (Wallace 1987), but, on November 23, Fattucci wrote: "[The pope] asked me to write to you because His Holiness wants to send the relics over there, and he said that you should have the baldachin made in proper form, large as if it were of marble, with the columns and pilasters all of framed and painted wood, and strong, and that you should modify the altar and the steps as it seems to you that it will be better, and in this way it will be as if it were made of marble. And make it so that the relics would be very safe" (DCCLXIV). Michelangelo must have replied by December 21, 1526, because Fattucci informed him on this date: "[The pontiff] says about the baldachin, that you should make it framed and plain and strong; about the colors, he leaves that up to you" (DCCXLVII).

The events in Rome in 1527 and in Florence in 1529–30 caused the suspension but not the cancelation of Clement's plans for the Tribune. In the fall of 1531, Giovanni Battista Figiovanni wrote to Michelangelo about the "papal arms in marble, which were placed under the pulpit [*sic*] and over the main door of the church, but on the inside, which was the shield with the head of a horse in the manner of an antique escutcheon and very beautifully carved for decorating the church, as well as the pulpit." According to Figiovanni, once informed of the installation of the arms, the papal secre-

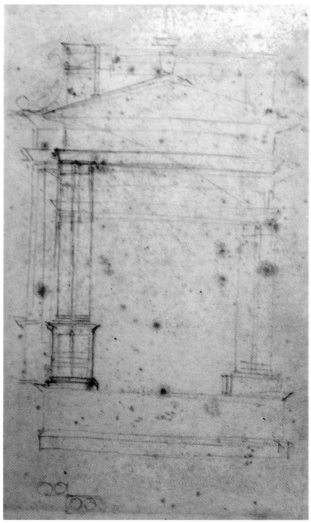

278. *(above left) Michelangelo. Perspective sketch of framed structure, perhaps baldachin for relics in San Lorenzo. Archivio Buonarroti, Florence, V, 29, f. 204v (C. 286v)*

279. *(above right) Michelangelo. View of architectural structure, perhaps baldachin for relics in San Lorenzo. Casa Buonarroti, Florence, A 40r (C. 177r)*

280. *(below) Michelangelo. Plan for Tribune of the Relics in San Lorenzo. Ashmolean Museum, Oxford, Parker 311r (C. 260r)*

tary, Pier Paolo Marzi, had written to him that "by the will of Our Lordship, His Blessedness does not want the papal arms there in the church at all, but only those of the family." Continuing, Figiovanni advised Michelangelo: "He never wrote to me about not wanting it there, so it was pursued; and I read 9 letters of his, after the arms were begun, and I did not find such a denial" (DCCCXXXII). For the form of the coat of arms, see Wallace (1987).

Judging from the reference to how many times Figiovanni had corresponded about the project, Michelangelo had begun the work at least by the summer of 1531, having finally chosen the solution of putting the Tribune of the Relics on the counterfaçade of the church over the main entrance. On October 7, 1532, Figiovanni requested from the artist, who had gone to Rome in September of that year, on behalf of Bernardo di Pietro Basso, supervisor of the work in Florence, "the design for what was still to be made for the balcony for which . . . he has installed the 2 columns with the 2 capitals, and to-morrow he erects the large corbels and cornice. . . . Wednesday, I believe the arms will be put up" (DCCCXCII). The last information on the progress of the work appeared in letters written on October 19 by Bernardo di Pietro Basso (DCCCXCIII) and on November 23 by Figiovanni (DCCCXCV).

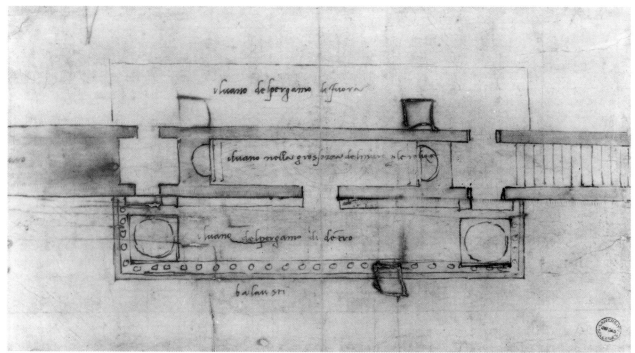

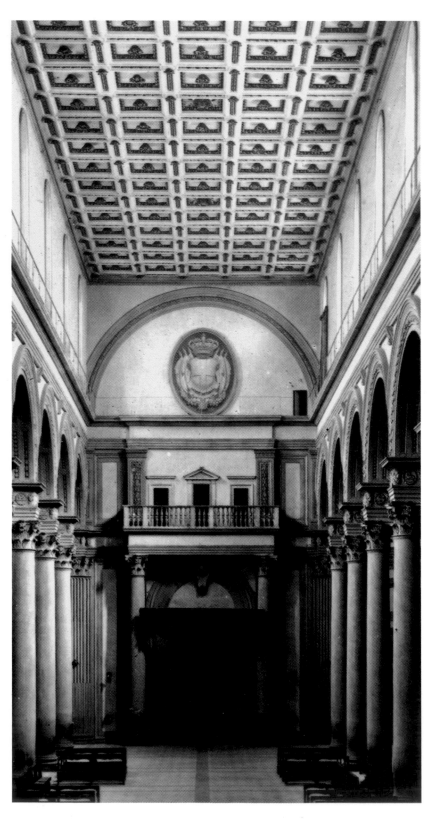

281. *Tribune of the Relics (above main portal). San Lorenzo, Florence*

By means of two papal bulls dated October 31 and November 16, 1532, Clement VII had formally donated the relics to San Lorenzo and granted full indulgences to those who would accompany them in the procession to Florence. He also gave instructions for their exhibition (Heikamp 1975). The urns arrived in Florence on December 3 (Luca Landucci) and were installed on December 13. Writing on July 19, 1533 to Sebastiano del Piombo, Michelangelo expressed complete satisfaction with the work. Responding on July 25, Sebastiano wrote that the pontiff "again was very pleased that it turned out to be a beautiful thing" (CMXIII).

Three graphic works are unanimously identified with the planning of the Tribune of the Relics. The first (fig. 276) shows the plan of the choir of San Lorenzo with a rectangular baldachin over the altar, for which are indicated architraves, column bases, and steps. The measurements of the choir space are noted as "19 *braccia* and two-thirds for each side" and those of the baldachin base as "9 *braccia* and one-half [by] 7 *braccia* and one-eighth," therefore it is easy to understand the pope's worry over the visual encumbrance of the baldachin in that location. Because this sheet bears an autograph record dated February 8, 1526 (1525 in Florentine style), it may be a preparatory sketch for the plan sent to Rome on February 4, 1526. For a contrary opinion, see Düssler (1959), who dated the sheet 1531–32. On the verso of this sheet (fig. 277) are two sketches showing front and side views of a portal flanked by two columns surmounted by a parapet with a balustrade. As Ackerman (1961) suggested, the drawing refers to the main door of the church and not to the entrance of the New Sacristy. Tolnay (1928) interpreted a third work, a perspective sketch of a square structure having a round-arched opening, as a preliminary study for the baldachin and dated it to c. 1525–26 (fig. 278). Although Wallace (1987) proposed that the drawing in fig. 279 referred to the baldachin project, it was previously identified as an altar or a wall tomb.

Firmly connected to the Tribune of the Relics is fig. 280, a horizontal section of the façade wall at the height of the Tribune showing a stair and a long, narrow space to store the relics cut out of the wall itself. Two balconies are indicated, one outside connecting through the wall with one inside, which is enclosed by a balustrade with columnar balusters and supported on columns placed next to the side entrances. The precision of this drawing led Ackerman (1961) to consider this the definitive plan prepared for the pope and approved by him in the fall of 1531. Scholars are in full agreement on the date, although significant differences in the executed work (fig. 281) can be noted, such as the shift of the supporting columns of the balcony to flank the center portal and the change from a balustrade of columnar elements to one having slender, turned balusters.

For differing views on the executed work, see Ackerman (1961), whose strongly limitative appraisal was based on a claimed absence of Michelangelo during the course of the execution, and Portoghesi-Zevi (1964), who recognized the ability of the architect to fit his work into the Brunelleschian context.

PORTAL OF SANT'APOLLONIA, 1525/35

282. *(above left) Giovanni Antonio Dosio. Elevation of door of Monastery of Sant' Apollonia. Uffizi, Florence, Drawings and Prints Dept., A 3018r*

283. *(below left) Giovanni Antonio Dosio. Detail of column base, plan of capital, and profile of molding of door of Monastery of Sant'Apollonia. Uffizi, Florence, Drawings and Prints Dept, A 3019r*

284. *(right) Monastery of Sant'Apollonia, Florence, detail of portal after Michelangelo's design*

The attribution to Michelangelo of the portal of the Monastery of Sant'Apollonia in Florence (fig. 284) maintained in Florentine guidebooks of the seventeenth and eighteenth century (Bocchi-Cinelli 1677, and Richa 1754–62) has been doubted almost unanimously by scholars since the early years of this century. Vasari (1550) wrote only that Michelangelo executed, "through the intervention of his nephew, who had become a monk in Santa Apollonia, . . . the ornament and the design of the altarpiece for the main altar" ("the altarpiece and the main altar" in Vasari 1568). The unique but important exception concerning the authenticity of the portal up until the 1960s, was Tolnay (1951), who gave credence to the Florentine guides. In 1967, Tolnay made a new contribution to the subject by publishing a sixteenth-century drawing of the elevation of the door from the Scholz Scrapbook (The Metropolitan Museum of Art, New York, 49.92.60r), which contained the measurements and a contemporaneous inscription: "Door of Santa Appolonia Monastery in Florence By the hand Of Michelangelo Buonaroti." On the verso of the drawing is the ground plan for the portal.

In 1975, Davis published a passage from the Florentine Academician Cosimo di Bartoli's *Ragionamenti accademici . . . sopra alcuni luoghi difficili di Dante. Con alcune inventioni et significati* (composed 1550–52; published by Francesco de' Franceschi, Venice, 1567), in which Bartoli compared the Doric-type order of columns in the vestibule of the Laurentian Library to that which Michelangelo "used again on those [columns] which were on the door of the Monastery of S. Appollonia" (cf. figs. 142 and 284). Davis also added to two known copies after the New York sheet by Giovanni Antonio Dosio (figs. 282, 283; published by Wachler 1940) a third one attributed to Giorgio Vasari the Younger (Uffizi, Drawings and Prints Dept., A 4655). Then, dating to 1594–1601 a replica after the Sant'Appolonia portal made for the Church of Sant'Onofrio di Foligno in Florence (which therefore cannot be assigned to Dosio, who was absent from Florence in those years),

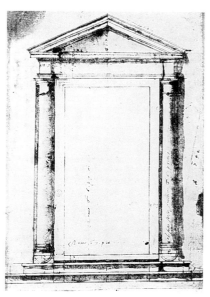

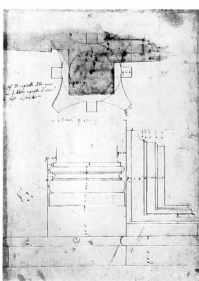

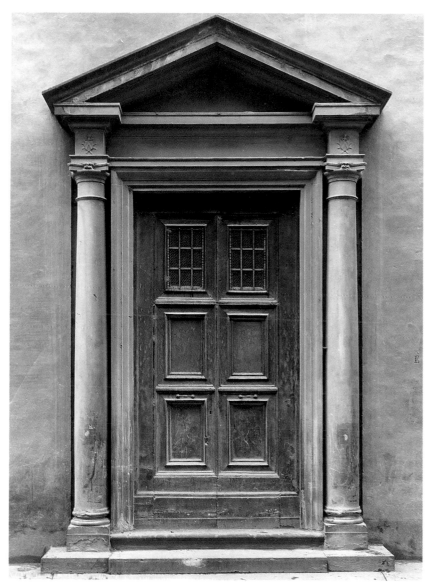

Davis precisely defined the alterations which had been made in the meantime on Michelangelo's work. (For a comparison of Dosio's drawings with the sheet in New York, see Bertocci-Davis 1978.) Convinced by the contemporaneous testimony of Bartoli, Ackerman (1986) returned to his earlier affirmation and again accepted the Sant'Appolonia portal (fig. 284) as an authentic Michelangelo work, dating it to the period of 1525/35.

DESIGNS FOR THE FORTIFICATIONS OF FLORENCE, 1528–29

285. *Michelangelo. Plan of wall between Tower of the Miracle and bastion for San Pietro Gattolini Gate, Florence. Casa Buonarroti, Florence, A 11 (C. 563r)*

286. *Michelangelo. Fortification of Prato Gate, Florence. Casa Buonarroti, Florence, A 28r (C. 564r)*

287. *Michelangelo. Plan for defense structure. Casa Buonarroti, Florence, A 28v (C. 564v)*

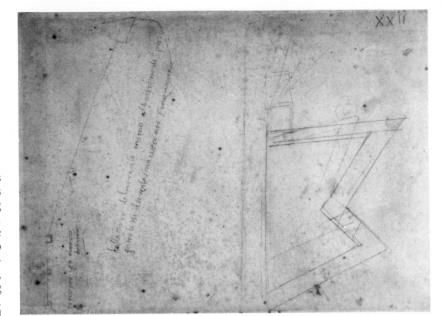

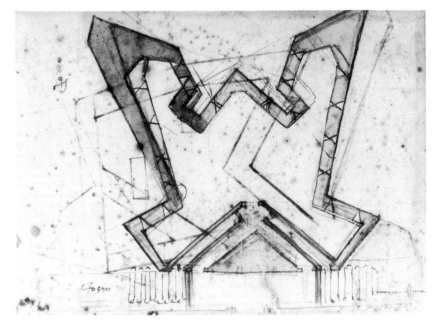

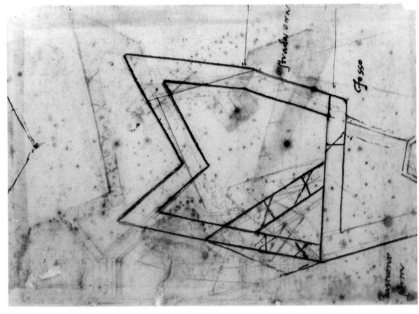

The city wall protecting Florence at the beginning of the sixteenth century was the third such enclosure. Begun at the end of the thirteenth century, it was brought to near completion in the first quarter of the fourteenth, with work on it continuing throughout the century. Twelve meters high, the wall was reinforced every two hundred *braccia* by towers forty *braccia* high and surrounded by a moat twenty meters wide. Inside was a ring road ten meters wide, which provided for rapid deployment of defensive troops and also prevented the building of houses against the wall. The city gates were guarded by towers thirty-five meters high. Preserved in the Uffizi is a precise rendering of the medieval wall by Baldassare Peruzzi (Drawings and Prints Dept., A 360r; for Peruzzi's part in the Florentine fortifications, see Adams 1978).

As did all medieval defense systems, the Florentine fortifications became obsolete due to the employment of heavy artillery. The high walls were useless against it and easily knocked down, constituting a serious threat to the personnel inside. The polygonal bastion thus became a necessary utility from which to strike at the attackers with cannonry and to protect the blind sections of the walls hidden from tower view, below which besieging forces could otherwise find easy refuge. Throughout the fifteenth century, Florence relied on a system of fortified outposts situated in the surrounding countryside, as well as on its geographic location in a basin, which made it difficult for attacking forces, if numerous, to secure the necessary supplies. This system continued in use into the sixteenth century and was successful against the Bourbon forces in 1527, according to a report by the ambassador Marco Foscari to the Venetian Senate.

Nevertheless, with these Italian campaigns of Charles VIII of France, the weakness of the medieval defenses in warfare was increasingly demonstrated. Already in 1522, Cardinal Giulio de' Medici showed concern for the problem of Florence's fortification (Manetti 1980), and at the beginning of 1526, as Pope Clement VII, he commissioned Machiavelli and Pietro Navarra to conduct a study and advance new proposals for the defense of the city. Machiavelli's report was ready by April 4, according to a letter to Francesco Guicciardini. For the main and largest section of the city on the flat terrain north of the Arno River, Machiavelli considered it sufficient to modernize the existing walls, lowering them in height and creating embrasures to accommodate cannons. But this same expedient was impractical for the quarters on the other side of the river, dominated as they were by the surrounding hills. For their defense, he proposed two options: enclosing the whole area, including the heights, to provide a barrier for "the great protection needed there"; or "taking away" the quarter of San Lorenzo, an action "part ineffective and part uncharitable." As a compromise, he suggested fortifying the section of wall between San Miniato and San Giorgio with bastions and "tearing down the quarter up as far as the San Miniato Gate." Before the end of April, Clement VII had assigned as Machiavelli's assistant the architect Antonio da Sangallo the Younger, who began the new defense construction. According to Manetti (1980) and Mariani (1984), a plan by Sangallo for fortifying the Faenza Gate is preserved in the Uffizi (Drawings and Prints Dept., A 1464v).

After the Medici were expelled from Florence in 1527, the Republic turned its attention to continuing the new defense works begun by the previous government. A heated debate ensued over the means for defending the city areas to the south, however, with Niccolò Capponi, the head of the Council, absolutely opposed at first to the fortification of San Miniato. The earliest sure documentation of Michelangelo's involvement in the defense project is a letter to him of October 3, 1528, in which Niccolò Paganelli, on behalf of Capponi, requested: "Tomorrow at three o'clock, be at San Miniato, because it was ordered that all your colleagues be there" (DCCLXXXI).

On January 10, 1529, Michelangelo became a member of the Nine of the Militia (*Nove della Milizia*), the board directing the armed defense of the Republic. On April 6, the Board of Magistrates

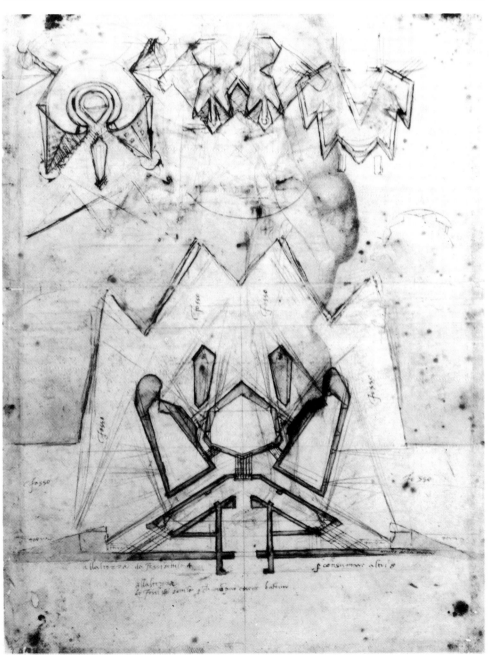

(*Dieci di Balìa*) ordained: "In consideration of the virtue and discipline of Michelangelo di Lodovico Buonarroti our Citizen, and knowing how excellent he is in architecture, among his other very special virtues and liberal arts . . . and, to continue, how his love and affection towards the state is equal to that of every other good and loving citizen, remembering the labor sustained and diligently employed by him in the aforesaid work up to this day without pay and lovingly, [we name the artist] governor general and procurator in charge of said construction and fortification of the wall . . . for the next year." The appointment carried a per diem compensation of one gold florin.

The decision to entrust Michelangelo with the responsibility of fortifying Florence was not surprising. As early as July 15, 1516, Argentina Malaspina Soderini, in recommending the artist to his brother Lorenzo, had described him as a "person who understands about architecture and artillery and knowing how to fortify the land" (*Carteggio indiretto* 33). Also, Michelangelo had been named supervisor of fortifications (*revisor arcium et fortilitium*) for Bologna on September 29, 1527, although it isn't certain that he carried out any activity in that capacity (Tuttle 1982). In Rome in 1545, the artist boasted about being more expert than Sangallo in "fortifying, with the study of it for a long time, [and] with the experience of what he had done" (Gronau 1918). Of great interest are both the declaration of his firm republican beliefs and the recognition of his labor and works rendered "without pay and lovingly" on behalf of Florence prior to April 1529, which testify to his patriotic zeal over a long period of time. On February 22, 1529, Michelangelo climbed the dome of the Florence Cathedral for a general survey of the city's defenses. In a letter of April 3, Marcantonio del Cartolaio, chancellor of the Nine of the Militia, confirmed that construction was under way on the bastions along the city walls and, in a letter of April 14, mentioned that Michelangelo "came twice every day" to visit the work sites. This assiduous attention to the execution of the fortifications was reported in the anonymous

290. *(left) Michelangelo. Plan of fortification for Prato Gate, Florence (top). Casa Buonarroti, Florence, A 27v (C. 567v)*

291. *(above right) Michelangelo. Plan of fortification for city gate, probably on south side of Florence. Casa Buonarroti, Florence, A 18 (C. 568r)*

292. *(center right) Michelangelo. Plan of bastion, presumably for gate on south side of Florence. Casa Buonarroti, Florence, A 23 (C. 569r)*

293. *(below right) Michelangelo. Plan of fortification, presumably for gate on south side of Florence. Casa Buonarroti, Florence, A 21 (C. 570r)*

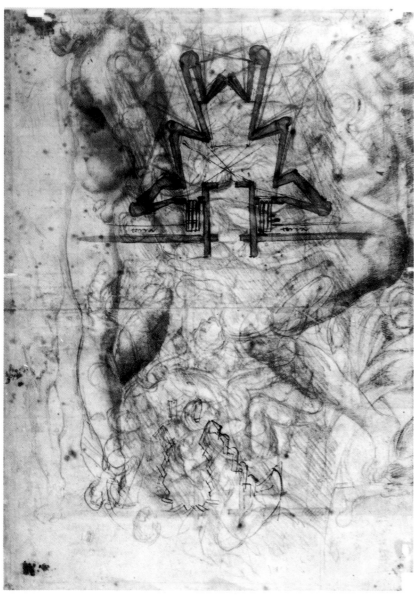

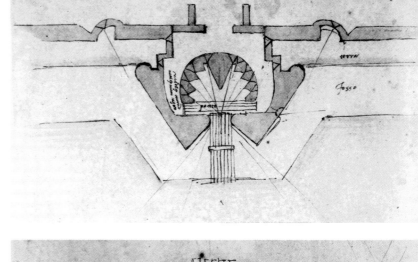

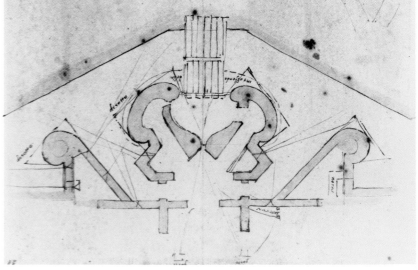

Breve istorietta dell'assedio di Firenze, in the *Storia fiorentina* by Benedetto Varchi, and in letters to Varchi from Giambattista Busini. In the role of expert on fortifications, Michelangelo inspected the defense systems of Pisa (June 4, 1529) and of Leghorn. In August, he went to Ferrara on commission from the Florentine *Balìa* "to see those methods of fortification," referring to the modern, bastioned city wall which Alfonso d'Este had ordered built there. On September 8, the artist was in Arezzo, and on September 16, he was back in Florence inspecting the city defenses with the military chief Malatesta Baglioni.

After Arezzo fell to imperial forces on September 18, the climate in Florence, then on the verge of siege, became poisoned by suspicions of treason, and, on September 21, Michelangelo suddenly fled the city for Venice, where he hoped to negotiate with the French. Declared a rebel by the Florentine Republic on September 30, the artist was nevertheless given safe conduct by the *Balìa* on October 20, allowing him to return home. He was back in Florence in November,

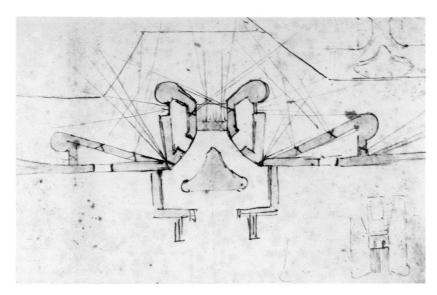

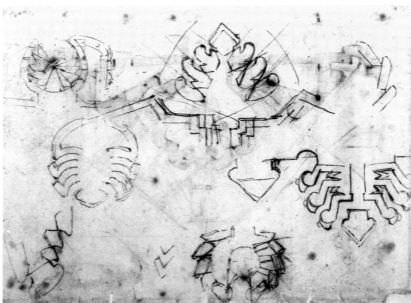

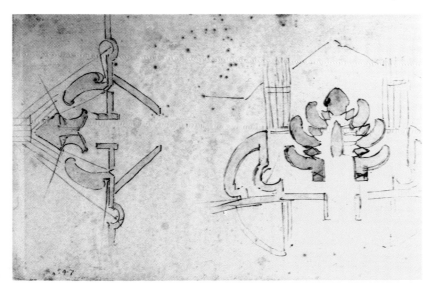

294. *Michelangelo. Plan of fortification, presumably for gate on south side of Florence. Casa Buonarroti, Florence, A 26 (C. 571r)*

295. *Michelangelo. Studies for fortifications. Casa Buonarroti, Florence, A 22v (C. 574v)*

296. *Michelangelo. Studies of fortification, presumably for gate on south side of Florence. Casa Buonarroti, Florence, A 24 (C. 573r)*

297. *Michelangelo. Plan of fortification for city gate, probably on south side of Florence, and other sketches for bastions. Casa Buonarroti, Florence, A 22r (C. 574r)*

298. *Michelangelo. Fortifications for city gate. Casa Buonarroti, Florence, A 25 (C. 572r)*

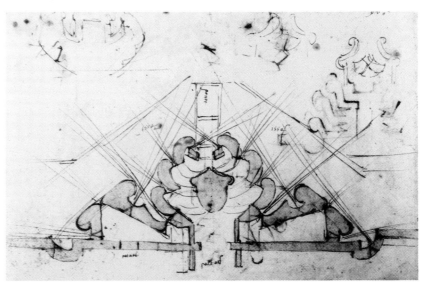

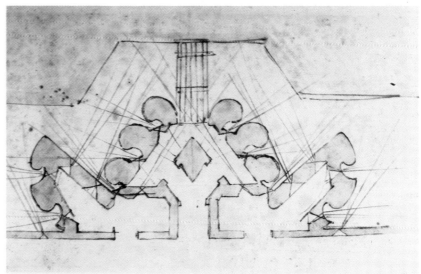

involved again in the ultimately unsuccessful defense of the city, which finally capitulated in August 1530.

Nothing at all has survived of the defenses designed by Michelangelo, which are listed in Varchi's *Storia fiorentina.* They had been made of packed earth mixed with straw and faced with unfired bricks composed of mud, oakum and manure. The permanent fortifications planned by Antonio da Sangallo the Younger and constructed under the restored Medici rule beginning in 1534 perhaps reflected to some degree the disposition of those provisionary, Republican ones.

A drawing of the protective system designed by Michelangelo around the Church of San Miniato al Monte, a point of capital importance for the defense of the city, appears in the lower right corner of a sheet attributed to Bastiano da Sangallo and preserved in the Uffizi (Drawings and Prints Dept., A 757v; Manetti 1980). A group of autograph drawings in the Casa Buonarroti, analyzed for the first time by Tolnay (1940) and related to the Florentine defenses, shows in detail nearly all the bastions corresponding with the city gates or guard towers. As Ackerman (1961) noted, while all of the sources make

205

299. Michelangelo. *Sketch of bastion for fortifications of Florence. Archivio Buonarroti, Florence, I, 78, f. 213v (C. 575v)*

300. Michelangelo. *Fragmentary plan of bastion for Giustizia Gate, Florence. Casa Buonarroti, Florence, A 19 (C. 576r)*

301. Michelangelo. *Study of fortification for Prato Gate. Casa Buonarroti, Florence, A 14r (C. 577r)*

302, 303. Michelangelo. *Studies of fortifications for Prato Gate. Casa Buonarroti, Florence, A 20r and A 20v (C. 578r and C. 578v)*

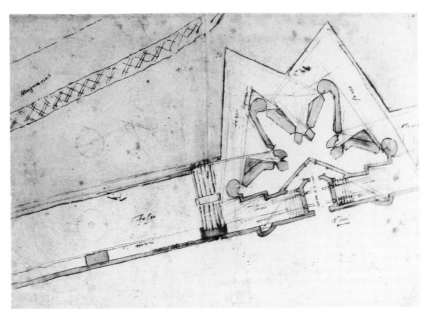

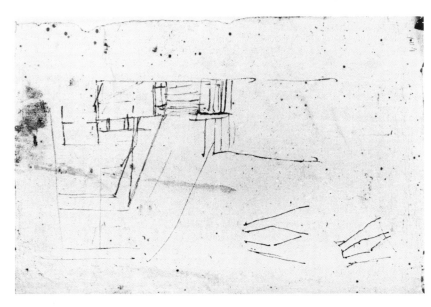

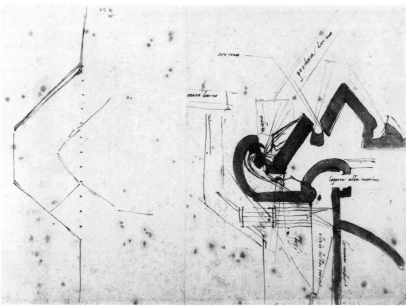

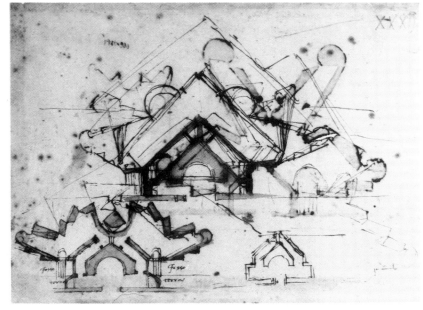

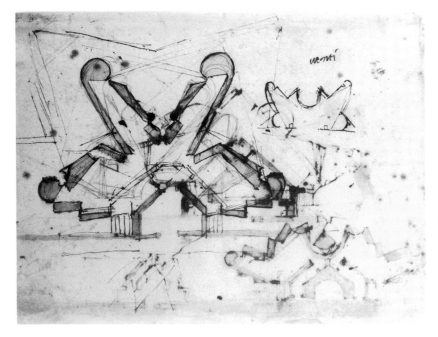

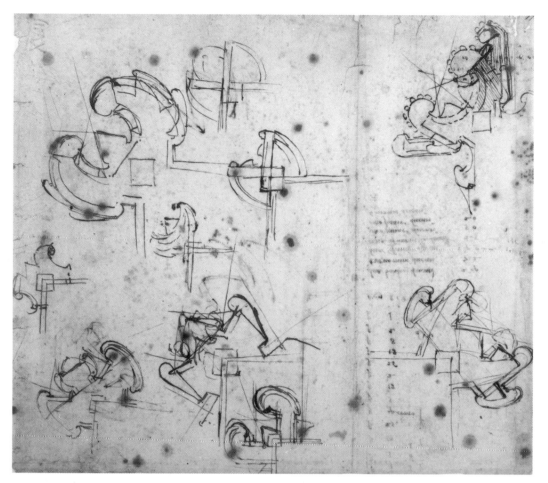

304. *Michelangelo. Studies of fortifications, probably for Prato d'Ognissanti Gate, Florence. Casa Buonarroti, Florence, A 17r (C. 579r)*

305. *Michelangelo. Plans for fortifications, probably for Prato d'Ognissanti Gate, Florence. Casa Buonarroti, Florence, A 17v (C. 579v)*

reference to the defenses for San Miniato, none of these drawings can be associated with that project, which, as Wallace (1987[c]) observed, should have been very well developed graphically, considering that Michelangelo arranged for monthly wages to be paid by the Republic to Stefano di Tommaso in the role of draftsman for the fortifications.

The hypothesis first formulated by Ackerman (1961) has now been accepted that the Casa Buonarroti sheets are traceable to Michelangelo's planning in 1528. Supporting such a conclusion are two autograph records, one on the verso of fig. 301 and the other on fig. 305, respectively dated July 25, 1528 and September 1528. These sheets employ the same graphic mediums and techniques—pencil, sanguine, and pen with bister wash—which appear to have been used for presentation drawings rather than for working studies (see fig. 159 which reproduces fig. 301 in color). For this reason, Hartt (1971) hypothesized that the drawings were part of a set of plans requested by the city government and therefore constituted unequivocal, precise indications for construction. But this could not have been carried out in the few months available between April and October 1529 and certainly not during the subsequent siege by imperial troops.

Autograph inscriptions on the sheets have allowed scholars, beginning with Tolnay (1940), to connect the plans with specific parts of the defense system. Shown in fig. 300 is a bastion in front of the "Iustitia" gate, the first one on the east end of the wall along the Arno. A plan for the same bastion appears in fig. 299 (bottom of sheet), identified by Barocchi (1964) and confirmed by Tolnay (1980). The plan in fig. 301 is for the bastion at the Prato Gate, to which figs. 302 and 303 refer certainly as preliminary sketches. Very likely related to that bastion as well are figs. 286, 289, 290 (although doubted by Ackerman 1961), and fig. 288 (identified by Tolnay 1980). Inscriptions on the drawings in figs. 307–311 relate these plans to the Prato d'Ognissanti Gate, and to them can be added figs. 304–306. The plan in fig. 285 is inscribed "from the tower of the miracle up to the bastion of S. Pietro

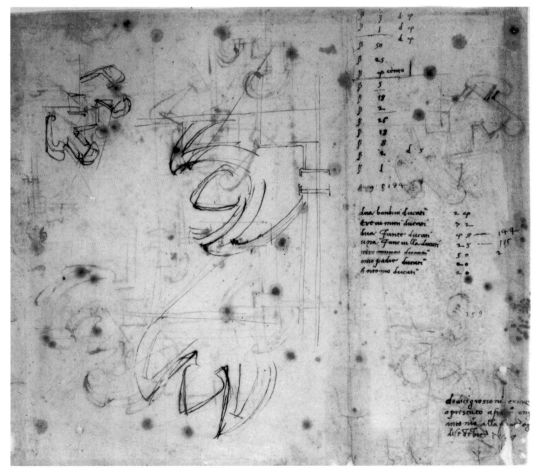

207

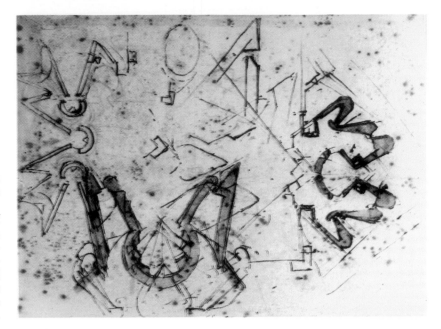

Gattolini," and figs. 291–298 have been connected with gates on the south side of the city.

The much-discussed chronology of the drawings can be compressed into a narrow time span, and they clearly exhibit a maturation of the different solutions. For example, the plans identified by their inscriptions with the Prato d'Ognissanti Gate show two stages, one in the form of a claw (figs. 307–309) and the other star-shaped (figs. 310, 311). Decisive for solving the relevant problem of the evolution of Michelangelo's ideas is the tracing of his sources. Sangallesque influences have been noted by Tolnay, Barocchi (1962) and Manetti (1980), and ties have been traced to the designs of Francesco di Giorgio Martini by Hale (1965) and Fiore (1978). Some solutions are close to those of Leonardo da Vinci (Pedretti 1972), perhaps mediated by Machiavelli (Marani 1985), while others have rapports with those of Baldassare Peruzzi (Pepper-Adams 1986). In general, the Casa Buonarroti drawings tend to show an evolution from simple, rectilinear plans of the Sangallesque type to solutions of a zoomorphic imprint, whose functional defects—the rounded elements frequently left dead zones where defensive fire could not reach—are corrected in the more mature, definitive ones, such as figs. 286, 287, 289, and 290 (Ackerman 1961). Following the analyses of Portoghesi-Zevi (1964), scholars have since emphasized the great importance of the artist's study of fortifications in the development of his architectural as well as his human career.

306. *Michelangelo. Bastions for Prato d'Ognissanti Gate, Florence. Casa Buonarroti, Florence, A 30 (C. 580r)*

307. *Michelangelo. Study for fortification of Prato d'Ognissanti Gate, plan of lower level. Casa Buonarroti, Florence, A 15 (C. 581r)*

308. *Michelangelo. Study for fortification of Prato d'Ognissanti Gate, plan of upper level. Casa Buonarroti, Florence, A 16r (C. 582r)*

opposite:

309. *Michelangelo. Plan for fortification of corner gate, perhaps Prato d'Ognissanti Gate, Florence. Casa Buonarroti, Florence, A 16v (C. 582v)*

310. *Michelangelo. Studies for bastion at Prato d'Ognissanti Gate, Florence. Casa Buonarroti, Florence, A 13r (C. 583r)*

311. *Michelangelo. Five sketches for bastion of Prato d'Ognissanti Gate, Florence. Casa Buonarroti, Florence, A 13v (C. 583v)*

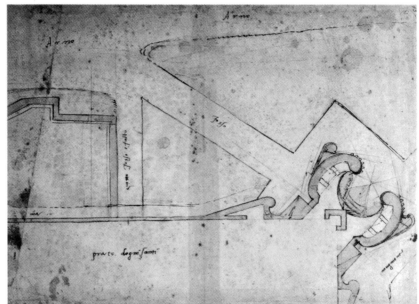

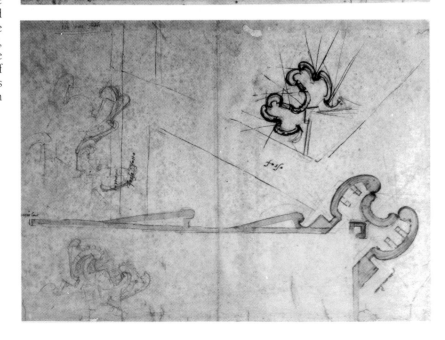

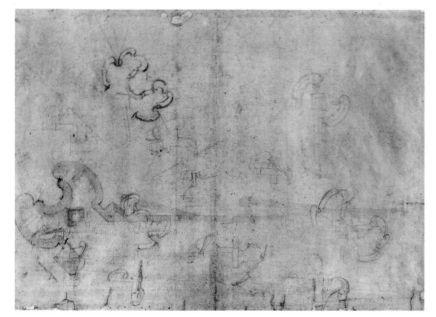

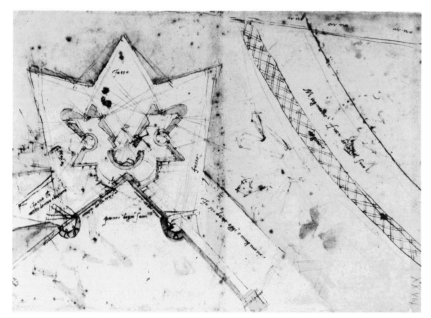

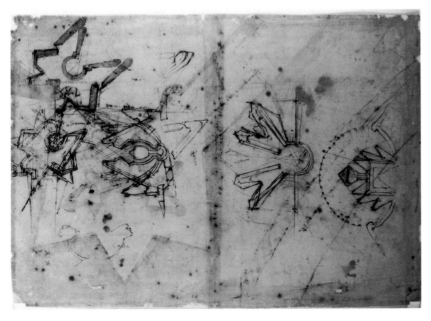

First mentioned by Condivi (1553) among Michelangelo's "designs for public and private buildings" was one created "in recent times for a bridge that went over the Grand Canal of Venice, of a new form and manner, and no longer seen." Later Vasari (1568) wrote that, following his escape from Florence in September 1529, Michelangelo went first to Ferrara and afterwards to Venice, "where it is said that he then designed for that city, having been asked by the doge, [Andrea] Gritti, the Rialto Bridge, a very rare design of invention and ornamentation." The idea to reconstruct the existing wooden bridge in stone had first been broached in 1502 (*Diari* of Marin Sanudo). In October 1507, the Council of Ten and the Zonta allocated funds for a first payment towards the building "of the aforesaid bridge made of stone," which was connected perhaps with the presence in Venice of Fra Giocondo (Calabi-Morachiello 1987).

In August 1524, the ramp on the Rialto side of the old bridge collapsed. Although proposals and models for a new stone bridge were discussed at that time by Doge Gritti, the Council of Ten, and the city patriarch D'Aquileia, the repair of the broken ramp was authorized in November. Finally, after the owners petitioned the Senate in February 1526, shops were rebuilt there.

The intention to replace the old bridge did not fade away entirely, however. On January 17, 1551, after many opinions, schemes, and discussions, the Senate named three supervisors for the new bridge project, instructing them to solicit information, designs, and models for it from Venice and elsewhere (Calabi-Morachiello in Tafuri 1984, and Calabi-Morachiello 1987). In 1554, the Venetian orator Benedetto Agnello wrote to Duke Guglielmo Gonzaga that the supervisors "had sent to different places to have models by the foremost architects of Italy, in order to make an excellent and unusual event" (Carpeggiani in Puppi 1980). Marcantonio Barbaro, writing in 1588, recalled that many models arrived from Rome and other parts of Italy "by the hand of strong professor-architects well trained in this art." Thus Michelangelo could have been involved in 1551.

In September 1557, the medieval bridge of Santa Trinità in Florence collapsed due to flooding on the Arno River. On April 9, 1560, Vasari, who had been asked by Cosimo I de' Medici to consult with Michelangelo regarding "some matters pertaining to our service" (Gaye 1839–40), reported that, together with Michelangelo, "we have attended to the design for the Santa Trinità bridge, which we discussed a great deal, for which I will bring communications by writings and drawings according to his intention, with the measurements which I brought to him according to the site." The "writings and drawings" in Vasari's possession at the time have not come down to us.

The bridge was built under the supervision of Bartolomeo Ammanati, the ducal "engineer," between April 1567 and August 1568, with the work of completion lasting until 1572 (Kriegbaum 1941). The bridge was blown up by retreating German troops on August 3–4, 1944, and all that remained standing at the war's end were the piers. But it was faithfully reconstructed in 1955 employing in part materials recovered from the Arno (fig. 160).

It is generally recognized that Ammanati, who was responsible also for interpreting Michelangelo's models in the construction of the staircase in the vestibule of the Laurentian Library, could have employed aspects of Michelangelo's original design for the Santa Trinità bridge, although we are not in a position to say to what extent.

Chapter Three

ROME, 1534-46

"My eye seeks beautiful things and my soul

at the same time its salvation." Poems, 107

By the time of his return to Rome in 1534, the state of what was called Michelangelo's "conversion" had come to a head. In reality, this was only a transition from intellectual tension to anxious religious calling, which manifested itself in a sense of duty to defend the Church in a conflict which was by then irremedial. In the planning of the Medicean New Sacristy and Laurentian Library in Florence, the objective of his research had been the convergence of the arts in a superior, unitary concept of art. But this idea of a "triune" art belonged to the humanistic ideology, which had died along with the freedom of Florence. Although talked about in Rome in the circle of Raphael, it was only in terms of a comprehensive universalism. In any case, if Michelangelo's goal was to be the defense of the Church, then art was only a tool and its aim was something other than being art. Michelangelo had in fact already moved his art from the speculative to the pragmatic plane with the designs of the Florentine bastions. There, no *a priori* synthesis was possible, only the exasperation and fury of art used as a weapon of war.

His first commission in Rome was *The Last Judgment* in the Sistine Chapel (fig. 312), a work of unique and violent fresco painting in which all intellectual reflection on the synthesis of the arts was vehemently suppressed. Clement VII had decided that on the wall behind the altar of the chapel there should be a fearsome representation of the Last Judgment in place of the altarpiece with the blessed, edifying image of *The Assumption of the Virgin* painted earlier by Perugino. The pope had begun to take seriously the danger posed by the Lutheran protest only after the Sack of 1527, when he had witnessed the devastation of Rome by the *Landsknechts*, or imperial mercenaries of Charles V. He could no longer ignore the fact that the corrupted clergy and Curia contributed to the instigation of the revolt and gave it a moral rationale. Since his youth, Michelangelo himself had been affected by the reformist preaching of Fra Savonarola, but the goal of the attack was no longer moral reform. The very doctrine of the Church was being challenged, and the Sistine Chapel was the site of the supreme ecclesiastical hierarchy, which had to be summoned to its grave responsibilities.

For that threatening representation of the Last Judgment, the commission could only have been given to Michelangelo, the most "*terribile*" as well as the most famous of the contemporary masters. Moreover, because he had painted the Sistine Ceiling, it was thought that there was no one better to make the new decoration harmonize with the old. But he did not in fact create a harmonious relationship between the two; instead he emphasized the contrast. Between Genesis and Revelation lay the whole history of humanity.

The physical contiguity of the two representations was antithetical conceptually. While Genesis could be visualized as an ancient, near-mythical legend, the end of the world could not be imagined. The Last Judgment was impossible to represent, because it was something which would take place outside of time and space, and yet it was—or ought to be—present in the human conscience. So, on that wall in that place of highest

liturgical importance, Michelangelo caused this event actually and dreadfully to come to pass. There was not a trace of architecture in the fresco. The world had ceased to exist, and there was not even a frame as a sign of separation between the awful reality of the End and the fantastic vision of the Beginning. He could have placed a limit, defined a plane of projection, or marked a pause, but that happening had no perspectival spatial order. The only space was the immense vortex caused by the gesture of the hand of God.

Clement VII had ordered the fresco while Michelangelo was still working in Florence, but the pope died before the artist could begin his work. Clement's successor, Paul III, who drew up a political and doctrinal plan of battle against the Lutheran heresy immediately upon his election, quickly grasped the ideological capacity of Michelangelo's composition. An agreement on it was then forged which eventually led the pope to entrust to this artist, giving him carte blanche, the definition of the form of the new Saint Peter's. This was an architectural commission of enormous responsibility, because it brought about radical changes with respect to the aims and intent of the Curia at the time, as well as to the prior interpretation of the subject on the part of the Rome school of architecture.

There had been no conceptual outline for *The Last Judgment* developed in advance by any theologian. Michelangelo himself conceived the program to demonstrate a very new doctrinal thesis about the essence of God as judge, the resurrection in the flesh, and the salvation of the soul by merit instead of grace. In this doctrinal and polemical enterprise, there was a complete absence of ecstatic blessedness. Instead, there were heated altercations and excited gestures even by the Elect, who continued their struggles in Heaven. The work was visually strong and excessively corporeal in its imagery, but this carnality had no sensual allure, which justified the nudity, or at least furnished a polemical pretext for it. It could be said, in the words of Saint Paul, that these figures "did not wish to be stripped naked but rather to have the heavenly dwelling envelop [them]" (2 Cor. 5:4). The quality of the paint, which was so transparent on the ceiling, had the physical consistency here of actual flesh, and the gesture of the artist's painting stroke embodied the same force as the gestures of the figures. Nothing at all was shown in perspective; all was action. Praxis was no longer justified by a superior theory but by the authenticity of the actual *furor*, or inspirational frenzy. Painting was not done by taking away, as in sculpture, but by the addition and accumulation of material, which was the logic of the resurrection in the flesh. The meaning of Michelangelo's so-called conversion, then, was a passage from intellectual abstraction to salvific action. Mannerism, which descended from him, consisted precisely of this investment of the making of art with spirituality, thereby giving greater value to the monistic, unitary procedure than to the dualism of theory and practice.

Michelangelo was already working on the project for the laic Piazza del Campidoglio when he composed the Pauline frescoes in the private chapel of the pope (figs. 313, 314). The subjects of the two frescoes created for Paul's meditation, the conversion of Saint Paul and the martyrdom of Saint Peter, were essential moments in religious life, and Paul III was a Paul-Peter. These events were both history and symbol—conversion was the renunciation of every worldly experience, and martyrdom was the offering of one's very life to God. Just as in *The Last Judgment*, every indication of space and time was removed from these compositions except the demarcation of the horizon between earth and sky. In the sky of the *Conversion*, Christ descended on a powerful beam of light amid a company of angels. In the *Martyrdom*, the sky was closed and silent, because death would not have been martyrdom had there been the comfort of the certainty of reward. In both frescoes, the compositions were nonperspectival and dissociated, with the converted hero and the crucified martyr each existing alone, one in the dazzling presence and the other in the distressing absence of God. The rearing, fleeing horse in the *Conversion* and the mechanical fumbling of the executioners in the *Martyrdom* were pivotal points for different but equally thoughtless movements of the crowd of onlookers in each scene— disordered and senselessly taking flight in the one, and confusingly grouped, crying and impotent in the other. For Michelangelo, as earlier for Alberti and Erasmus and a little later for Brueghel, "crowd" (*folla*) was a metonym for "folly" (*follia*). Michelangelo had been thinking of the Campidoglio at that time as an open architecture, symmetrical but not perspectival, with a strong focal point (the *Marcus Aurelius*) at the center of a space which people would fill up in the same careless, disorderly fashion as one sees in the frescoes of the two saints. Perhaps born out of his decisive religious experience was the idea of Rome as a city of faith crowded with ignorant believers surrounding those who had been elected by God. It was, in any case, the early germ of the nonnatural spatiality of Michelangelo's Rome architecture.

Also in these years, Michelangelo brought to a close, albeit in a negative way, the typical Florentine question of the unity of the arts in the final, disappointing version of the Tomb of Julius II (No. 5). Having conceived its original design forty years earlier to be a total work of art, he came to view it as a failure, and this had a significant impact on his life and artistic work. Separating himself finally from this longtime obsession, he exhausted to the point of sarcasm that self-criticism which was also a criticism of the idea of the antique and how he connected it, although dissenting, to the universalism of the Renaissance. He put at the center of the tomb a single remnant of his first project, the large statue of the Old Testament Moses sculpted about 1515, giving it an architectural and sculptural backdrop which demonstrated how, in his critical rethinking, he had tied his recollection of the first two tomb designs to that of the New Sacristy. But he quickly created a discordance by the difference in size of the Moses figure with respect to the other statues. This was not for an ingenuous reason of hierarchy, as in medieval art where the sizes of the personages were scaled according to their importance. It was instead to evoke that mythico-heroic "ideal" of his own youth, while somehow disavowing it as rhetorical in the comparison with

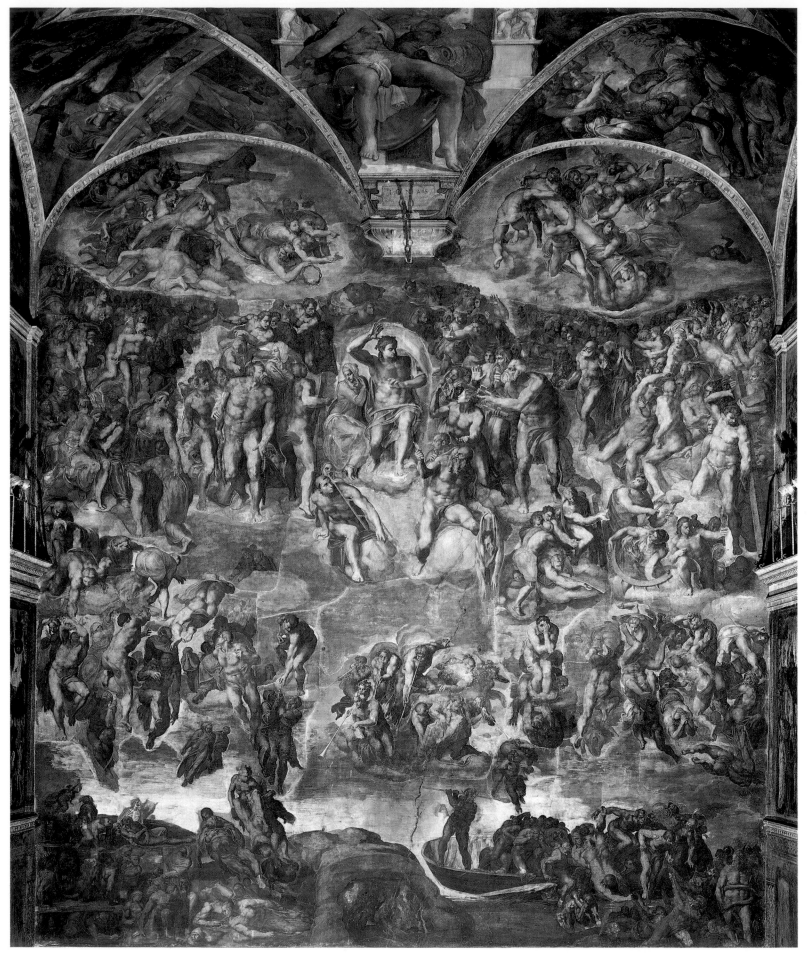

the devoted modesty of the two female figures in prayer. There was a double irony in the comparison, and this very irony manifestly altered the harmony of the proportional relationships, which were themselves syntactico-rhetorical. The disproportion was established by not adjusting the scale between the first level and the second, which appeared to be taller than the first. The two levels were in fact equal in height, but the first appeared lower due to the projection of the plinths and volutes, and the second higher due to the slender pilasters (fig. 315). The monument was completely frontal, but empty spaces were left between the stelae-pilasters so that the framework appeared deeper than it actually was. No longer bearers of a restricted semantic premise, the architectural elements acquired a meaning only in that abnormal context. The painted architecture of the Sistine Ceiling also figured into this self-critical balance with a thread of irony. The first level of the tomb evoked the thrones of the prophets and sibyls, while the second echoed the subtle, white, luminous relief of the pilasters of the archivolt. At this point, almost by an overturning of the logical order, the elements of the architecture, which no longer grew out of an analogy with the parts of the human body, capriciously and even mockingly reassumed human form. The giant volutes on the first level rhymed with the twisted beard of the prophet, the pilasters below became caryatids and those above funerary stelae, and (as later in the Vatican dome) the candlesticks, instead of illuminating the scene from below, stood at the summit as sentinels of ritual (fig. 316). This was 1545, and that unharmonious and, in a certain sense, self-parodying monument with its fictitious ritual ending in ceremony was the manifesto of Mannerist architecture—an architecture which preserved and sometimes exaggerated figural monumentality but was inflected with practical necessities and also with the moods of the moment.

The Piazza del Campidoglio

Beginning in 1546, Michelangelo devoted himself to the construction of Saint Peter's, which, for this deeply religious artist, was a responsibility that paralyzed every other thought. Earlier, however, he had worked on the project for the renovation of the Piazza del Campidoglio (No. 18), although it is not known to what point he obeyed the orders of the pope or followed his own idea and then obtained the pope's approval for it. Among modern scholars there are those who doubt that he ever drew up a complete plan for the Capitoline project. Nevertheless, the complex is absolutely unitary, in spite of the fact that the construction was very slow and marked with phases of uncertainty, especially with regard to the addition of the third building called the New Palace. Very little of the work was supervised by Michelangelo himself, but contemporaneous graphic documents exist by Leonardo Bufalini and Étienne Dupérac, which were obviously derived from an organic scheme or design sufficiently developed to allow for the reconstruction of the form as conceived by the master. This overall plan has been dated to around 1540, but it is certain that Michelangelo continued to think about the Campidoglio even while he was attending to the building of Saint Peter's. There was, after all, an ideological and urbanistic relationship between these large enterprises, with each constituting a pivotal point of the bipolar pontifical power—the laic and the apostolic. Through these works a true ideological partnership was established and developed between Michelangelo and Paul III, who had decided to conduct a war against Lutheranism that was both doctrinal and political. The Lutheran assault had two major targets—the temporal power of the institutional Church and the construction of the new church edifice. Paul III understood that art could be a powerful weapon and that Michelangelo was an artist who charged his works with forceful, profound conceptual content. This sodality between the pontiff and the artist was much more deliberate and decisive on both sides than it had been thirty years earlier between Michelangelo and Julius II. The Campidoglio was the seat of the civic government of Rome, comprised of the senator and the conservators, which had neither autonomy nor political authority, nor was the pope proposing to concede these to it. But he wanted his own power to have both a religious pole and a laic pole, even if in image only, and because the support of the contemporary Holy Roman Emperor was necessary to maintain his political power, he decided that the seat of the laic pole would evoke explicitly the ancient Roman Empire. In January 1538, he had transported to the Campidoglio the equestrian statue of Marcus Aurelius (emperor, A.D. 161–180), which was in the Lateran. The Capitol was a place sacred to the memory of ancient Rome, and Sixtus IV had made of it a kind of *antiquario*, or museum of antiquities, preserving on the hill remains and fragments of ancient sculpture and architecture. It is known that Michelangelo had at first been opposed to moving the Imperial statue to what had been the heart of Republican Rome, where the glorification of the Empire seemed to him to be incongruous. But once he accepted the accomplished fact, he concerned himself with its placement in what would be the focal point of the piazza, thus carrying out, although not passively, the political intent of the pope. Conscious of the high artistic, historic and symbolic value of that ancient bronze, he planned the piazza as a function of its sculptural nucleus. It would now symbolize the contemporary city and State, therefore it would simultaneously be isolated at the summit of, yet in direct communication with, the whole urban space. It is known that Michelangelo thought a great deal about the coincidence of opposites, thus, for that plastic nucleus reinforced with the dignified, double-ramped staircase of the Senator's Palace as a backdrop, he designed a surrounding space which was symmetrical and opened out in many directions along the oblique fronts of the palaces and the broad causeway connecting the piazza with the city (fig. 318). Consequently, the architecture of the piazza was conditioned by the presence of the sculpture, but it was not just a question of a solid nucleus surrounded by open space. It also involved the relationship between ancient and modern, a problem which was not just aesthetic nor just Roman. Michelangelo knew that the strong argument behind the political action of the Church was historical antiquity, yet this was absolutely current in that it was also in effect a conflict of ideas.

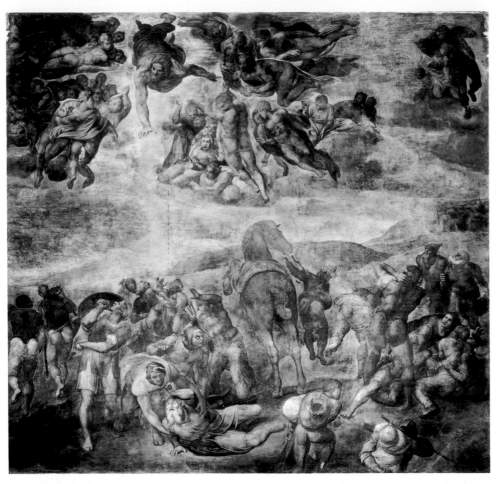

313. *Michelangelo.* The Conversion of Saint Paul. *Pauline Chapel, Vatican Palaces, Rome*

314. *Michelangelo,* The Martyrdom of Saint Peter. *Pauline Chapel, Vatican Palaces, Rome*

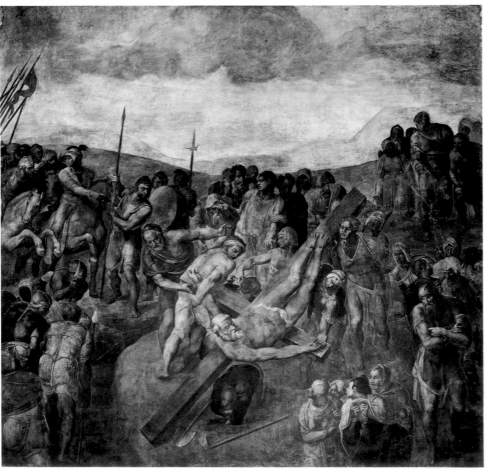

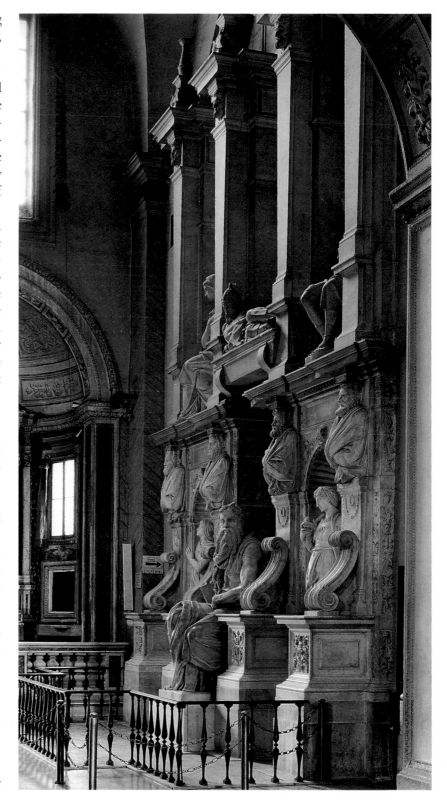

Here was the opportunity to demonstrate that the antique was not being interpreted in the classical sense of canon and catharsis but, to the contrary, in flagrant contrast with the modern.

Although the piazza was still rough terrain, the two existing buildings—the old Senator's Palace and the more recent Conservators' Palace—could not be removed but only redesigned on the façades (see fig. 352). The buildings were not perpendicular to one another; the front of the fifteenth-century Conservators' Palace formed an acute angle with that of the Senator's (see fig. 317). On the side opposite the Conservators' Palace, where the new third structure would be built, the Capitoline area was overlooked by the Church of Santa Maria d'Aracoeli (see fig. 353), whose long flight of steps also served as access to the Capitoline palaces.

This third palace was neither requested nor necessary, and the municipal government apparently had no interest in building it. Other solutions were sought, and it was not until 1604 that the exhausting work on Michelangelo's design began by the explicit order of Clement VIII. The resistance to construction had not been motivated only by problems of the economy. The municipal government depended on the Vatican, but it was under the paternalistic protection of the Franciscan Monastery of Aracoeli. The third palace would create a break in or a destruction of that nexus, which neither the religious brothers nor the civil administrators wanted. But the pope wanted it, to the end that the politics of the State would be formally distinct from the apostolic teaching of the Church. Whether authentic or opportunistic, this expression of secularity could only have pleased Michelangelo, in whom the regret over the fall of the Republic of Florence still burned. Thus, not only because of his tendency to self-critical rethinking did he mentally associate the planning of the Capitoline complex with the laic Laurentian Library in Florence—an open, luminous space with symmetrical walls, whose floor and ceiling mirrored and dematerialized each other. On the Campidoglio, the "ceiling" was the natural sky, which the pavement reflected and transformed symbolically.

The binomial of laic and religious was parallel to that of antique and modern. Other than the walls of the Sullan Tabularium (78 B.C.), on which the Senator's Palace had been erected, nothing remained of the antique which could be taken as an architectural model or guide for the modern construction. No "rebirth" was possible. The antique could only be quoted, evoked and commemorated, as seen in the installation of the antique river god statues against the staircase of the Senator's Palace (figs. 322, 323) and the incorporation of remnants of the Fasti, ancient consular and triumphal calendars, in the courtyard of the Conservators' Palace (see fig. 359).

Once the relationship of a respectful, reciprocal independence between the civic government and the Franciscan convent was defined, it was necessary to rationalize the relationship of the Capitoline complex with the other pole of power, the Church, and to explain as well that the common factor of the dipolar powers was the city itself. Therefore, to provide for a view from the piazza high over the city, Michelangelo created a large roof

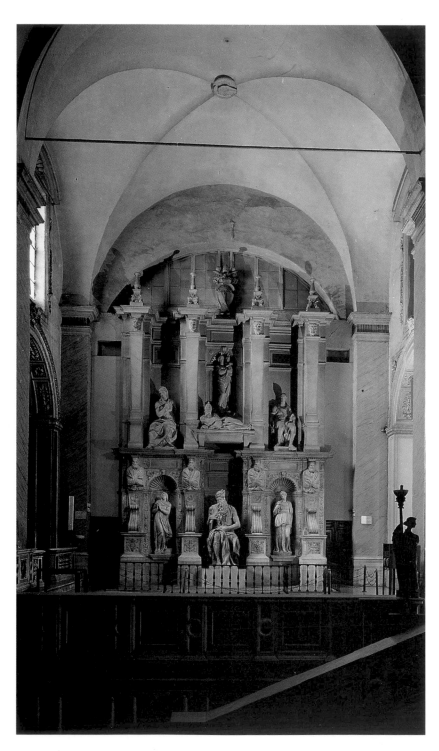

terrace decorated with statues on top of the Senator's Palace, knowing that on the distant horizon would rise the imposing mass of Saint Peter's. The Capitoline complex would have two levels similar to those in the Laurentian Library—from the plane of life, the city, one ascended to that of public power. Still higher up was the Franciscan church, indicating that the worth of the soul was above everything. The causeway between the city and the seat of power was one of Michelangelo's most daring architectural inventions. Joined at the bottom with the steps to the Aracoeli, it diverged from them and ascended on a gentler incline (fig. 360). The symbolism was obvious—hard and difficult the way of the church, easier and shorter the way to earthly power, and the common point of departure, the different levels in height, and the divergence of these two ramps could not have escaped notice and reflection. More than abstract symbolism, it was visualized, coerced thought—nearly an imposed behavior. The divided, deviating rise of these two long pathways, an enormous urbanistic anomaly, disavowed *a priori* any obligatory symmetrical equilibrium. Coexistence did not mean parity, and Rome was and would remain a diverse, irregular city.

The strong sculptural nucleus of the complex was situated on the median axis of the piazza. Michelangelo planned the foundation of the equestrian statue carefully and accurately, and yet his first effort was not enough. He returned to it years later just to execute on its corners four "ornaments" which would suggest an escape towards the empty spaces between the buildings—the stronger and more concentrated the scupltural axis, the more ramified and ambiguous the directional views. The staircase, whose construction was directed by the artist, was visually connected with the front of the Senator's Palace and with the Imperial statue, beyond which the sculptural axis of the piazza ended in the inclined plane of the causeway. It is easy to recognize in this double-ramp staircase its derivation from the designs for the staircase of the Laurentian Library vestibule (figs. 320, 321). The palace stairs led directly from the level of the piazza to the main (second) floor where the Council rooms were located, and the ground floor was nothing more than a neutral, load-bearing surface. The architecture really began at the top of the steps, above which a small balcony was to have been built to be used for the improbable pronouncements of the senator to an equally improbable gathering of citizens. That the staircase was the major element of the design was made obvious by the shallow pilasters installed halfway up the façade. The actual frontal plane of the palace was just a flat surface exposed to light—a backdrop, as it were. The windows with their ornamented frames lined the façade like soldiers in full-dress uniform, and the large coats of arms conveyed the formal, official character of the building. Strongly sculptural, the staircase followed the slight rise of the ground plane and projected into the piazza with a plastic vigor accentuated by its central alcove.

Michelangelo had not wanted the Imperial statue in the sanctuary of Republican Rome, but once it was there, he gave it a new meaning which conformed it to the location—that is, he "de-historicized" it with a subtle

cosmological rationale. From his neoplatonic point of view, after all, history was something like an "eternal returning" and therefore the ancient authority of Imperial Rome had returned in the form of the apostolic authority of the pope. Then, at the base of the statue, he invented that extraordinary pavement of gray and white stone with a central twelve-pointed star (fig. 319). Radiating outward, repeating itself in ever widening eccentric and epicentric curves, it became an elliptical orbit of symbolic light which reflected and idealized the natural light of the physical sky. Ackerman recognized in this design the iconic scheme used by Isidoro of Seville in his *De natura rerum* to depict the movement of the planets around the earth — therefore, *Roma caput mundi*. Following after that great intellectual, Michelangelo also did not consider symbol as abstraction. For him, an awareness of conceptual content did not reduce but instead heightened the power of the imagination. The "astral" light of the piazza pavement was different from but no less illuminating than the natural light which it reflected.

The fronts of the palaces were designed as a function of that light. They were the screens on which took place the osmosis of the physical light which fell from above and the intellectual light which rose from below. The Senator's Palace has in fact been described as a diaphragm between the strong plastic body of the grand staircase and the space existing behind it, which was once part of the Roman Forum. In the Conservators' Palace, which contained more offices and people, Michelangelo confronted the problem of a utilitarian edifice where people resided and worked. It was not a question of being representative; the fact that it was on the Campidoglio was sufficient for that. The difficulty was to reconcile its practical function with an image that would not be dissonant in the new context. The building had been constructed by the order of Nicholas V, and architecturally it was quite dignified. Even the refacing of its façade would not have been justified were it not within the framework of an organic project to give the whole piazza a different meaning and representation. For Michelangelo, the making of architecture was above all re-signifying something which already existed by adapting it to a new function. In this case, the function would no longer be just administrative but also, at least formally, political. The Conservators' Palace would have a symmetrical twin, the use and function of which had not yet been established or even anticipated. Therefore, these two palaces did not signify a clear functional rationale; rather, they were necessary components of a context whose signification lay outside the individual functions of the spaces and structures. The front of the new building would have the same oblique orientation as that of the Conservators' Palace, thus defining a broadened perspective which reconciled the taller façade of the Senator's Palace and reaffirmed the connection between its staircase and the equestrian monument.

The Rome school of architecture, with Donato Bramante, Raphael, and Baldassare Peruzzi, had established an important typology of modern civil structures, which Michelangelo had to consider and take a position on with regard to his work for the civic seat. The principle of this typology was volumetric balance and a corresponding proportionality of height, width, and depth. A mean, or average, was sought with a view towards a harmonic context for the buildings. Such a proportional structure projected a calculated, slow graduation of the lights and shadows, which answered the requirement for a mitigated, diffuse, uniform illumination. Michelangelo did not agree with this, creating instead for the Capitoline piazza a condition of lighting that went beyond the normal to the point of being metaphysical. Owing to his painterly experience, he gave the architecture a decidedly luministic aspect.

The threshold of the metaphysical was attained only by surpassing the boundary of the physical, and this transition would be fulfilled on the façades of the twin palaces (fig. 319). There were two sources of illumination: the natural light falling directly from the sky and put into vibration by the slender balusters of the roof gallery; and the reflected light rising from below and rendered nonnatural by the orbital turnings of the pavement design. Such a strong projection of the roof cornice was certainly unusual, but the function of that dark "eyebrow" (which will return on the Farnese Palace) and the plain frieze below it was to act as a filter, neutralizing the natural light and corresponding, at the top, to the dark depth of the portico below (see fig. 327). These dark areas intensified by contrast the luminosity of the wall surface. On these palace façades appeared for the first time the unique order of giant pilasters which then reappeared, more strongly orchestrated, on the exterior of Saint Peter's. They had no load-bearing function but, raised on high plinths, they created imaginary thrusts in height. Their planar faces were flooded with light, but it was a light already dematerialized and transfigured by the pattern of the pavement. The stronger the light, the clearer the geometry; space, light, and geometry were all one for the artist. To these verticals were contrasted the horizontals of the wide entablature and the trabeated stringcourse between the stories. Compressed below, as if under the weight of the trabeation, were the unassuming columns of the portico. No proportionality could exist between these short columns in shadow and the very tall, luminous pilasters. Instead, as in music, there was a sudden passage from very soft to very loud — from low, humble tones to the highest and most triumphal.

The newest element of the palace design, with respect to the current typology, was this contiguity of two opposed values — that of the dark void of the portico below and, without any transition except for the compressed molding of the stringcourse, the emergent plane of the second level, which created a sharp coincidence of contraries decidedly antiperspectival and luministic. This innovation was promptly absorbed by Palladio, who left Rome in 1548 without seeing the constructed palace but certainly its design would have been known to him. The unique order and the juxtaposing of maximum light and maximum shadow without the gradual mediation of the arch would become structuring factors of his own civil buildings. Thus, there was a point of tangency between these two great masters of Mannerist architecture, as well as a point of encounter between Rome and Venice. Not

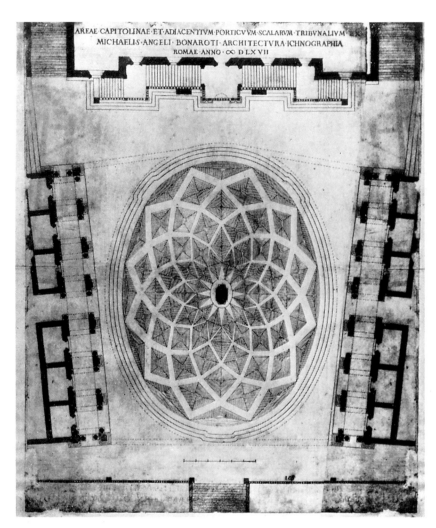

317. *Plan of Capitoline piazza (based on "architectural plan by Michelangelo Buonarroti"). Print published by Bernardo Faleti, Rome, 1567*

without consequence was the fact that Michelangelo had gone—more precisely, had escaped—to Venice in 1529, when he realized the increasing danger posed by the siege of Florence. Already working in Venice at the time was his old Tuscan rival Jacopo Sansovino, who had a close relationship with the painter Titian. The façade of the Sansovinian Library of San Marco, of 1537, was undoubtedly a courageous attempt at "Titianism," or "tonal" architecture, and while Michelangelo did not see the actual library, he must have been informed about it. He acknowledged that light and shadow could be factors of construction, but he did not make concessions to the sensibility; rather than giving in to visual emotions, which he wanted to be strong, he reacted to them. Nor did he entrust the tonal modulation of the architectural planes to the sculptural decoration as Sansovino did. On the luminous plane of the large pilasters, he compressed the opposites of the deep portico and the flat wall surface of the story above it (fig. 329). He dwelt on the connections between contradictories, marking the break between the stories with the trabeated stringcourse, just as he marked the break between two strophes in his poetry, while rhyming the columns of the portico with the smaller ones of the windows above. The columns were the same iconic image—the same parole from the lexicon, even though the portico receded and the second level emerged. He hit on this idea, then, of framing the window voids with the same, but smaller, cylindrical forms as those below, which succinctly connected the dark void of the portico with the advancing plane of the plinths and pilasters. In sum, the façade did not avoid but clearly overturned the perspective structurality of civil Roman architecture. And this was not only a matter of the effect but also of the structure of the image.

He eliminated all graduation of tonal values by taking away the decoration that was the agent of this graduation in the classical scheme. Because the effusion of light was in rhythm with the design of the pavement, and that light was nonnatural, the classical decoration turned into pure ornamentation—the prolonged beat of the dentils of the trabeation, the rhyme of the balusters of the window galleries with those of the roof gallery, and the echo of the shells in the window pediments in the "boiling" acanthus capitals of the pilasters. There was, of course, no volumetric development corresponding with the compressed structural spatiality of this new front for the palace; as in the design for San Lorenzo, an autonomous façade was provided for a preexisting building, and this autonomy involved placing that façade in relation to the foreground space rather than with the space contained by it—that is, with the void of the piazza rather than with the volume of the palace structure.

Michelangelo repeated here the solution he had devised for San Lorenzo using returns, like "turned-back cuffs," wrapping around onto the sides of the building. In this way, the façade was not subordinated to the interior but rather enclosed and bestowed on it, by implication, an orientation towards the space in front of it. The façades of these two Capitoline palaces functioned as walls for the piazza and lateral screens for the physical light

318. *Étienne Dupérac. Elevation view of Capitoline complex based on Michelangelo's plan (see fig. 317). Print published Rome, 1569*

pages following:

319. *Piazza del Campidoglio seen from clock tower on Senator's Palace. Rome*

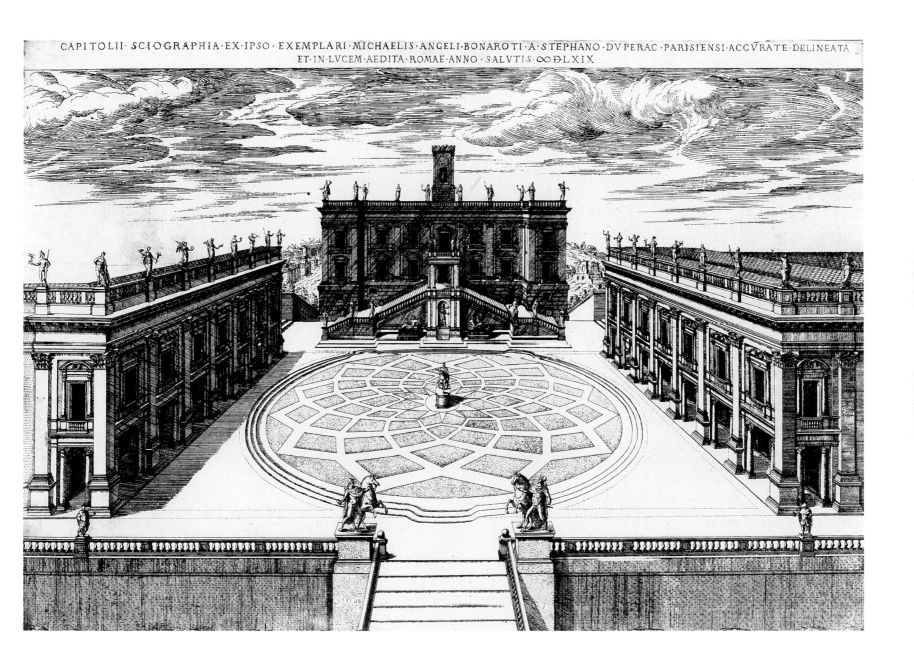

CAPITOLII · SCIOGRAPHIA · EX · IPSO · EXEMPLARI · MICHAELIS · ANGELI · BONAROTI · A · STEPHANO · DVPERAC · PARISIENSI · ACCVRATE · DELINEATA ET · IN · LVCEM · AEDITA · ROMAE · ANNO · SALVTIS · ∞DLXIX

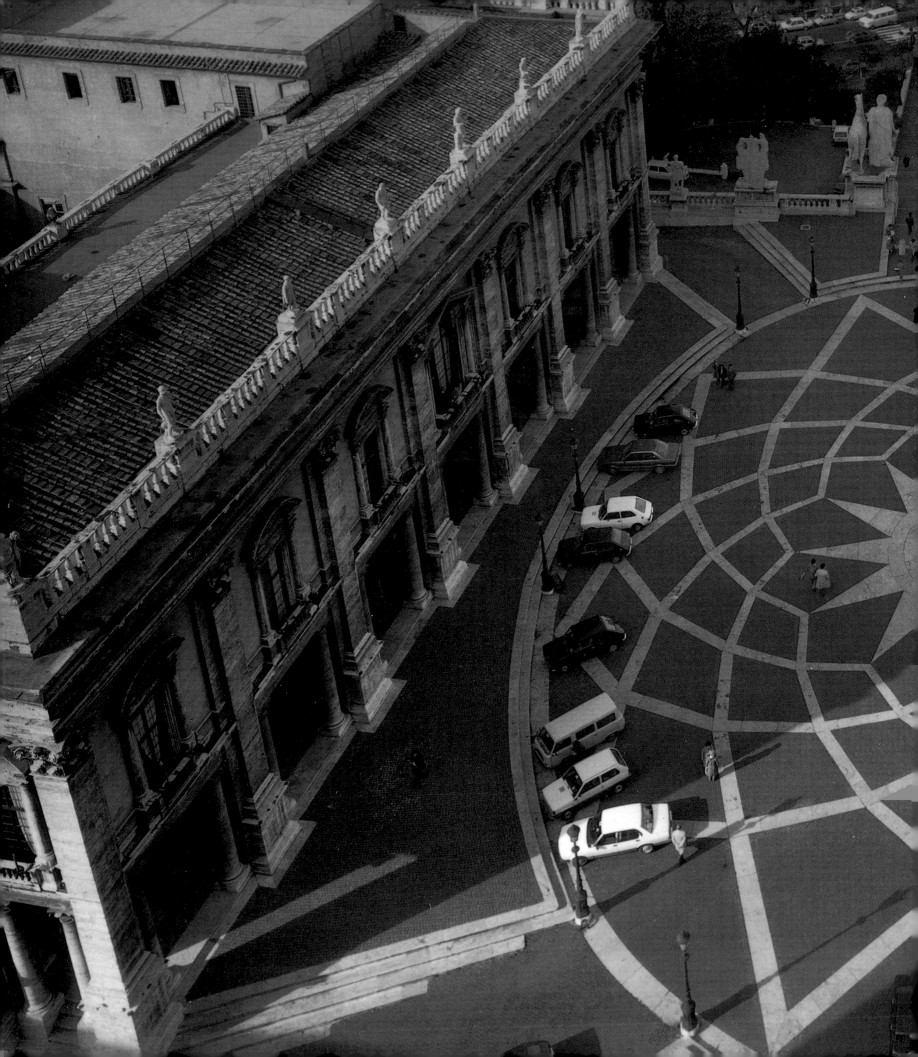

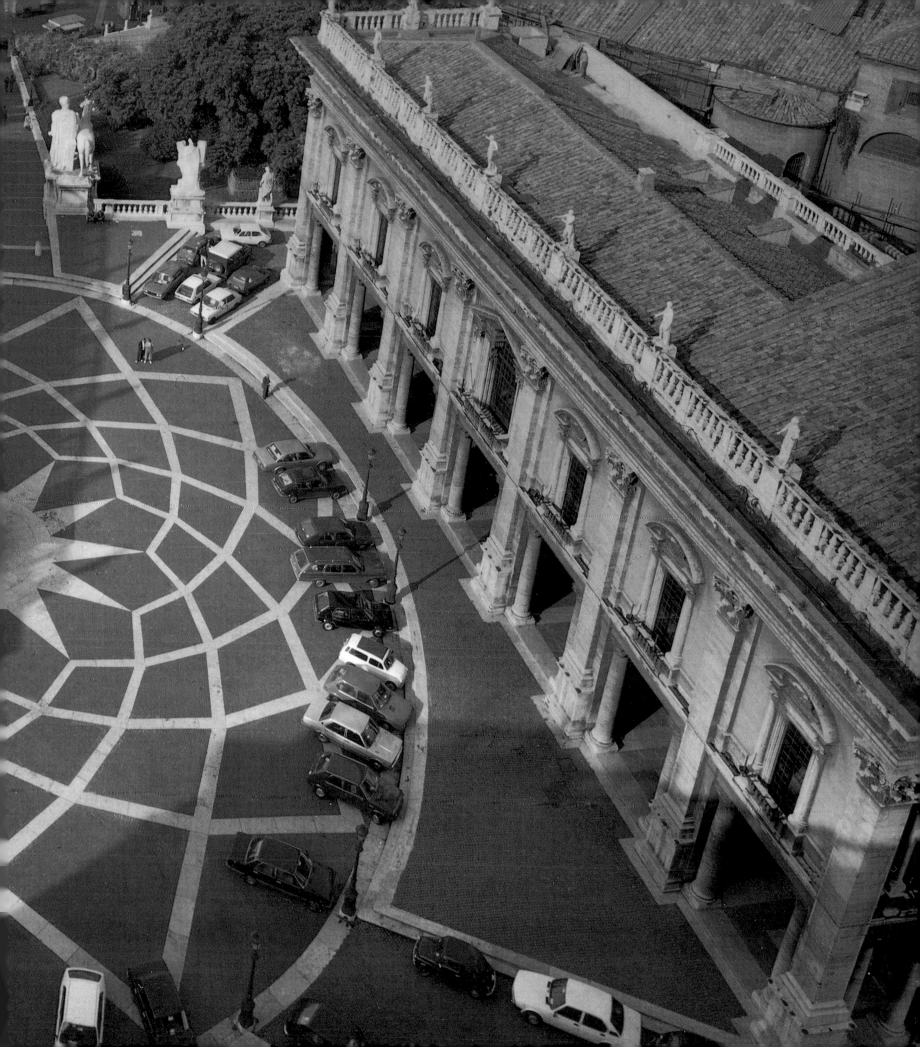

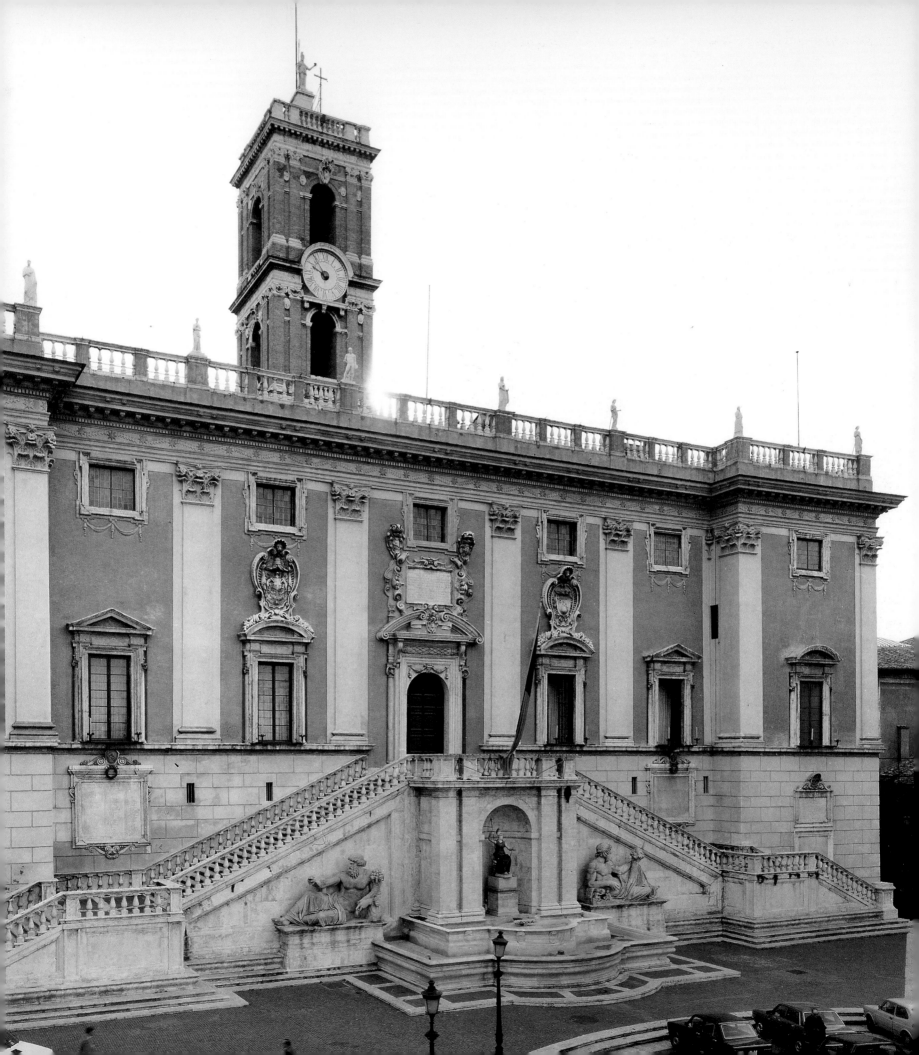

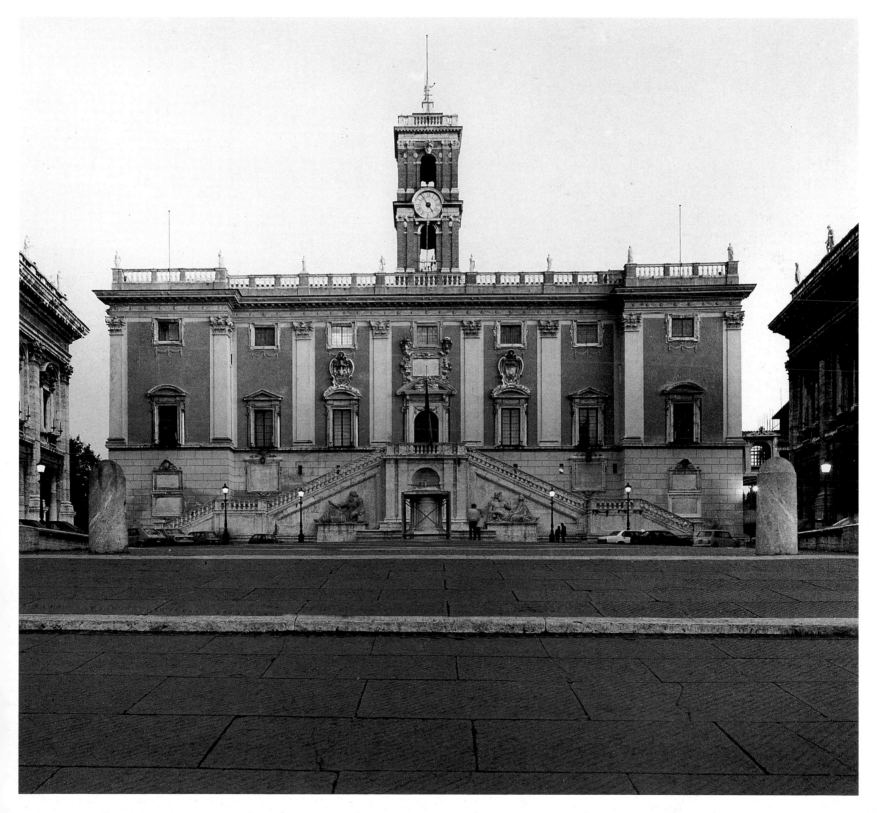

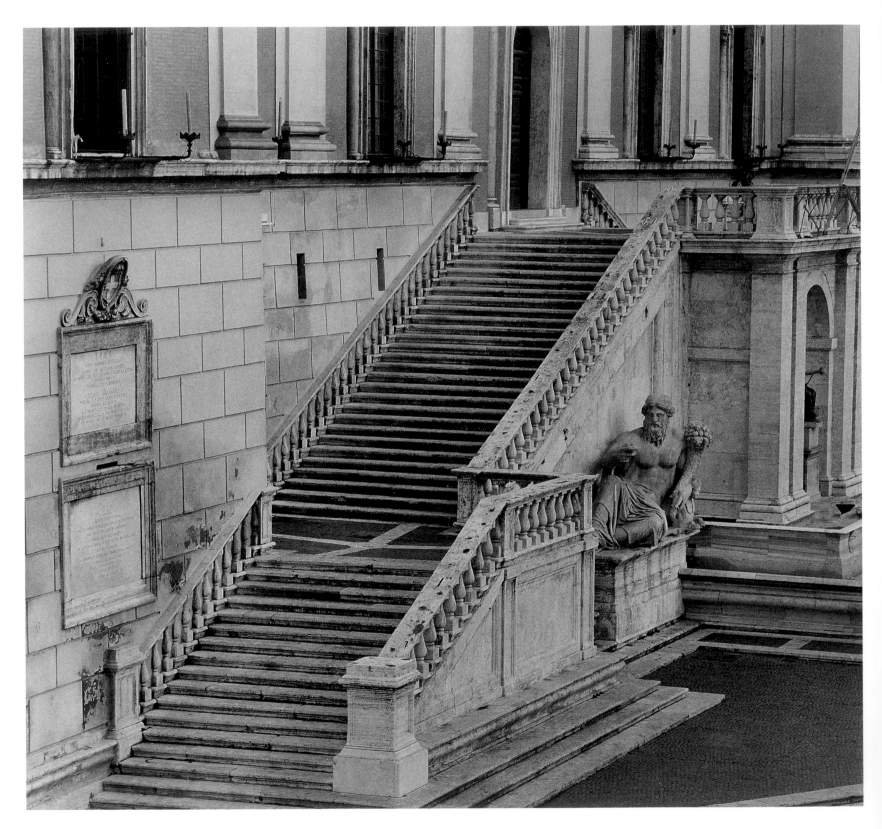

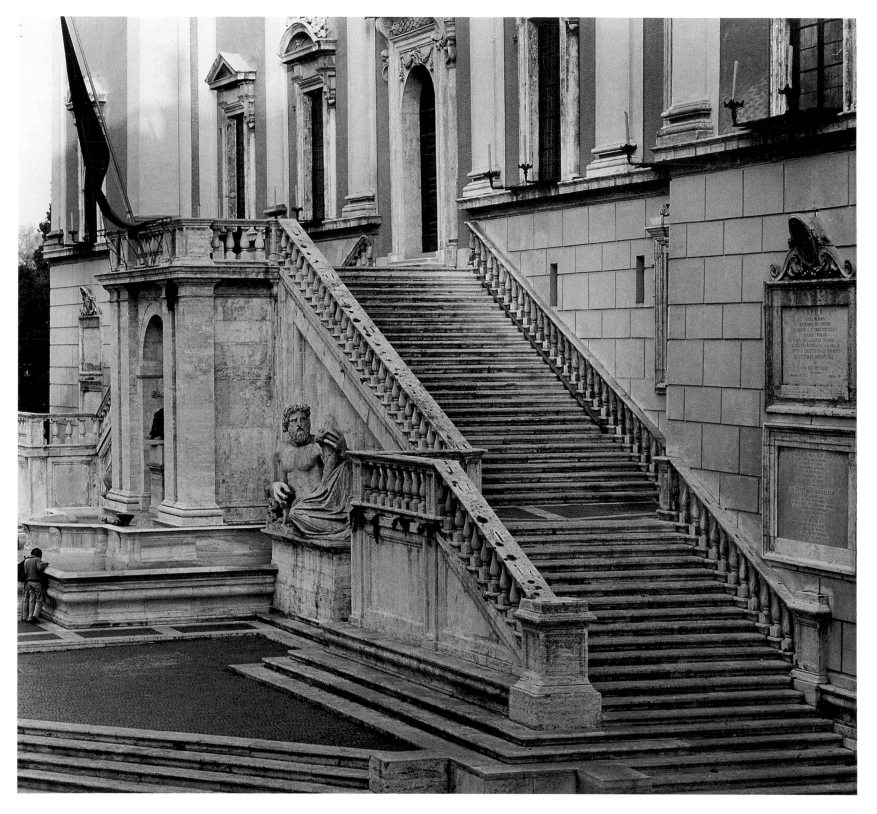

325. *Senator's Palace, staircase,*
intermediate landing and (upper right)
main landing with base for balcony never
completed. Campidoglio, Rome

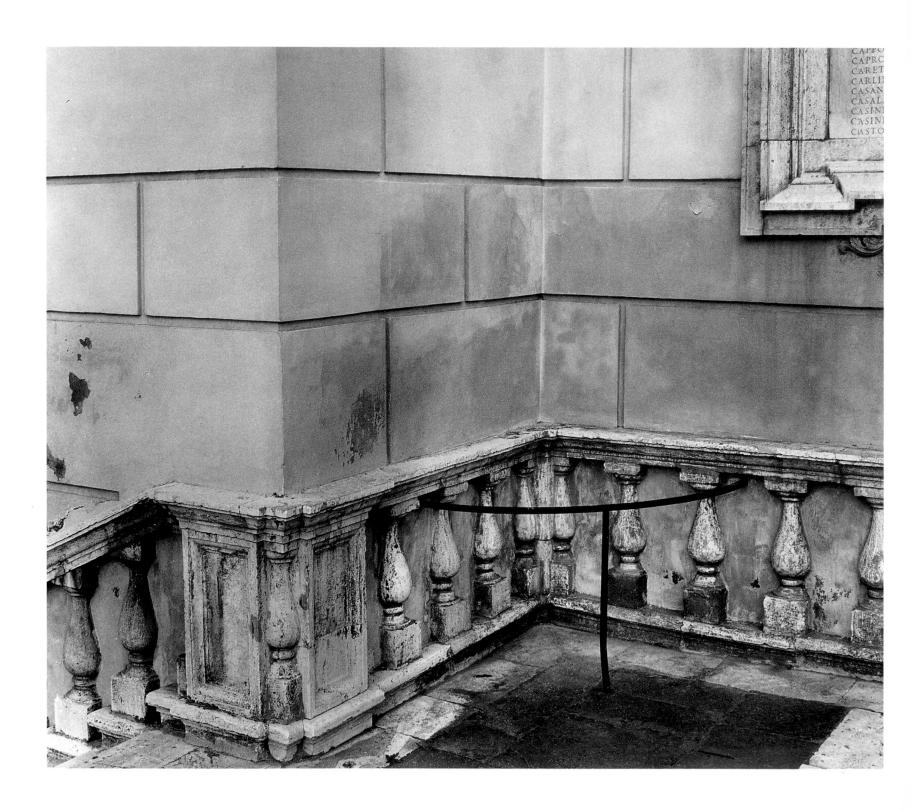

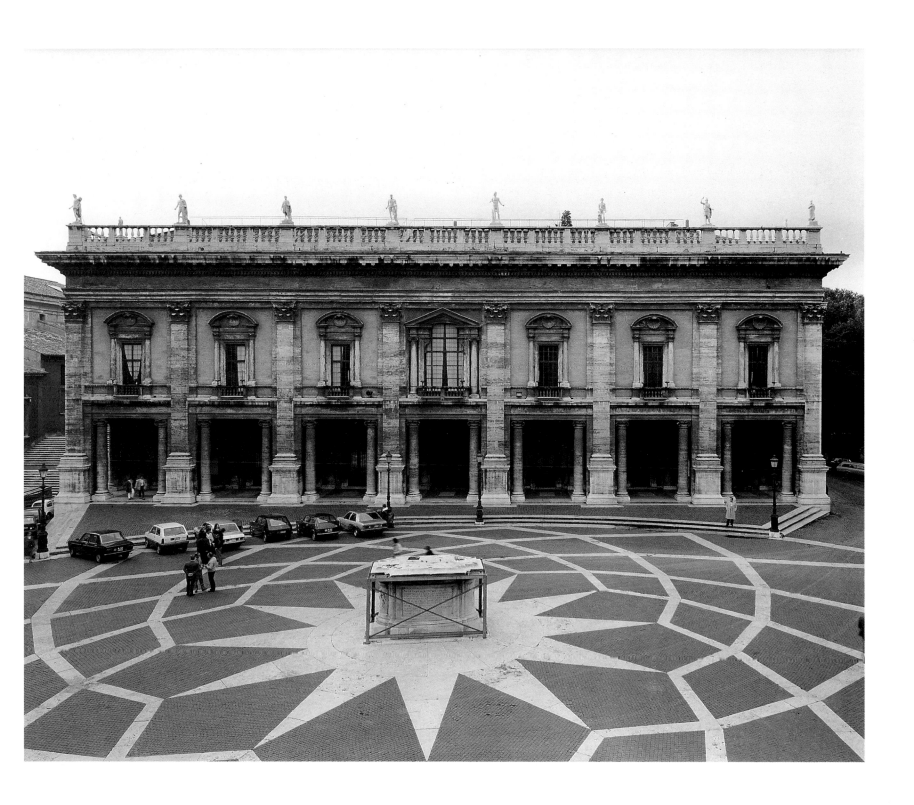

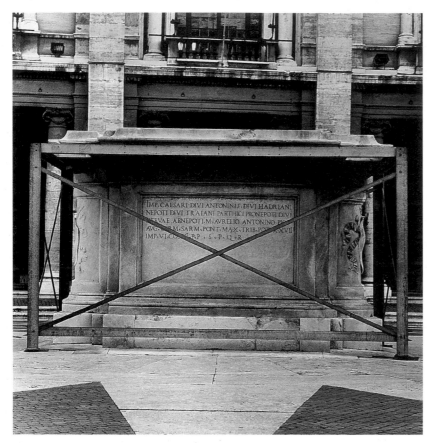

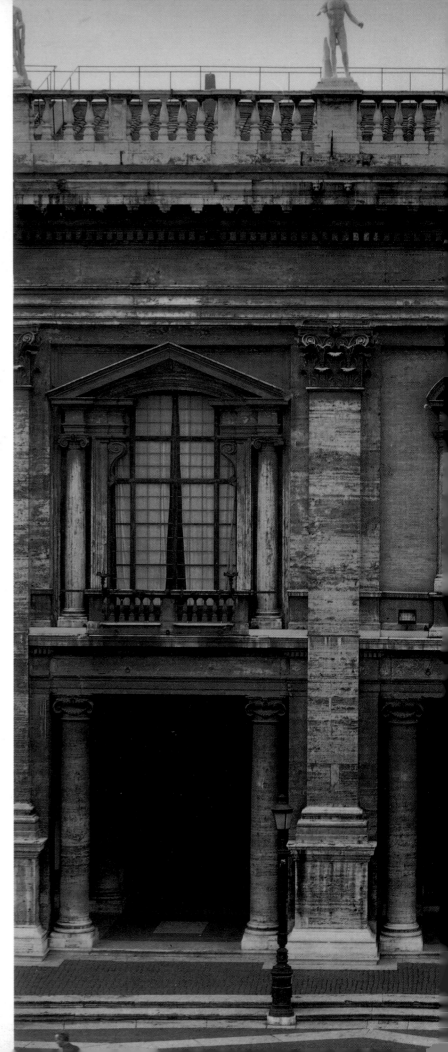

received and re-signified by the design of the pavement, then dispersed again as "astral" light. The return faces were the width of only one bay, and this depth constituted the "thickness" of the façade, which was thought of as a raised plane rather than as volume—in essence, as a bas-relief. Thus, the structure of Michelangelo's architectonic spatiality was still, and would remain, that of the *schiacciato* relief derived from Donatello, with its levels quickly flattening out in recession one after the other. Michelangelo had studied and experimented with this type of relief in his early years, and in passing to sculpture in the round, he had simply eliminated the background plane while preserving the intensity of the single point of view. It was this same visual intensity which the artist then imposed on his architectural images as compensation for—or better, for the surpassing of—the re-nounced representationalism.

The Farnese Palace

Paul III was a great pope, but he had the not unmerited reputation of an outright nepotist. In addition to his greed for riches and power, he wanted the image of the pope to reflect the double prestige of apostolic father and temporal sovereign. Obliged to do politics with the Holy Roman emperor and the king of France, he found this double sovereignty to be useful in his maneuvers. Obviously, the family of a sovereign should enjoy a certain

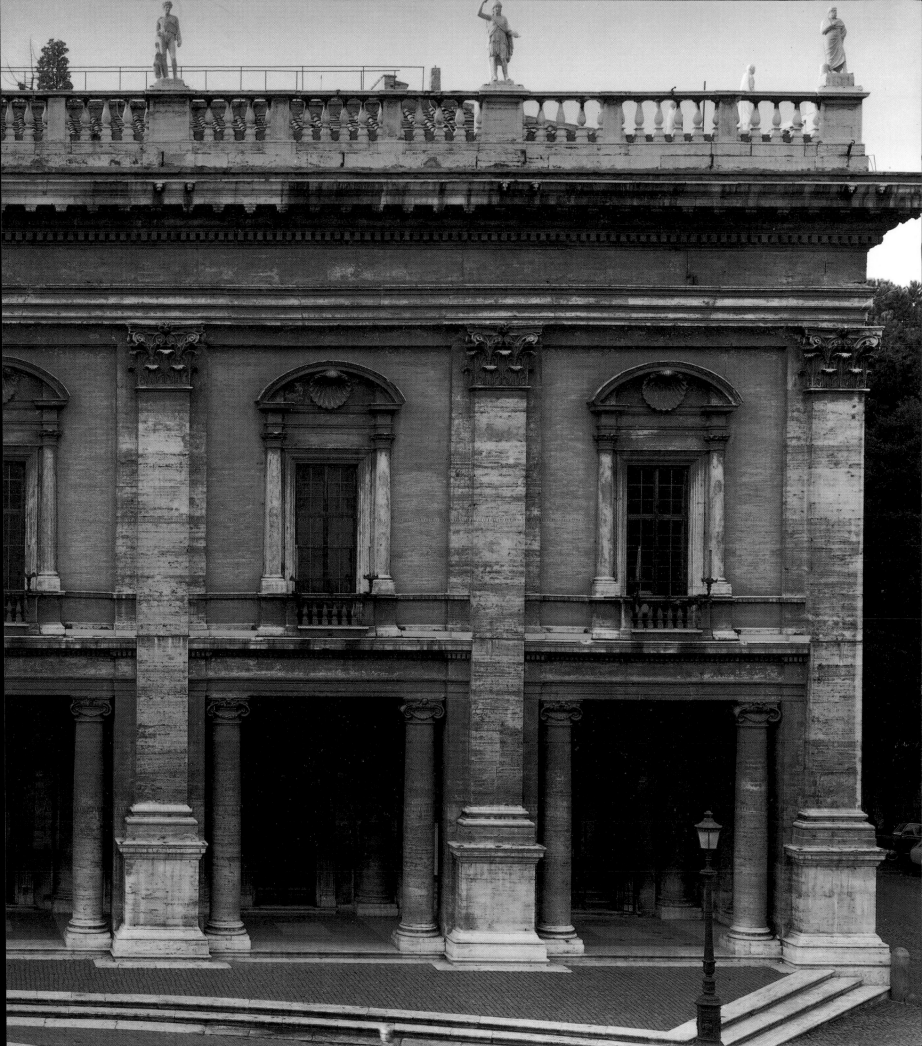

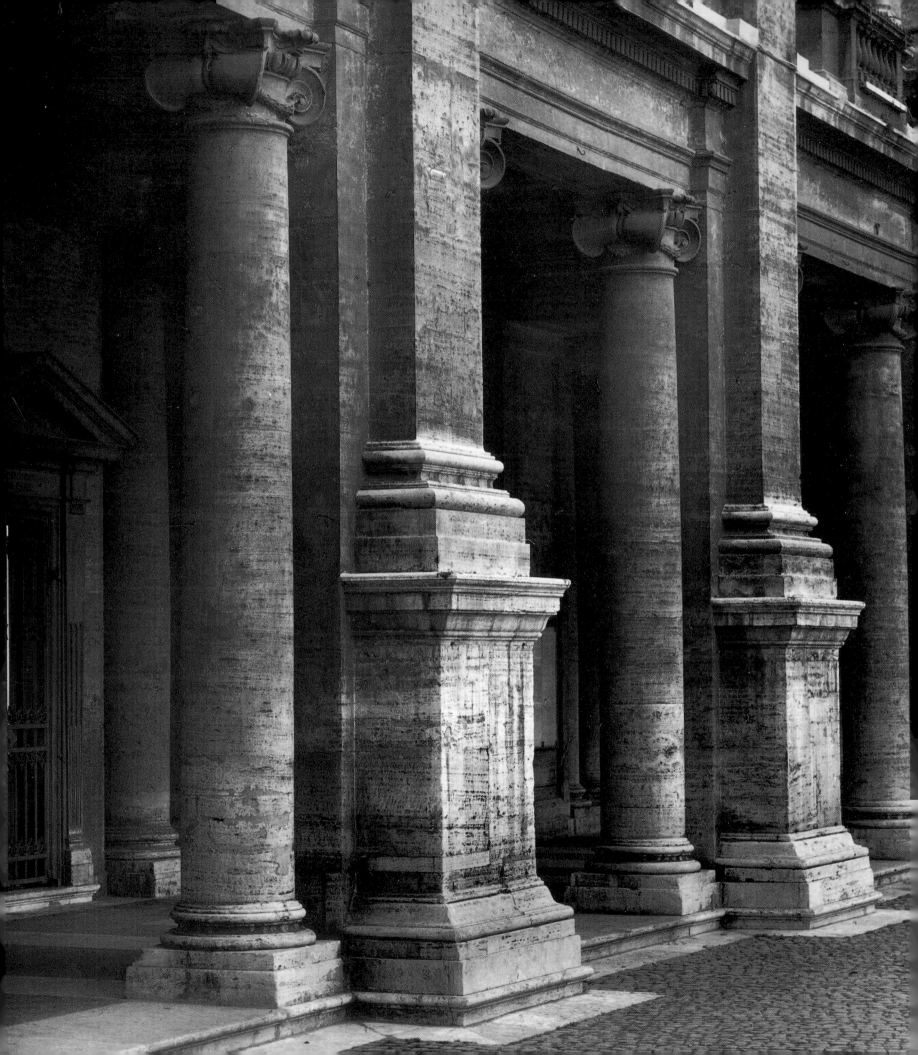

330. *Conservators' Palace, portico, relationship of giant order of pilasters and columns. Campidoglio, Rome*

331. *Conservators' Palace, detail of window on second floor. Campidoglio, Rome*

332. *Conservators' Palace, central window on second floor by Giacomo della Porta. Campidoglio, Rome*

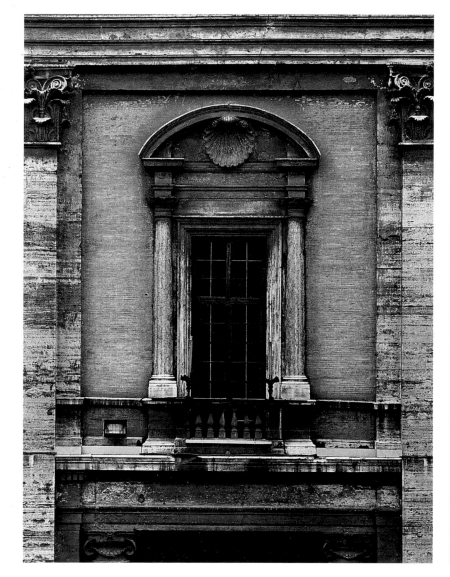

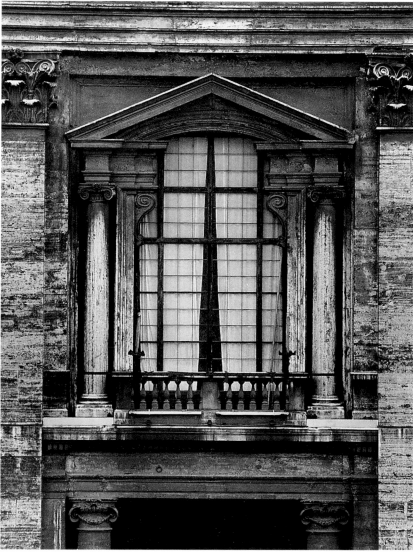

333. *Conservators' Palace, portico.*
Campidoglio, Rome

334. *Conservators' Palace, portico interior*
with rhythmic succession of bays.
Campidoglio, Rome

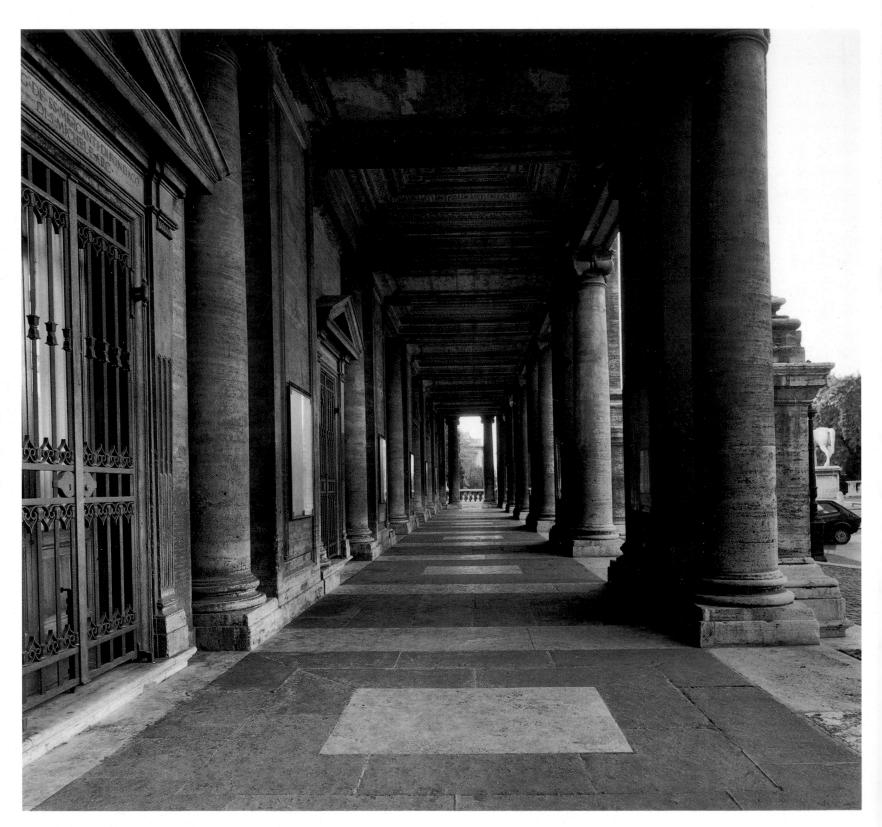

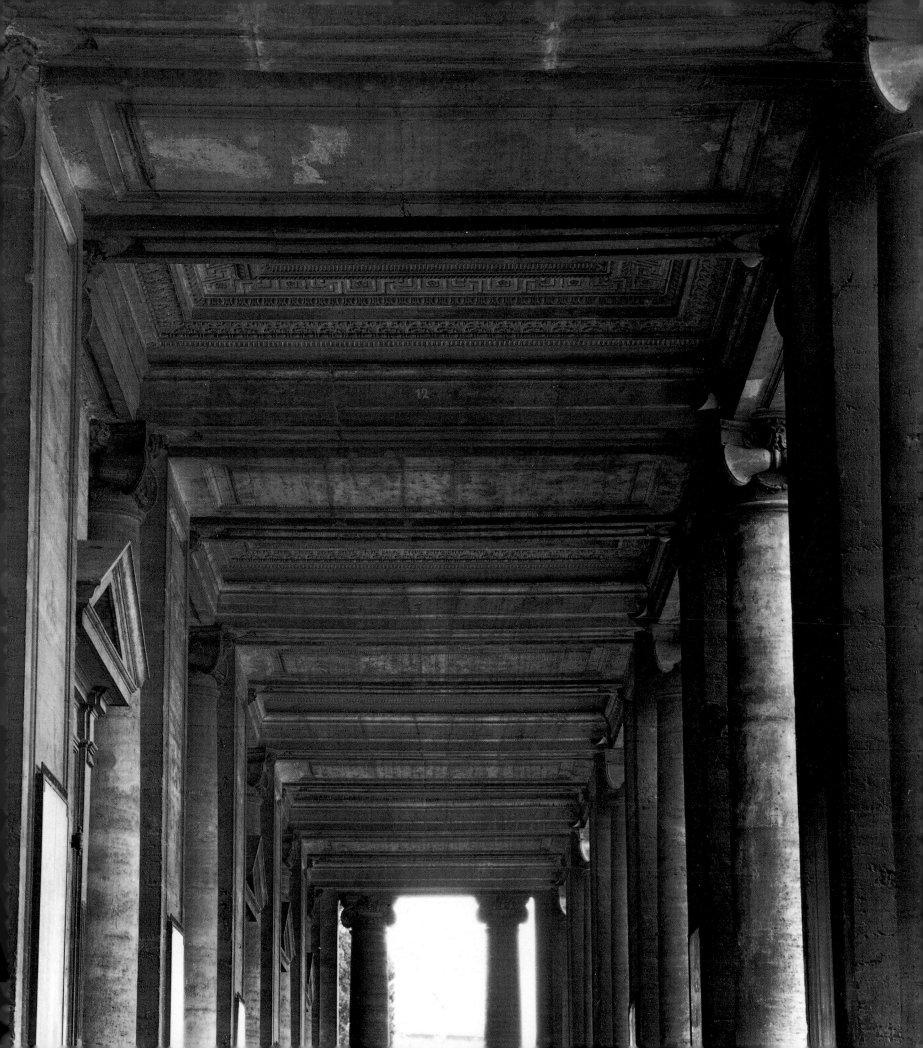

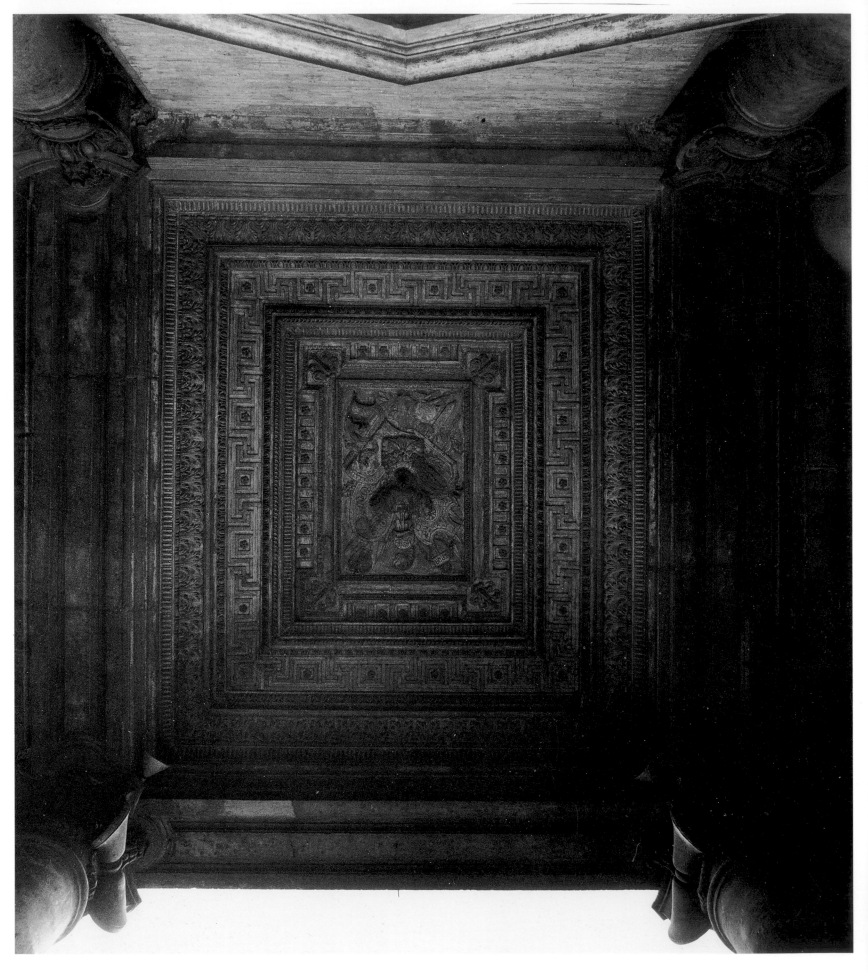

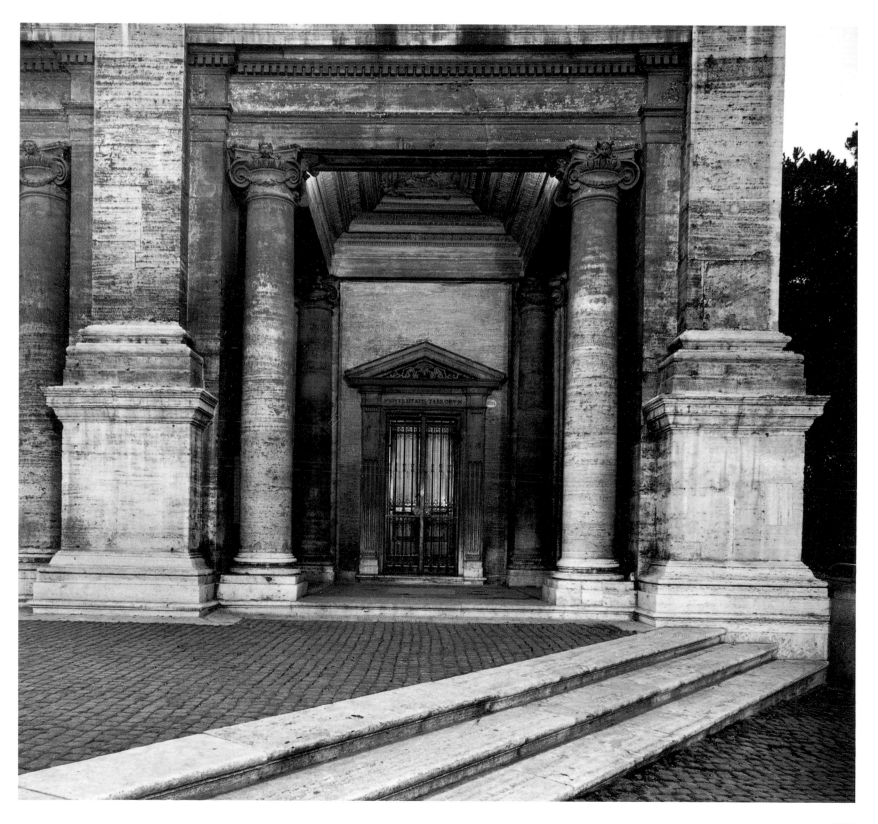

dynastic investiture, and out of this came the importance of and necessity for providing the pope's family members with a residence which was practically royal. While still a cardinal, Alessandro Farnese had decided to have a majestic palace built on the Campo dei Fiori, for whose construction he commissioned Antonio da Sangallo the Younger, soon to be the most quoted of the professional architects working in Rome at that time. This palace had already been "brought to a very good conclusion," when Cardinal Alessandro became Pope Paul III in 1534. This demanded "a palace no longer for a cardinal but for a pope," and Sangallo immediately enlarged upon his original design.

At Sangallo's death in 1546, strange as it was, the pope did not want the work on either the palace or Saint Peter's to be continued by this architect's collaborators, in spite of the fact that they already had in hand the necessary elements for doing so. Instead, Paul commissioned Michelangelo to make both structures. As an architect, the artist had done very little work in Rome, and even the Campidoglio was still only an idea. But he had painted *The Last Judgment* and the Pauline frescoes, which was sufficient to demonstrate not only his doctrinal and religious zeal but also his extraordinary use of empathy in his communication through images. While the Farnese Palace did not have an intrinsic meaning comparable to that of the new Saint Peter's, in assigning both projects to Michelangelo, the pope wanted each of these edifices to move from the plane of being just a dignified building to one which gave evidence of its specific conceptual content. Knowing how difficult the artist was about commissions for work, it is not so easy to understand why he accepted the pope's commission to succeed Sangallo, whom he detested, in the construction of the Farnese Palace which was already in an advanced stage (No.19). Rather than malice or an opportunistic compliance with the wishes of the pope with an eye to the commission for Saint Peter's, it was more likely owed to his urge to change radically, with only a few strokes by the master, the meaning of something which already existed. By doing this, commented Ackerman, "he created the masterpiece of his rival." Or was it not really his masterpiece and therefore humiliating to the memory of the rival?

His interventions were very few on the Farnese façade (fig. 339), which had already been built up to the third story where the windows had even been partly executed. In essence, he only raised the overall height of the façade a little, created a larger entablature, and altered the form of the window-loggia at the center of the second story above the main entrance. Previously, he had expressed the representativeness of the Conservators' Palace on the Campidoglio through its entablature and window design. In the Farnese, he emphasized these to the point of exaggeration, probably because he was quite aware of the effect their inconsistency would create.

Sometimes, works of pure skill reveal the dynamic of the artist's mind in action. He heightened the wall of the third level of the palace façade, not to correct a disproportion between height and width but rather to give the façade a scenic frontality. He also transformed the entablature above it,

which would otherwise have been only a border. Projecting more than before, the new roof cornice had a function in forming a "visor" of shadow, which made the neutral, inert surface of the wall plane appear brighter by contrast. In addition, by sharply separating the wall surface from natural space, the cornice put the façade in relationship with the piazza which, as shown in an engraving of 1548 by Nicolas Beatrizet (fig. 376), was given a perspective design. Although this design did not have the cosmic symbolism of the Capitoline pavement, the type of relationship was the same. The visual effect was the clear detachment, mediated by that dark eyebrow of the cornice, between the space of nature and the architectural space. Once this was achieved, the large cornice was then reduced effectively to a purely heraldic element, a sign of power. The entablature moldings had no interconnection (fig. 342). First came a band decorated as if by embroidery with a repeat of the Farnese lily, and immediately above it was placed a band of dense, throbbing dentils giving a strong, fast beat to the alternation of light and shadow, a typical Michelangelesque element. This beat was accelerated yet softened in the egg-and-dart molding which followed, with the rounded elements creating the same rapid alternation between bright light and dark shadow as did the dentilled molding. Surmounting this band was the strong, deep, roof projection supported by large brackets, only the curled tips of which emerged into the light. The vertical face of the cornice was finished off with a plain narrow band topped with a reverse ogee molding ornamented with animal heads.

As in the Capitoline palaces, at the center of the façade was a large window area constituting a loggia-tribune unlikely ever to be used as such (fig. 343). This was already in the Sangallo design but as a pleonasm of the main entrance below it. Michelangelo's alteration, as on the entablature at the top, was simple but energetic. He suppressed the repetition of the arch, substituted a very large escutcheon for the pediment, enlarged the window opening, and doubled the flanking columns. But in the end, the artist did not transform a cardinal's residence into a "papal" palace. The pontiff actually lived in the Vatican, and this seat of the Farnese family and its court became in reality the annunciation of and a program for the neofeudalism of the Counter Reformation which began precisely with Pope Paul III.

The construction work on the courtyard and the palace interiors was less advanced, and in these areas there was no obligation to show to the general public the paternalistic, authoritarian face of power. Sangallo had built the courtyard portico and the floor above it as a model of architectural protocol in composition (fig. 344). On those levels which he designed, he successfully united in each of the bays a complete hierarchy of architectonic personalities: the screening of the small balusters; the window pediments *all'antica* as solemn as ceremonial "cocked hats"; and the half columns and lightly outlined arches as a metaphoric guarantee of the balance and stability of power. On the top level, Michelangelo had a free hand, but he did not employ it polemically as he had on the façade. He left the first two levels as they were, in order to preserve the tone of conventional officiality which had

a reason for being in that location. But to the third level, he gave accents of eccentric elegance, justified because a court, even pontifical, had its worldly side (fig. 345). On this final level, the artist changed the tune, so to speak, and sought effects of lightness, and not just in the sense of statics. The short mezzanine level which he placed between the second and top floors had a practical reason—to house the servants, but it created a distinct visual separation between the levels as well. In addition, the line of small windows installed there reversed the meaning of the pseudo balconies placed under Sangallo's windows on the second level (fig. 346). These voids provided lightness and gracefulness, making the windows of the top level seem, even though they were not, taller and narrower. The size of the bay was a given, but the top level was disconnected from the proportionality established by the roundheaded arches of the levels below by a different configuration. The double pilasters created a slight perspective recession as they emerged from the background, raising the level of luminosity of the planar surface and amplifying the sense of space around the windows. Sangallo, with the large triangular pediments touching the imposts of the arches above them, had attempted to tie the windows to the wall structure and to the deep voids of the portico arcade below. Michelangelo did just the opposite by isolating the windows, preserving their iconic image while giving them a great elegance and explicit worldliness. But he could not isolate these architectural icons without also dissolving the static syntax of weight and support. Because this had its own iconic meaning, Michelangelo worked with delicacy, proceeding by way of subtle infractions to the logic of the static system and thereby obtaining, with a minimum of means, an effect of voluble lightness in contrast with the equilibrated weights on the levels by Sangallo.

Michelangelo employed as agents of dissociation the two-step pilasters, whose emergent faces linked up with the space of the courtyard and included it with the wall, the frieze above the pilasters separating their capitals from the cornice, and the window pediment detached from the window frame (fig. 347). The jambs of the window were not fully supported on the sill; instead, the outermost element of the splay went down to, but again did not rest on, the stringcourse below. Sangallo, on the other hand, had respected the rules; his window jambs rested on the windowsill and the volute brackets at the top supported the pediment. Michelangelo also concluded the jambs of his window frame at the top with brackets, but these supported nothing. Moreover, he attached to their faces more iconic details—a lion's head in relief, a scaly epaulet, and a useless grooved support held up in turn by ineffective dentils. Thus his brackets were no longer a concentration of forces but a combination of images without any meaning or motive other than being, semiotically, heraldic. The detached window pediment was a purely decorative form made large and important because it was emblematic. Its shape evoked like an echo the arches of the two floors below, and, although separated from the window itself, its

dentilled brackets rhymed with the dentils of the brackets on the window frame. The strongly projecting window pediment contained nothing but a double floral festoon, whose curves contradicted that of the pediment arch. It was a superficial quotation of the antique, purely formalist but assonant with the capitals of the pilasters, which were not only insignia of social rank but also had an important visual function as well. With their curly acanthus leaves they captured, agitated, cadenced, and then retransmitted the light. Because they were separated from the shadow of the cornice by only a band of the frieze, the palpitation of light on these capitals was intense. The window pediment then received that same light on its projecting arch, denaturalizing it and making it the scenic illumination of a completely artificial space where diplomatic ceremony ended in a discreet social celebration. The courtyard entablature repeated in a reduced and refined way the form of the external one—an eyebrow of dark shadow over an alternation of decorative moldings with flat, light-reflective bands (fig. 344).

The enjoyment of the beauty of nature was a privilege of class, and the opening of the courtyard out towards the Tiber and the distant hills gave the Farnese Palace a double character of ceremonial austerity and courtly grace. One knows, of course, that the most observant protocol and etiquette allow for some educated transgression. Michelangelo was an aristocratic intellectual, even if, "coquettishly," he called himself a manual laborer. In the Farnese Palace, the refined interpretation was related to a social group not his own, although he understood its needs and complexities. His personal interest was not in social customs, however, but in architecture, a branch of the arts where the other branches came together and were resolved—or extinguished—through an *iter* actually experienced by the master. Michelangelo did not interpret that world of near-royalty, which was one he certainly did not care for, in the spirit of a courtier. Rather, he did it because he was persuaded that architecture was art, and, like all art, it was capable of illuminating the conscience of its users, not through edifying paradigms but by exerting a strong influence on their very mode of existence. He was a great master of what would later be termed *Einfühlung*, or empathy, in architecture. For this reason—his morose praise of times past notwithstanding—he should be considered the first modern architect.

While he worked on the Farnese Palace, he continued to think about the Campidoglio and probably even about Saint Peter's. He was preparing to make architecture charged with ideological potential and theological argumentation, and in order to do this, naturally he had to break down that theory of architecture which was constructed on a theory of nature and a theory of the antique, or history. This was the reason for his deconstruction of the contemporary language of constructing. His next work, Saint Peter's, was the first example of *Gebrauchsarchitektur*, the goal of which, in the transcendental sense, was the ultimate salvation of humanity.

338. *Michelangelo. Study of window for third floor of courtyard face for Farnese Palace, Rome. Ashmolean Museum, Oxford, Parker 333r (C. 589r)*

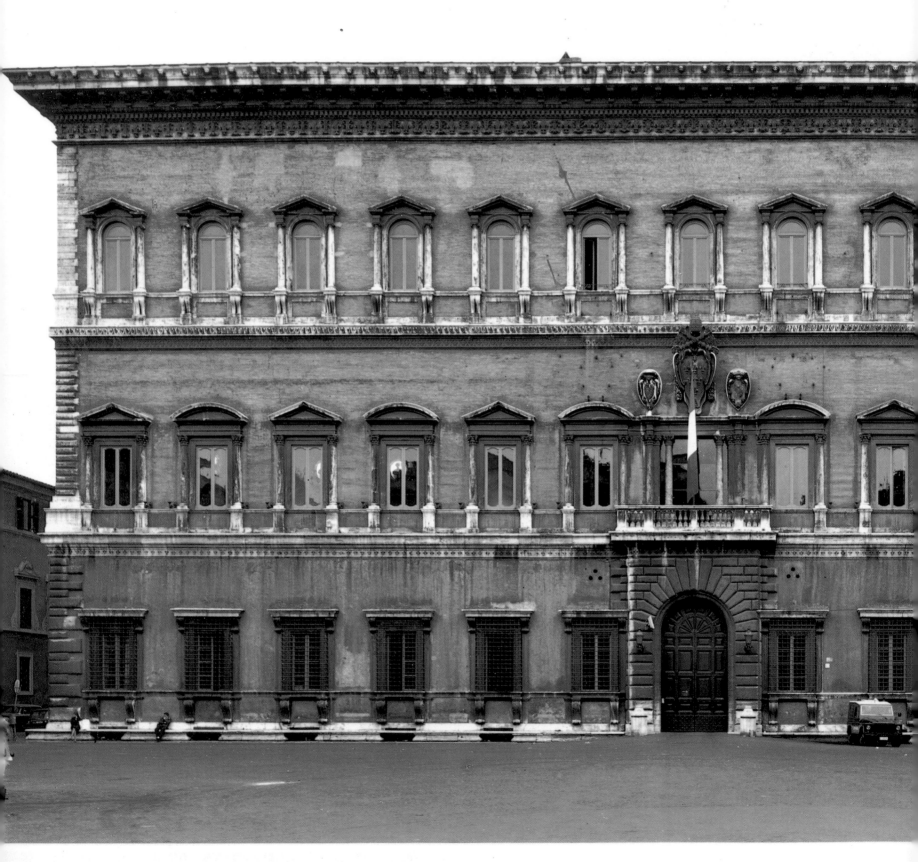

242

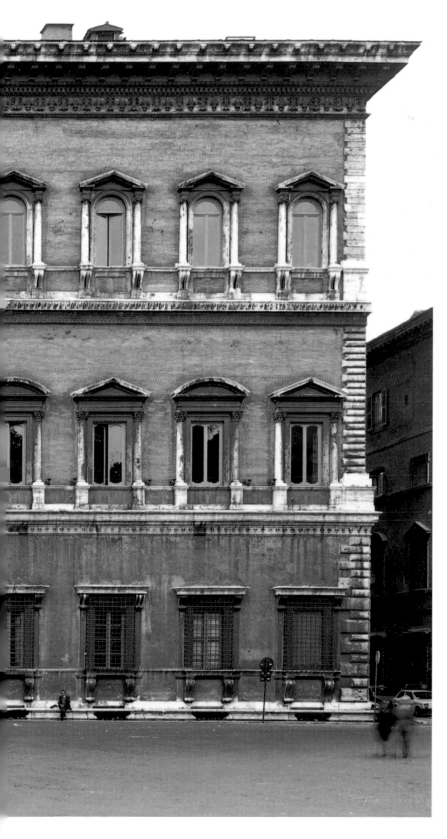

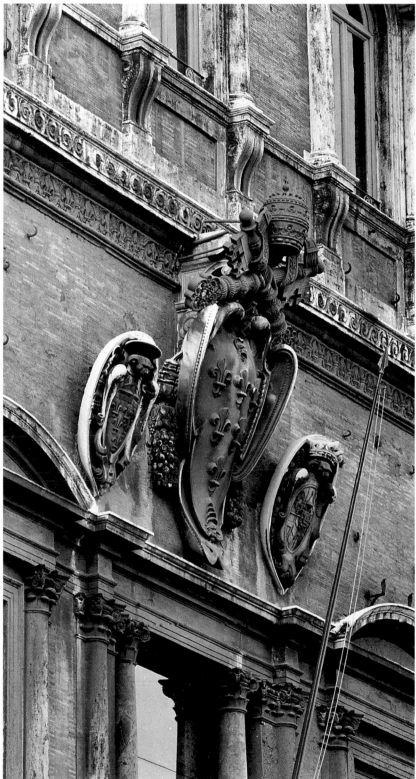

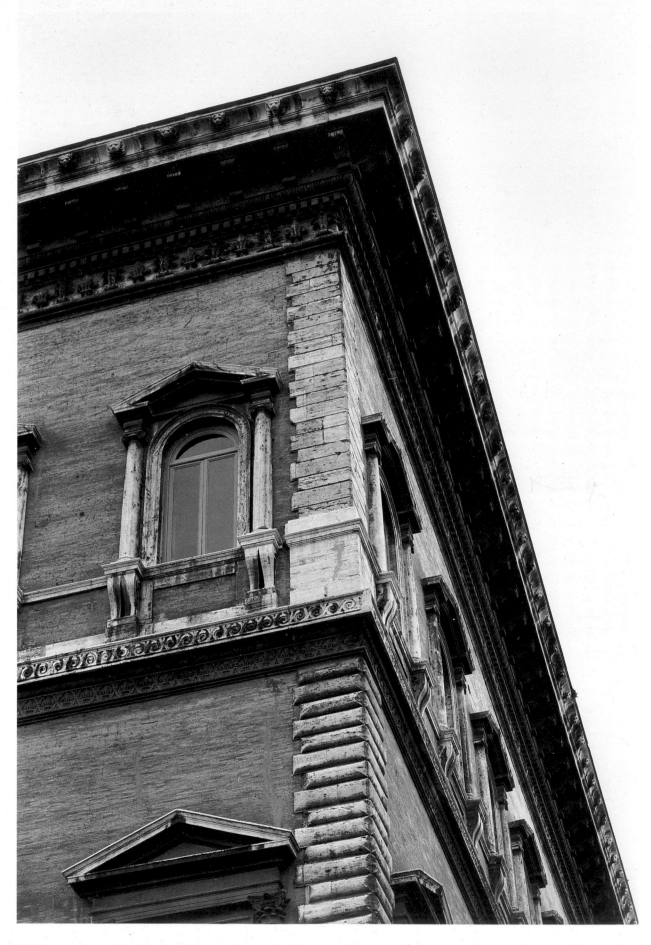

341. *Farnese Palace, Rome, detail of exterior cornice designed by Michelangelo*

342. *(opposite) Farnese Palace, Rome, detail of articulation between exterior cornice and wall plane*

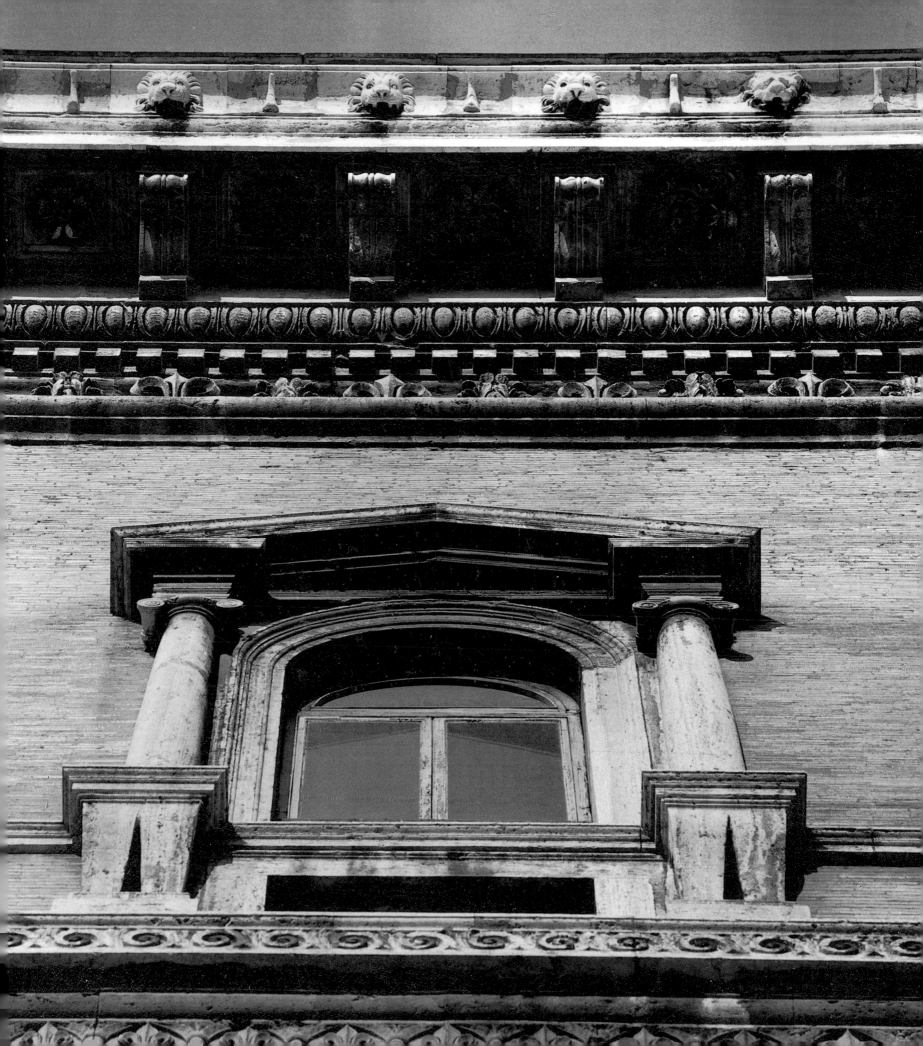

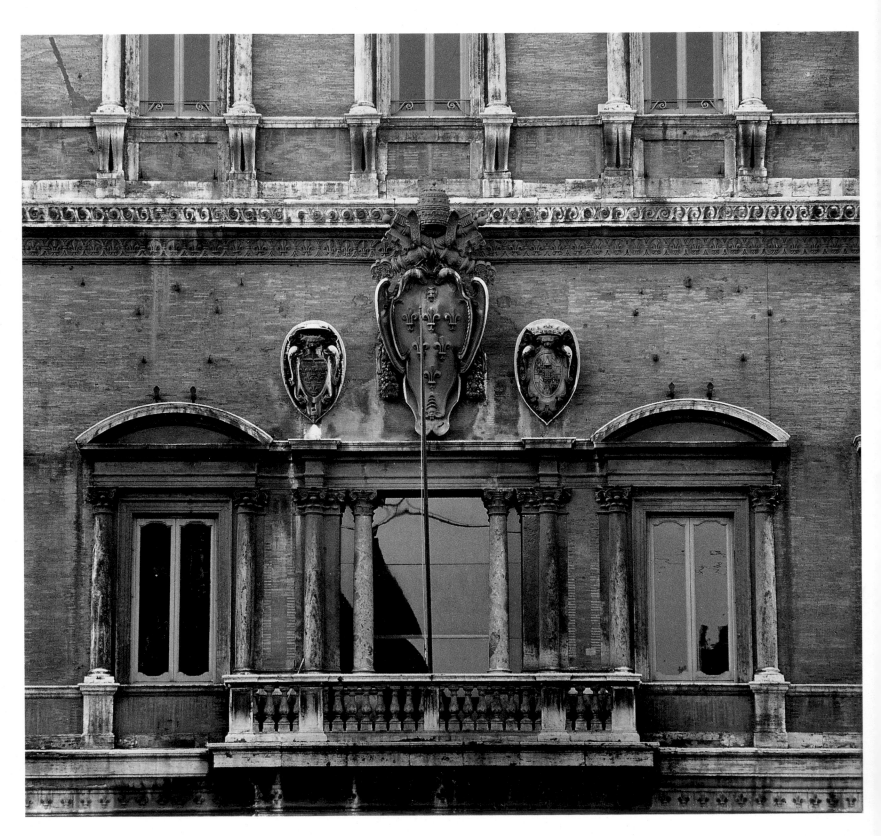

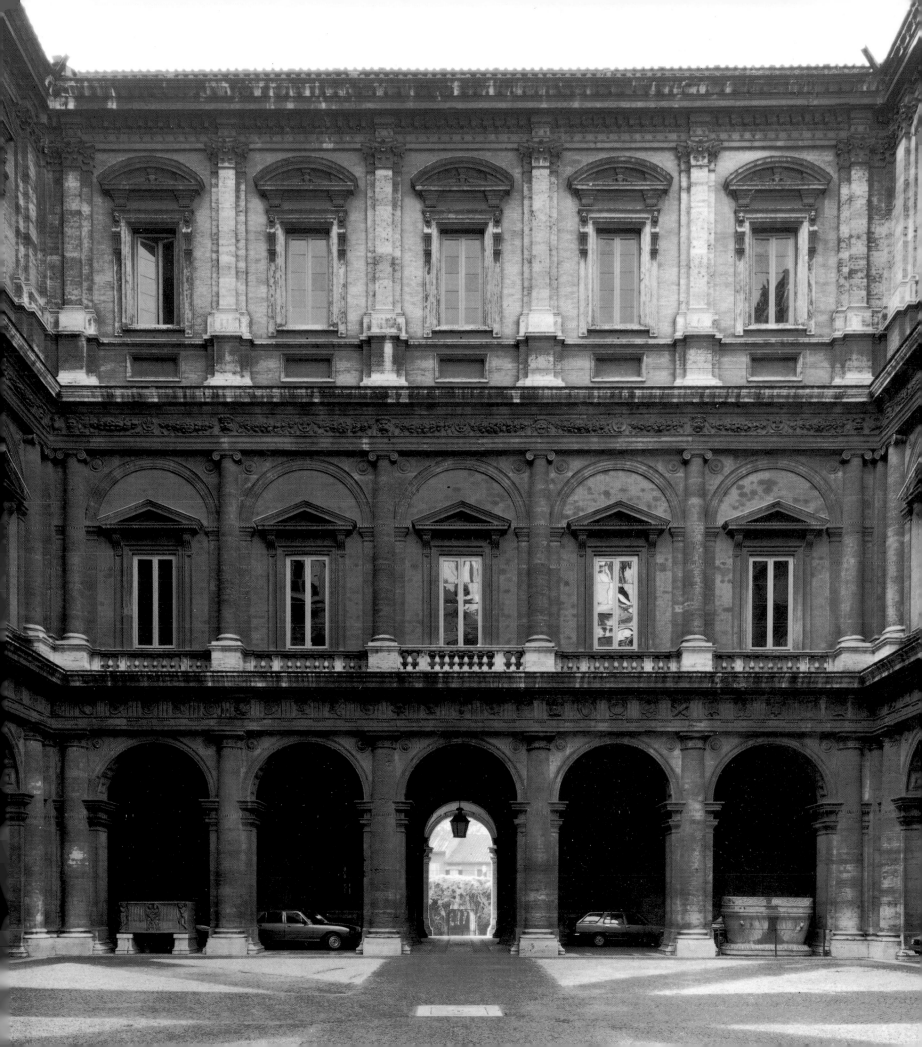

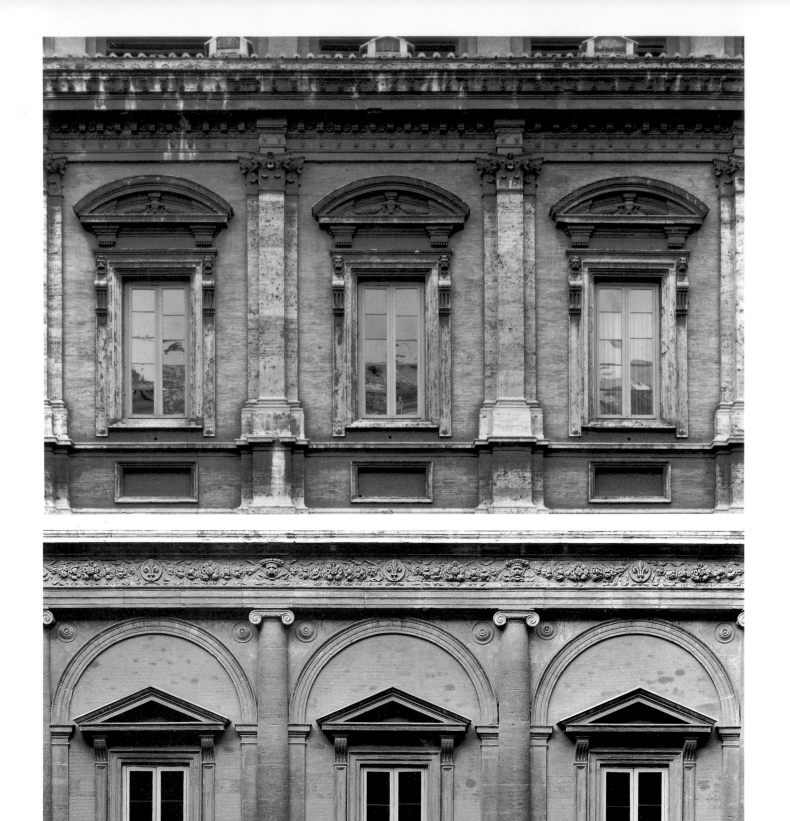

345. *(opposite above) Farnese Palace, Rome, courtyard, third floor designed by Michelangelo*

346. *(opposite below) Farnese Palace, Rome, courtyard, second (main) floor executed under Michelangelo's direction after design by Antonio da Sangallo the Younger*

347. *Farnese Palace, Rome, courtyard, detail of window on third floor*

pages following:

348, 349. *Farnese Palace, Rome, interior views of gallery on second (main) floor opening onto courtyard*

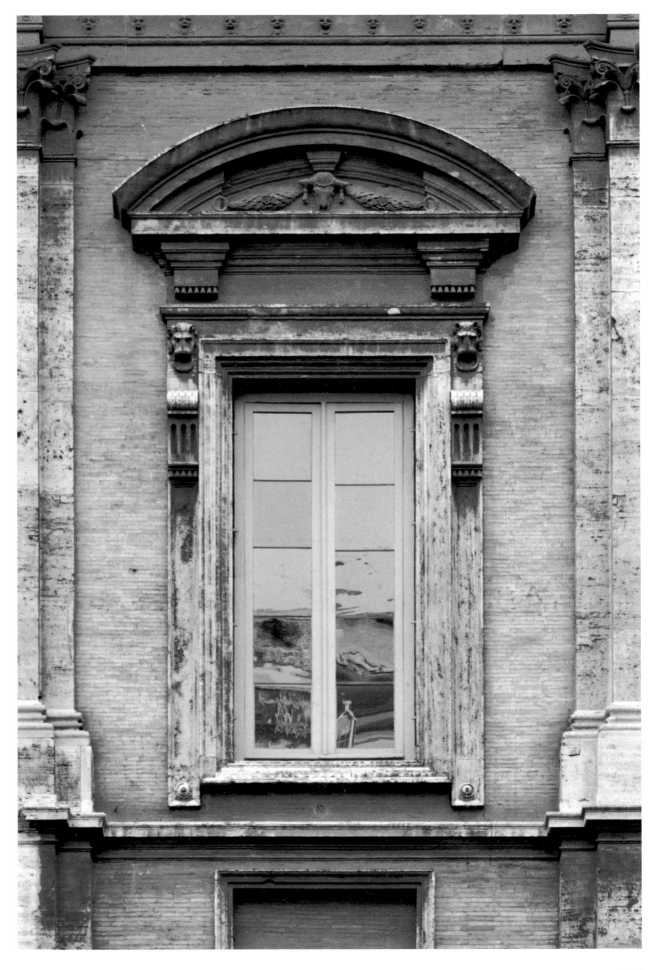

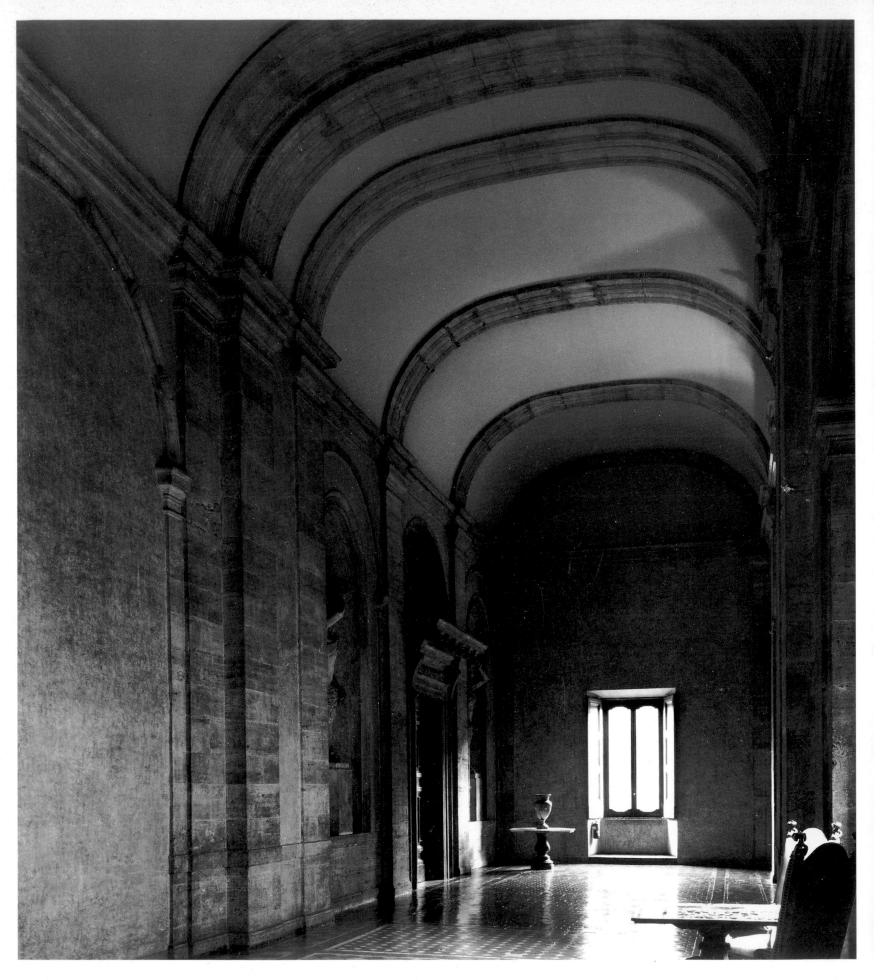

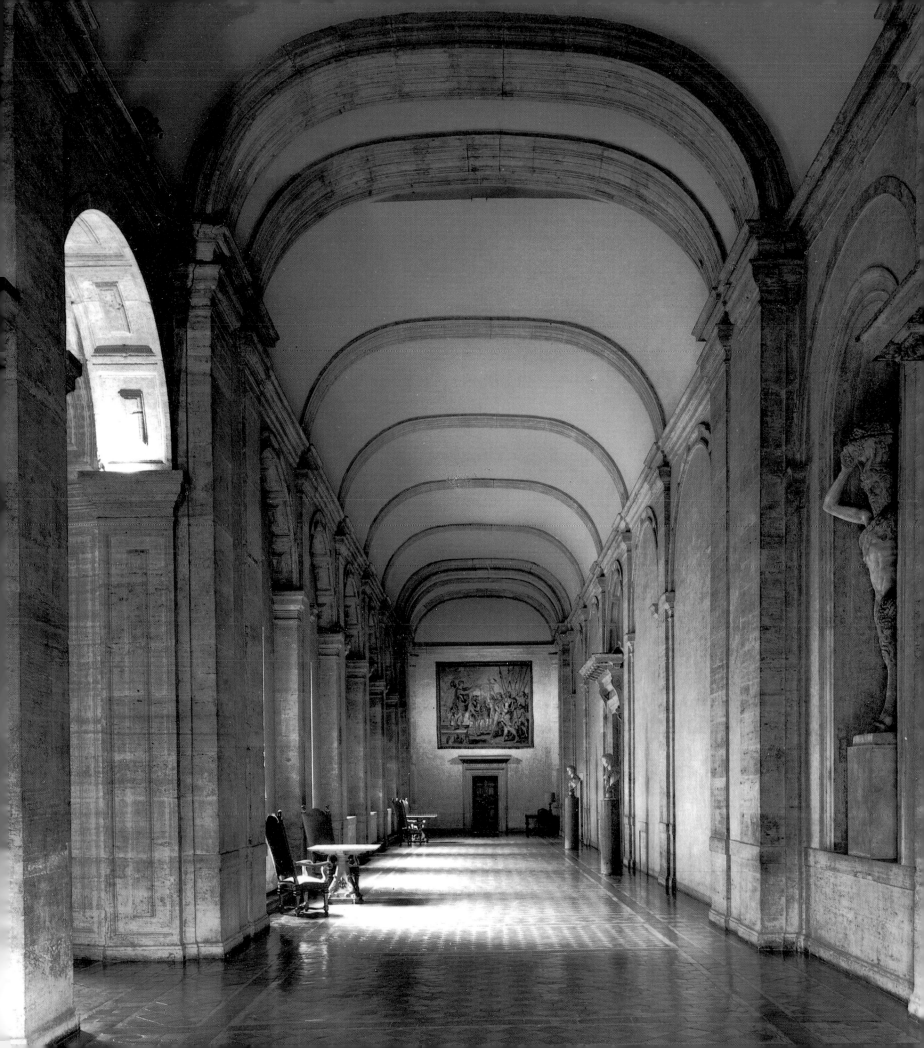

The state of the Capitoline *asglum*— the saddle of the hill from the southern plateau of the Capitol proper up to the *arx*, or citadel, on the north—was depicted in a series of drawings from around 1536 by Dutch artist Maerten van Heemskerck (Hülsen-Egger 1913–16). The Heemskerck sketch in fig. 350 shows a view of it framed between antique monuments, an obelisk and a column. At the left is the Senator's Palace, constructed in the twelfth century on the ruins of the Republican Tabularium (78 B.C.) and renovated at the end of the thirteenth on the model of city palaces in central Italy. It appears in its fifteenth-century configuration except for the bilevel loggia at the right end, probably sixteenth-century, with access at the front from a flight of steps (Elia 1986). Towards the right of the picture in the area which lies opposite the Church of Santa Maria in Aracoeli (reconstructed in the thirteenth century) is the Conservators' Palace, built as the seat of the *bandaresi*, or city militia, but later used for the offices of the municipal corporations and the conservators, or elected magistrates, of Rome. The façade of this building has a columned portico, also fifteenth-century and belonging to the period of Nicholas V. (For phases of construction on these palaces, see D'Ossat-Pietrangeli 1965.)

Traditionally, the impetus for the sixteenth-century project to renovate the Capitol is considered to have been the triumphal entry of Emperor Charles V in 1536 following his victory in Tunisia. In preparation for the celebration of this entry, the city council resolved on November 30, 1535 that "the People at its expense would have the piazza of the Capitol decorated with scenes and other necessary things, including the ascent and descent for this piazza" (Lanciani 1902). But this ephemeral decoration was never carried out, and the imperial procession circled the hill without ascending to the top. The Campidoglio had actually been the scene of provisional decorations earlier, on the occasion of the Medicean celebration in September 1513, when a real "theater" was constructed there of wood (Bruschi in Cruciani 1969). But more than being tied to the celebration of the

imperial entry, the renovation project for the Capitoline Hill involving the work of Michelangelo was deeply rooted in the urban redefinition, both political and ideological, begun by Paul III in the early days of his pontificate, as recently many scholars have emphasized (D'Onofrio 1973, and Spezzaferro 1981). This enterprise of the Farnese pope was lauded in the funeral oration for him given by Romolo Amaseo (Amaseo 1563).

Prior to January 1535, a turreted villa had been built for Paul by Jacopo Meleghino next to the Aracoeli and connected by a hanging bridge to the Palazzetto of San Marco, which Paul, the former Alessandro Farnese and a member of the Roman nobility, had chosen for his private residence (for the villa, see Hess 1961). With the wall ringing the slopes of the citadel, this arrangement resembled that of the Castel Sant'Angelo-Passetto-Vatican Palaces complex.

The first sure evidence of a reconstruction project involving the Capitoline palaces and the piazza was September 22, 1537, when the municipal administration resolved to use money obtained from the office of the Capitoline Camera to restore the Conservators' Palace. In the senate council session of October 23, it was established that a third of those funds "would be spent on the embellishment and enlargement of the palace and the piazza" (Pecchiai 1950). Towards this end a building committee was formed which soon included the commissioner of antiquities, Latino Giovenale Manetti, who was sufficiently close to the pontiff to be termed "*longa manus*," or highly influential. Already in the session on October 22, Manetti had offered for the construction project all of the travertine stone uncovered in the course of the work being carried out by the commissioners for the roads. On November 26, Mario Maccarone was appointed "overseer of the construction for the piazza and the palace," with a salary of five ducats per month, to carry out the work which was being defined, although only summarily, at this date. In the meantime, the Chapter of the Church of the Lateran, having gotten wind of a certain

intention of the pope, sent two representatives to the session of November 28, 1537, "who pleaded with His Holiness not to remove the bronze horse, namely of M. Aurelius Antoninus" from the Lateran piazza (D'Onofrio 1973). The pleas of the Chapter were in vain, because, on January 12, 1538, "the bronze equestrian statue of M. Aurelius Antoninus, which stood in the Lateran for several hundred more than one thousand years, by general agreement of the Lord Canon and the Chapter by order of Our Lordship Lord Paul III was removed from there, not without the greatest regret of all, and brought to the Capitol" (D'Onofrio 1973). A few days later, on January 25, the pope went to see "our new construction around the walls of the City and the area of the Capitol newly articulated with the bronze horse of Constantine [*sic*] carried from the Lateran to the Capitoline piazza" (Diary of Biagio Martinelli, master of papal ceremonies, cited in Künzle 1961).

Whether or not Michelangelo was involved by this date in the project for renovating the complex, and if so in what way, is a much debated question. In a letter written by Giovanni Maria della Porta to Francesco Maria della Rovere, the representative in Rome of the Duke of Urbino, it was reported that "the pope is having the horse taken from Saint John Lateran and put on the piazza of Campidoglio, showing that it was a symbol of the Romans. . . . Michelangelo argued strongly, according to what he told me, that this horse not be taken away, thinking that it was better where it was, but he had not to any degree dissuaded the pope, [and] His Holiness wanted similarly to move the two Horses [the *Dioscuri*] and statues from Montecavallo." Those scholars who maintain that Michelangelo planned the renovation of the Capitoline complex as early as 1537–38 connect this with the fact that the sculptor was granted Rome citizenship on December 10, 1537. Nevertheless, the first sure evidence of Michelangelo's involvement was on March 22, 1539, when the conservators allocated the sum of 320 ducats "to spend for the benefit of the Palace" and decided to use it "partly to renovate the

statue of M. Antonius existing in the Capitoline piazza, according to the judgment of Michelangelo, sculptor, and partly towards making the walls in said piazza" (Lanciani 1902–12).

Even though the inscription on the existing base of the statue (fig. 328) records the date of 1538 and the names of the conservators in the first half of that year, this base has generally been identified with the one discussed in the March 1539 proceedings (D'Ossat-Pietrangeli 1965; Ackerman 1961; and Künzle 1961), which was then modified by the documented addition of "four ornaments (*membretti*)" in the early 1560s. In its simplified form, without the additions on the sides, the base appears in a series of depictions datable between 1538 and 1550 (figs. 351–354).

The strongest argument against the attribution of the base to Michelangelo rests on a drawing by Francisco de Hollanda, certainly done before the artist's return to his homeland in 1541, which shows the sculpture in a very off-center position almost at the corner of the Conservators' Palace (fig. 351). From this could be deduced a date of 1538 for the first base, not by Michelangelo, and the detachment of the overall renovation project from a date in the late 1530s. But this hypothesis runs counter to the large number of depictions showing the axiality of the equestrian group, such as the print view in fig. 352, which can be dated to c. 1544 (published 1562).

Calling attention to the view of the Piazza del Campidoglio in the fresco decoration of the Sala delle Aquile in the Conservators' Palace (fig. 355), attributed to Cristofano Gherardi and dated about 1543 (Aliberti-Gaudioso 1981), Sommella (1989) theorized that the rectangular base shown here, decorated with a festoon held up perhaps by animal heads and bearing a coat of arms, was installed in 1538 and left in place until its transformation by Michelangelo in 1554, although the payment for the latter was not made until ten years later. According to Sommella, Michelangelo reworked the existing marble base at that time, not only adding the "four ornaments" but also reshaping entirely the form of the base. This reconstruc-

350. (above) Maerten van Heemskerck. View of Capitoline piazza. Staatliche Museen, Berlin-Dahlem, Print Dept., 79 D 2, f. 72r

351. (below) Francisco de Hollanda. Equestrian monument of Marcus Aurelius on Capitoline piazza. Biblioteca Reale, The Escorial

SIC · ROMAE

PAVLVS III PONT MAX STATVAM AENEAM
EQVESTREM A S·P·Q·R ANTONINO·PIO·ETIAMTVM
VIVENTI·STATVTAM·VARIIS·DEI N VRBIS·CASIB
EVERSAM·ET A ST XTO·IIII·PONT MAX·A DLATE
RAN BASILICAM·R EPOSITAM·VT MEMORIAM
OP·PRINCIPIS·CONSVLEBLT:PATRIAE Q·DECORA AT
Q·ORNAMENTA·RESTITVERLT:ET S·N HVILLIORI·LOCO·IN
ARLAM CAPITOLINAM·TRANSTVLIT·ATQVE DICAVIT

tion of events was corroborated in the archaeological examination by Ferroni-Sacco (1989), who pointed out the problem in the reconstruction proposed by Künzle (1961) of justifying the absence of holes corresponding to the iron supports necessary to anchor the horse's hooves. But Sommella's theory provided no valid explanation for the fact that the drawing by Francisco da Hollanda (fig. 351), dated no later than 1541, and the engraving by Beatrizet (fig. 356), published in 1548, both show bases differing in appearance from that in the Sala delle Aquile fresco and from the existing base. No doubt valuable information will be forthcoming from the scientific analysis of the base anticipated during the next restoration.

The placement of the *Marcus Aurelius* in the Capitol certainly conditioned the development of the complex but did not presuppose it, as Ackerman (1961) tended to believe. Of greater significance is the orientation of the wall shown closing off the side of the piazza opposite the Conservators' Palace in fig. 353, which has been identified as the one whose construction was decided upon in March 1539, at the same time as Michelangelo's involvement in the installation of the sculpture. Referring to Leonardo Bufalini's 1551 plan of Rome, it can be demonstrated that the wall was set at the same acute angle of about eighty degrees with respect to the front of the Senator's Palace as the façade of the Conservators' Palace. This conforms to the ingenious spatial configuration that characterizes the piazza today. (For pertinent remarks on this as the ideal Vitruvian "forum," and whether it was personally interpreted by Michelangelo himself, see Bruschi 1979; and for the geometric generation of the piazza from the position of the *Marcus Aurelius*, see Thies 1982).

Because of the scarcity of funds and the irregularity of their allocation, a problem which would color the whole story of the work project, the construction went forward slowly. Complaints about this were registered by the chief conservator in the session of September 11, 1542, although he attributed this to the absence of the two deputy supervisors (Pecchiai 1950). Their replace-

ment by the meticulous Prospero Boccapaduli may not have actually accelerated the progress of the work, but it had the merit of providing the means for us to better follow the slow playing out of the project. This new deputy maintained a highly detailed book of "accounts, measures, and other matters concerning the construction on the Campidoglio" (Archivio Storico Capitolino, Carte Boccapaduli, arm. II, mazzo IV), which records all payments made between 1544 and 1554, some of which no doubt refer to works actually executed earlier. On March 3, 1544, an account was settled in full for the work completed on the construction of the triple-arched loggia of tufa at the top of the stairs leading to the area of the right transept of the Church of the Aracoeli (see fig. 353). This loggia, which was definitely not by Michelangelo, was probably the work of Nanni di Baccio Bigio (Coolidge 1945–47), although, according to Giovanni Baglione, the elegant door inside the portico was owed to Vignola (D'Ossat-Pietrangeli 1965).

On October 12, 1547, payments had been issued for the work "of tearing down the loggia which was in the Senator's Palace [and for making] the new stairs of the palace" (Pecchiai 1950). These entries were concerned only with the right half of the staircase, whose construction had actually begun on the left side, as shown in fig. 352. According to D'Onofrio (1973) and Elia (1986), the work on the staircase project was initiated before 1544, which would explain why Boccapaduli's account book showed no record of payment for the left half. The drawing in fig. 357 has been widely accepted as a first design for the Capitoline staircase, perhaps even derived from the one conceived for the vestibule of the Laurentian Library. The fact that this sheet includes sketches for the Tomb of Cecchino Bracci, who died in January 1544, renders very unlikely the identification proposed for it by Wilde (1953) as the alcove of the Belvedere. In addition, this chronological reference is not incompatible with the documents cited and thus ties the design to 1544.

It should be noted that the print in fig. 352, the drawing in fig. 357, and the

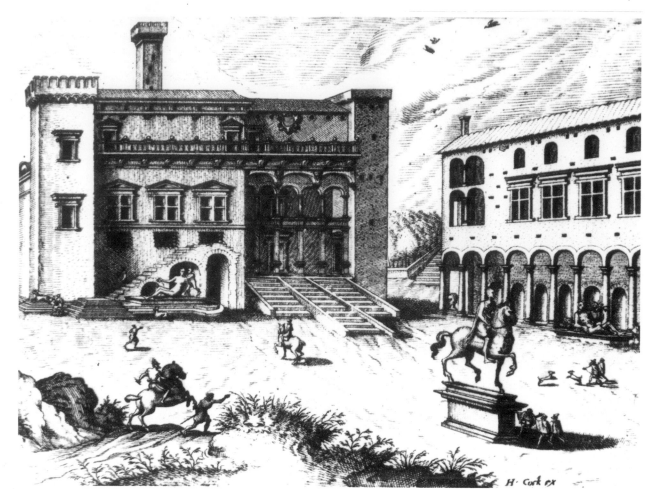

352. *Anonymous, 16th c. View of Capitoline piazza. Print published by Hieronymous Cock in* Operum Antiquorum Romanorum Reliquiae, *Antwerp, 1562*

353. *Anonymous, 16th c. View of Capitoline piazza. Herzog Anton-Ulrich Museum, Brunswick, Print Dept.*

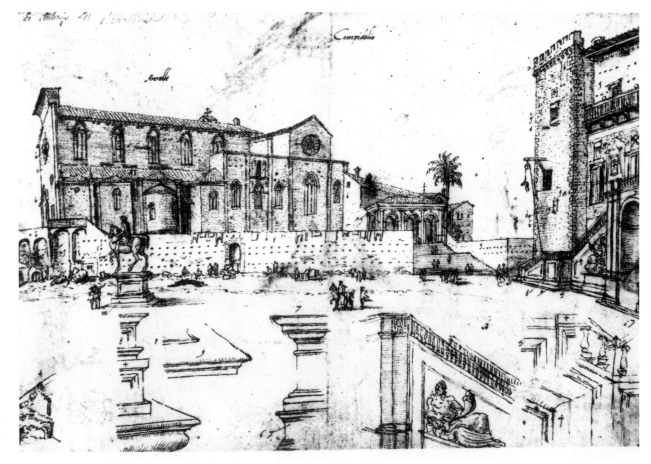

accounts published by Pecciai (1950) all define a double staircase having on either side a single, continuous flight of steps, rather than two sections per flight as in the actual staircase. This, and a series of other differences noted by scholars, including a change in the relationship between the balusters and the newels, as well as between the balustrade and the terminating newel-post, suggest an ideation process on the part of Michelangelo which, as usual, involved rethinking of the design. The execution of the staircase was perhaps carried out by one of his collaborators (D'Ossat-Pietrangeli 1965, who published three drawings, not autograph but certainly from the workshop, preserved in the Archivio Storico Capitolino). The documentation proves that the right half of the staircase of the Senator's Palace under construction in 1547 was completed in 1552. In April 1554 an estimate was given for the entrance door subsequently executed, which is visible in figs. 354 and 358. The original door can still be recognized today, if one mentally takes away the ornate framing added in 1598 by Giacomo della Porta. D'Ossat-Pietrangeli (1965) have demonstrated that the account records, among them one of May 21, 1552, referred to the start of the work on a loggia to be erected over the top landing of the staircase, for which there are still visible *in situ* the beginnings of the supporting pillars (see Portoghesi-Zevi 1964, fig. 490, for photographic reproduction). The projected balcony appears completed in Dupérac's depictions of 1568 (figs. 361, 362). Ackerman (1986) doubted the likelihood of the reconstruction of the balcony's appearance made by D'Ossat (1965; and repeated by Tafuri 1975), which showed a small column at the center of each of the three open sides of a loggia overlooking the piazza. This was contingent upon, among other things, referring to this period a chronologically earlier document in the Casa Buonarroti (fig. 69).

In conjunction with the designs for the entrance door and the new stairs, the problem of the regularization of the façade of the Senator's Palace would certainly have been considered, and there is preserved among the Boccapaduli ac-

354. (above) Anonymous, 16th c. View of Capitoline piazza. The Louvre, Paris, Dept. of Drawings

355. (below left) Cristoforo Gherardi (attrib.). View of Capitoline piazza, detail of fresco showing equestrian monument. Sala delle Aquile, Conservators' Palace, Campidoglio, Rome

356. (below right). Nicolas Beatrizet. Equestrian monument of Marcus Aurelius. Print published by Antoine Lafréry, 1548

counts of 1544–54 (commented on by Pecchiai 1950) an anonymous and undated item specifying a "calculation of the expense which will go for the restoration of the palace of the Very Illustrious Lord Senator." A specific record exists also for the "measurements of the work on the wall made by master Antonio de Tarda, and fellow masons and helpers, and the new stairs of the Palace of the Senator towards the Consolatione . . . measured by me Mario Macerone, superintendent of said construction, the 12th day of October in 1547" (Pecchiai 1950; published in full in Thies 1982). The only record of payment, dated previously on August 17, was for the "tearing down of the walkway (coritore) and remaking it with balusters over the main door," but this reconstruction of the long gallery, or balcony, just above the new entrance doors must have included the demolition of the two-story loggia, the subsequent refacing of the exterior, and the reinforcement of the palace structure. Therefore, the assumption can be made that the façade would have resembled the view shown in fig. 354 around this time.

Contemporaneous with the staircase construction is the episode of the arrangement by Michelangelo of the fragments of consular and triumphal Fasti, incised lists of consuls and other Roman magistrates, from the inside surfaces of the destroyed triumphal arch built in A.D. 29 in honor of Augustus (De Grassi 1947). Discovered in 1546 in the Forum, the fragments were placed soon afterward in the courtyard of the Conservators' Palace. An engraving of Michelangelo's installation design (fig. 359) was published by Marliano (1549) and by Panvinio (1558), both of whom attributed it to the sculptor. The design, which recalls the earlier aedicula of Castel Sant'Angelo (No. 4) and the later façade for the Sforza Chapel inside the Church of Santa Maria Maggiore in Rome (No. 29), can be dated between June 13, 1548, when Gentile Dolfini and Tommaso de' Cavalieri were appointed overseers for the execution of the work, and 1549, when Marliano's book was published. Michelangelo's installation was changed in 1586, when the Fasti were transferred to the Sala

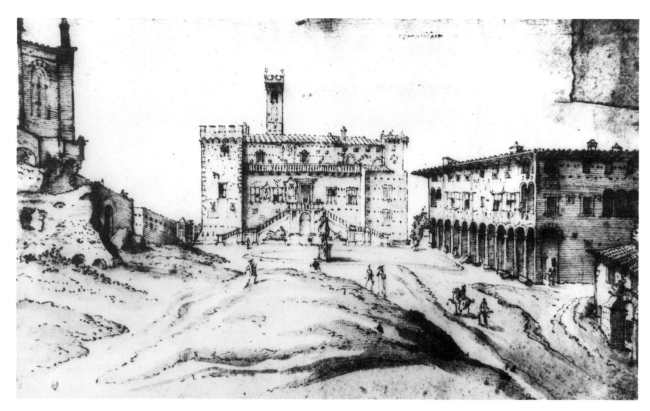

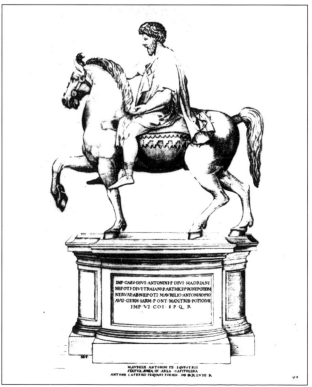

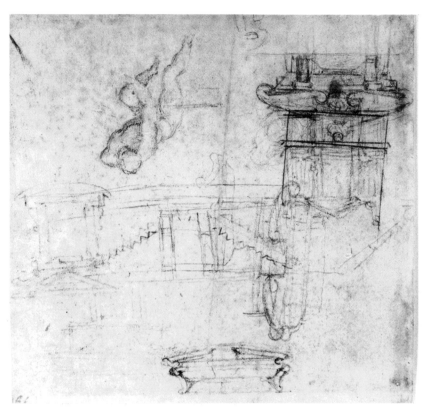

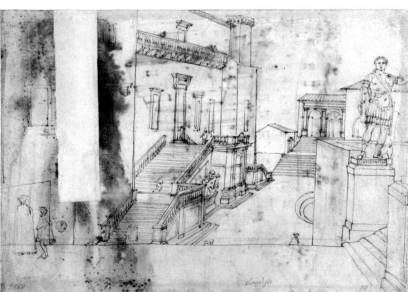

della Lupa inside the Conservators' Palace, and the aedicula was redone.

The final estimate was rendered on November 8, 1553 for the loggia in tufa on the south side of the hill, symmetrical with the one completed in 1544 at the entrance to the Monastery of the Aracoeli seen in fig. 353. Certainly the design of the south loggia, correct but banal, cannot be attributed to Michelangelo, although it should be mentioned that the access stairs, and by consequence the plans for the work, can be dated prior to 1547.

In March 1554, the masters of the Capitoline works, Ludovico da Carona, called Caronica, and Antonio de Tarda, began to build the retaining walls of the terrace for the monumental access to the piazza, that is, the causeway which rises along the slopes of the hill after diverging at the bottom from the medieval steps to the Aracoeli. This work was not completed until September 1565, because the workshop practically ceased to function during the pontificate of Paul IV from 1555 to 1559, years in which the average annual expense was scarcely two hundred ducats (Pecchiai 1950; and Siebenhüner 1954). An anonymous view of the Capitol from below (fig. 360), which can be dated a few years before 1577, shows the access ramp as it was prior to the intervention by Giacomo della Porta, who was responsible for terracing the causeway incline with timbers and adding the balustered rails at the sides (payments in 1581–82). He also modified slightly the gradient of the ascent, lessening the steepness by lengthening the approach into the piazza. With the succession of Pope Pius IV in 1559, the Capitoline project had been resumed with great energy. Pius showed far more interest in the prosecution of the work than his papal predecessor, and specific funds were allocated for it in 1561, including in particular the proceeds from the tax paid by innkeepers on the importation of wine into the city. Following some disagreements with the Capitoline administration, the funds were reconfirmed by a papal *motu proprio* in April 1565.

Payments were made on April 30, 1561 for the balustrade at the entrance to the piazza, later modified for the installation of the statues of the *Dioscuri* (in 1585 and 1590) and the "trophies of Marius." On July 30, 1561, the payments began for the renovation of the piazza proper. Estimates were submitted on April 24 and 26, 1564 for the following projects: construction of a water drainage system; the articulation of the open area with a triple ring of steps in an "ovate" form; and the cutting back of the slope of the hill towards the city at the sides of the causeway to give the piazza the appearance of a terrace overlooking the Via Capitolina towards the Piazza Altieri. At the same time, the sum of six hundred ducats was allocated for "getting rid of the houses at the foot of the mount." During the work on the piazza, the equestrian statue of *Marcus Aurelius* was removed and reinstalled. A payment recorded for "four ornaments (*membretti*) with the guide, base, pediment, cornice with the two heads, and everything else added for the placing of the horse," although undated, certainly refers to the first years of the resumption of the work after 1561 (Künzle 1961).

Already in a meeting on November 5, 1561, Pius IV had stressed the importance of executing major repairs on the Senator's Palace, damaged on the interior to the point of being unusable due to the worn-out roof. For this purpose, the city allocated a thousand ducats, which was not enough because another entry was recorded on February 1, 1563 for the "measure and estimate for the work of masonry and roofs made in the palace of the Lord Senator in the Campidoglio, measurements presented by the lord deputies, that is, Master Tomao de Cavalieri and Master Angniolo Albertoni and measured by me Master Mario Macarone and by me Jacapo della Porta, architect," for a total of 1,261 ducats and four *baiocchi*, a papal coin of small value (Pecchiai 1950). In addition to precise indications of the work executed, consisting mainly of the palace roofs, this document furnishes us with two other important pieces of information: the naming of Giacomo della Porta for the first time in the workshop of the Capitoline project, although as just a surveyor; and the confirmation of Tommaso de' Cavalieri as deputy for the

construction of the Senator's Palace. (For Cavalieri, a friend of Michelangelo and a prominent personality in the artistic world of Rome, see in particular Frommel 1979.)

This specification of the role of Cavalieri with regard to the "measuring" renders less credible the attribution to this Roman gentleman of a design for the reconstruction of the palace, a hypothesis based on a record of payments made on April 24, 1564 to Master Ludovico, a mason, "for all the work done in the palace of the Lord Senator from the foundation up to the top according to the new design by master Thomao del Cavalieri approved by Our Lordship" (Pecchiai 1950). But, as Ackerman (1961) pointed out, Boccapaduli's account book specified precisely that the work was executed "according to the new design left with master Thomao del Cavalieri made by commission and order of Our Blessed Pope Pius IV." Thus, the deputy was only the trustee in this matter and certainly not the creator of the "new design," which obviously referred, given the minor sum of 127 ducats and fourteen and one-half *baiocchi*, to the reparation work already under way. While the construction of the new façade of the Senator's Palace would not be undertaken until the 1580s, the work on the exterior of the Conservators' Palace began in 1563. Following the work of buttressing the fifteenth-century portico, construction proceeded from right to left in vertical sections, building bay after bay from the ground up to the roof cornice. Pius IV had made the official decision on March 11, 1563 to initiate the work (Pastor), which was carried out by Guidetto Guidetti, "selected to execute the orders of master Michelangelo Buonarruoto in the construction of the Campidoglio" (Pecchiai 1950). That Guidetti was simply an executor of the designs of Michelangelo is evident from the duties enumerated in the payment to him of twenty-five ducats on December 10, 1563: "For his labors employed in the present year in making drawings for the building of the Campidoglio, for both the ground plan as well as the façade, making models for said work, making oblique drawings of the arches

in actual size, supports for the columns, profiles of the cornice, and all the other things." We note in passing that the monthly compensation to Guidetto was five ducats, equal to that of the supervisor Maccarone; the architect drew twenty-five ducats on July 26, presumably for the five months from March to July inclusive, and twenty-five on December 10 for August through the end of the year. We know that on June 8, 1563, the foundations were laid for the first pilaster, the last on the right end of the building towards the causeway, which was paid for on April 26, 1564, along with the walls from the right corner "up to the level of the first cornice"—that is, up to the top of the portico on the ground floor (Tolnay 1932). On October 31, the travertine facing was installed "on the new portico of the Palace of the Conservators from the level of the first cornice down . . . and for both of the first pilasters with their side junctures" (Tolnay 1932).

Michelangelo died in February 1564, and Guidetti died also in the fall of the same year. On December 12, Giacomo della Porta was paid as "the architect succeeding after the death of Master Guidetto" (Tolnay 1932, and Pecchiai 1950). A new phase opened in the history of the workshop, which certainly continued to follow as much as possible the supply of designs left by Michelangelo but became involved as well in the planning of certain elements which had not been anticipated or studied by him. In 1565, other payments were made "for the pilasters in front and another towards the Caffarellis," indicating those of the second bay on the piazza and one flanking the bay on the end of the building towards the city, all of which were based on the pilasters of the first bay already executed while Michelangelo was still alive (fig. 336). On August 24, 1565, the wood model was finished "for the entablature and capital of the pilaster on the corner of the façade of the palace. . . . [This] model was used for the construction of the palace of the Lord Conservators" (Pecchiai 1950). On December 31, Giacomo della Porta was paid for the design "of the entablature in actual form in the hall of the Lord Senator." Tolnay (1932) believed that this

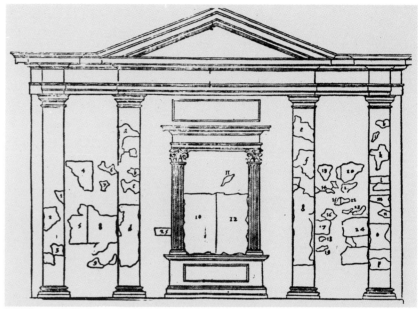

referred to the cornice for the Senator's Palace, but, from Siebenhüner (1954) on, scholars have held on well-established grounds that the design was instead for the entablature of the Conservators' Palace, referred to explicitly in the account of August 24, which had been made and placed temporarily in the audience hall of the other palace. In 1567, the third bay was finished, the stucco reliefs were executed for the first three ceilings inside the portico, and the first four statues were installed on the rooftop balustrade. In 1568, Della Porta was paid for designs of the entrance door and of the window for the fourth bay under construction in April 1569. (Hess 1961, attributed the window to Jacopo del Duca, however.) Also in 1569, the fifth bay was completed. The last composite capital "for the pilasters of the façade for the side towards the steps" (that is, for the loggia of Julius III) was executed in 1580. On May 12, 1583, the contract was drawn up for the "remaining balusters, bases, pedestals, and pediments above the entablature." In 1586, with the installation of the last statues on the roof gallery, the façade of the palace was considered finished. The second bay on the side of the building towards the city was not added until the mid-seventeenth century to correspond with the design of the New Palace.

Work on the Senator's Palace was begun around 1573–74 with the renovation of the interior, which determined the façade elevation and the size and rhythm of the windows. Of particular importance, because the height of the grand salon on the main (second) level was increased with a vaulted ceiling, the windows on the level above were reduced to small openings (see fig. 321). A preliminary design for this, dated probably in the late 1560s, is preserved in a drawing in the Staatliche Museen, Berlin (Print Dept., Kdz 16798, published by Winner 1967). In February 1578, after the old belltower was struck by lightning, the conservators decided to reconstruct it according to a design by Martino Longhi the Elder, who completed the work on it in 1583 (Patetta 1980). A medal struck in 1579 (reproduced in Siebenhüner 1954), shows the new belltower, as well as the large new windows in travertine executed in 1576–77 by the stonecutters Meo and Marchionne after Della Porta's design, and the giant order of pilasters going only as far as the two lateral tower areas. In 1588–89, after Sixtus V ordered the Felice aqueduct to be extended up to the Campidoglio, a fountain was built on the design of Matteo da Città di Castello at the base of Michelangelo's grand staircase, and in 1592 a statue of Minerva

257

360. (above) Anonymous, 16th c. View of Capitoline piazza. Staatsgalerie, Stuttgart, Graphics Coll., no. 5805

361. (below) Étienne Dupérac. Perspective view of Capitoline piazza, according to plan of Michelangelo (preliminary drawing for print). Christ Church, Oxford, 1820

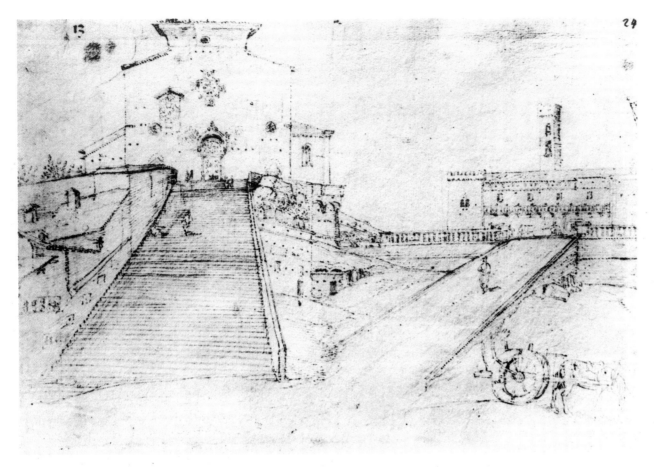

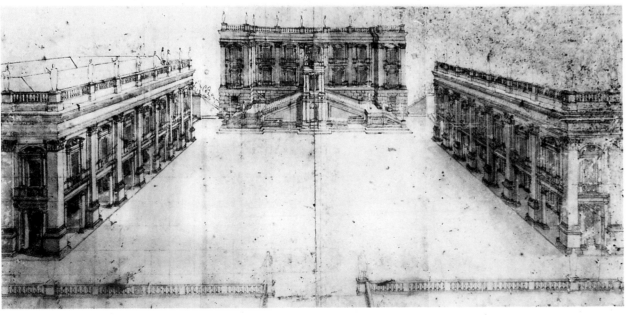

was placed in the central niche, where it still stands today (fig. 320). The façade of the Senator's Palace was not completed until the early years of the seventeenth century under Girolamo Rainaldi, the successor to Giacomo della Porta at his death in 1602. Only in 1603 was the construction of the foundation for the third building facing the Conservators' Palace, called the New Palace, ordered by Clement VIII. Subsequent to an interruption of over forty years, the work was resumed under Innocent X and finally concluded after the middle of the century. (For the New Palace and its functions, see Güthlein 1985, who corrected considerations by D'Onofrio 1973.)

Michelangelo's contribution to and determination of the actual appearance of the Capitoline complex is not a matter of doubt. Precisely in what manner, to what extent, and according to what course of events are all still the subjects of scholarly dispute, however. In other words, the object of the debate is whether or not there ever was in existence an overall plan by Michelangelo for the complex which we can recognize, and, if so, how should it be reconstructed, to what extent was it respected in the long development of the work project, and to what period should it be dated?

As seen above, the administrative documents record Michelangelo's name on only two occasions—in 1539, when it was decided that the base of the equestrian group should be "reshaped" according to the advice, rather than the design, of Michelangelo ("*iudicium Michaelis Angelis sculptoris*"), and again in 1563, when Guidetti was paid "to execute the orders of master Michelangelo Buonarruoto in the building of the Campidoglio." Evidence of an overall plan by Michelangelo for the piazza and the palaces around it exists only in the form of Vasari's account in the second edition of the *Vite* (1568; in the 1550 edition, the Campidoglio design was only briefly mentioned). Praising the concept for the complex as "a very beautiful and rich design," Vasari described the Senator's Palace as having "a façade of travertine and a staircase with two banks of steps going up to the landing,

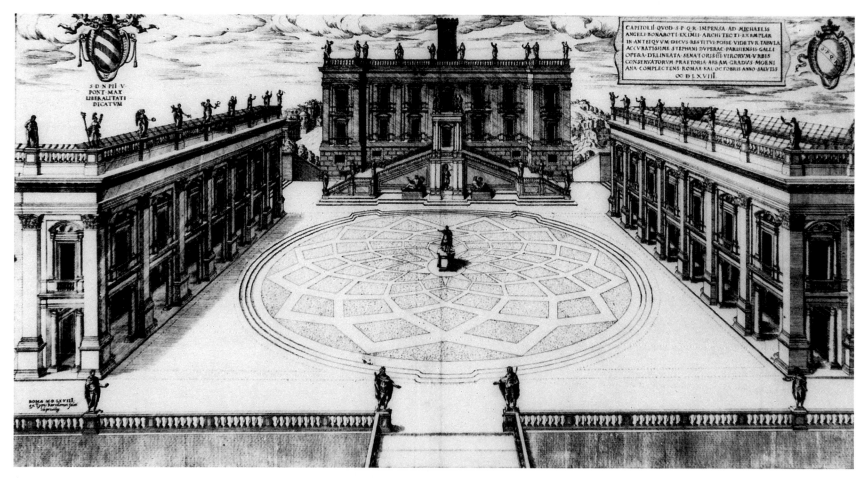

from which one entered into the middle of the grand salon of the palace, with rich balustrades filled with varied balusters, serving as stair rails and for the parapets. . . . [The staircase was decorated with] two antique river gods of marble on top of some foundations, one of which was the Tiber and the other the Nile, each one measuring nine *braccia*, which was very unusual; and in the middle a Jove had been put in a large niche." The projected design for the Conservators' Palace showed "a rich and varied façade with a loggia at the bottom filled with columns and niches, where there were many antique statues, and all around were various ornaments also on the doors and on the windows, a part of which were already installed." Vasari continued: "And facing this, there will follow another similar [palace] on the north below the Aracoeli; and at the front a terraced ramp on the west side,

which will be flat with a wall and parapet with balusters, where the main entrance will be, with an order and pedestals on which go all the nobleness of the statues, with which the Campidoglio is enriched today."

In his description of Michelangelo's "very beautiful design," Vasari included neither the loggia of Paul III on the side of the Aracoeli nor the loggia of Julius III facing it. Moreover, in comparing Vasari's description with the other basic body of evidence for an overall plan by Michelangelo—the print views of the Capitol published in Rome between 1567 and 1569 by Bernardo Faleti—some important differences can be seen, which proves the reciprocal independence of these two sources and negates the thesis of D'Onofrio (1973) that Vasari was acquainted with the Dupérac etching published by Faleti in late 1568 (fig. 362).

An earlier view published by Faleti (fig. 317) carries the inscription: "Ground plan of the Capitoline area and adjacent portico, stairs, [and] tribune by Michelangelo Bonaroti. At Rome, in the year 1567." Depicted here are: the two lateral palaces; the staircase of the Senator's Palace, at the top of which are two bases obviously meant to support the balcony; the complex star design of the pavement, which was never executed; and the connection between the piazza and the access stairs, with the balustrade showing indications of the bases for four statues. With regard to the pavement design, the piazza was depicted with simple geometric partitioning in a seventeenth-century drawing by Lionel Cruyl in the Cleveland Museum of Art. Only in 1940 was the star pattern executed in the pavement of the Campidoglio in close replication of that depicted in the 1567

print. More information exists in the perspective view of the complex in Dupérac's etching of 1568 (fig. 362), which is dedicated to Pius V and bears the inscription: "Model of the Capitol which the Senate of Rome commissioned from Michael Angelo Bonaroti, excellent architect, who was seen to be able to restore the former glory; the image of the buildings drawn very accurately by Étienne Dupérac, of Paris, France, the palaces of the senator and the conservators, very illustrious men of Rome, from the piazza steps towards the surrounding city walls; at Rome, the first day of October, in the year of salvation 1568." (The preparatory drawing for the print, done in reverse for transfer to the etching plate, is shown in fig. 361.) A slightly later Dupérac print (fig. 318), differing only in small details, is inscribed: "View of the Capitol from the model of Michelangelo Bonaroti himself

259

363. *Michelangelo. Two ground plans and elevation of portico of Conservators' Palace. Ashmolean Museum, Oxford, Parker 332v (C. 605v)*

364. *Michelangelo. Design for window, probably for Conservators' Palace. Asmolean Museum, Oxford, Parker 332r (C. 605r)*

365. *Circle of Étienne Dupérac. Perspective view of Capitoline piazza, according to Michelangelo's plan. Pierpont Morgan Library, New York, on loan from Giannalisa Feltrinelli Coll., Dyson Perrins Album, f. 15r*

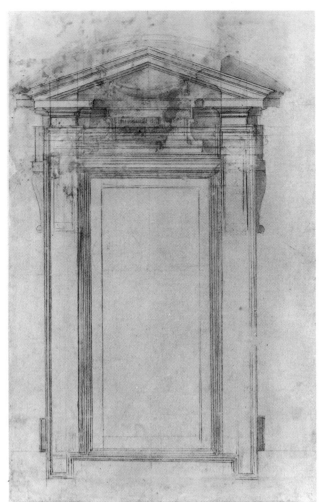

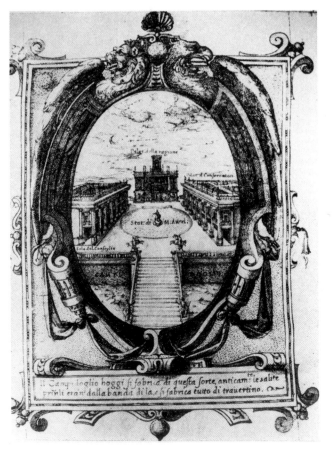

by Étienne Dupérac of Paris, accurately drawn and published in Rome in the year of salvation 1569." In this depiction, the statues of orators shown flanking the entrance to the piazza in the 1568 print (fig. 362) have been replaced by those of the *Dioscuri*, and the segmental-arched window pediments of the Senator's Palace have been changed to an alternation of segmental-arched and triangular pediments. Another print published by Faleti in 1568, showing only three bays of the Conservators' Palace and perhaps indicating what was actually constructed at the time, is inscribed: "Portico and appearance of the

Capitoline palace accurately measured with the good, diligent art of proportion, drawn in Rome, in the year of salvation 1568."

From what we know was already carried out around 1568, these print depictions are absolutely coherent with one another (figs. 317, 318, 362). The Conservators' Palace is shown with seven bays completed by a repetition of the corner bay constructed while Michelangelo was still alive, and there is no indication of any emphasis on the central bay, for which we know that Giacomo della Porta was working on designs of the door and window about that time. The New Palace is projected as an absolutely faithful replica of the Conservators' Palace opposite it. The Senator's Palace, however, looks very different from the way in which it was finally executed by Della Porta. The staircase, already constructed by this date, stands out against a wall of rusticated ashlar having two fenestrated levels and a giant order of pilasters. Like the palaces on either side, the Senator's is also crowned by a roof gallery with statues placed there in correspondence with the façade pilasters. The center bay of the building which, with the base of the *Marcus Aurelius*, lies on the bisecting axis of the piazza, is strongly accented by the vertical succession from the niche with a statue, to the balcony, to the large central window, and to the belltower, all on axis with the main entrance. The piazza is shown with the motif of the star, from whose twelve points extend outward thin lines of stone which turn in a spiral, widening and intersecting with each other and connecting two-by-two along the curve of the ellipse outlined by a continuous bank of three steps. Ackerman (1961) recognized in this stellate design a reference to the medieval "schemata" of cosmological inspiration, while D'Ossat (1989) pointed out the similarity with marble panels in the Cathedral of Santa Maria del Fiore, Florence, and the Pisa Cathedral.

An interesting view of the Capitol, from the circle of Dupérac and dated a few years later than the prints published by Faleti, exists in a manuscript previously in the Dyson Perrins Collection (Ashby 1916), which was executed for an important individual probably on the occasion of the Holy Year of 1575 (fig. 365; Smyth 1970). The depiction repeats the Capitoline view in the 1569 etching by Dupérac (fig. 318) except from a vantage point encompassing more of the causeway up to the piazza. It also lacks any pavement detail except for the shallow ring of steps. The palaces are inscribed in the drawing according to their anticipated uses: "Ragione" (Senator's Palace); "Conservatori"; and "Consiglio" (New Palace). The inscription below further clarifies the subject: "The Campidoglio today is built in this manner, formerly the main stairs were at the side there, and it is made entirely of travertine" (which agrees with Vasari's description of 1568).

While the print depictions discussed above repeat faithfully what was already executed in the Capitol at the time, they reconstruct only approximately, with contradictions, what had not yet been built. But, if they are not of great assistance to us in clarifying, except in broad outlines, the original concept of Michelangelo, the autograph drawings of the artist and his immediate circle, or their copies, advance us a few more steps. In addition to fig. 357 discussed earlier, commonly identified with the staircase of the Senator's Palace, drawings on two sheets in the Ashmolean Museum, Oxford, have been related to the planning of the Conservators' Palace (figs. 363, 364, 366). In fig. 363 are ground plans and perhaps elevations of a portico first identified with the renovation of the Capitol by Tolnay (1956). The large plan at the center shows three bays with pairs of embedded columns recalling those in the vestibule of the Laurentian Library, while the plan along the left edge of the sheet, visible by turning it ninety degrees clockwise, indicates fourteen freestanding columns in seven bays as they exist today. The study for a window on the recto of the same sheet (fig. 364) also refers to the Conservators' Palace (D'Ossat-Pietrangeli 1965), although it varies from the window design actually used. The elevation drawing in fig. 366 has been tied to the Conservators' Palace as well (Ackerman 1961; Portoghesi-Zevi 1964; D'Ossat-Pietrangeli 1965; and Thies 1982), and on its recto (fig.

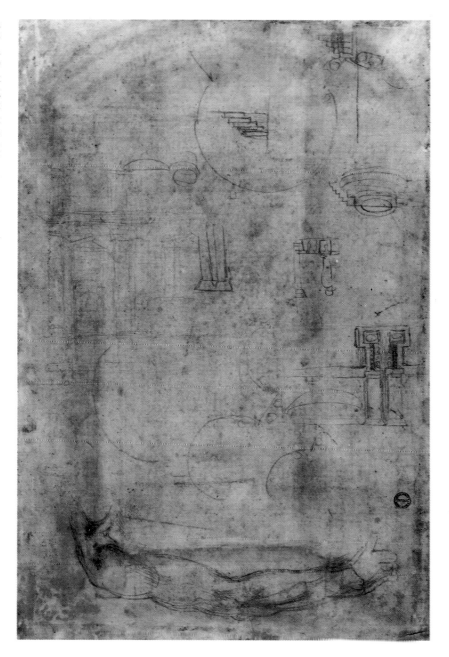

338) is a study certainly identifiable with the window on the third floor of the Farnese Palace, which is datable around 1547. A drawing of an aedicula with a rectangular niche above it (fig. 367), usually assigned to an assistant of Michelangelo, has been related to the Capitoline complex by D'Ossat-Pietrangeli (1965), who made a precise comparison between it and an aedicula with an inscription on the Conservators' Palace. Sketches of a portal on the recto of this drawing (fig. 489) are related to the Porta Pia, thus favoring a later date for the sheet. Hartt (1971) connected with the portico of the Conservators' Palace a series of studies of Ionic capitals in the Casa Buonarroti (A 55, A 56, A 82, A 83, A 86, and A 87 [C. 289, C. 290, C. 288, C. 291, C. 287, and C.

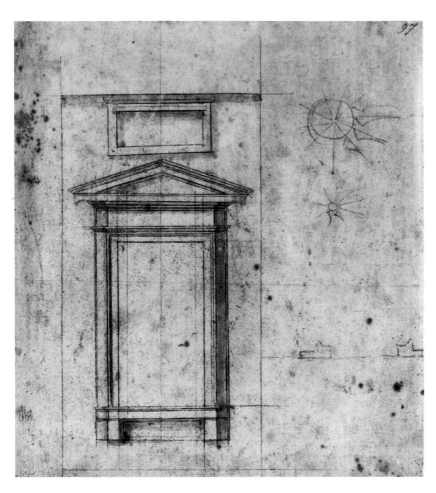

292]). Generally, these have been dated at the beginning of Michelangelo's architectural career, however, and they were connected with the Tribune of the Relics in San Lorenzo by Thode (1908) and the *Corpus*. Other drawings, although not autograph, have a primary importance for the reconstruction of the history of the work project in the 1560s, especially three sheets, recto and verso, attributed to Giacomo della Porta in the early years of his work on the construction immediately prior to or following Michelangelo's death (figs. 368, 369; and Albertina Museum, Vienna, Ital. Arch. Rom 29r-v and 31r-v). The state of the work around 1564 is shown in fig. 368, with the first two bays completed "from the first cornice down" and the related pilasters of the giant order partially indicated. Of a slightly later date is the ground plan of the portico for the

Conservators' Palace preserved in the Albertina (Rom 31). The numerous drawings in the so-called Scholz Scrapbook constitute a different problem. Generally assigned to the circle of Dupérac and connected with the Campidoglio project, they are based on either the actual works of Michelangelo or drawings by the master's immediate circle. Clearly datable after the 1560s, the Scrapbook sheets in the Metropolitan Museum of Art, New York, comprise the following images: a ceiling decorated with a coat-of-arms, probably in the portico of the Conservators' Palace (49.92.2r); the Ionic capital of the Conservators' Palace (49.92.10r-v); details of the Conservators' Palace portico and giant order (49.92.27r); a door of one of the University offices in the Conservators' portico (49.92.27v); sketch of a bay, and details of a portico (49.92.64r-

v); a ground plan and elevation of the base of the *Marcus Aurelius* (49.92.65r-v); a window of the main level of the Senator's Palace (49.92.69r-v); and a ground plan and horizontal section of the staircase of the Senator's Palace (49.92.70r-v). Datable to the same period are two drawings previously attributed to Vignola (Uffizi, Florence, Drawings and Prints Dept., A 7922r and A 7923r, with the latter related to Scrapbook drawing 49.92.27v). In the Uffizi collection are other drawings from the Capitoline project attributed to Giovanni Dosio: a view of the staircase of the Senator's Palace (fig. 358); a view and section of the porticoes on the ends of the building (A 374r); and a detail of the entrance door, surely derived from Della Porta (A 1768).

The numerous drawings cited above confirm what is known from the account book documentation—that the major planning of the Conservators' Palace was done by Michelangelo, and Giacomo della Porta was introduced into the planning at a stage when the construction had begun but was not completely defined. Therefore, some of the copies could only derive from Della Porta's solutions. But these do not combine to give an answer to the fundamental question—did a comprehensive plan by Michelangelo exist and, if it did, to what period can it be dated? There are ardent supporters for both sides of the argument. To mention only a few, Ackerman (1961), D'Ossat-Pietrangeli (1965), Frommel (1979), Bruschi (1979), and Thies (1982) all held to the idea of a complete overall plan by Michelangelo for the complex, which is represented in large part in the Dupérac etchings. The majority of scholars dated this plan on stylistic grounds to the years immediately preceding the Saint Peter's commission, with the work then executed carefully, but with a few changes, after the death of the master by his continuers. In an opposing argument, Bonelli (in Portoghesi-Zevi 1964) distinguished different periods when Michelangelo intervened in the Capitoline landscape, first as "sculptor" for the placement of the antique works and then, towards the end of his life, becoming involved in the planning of the fa-

çade of the Conservators' Palace, the construction of which was interrupted suddenly at the first bay. The silence of the documents "speaks," paradoxically, in favor of this hypothesis because Michelangelo is named only twice—the first time in 1539, on the occasion of the "reshaping" of the statue base, and the second just a year before the artist's death, when work began on the Conservators' Palace. Speaking also in support of Bonelli's conclusion is the definitive attribution to different architects of the loggias of Paul III and Julius III. For anyone familiar with the planning practices of Michelangelo, the most powerful evidence for a theory similar to Bonnelli's is the absence of any hint of models, either in clay or in wood, which were nearly always a necessary step for this Florentine architect. Of prime importance in support of the first hypothesis, however, is the character of "assemblage" in the different solutions encountered in the Dupérac prints, as previously pointed out by Ackerman (1961). Besides the old historiographic tradition (Vasari speaks only of a "design" in 1550 without further specification), the arguments in favor of the first thesis are, basically, the strongly unitary aspect of the piazza and the buildings around it, excluding the two loggias (which could have been planned even before 1539), and the formal genesis of the complex from the location of the equestrian statue. Included in this is the wall on the side towards the Aracoeli (see fig. 353), which already marked off precisely, if only provisionally, the trapezoidal space of the existing piazza. Further support comes from the fact that the only interventions in the piazza documented from 1544 to 1564 were surely autograph works by Michelangelo: the existing base of the *Marcus Aurelius*; the ramp of the staircase of the Senator's Palace; the first bays of the Conservators' Palace, and the causeway access to the piazza. This excludes, of course, the hypothesized intervention in the planning by Tommaso de' Cavalieri, with the role of this Roman nobleman having been reduced to that of deputy for the construction, which was faithfully interpreted from the ideas of Michelangelo.

368. *(above) Giacomo della Porta. Elevation of two bays of façade of Conservators' Palace. Albertina, Vienna, Graphics Coll., It. Arch. Rom 30r*

369. *(below) Giacomo della Porta. Ground plan of two bays of façade of Conservators' Palace. Albertina, Vienna, Graphics Coll., It. Arch. Rom 30v*

Very probably, in spite of his early opposition to the removal of the *Marcus Aurelius* to the Campidoglio, Michelangelo was called on, by virtue of his competence as a sculptor, with regard to the placement of the equestrian group and the statues of the river gods. This essentially completed the transformation of the Capitol, begun much earlier by Sixtus IV (see Miglio 1982), from a place symbolic of Republican Rome to a showcase for the antiquity and excellence of the modern city. This commission then precipitated the conception by Michelangelo on his own, although only in the broadest outlines, of an architectural project for the Capitoline landscape. Thus, rather than conforming himself to the very limited requests of a reluctant patron, from time to time he suggested his own ideas.

This is not to say, however, that there never existed a detailed overall plan for the complex which could be dated with certainty (although, given the significant evidence of the three drawings, autograph or from Michelangelo's immediate circle, which range in date from c. 1544 [fig. 357] and c. 1547 [fig. 366] to his last years [fig. 367], this would not have been decisive). As known from his other projects, Michelangelo's way of doing architecture anticipated, from the interior of a very general concept, different solutions carried forward at the same time, with a choice made from among them only as the time of execution neared. Not only were modifications to the design of the details done up to the last moment, but also changes were made in what had already been completed. Ackerman (1968) expressed this as Michelangelo's habit of "keeping his plans in a state of continuous fluidity so long as every detail had not yet been executed." For this reason, Dupérac's print depictions cannot be relied on. Therefore, beyond the few remaining autograph fragments—the base of the *Marcus Aurelius*, the stairs of the Senator's Palace, and the first bays of the Conservators' Palace—and the general bearing of the existing piazza, we cannot know anything about how Michelangelo would have carried out the whole Capitoline complex, had he lived long enough to do so.

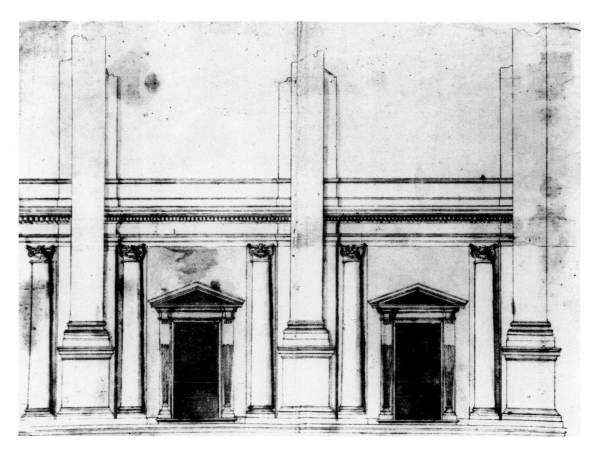

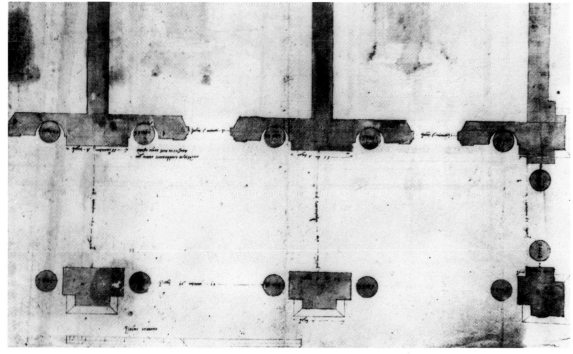

370. *Anonymous, mid-16th c. (1541–46). View of Farnese Palace, Rome, under construction. Biblioteca Nazionale, Naples, XII.D.1, f. 8r*

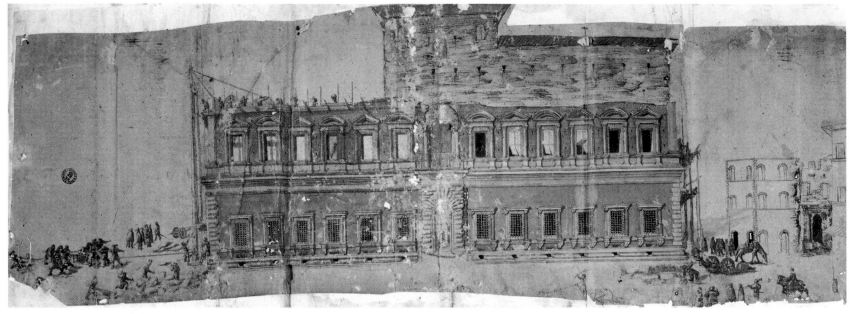

On January 30, 1495, Cardinal Alessandro Farnese acquired from the Augustinians of Santa Maria del Popolo the Ferriz Palace, formerly the Albergati, on the Via Arenula, and subsequently he acquired the houses and lands adjacent to it (Frommel 1973, and Spezzaferro 1981). Around 1513–14, the cardinal commissioned Antonio da Sangallo the Younger, then at the beginning of his independent professional career, to design a large new palace. Contrary to what scholars had long believed on the basis of information in the 1518 guide to Rome by Fra Mariano da Firenze, this structure was apparently not built entirely from the ground up. Di Mauro (1987 and 1988) published a view of the palace under construction, dated after 1541 (fig. 370), which shows an existing building, perhaps the fifteenth-century Ferriz Palace, being incorporated into the right end of the new Farnese structure designed by Sangallo. This depiction, which puts in doubt some elements of the chronological reconstruction by Frommel (1981) to be discussed later, exhibits some curious details, such as the excessive dimensions of the older building whose height is equal to or even exceeds that of the new palace. Also, the corners of the new building are treated in different ways. Those on the ground floor are decorated

with flat quoins on the right and rusticated "cushion" quoins on the left, while on the second floor both corners are depicted with giant-order pilasters. Two studies by Sangallo for giant-order pilasters are preserved in the Uffizi (Drawings and Prints Dept., A 302v and A 998r), but it is uncertain if they were ever executed.

The acquisition of materials for the construction of the palace is documented in a series of contracts dated March 21, 1515, December 6, 1517, July 4, 1520, and July 1521. This gives evidence that the building activity went forward on a regular basis according to the availability of funds from the not unlimited finances of the cardinal. "In an orderly way every year, a certain amount was built," wrote Vasari, and this continued at least up until 1527. Cardinal Alessandro's election as pope, which took place in 1534, provoked an important change in the project: "Pope Paul III, while he was Alessandro, cardinal Farnese, brought said palace to a very good conclusion, and on the façade in front had made part of the first row of windows [and] the salon inside, and had started on one side of the courtyard; but not much of perfection could be seen yet on the front of this building. When [Alessandro] was created pontiff, Antonio [da Sangallo] changed the first

design completely, thinking that he had to make a palace not for a cardinal, but for a pope. Therefore he tore down several houses around it and the old staircases [which] he rebuilt again and less steep, [and] he enlarged the courtyard on every side, and likewise the whole palace, making larger stairwells and larger numbers of rooms and more magnificent" (Vasari 1568).

Other than Vasari's testimony, the most important evidence for the first Sangallo project, referred to as the "palace of the cardinal," is a plan of the ground floor preserved in Monaco (fig. 371). Once attributed to Philibert de l'Orme (Blunt 1958), the plan was subsequently assigned to Jean de Chenevières and dated around 1525 by Frommel (1973). Numerous drawings by Sangallo were used by Frommel (1981) to reconstruct precisely in large part the 1514 project, which anticipated a three-story building with an interior courtyard quite similar to, although costing a great deal more money than, the Baldassini Palace also being built by Sangallo around that same time.

The conversion of this "palace of the cardinal" into the "palace of the pope" comprised three basic elements: a decisive change with regard to the spacious piazza to provide servants' quarters along the side towards Via Giulia; an

increase in the number and size of the rooms, which took into consideration also that, with the death of one of the two heirs of Cardinal Ranuccio Farnese, there was no longer a need for the two apartments initially wanted by the cardinal; and finally, the construction of a much larger main staircase.

Due to the fact that no new contracts were drawn up between 1527 and the spring of 1541, Frommel (1981) hypothesized a long period of stasis for the work on the Farnese palace. The 1536 testimony of Johannes Fichard, describing the "elegant and splendid . . . palace of the Farnese . . . [with] its middle part not yet finished," does not repudiate Frommel's reconstruction of events, and the work documented on the palace in 1535 can be related to simple reparations. The long interruption is explainable by more urgent needs both on the part of the family (the transformation of Castro, the seat of the dukedom of Pier Luigi Farnese, into a modern city; see Giess 1978) and on behalf of the State (the work on Saint Peter's and the new fortifications of Rome), for which Sangallo also had the responsibility. During the winter of 1540–41, however, he was completely occupied with the enlargement of the palace, and the plan in fig. 372 was identified by Frommel as a variation very close to his definitive one

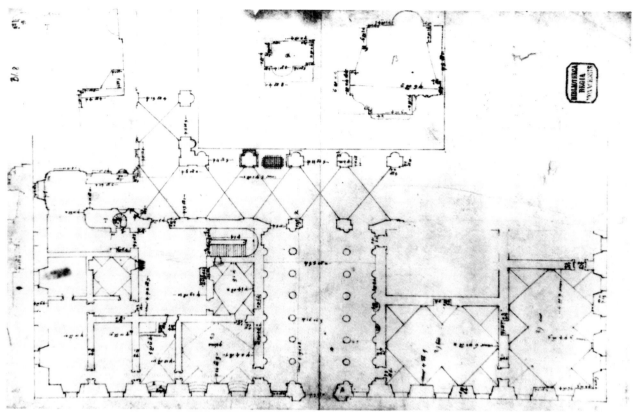

for the ground floor. Two more Uffizi sheets (figs. 373, 374) were also connected to the palace by Frommel as slightly later studies by Sangallo for the secondary stairwells. Due to the considerable financing assured by the pope and the Farnese family (on the method of payment for the entire undertaking, see Uginet 1980), the building of the palace proceeded at a somewhat quicker pace. A letter of early January 1546 from Nardo de Rossi, a stonecutter working on the palace, to Antonio da Sangallo, who was in Rieti at the time, provides evidence that the main façade up to the second level was finished, and some of the windows had been built by this date. A year later, on March 2, 1547, Prospero Mochi, an agent of Duke Pier Luigi Farnese, reported that "the front face is nearly finished in height up to the last row of windows; it lacks there only the cornice, which has the eaves and the decoration to be made, for which a trial piece has been installed towards the village of San Gironimo [right end of the façade] in order to satisfy His Blessedness. . . . The cloister with the colonnade [in the courtyard] is enclosed all around, and the rooms towards San Gironimo are nearly built, with its chapel at the end of the corridor, which will soon be habitable. And towards the Catena and Todeschi [left side] the servants' hall and pantries and public and private kitchens, and most of the cellar with the water storage facility, the largest and most convenient that I have ever seen. . . . The iron grilles all around are almost completely installed."

In the course of the year between the two letters cited above, Sangallo had died, on September 29, 1546, leaving the façade of the palace nearly finished, the ground floor of the courtyard certainly completed (probably with the work on the stonecutting for the second floor considerably under way), and the right side of the palace almost ready for occupancy. According to Vasari (1568), while Sangallo was still alive, Paul III invited Perino del Vaga, Sebastiano del Piombo, Michelangelo, and Vasari himself to present designs for the entablature of the palace in competition with Sangallo, who would then carry out the selected design. Quite probably, Vasari

altered slightly the succession of events (Ackerman 1961), anticipating by just a few months the entrance of Michelangelo into the Farnese workshop. In reality this took place shortly after Sangallo's death, as did the acceptance by the sculptor of the task of building of Saint Peter's. It would be difficult to believe that, in the climate of heated rivalry (if not to say hatred) between Michelangelo and Sangallo, the two architects would have agreed to collaborate, especially because Sangallo's own design for the crowning of the façade of the Farnese Palace would surely have been defined by the summer of 1546 (reflected in part in the façade elevation in fig. 375, which is obviously earlier than the Naples drawing in fig. 370 and certainly not related to the competition described by Vasari). As noted by Frommel (1981), Michelangelo had in fact only agreed to replace Sangallo in the construction of the palace for the family of Paul III on condition that he would be completely responsible for the architectural undertaking and also in the posi-

tion to make modifications including significant ones. (It should be noted that, unlike what happened in the Vatican construction, the makeup of the Farnese workshop was not changed, and the executors remained in their positions.)

The intervention of Michelangelo, who had to take into account the large amount already built, was limited to only a few corrections which were nevertheless very important in changing appreciably, almost to the point of reversing, the Sangallesque signification. The first change, decisive for defining the overall appearance of the main façade, was that regarding the design of the entablature. According to Mochi's letter cited above, a trial installation of a wood model for this was in place in March 1547 at the right end of the façade, as an experiment in actual scale of the visual effect of Michelangelo's design and also probably to show the pontiff the necessity for raising the façade by a few *palmi*. Verification of this kind was not unusual in Michelangelo's way of

working, if one thinks of the full-scale elevation drawings for the New Sacristy in San Lorenzo, nor was it in the Farnese workshop considering the different proposals for the corner decorations of the palace shown in fig. 370.

But this trial piece of cornice elicited quite a few criticisms, especially from the circle of the original architect's supporters, the so-called "Sangallo Sect." For example, Giovanni Battista da Sangallo expressed strong reservations about the solution in a letter to Paul III, saying that not only was it counter to all Vitruvian principles, but "it was so heavy that it threatened to pull down the façade." He added sarcastically: "The cornice is bigger than the façade, [and] it will be necessary to prevent the house from flying away with the cornice" (Pagliara 1982). This hint of problems in the static order created by the wood trial piece is significant, because criticisms especially of a technical or constructional nature would have been leveled by representatives of that circle of correct professionals formed in Rome

372. *Antonio da Sangallo the Younger.*
Plan of ground floor of Farnese Palace.
Uffizi, Florence, Drawings and Prints Dept.,
A 298r

373. *Antonio da Sangallo the Younger.*
Study for stairwell of Farnese Palace. Uffizi,
Florence, Drawings and Prints Dept., A
1260

374. *Antonio da Sangallo the Younger.*
Study for stairwell of Farnese Palace. Uffizi,
Florence, Drawings and Prints Dept. A 952

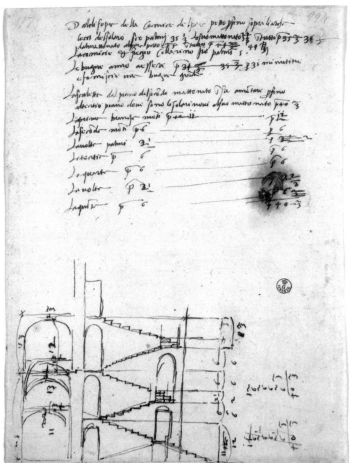

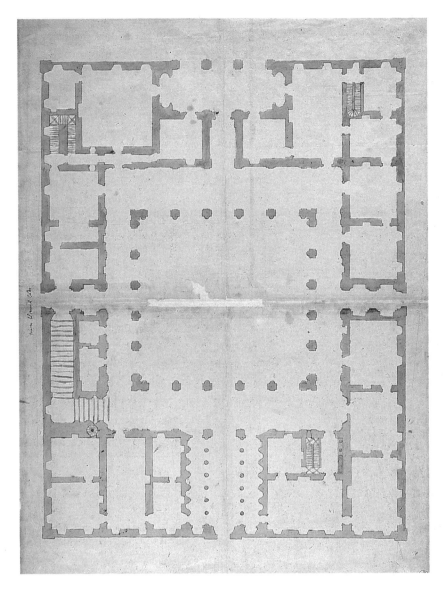

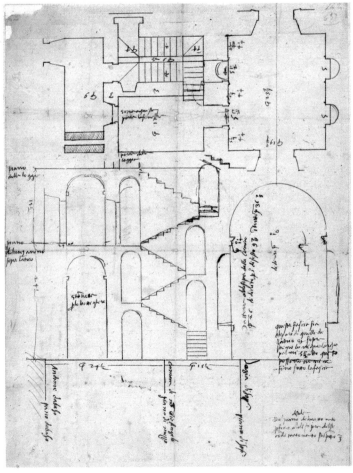

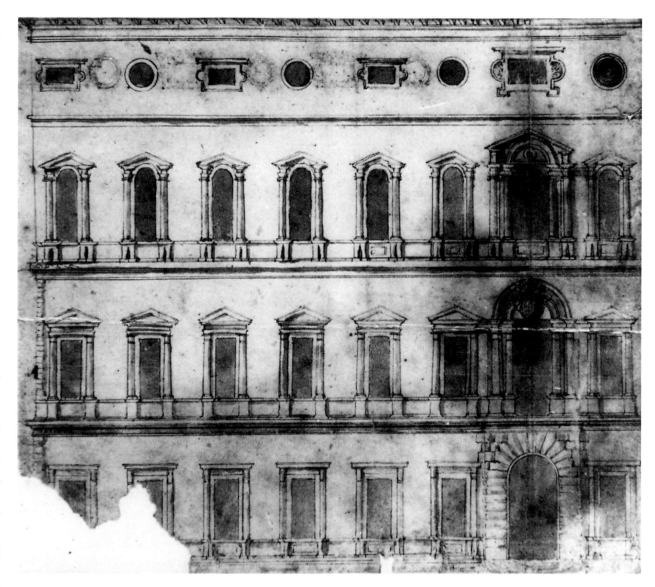

during the many years of the Sangallo monopoly on public works. A similar accusation made by Nanni di Baccio Bigio, another member of the "Sect," was reported to Michelangelo by Francesco Ughi in a letter of May 14, 1547: "Among other things . . . [Nanni] said that you had made a model of a cornice for the Farnese Palace so large that, even though only of wood, the façade had to be propped up; that he expects that you had set about having said palace ruined in every way, and there would be more damages to follow" (Gotti 1875). In actuality, according to the military engineer Galeazzo Alghisi, who documented the episode in his *Delle fortificazioni* (Venice, 1570), the cause of the damages which appeared on the architrave and stringcourse on the right side of the palace façade was a defect in the foundations. This necessitated the costly work of buttressing and then rebuilding. The episode was also recorded by Flaminio Vacca, and some wall repairs are evident in a view of the façade published in *Le Palais Farnèse* (1981, II, plate 160a.) Once the necessary repairs were done, the stone entablature was installed, which increased the height of the façade by three or four *palmi*, or about the same amount as two or three of the ashlar quoins on the corners of the building. This increase in height was a proportional adjustment of the third level with regard to the depth of projection of the roof cornice. On July 6, 1547, Paul III went "to see the construction and the cornices which had just been placed on his palace." (For the status in July 1547, see Eiche 1989.)

Vasari (1568) attributed also to Michelangelo "the large marble window with very beautiful variegated columns, which is above the main door of the palace, with a very large, beautiful coat of arms, and of different marble, of Pope Paul III" (fig. 343). Michelangelo's intervention was extremely simple and yet radical. As if correcting an error made by an inept pupil, he abolished with a stroke of the pen the concentric arches springing from pairs of columns and half columns flanking the central window already built by Sangallo (still visible in figs. 370 and 375). He replaced this with a plain architrave supported by an added pair of variegated columns, above which he installed the giant escutcheon with the Farnese arms, an object very much out of scale. In this way, he interrupted the monotonous alternation of triangular and segmental-arched window pediments and, by placing a strong emphasis on the center of the façade, upset the sense of Sangallo's uniformly varied metrics. The completed façade of the palace, appearing as it exists today except for the small escutcheons added much later, is recorded in two versions of a commemorative medal and in an engraving published in 1549 (fig. 376), which establishes the *terminus ante quem* for the completion of Michelangelo's façade for the Farnese Palace.

As for the interior, Vasari (1568) wrote: "He followed inside from the ground floor up of the courtyard by two more floors with the most beautiful, varied and graceful windows and ornaments and final cornice that have ever been seen; that place there, by the toil and energy of that man, has today become the most beautiful courtyard in Europe. He widened and heightened the grand salon, and gave order to the vestibule in front, and with a varied and new method of sesto in the form of a half oval created the ceiling vaults of said vestibule" (see fig. 348). At the time of Sangallo's death, the colonnade on the ground floor of the courtyard was already in place, judging from the testimony cited earlier of Prospero Mochi, and in all probability the execution of the Ionic order on the floor above was very advanced.

Based on Vasari's testimony, Frommel (1981) asserted that the windows on the second floor of the courtyard were by Michelangelo, but this has been dis-

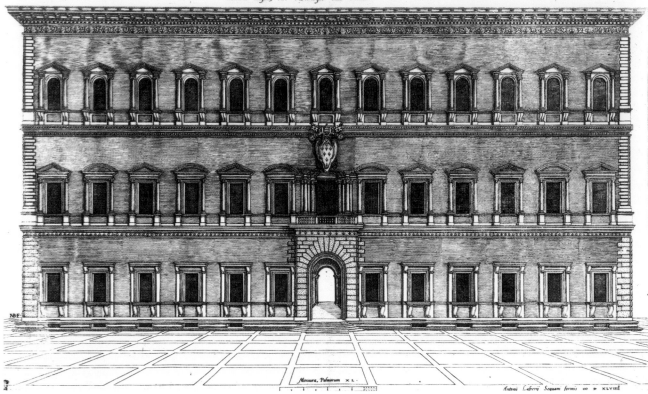

376. Nicolas Beatrizet. *Façade of Farnese Palace, according to Michelangelo's design. Print published by Antoine Lafréry, 1549*

377. Antoine Lafréry. *Southwest face of courtyard of Farnese Palace, according to Michelangelo's design. Print published by Antoine Lafréry, 1560*

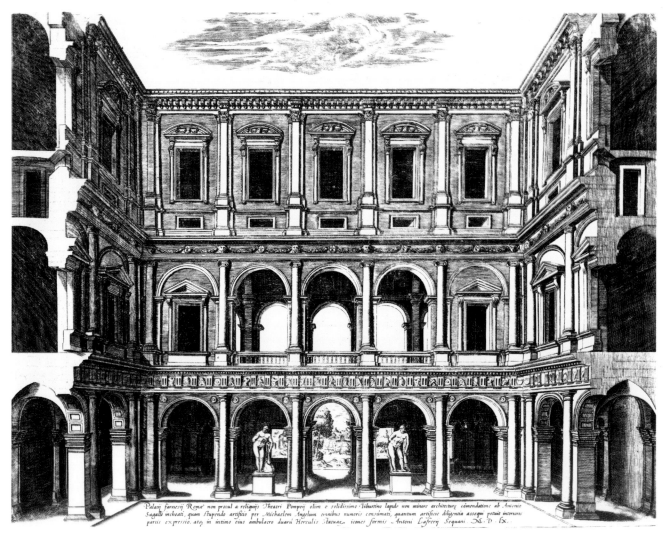

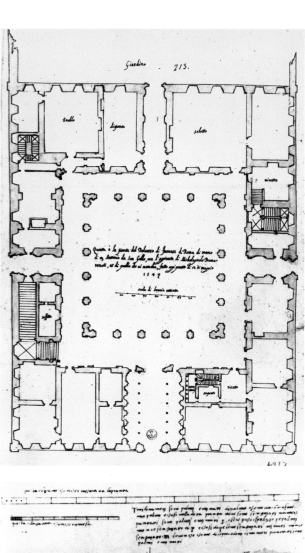

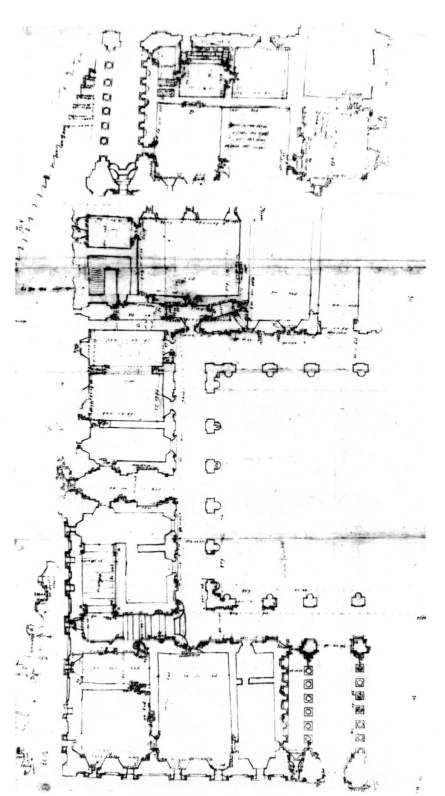

378. *Giorgio Vasari the Younger. Copy of plan for ground floor of Farnese Palace. Uffizi, Florence, Drawings and Prints Dept., A 4927*

379. *Anonymous, 16th c. Plan of ground floor of Farnese Palace. Albertina, Vienna, Graphics Coll., It. Arch. Rom 1073*

380. *Anonymous, French, c. 1560. Plan of ground floor of Farnese Palace. Kunstbibliothek, Berlin, Hdz 4151, f. 97r*

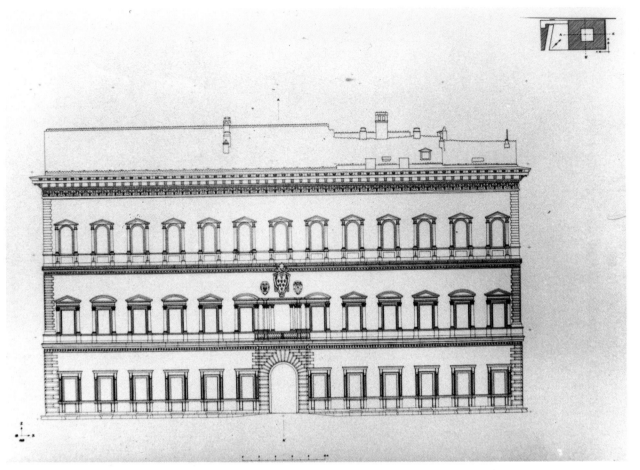

puted by other scholars (Ackerman 1961, for example, assigned the windows to Vignola, the architect who replaced Michelangelo on the project after 1549). While the only windows on the lateral wings dating from the sixteenth century are in the arcades, the sides of the courtyard corresponding to the façade on the piazza and that on the garden side were brought to completion somewhat earlier (Letarouilly 1849–66). Definitely attributable to Michelangelo are: the Ionic frieze with lilies and masks connected by garlands immediately above the second story (fig. 346); the mezzanine level; and the entire third-floor order, where the artist substituted for Sangallo's half column a Corinthian pilaster resting on a high pedestal with a dado between the pilaster base and the pedestal, following the example of the Colosseum (fig. 345). In the window design for the third floor,

probably the most fantastic element of the whole palace (see fig. 338), Michelangelo pushed beyond all limits the dissolution of tectonic grammar and logic (Frommel 1981; for a linguistic analysis of the window, see Hedberg 1970–71).

The elevation of the courtyard as conceived by Michelangelo was very closely tied to the renovation of the second floor and the body of the building behind it. For the interior of the "vestibule," actually a gallery, on the second floor at the rear of the main façade, Michelangelo abandoned the Sangallo system, which anticipated vaults, as on the ground floor, having a semicircular section and resting on pilasters and half columns of the same height as those on the exterior of the arcade. Instead, he created a barrel vault with a lowered sesto "in the form of a half oval" springing from the trabeation that concluded the "Doricizing" Ionic order of pilasters without

bases—linguistically improper from a classicistic point of view (see fig. 349). In this way, Michelangelo unified the whole northeast wing of the second floor, including the two arcades corresponding to the Sangallo staircase. But then he rejected the idea of correspondence between the four faces of the courtyard (another rather eccentric fact, for which he had taken as a precept the Vitruvian *dispositio*). Having in fact raised the height of the "vestibule" in the main wing, he was able to carve out above the two galleries of the lateral wings, in a space nearly three meters high, two mezzanine levels whose windows were cut through the dado of the order of the third floor (see fig. 377).

We do not know in what way he conceived the fourth wing with the garden behind it (on the southwest), because the wood model for it, executed in July 1549, was destroyed. The model was

paid for on July 6 and 18 to "master Gio. Pietro woodworker on account for the model of the loggias of the palace towards the garden." From Sangallo's plan of the ground floor of around 1540 (fig. 372), we know that he had projected a loggia opening into the garden and flanked by rectangular niches (top of plan). A plan attributed to Giorgio Vasari the Younger (fig. 378), who had copied an earlier design, shows a completely different solution of a long, narrow vestibule—practically a corridor—opening through to the garden, which was articulated with pilasters. The drawing is inscribed: "This is the plan of the Farnese Palace in Rome by the hand of master Antonio da San Gallo, with the addition by Michelangelo Buonarruoti, and that which is lacking there, made today, this 12th day of May 1549." Derived from the same prototype is a similar plan in fig. 379, which shows the corridor to the garden lined with niches, probably for statues.

Judging from the absence of measurements in the area in question on the Vienna plan in fig. 379 and on the anonymous plan in fig. 380, up to the summer of 1549 nothing was constructed, except the small stairwell and the walls of the "servants' hall (*tinello*)" on the south corner, which would have jeopardized some other solution. The idea of a corridor leading to the garden, replicating in smaller dimensions the Sangallo vestibule at the main entrance, cannot be attributed to either Michelangelo or Sangallo, according to the majority of scholars, who believe it was an idea formulated by an anonymous sixteenth-century draftsman.

The only sources, both somewhat later, for reconstructing Michelangelo's project of the summer of 1549 are Vasari's account (1568) and Antoine Lafréry's engraving dated 1560 (fig. 377). Vasari wrote that "because there was found in that year at the Antonine Baths a marble seven *braccia* on each side, on which was carved in antiquity a Hercules on top of a mountain, who held a bull by the horns, with another figure helping him, and around that mountain different figures of shepherds, nymphs, and other animals (a work certainly of extraordinary beauty, which, seeing that

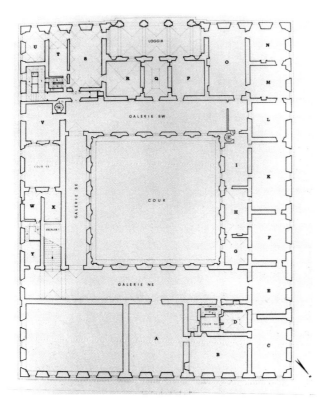

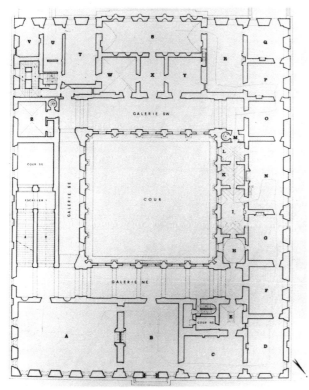

the figures were perfected in an unbroken stone and without pieces, which was judged to have been used for a fountain), Michelagnolo advised that it be placed in the second courtyard, and there restored to make it spout water in the same way, which pleased everyone. This work henceforth was restored by the Farnese lords with enthusiasm for such an effect; and then Michelagnolo ordered that a bridge be made directly to it, which would cross the Tiber River, so that it would be possible to go from that palace across the Tiber to another palace and garden of theirs, because directly from the main entrance facing the Campo di Fiore could be seen at a glance the courtyard, the fountain, the Iulia road, and the bridge, and the beauty of the other garden, up to the other door, which opened onto the trans-Tiber road. What a rare and dignified thing for that pontiff, and all by the virtue, wisdom, and design of Michelagnolo."

The unique visual source for reconstructing the project, the Lafréry engraving (fig. 377), depicts only the courtyard in a view from the main entrance vestibule, which doesn't allow for any reconstruction of the appearance of the garden façade. About this we can only say that it would have had, next to the loggia opening out to the rear, two lateral projections forming a U-shape similar in design to that of the Farnesina by Baldassare Peruzzi, which was the prime model for a suburban villa up to the early years of the sixteenth century.

There are strong reservations among scholars (for example, by Bonelli in Portoghesi-Zevi 1964) about Vasari's account of a scheme by Michelangelo to create a visual axis more than four hundred meters long—that is, a view from the Piazza Farnese and the Via della Lungara—with the *Farnese Bull* as the focus. (The *Bull* was found in 1545 near the Baths of Caracalla and taken by 1547 to the Farnese Palace.) Indirect confirmation for the existence of such a project is found, however, in a letter written by a Rome correspondent to Cosimo I de' Medici in Florence on July 21, 1548: "Yesterday morning [His Blessedness] went to his garden across the Tiber and because he wanted to lengthen the roadway for the Sixtus bridge, he designated that a wooden bridge be made over the Tiber, which will be in a straight line from the palace to said garden" (Frommel 1973). On this basis, Spezzaferro (1981) attributed to Paul III alone the idea to build a bridge over the river to connect the palace to the garden, thus creating an axis along the Via dei Baullari, which connected the Piazza Farnese to the Piazza Navona. But nothing exists to discredit Vasari's account, except that the execution of this supposed project would have entailed many technical difficulties and considerable expense. On the other hand, as Lotz (1981) pointed out, the original paving design of the Piazza Farnese, probably attributable to Michelangelo and shown in Beatrizet's engraving of 1549 (fig. 376), has a strong grid pattern organizing the space of the piazza in a manner presupposing a canonical view from the palace towards the river.

After the death of Paul III, the flow of funds lessened, or at least slowed considerably, now that it depended on the pockets of the nonprosperous heirs, especially Cardinal Ranuccio Farnese, and as a result the palace workshop experienced a period of idleness. Already by 1550, and documented from 1557, Vignola had replaced Michelangelo as the palace architect. He continued the work mainly on the two lateral wings and on the completion of the interior, which was soon occupied by Cardinal Ranuccio. An inventory of properties done after Ranuccio's death in 1565 provides enlightenment on the state of advancement of the palace, the rear areas of which were still not yet completed. In fact, alternative solutions for completing the courtyard and the garden façade were proposed in a *Discourse* by Guglielmo della Porta. The final definition of the rear façade of the palace—quite independent of Michelangelo's design—took place only after the direction of the work was taken over in 1575 by Giacomo della Porta and prior to 1589, the date inscribed on the garden façade. (For the history of the construction after 1550, see Lotz 1981.)

SAINT PETER'S AND THE LAST ARCHITECTURAL THOUGHTS

"Infinity humanly contracted." Nicholas of Cusa

Saint Peter's in the Vatican

For a strong believer such as Michelangelo, what had the responsibility for constructing the mother church of Christianity meant in a time when the Christian community was shattered, the dogmas refuted, and the authority of the pope and Curia contested? Was this conflict not the perfect opportunity and pretext, if not the true motive, for the rebuilding of the Vatican church in Rome? Not just in Germany but everywhere, the scandal over the selling of indulgences had spread and rekindled the old argument about the extravagance of the Curia and the corruption of the clergy. More important, it had opened up the critical doctrinal issue of the legitimacy of the very existence of the Church, of its mandate, its presence, and its actions. Faith was the axis of Michelangelo's thought and the basis of his internal dispute with the methodical skepticism of Leonardo da Vinci. This faith, rendered more combative in his youthful ardor by the apocalyptic preaching of Savonarola in Florence, brought him close to the supporters of Catholic reform in Rome. He condemned the immorality of the clergy and the luxury of the Curia, and he told Julius II, at the time of his work on the Sistine Ceiling, that he would not use gold to decorate the clothing of the ancestors of Christ depicted there, because they had been poor. The mandate to continue the new Saint Peter's, with the permission to change what had already been done (although within reasonable limits), meant first of all to reduce the empty triumphalism of the sumptuous and complex design of Antonio da Sangallo the Younger, then to render visible in architectural form the true doctrine, and finally to make the church-Church a strong weapon in the struggle against heresy. It is well known that Michelangelo was scrupulous about this commission to the point of obsession; the salvation of his soul would depend upon the result obtained in carrying out this enormous task. He was old, and death was near.

The problem was not just the form of the building; it involved necessarily all of Rome, a city not yet a civil exemplum but chosen and destined by God for true devotion—the *periékon* of which the Vatican church was the sacred nucleus. And Michelangelo was still upset over the Florentine tragedy. Rome had suffered the same destruction in 1527, and the danger of sacrilege still weighed on it. He dreamed of defending religious authority with that church structure, just as he had convinced himself that he could defend the freedom of the Republic of Florence with the designs for the city's fortifications.

It was not a new problem. The restoration and renovation of the original Constantinian basilica-plan church, and with it the renewal of the city of Rome, had been talked about for a century—from the time of the end of the schism in the Western Church, when the pope returned to Rome and his great political authority demanded a dignified seat. In a culture which had revalorized antiquity, Rome was the pillar of its prestige, and it was Leon Battista Alberti, the great architect and humanist, who argued for the restoration of what remained of its antique heritage. Half a century later,

Bramante and Raphael had developed an organic plan for *renovatio urbis*, the renewal of the city. It had been necessary to go back to the sources—to Vitruvius, and to the actual remains of antique Rome. But, to render the findings useful in future planning, the varied, frequently contradictory data had to be coordinated and a "rule" deduced from the historical documents in order to create a cultural foundation on which the many architects working in Rome could rely. A true class of skilled professionals was thus formed, which functioned according to the principle established by Bramante and Raphael of diversity within uniformity. The enlargement of Old Saint Peter's was begun with the new choir designed by Bernardo Rossellino, but, in 1505, Julius II decided to demolish the whole structure and build an entirely new church, for which he commissioned Bramante to make the plan. Julius II was aiming for equilibrium in the Italian city governments, whose dissensions were being fomented from the outside, especially by France, and there was also widespread religious unrest for which Savonarola was blamed. Bramante planned the new Vatican church to be auspicious of a rediscovered (but in reality unrecoverable) harmony. An image of clear and perfect equilibrium, it was to be a Greek cross with a hemispheric dome as large as that of the Pantheon suspended over its crossing. This architect's intention was evident to contrast the emblematic church of Christianity with the emblematic temple of antique polytheism. Michelangelo, of course, threatened this concept in wanting to place the tomb monument of Julius II, on which he was working at the time, in the center of the new church as a symbol of concentrated power rather than of superior harmony.

Bramante began his new church structure by building the four huge central piers, but his studies, hypotheses, and proposals were never completed. In 1520, after the death of Raphael, Bramante's follower at Saint Peter's, Antonio da Sangallo the Younger was named head of construction, and the building program was energetically resumed—finally—in 1539 according to his sumptuous design (rendered in an expensive model), which was to be the rejoinder and challenge to Lutheran moralism. After Sangallo's death in 1546, Paul III ejected his collaborators, dubbed the "Sangallo Sect," and conferred the commission on Michelangelo (No. 20), giving him carte blanche and even the permission to tear down part of what had already been built. Why?

Obviously the pope had changed his mind. He understood that the art of Michelangelo—whether painting or sculpture or architecture—had an ideological potential that could be a weapon in the war against the Reform. Michelangelo had said to Vasari, and maliciously caused him to repeat, the worst possible things about Sangallo's design. Vasari, who himself had praised the wood model prepared for Sangallo by Antonio Labacco, wrote that the construction project under Sangallo had been a scandal and only for the making of money by those involved. In a more gentlemanly manner, Michelangelo criticized the artistic deficiencies, saying that the church "was gloomy to the eyes" and "with so many projections, spires, and bits of pieces, that it looked more like a German work than a good antique style or a beautiful and charming modern manner." The accusation of Germanness, and the air with which it was delivered, was perfidious but not without reason. In a letter to Ferratino of 1546–47, the artist's condemnation was even harsher of Sangallo, whom he accused of wanting the interior of the church to be dark so that his "scoundrelisms" would not be seen. Moreover, he considered Sangallo's design to be a confounding of the form which Bramante had actually wanted—"clear and open, luminous and set apart all around." Certainly he had never been a friend to either Bramante or Raphael, but in his design for Saint Peter's, he referred to Bramante in the same way that, in the New Sacristy in the Church of San Lorenzo, he had revived and re-signified the Old Sacristy by Brunelleschi. It was not his own idea, but it was a clear idea with respect to which he could define his own with just as much clarity—all that was equilibrium became tension, and that which was proportion became rhythm. But had not the ideal and historical image of the Church, for which the new Saint Peter's would be the visible image, changed in this same way?

Michelangelo reduced and contracted the preceding plans, but not just in a spirit of austerity. As Vasari put it concisely, he wanted less form and more grandeur. By "form," he meant the reality of the construction, and by "grandeur," he meant the light-filled vastness of its spaces. Even with respect to Bramante's plan, from which he revived the pure Greek cross, the new plan was more simplified (see fig. 384). No longer was there a proportional declination of spaces within the large arms of the cross. Instead there was a single square with four apsidal bodies forming the cross. There were no flat walls and no logical correlations between empty and filled space. Having reinforced the four center piers erected by Bramante, Michelangelo surrounded each one with a continuous succession of pilasters alternately turning to the inside and then to the outside, modeled as bundles of force in tension. Evident in the ground plan was the fact that Michelangelo's simplification of the structures and rupture of the proportional relationships would result in a more immediate and intense visual perception, which he achieved in his painting through foreshortening and color. That maximum of visual intensity, owed also to the enormous size which promoted views along different perspective angles, had its doctrinal reasons. The Protestants believed in justification by grace, thus the mediation of the Church was superfluous. On that basis, its divine institution and its concrete, visible presence in the world were therefore contested. The church edifice could not be the visible materialization of the Divine Essence but only the visualization of the spiritual impulse, which the Church organized and directed by divine mandate. By consequence, the church of Saint Peter was the materialization of the Visible Church and as such could comprise nothing that was obscure or arcane. Michelangelo seemed to be proposing precisely this ultravisibility in reconciling two seemingly contrary qualities—the lucidity of the images and the tension of their forms. The key concept and the reason for his contraction of the architectural elements was

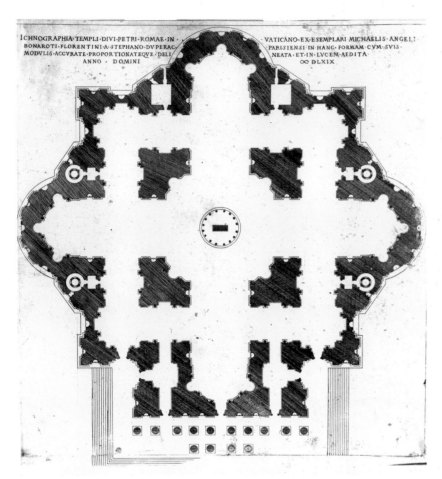

ICHNOGRAPHIA·TEMPLI·DIVI·PETRI·ROMAE·IN· BONAROTI·FLORENTINI·A·STEPHANO·DVPERAC· MODVLIS·ACCVRATE·PROPORTIONATEQVE·DELI NEATA·ET·IN·LVCEM·AEDITA· ANNO·DOMINI VATICANO·EX·ESEMPLARI·MICHAELIS·ANGELI· PARISIENSI·IN·HANC·FORMAM·CVM·SVIS· NEATA·ET·IN·LVCEM·AEDITA· ∞·ⅮLXIX

unity, a value rooted in the thought of Michelangelo since his early neo-platonic formation. It was an intellectual value now exalted in the religious, and it had theological substance in explaining the unity of the human and divine nature of Christ and the one-and-triune essence of God. But it also assumed a polemical rationale in that historical emergency. The Lutheran Protest may have provoked defections, but it had not been able to split the spiritual unity of the Christian ecumene. Unity was as essential to the religious as love—the love of God for humanity and of humanity for God. The dualism of cause and effect leading to objective cognition was not desired—only ultimate absorption. For that reason, Michelangelo, as seen in both his poems and his letters, avoided all deductive, logical, and syllogistic thought, which implied a dualism—a separation and a jux-taposition of object and subject—that he could not accept. This very fideism, to which his intellectualism was finally reduced, was not a logical consequence of a revealed and irrefutable truth. It did not descend from Heaven, he inhaled it, and the anxiety of knowing God was also a recogni-tion of his own human limit. This explained his state of agitation over the problem of completing the work, the possibility of dying before having concluded it, and the predictable and perhaps calculated misunderstanding on the part of his successors—as in fact it happened and was destined to happen. Michelangelo himself had rejected *a priori* every connotation of perpetuity; he did not want to construct an image of a universal and eternal Church, but one infinitely more vivid—of a threatened Church in defense of its own truths and involved in the political conflicts of the time as well. It was not possible to fuse into a single image both perpetuity and timeliness, so Michelangelo chose the latter.

As it stands today, Saint Peter's was the product of many architects working at different times on the basis of Michelangelo's design. It was partly constructed under his direction but not sufficiently to allow for a textual reconstruction of the image actually conceived by him. Even though Michelangelo was considered a "godlike" artist, his strongly centralized plan was distorted only a few decades after his death by Carlo Maderno, with the addition of the longitudinal section constituting a nave. The spirit of the propagation of the faith in the Counter Reformation commanded crowds of believers in reverence to the hierarchy. The congregation was not less important than the rite, it was the rite itself. Besides destroying the centrality of the structure, Maderno's addition also degraded the dome, the pivotal point of that centrality, to a purely liturgical function.

A few decades later, Gianlorenzo Bernini was able to transfigure Michel-angelo's image without distorting it. He was a much greater artist than Maderno ever was, but the condition of the Roman Church had changed also. It was by then victorious, not because it had conquered the heresy but because it had extended the boundaries of the Christian ecumene without limit through its missionary efforts. The space created by Bernini was really the space of surprising discoveries and miraculous events. And Bernini, one of the first artists to be "aesthetically modern," understood the concealed,

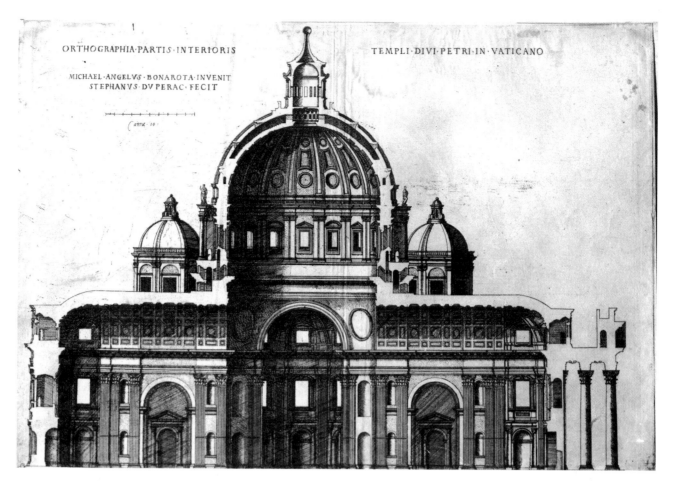

385. *Étienne Dupérac. Section of elevation of Saint Peter's in the Vatican, according to Michelangelo's design. Print*

386. *Étienne Dupérac. Exterior view of Saint Peter's in the Vatican, according to Michelangelo's design. Print*

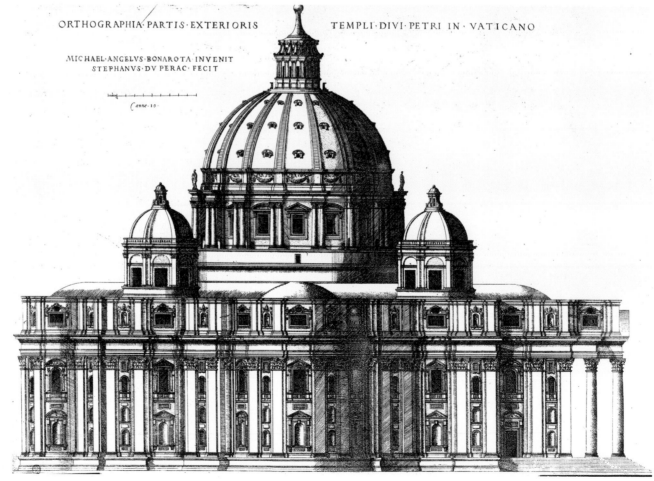

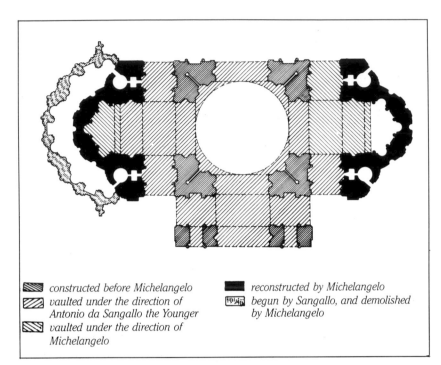

387. *Schematic illustration of successive constructions by Antonio da Sangallo the Younger and Michelangelo in Saint Peter's in the Vatican. From Ackerman (1986; based on Millon-Smyth 1969)*

constructed before Michelangelo
vaulted under the direction of Antonio da Sangallo the Younger
vaulted under the direction of Michelangelo
reconstructed by Michelangelo
begun by Sangallo, and demolished by Michelangelo

and probably rejected or repressed, modernity of Michelangelo. Today Michelangelo's image of Saint Peter's cannot be perceived except through the triumphalist interpretation given to it by Bernini.

Still very young in 1624, this Baroque master animated and ventilated the space under the dome with the glittering baldachin, which received the full light. He wanted nothing architectural there; a tabernacle in that crossing would have been a cricket cage. So he made that processional object, light and portable, with the festoons fluttering in the wind. He made it very large, but in a way that stimulated people to see it even larger. It was his first gesture in Saint Peter's, and with it he revealed and explained "creative thinking," before his near contemporary Descartes would theorize rational thinking.

The baldachin lived in that space without occupying it physically, restoring in the imagination the prestige of centrality to the dome, which could not be seen from the nave but, thanks to the baldachin, could be sensed. Its celestial light was re-naturalized, and its piers were then animated with heroic saints in the niches and spectators in the galleries. Michelangelo had transposed art from cognition to interior existence; Bernini made it life and world. Then he corrected the ungraceful nave of Maderno, turning it into a large, festive vestibule. Later, he completed his interpretation of Michelangelo with the elliptical piazza of 1656–67, which gave an urbanistic and, allusively, ecumenical dimension to the Vatican church.

Bernini expanded what Michelangelo had contracted for the purpose of creating a unity of the whole. Unity was the passage from the symmetric to the continuous and the elimination of all obliged dualities. No longer was there a juxtaposition of flat and raised, architecture and decoration, interior and exterior, filled and void. The building was like a statue; it was impossible to see the front and the back at the same time, but the visible made it possible to imagine the nonvisible. All of the preceding designs had anticipated many parts proportionalized and coordinated, but Michelangelo wanted each architectural element to preserve its own uniqueness and carry in itself, as in foreshortening, the totality of the work.

The Bramante dome was designed to be imposed from the top in order to weld the conjunction of the proportional but distinct bodies. Michelangelo arranged instead for all of the elements connected with the dome to grow upwards from the ground in a single thrust from base to apex. Thus the dome was not placed from the top like a benediction, it emerged from the ground in a continuous ascent towards the Divine. Michelangelo had determined from the beginning that the dome would be the convergence of forces in action and not a factor of the static equilibrium. His first thought was to reinforce the four load-bearing piers constructed by Bramante, who had sized them for a static function. Michelangelo empowered them for a dynamic function, or, more precisely, to make manifest the internal dynamic of the architectural form of the entire building. Vasari, undoubtedly solicited by the master himself, dedicated page after page to the very detailed account of the ideational process, in particular for the external cap

of the dome. This was not done to educate others about a useful invention, for the dome of Saint Peter's remained the only one of its kind. Instead, it constituted a description of intellectual, mathematical research rather than of a technical invention. The size of the dome as previously established by Bramante was not an insurmountable difficulty. The curvature caused a problem, certainly, but why did the problem become an obsession? That dome would become over the centuries, as in fact it was, the symbol and visible image of the unity of the Christian ecumene in the Roman Church. But given the metrical data which existed, weren't the possibilities very few for altering a nearly obligatory form? Other than the technical difficulties, what was the problem which really worried—no, practically obsessed—Michelangelo?

It is known that the external form of the dome of Saint Peter's was subsequently changed by Giacomo della Porta—so significantly in fact that the wood model made for Michelangelo was altered and damaged in the process. The raising of the sesto of the dome in the course of construction in 1588 was decided under Sixtus V, the pope who had entrusted Domenico Fontana with the reform of the arrangement and also of the structure of urban Rome. Fontana was an assistant to Della Porta in the construction of the dome which, in order to express the identity between Saint Peter's and Rome, had to be visible from every part of the city—whose perimeter had been extended by Fontana. The sesto was raised at that time by more than eight meters, and the dome took on its actual ogival form. Wittkower demonstrated reliably that Michelangelo had designed the external hemispheric cap to be equal to that of the internal dome, and the problem which tormented the artist for a long time was really that of the superimposition of two equal hemispheric caps on the same base.

In changing the dome, Della Porta probably bowed to motives of religious expediency. The Counter Reformation preached the worship of the masses, the proselytizing of the Word, and the appeal to the emotions. With the raised sesto, the dome pointed towards Heaven and exhorted to prayer. Assuredly, Michelangelo abhorred that kind of emotionalism, but it is quite certain, as seen in the drawings at Haarlem and Lille (figs. 388, 389), that early on he had thought about a dome with a raised sesto on the external cap. It is also certain that he even thought of combining his dome design with that of Brunelleschi's dome for the Cathedral of Florence, for which he acquired some metrical data required for his study through his nephew. This was not just Tuscan patriotism, even though the relationship between Florence and Rome had been primary in Michelangelo's thoughts since his early years and involved religious problems (the scholastic versus the platonic foundation of the philosophy of Christianity) as well as specific cultural problems (the antique). But what connection could there have been between the dome of Saint Peter's and the great humanistic culture of Tuscany, of which Michelangelo was the ardent, defeated defender? Could it still have had the same rationale as in the time of the Sistine Ceiling—as a solemn affirmation of Florentineness in Rome? As Alberti said, the dome of Santa Maria del Fiore was "large enough to cover all of the Tuscan peoples," and this was not merely rhetorical praise. The novelty of the Florentine dome was in its double religious and political significance, which alluded to the consent and protection of God for the civil commitment of a citizenry made up of many "peoples." The dome of Saint Peter's, then, would ideally cover all of the "Christian peoples," protecting and making manifest their unity.

Michelangelo changed his mind and certainly not without an ideological motive. Probably, he thought that the dome of the Visible Church should have a character of absoluteness and universality expressive of a truth no less theoretical than theological. In any case, it was not a question of taste but of concept. With the definitive choice of the hemispherical dome, Michelangelo approached only in appearance the Bramantesque idea. In fact, this exterior analogy gave more force to the overturning of the conceptual significance—from static to dynamic and from gravity to thrust. And there was probably another motive. A dome with a steeper sesto would have been incompatible with the colonnaded front, and therefore the thrust would not have carried from the ground up, as he expressly wanted. Moreover, the evocation of the Pantheon, although only on the façade, seemed necessary in order to resolve quickly, with that essentially superficial similarity, the problem of the antique.

The dome with a hemispheric cap retained its form in elevation, and to provide height he made the tall drum, one of the few elements constructed under his direction. On the interior of the drum, there was only a corona of large windows between paired pilasters. The interior of the dome itself was illuminated from the lantern, while the windows provided very bright light to the crossing. As in the earlier New Sacristy, the dome and the lantern formed a functional device which captured the natural light, exalting and raising it to the sublime, then re-transmitting it as intellectual light to the elements predisposed to receive it. The source of illumination at its base had no precedents, yet because of it, the dome no longer weighed upon the drum, and the barrel vaults of the four arms were strongly lit.

On the exterior, the tall drum was the collector and transmitter of light, just as it was in the Medici chapel in San Lorenzo. The windows were confined between strongly projecting pilasters from which pairs of columns were thrust outward (see fig. 403). The cylindrical shafts of the columns were charged with physical light, bestowing on it the abstractness of their geometric forms. From there the light was brought into the interior through the windows whose pediments, like large eyebrows, concentrated and prevented it from escaping upward, where in any case it would have been stopped by the cornice. The short sections of trabeation above the paired columns corresponded with the ribs of the dome, providing only illusory support to the wide frieze decorated with floral festoons. The true connection was luministic between the light accumulated on the double columns and then passed on to the ribbing. Michelangelo had made the tripartite ribs the same width as the pilasters of the drum, and more strongly

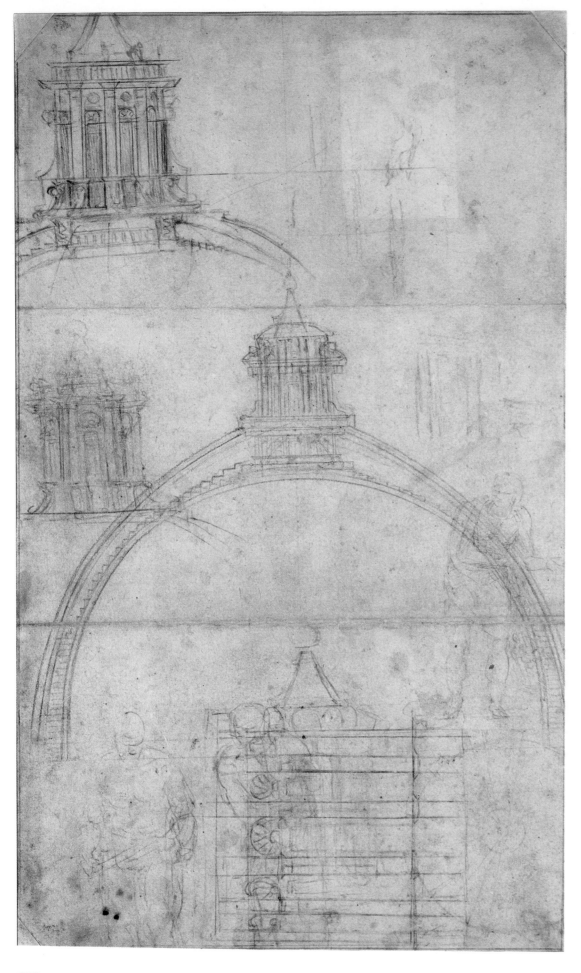

388. Michelangelo. Studies for dome and
lantern of Saint Peter's. Teylers Museum,
Haarlem, A 29r (C. 596r)

389. *Michelangelo. Elevation of drum and lantern of dome for Saint Peter's, with detail of attic elevation (or city gate according to others), and ground plan of paired columns of drum. Musée d'Art et d'Histoire, Lille, Wicar Coll., 93–94r (C. 595r)*

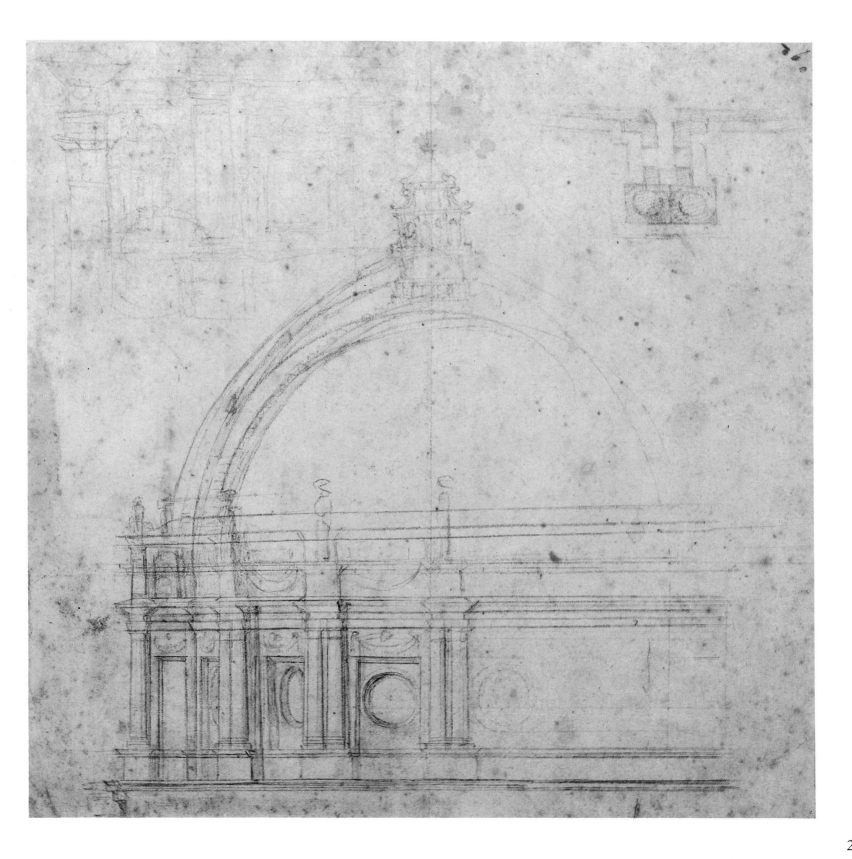

projecting than those carried out by Della Porta. The strange oculi with their little roofs in the taut spandrels can be explained by the fact that they made the covering of the dome appear to be thin, like a sheet of paper. This was necessary to create a sense of weightlessness to match the luminosity of the color, which appeared even brighter than that of the sky, as if the natural light were concentrated and made metaphysical on that hemispheric volume.

The dome was comprised of two caps for reasons of statics, but also because there were two on Brunelleschi's dome, and it was necessary for this image of pontifical power to have a Florentine component. But Michelangelo never had an idea with only one meaning, and there was also a doctrinal rationale for that relationship of concave form to a closed space and convex form to an open one. The church gathered up on its interior the devotion of the faithful offered to the Lord by the priests of the cult, therefore its image should be one of ascension without any load-bearing thrust. As in every thought or act of love, the straining of the spirit towards God should not have earthly motives and impulses. Instead it should be generated spontaneously from the renunciation of every worldly, substantially logical thought. Thus Michelangelo went back to the plan of Bramante, which was perfectly logical in its proportionality, and destroyed it. The approach to the divine was certainly not to attribute to God and to humans the same way of thinking — the *docta ignorantia* was not *ignava ratio*, it was its opposite.

He suppressed the walls as divided planes, and made the wall system of the church a unitary sculptural body with projecting and receding parts, like a bundle of pilasters tied to one another. The lines of force rose from the ground along the moldings and reliefs of these walls, modeled like statues, to end by visually communicating to the dome the currents and flows of force created by their very form. So concerned was Michelangelo with the sculptural unity of the wall mass that he refused to think of the wall system as a composition of constructed bodies joined together. The external contour was a square whose corners projected between the large apsidal curves of the arms of the cross (fig. 384), and to avoid the effect of a conjunction of distinct elements, Michelangelo inserted between them oblique planes. These short planar faces, "emptied" by the carving out of niches and windows and reinforced by the redoubling of pilasters and the deep marginal framings, were like volumes embedded and transposed by force between the sharp corners and the curves (figs. 396–398). Thus turned into uneven lozenge forms, the wall planes seemed to rotate slowly. This was an architecture entirely additive and not reductive, as seen in the superimposition of the pilasters to form deep, narrow slits interpenetrating one another in sharp foreshortenings (fig. 397). The wide, smooth outer pilasters were in contrast bathed in the full light that culminated in the luministic "boiling" of their Corinthian capitals. This very new, inimitable way of constructing architectonic form had, almost incredibly, distant roots in his sculpture. There, instead of continuously rounded forms, he had opposed the broad

contours of the frontal view, nearly flattened by the direct light, with others in foreshortening, abbreviated and penetrated, like large dark crevices of shadow, a technique which had descended in turn from *schiacciato* relief. That way of forming remained fundamental to all of the artist's work, because he stripped away every logical, or normal, or natural evolution of the form. He bound together the contrary values, not for the purpose of contrast or for abbreviated connections, but for a dramatic, internal, unstoppable passage from one value to its opposite. The rapid graduation of shadow on the sharp edges of the composite pilaster receding into imaginary clefts or crevices, seeming to communicate with the interior, was the contrary of the bright light on its outer face like a flattened column. Wherever these emerging and receding volumes left free a section of wall, it was quickly filled up with windows and niches with prominent frames, and these deconstructed structures quickly translated into eccentric license. Their purpose, after all, was to prevent the planar "pause" from making a wall, and yet the communication between internal and external, which they designated in reality, was not in terms of opposites. The important fact was that the form modeled by the pilasters would revolve.

Michelangelo was obliged to confront the problem of the obvious impossibility of seeing exterior and interior at the same time, which was also the innate difficulty with sculpture. Obviously, the part not visible should in some way be implied, or almost complemented, by that which was visible. Saint Peter's was the Visible Church and its visibility, whether intellectual or spiritual, ought to be complete and absolute from all points of view yet, paradoxically, from none of them. It could not be an object for which could be seen, separately, the right side and the wrong side, and ideally it should appear the same from the inside as from the outside. Paul III, in an impulse of liberality and trust, authorized the demolition of certain redundancies of the Sangallo construction, and Michelangelo was therefore able to reduce and contract the perimeter of the building, eliminating the ambulatories on the inside curve of the apses of the arms of the cross which impeded the circulation of the mental view between internal and external. The arms of the cross, barrel-vaulted, ended at the center in arches tangent to the base of the dome with a purity of sign which referred back to the Medici chapel. They connected the four large center piers with the exterior and acted as the "solder," more marked on the inside than on the outside, between the vast wall system and the dome (see fig. 385).

Just as an unstable equilibrium is contingent upon a single point and does not allow for approximations, in the architectural irrational the smallest error could result in absurdity. But was this not the same for theological propositions? Michelangelo knew how to work on the razor's edge, not only because of the envious lying in wait. He feared with good reason that, after his death, his "successors" would change his high architectural ideas. Therefore, he concerned himself with fixing certain obligatory verifications, but the precaution was not of much use. While the artistic community of Rome was not openly hostile to him, it was diffident. There was a tacit anti-

pages following:

390, 391. *Michelangelo, Giacomo della Porta, and Luigi Vanvitelli. Wood model of dome and drum for Saint Peter's, exterior and interior. Works of Saint Peter's in the Vatican, Rome*

Michelangelesque intention in Vignola's *Regola*, which was the only manual of its kind, useful for everyone, and not without well-grounded motives. The undeferrable urban renewal of Rome was approaching, which would certainly present opportunities for majestic works of modern construction. In all sincerity, Pirro Ligorio raised the disciplinary question of whether it was proper for the Vatican church itself to be an example of the transgression of the rules. Was it right, in a building which would be a model, to propose unreproducible solutions? And why was Michelangelo allowed so much license? He allowed himself these licenses because, after having painted the frescoes in the Pauline Chapel, he had practically renounced figural representation—that is, verisimilitude. He had renounced it because he believed in experience fully lived and not disavowed but surpassed. He knew also that the irrational, if not carried to the point of folly, imposed serious religious and moral responsibilities about which he was deeply concerned.

With the *Regola*, Vignola responded to the practical requests of the architects. The importance of being practical was preached everywhere, and practice was justified insofar as it translated a theory into action; but in the Counter Reformation, theories didn't count, only precepts. Opportunely, Vignola substituted a simple collection of norms for theory, and, because obedience was the primary virtue of the Christian, their use became meritorious. Michelangelo rejected theory and preceptism, and he took responsibility for his transgression and license, which was permissible if completed in an impulse of love. Thus it happened that the major church of Christianity, the image of the Visible Church, was the most nonconformist of his architectural efforts, at least in the mind of the elderly artist.

In this work, the not-finished was no longer a matter of the fading away of representation, it was a surpassing of self almost to the point of self-negation. Art could no longer be the product of a "finished" thought. It was said repeatedly that Michelangelo, old and ill, could no longer apply himself to the construction, and he went more and more rarely to the work site, yet, in reality, he considered his work on the Vatican church to be tied to his own extreme condition of existence. He had renounced representation, and it might well be asked whether this was an act of humility, or one of pride. The essence of his sculpture and painting, de-representationalized, had passed wholly into his architecture. Saint Peter's, where certainly there was no question of a synthesis or unity of the arts, was in fact the most sculptural of his architectural works, and in a sense it contained and summarized—through the will of the artist in exhausting himself totally in this work—the lived experience of his whole life.

The sensitive transition from sculptural and painterly representation to architecture began after the almost provocatory (or so it was considered by his contemporaries) figurative exuberance of *The Last Judgment*. After his return to Rome, Michelangelo made very little sculpture and without any official commission: the *Brutus* of 1537, a bust composed in commemoration of the death of the Florentine Republic; later on, the modest statues of

Leah (fig. 91) and *Rachel* (fig. 90); and finally *The Deposition* (fig. 392) and *The Rondanini Pietà* (fig. 393), made while thinking about his own tomb. In his last work, *The Rondanini Pietà*, the stylistic "not-finished" was merged with the lived "not-finished" of his own existence which was coming to an end, and on the base of this final union of art and existence he signed his name. The artistic-existentialist "not-finished" of this *Pietà* was the same thing as the "never-begun" of the Church of Santa Maria degli Angeli.

It is known that Michelangelo unexpectedly interrupted work on the *Deposition*, today in the Florence Cathedral, and immediately considered destroying it. Then he changed his mind and left it for Tiberio Calcagni to try to finish, but the marble broke, according to Vasari. The statue was later given to Michelangelo's friend Francesco Bandini. According to the original concept, this would have been a work of great importance—marking the artist's passage from the intellectual research of the Florentine period to his religious calling in Rome and having therefore the same internal tension as the two Pauline frescoes. The sculpture depicts four entwined figures: the Virgin and Mary Magdalene holding up a dead or resurrected Christ, one can't tell which; and looking down on these figures from above, more spectator than participant, a Nicodemus who may very well be, as it has been suggested, a symbolic self-portrait. In his youth, Michelangelo had sculpted the magnificent *Pietà* (1498–99) destined for the Chapel of the King of France in the Old Saint Peter's, a work technically of finished perfection, almost like ivory. The theme of the real death of Christ, and therefore the significance of the resurrection, was very popular, from a philosophical point of view (one thinks of Nicholas of Cusa) more than a strictly theological one. And in current terms, it posed a problem similar to the rebirth or resurrection of the antique. The theme fascinated Michelangelo, just as it had attracted Botticelli for the same neoplatonic implications. This *Pietà* was Michelangelo's first statuary group, and in it the young artist reconciled the two main influences on his own formation—Donatello and Botticelli, which was similar in effect to reconciling the substantially naturalistic concept of rebirth with the spiritual concept of resurrection. Botticelli's imagery was pure vision and did not involve problems of expression and implication. In his *Madonna of the Steps*, Michelangelo had studied the "*stiacciato*" relief of Donatello, which presented the nonvisible parts as presumed and therefore implicit in the visible ones. The statue for Saint Peter's was conceived as a high relief to be seen frontally, with the nonvisible parts presumed and implied. It was already a "not finishing" of an image otherwise rendered in a perfect technical finish.

But, returning to the statuary group of *The Deposition* in Santa Maria del Fiore, why had Michelangelo stopped work and abandoned it without completely repudiating it? I can think of a possible answer—because the problems posed with that work had been reproposed on a grand scale and without the moderating mediation of the human figure in his design for the new Saint Peter's. In *The Deposition*, in fact, everything moved from the ground up on one side through the flexed leg of Christ and its salient thrust,

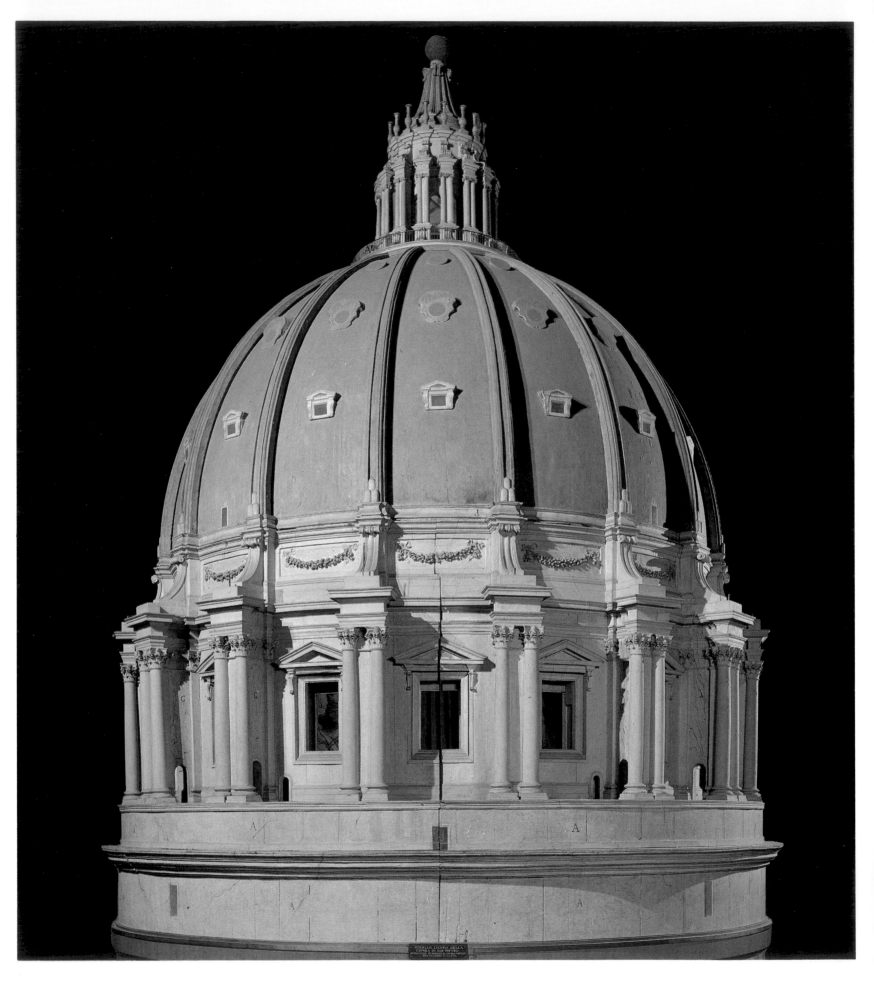

282

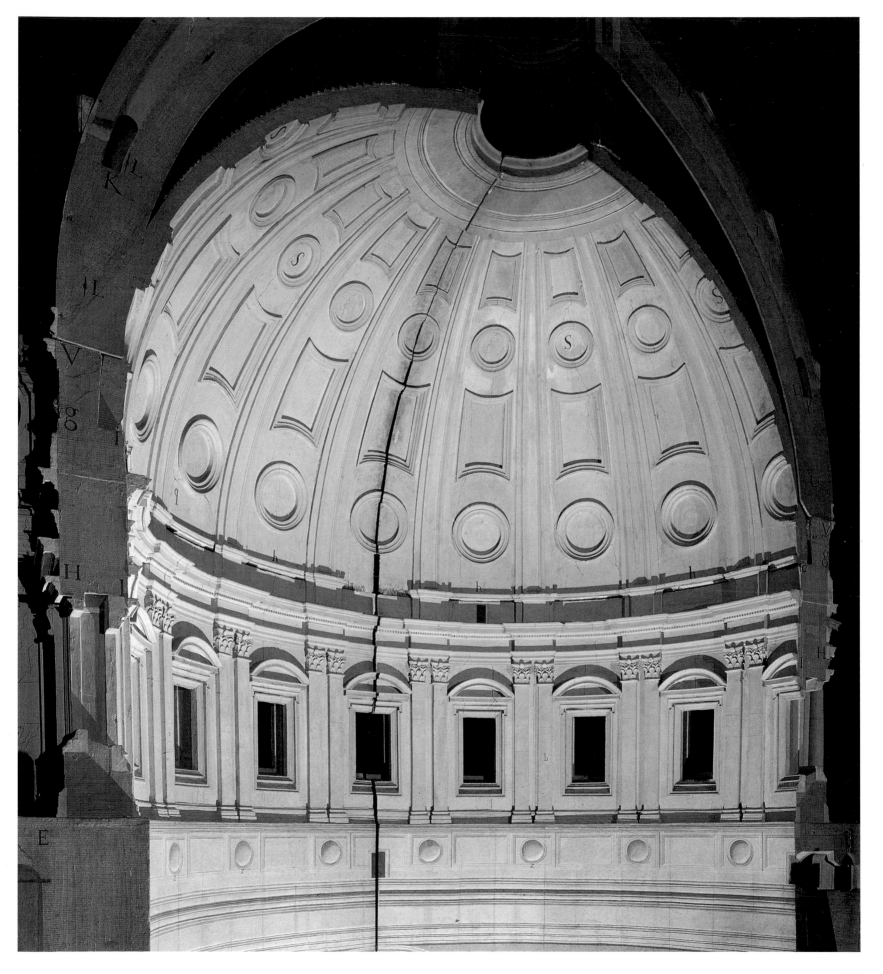

then fell back down again through his arm on the other side. Also, the arms of the three figures formed a rhombic space in which a vital force was preserved or rediscovered in the curve of the body of Christ. The same forms, in sum, speak of both death and resurrection. Is there a more sublime *coincidentia oppositorum*? More than in the faces of the figures, this is revealed in the "architecture" of the gestures—that lozenge of space from the interior of which rises a luminous form, the body of Christ, with everything leading back to a great curve, from the arm which touches the shoulder of Mary Magdalene to the touching of the two sorrowing heads, like the dome of a cathedral over which is raised the "lantern" of the witnessing figure of Nicodemus. On the point of being dissonant, and certainly disproportional in that intensely pathetic group, is the gigantic figure of Christ, dead and resurrected, humanly suffering. Ultimately, this is the terrible Christ of *The Last Judgment* or, in another sense, the heroic *Moses* between the female orants on the Tomb of Julius II. With religious calling prevailing over intellectual pride, Michelangelo believed that there was a necessary difference within the unity of the Church between shepherds and sheep, a distinction which was in his mind not hierarchical but the will of Providence for the salvation of humanity. In the planning of the new Saint Peter's, he knew that the ritual of the temple should be united with the choral devotion of the faithful, thus, in defining the huge skeletal framework and its subtle decorations, he did not worry about their reciprocal proportionalities. Nor was he daunted by the coexistence of solemnity and fantasy; on the contrary, it seemed necessary to him, because both were included in the rhythm of the hymn and the litany. There could be grandeur without pride, and eccentricity without sin. In the long and tormented history of Michelangelo, the Vatican church, unfinished and disfigured, was his final, highest achievement. With it he preached that collective salvation, more than a doctrinal thesis, was an agonizing need of humanity, and again he was not understood.

Not understood by anyone, that is, except Bernini, who, a century later, understood and not only repeated but shouted Michelangelo's message to the world in that elliptical, colonnaded piazza in front of Saint Peter's (fig. 514). Once again he set off the dome, which Maderno had degraded by the extension of the nave, with a truly honest and respectful façade for which it was a glorious finale. The form of the dome was recalled in the piazza, but magnified and expanded into an ellipse, then split like an immense piece of fruit so that it could hold the people of the city and of the world. He evoked the drum of the dome in his colonnade, enlarging it and, with the perspective of the four coupled columns, forming a huge aureole, thus making the eccentric church structure the idealized center of the urban space.

The last architectural thoughts

While building Saint Peter's, Michelangelo was occupied with nothing which was not in some way connected to that enterprise—or to the restoration of his relationship, through Vasari, with Florence and the Medici. In suspense at the time in Rome was the complicated question of the church of the Florentine Nation on the left bank of the Tiber, San Giovanni dei Fiorentini (No. 28). Cosimo I de' Medici wanted Michelangelo to build it, but, because of his age, the artist accepted only the limited charge to provide ideas for it and declined in advance, in favor of Tiberio Calcagni, the direction of the actual construction. He wanted to please Cosimo, but probably the idea of an important church on that particular site attracted him also. It would be near, or actually in sight of, Saint Peter's and at the entrance to the Via Giulia, as well as in the vicinity of the Farnese and the Chancellor's Palaces. The Florentine Nation, which was the most powerful financial force in Rome at the time, could not have wished for a place of greater prestige for their own church.

A first commission for the church structure had in fact been given by Leo X to Sansovino and then transferred to Antonio da Sangallo the Younger. From the beginning, a central-plan building had been projected because it conformed best to the site, and the final longitudinal plan by Giacomo della Porta and Carlo Maderno was owed to their compliance with Tridentine dictates. Michelangelo was certainly pleased, however, with the idea of a centralized structure rising on this site, which would form a triangle of similar volumes with Saint Peter's and Castel Sant'Angelo. Also, it would be the bond that tied the Vatican church to the city. By being centralized in plan, the structure would have a charge of energy to compensate for its smaller mass, which helps to understand why Michelangelo sought the maximum concentration of forces in tension and opposition in his designs for the church.

According to Vasari, Michelangelo accepted the planning of this church because, in "his old age, he was occupied with sacred matters, which would be in honor of God, then for the love of his native Florence, which he always loved." After a very short time, while the ground was being prepared, "and thinking that he would do nothing, he informed [the deputies of the Florentine Nation] that he had already employed Tiberio Calcagni . . . and he showed them five designs of temples."

These energetically sketched designs show the extraordinary vitality of the elderly artist. While they were only ground plans, they were not prefigurations but architectural images complete within themselves, like those of the Florence fortifications. They contained the power of the complete edifice, whose construction was of little interest to him; others would take charge of it. He was asked to choose between these designs, and one was selected, but soon the difficulties began—the wealthy Florentine Nation could find no more money. It was 1559, and the rigors of the Tridentine decisions were being felt, especially one dictating that the form of the church should be adapted more to the congregation and to the preaching than to the Eucharistic rite. For that reason, even though the central plan was more suited to the site, Giacomo della Porta constructed a hall church in 1582, and Maderno raised over its crossing a dome more ogival than that of Saint Peter's.

392. *Michelangelo.* The Deposition
of Christ *(Pietà). Cathedral of Florence*

393. *Michelangelo.* The Rondanini Pietà.
Museo del Castello Sforzesco, Milan

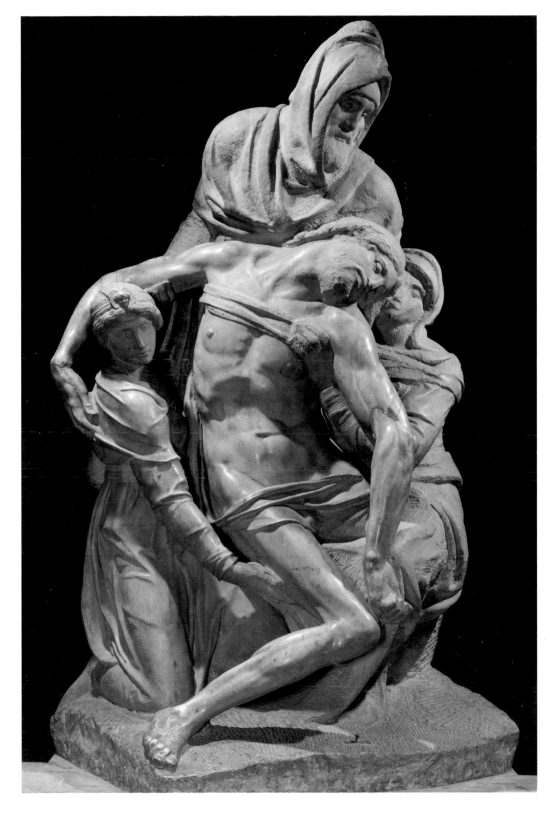

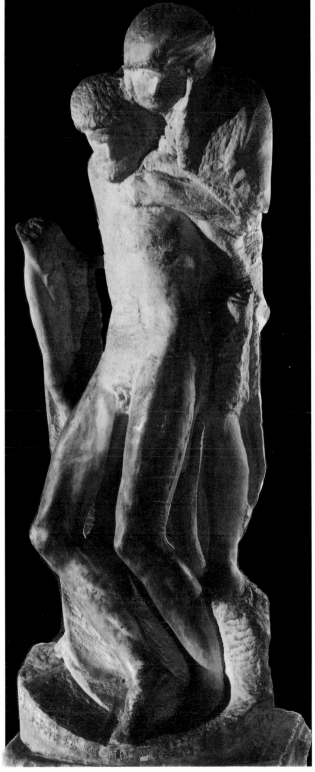

392. *Michelangelo.* The Deposition
of Christ *(Pietà). Cathedral of Florence*

393. *Michelangelo.* The Rondanini Pietà.
Museo del Castello Sforzesco, Milan

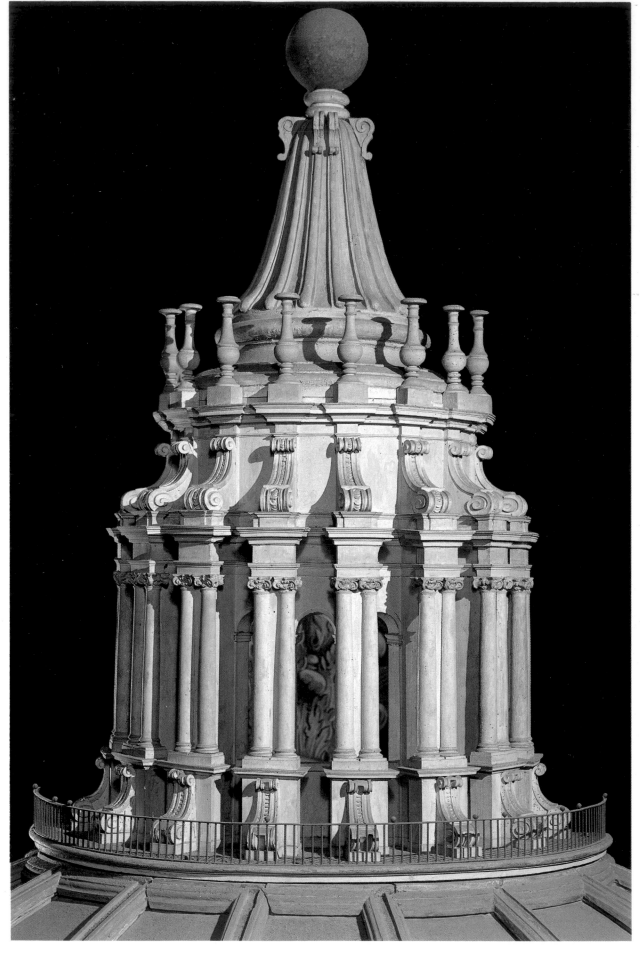

394, 395. *Michelangelo, Giacomo della Porta, and Luigi Vanvitelli. Wood model of dome and drum for Saint Peter's, detail of lantern exterior and interior. Works of Saint Peter's in the Vatican, Rome*

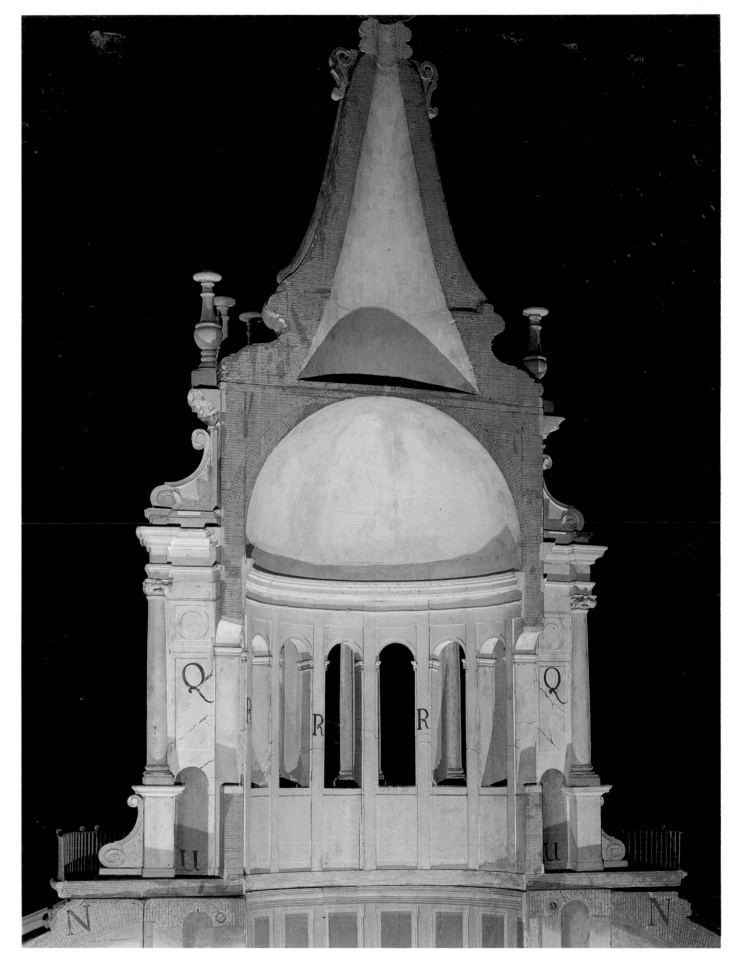

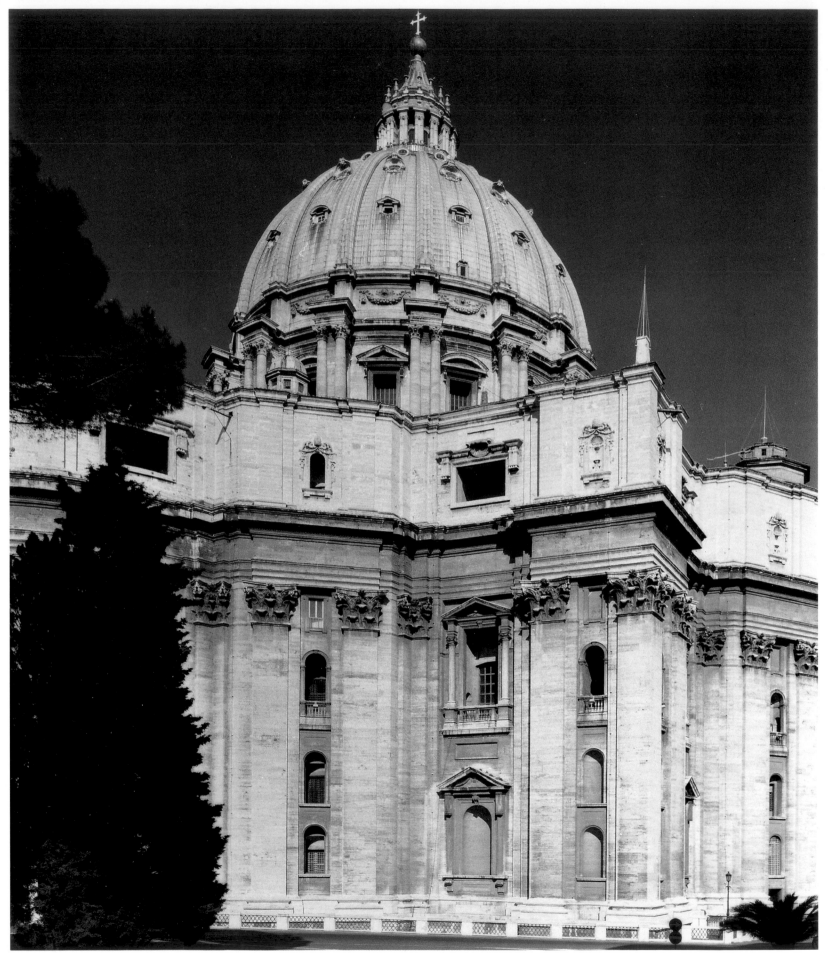

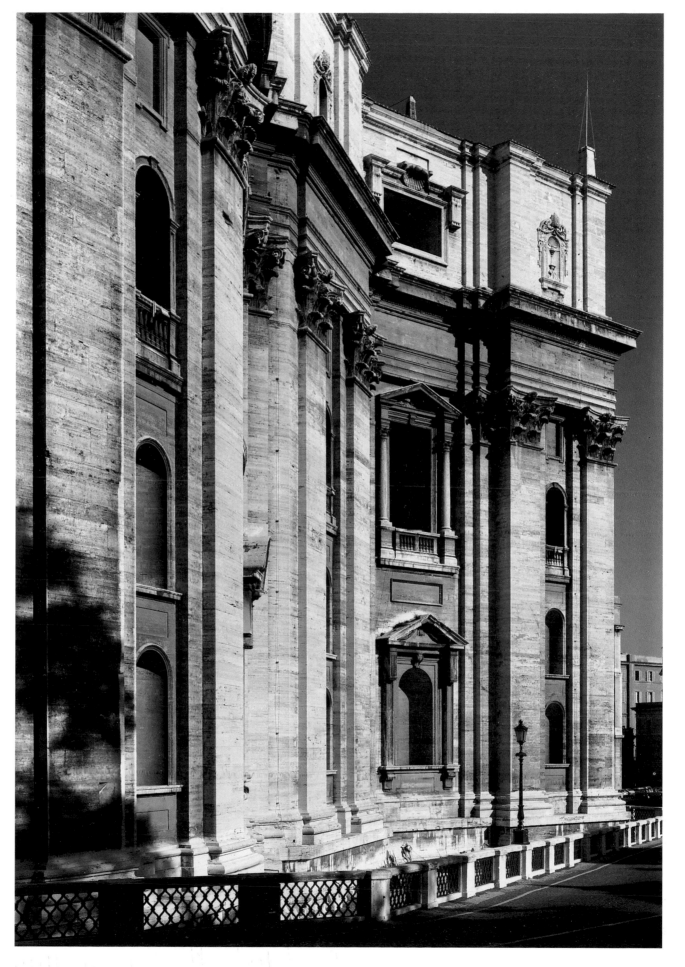

396, 397. *Saint Peter's in the Vatican, details of giant order of pilaster on exterior*

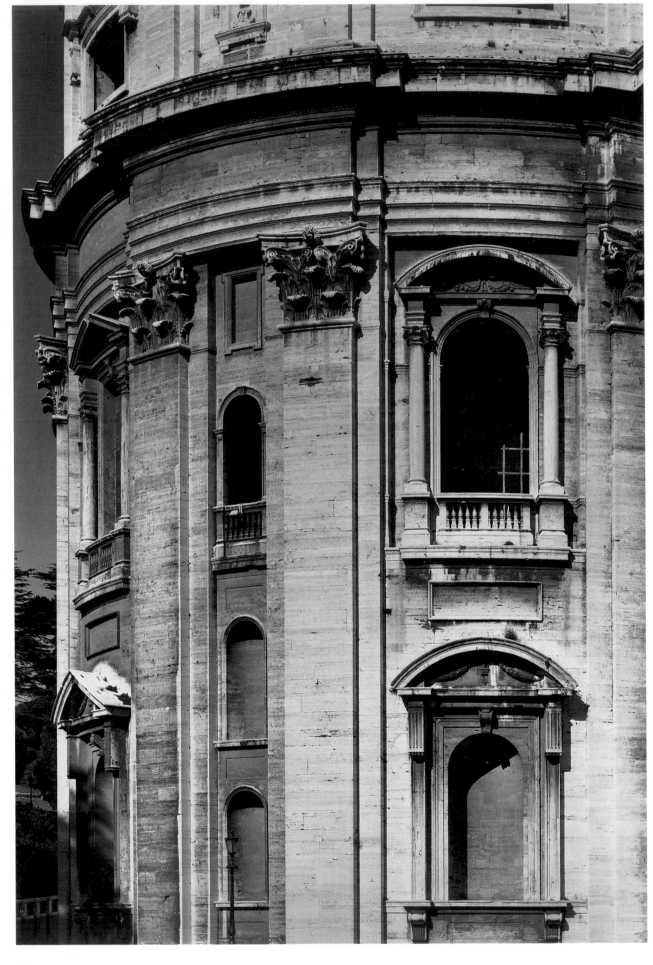

398. *Saint Peter's in the Vatican, detail of convex apse*

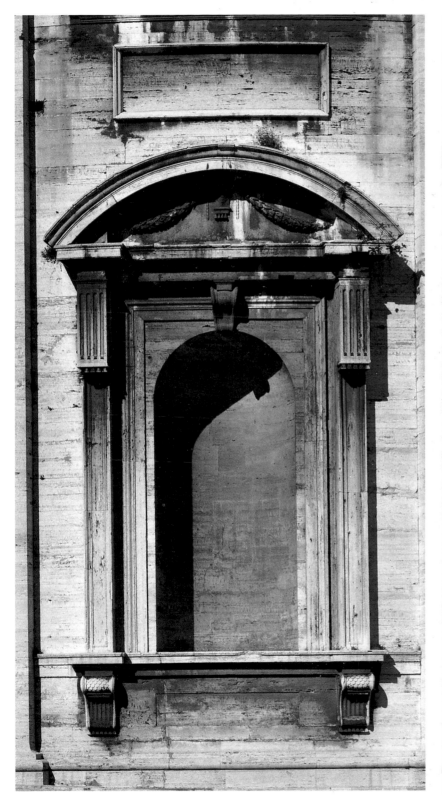

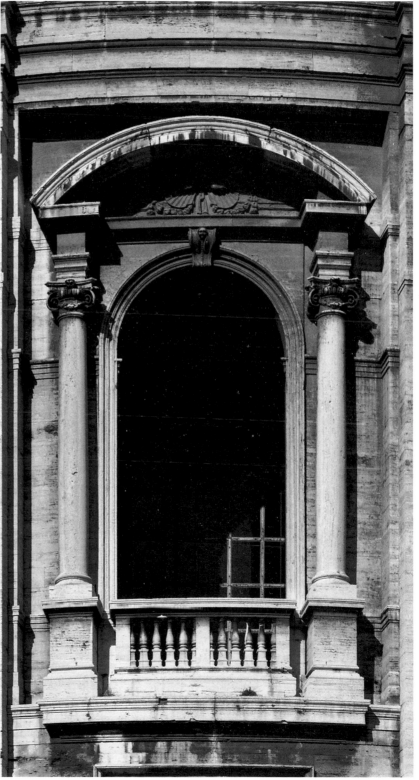

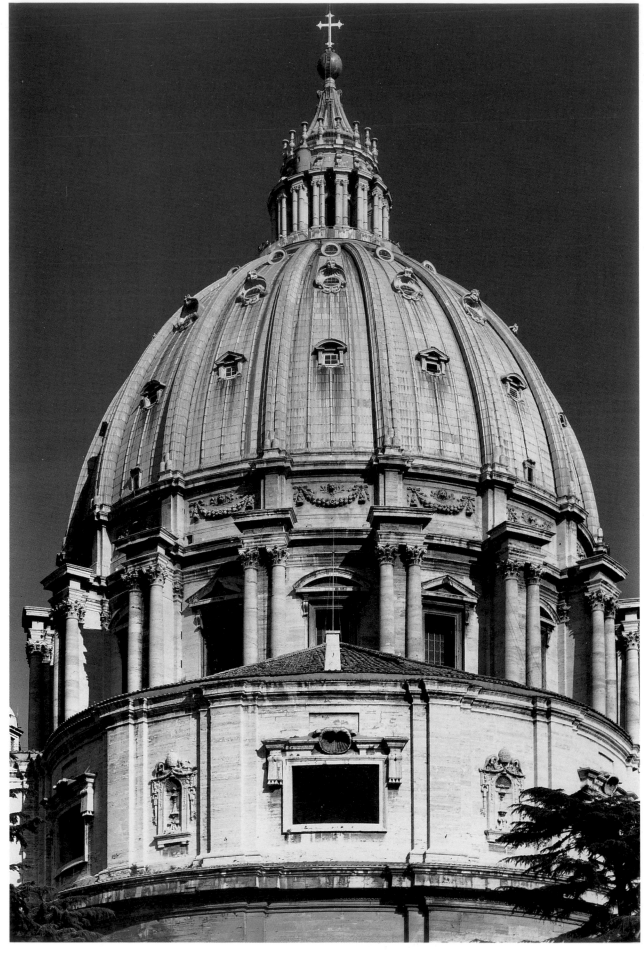

401. *Saint Peter's in the Vatican, detail of dome and drum on exterior*

402. *(opposite) Saint Peter's in the Vatican, detail of drum and ribs of dome on exterior*

pages following:

403. *Saint Peter's in the Vatican, detail of drum and its terminating cornice on exterior*

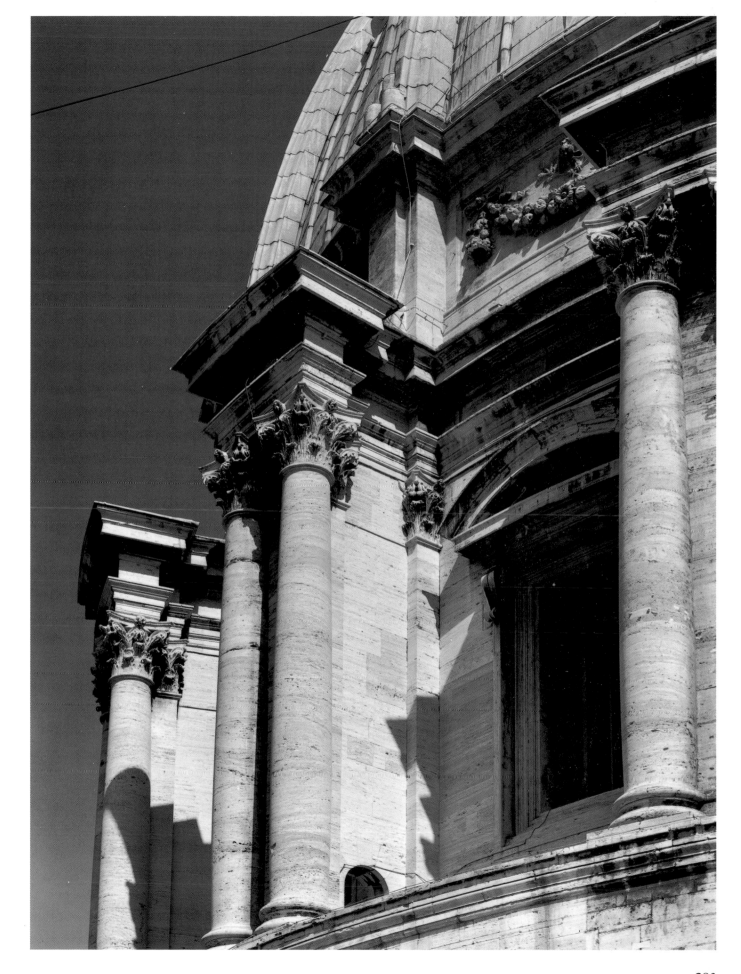

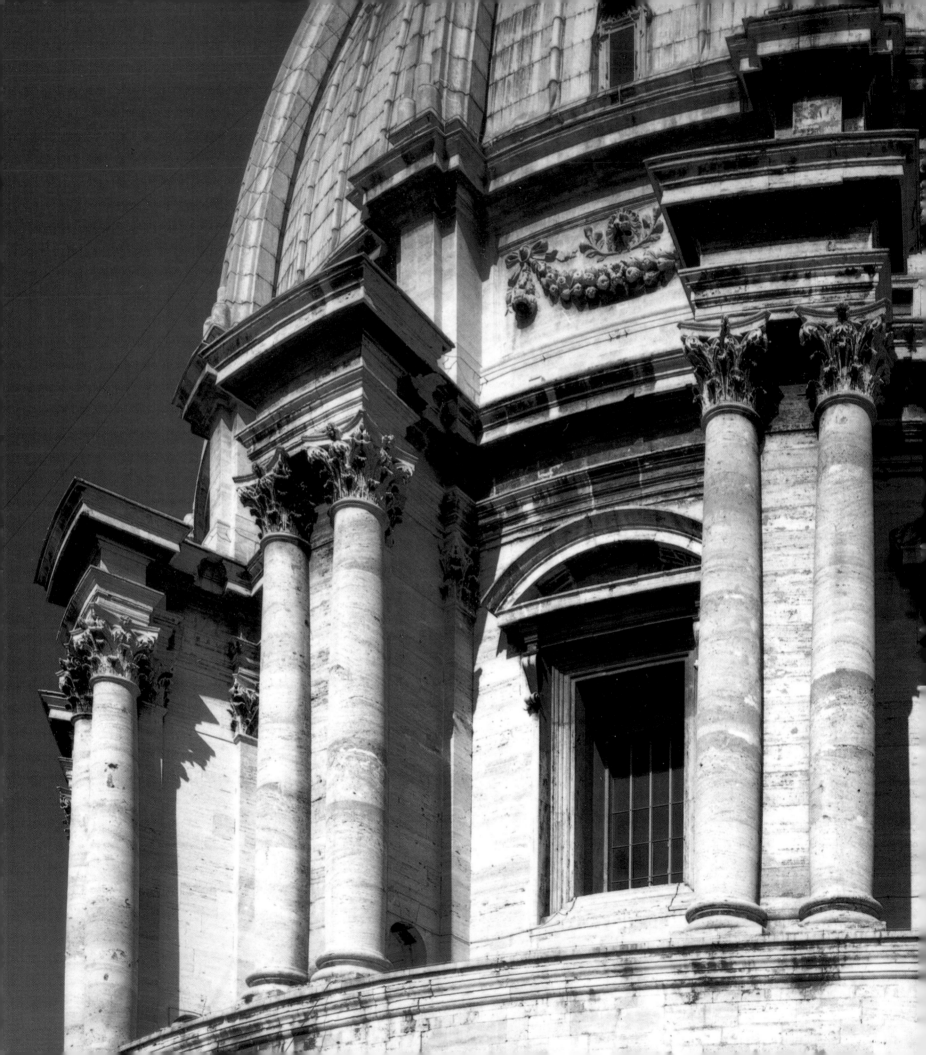

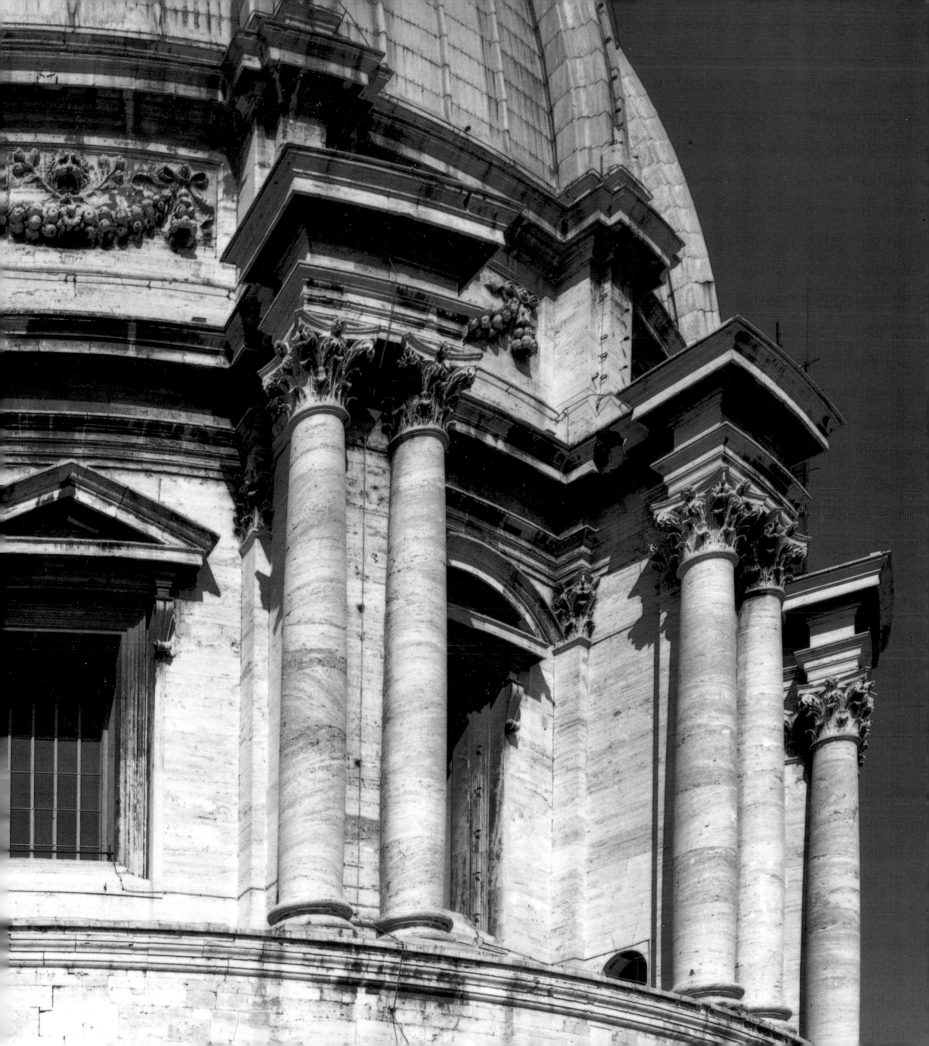

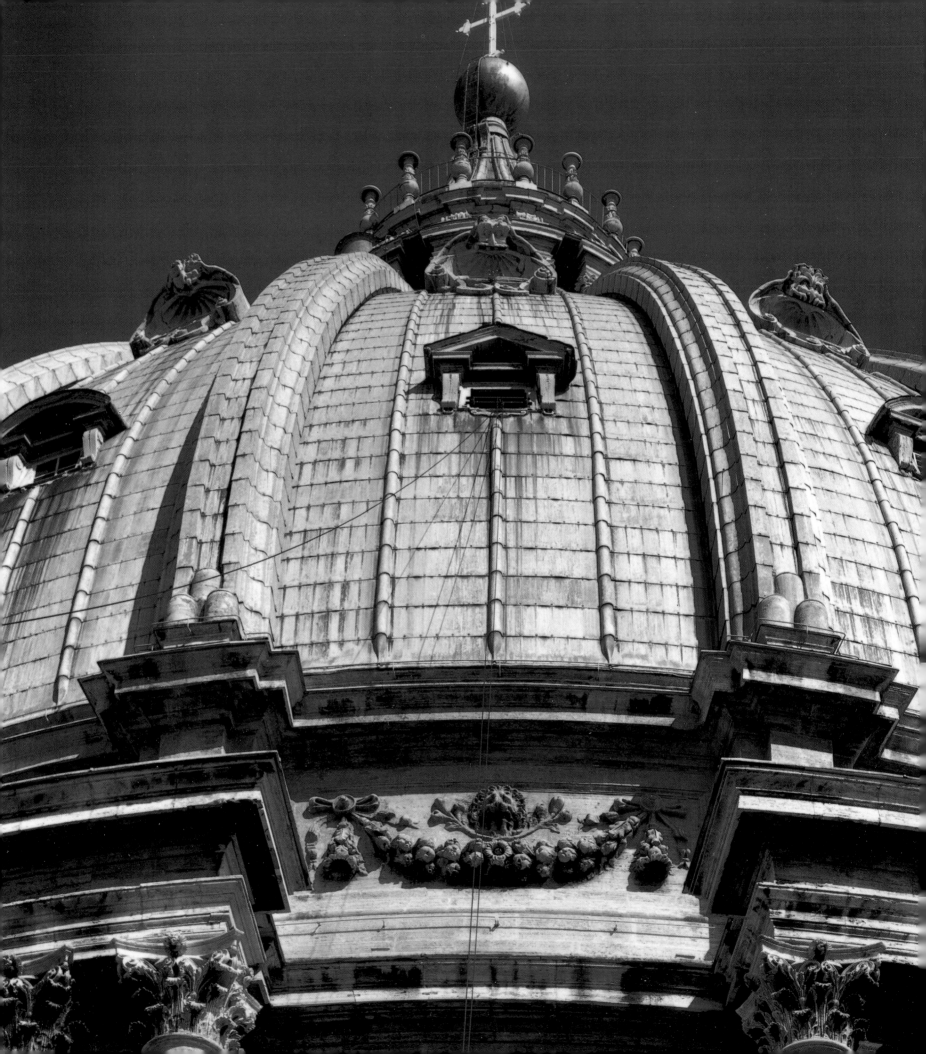

404. Saint Peter's in the Vatican, detail of
dome exterior showing relationship of ribs
of dome with paired columns of drum.
(Ribs and windows of external cap were
not carried out by Giacomo della Porta as
Michelangelo had intended.)

There is evidence that a wood model was made of Michelangelo's design, but all that remains with certainty of his creation is a small group of drawings (see figs. 405–407, for example). Decio Gioseffi posed the problem with great clarity. First, are the drawings actually those which were presented to the deputies, or at least faithful copies of them? Second, assuming that they are, do they represent different plans or successive phases of one planning process? Finally, did Michelangelo stop with these plans or go on to others? On the first point, one can only agree with Ackerman and Gioseffi that the preserved drawings are indeed those about which Vasari spoke. As for the second issue, it is clear that each plan was complete within itself, but their succession shows that they were the outgrowth of a single planning process. The highly finished drawing in the Uffizi, assigned by Ackerman to Calcagni (fig. 475), proves that Michelangelo actually selected as the final revised version the one which was the most complex.

The ground plan only provided an approximation of the elevations. More, but not everything, would have been provided in the clay model, which for Michelangelo was the essential moment of his planning. Only the wood model would have been complete in the details, but how can one know up to what point the transcription followed the original text? And why, counter to all of his habits, would the master have defined the details, when from the beginning he declared that he would not direct the construction? Besides, models usually served in particular for the presentation to the patrons, who in this case had approved the design of the church based on his drawings. Derived from the wood model were the drawing by Giovanni Dosio (fig. 478) and the prints of Jacques Le Mercier (fig. 476, published 1607) and Valerien Régnard (published 1683), about which modern scholars have had much discussion with regard to reconstructing the elevations for a structure which, in Michelangelo's mind, very probably was concluded with the design of the ground plan.

The chronology of the drawings has been exhaustively studied by Frey, Ackerman, Bettini, and more recently Tafuri. The plan in fig. 405 came first, while those in figs. 406 and 407 demonstrate the rapid evolution of an idea. Then there was a final invention documented by the drawing attributed by Ackerman to Calcagni as a finished copy of the final idea of the master (fig. 475). This last coincides with the partial copy, more concisely interpreted, by Oreste Vannocci Biringucci (fig. 473). The first design (fig. 405) was a preliminary critique of Sangallo's concept, which Michelangelo preserved in general arrangement probably in order to utilize the already partially excavated foundation. Two references, nearly obligatory, were already evident in the rotunda planned by Sangallo—the rotunda of the Church of Santa Maria degli Angeli in Florence by Brunelleschi, and the Pantheon, and Michelangelo retained these while transforming by articulation the purely volumetric form of Sangallo's design. Santa Costanza was obviously the source for the idea of the peribolos, the ring of columns connected to the perimeter wall by a continuous barrel vault, which created a corona of shadow around the illuminated space under the dome. The perimeter wall and peribolos formed a coherent body in the half-shadow of the barrel vault, and the perpendicular intersection of the two axes implied a cross inscribed in the circle. The curving sides of the circle projected beyond the square podium of the rotunda, thus combining the two different volumetric bodies into a single plastic organism. On the interior, the space had a rhythm of rotation, with the pilasters on the perimeter wall connected through the wide barrel arches to the "halo" of the peribolos, which in turn was related to the diagonal corners of the octagonal base of the altar, or perhaps baptismal font, at the center. At the ends of the two axes and penetrating into the central space were four vestibules, with the one at the main entrance a kind of rectangular pronaos, or porch, having an internal apsidal shape. This obviously linear circularity nevertheless contained in potency a sculptural articulation and structuring which would be developed in successive designs.

Within a short period of time, Michelangelo created another, quite audacious design. From a careful calculation descended from the antique icon of the round temple, he jumped suddenly to a different and previously unknown architectural image—a heavy yet articulated and modeled wall system on an octagonal scheme with four plain faces and four having projecting semicircular apses (fig. 406). There was an alternation of long and short elements, of expanded and contracted forms, and, between them the break of the penetrating voids like foreshortenings. All of one side was taken up by the so-called entrance portico, a rectangular pronaos with apse ends, almost as if to announce the excited architectonic gesturing of the interior space. The peribolos, contracted and retracted, was now presented in the form of wide piers connected to the perimeter wall by short sections of barrel vault. No longer continuously vaulted, this furrow still provided a ring of shadow around the illuminated central space. Also, the circular connective element of the composition still existed in this plan, with the intersecting diagonals generating a continuous ring of Saint Andrew's crosses seemingly in rotation. The innovation here was the wall mass compacted and modeled almost like clay, just like that of Saint Peter's but more audacious in the bonds of force tensed like muscles under a burden. The synthesis of the arts no longer interested the artist, yet he designed this church as if it were a statuary group seen from the inside.

But he was not finished, and the next step he took was even more surprising. The body of the church became more contracted, with four chapel-rotundas terminating the oblique axes (fig. 407). The peribolos, now consisting of double piers connected to the massive walls across short barrel vaults, reduced the central space to a degree, and the vestibule spaces, greatly enlarged, extended inward to form a large Greek cross joined at the center with the arms of a Saint Andrew's cross marked by the axes of the chapel-rotundas. The first solution of four vestibules forming a cross within a circle was represented but transfigured in a design that was otherwise freed from and outside of any previous scheme whatsoever. Two elements

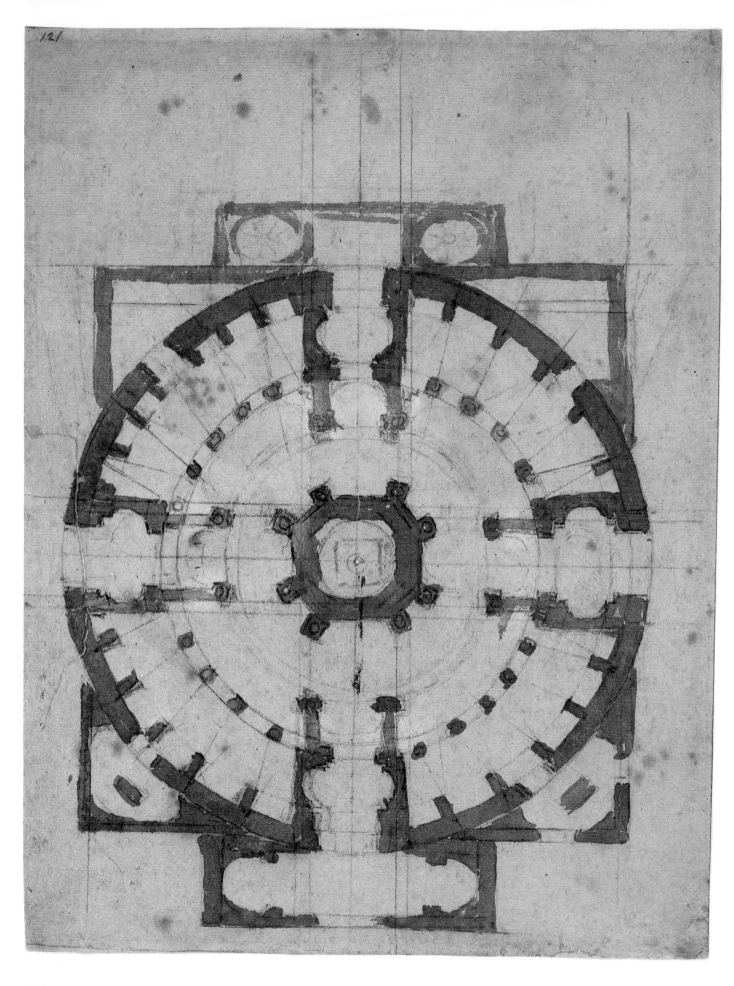

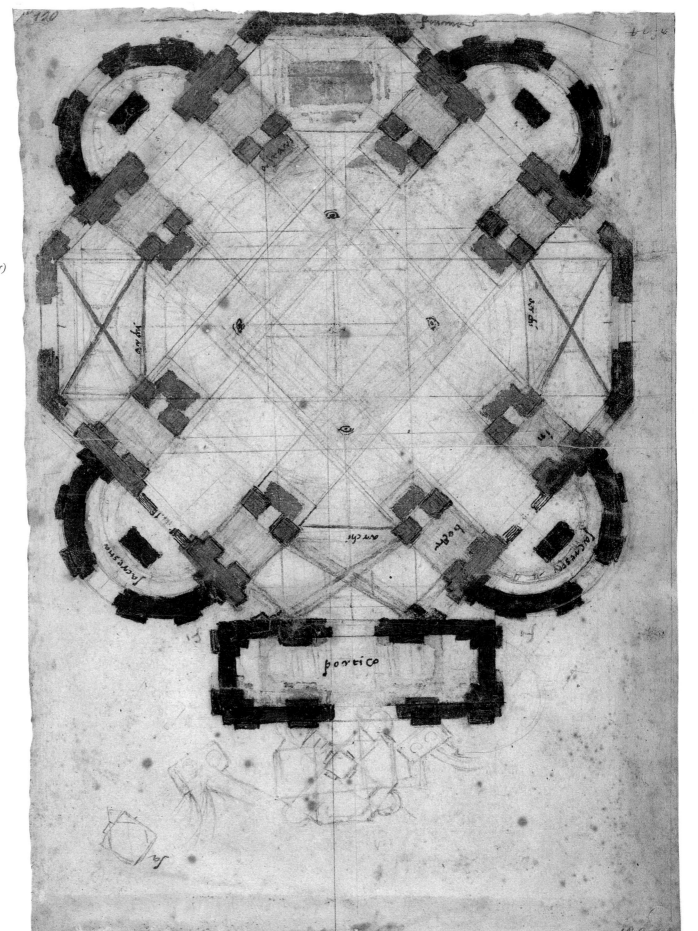

405. *(opposite) Michelangelo. Plan for San Giovanni dei Fiorentini, Rome. Casa Buonarroti, Florence, A 121 (C. 609r)*

406. *Michelangelo. Plan for San Giovanni dei Fiorentini, Rome. Casa Buonarroti, Florence, A 120r (C. 610r)*

stood out—the heavy, compacted mass of the walls between the chapel-rotundas and the extraordinary importance of the entrance vestibules, whose apsidal spaces connected with the spaces of the barrel vaults and with the central space, so that, ideally, the priests of the cult could be seen from every part of the church by the faithful.

Then he took another, final step which is documented in two drawings, one a polished plan attributed by Ackerman to Calcagni (fig. 475) and the other a partial plan of a more lively and penetrating kind by Biringucci (fig. 473). In the latter appears, more nervously thus more faithfully indicated, the projection of the rectangular vestibules beyond the gentled curves of the chapels. The perimeter, in the first plan a perfect circle, was now a collection of disjunctive bodies connected only by their repetitions as if by metric necessity. The peribolos, an element of connection, had disappeared entirely, and the whole church was shaped (or modeled) by the density of the wall and the luminosity of the interior space. A new fact emerged here, which was the indication of a late but nevertheless sophisticated interest in the pure primary forms of the architectural lexicon. The memory of the piers of the preceding peribolos remained in that agitated wall mass as columns, near each other but not paired, at the ends of the short interior wall sections—two pure cylindrical forms created to exalt the light and separated by a narrow niche. Why were these simple, unadorned architectonic shapes, illuminated differently and charged in a strict tension with the wall masses, placed between the light-filled globe of the central space and the tormented voids of the vestibules and chapels? And why was that sharpening of the customary refinement proper in a Florentine church in Rome? Perhaps the aged master felt himself still to be the bearer of a refined Florentine intellectuality in the officialdom of the papal court.

The Sforza Chapel in the Church of Santa Maria Maggiore in Rome (No. 29) was meant to hold the tombs of the Sforza cardinals, Ascanio and Alessandro. Michelangelo "commissioned Tiberio Calcagni, under his supervision" to complete the chapel, wrote Vasari, but it remained "unfinished at the death of that cardinal, and of Michelangelo and of Tiberio Calcagni." Because the ultimate execution was scarcely accurate and at best approximate, the extant chapel is essentially the copy of a lost original which preserved in translation the elements, but only the elements, of a shining invention (fig. 408). Its simplicity—a deep, square presbytery and two curved side chapels—was just as and perhaps more paradoxical than the final version of the Tomb of Julius II. For example, what was the purpose of that large trapezoidal window (fig. 409) used in the apsidal "domes" of the side chapels? It contradicted the continuity of the wall curvature, it neither illuminated nor decorated, and it was clearly incongruous and discordant—but this was the signature of Michelangelo. Who else could have "fished up" that strange window, narrowed towards the top, invented originally for the New Sacristy (cf. fig. 9)? It is not enough to say that it was the recollection of an old man, however. It introduced onto that curved ceiling surface an accentuated linear perspective, accelerated and at the same time contra-

dicted, and the curvature of the chapel space was irregular as well. With its slow rotation hastened and narrowed at the ends, it formed a contracted armpit from which pilasters were projected on the transverse, in an exaggerated manner and with improvised energy, indicating the diagonals of the space. This abnormal design of the pilasters in fact created the architectonic space of the chapel. On either side of the entrance were pairs of columns, one inside under the contracted armpit of the curved ceiling like a "hinge," and the other outside, isolated on the transverse axis of the space. Nearly hidden in the contracted corners, the interior columns were not only revolving forms but they also provided the "spring" for the transverse bodies of the pilasters. Freestanding and fully exposed to the light, the exterior columns—pure, sculptural, cylindrical forms—reached towards the central void. Behind them were the pilasters like tensed muscles and the slow, relaxed recession of the chapel interior. The value of these unadorned, regular forms was essentially that of liberating the accumulated tension. Just as certain words were valued in Michelangelo's poetry simply for the quality of their sound, the four projecting columns were valued for the white purity of their cylindrical forms. In this last phase of the master's career emerged his genuine but long-repressed search for an "abstract beauty"—a Parnassian elegance manifested in concentrated power. It was the last sign, or the return, of his Florentineness.

Michelangelo's nostalgia for Florence had its importance, and probably he did not want to ruin that melancholy sweetness by returning to the city, which both Cosimo I de' Medici and Vasari urged him to do. In saying that he was unable to leave the work of Saint Peter's, with which he was increasingly less occupied, Michelangelo was torn between desire and reluctance. But, along with the reluctance came a quickening of his spirit, the sign of an indelible Florentineness. With pleasure, he accepted the task of redesigning the steps in the vestibule of the Laurentian Library, which Cosimo wanted finished. He lied, saying that he had lost the original, toiled-over plans of the past, when in fact he had used them to design the grand staircase for the Senator's Palace on the Campidoglio. His long letter to Vasari of September 1555 was full of irony, as well as of his own dreams of the time. The designs were lost, but they were recalled as "something clumsy." Clumsy? That solemn ascent from the dramatic plane of life to the clear serenity of scholarly study? But the humanistic ideology was finished now, and scholarly research was conceded only by the liberality of a prince. For the new "ovate" staircase, he even made a clay model—a plastic object like a work of sculpture. The ramp at the middle resembled a long wave held in by two heavy balustrades; the freedom of the culture had some limits. At the sides were subordinate ramps, "two wings, one here and one there, which would follow the steps there, but not ovate." At this point, the irony bordered on sarcasm—His Lordship would ascend by the center ramp, and his following by the "wings," which did not reach the summit. The painter to the court of Lorenzo the Magnificent had been Botticelli, but the painter to Cosimo I was Bronzino.

Even more so than Vasari, Bartolomeo Ammanati became the Tuscan interpreter of Michelangelo's Florentinism. It fell to Ammanati to execute the vestibule staircase, and he wanted it more expensive—of dark marble. In the same way, he redesigned with Florentine elegance Michelangelo's invention for the bridge of Santa Trinità (No. 17), and he made out of it an exquisite design befitting the refined artist of a refined court. But wasn't that bridge with piers in the form of a prow still coherent with the bastions designed thirty years earlier for the Republic of Florence?

Vasari, the very good friend and confidant of Michelangelo, borrowed from the Campidoglio the idea of the two palace façades confronting each other, when he designed the Uffizi complex in Florence. He also recalled the solution of the little windows laid down below the large ones of the main (second) level, and he brought both together, though alternating the pediments between triangular and curved. It was a noble attempt to translate the wholly conceptual architecture of Michelangelo into a building for ordinary public use.

Of an unquestionable and paradoxically aberrant logic was the Michelangeloism of Buontalenti, the court architect à tout faire of Grand Duke Cosimo I. All of the licenses were permitted to him, including that of eccentric beauty. His loquacious brilliance was given an alibi in Michelangelo, but, to de-problematize the master, Buontalenti upset his propositions in an almost methodical manner. In the Medici Casino, to give only one example, he copied freely the window by Michelangelo in the Medici Palace, but then at the base of it, between the brackets, he placed a huge shell, a sufficiently frequent Michelangelesque motif yet in that location no longer irregular and unprejudiced but arbitrary. Essentially confirming the prophecy of Vasari, what Buontalenti particularly admired in Michelangelo's architecture were the decorations, which were not subordinate to any rule. Rather than making them dependent to a reasoned structure, he associated them freely with the surroundings, generating a kind of garden of fantasy—as if art, no longer obliged to imitate nature, was constrained to imitating it.

"No one has the whole garment before the very end of art and life," wrote Michelangelo, and he lived his separation from the world hour by hour up to the end of his earthly life. The Rondanini Pietà, on which he was working when he died, was his diary, confession, renunciation, and martyrdom all at once, as he waited for death and yearned for resurrection. He was religious, and yet he felt that, even with death near, he was not exempted from the task of the artist. He really wanted to take his leave without making a drama out of it. The last pontiff for whom he worked, Pius IV, was another Medici, who, as soon as he was elected in 1559, understood that Rome ought to be enlarged and re-signified. Although the problem of direction for the overall program was not confronted until 1585, when Sixtus V commissioned Domenico Fontana as the supervisor, Pius IV gave the city another long, wide, elegant axis road, the Via Pia, known today as the Via XX Settembre. This straightaway went from the site of the once famous villa of Cardinal Ippolito d'Este (where the palace of the Quirinal was subsequently built) up to the Aurelian Wall, where the city ended among vineyards and villas. Pius gave the commission for the new city gate to Michelangelo in 1561 (No. 30), and he also decided that same year on the recuperation, more symbolic than architectural, of the nearby Church of Santa Maria degli Angeli (No. 31). In his mind the two events were related.

The city gate was a contemporary architectonic theme. New warfare strategies had moved the combat away from the city walls, thus allowing the gates to become ornamental. In 1551, Serlio had written his "extraordinary" book on the morphology, typology, and symbology of city gates, which was for architecture what Ripa's Iconologia was for painting—a repertory of the hidden meanings of the visible forms. And Michelangelo certainly would have been familiar with it. The singularity of the Porta Pia was in having its major orientation towards the inside and the city, but it was the city of the Church, whose heraldic arms were not emblems but instruments of devotion. Rome was more pious than holy.

Ackerman justifiably observed that the Porta Pia was like the backdrop for a theatrical scene, and he cited appropriate examples illustrated by Serlio in the first volume of his Trattato (1545) as proof. Thus, Michelangelo anticipated the idea of the city-as-theater, which Bernini took up as a major enterprise in the seventeenth century. Vasari described Michelangelo's three designs for the Porta Pia as "extravagant and very beautiful," made as an image "of celebration and gaiety." Along with the lappets and patens were obelisks, battlements to hold Medici banners or maybe cannons, cartouches without inscriptions, windows in image only (blind), and, naturally, an ostentatious portal (figs. 485, 415). Every extravagance was permissible in that location, but with regard to what? The polemical target was the reigning concept of the antique, which was less humanist and more conformist. For Michelangelo, making something extravagant meant to deconstruct and defunctionalize the terms of the architectonic lexicon, and here concepts had been reduced to emblematic, heraldic images, thus creating more of a system of signs than a symbology. Lappets and patens said only that the priests ruled, and the showy cartouches without epigraphs were emblems of the reigning preceptism. Extolling an interior that wasn't there, the windows of the Porta Pia recalled his first functionally deconstructed window in the Medici Palace, just as the trapezoidal window in the new Sacristy had been evoked in the Sforza Chapel.

Having liberated his long-smoldering anticlassicism, Michelangelo accumulated contradictions on this gate, harnessed and plumed like a court dignitary. He embedded two gates one inside the other, and then suggested a third glued flat to the wall. He made a sharp distinction between the ceremonial gate and the actual inner one, rustic and nearly overwhelmed by the large, projecting, triangular pediment which covered it. According to the logic of modern architecture, the Porta Pia was a monster—and Michelangelo was the uncorrupted father of the ornamental monster of Mannerist poetics (for example, Palazzo Zuccari and Bomarzo). The fluted pilasters were powerful, but they were stopped before they received any weight

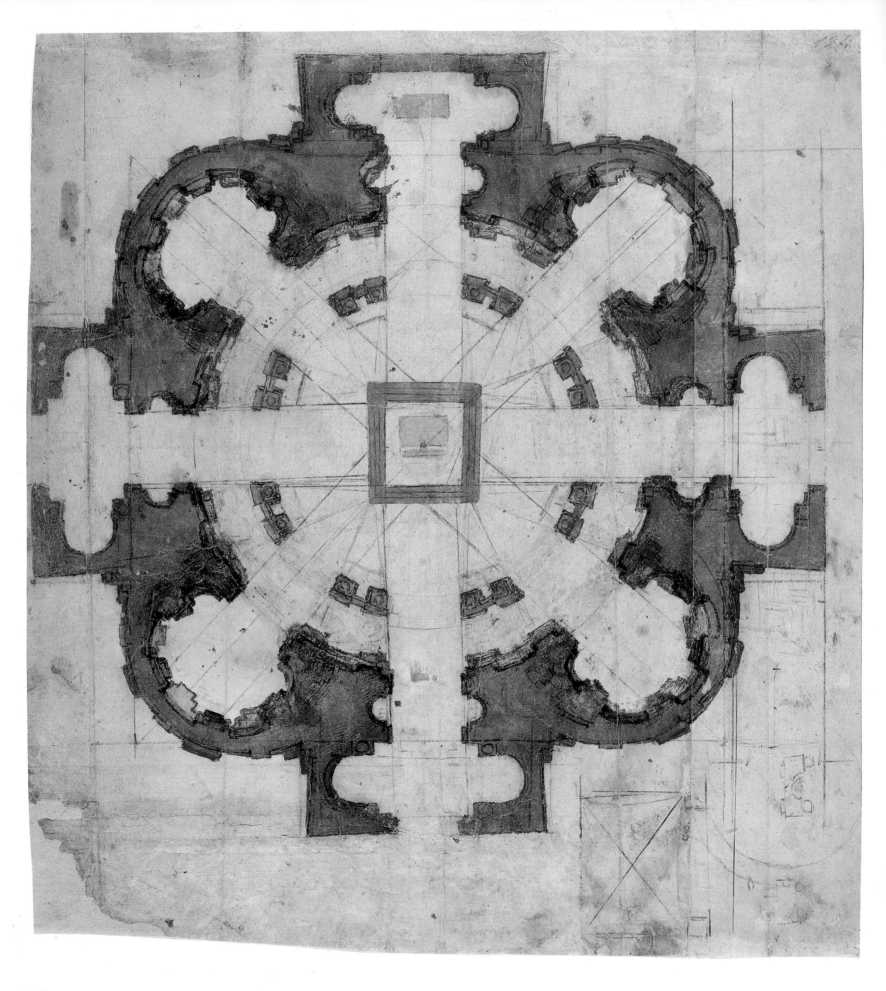

407. *Michelangelo. Plan for San Giovanni dei Fiorentini, Rome. Casa Buonarroti, Florence, A 124r (C. 612r)*

408. *Plan of Sforza Chapel, Santa Maria Maggiore, Rome. From Portoghesi-Zevi 1964*

whatsoever, even implied, and the large corbel supported jokingly a line of presumptuous, impotent dentils. Over it all stood, like a plumed helmet, the curved and broken pediment, the ends of which formed two large scrolls like tightly wound springs without movement, holding up a festoon and an unadorned, inscribed tablet. At the summit, finally, was a magnificent crowning (which would soon fall) just to carry the heraldic symbols. Certainly, that brilliant display of a worldliness which made a joke out of the nonsacred was surprising, but the Manneristic mind, having bound art to existence, coupled without prejudice the categories of sacred and profane — just as Titian did in those same years and Shakespeare would do later.

Decio Gioseffi correctly described the Porta Pia as more painterly than architectonic. The carpet of bricks gave a natural warmth to the wall surface against which the gray stone elements stood out with a cool light. These were drawn, cut, and incised with force, and the play of the lights and darks moved from the coarse ashlar with its horizontal furrows to the intense alternation of light and shadow in the vertical fluting of the pilasters, and on to the lively beat of the dentils, which contrasted with the diffuse illumination on the lofty pediment and the dark depths of its tympana. This chiaroscuro not only created relief elements on that street backdrop but produced intense color as well. Here in the real architecture of the Porta Pia, Michelangelo seemed to have found again in old age the nonnatural coloration of the painted architecture on the Sistine Ceiling.

As always, each of Michelangelo's ideas had an opposite. Where the Porta Pia was a lighthearted song, or madrigal, the Church of Santa Maria degli Angeli (No. 31) was a deep meditation without words. He had deliberately renounced painting and sculpture, and therefore representation, and made only architecture. Then, with death near, he renounced architecture as well, reducing it to a gesture. And his work ended with a final enigma — but what else was art? The Baths of Diocletian constituted the major surviving complex of antique architecture in Rome, and naturally there had been no lack of studies for its restoration and reuse, including those of Antonio da Sangallo the Elder and Baldassare Peruzzi. With the new thoroughfare of the Via Pia, the complex had been made a part of the city and its future developments (see fig. 501). A Sicilian priest and self-styled visionary, Father Lo Duca, had been determined to make a church out of the *tepidarium* of the Baths, but after installing several altars there, he could do nothing more. Then in 1561, Pius IV finally paid attention to him, took the matter to heart, and decided to construct the church, which would be attached to a Carthusian monastery. This was an important decision, because the increasing post-Tridentine rigorism had reopened and even intensified the debate about the compatibility of pagan culture with that of modern Christianity. The problem was particularly serious in Rome, for whose structural reform it was necessary to set forth a clear definition of the value and the significance of its remains from antiquity. But with the decision of Pius IV, the Church declared its own thesis — the survival of the remains of the Roman monuments had been willed by Providence.

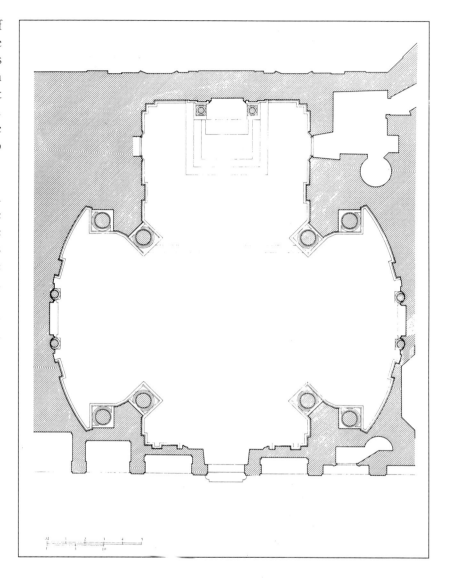

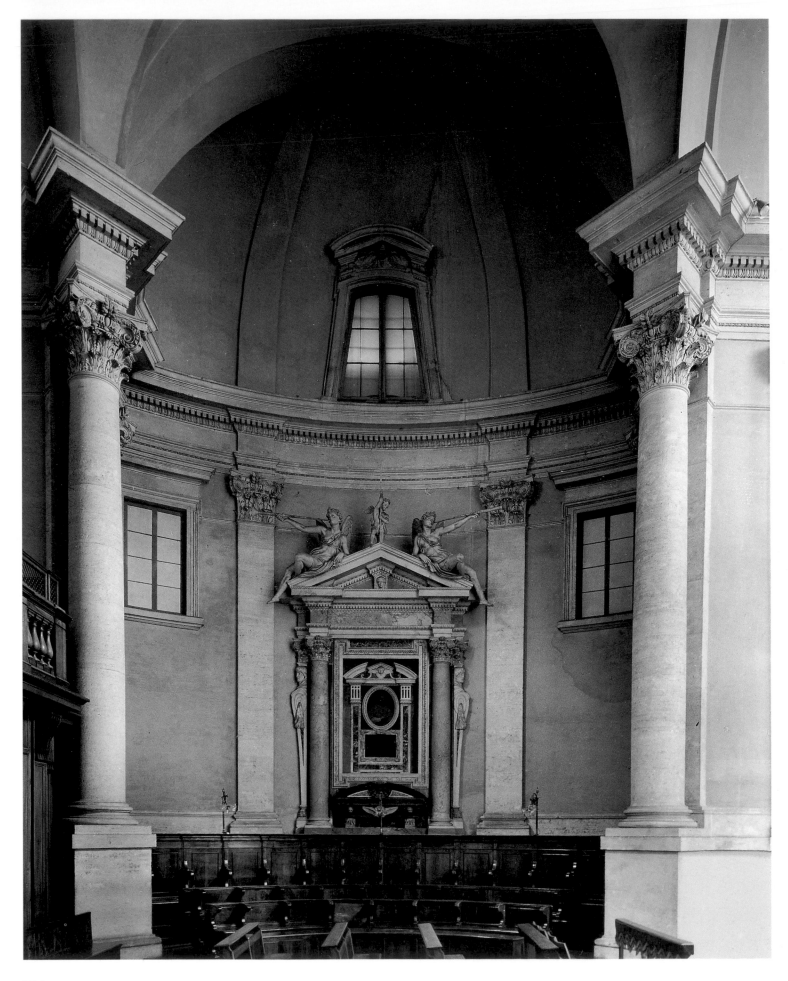

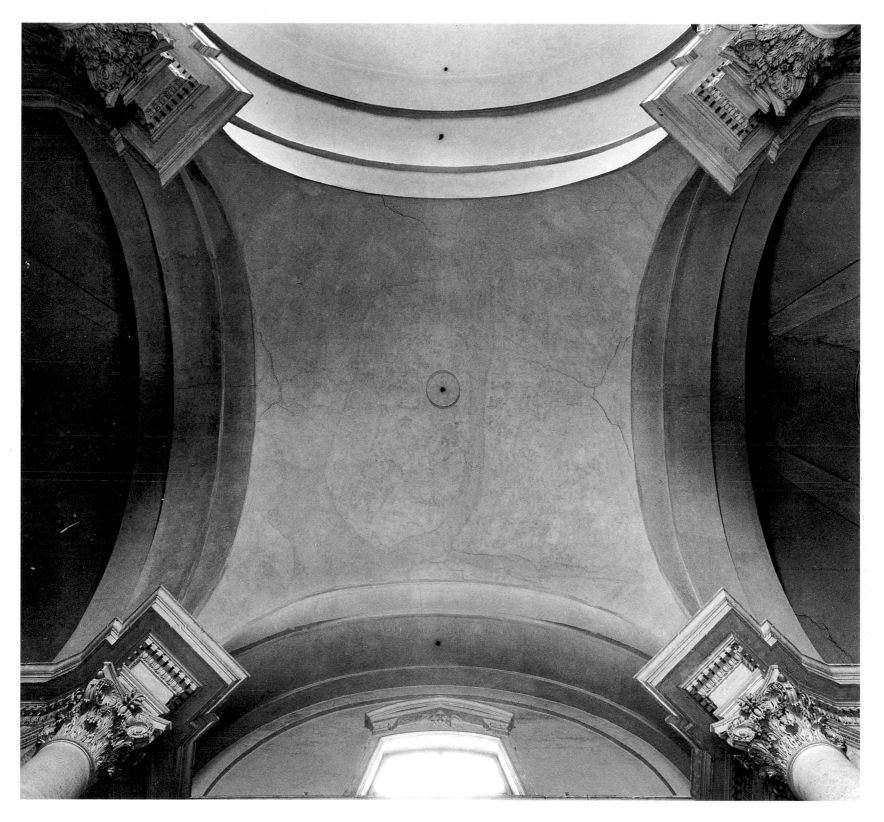

409. *Sforza Chapel, view into side chapel showing relationship of columns and curved wall. Santa Maria Maggiore, Rome*

410. *Sforza Chapel, central ceiling vault. Santa Maria Maggiore, Rome*

411. *Sforza Chapel, view of altar wall.*
Santa Maria Maggiore, Rome

412. *Sforza Chapel, view of entrance with*
angled pilasters and projecting columns.
Santa Maria Maggiore, Rome

413. *(opposite) Sforza Chapel, detail*
of column projecting into main space of
chapel. Santa Maria Maggiore, Rome

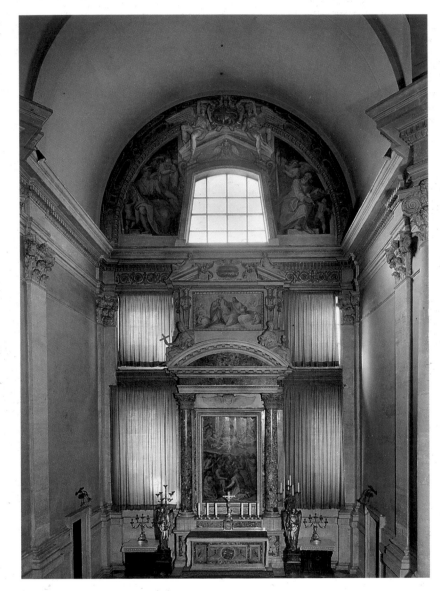

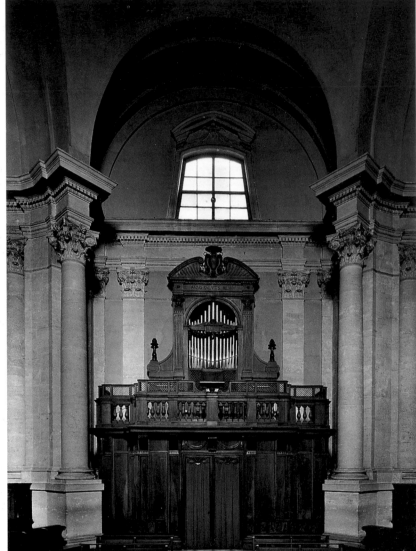

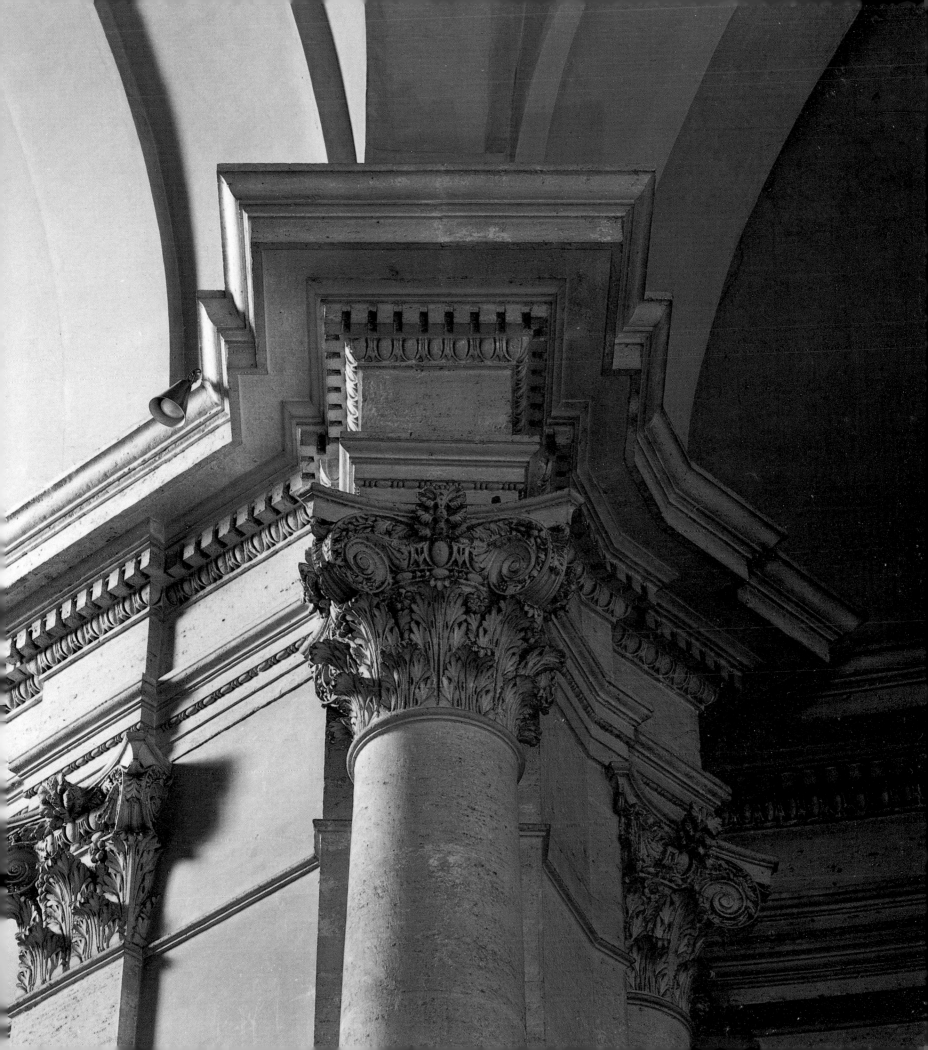

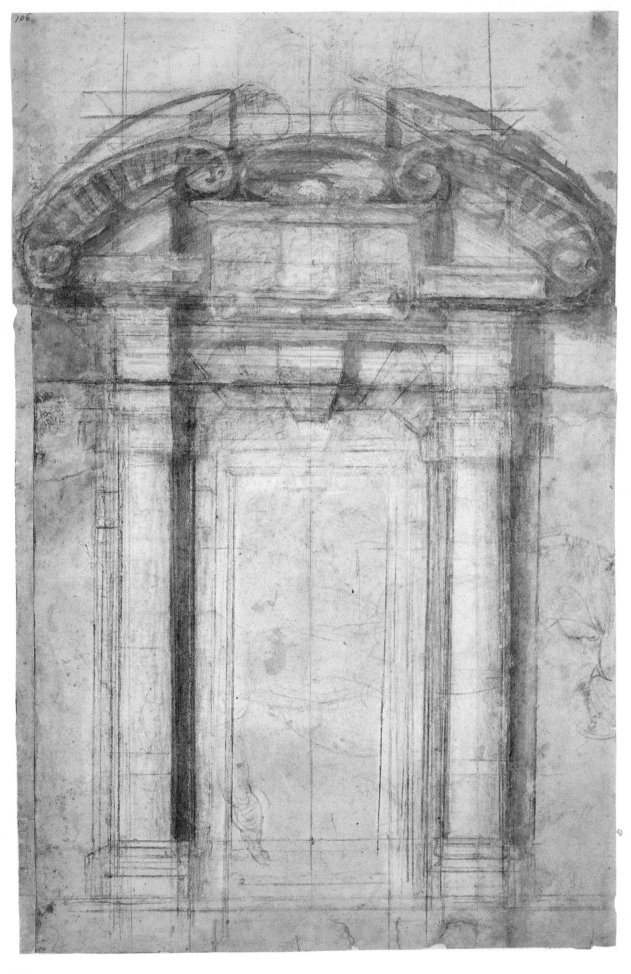

414. *Michelangelo. Study for portal. Casa Buonarroti, Florence, A 106r (C. 619r)*

Whether or not he had contributed to it, Michelangelo could only have made that thesis his own. He did not just protect those things he admired as an artist, he also stated his aversion to the programs of *renovatio*, to the classicistic interpretation of the antique, and to the reduction of the antique to precepts for modern construction. The antique was what it was, and it could not be changed. It was useless to try to reactivate and adapt it. That is why, when Paul III decided to move the *Marcus Aurelius* to the Campidoglio, Michelangelo opposed it.

Vasari was very circumspect in recording the matter of Santa Maria degli Angeli. According to him, the pope, priests, and lords were astonished by "the most beautiful considerations done with judgment, using the whole framework of these baths." In reality, Michelangelo did almost nothing there. He limited himself to marking off the space with some dividing walls and creating a deep presbytery (fig. 418). In contradiction with Father Lo Duca, who wanted to preserve the established longitudinal axis as the nave of the church, Michelangelo designed the minor axis from the vestibule-rotunda to the altar as the principal focus. That was all. Zevi saw rightly that, in this church, Michelangelo's refusal to "construct" was the supreme text of the not-finished and the highest point of his transcendentalism. Art was no longer the making of an object but the contemplation of an idea. The inscription behind the altar explains everything: "*Quod fuit idolum nunc est templum Virginis* (That which was a pagan temple is now the temple of the Virgin)." A miracle had been wrought—not a natural rebirth but a spiritual resurrection. Michelangelo himself was nothing more than the instrument of Divine Providence. It was his last gesture and claim; it is not for me to judge whether it was a gesture of extreme humility or of unbounded pride.

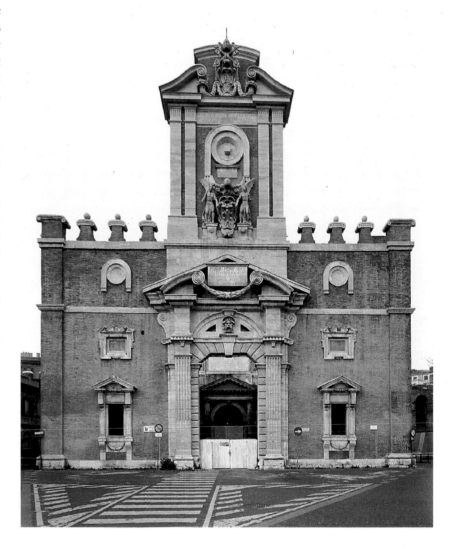

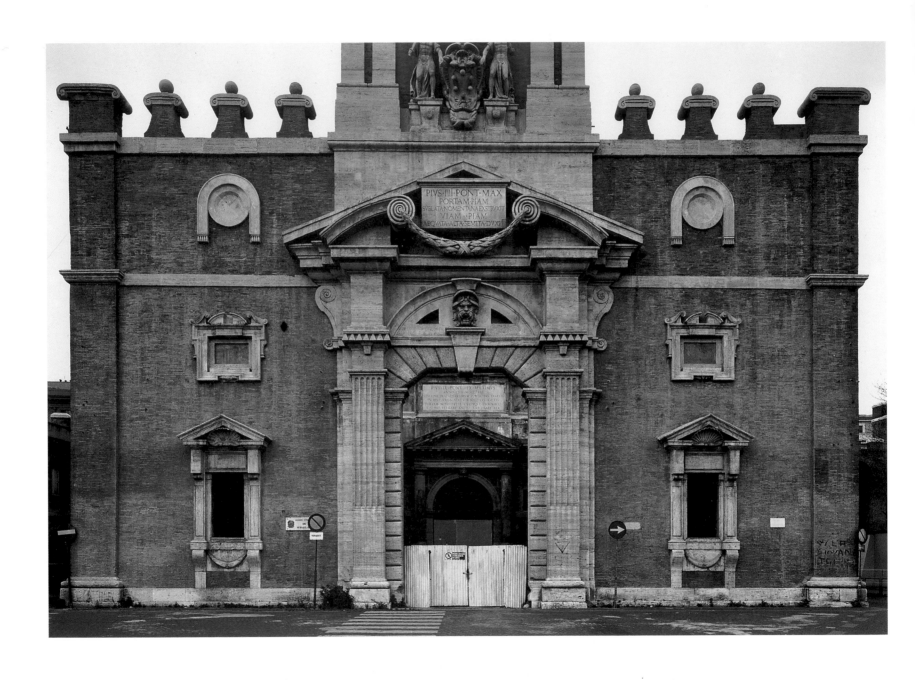

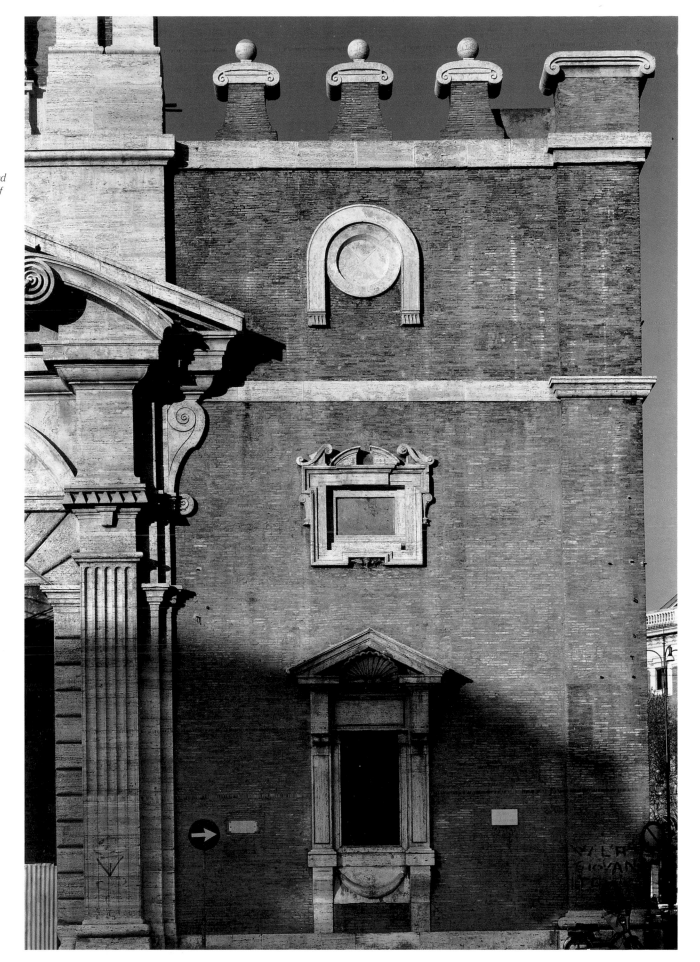

417. *Porta Pia, Rome, detail of blind windows, paten decoration, and roof battlements*

418. *Plan of Santa Maria degli Angeli, Rome, with indications in black of additions made by Michelangelo to original structure of Baths of Diocletian. From Siebenhüner 1955*

419. *Santa Maria degli Angeli, Rome, great hall of Baths of Diocletian*

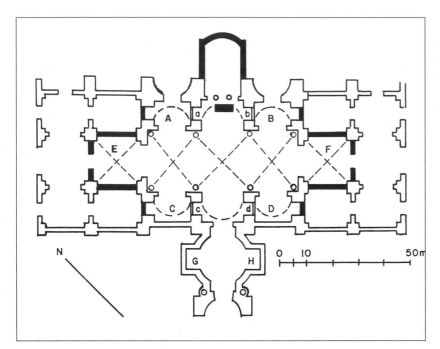

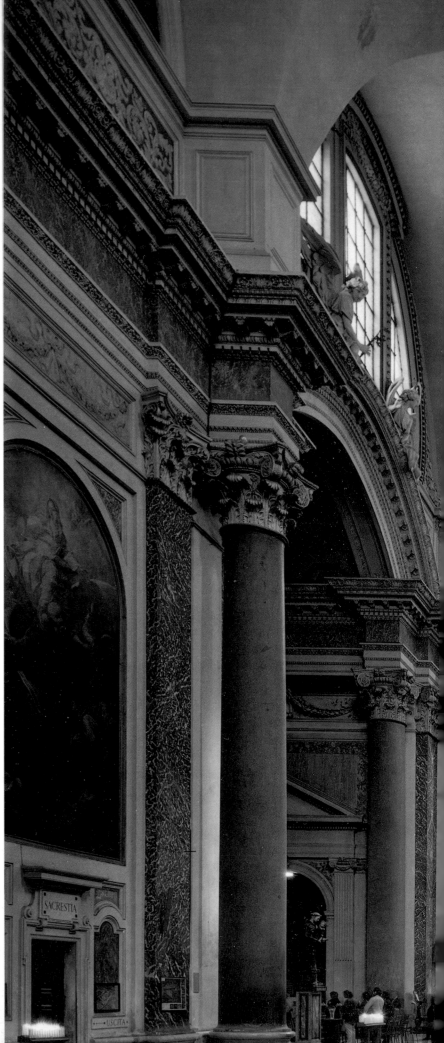

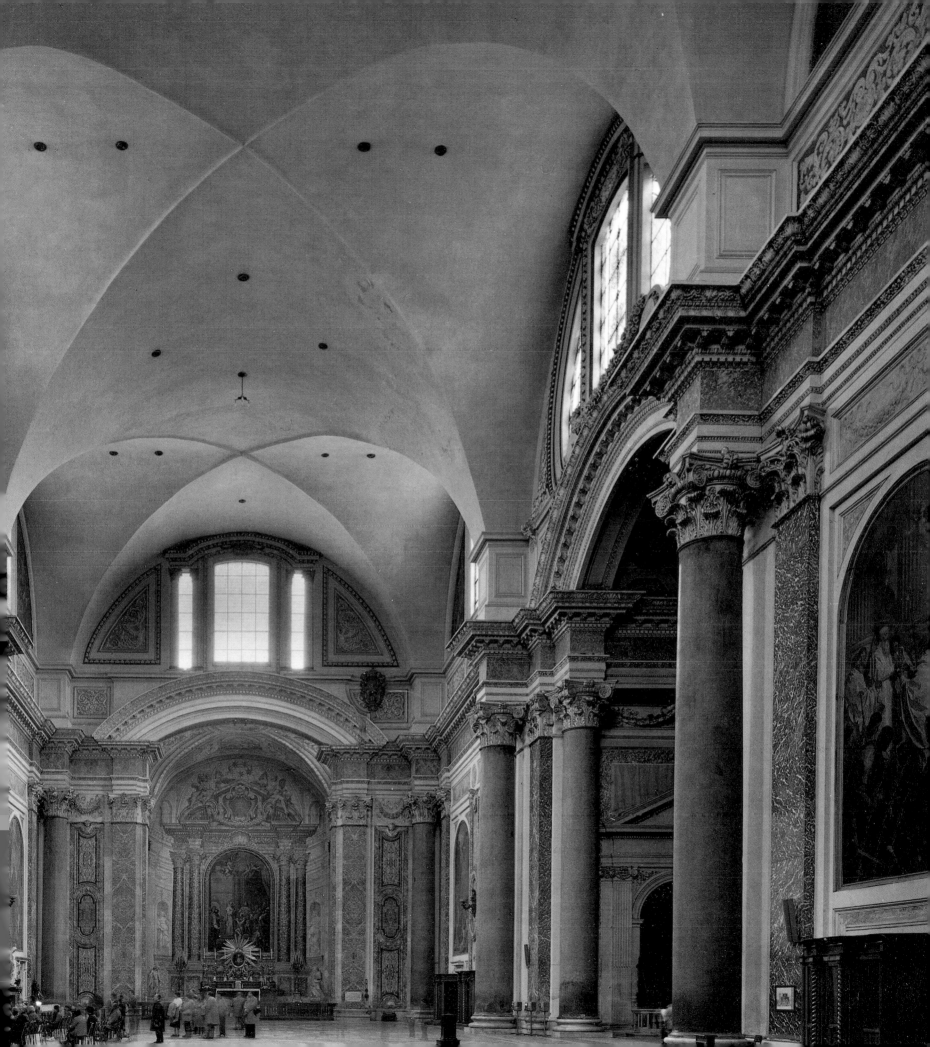

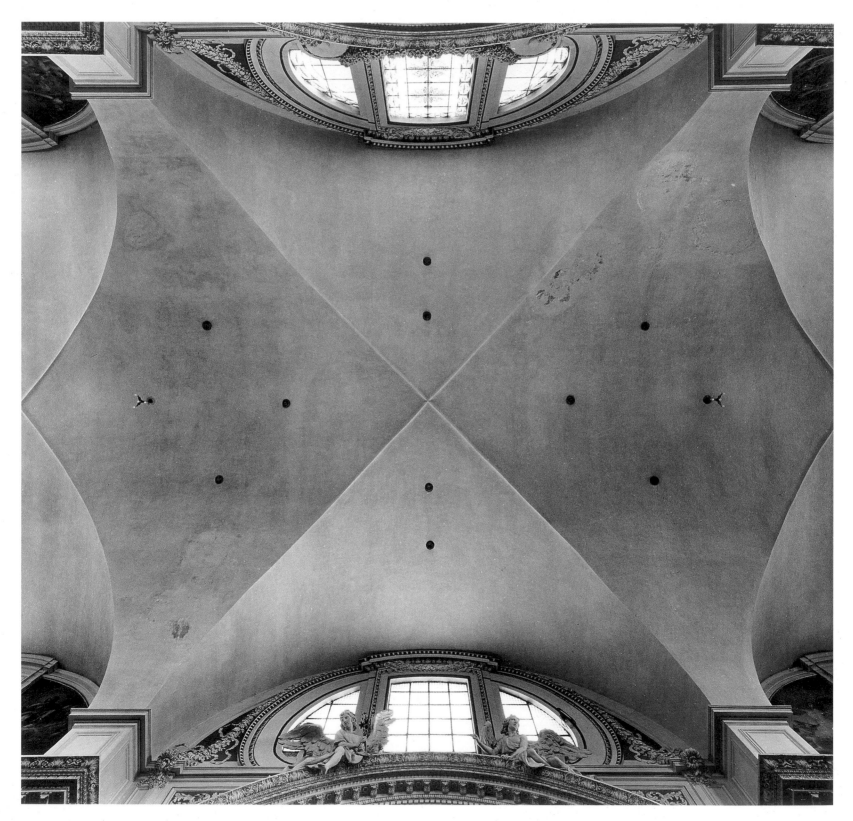

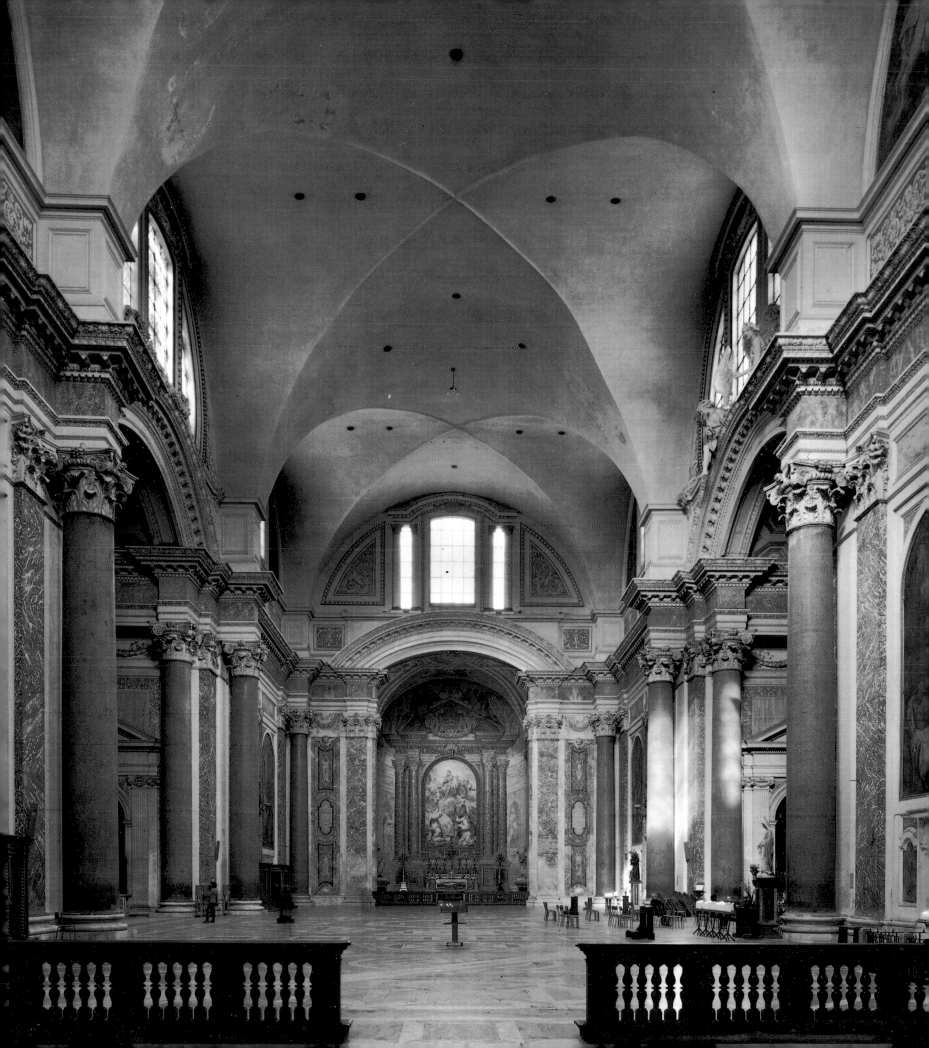

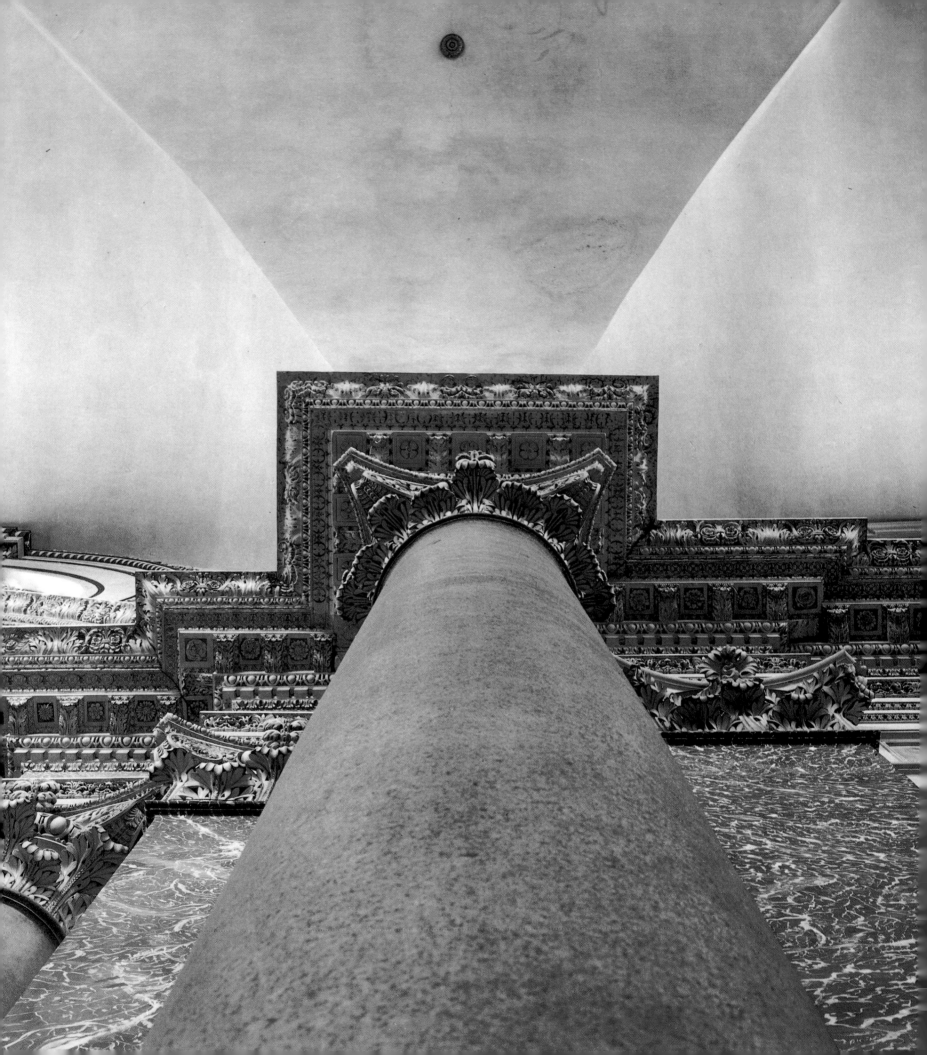

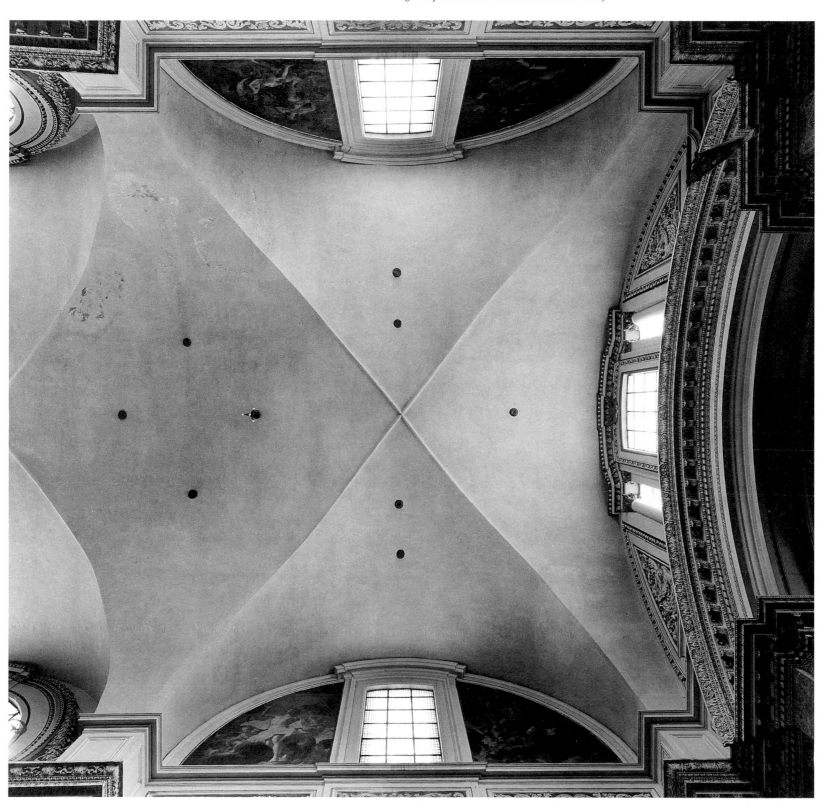

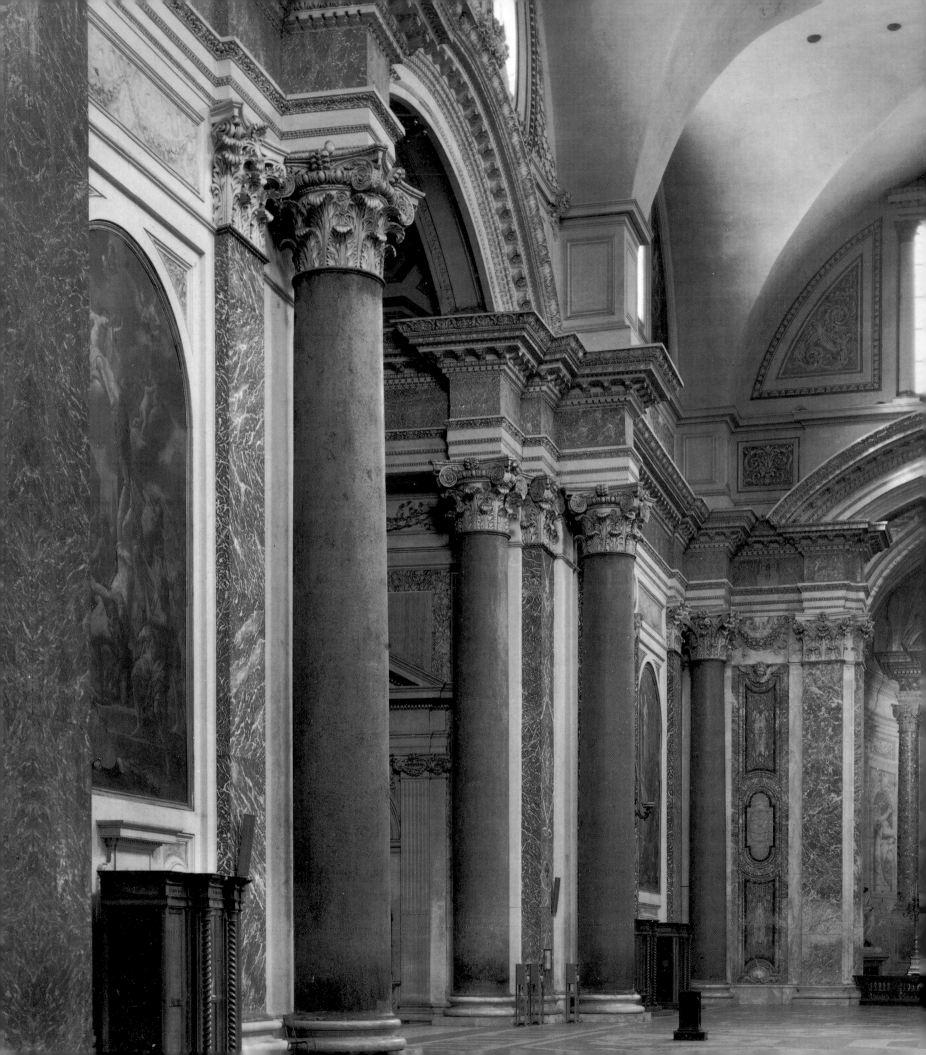

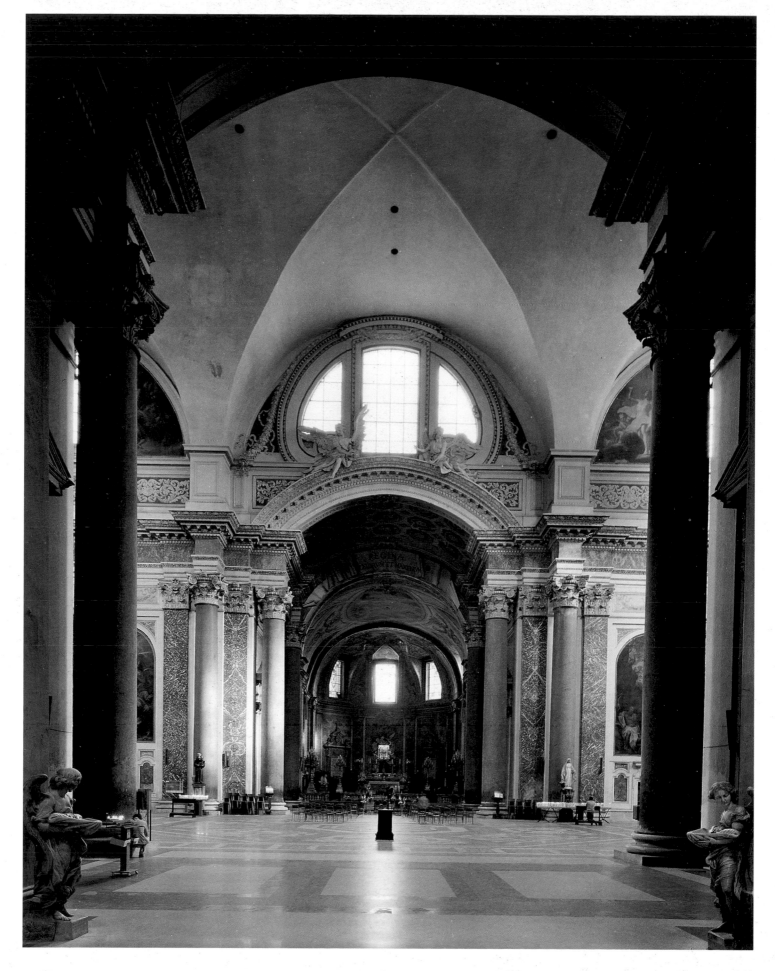

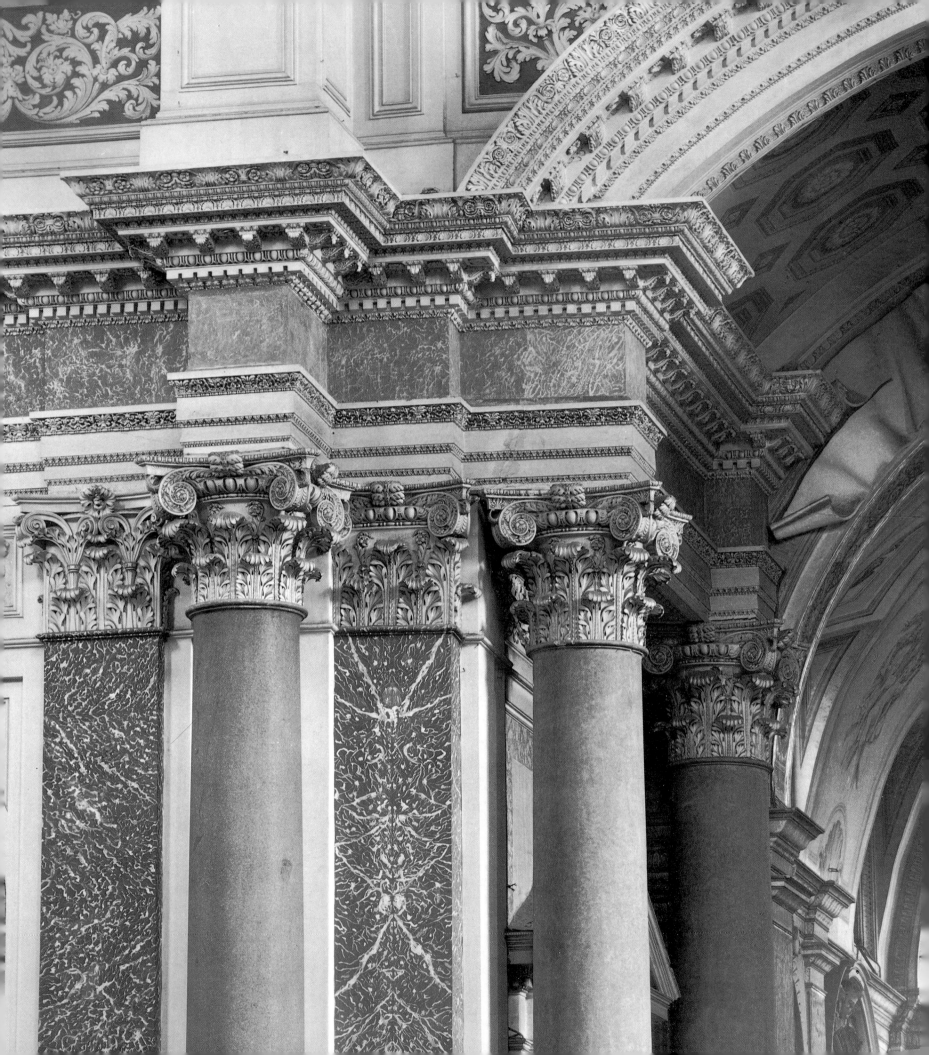

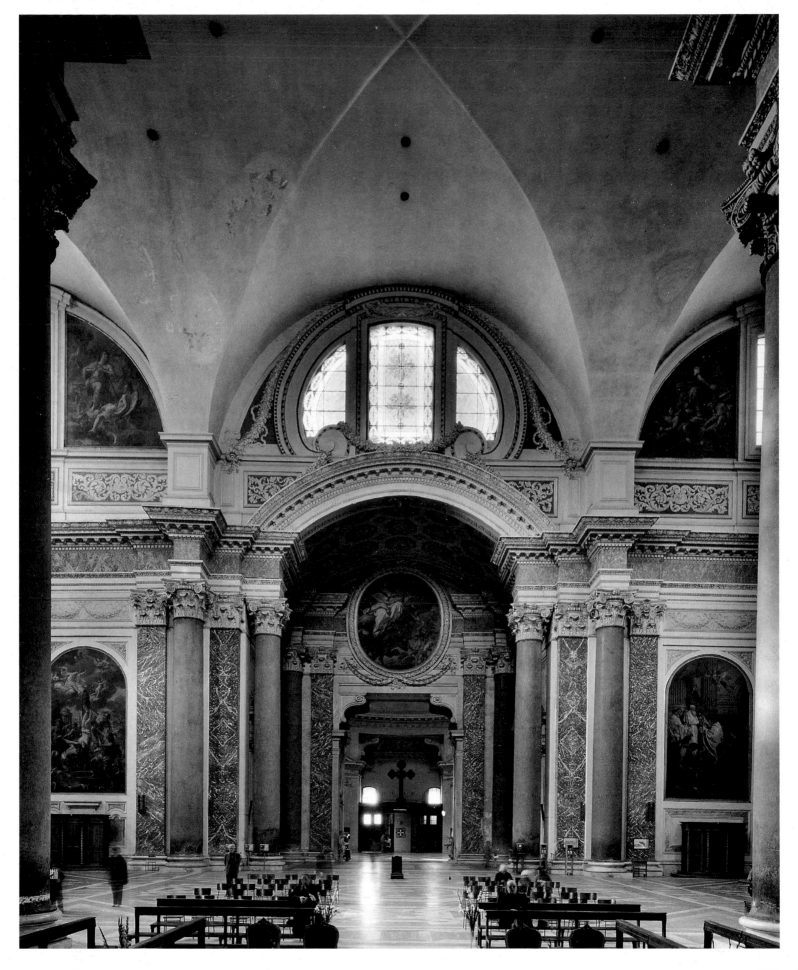

It is outside our topic and would occupy half of the space at our disposal to give an account of the complex history of the reconstruction of the Vatican church. Begun by Nicholas V in the mid-fifteenth century with the construction of a new choir by Rossellino for the Old Saint Peter's, the project was resumed by Julius II in 1506 under the direction of Bramante (for the Bramante plans and the first years of construction on the new Saint Peter's, see Metternich 1975, Frommel 1976, and Metternich-Thoenes 1987).

At Bramante's death in 1514, Leo X named as architects for the new Saint Peter's the aged Fra Giocondo (Giovanni Monsignori) and the young Raphael Sanzio, assisted by Giuliano da Sangallo in the role of second architect. The following year, Raphael assumed sole responsibility due to the death of Fra Giocondo and the return of Giuliano to Florence (for Raphael's plans and the 1514–20 phase, see Frommel 1984). At Raphael's death in 1520, Antonio da Sangallo the Younger, who had been second architect since 1516 and present in the workshop almost from its beginning, succeeded him, and Baldassare Peruzzi was named as the assistant. First during the pontificate of Hadrian VI and then following the Sack of Rome, the work underwent considerable slackening which lasted until the election in 1534 of Pope Paul III, who actively sought to reorganize the workshop. (For the status of the construction in 1535, the drawings of Maerten van Heemskerck are very important; see Carpiceci 1987.) In 1539, by threatening to suspend the monthly wages, the pontiff was successful in getting Sangallo to initiate work on a large wood model for the new church on a scale of 1:29 (Silvan in Fagiolo 1986). The model was executed by Antonio Labacco and served as a precise guide in the subsequent activities of the workshop (Benedetti 1986; and Zander 1986, with a note by Gabrielli).

The model cost an enormous sum of money—4,184 ducats according to the scandalized Vasari, but probably closer to 5,500 to 6,000 in the computation from existing records done by Frey (1913). Within the year, Sangallo promptly resumed work on the church according to his new plan. At his death in 1546, the deputies overseeing the construction attempted to call in Giulio Romano from Mantua, but he himself died barely a month later on November 1. In mid-November, Paul III decided to appoint Michelangelo as the architect for the building project, and, on January 1, 1547, the commission was ratified in spite of the reluctance of the artist, who later remembered having been "against my wish by very great force put to work on the building of Saint Peter's by Pope Paul" (MCCLVII).

Michelangelo's reluctance was well justified. Already past seventy, he entered a workshop which had been dominated up to that point by Antonio da Sangallo and his fiduciaries, if not directly by members of his own family. The "Sangallo Sect," as Vasari dubbed them, had, in the twenty-five years of controlling the building project, tied up many of the financial interests related to it. Sangallo's "continuers," and their allies among the deputies for the construction, counted on the precisely defined model for the church, only recently completed and costing a great deal of money, which seemed to constitute a sure investment on the basis of which they would carry on the work. But the problem was not just an artistic one, it was also religious in nature. The Protestants had made accusations of corruption involving the construction and the deportment of the church project, which was absorbing funds from the whole of Christianity. The Protestants were not alone in shooting arrows of criticism. Rumors of larceny and simony, probably well-founded, disturbed the consciences of many Catholics, among them Michelangelo himself (De Maio 1978).

Letters, published by Ciulich (1977–78) and commented on by Saalman (1978), from correspondents in Rome to Monsignor Filippo Archinto, one of the most influential deputies of the construction, who was in Trent for the Council at the time, permit us to follow the first moves by Michelangelo, which were totally unconventional. After having "put some young men to work designing the model," he interrupted the work in course on November 30, and, calling to him Nanni di Baccio Bigio and Labacco, two eminent members of the Sangallo Sect with important duties in the workshop, "he said to the two of them together who happened to be sent that he no longer wanted them in Saint Peter's, because he wanted to place his own men" (in another, canceled, version: "Then he did not omit to say that he did not want those . . . who had been man and official and minister at the time of Sangallo"). The letter continued that, on the next day, December 1, after the deputies had "the fraternity summon said Michelangelo as it had been the custom with Sangallo, . . . master Michelangelo made himself understood that he did not want to come to our fraternity and that he did not have and did not want to have anything to do with us over the building of Saint Peter's, but only with the Pope."

Michelangelo had launched a precise, three-pronged attack. The first move was the disavowal of the model by Sangallo. In one of his visits in the presence of the whole Sangallo Sect, according to Vasari, Michelangelo expressed his opinion that the church prefigured in the model was "gloomy, and . . . on the outside too many orders of columns one on top of the other, and with so many projections, spires, and bits of pieces, it looked more like a German work, than a good antique style, or a charming and beautiful modern manner." Next, the artist set about replacing the company of collaborators with men in whom he had confidence, and, finally, he arranged to report directly to Paul III, thereby going over the heads of the untrustworthy fraternity of construction deputies who were suspected of being corrupt. Having rejected any compensation for his work, the only other condition Michelangelo had imposed on his acceptance of the commission as architect for Saint Peter's was that he have a free hand in the direction of the workshop. Within the first few days, he appointed as second architect Juan Bautista de Toledo, who was also involved in the role of fiduciary in the administration of the construction, although this move was not successful in eliminating the power of the deputies (for the role of Juan Bautista, see Vicuna 1966, and Giner Guerri 1975). He also replaced Labacco with Vincenzo Luchino and sidelined Nanni di Baccio Bigio, whom he was unable to remove completely. While Jacopo Meleghino technically assumed the position of Sangallo as first architect, Michelangelo was in every respect solely responsible for the entire construction project.

On January 25, 1547, Michelangelo's first direct encounter with the deputies took place, the events of which allow for a better understanding of the nature of the contention. According to a letter to Archinto (Ciulich 1977–78), Michelangelo intervened at the order of Paul III in a meeting of the construction group in a very undiplomatic way almost seeking to provoke, declaring: "Our Lordship sent me to tell you . . . that I could come to this fraternity to make known to Your Lordships what I want. Now that His Holiness has given me the commission for the building of Saint Peter's, I say that I don't want anyone else to be involved in it except myself, and nothing is to be done other than that which master Juan Bautista will say here on my behalf. . . . And I don't want there to be so many frauds and thefts perpetrated in the construction, such as that in which the seller of travertine is also the one who makes the terms; and I don't want anything built with any lime, stone, and pozzolana except that which is satisfactory to me." With regard to the theme of corruption, and vital to the understanding of it, is a much later letter of July 1, 1557, in which Michelangelo justified not being able to return to Florence for the reason of "not giving the opportunity for the thieves to come back to rob, as they still raise concern" (MCCLX). Michelangelo's victory was complete on March 11. The deputies had lamented to the pope that Michelangelo, plans in hand, wanted to tear down the ambulatory already begun by Sangallo, thereby squandering "better than one hundred thousand *scudi*." (A precise estimate of 85,563 *scudi* and 80 *baiocchi* was published in Ciulich 1983, a valuable source for an accurate account of the status of the work on the hemicycle, or ambulatory, subsequently demolished by Michelangelo.) In response to these

428. *Anonymous addition to Notebook of Maerten van Heemskerck, 16th c. View of Saint Peter's in the Vatican from north. Staatliche Museen, Berlin, Print Dept., 79 D 2, f. 60r*

429. *Anonymous addition to Notebook of Maerten van Heemskerck, 16th c. View of Saint Peter's in the Vatican from southeast. Staatliche Museen, Berlin, Print Dept., 79 D 2, f. 60v*

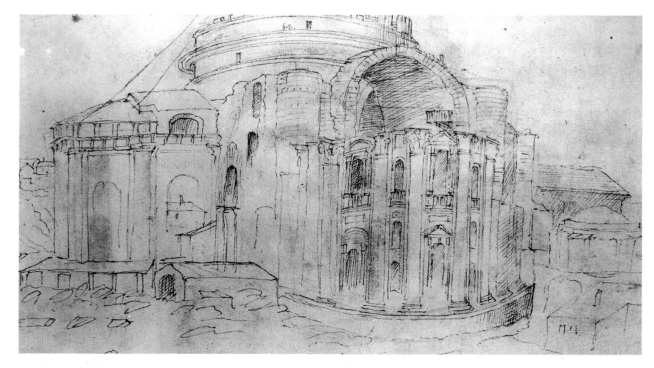

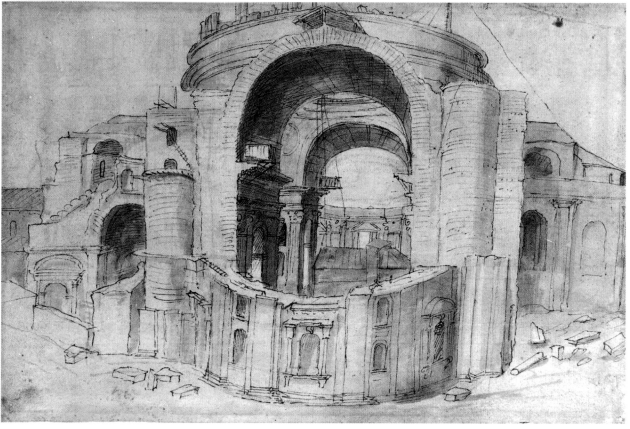

430. (above) Giorgio Vasari the Elder. Paul III Gives New Energy to the Building of Saint Peter's in the Vatican. *Salone dei Cento Giorni, Chancellor's Palace, Rome*

431. (below) Antonio Labacco. Wood model of Saint Peter's in the Vatican according to design of Antonio da Sangallo the Younger, showing interior of west arm with insert of model for domed vault of Chapel of the King of France according to Michelangelo's design. *Works of Saint Peter's in the Vatican, Rome*

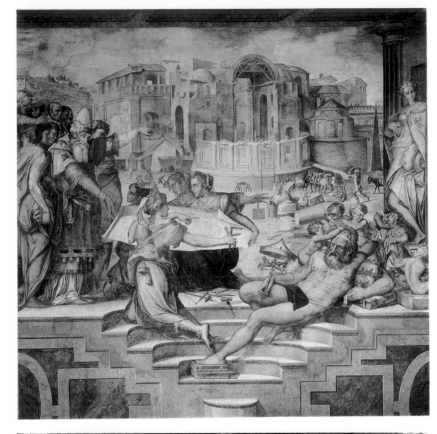

complaints, Paul told the deputies, whom he had called to Castel Sant'Angelo, "that it did not seem bad to him to squander one hundred thousand *scudi* in order to save three hundred thousand." Moreover, he said that he had put Michelangelo over them "for the chief of the architects, on whom the others had to depend, and that, in Saint Peter's, he himself would have neither more nor less done on matters concerning the architecture than what master Michelangelo had ordered."

Michelangelo's attitude with regard to Sangallo's wood model can be interpreted not only from Vasari's comments but also from a letter sent by the artist himself to a certain Bartolomeo—not Ammanati (Milanese 1875) but probably Ferratino, one of the deputies (Frey 1916)—between the end of 1546 and the first few days of 1547. In it, he wrote: "And one cannot deny that Bramante was as skillful in architecture as any other from antiquity until today. He presented the first plan of Saint Peter's, not full of confusion but clear and open, luminous and isolated at the same time, so that it did no harm with regard to the [papal] Palace; and it was considered a beautiful thing, as is still evident. So that whoever diverged from that aforesaid order by Bramante, as Sangallo has done, diverged from the truth; and this can be seen in his wood model by anyone with an objective eye. He, with that circle which he made outside, first of all took away all the light of the plan by Bramante; and not only this, but of itself, it also has no light. . . . In surrounding the composition by Bramante with the addition shown on the model, it will force the destruction of the Pauline Chapel, the rooms of the Piombo [Seal], the Rota, and many others, nor will, I think, the Sistine Chapel escape without harm. As for the part of the circle outside already made, which they say cost 100,000 *scudi*, this is not true, because it could be made for 16,000, and little would be lost in tearing it down, because the stones making the foundations would not come into the matter again, and the construction would save two hundred thousand *scudi* and three hundred years of time" (MLXXI). Michelangelo's aims at the time

he took the commission can thus be summarized as precisely as Vasari did—"more majesty and grandeur, and facility, and a greater design of orders, beauty, and convenience," effected by going back to the rhythm of Bramante's clear central plan. For this reason, the necessity was preordained for demolishing what Sangallo had already begun to build of the "circle outside"—that is, the external rings of the hemicycles, or semicircular ambulatory apses, which were to have terminated three arms of the cross on the north, south, and west, with the east reserved obviously for the façade. The amount of work already executed by Antonio da Sangallo the Younger in the last years of his activity can be determined from the accounting records of the construction and from various contemporary depictions. Particularly useful is Vasari's fresco in the Chancellor's Palace (fig. 430) painted in 1546, which shows the state of advancement of the work in the year of Sangallo's death. The east arm, which had been separated for liturgical purposes from the remains of the Constantinian basilica-plan church by a dividing wall in 1538, had been completed. The south arm was vaulted from the piers of the crossing erected by Bramante up to but excluding the apsidal "Chapel of the King of France," although that ambulatory wall had been completed and work on its exterior stone facing, as indicated on the wood model, had already begun. Also, the foundations of the north arm and its ambulatory apse were under way, and the area was vaulted between the north arm buttresses and the corresponding crossing piers. This situation was summarized in the reconstruction plan published by Millon-Smyth (1976), which differs from that of Ackerman (1961) only in the appearance of the passageway between the north and west arms, which Ackerman proposed as already vaulted by Sangallo, and the absence of the external ring of the ambulatory apse of the south arm, already built in 1546 but immediately torn down by Michelangelo (cf. fig. 387, plan reconstructed by Ackerman 1986 after Millon-Smyth 1969).

Michelangelo's first model, executed in fifteen days and costing barely

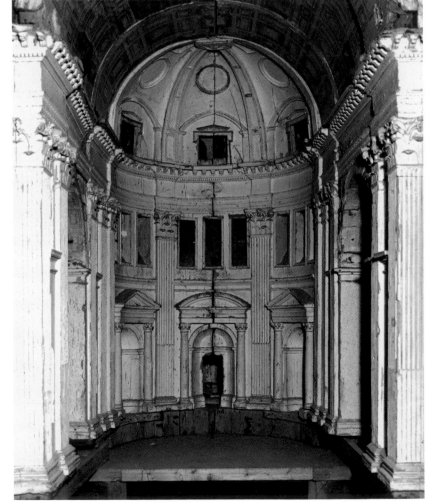

twenty-five ducats, according to Vasari (whose account Saalman 1975 doubted), was probably made of clay, as Tolnay (1930) suggested. Besides giving first form to the artist's ideas, it would have been used to demonstrate to the pontiff, who had to approve it, the utility of the demolition of the outer walls of the ambulatory apses begun by Sangallo. According to a letter of December 25 to Monsignor Archinto (Ciulich 1977–78) and "an account, dated December 11, for the wood which was used in the work of the model which Master Michelangelo, Architect, had made" (Pollak 1915, and Frey 1909), by December 1546 Michelangelo had begun a second model in wood, probably with some encouragement from the pope, of the actual counterplan which the deputies of the construction feared would "diminish that of Sangallo" (letter of January 13, 1547, in Ciulich 1977–78). This model, which cost eighty-seven ducats (Frey 1916) and was finished less than a year later in the fall of 1547, has disappeared. Undoubtedly related to it, and as far as we know the only example showing the whole building, is the model depicted in the painting by Domenico Passignano (fig. 432) executed as part of the redecoration of the Casa Buonarroti begun in 1619. Millon-Smyth (1976) analyzed the payments to the carpenter who executed the second model and hypothesized that it would have shown, although not completely, the interior and exterior of Michelangelo's design on a scale of 1:96. Saalman (1975) differed in thinking it was a partial work on a larger scale of 1:30, but he was not convincing in his identification of the "55 columns," for which the carpenter was paid, as balusters. Certainly, the model of 1547 would have had a normative value with regard to its submission for the approval of Paul III, which was apparently delayed for some time, if that is the sense of Vasari's statement (1568): "The model which Michelangelo had made was finally approved by the pope." In any case, only in October 1549 did Paul issue a *motu proprio*, or official notice, on the matter (reconfirmed by Julius III in 1552). If, as I believe, the "model by master Michelangelo Buonarroti" according to which

Pirro Ligorio and Vignola were charged with continuing the work on Saint Peter's in July 1564 (Ciulich 1983) was indeed the model executed in 1547, then it follows that the validity of Michelangelo's initial plan was preserved in the course of the work project. The model could not have had a great degree of detail, however, because Michelangelo integrated it with subsequent models, according to his typical *modus operandi* of solving problems one by one as they presented themselves in the course of the work. The progress on the work is clarified both by the construction documents and by graphic records. The projects undertaken by Michelangelo, "who brought Saint Peter's to a lesser size, but to a much greater magnificence" (Vasari 1568), included: the destruction of the external walls of Sangallo's ambulatory and transformation of the interior walls to enclose the body of the church; building of the three corridors connecting with the lateral arms; and creation of the three apsidal chapels. Plainly rejecting the replication of the large Greek cross with four smaller crosses in the corners of the square, Michelangelo achieved a greater simplicity and organic quality by reinforcing the four corner buttresses (planned by Bramante and weakened by Sangallo in opening passageways through them), rounding off the corners of the square in which the cross was inscribed and reshaping the constructed walls, uniting the choir directly with the lateral arms (see fig. 384). We do not know if Michelangelo's 1547 model included the shape of the large central dome, but Passignano's depiction of 1619 shows a dome profile with a raised sesto. Tolnay (1964) and Einem (1973) believed that this copied the 1547 model, but others, most recently Millon-Smyth (1988), thought this signified only that Passignano had united elements of the model with those seen in reality on the constructed church. There is no doubt that the problem of the closure of the church at the top by a mighty plastic organism was posed from the beginning. In a letter of July 30, 1547, Michelangelo asked his nephew Leonardo Buonarroti in Florence to send him "the height of the dome of Santa Maria del Fiore, from

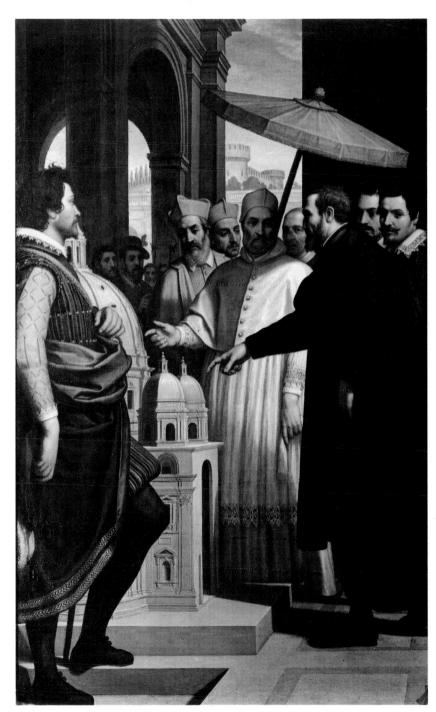

433. *Michelangelo. Studies for domed vault of Chapel of the King of France in Saint Peter's. Casa Vasari, Arezzo, cod. 12, cap. 22 (C. 593r)*

434. *Michelangelo. Plan of domed vault for Chapel of the King of France in Saint Peter's. Casa Vasari, Arezzo, cod. 12, cap. 24 (C. 594r)*

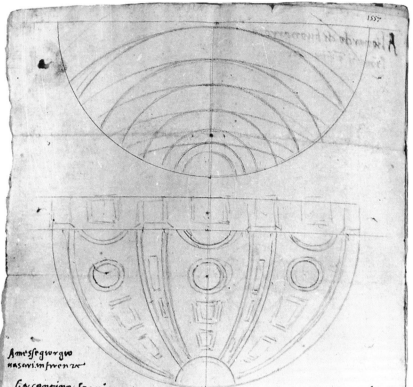

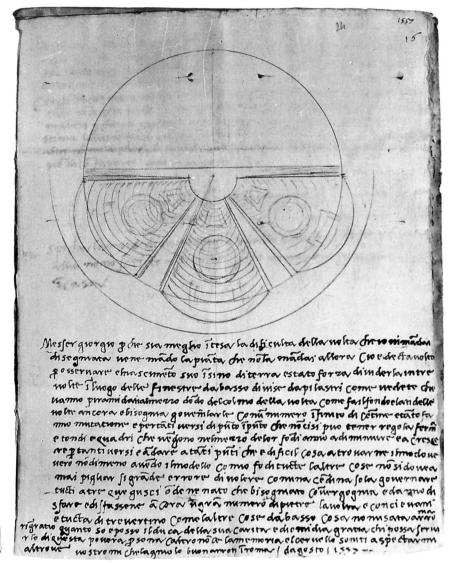

435. (above) Michelangelo. Sketch of elevation of domed vault of Chapel of the King of France in Saint Peter's. Musée Bonnat, Bayonne, 681v (C. 348v)

436. (below) Michelangelo. Structural diagram of portion of ceiling vault of Chapel of the King of France in Saint Peter's. The Louvre, Paris, Dept. of Drawings, 842v (C. 422v)

where the lantern begins down to the base, and the height of the whole lantern." The need to execute another model of the dome at the time the problem presented itself, as we will see, demonstrated that he could only have arrived much later at a definitive solution (if he ever arrived at one at all, which both Brandi 1968 and Tolnay doubted). In the model depicted in the painting, the façade is lacking, and we don't know if this was because a separate model for it had been executed or perhaps a model was never made at all. It is certain, however, that by 1547 Michelangelo intended to return to the central plan of Bramante, thus rejecting not only the façade design of Sangallo's model but also the planned extension in length of the fourth arm of the cross into a "nave."

The sequence of the work, resumed at the beginning of 1547, allows us to confirm that this second model by Michelangelo was authoritative so long as, having developed a different or more detailed solution, he had not executed a subsequent model on a more detailed scale. In 1547–48, construction was continued on the walls of the north arm, and the framework for the vaulting was constructed in 1549 (the fact that the vaulting for the south arm was already done required the continuation of the barrel vault throughout). After the demolition of the external wall of the south ambulatory apse in 1548–49, which was still visible in an anonymous drawing added to the Notebook of Maerten van Heemskerck (fig. 429; see Hülsen-Egger 1913–16, fig. 35), the first and second levels of the Chapel of the King of France were built by 1551, and reinforcements were made to the piers into which spiral staircases were then cut (1550–52). Following the making of a new wood model on a more detailed scale (paid for in 1549), and the installation of a large winch in the summer of 1548, the circular entablature at the base of the drum of the main dome was constructed on the preexisting pendentives. The completion of this entablature ring, more than six meters high and "a marvelous thing, graceful, and very different from all others" (Vasari 1568), was celebrated in February 1552.

At the beginning of 1551, according to Vasari (1568), "after Michelangelo had already built the apse of the king, where there are the three chapels, and the three windows created above them [that is, concluding the first and second levels of the closure of the south arm]," the deputies and the overseers connected with the Sangallo Sect "said that this apse will allow for little light." Called into the presence of the pope, Michelangelo refuted this, saying that, "above these windows will go three others in the vault, which will be made of travertine." As Ackerman (1961) noted, because the deputies were acquainted with the 1547 model, it is very likely that, in defining the conclusion of the south arm at the end of 1550, Michelangelo had brought about some modifications to his original design. In a letter written a few years later, Michelangelo in fact emphasized "how important it is to all the rest of the building"—that is, the vaulted closure of the south arm, which was decisive for the illumination and therefore the arrangement of the interior. There is testimony as well that Michelangelo had made a subsequent partial model in preparation for the vaulting of the Chapel of the King of France. Millon-Smyth (1976), repeating an observation made to them by Metternich, noted that a later vaulting solution had been inserted into Sangallo's model at the end of its west arm (see fig. 431). Not only was this completely anomalous in comparison with the vaulting of the other arms of the model, but also it was the actual solution carried out by Michelangelo in the south arm. Millon-Smyth argued convincingly for the identification of this partial model as an addition by Michelangelo for the purpose of experimenting with the effect of his new design on the same scale as that used by Sangallo. In two letters from Michelangelo to Vasari on July 1 and August 17, 1557 (MCCLXI, MCCLXIII; reported in Vasari 1568), the artist discussed problems which had arisen in the construction of the ceiling vault of the Chapel of the King due to the discovery in April 1557 of an error made by the superintendent Sebastiano Malenotti. This was so serious that it led to the demolition of all that had been done

327

437. (left) Giovanni Orlandi. Elevation of apse hemicycle on exterior of Saint Peter's in the Vatican. Print dated 1562; published by Vincenzo Luchino, Rome, 1564

438. (above right) Anonymous, 16th c. Elevation of apse hemicycle on exterior of Saint Peter's in the Vatican (attic not included). Uffizi, Florence, Drawings and Prints Dept., A 95r

439. (below right) Anonymous, 16th c. Plan of apse hemicycle for Saint Peter's in the Vatican. Uffizi, Florence, Drawings and Prints Dept., A 96r

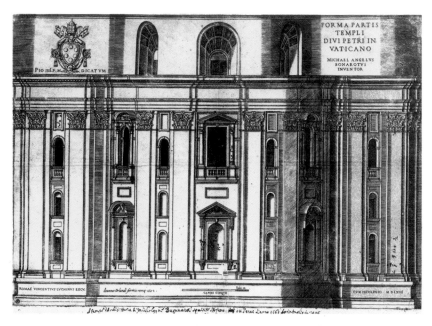

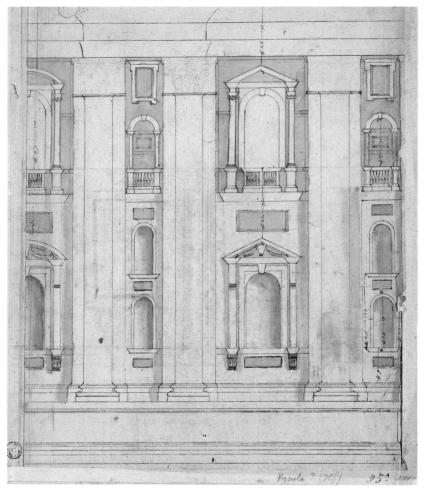

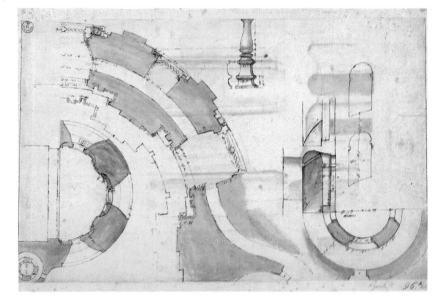

and a delay of many months, with the vault being sealed only in May 1558. Using this information, Millon-Smyth (1976) were able to deduce in detail the innovative aspect of the ceiling vaulting invented by Michelangelo. In misinterpreting the model and plans of the artist, who had been absent from the workshop too long, the supervisor had built the framework for the vault by laying the boards in place in concentric arches over the entire opening of the semicircular apse. Instead, an "infinite number" of measurements had been necessary, so that the framing arches would vary from time to time, one after the other, as the installation proceeded, as demonstrated in the autograph drawings of the vault structure connected with the above-mentioned letters from Michelangelo to Vasari (figs. 433–436).

The effect of the vault, developed so that viewers would be able "to see it from the ground all worked of a piece" [and all in travertine], "something not used in Rome" (Vasari 1568), was lost because of the eighteenth-century decoration. Besides not allowing an appraisal of the relationship between the giant order of pilasters and the closure of the vault, this irremediably changed the light values planned by Michelangelo, who had studied intensively the illumination of the interior for the purpose of reaffirming the centrality of the building and remedying the poor "lights" of the Sangallo model. Towards this end, in creating the large windows which provided light to the apse interior, Michelangelo moved their external openings just slightly towards the east with respect to the interior ones, as noted by Millon-Smyth (1976). The main altar of the church was located in an eccentric position under the central dome, displaced about a meter to the west of the center of the crossing, where the Tomb of the Apostle was located. Therefore, with this carefully studied misalignment of the inner and outer openings of the windows in the south apse, Michelangelo managed to have the openings of the center windows on the second and attic levels line up precisely when viewed from the main altar, which was important just from the liturgical standpoint.

The completion of the vaulting of the Chapel of the King of France and its related openings brought with it the creation of the external attic facing and the external decoration of the south apse, which was completed in 1558, although there is some doubt as to its effective conclusion. We know, in fact, that the facing of the attic level had two versions, the first one shown in a print by Giovanni Orlandi dated 1562 (fig.

440. *(above) Michelangelo (attrib.). Half-section of attic of dome of Saint Peter's, and profile of dome of Pantheon, Rome. Casa Buonarroti, Florence, A 35v (C. 603v)*

441. *(below) Michelangelo (attrib.). Study with measurements for wood model of dome of Saint Peter's. Casa Buonarroti, Florence, A 35r (C. 603r)*

437) and the existing one depicted in a print by Monogrammist HB dated 1565. Two hypotheses have been advanced to explain this. According to Millon-Smyth (1969), Michelangelo conceived and executed the attic level as a plain surface without any architectural partitions and having roundheaded windows with deep jambs, which is depicted in fig. 437 and on the model in the Passignano painting (fig. 432). The attic as it is today would then have been the work of Pirro Ligorio, who succeeded Michelangelo in July 1564. According to this hypothesis, the drawing in fig. 438 of the external face of one of the hemicycles without the attic level would be dated to about 1555, while fig. 439, showing cross sections of the attic and the second level of the south hemicycle (copied in part on a sheet in the Scholz Scrapbook shown in fig. 442), would not be earlier than the end of 1558.

The second hypothesis by Hirst (1974) is based on the identification of a sketch in black pencil, drawn freehand by Michelangelo in the top left corner of a sheet in Lille, as the first study for the actual exterior revetments of the attic (figs. 389/444). Millon-Smyth (1975) related this sketch to the Porta Pia but hypothesized that it could have been reused later by Ligorio for the attic design. Hirst, on the other hand, concluded that the attic level, interrupted in 1557, was completed in its present form while Michelangelo was still alive, in which case fig. 438 would have been executed prior to the 1547 model, and fig. 439 would date c. 1547. Each of the above hypotheses has its supporters. Keller (1976) and later Ackerman (1986) agreed with Millon-Smyth, who reconfirmed their own conclusions on several occasions, most recently in 1988. Those on the side of Hirst were Saalman (1975), the *Corpus*, Elam (1981), Joannides (1981), and Nova (1984a).

Another problem even more debated by scholars, almost to the point of becoming a "quarrel," concerns Michelangelo's conception of the central dome. In January 1554, the drum was already in progress and the first payments were made for the columns of the buttresses.

The progress of the work, which slowed noticeably at the end of 1556 due to Paul III's war with Spain, is documented in a series of drawings, including: two anonymous sheets added to the Heemskerck Notebook (figs. 428, 429), dated to the middle of 1556 by Millon-Smyth; and a drawing by Giovanni Dosio perhaps from 1563 (Uffizi, Florence, Drawings and Prints Dept., A 91). According to Vasari (1568): "Seeing that he was employed little in Saint Peter's, and having already carried forward the large part of the decoration of the windows inside, and of the columns outside, which ran around above the circular cornice where the dome was then to be placed, [Michelangelo was urged] by his great friends, such as Cardinal di Carpi, master Donato Gianotti, and by Francesco Bandini, and by Tommaso de' Cavalieri, and by Lottino, . . . because he saw the delay of directing the dome, [that] he should at least make a model for it." The eighty-one-year-old artist could also have been influenced by the recent invitation from Cosimo I to resettle in Florence (MCCXLIV, MCCLV).

The first model for the dome, in clay, was paid for in July 1557. Between November 1558 and November 1561, a model in wood of the drum and dome was created on the basis of the clay one, on a scale of 1:15 and measuring five meters high by four wide, which is preserved today in the Works of Saint Peter's (figs. 390, 391). This model in its present form, the detailed description by Vasari (1568) of Michelangelo's model and Dupérac's etchings after it (figs. 385–386), as well as a few autograph drawings by Michelangelo constitute the basic givens of the problem. The work on the great dome, which had resumed in mid-1561, had arrived only as far as the capitals of the pilasters and the buttresses for the drum by the time of Michelangelo's death in February 1564. (It would not be completed until 1593 under Giacomo della Porta.)

As it is widely recognized, while Dupérac's etchings and Vasari's description define a model with a hemispheric dome (for which Vasari even described the geometric method used by Michelangelo to develop the desired curvature), the existing wood model has a

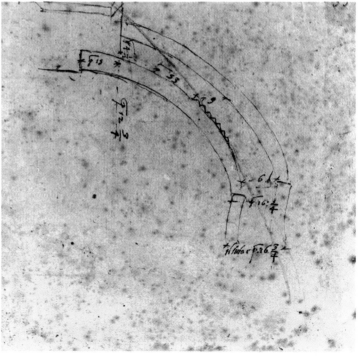

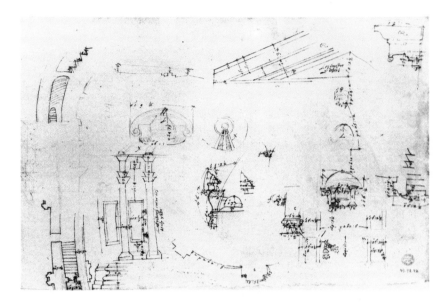

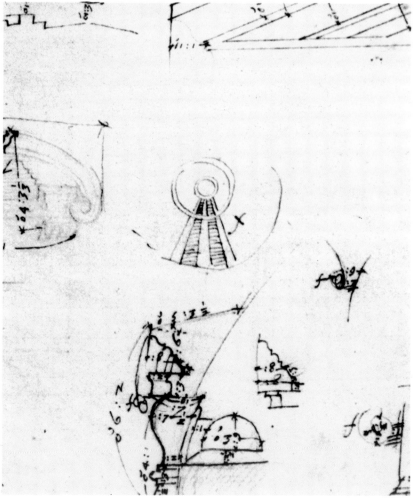

dome consisting of separate internal and external caps with the exterior cap having a raised sesto, or elevated profile. This is the design followed essentially by Della Porta in the execution of the actual dome. The internal hemispheric shell of the model agrees with Vasari's description, except for the telling difference in the window pediments of the drum, which are triangular on the exterior and segmental-arched on the interior, while Vasari and Dupérac's prints attest to the design developed while Michelangelo was still living of an alternation of these solutions on both exterior and interior. Given this evidence, scholars since Alker (1922) and Brinckmann (1922) have theorized that the external shell of the model could have been replaced or radically modified under Sixtus V, whose coat of arms appears at the base of the ribs. While there is no documentary evidence for this theory in the accounts of the construction, it is supported by the testimony of Giacomo Grimaldi, the archivist for Saint Peter's in the last years of the sixteenth century (Orbaan 1917).

Accepting the idea that the external cap of the model was redone—opinions for and against which are nearly equally divided up to now—does not solve the problem, because it is demonstrable that Michelangelo himself studied both solutions, undecided between a hemispheric curvature recalling the Pantheon and a higher profile similar to that of the dome of the Florence Cathedral. Certainly, the solution of the raised sesto for the external cap was documented in 1548 by a sketch, perhaps not autograph but connected with the workshop, drawn on the verso of a sheet recording the attendance of the workmen in the week of October 6–12, 1548 (Archive of the Works of Saint Peter's; see Brandi 1968). On the famous Lille sheet (figs. 389/444), considered entirely autograph, Michelangelo studied different contours for the internal cap, at least one hemispheric and another slightly elevated. Wittkower (1933) was the first to date this drawing to 1546–47 and thus relate it to the second model. Up to the present, his dating has had wide acceptance, although Saalman (1975) proposed 1552–54. Because the

Lille sheet shows a twelve-sided drum, it is impossible to date it after 1554, the year that construction on the drum began, although Joannides (1981) dated it to 1557–58. Most scholars believe that the Lille sheet preceded, although not by very much, the Haarlem drawing of the dome (figs. 388/447), but the latter, which shows a dome with a raised sesto (*Disegni italiani* 1983), does not postdate the Lille sheet sufficiently to be connected with the second wood model of 1558–61, as Joannides (1981) thought.

According to a suggested hypothesis of Millon-Smyth (1988), Michelangelo compared the curvature possibilities of the dome of Saint Peter's with the hemispheric dome of the Pantheon in fig. 440, while on the recto of this drawing (fig. 441), plausibly dated 1559–60 by Tolnay (1932), both the interior and exterior caps of the dome are hemispheric. A plan of the buttress and a portion of the drum (fig. 446), previously dated 1546, has recently been connected with the model of 1558–61, to which its measurements relate on a scale of 1:15. If this hypothesis is accepted, it would mean acknowledging that, up to a very late date immediately preceding the definitive execution of the second model (which is not impossible), Michelangelo had opted for circular "oculi" in the drum, as shown in the Lille drawing, and not rectangular windows. A sketch in the Ashmolean (fig. 445), dated 1557 on the basis of a letter fragment contained on it, shows a hemispheric external cap. In the final analysis, it seems possible to date to the period of 1546–47, or slightly later, those drawings which are similar to the Florentine dome, and to 1557–60 those which accentuate the hemispheric solution for Saint Peter's. But this probable course of events appears completely linear and therefore not exactly Michelangelo's usual way of creative thinking, which was certainly less schematic and sufficiently fluid to admit the possibility of both solutions up to the moment just precedent to the execution of the second wood model. On the other hand, it cannot be assumed that Michelangelo had not made a choice up to the last moment. The obligation to construct a large model which would serve as a "last will

444. *(above left) Michelangelo. Elevation of drum of dome and of lantern of Saint Peter's; detail of attic of dome (or of city gate); and ground plan for paired columns of drum. Musée d'Art and d'Histoire, Lille, Wicar Coll., 93–94r (C. 595r)*

445. *(below left) Michelangelo. Sketches of top of dome, and section of lantern of Saint Peter's. Ashmolean Museum, Oxford, Parker 344r (C. 601r)*

446. *(right) Michelangelo. Partial plan of drum of dome of Saint Peter's. Casa Buonarroti, Florence, A 31 (C. 600r)*

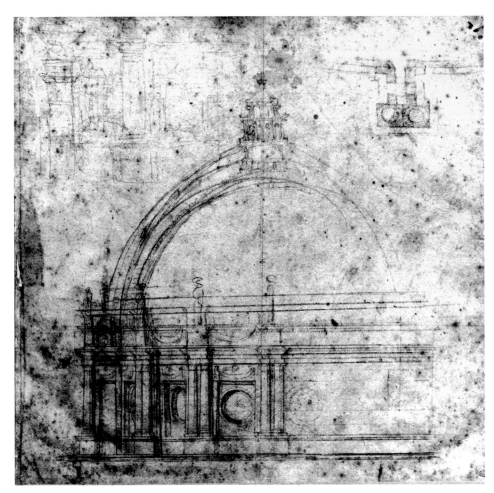

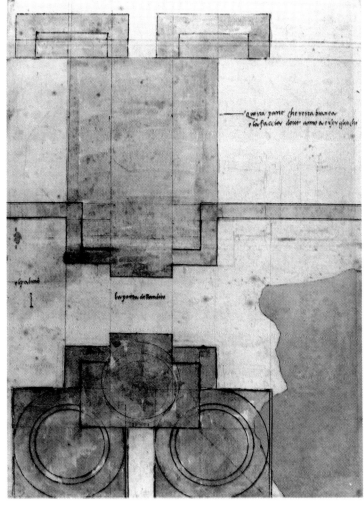

331

447. *Michelangelo. Views of the lantern, and section of dome of Saint Peter's. Teylers Museum, Haarlem, A 29r (C. 596r)*

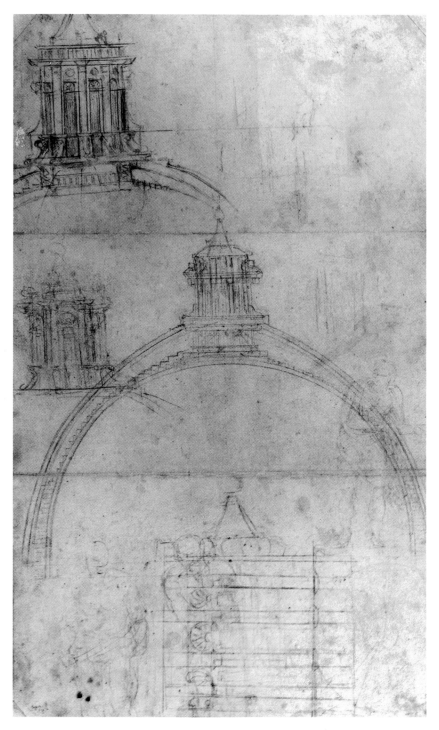

448. *Michelangelo. Plan of base of lantern, and figure studies. Teylers Museum, Haarlem, A 29v (C. 596v)*

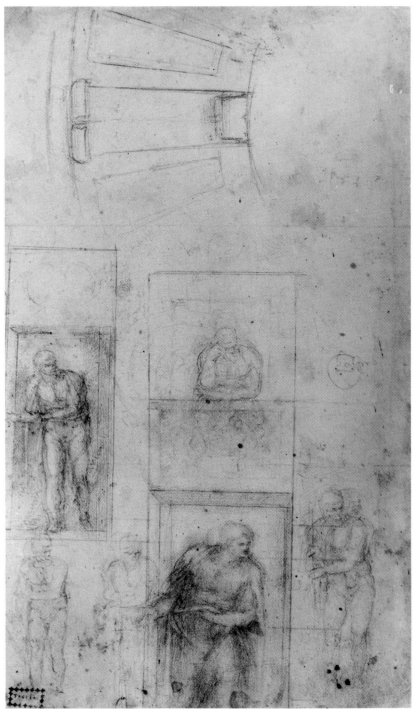

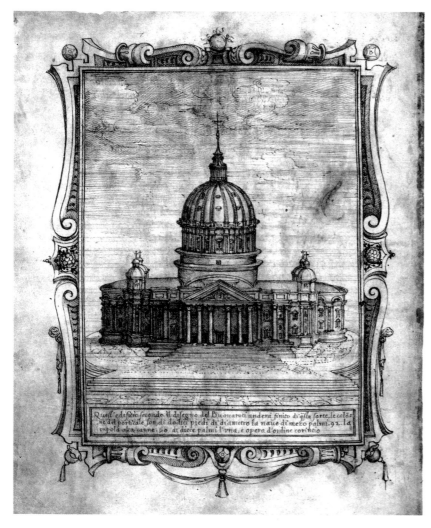

In the construction of the dome during the final decade of the century, the two-step attachment between the ring of ribs and the base of the lantern was noticeably altered and loosened as well, making Della Porta's lantern a banal simplification of the one planned by Michelangelo. A detail on the Scholz sheet (fig. 443) permits the clarification of the configuration of the curious element interposed between the lantern and the oculus in Michelangelo's design, which is depicted also in the Dosio drawing in fig. 452 and the Dupérac etching in fig. 386. It appears as a grid formed by three concentric circles connected by spokes which supported a framework, probably metallic, by means of which to see into the lantern from the outside, as Vasari said, but also probably to graduate and diffuse the light. (Körte 1932, citing Frey 1913, noted that, in a meeting of 1564–65, the lack of direct illumination was a point of criticism.)

Further confirmation for the fact that the wood model of 1558–61 originally had a dome with a hemispheric profile comes from a view of Saint Peter's in the former Dyson Perrins Album (fig. 449) attributed to the circle of Dupérac and dated to c. 1574–75 by Smyth (1970). The view is inscribed: "This building according to the plan of Michelangelo will be finished in this way, the columns of the porch are twelve *piedi* in diameter, the nave at the center 92 *palmi*, the dome 60 *canne* of ten *palmi* each, and the work of the Corinthian order." Obviously, the intention of the drawing was to document faithfully the plan of Michelangelo, and its author took a particular interest in presenting the configuration of the façade as it was to be built according to that plan. The porch would have consisted of six giant-order Corinthian columns supporting a triangular pediment high enough to extend above the top of the attic level (although this might only mean, in this instance, an imprecision in the drawing).

The hypothesis that Michelangelo could have conceived a façade design similar to that described above, rests on the 1569 etched copy of the ground plan of Saint Peter's (fig. 384), which was either derived from the 1546 model (Ackerman 1961; although it should be noted that the model shown in Passignano's painting in fig. 432 clearly lacks a façade) or based on an interpolation of Vignola (Thoenes 1968). More recently, additional confirmation has been found in a drawing in Naples (Biblioteca Nazionale, XII.D.74, f. 22v) published by Keller (1976), who dated it c. 1564–65. It is a matter of record that the single autograph sketch by Michelangelo connected, albeit only hypothetically, to the façade of Saint Peter's, possibly related to the second model in wood of 1546–47, shows a porch with five columns (fig. 454). The *Corpus*, reviving the observation of Tolnay (1927), hypothesized that this was only an error caused by the rapidity of the sketch, which should be interpreted as having six columns instead of five, otherwise the main portal of the church would have been on axis with the middle column. In summary, there is simply not enough evidence, as is also the case with the lateral domes, to hypothesize that, after the first idea, Michelangelo returned to the question of the façade and put the matter into operational terms. Even the medal of Gregory XIII, of around 1580, seems to represent Michelangelo's idea in only a vague and imprecise way.

and testament" to his successors would not have allowed for alternative possibilities. Moreover, a number of depictions demonstrate that the dome of the model was undoubtedly hemispheric: drawings from the circle of Dupérac (fig. 442, and two sheets in the National Museum, Stockholm, Cronstedt 1305 and 1375); and drawings by Giovanni Dosio done certainly from the wood model (figs. 450–452, and Uffizi, Drawings and Prints Dept., A 2032, A 2033). For an analysis of the drawings, see Millon-Smyth (1988). With their aid—in particular the Scholz Notebook drawings of the exterior elevation (The Metropolitan Museum, New York, 49.92.1) and a section of the model (fig. 442), it is possible to confirm that the ribs of the dome as planned by Michelangelo projected more than those executed by Della Porta. In addition, the ribs continued up to the ring at the base of the lantern at the same width as the projecting buttresses of the supporting columns of the drum and the pilasters of the attic level (narrowed also by Della Porta). The surface of Michelangelo's dome would thus have been strongly innervated rather than divided into segments as executed. Also, the dormers were planned to reduce in size as they approached the top, in order to emphasize the vertical continuity of the dome surface, whereas Della Porta changed the actual shape of the window from row to row, reinforcing a reciprocal horizontal connection.

450. *(left) Giovanni Antonio Dosio. Section of dome and of lantern of Saint Peter's, from final model by Michelangelo. Uffizi, Florence, Drawings and Prints Dept., A 2031*

451. *(above right) Giovanni Antonio Dosio. Half-section of dome, and lantern with top part of dome of Saint Peter's. Uffizi, Florence, Drawings and Prints Dept., A 92r*

452. *(below right) Giovanni Antonio Dosio. Section of dome of Saint Peter's, from final model by Michelangelo. Uffizi, Florence, Drawings and Prints Dept., A 94r*

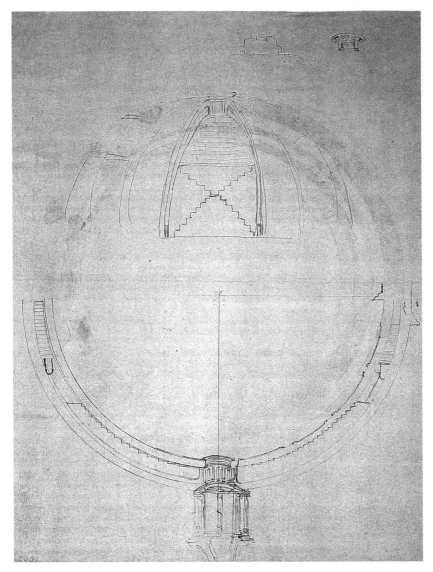

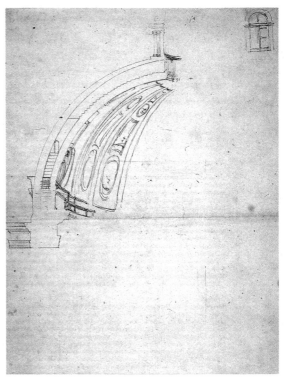

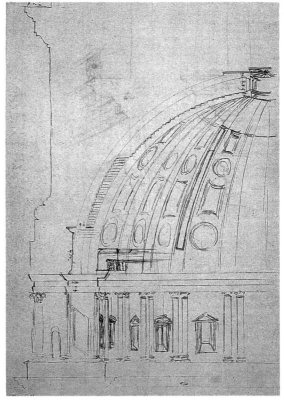

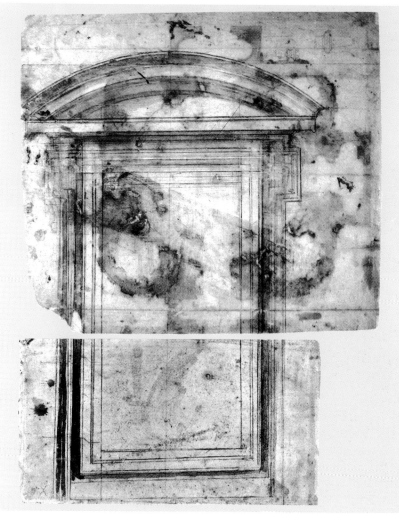

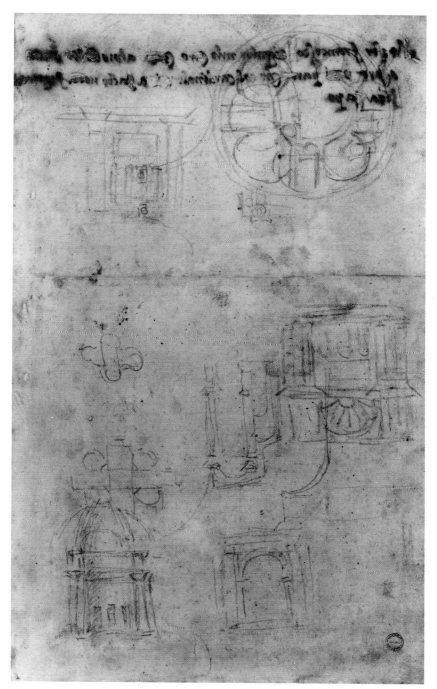

453. *Michelangelo. Design of window with curvilinear pediment for drum of Saint Peter's. Superimposed drawings: Casa Buonarroti, Florence, A 124v (top) and A 103v (bottom)*

454. *Michelangelo. Sketch showing relationship between façade of Saint Peter's and Vatican Palaces. Vatican Apostolic Library, Rome, Cod. Vat. Lat. 3211, f. 92 (C. 592r)*

455. *Michelangelo. Architectural sketches for Saint Peter's and [perhaps] for San Giovanni dei Fiorentini, Rome. Ashmolean Museum, Oxford, Parker 344v (C. 601v)*

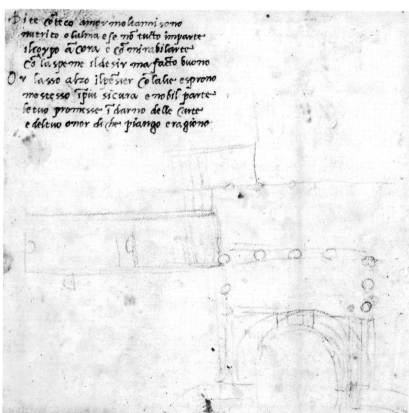

456. *Michelangelo. Sketches of man on horseback, and of fortifications. Uffizi, Florence, Drawings and Prints Dept., F 14412v (C. 379v)*

"The deceased Paul understood the two very serious and very dangerous enemies to the good fortune of Rome: numerous and almost yearly plagues, and fortifications nearly all impaired, leaving Rome vulnerable to its enemies" (Amaseo 1563; cited in Spezzaferro 1981). As this excerpt from Romolo Amaseo's funeral oration for Paul III makes clear, one of the first preoccupations of the Farnese pope was that of providing for the defense of the city, which had earlier proved totally inefficacious in the Sack of 1527. According to Vincenzo Scamozzi's *Idea dell'architettura universale*, Paul concerned himself with the problem immediately after his election in 1534, but the work, which had been entrusted to Antonio da Sangallo the Younger, began only in 1537 with the installation of defenses on the left bank of the Tiber (for the role of Sangallo and the Uffizi drawings, see Fiore 1986).

As for the fortifications of the Vatican area itself, Paul III convened a special assembly in 1542 participated in by the major experts on the subject. Subsequently, the first cornerstone was laid on April 18, 1543, for the bastion of Santo Spirito (for the ceremony, see Guarico 1552). At the beginning of 1545, however, controversies arose between Sangallo and the military commander, Giovanni Francesco da Montemellino. Sangallo intended to ring all of the Vatican heights with bulwarks, especially the summit of Sant'Antonino, but Montemellino advised instead that the valley be fortified, thereby decreasing the distance of the walls to be defended (Guglielmotti 1887; see Marconi 1966 for the plan by Sangallo, with criticisms by Montemellino preserved in the Vatican Apostolic Library, Rome, Cod. Barb. Lat. 4391, c. 4). In order to settle the controversy, Paul III called another assembly, in which "he wanted Michelangelo to participate also, because it was known that the fortifications made around the hill of San Miniato in Florence had been arranged by him" (Vasari 1568). In his report sent to Ammanati, Guglielmo della Porta stated that Michelangelo did not take a position, but reserved "his opinion . . . [for] when the time came" (Gronau 1918). Vasari, on the other hand, wrote that Michelan-

gelo "spoke freely of his opinion contrary to Sangallo and many others." This provoked an argument, during which he was accused of not being an expert in the field of fortifications because he was a painter and sculptor. He responded to Sangallo "that, regarding fortifying, with the study of it for a long time, [and] with the experience of what he had done, it seemed to him that he knew more about it than [Sangallo] or anyone in his family."

Michelangelo's resentment, probably more acute because of the Medici-line position held by Sangallo in the 1530s, was made explicitly clear in a letter from the artist on February 26, 1545 to Cardinal Tiberio Crispi, chamberlain of Castel Sant'Angelo, who was overseer of the work of fortifications of Borgo as well (Pagliucchi 1906–9). In it, Michelangelo wrote: "It seems to me that, with reason and with strength, the bastions initiated could be defended and followed up, and, doing nothing, I doubt much worse could be done" (thus faulting Montemellino's idea). At the same time, he suggested: "About following up, I don't say particularly that which was begun, but only the arrangement of the Mount, improving it without harm to what is done with the advice of the commander Giovan Francesco [Montemellino], in order to have the opportunity to remove the governor who is there, if it is as they say, and to put there said commander Giovan Francesco, whom I find capable and honest in everything." And in case the chamberlain would decide to get rid of the "governor who is there" (that is, take the commission away from Sangallo), Michelangelo mentioned: "I offer myself for it in honor of the Pope, although many times I am asked, not as an equal but as a shop boy in everything" (MXXXVIII).

The work continued under Sangallo during 1545 but soon came to a complete halt because of new disputes, as reported in a letter of January 4, 1546 from Prospero Mochi to the duke of Parma (Guglielmotti 1887, and Rocchi 1902). We learn again from Mochi after Sangallo's death: "Mister Michelangelo has had the position of Sangallo together with [Jacopo] Meleghino; that mister Michelangelo now has obedience. His Blessedness said to us that,

as far as the design, he has ordered that mister Michelangelo would be obeyed and no one else. . . . The advice of mister Michelangelo will be this: where the flank [of the bastion] already prepared has a range of fire towards the guardtower (*cortina*) of Nicholas V, he wants in the same place to fire away from the tower, and to make an intermediary which would have two flanks, [that is,] a prong, or small bulwark, or platform, which would have eight gun positions, four per side, high and low; the one would fire towards the entrance gate of the tower at the Spinelli [at Sant'Anna Gate on the side of the Spinelli Palace], and the other at the first range towards the Nicholas [tower]." Thus, modifying an idea of Montemellino in a *primo parere* of June 4, 1545 (published in Guglielmotti 1887), Michelangelo had planned a bastion with two flanks on

the east side of the Belvedere. We know that this was under construction on February 20, 1548 from a letter of that date to Ottavio Farnese, in which Montemellino criticized "the fort begun at the Belvedere, according to the design of the expert Architects," and proposed that "the wall which had been started ought not to be continued to the top." In March of that year, Jacopo Castriotto assumed the role of director of the Vatican fortifications, probably on the favorable advice of Michelangelo.

Ackerman's thesis (1961) is completely acceptable that, "during the period of Michelangelo's activity, the construction [was] barely initiated," therefore the traditional attribution to him of the fortifications east of the Belvedere remains "not proven," in spite of the rigorous monumental style of this defense work. Three drawings have

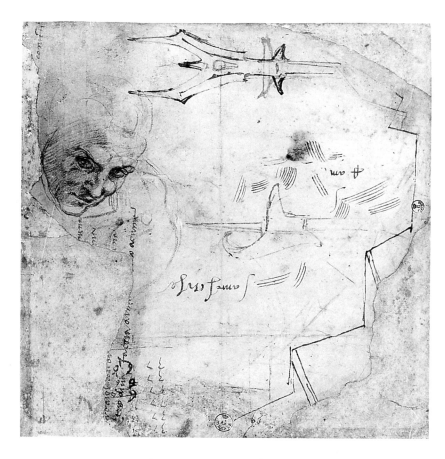

457. *Michelangelo. Autograph fragment of poetry, two sketches for halberd, and plans for fortifications. Uffizi, Florence, Drawings and Prints Dept., F 14412r (C. 379r)*

been traced to the brief period in which Michelangelo was working on the walls of Rome: fig. 457 (verso in fig. 456); and Vatican Apostolic Library, Rome, Cod. Vat. Lat. 3211, f. 84v and f. 93r). Mariani (1985) demonstrated that in these drawings Michelangelo had rethought examples of the work of Francesco di Giorgio Martini.

RESTORATION OF THE SANTA MARIA BRIDGE, ROME, 1548

On July 27, 1548, as reported by Battista Theodorico, the people of Rome commissioned for the completion of the restoration of the bridge of Santa Maria, the ancient *pons Emilius* connecting the trans-Tiber (*Trastevere*) district with the city, "Michel Angelo Bonaroti, *homo singularis*, whose virtue has been commended and proposed to us by His Holiness." According to the minutes of this Capitoline meeting, the artist, "in order to please His Blessedness and to do something agreeable for the people will undertake this labor with the others which he does on our public buildings as a good Roman citizen and lover of this country" (Lanciani 1902–12).

July 23, 1548, "by order of the great mister Leonardo Boccaccio, commissioner general," the collection of taxes was begun for the restoration of the bridge, an unpopular but necessary provision because, if the intervention were not carried out, it was feared that "the two arches [would be ruined] with greater expense and inconvenience to the people." Spezzaferro (1981) connected this commission given by the city—but proposed and perhaps directly imposed by Paul III—with the contemporaneous idea of Michelangelo to build a wooden bridge across the Tiber at the site of the Farnese Palace. Just as important, however, were the other "public buildings" for the city (that is, the Capitoline complex).

Payments were made on the work from October 5, 1548 to January 22, 1549 (published in Podestà 1875), but some items referred to the "payment of salary for the time served and for serving in fulfillment to last August 10 [1548])." Quite a few reservations were expressed at the time about the work planned by Michelangelo. For example, a letter from Paolo Giovio to Cardinal Nicolò Gaddi of October 7, 1548 stated that "the good Boccaccio [deputy commissioner for the project] went off to Florence to refresh himself, and in the meantime he will review the account of the futile construction of the unrestored bridge" (letter cited in Spezzaferro 1981). Vasari (1568) recorded that "Michelangelo ordered, by means of caissons, the rebuilding of and the making of diligent repairs to the piles; and further, he completed a large part, and

had great expenses in wood and travertine to the benefit of that work." The record of payments testifies to the acquisition of the timbers and iron spikes, evidently to put in the river bed, and to the work by the carpenters, probably to make the caissons necessary to rebuild the bridge piers. But the death of Paul III in 1549 and the election of Pope Julius III put an end to the work on it by Michelangelo. As Vasari (1568) wrote: "It happened in the time of Julius III in conjunction with the clerics of the Camera in the matter of putting an end to it, that the architect Nanni di Baccio Bigio was proposed among them, who with little time and money would complete it, [and] they gave the contract to him; and with a certain manner they urged under pretense of good will that Michelangelo be relieved, because he was old and couldn't take care of it, and as things stood, he would never see it to the end. The pope, who wanted little trouble, not considering what could happen, gave authority to the Camera clerics, who, in their way, took care of it. They decided on it then, without Michelangelo knowing otherwise about it, with a liberal agreement to Nanni, with all the materials." The contract was drawn up July 3, 1551 with this member of the old Sangallo Sect. In a letter to Ottavio Farnese on March 17, 1553, Baccio, after spitefully recalling "how much money was spent . . . by Michelangelo and Boccaccio," bragged about having finished the restoration of the bridge in fifteen days, correcting as well the serious errors committed, in his opinion, by Michelangelo. But the bridge, according to Vasari, was "totally weakened and completed reduced," because Baccio "lightened the weight by selling off a large amount of travertine, by which the bridge had been supported and grounded, weighed down, and made stronger, safer and sturdier." The bridge collapsed in September 1557.

Referring to a sketch by Giovanni Dosio (Uffizi, Florence, A 2582) showing the "Santa Maria Bridge with the part restored," Ackerman (1961) wrote: "Although the heaviness of the style suggests an attribution to Nanni [di Baccio Bigio], it could be assumed that it was initiated by Michelangelo."

STAIRCASE IN THE UPPER COURT OF THE BELVEDERE IN THE VATICAN, 1550–51

458. *Bernardo della Volpaia. Ground plan of Belvedere Court, Vatican Palaces, Rome. Soane's Museum, London, Coner Codex, f. 17*

459. *Giovanni Antonio Dosio. View of Belvedere Court, Vatican Palaces, Rome. Uffizi, Florence, Drawings and Prints Dept., A 2559*

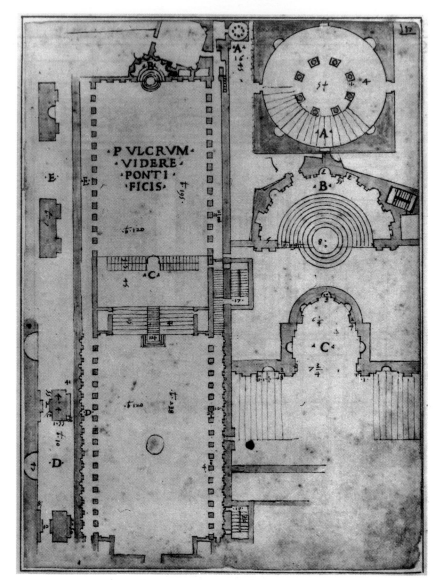

Speaking of Michelangelo's activities during the pontificate of Julius III, Vasari (1568) wrote that "neither at the Villa Giulia [had the pope] made a single thing without his advice, nor in the Belvedere, where the stairs were remade which are now there in place of the half circle, which came out in front, rose eight steps, and another eight in turn went inward, made earlier by Bramante. Michelangnolo designed and had made there that square one with balustrades of tufa, which is there now, very beautiful. Vasari had that year finished printing the Lives of the painters."

The mention of the Torrentina (first) edition of the *Vite* dates the staircase design by Michelangelo to 1550–51, which is confirmed by a payment recorded on September 20, 1551 for "4.45 ducats to the workers who brought different stones of tufa in order to make the stairs of the Belvedere" (Ackerman 1954). The status of the courtyard at the beginning of the pontificate of Julius III can be seen in a 1550 engraving of it by Hendrick van Cleve (see Ackerman 1954, cat. no. 26). The subsequent destruction of the double, circular staircase designed by Bramante was rendered necessary because of the construction of an apartment at the sides of the exedra. The niche in the exterior wall in Bramante's design was transformed into a semicircular connecting passageway by the construction of a second wall at the top of Bramante's steps. (For Bramante's design for the Belvedere, see Bruschi 1969; and for a reconstruction of the staircase, see Ackerman 1954, plate II, based on the plan in Serlio's *Terzo libro*.)

The appearance of the area before and after the intervention by Michelangelo can be seen by comparing the drawing in the Coner Codex (fig. 458) with a plan in the Scholz Scrapbook (The Metropolitan Museum of Art, New York, 49.92.72; see Tolnay 1967). The latter, which should be considered as having been taken from an idea of Michelangelo, shows a niche in the center part of the staircase base, which, although we don't know if it was ever constructed, would have made Michelangelo's staircase for the Upper Belvedere resemble that of the Senator's Palace.

Michelangelo's Belvedere staircase appears in its completed state in two views, one attributed to Bartolomeo Ammanati (fig. 460; see Ackerman 1954, cat. no. 30) and another by Giovanni Dosio (fig. 459). Both show that the large shell niche, completed according to the design of Pirro Ligorio in 1562, had still not been constructed, whereas to judge from the above-mentioned plan in the Scholz Scrapbook, Michelangelo intended to articulate the semicircular wall with six niches for as many statues.

Although the conception of the whole two-story villa for Julius III in the Belvedere has also been attributed by some to Michelangelo, documentation exists to show that Girolamo da Carpi directed the work, probably using a design by Vignola (Ackerman 1954).

Notable alterations were made later on the original Belvedere staircase. The bronze pine-cone from the atrium of Old Saint Peter's was installed there under Paul V, and the original tufa stone balustrade was replaced at the beginning of the eighteenth century during the pontificate of Clement XI. Also under Clement, the additions were made of the Albani family coat of arms, the large balls on pedestals at the bottom of each stair ramp, and possibly the fountain at the center of the base (see fig. 461).

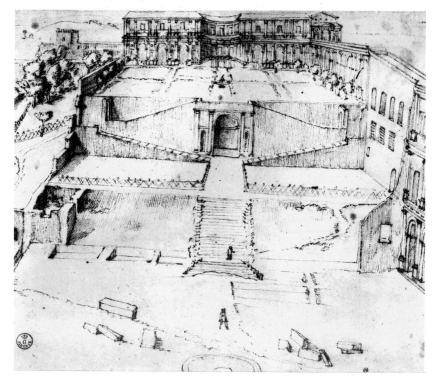

MODEL FOR THE CHOIR OF THE CATHEDRAL OF PADUA, 1551

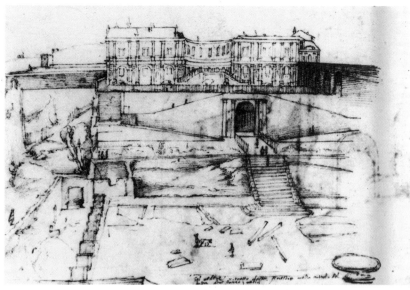

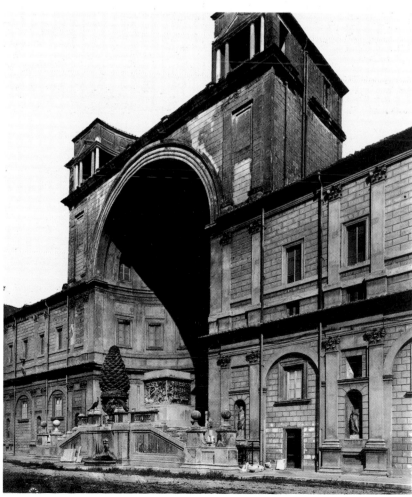

460. (above) Bartolomeo Ammanati (attrib.). View of Belvedere Court, Vatican Palaces, Rome. Fogg Museum, Cambridge, Mass., 1934.214r

461. (below) Pine Court, staircase. Vatican Palaces, Rome

After a series of litigious controversies between Cardinal Francesco Pisani, bishop of Padua, and the canons and benefactors of the Chapter of the Cathedral, first with regard to the division of expenses and then over the design itself (summarized in Bellinati 1977), the judicial decision was rendered in Venice in October 1549, which established, "in what proportion and under what form, the construction and building of the choir." Pisani (responsible for two-thirds of the costs) and the canons (responsible for the rest) were anxious to begin construction of the new choir in the spring of 1550, according to the design of Jacopo Sansovino, who was also made overseer for the project.

New controversies emerged before the work actually began, however, and on January 2, 1551, Cardinal Pisani proposed that the choir be built according to a "model made by the very skillful lord Michelangelo" with the collaboration of two overseers, Andrea da Valle, selected by the cardinal and supported by Alvise Cornaro (Alvarez 1980), and Agostino Righetti da Valdagno, representing the canons of the Chapter. On January 5, the canons approved the model presented by the cardinal and officially appointed the two overseers.

The "term[s] by which the building of the Cathedral of Padua will be given to the mason, who will offer to make it," made explicit reference to a model, probably in wood, which was sufficiently detailed to permit the exact reproduction from it of the "capitals, architraves, friezes, and cornices, . . . crowning of the roof, . . . the vaults over the church, . . . [and] the planning and covering with tiles." On April 6, 1551, the "estimate (poliza)" for the work was presented by the "builder (muraro)" Giacomo di Castellione, and a year later, on May 6, 1552, Cardinal Pisani presided over the ceremony for laying the cornerstone. The construction went forward rapidly and, after a short suspension of activity in 1558, the work was nearly finished in 1570 at the time of Pisani's death. Up to what point the Paduan superintendent of works followed Michelangelo's model, in the absence of the artist or any representative on his behalf, cannot be known. An analysis of the existing choir has demonstrated decisively that it was independently executed. Tolnay (1965) recognized in its form a relationship with developments at the time in Saint Peter's under Michelangelo, but a document dated June 13, 1552 attests that "master Andreas [da Valle] designed the form and model for this temple building, and the invention of the manner of constructing same is his." Moreover, the sixteenth-century ground plan for the Cathedral of Padua (published in Alvarez 1964–65) seems not to have many connections with the Rome architecture. Therefore, rather than by the hand of Tiberio Calcagni, as has been hypothesized, it appears to have been a local interpretation, probably really by Andrea da Valle (suggested by Carpeggiani (1975), who extended Michelangelo's "model" for the choir to the entire Cathedral.

MODEL FOR THE FAÇADE OF A PALACE FOR JULIUS III IN THE MAUSOLEUM OF AUGUSTUS, ROME, 1551–52

462. *Mausoleum of Augustus, Rome*

463. *(below) Fabrizio Boschi.*
Michelangelo Presents a Model of
a Palace to a Pope. *Casa Buonarroti,
Florence*

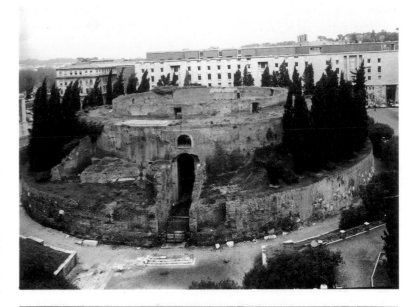

Condivi recorded that, during the pontificate of Julius III, "Michelangelo . . . made, at the request of His Holiness, a design of a façade for a palace which he had in mind to build in Rome. This, seen by all as unusual and new, did not owe to the manner or law of anything antique or modern." The testimony of Condivi, who wrote shortly after the event, was confirmed by Vasari (1568): "[Julius III had Michelangelo] make a model of a façade for a palace which His Holiness wanted to make near San Rocco, wanting to make use of the remaining walls of the Mausoleum of Augustus [fig. 462]. There was never before seen the design of a façade more varied, nor more ornate, nor newer in manner and order. As it was seen in all his things, he never wanted to be obliged to the law, either antique or modern, for architectural matters, because he had the proper genius to discover always new and varied things, and not at all less beautiful. This model is today owned by Duke Cosimo de' Medici, to whom it was given by Pope Pius IV when he came to visit him in Rome, [and] who holds it among his most prized possessions."

Millon (1979), after studying receipts and disbursements of monies "for the model for Our Lordship" recorded between November 1551 and February 1552 in a dossier preserved in the Archivo della Reverenda Fabbrica of Saint Peter's (IV, 33, pacco 3; published in part by Podestà 1875, and Frey 1909), excluded the possibility that the model of a building being presented by Michelangelo to Julius III in the painting by Fabrizio Boschi (fig. 463) had any relationship with the palace project in question. This contradicted previous assumptions about the model in the painting, which is inscribed "Roman Curia."

The accounts Millon (1979) published provide only vague information insufficient for a complete reconstruction of Michelangelo's concept, but the limewood model, on a scale of 1:24 or 1:30, included sixteen columns, sixteen half columns or pilasters, seven square windows, five window returns, an unspecified number of mask decorations, and 385 balusters. From this can be deduced a two-story façade having seven bays and perhaps a balustrade all around the cylindrical crown of the existing Mausoleum of Augustus.

The most unusual aspect of the project, as Ackerman (1961) pointed out, was the utilization of a preexistent structure from the Classical era. Julius III quickly abandoned this idea, however, and commissioned Bartolomeo Ammanati in the autumn of 1552 to convert the former Cardello palace, which had been acquired a few months earlier by the Del Monte family. (On the Del Monte Palace and the work of Ammanati, see Nova 1983.)

MODEL FOR THE CHURCH OF
IL GESÙ, 1554

464. *Nanni di Baccio Bigio or Bartolomeo de Rocchi, with corrections perhaps by Michelangelo. Plan of Church of Il Gesù, Rome. Uffizi, Florence, Drawings and Prints Dept., A 1819 (C. 604r)*

In 1550, the young Society of Jesus obtained permission to construct its mother church in Rome, in the area where it now stands, according to a design by Nanni di Baccio Bigio with the advice of Vignola. A ground plan for the church with a drawing of the surrounding area by Nanni is preserved in the Bibliothèque Nationale, Paris (see Pirri 1941, and Bösel 1985). Except for the placement of the cornerstone in December 1550, the construction of the church, which had been supported by Francesco Borgia, was delayed for four years due to controversies with the proprietors of the buildings already existing in the area, especially the Altieri and Muti families. In early 1554, Cardinal de la Cueva asked Michelangelo for a new design. In a letter of June 10, 1554, Father Juan Alonso de Polanco, provincial of the Jesuit order, wrote: "With regard to our church, Master Michel'Angelo, the sculptor, has been to see the location and agreed to make the model in such a way that, with the help of God, he would quickly begin to build it" (Pirri 1941). In a letter of June 14, Polanco called the artist "the most famous man who now exists," and again, in a letter of June 21, spoke of him as "the one who directs the important business of the work of Saint Peter's, and is esteemed as the most famous man there has been for a very long time" (Pirri 1941). On July 21, 1554, the commission to Michelangelo was confirmed in a letter to Didaco Hurtado from the founder of the Jesuit Order himself, Ignatius of Loyola, who wrote that the famous architect had accepted the commission "out of devotion only, without any profit" (Pirri 1941; for Michelangelo's relationship with the Jesuits, see Calì 1980 and De Maio 1978).

It is not possible to determine what concrete form Michelangelo's task assumed, and the "model" mentioned by Father Polanco could just as well have been only a simple ground plan. In any case, after the second cornerstone was laid on October 6, 1554, the disagreements with the owners of the surrounding properties resumed, and actual construction of the Church of Il Gesù was begun only in 1568 under the direction of Vignola.

Popp (1927) identified the ground plan in fig. 464 as one originally developed in 1550 by Michelangelo for Julius III and related to the pope's idea to erect the Del Monte family funerary monuments in the Church of San Giovanni dei Fiorentini in Rome (No.28). According to Popp, this same plan—inscribed at a later date, "Of the Jesu at the Altieri by Michelangelo buon Arroti"—was subsequently offered by the artist to Cardinal de la Cueva for Il Gesù. This proposal was rejected by Nava (1936), who confirmed the traditional attribution of the design in question to Bartolomeo de Rocchi, but it was accepted by Tolnay (1951), who indicated the points of contact between it and Alberti's design for Sant'Andrea in Mantua. Ackerman (1961), on the other hand, identified the plan as a variant of the design by Nanni di Baccio Bigio, possibly retouched by Michelangelo in view of the corrections in sanguine on the already finished drawing to reduce the length of the transept and the width of the main apse. Ackerman's proposal, agreed with by Portoghesi-Zevi (1964), seems the most probable.

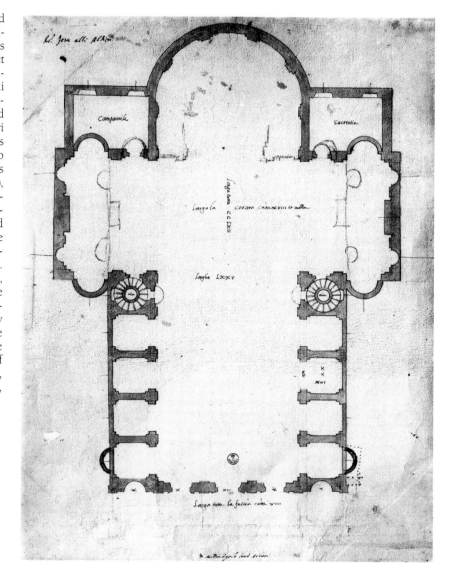

No. 27

DESIGN FOR THE RENOVATION
OF THE AREA AROUND THE
COLUMN OF TRAJAN, ROME,
1558

No. 28

DESIGNS AND MODEL FOR SAN
GIOVANNI DEI FIORENTINI,
ROME, 1559–60

The acts of the meeting of the municipal assembly in Rome on August 27, 1558 inform us of a projected plan by Michelangelo for the renovation of the area surrounding the Column of Trajan, which had been torn up and left in a state of rough terrain by the excavations done under Paul III to uncover the base of this antique monument.

"Because the Trajan Column is one of the most beautiful and complete antiquities which are in this city, it seems a proper thing that the place where it stands should be adorned and arranged in a way which corresponds to its beauty. And there has been submitted on this a design by Michel Angelo" (Gnoli 1886; Lanciani 1902–12). The project, presented by Alessandro Ferreo, was approved with eighty-six favorable votes and four opposing ones, but, as far as it is known, Michelangelo's idea was never followed up.

On June 11, 1484, the Archconfraternity of the Pietà, founded forty years earlier with a program of mutual aid for Florentine citizens living in Rome, took a long-term lease from the Chapter of Saints Celso and Giuliano on an area next to the Tiber to build a small oratory. As recorded in a contemporary chronicle on August 11, 1508, during the course of work on the Via Giulia, which was to originate at that very site following the planned construction of the *pons triumphalis*, "the pope sent Bramante with his workers to tear down" the oratory, perhaps also with the intention of striking a blow at the political power of the Florentines (Tafuri 1973). They evaded the affront, however, by immediately embarking on September 10 on a project to construct a new church to stand at the monumental entrance to the street being built for Pope Julius II. The design for the church, perhaps by Bramante, was delivered on December 31, 1508.

The church project was then interrupted due to the failure of the urban initiative of Julius II, but with the election in 1513 of Pope Leo X of the Medici family, the Florentine Nation resumed their planning. Bentivoglio (1975) rediscovered and connected with the Church of San Giovanni dei Fiorentini two designs for a central-plan church by Giuliano da Sangallo (Vatican Apostolic Library, Rome, Cod. Barb. Lat. 4426, c. 61r, 74, and 59v), probably from 1513 (Tafuri 1986). The exact site was established on August 12, 1513, in spite of the easily predictable problems of constructing a building on the bank of the Tiber (for the political ramifications of this, see Günther 1984a, 1984b, and 1985). With a bull of January 29, 1519, Leo X conveyed a series of privileges related to the building of the church. Shortly before that, in 1518, the pope had announced a competition for the design, which, according to Vasari, pitted against each other Raphael, Baldassare Peruzzi, Antonio da Sangallo the Younger, and Jacopo Sansovino, with the last being named the victor perhaps for reasons of cultural diplomacy (Tafuri 1987). After the ceremony for placing the cornerstone in 1519, construction began the next year with

the foundation. This was especially long and costly, because the church was built on ground that did not allow for the possibility of developing a piazza in front of it. In January 1521, Sansovino was replaced by Sangallo, who had presented a new design alternative to that of his rival (Tafuri 1986). Between April and November of that year, Simone Mosca received payments for the "diamonds and lilies" to decorate the façade of the church.

It is impossible to provide here an accounting of the very extensive bibliography and large amount of critical discussion about the various designs developed for San Giovanni dei Fiorentini between 1513 and 1521. Reference should be made, however, to the pioneer work in documentary contributions of Nava (1935 and 1936), to the classic Siebenhüner (1956), and to Tafuri (1973) and Schwager (1975). Tafuri (1984a and 1985) drew attention to a design from the circle of Raphael (Staatmuseum, Monaco, 36/1928b), perhaps by Giulio Romano (Tafuri 1989), which probably reflects Raphael's ideas of 1518. Tafuri (1986 and 1987) also made new contributions concerning the designs by Sangallo.

The convention prevails that the church was initially thought of in 1518 as a central-plan building with a diameter of about one hundred twenty *palmi*. It then evolved into a basilica-plan structure in the final design by Sangallo (Uffizi, Florence, Drawings and Prints Dept., A 175 for the ground plan and A 176 for the façade elevation). The foundations were constructed, and the façade, still partly visible behind the existing one by Alessandro Galilei, was scarcely begun when the workshop underwent a long period of stasis. The work was resumed only in 1583 on the basis of a design by Giacomo della Porta.

The story of Michelangelo's involvement in the planning stages of the church is long and complex. It began in August 1550, according to his letter to Vasari on the subject of the request by Julius III concerning the Del Monte family funerary monuments planned originally for the Church of San Pietro in Montorio (for the chronology of the Del

Monte Chapel in San Pietro in Montorio, see Nova 1984b). Michelangelo wrote: "[The pope] told me that he was resolved not to put said sepulchers in the Montorio but in the church of the Florentines, and he asked me for my opinion and the design, and I supported him strongly in it, thinking that by this means said church would be completed" (MCXLVIII). This idea of the pope's lasted barely two months. By October 13, he had returned to the site originally planned, probably because of the huge costs he would have had to underwrite for the construction of the Florentine church. On that date, Michelangelo wrote again to Vasari: "There seems not to be anything more for me to think about on the church of the Florentines" (MCLV).

Popp (1927) connected three designs by Michelangelo to the 1550 project for San Giovanni (fig. 464; and Kupferstichkabinett, Dresden, D. 390 and D. 391), a hypothesis shared by Battisti (1961) but having little evidence to support it. Schwager (1975) attributed to Vignola an oval-plan church in the Album of Vittorio Casale preserved in Madrid (Biblioteca Nacionale, Drawings Dept., 16–49, f. 86), and connected it with the idea of Julius III to locate the Del Monte family tombs in San Giovanni. The Vignola plan was copied by Oreste Biringucci (Biblioteca Comunale, Siena, S.IV.1, f. 42v) and by Giovanni Dosio (Uffizi, Florence, Drawings and Prints Dept., A 233; erroneously identified by Ackerman 1961 as a plan related to Michelangelo).

In 1559, probably with the expectation of financial aid from Cosimo I de' Medici, the Florentines again revived the idea of building a church of the Nation in Rome. Vasari (1568) wrote: "Gathering together all the heads of the wealthiest families, promising each by percentage according to their contributions to be remembered in said building, thus they collected a good sum of money; and it was discussed among them whether it was best to follow the old design, or better to make something new. It was resolved that they wanted something new built on the old foundations. And finally they appointed three overseers of this construction, who were

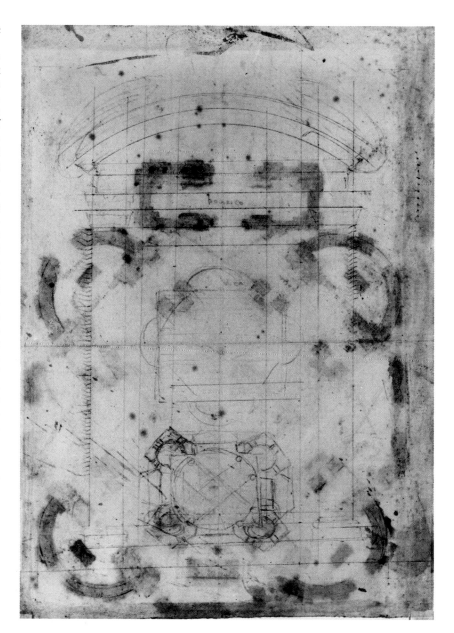

465. *Michelangelo. Study of window, and two ground plans of central-plan church, probably for San Giovanni dei Fiorentini. Casa Buonarroti, Florence, A 120v (C. 610v)*

Francesco Bandini, Uberto Ubaldini, and Tommaso de' Bardi, who requested Michelagnolo for the design, recommending him for it, even though he was the black sheep of the Nation having thrown away so much money, never having profited anything, who, if his virtue was not pleased to finish it, they would have no recourse. He promised them to make it with more devotion than he had ever made anything before, because willingly in his old age he exerted himself on those matters which would prove to be in honor of God, then for the love of his nation, which he always loved." Vasari's account is confirmed by a letter written to Michelangelo on October 26, 1559 by Cosimo I, evidently at the request of the Florentine Nation and probably to sanction his own financial obligation: "You know of the decision which the Florentine Nation recently made there in Rome about carrying forward the construction of the church of San Giovanni, something which pleased us very much. . . . And because all would have to be done in the most economical manner possible, we would pray you, if you don't mind, to put your hand to it a bit, and especially in making a design of good grace and proportion for all those considerations which are there, which could not be reserved to better judgment than your own" (MCCCIII). A few days later, on November 1, 1559, Michelangelo replied to Cosimo: "[I have] already made several designs suitable for the site, which the above mentioned deputies gave me for this work [the number of deputies was five here rather than three as in Vasari]. They, as men of great skill and judgment, chose one of them, which in truth seemed to me the most honorable [and] which will be drawn and designed more clearly than I could, because of my old age, and sent to Your Very Illustrious Lordship; and that one will be followed, as it will appear there" (MCCCV). The fact that Michelangelo, only a few days after the grand duke's request, told him that he had already executed several models, one of which had been chosen by the deputies (although they would submit it on November 10 for approval by Florence), only confirms the impression of a desire to involve

Cosimo in the serious obligation of the construction.

According to Vasari (1568), Michelangelo employed Tiberio Calcagni first to make a plan of the site, then to do a polished copy of the selected design, and finally to execute from this design a terra-cotta model eight *palmi* high, "of which, very pleasing to the whole nation, they had made then a wood model." The wood model existed in the church up to 1720, when it was destroyed (Titi 1763). In March 1560, Tiberio was sent to Cosimo I to show the design in order to convince him to finance the project. A more propitious moment could not have been chosen; that same month, Cosimo's son Giovanni had gone to Rome, accompanied by Vasari, to receive the cardinal's hat from the pope. In the letter which accompanied the plans to be shown to Cosimo, Michelangelo wrote: "These deputies over the construction of the church of the Florentines resolved to send Tiberio Chalchagni to Your Very Illustrious Excellence, which pleased me very much, because with the designs which he carries, it will be, more than with the plan which you saw, only a matter of making it; and if these satisfy, it will be possible to initiate from them, with the help of Your Excellence, the making of the foundations and to carry out this holy task" (MCCCXIX). According to Tiberio, the designs were well-received by Cosimo—"nothing could have pleased him more" (MCCCXXVII). Cosimo himself replied to Michelangelo on March 29, promising that "soon we will resolve this as to how much we are affected" (MCCCXXVI), and later, on April 30, he affirmed: "Your design for the church of the Nation has enamored us" (MCCCXXXII).

On May 2, Tiberio took leave of the grand duke in Pisa, after he had "negotiated with His Very Illustrious Excellence the matters concerning the building of the church of the Florentines (MCCCXXXIII). On May 31, agreements were signed with the master of works Matteo da Castello (Nava 1936) and construction was begun. On the advice of Michelangelo, who was old and too involved with the building of Saint Peter's to undertake more work,

the actual construction was given to Tiberio to direct. Two years later on June 28, 1562, Tiberio was replaced by "Master Guido architect and workman for the construction" (Nava 1936). Due to the death of Cardinal Giovanni de' Medici in 1562 and the loss of interest on the part of Cosimo I consequent to his having spent five thousand ducats, "the allotments for the building were lacking," and the workshop was permanently closed. Construction would not resume on the church until twenty years later under Giacomo della Porta.

From the letters and the account of Vasari (1568), the following events are known. Between July and October 1559, Michelangelo developed "five plans for the most beautiful temples," one of which was selected, "polished up" by Tiberio, and sent to the Medici court on November 10. Tiberio then executed a fairly detailed clay model eight *palmi* high (178 centimeters),

466. *Michelangelo. Two plans for central-plan building, probably for San Giovanni dei Fiorentini. Casa Buonarroti, Florence, A 123 (C. 608)*

467. *Michelangelo. Plan for San Giovanni dei Fiorentini. Casa Buonarroti, Florence, A 120r (C. 610r)*

468. *Michelangelo. Plan for San Giovanni dei Fiorentini. Casa Buonarroti, Florence, A 121r (C. 609r)*

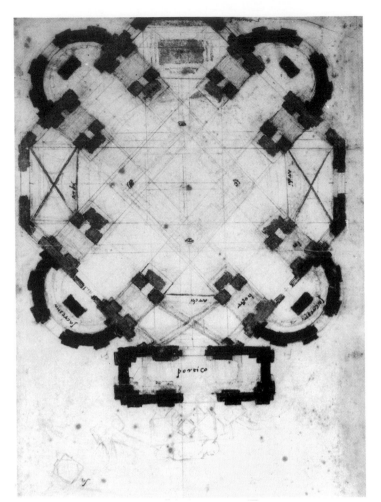

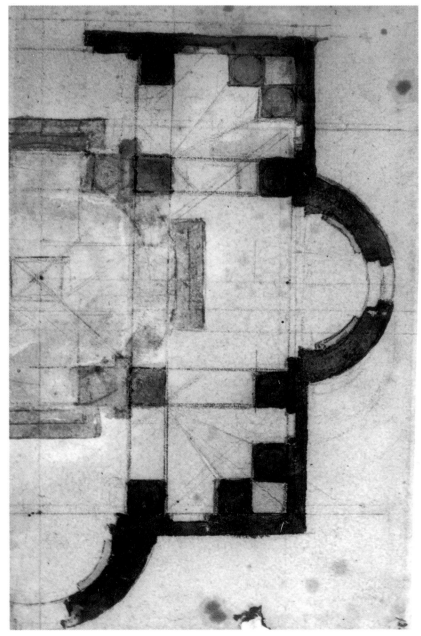

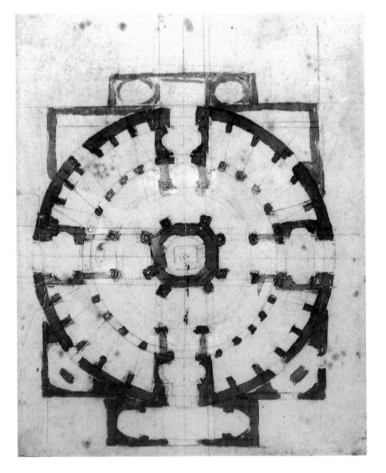

which was followed up with one in wood. Before March 1560, Tiberio executed a new set of ground plans, elevations, and probably sections, of the type more easily understood by laymen. It was these drawings, not the first five variations, which were then taken to Cosimo I.

Frey (1920) identified four sheets by Michelangelo as being unequivocally related to the project for San Giovanni.

Certainly having the quality of a presentation drawing is the ground plan shown in figs. 405/468, which has on its verso architectural studies considered by Tolnay (1932) and Ackerman (1961) to date later than the plan on the recto and immediately prior to the final plan of March 1560. The plan in figs. 406/467 was begun as a presentation drawing yet seems still somewhat experimental (Hirst 1989), although Ackerman

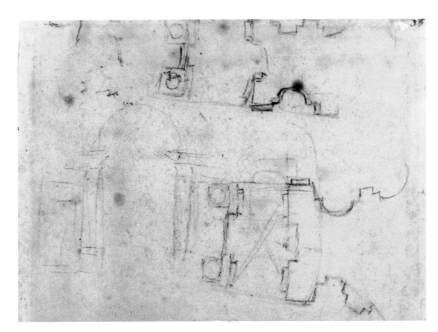

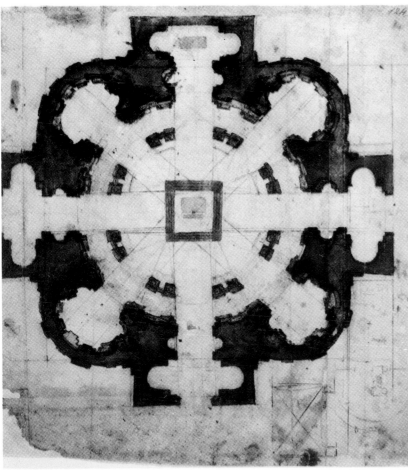

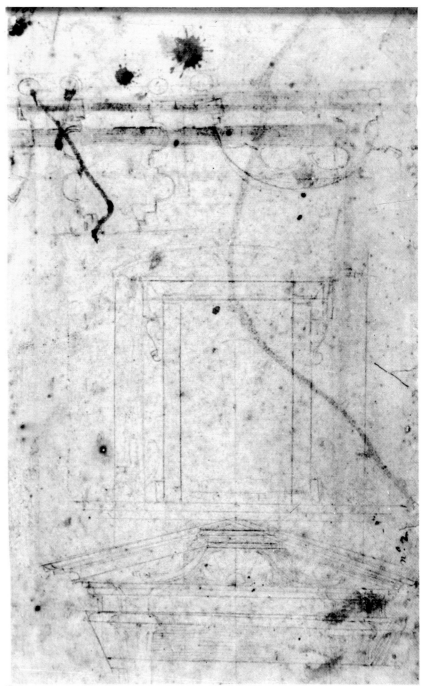

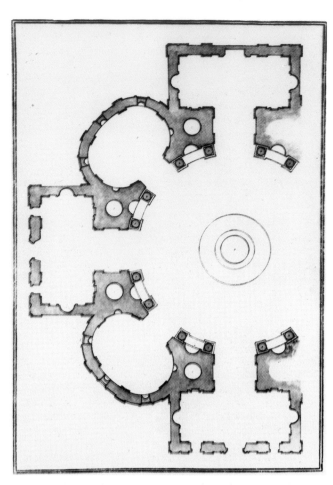

472. *Giovanni Battista Montano (attrib.). Ground plan after Michelangelo's wood model for San Giovanni dei Fiorentini. Ashmolean Museum, Oxford, Talman Cod. X, f. 7*

473. *Oreste Vannocci Biringucci. Copy after Michelangelo's plan for San Giovanni dei Fiorentini. Biblioteca Comunale, Siena, S.IV.1, f. 42r*

474. *Anonymous, 16th c. Copy after Michelangelo's wood model for San Giovanni dei Fiorentini. Staatliche Museen, Berlin, Print Dept., Kdz 20.976*

475. *(below right) Tiberio Calcagni. Plan for San Giovanni dei Fiorentini. Uffizi, Florence, Drawings and Prints Dept., A 3185*

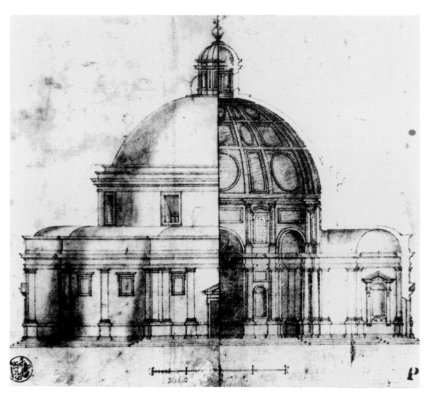

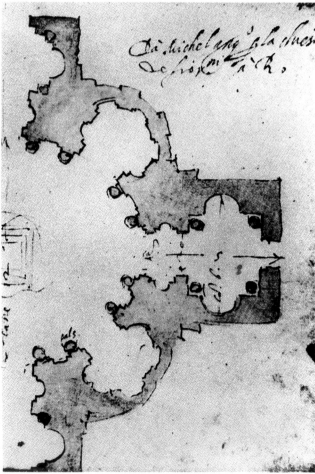

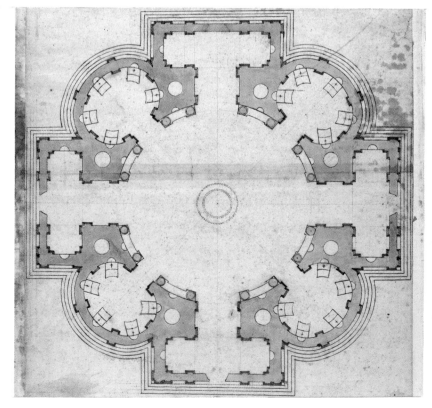

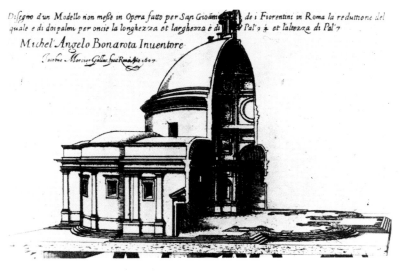

Disegno d'un Modello non messe in Opera fatto per San Giovãi͡ . . . de i Fiorentini in Roma la reduttione del
quale e di doi palmi per oncie la longhezza et larghezza è di . . . Pal'9 ¼ et l'altezza di Pal'7

Michel'Angelo Bonarota Inuentore

Carolus Mercier Gallus fecit Romæ An: 1607.

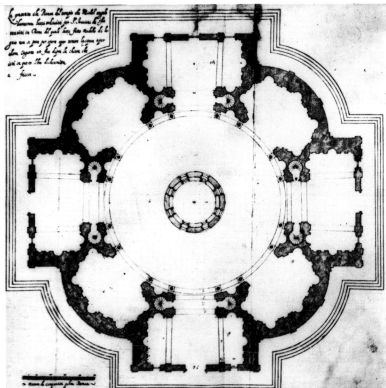

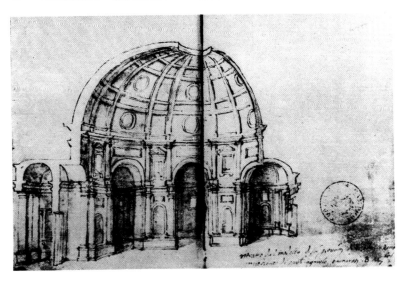

476. *(above) Jacques Le Mercier. Copy after section of Michelangelo's wood model for San Giovanni dei Fiorentini. Print dated 1607*

477. *(center) Giovanni Vincenzo Casale. Ground plan after Michelangelo's plan for San Giovanni dei Fiorentini. Biblioteca Nacional, Madrid, Drawings Dept., Album of Vittorio Casale, f. 174–5*

478. *(below) Giovanni Antonio Dosio. Copy after Michelangelo's wood model for San Giovanni dei Fiorentini. Biblioteca Estense, Modena, ms. Campori App. 1775 = a.Z.2.2. (C. 140v-141r)*

(1961) noted that it was probably to be shown to laymen, as evidenced by the autograph inscriptions, such as "*archi* (arches)," "*in bocte* (barrel vault)," and "*portico* (porch)," thereby clarifying what a professional would have immediately perceived. The verso of this plan (fig. 465) also has architectural sketches probably connected with San Giovanni. The third plan (figs. 107/470) is without doubt very close to if not actually the selected design due to the existence of a rather mediocre copy of it attributed to Tiberio Calcagni (fig. 475). Hirst (1989) recognized not only the highest quality of the third autograph plan but also its graphic complexity, which recalls the manner of Borromini in the drawing of his architectural plans.

Other Michelangelo drawings, all in the Casa Buonarroti, have been connected in various ways to the San Giovanni project. It is unanimously accepted that the studies for a variant of the relationship between the ambulatory and the side chapels in fig. 469 predate the plan in fig. 470. Most scholars, with the notable exceptions of Frey (1920) and Ackerman (1961), agree that fig. 466 is a related study for the church, perhaps in a preliminary phase of approach to the problem. Joannides (1978) recognized that part of a window frame on the verso of the plan in fig. 471 was the lower section of a window whose upper section appears on the verso of the plan in fig. 470 (for the reconstituted window drawing, see fig. 453). From this, he assumed, probably correctly, that the partial ground plan at the top of fig. 471 referred to the chapels of San Giovanni.

There are two certain testimonies for the wood model preserved in the church up until 1720. The first is a 1607 engraving by Jacques Le Mercier (fig. 476) inscribed: "Design of a Model never made for San Gioanni de i Fiorentini in Rome, the reduction of which is of two *palmi* per *oncie*, the length and the width is of 9 1/4 *Palmi* and the height of 7 *Palmi*. Michel Angelo Bonarota Inventor. Jacques Mercier, France, made it in Rome in the Year 1607." The other is a print by Valerien Régnard, published in 1684, which is inscribed: "Elevation of the exterior and interior for the desig-

nated temple of San Giovanni Battista, of the Florentine Nation in Rome, Michaele Angelo Bonnaroto architect." The preparatory drawing for Régnard's print (fig. 474; published in the *Corpus*) was pointed out by Noehles (1969), who also published the plan in fig. 472 (attributed to Giovanni Battista Montano by Karl T. Parker in 1976).

Important differences between the supposedly final ground plan in fig. 470 and the wood model were analyzed by Panofsky (1920). Also, Ackerman (1961) deduced that there was a phase of final ideation on the part of Michelangelo between the final plan and the wood model, judging on the basis of the copy of the plan by Biringucci in fig. 473 and the copy after the wood model by Dosio (fig. 478; Luporini 1957). The Biringucci drawing in all probability reproduced a graphic idea of Michelangelo's close to the solution of the model, which anticipated the elimination of the ambulatory separating the chapels from the central space under the dome. Also valuable here is the indication of the complete measurements of the building created by Michelangelo—twenty-two *canne* overall and twelve *canne* as the maximum diameter of the dome. The total length, at least, coincided with that in Sangallo's final design—220 *palmi* as inscribed on two extant ground plans for it in the Uffizi (Drawings and Prints Dept., A 199 and 200). Thus the request of the patrons to build the new structure "on top of the old foundations" (Vasari 1568) was carried out, while at the same time it was necessary to execute new "foundations" (MCCCXIX), apparently for the lateral areas.

The differences between Dosio's drawing (fig. 478) and the print depictions (figs. 474, 476) after the wood model, as well as the imprecise copy by Giovanni Casale (fig. 477; Battisti 1961), are not so great as to hypothesize, as does Ackerman (1961), that there were two separate wood models. Instead, it is probable that Dosio had access to the clay model prepared under Michelangelo's supervision. If accurately rendered in its details, as some scholars believe, the scale of 1:24 used by Dosio in his drawing would support this, but Ackerman (1961) doubted it.

347

479. *(above) Michelangelo. Sketches of
plans for Sforza Chapel, Santa Maria
Maggiore, Rome; and architectural details.
Casa Buonarroti, Florence, A 104 (C. 624r).*

480. *(below) Michelangelo. Sketch of plan,
perhaps for Sforza Chapel, Santa Maria
Maggiore, Rome. British Museum, London,
1946–7–13–33a-r (C. 623r).*

Following his discussion of the design for the Church of San Giovanni dei Fiorentini, Vasari (1568) added that Michelangelo "had Tiberio [Calcagni] hired, by his order, at Santa Maria Maggiore, on a chapel begun for the cardinal of Santa Fiore, left unfinished because of the death of that cardinal, and of Michelangelo, and of Tiberio, which was a very great loss of that young man." Cardinal Guido Ascanio Sforza, archpriest of the Liberian-era basilica of Santa Maria Maggiore, died in 1564, the same year as Michelangelo, and Tiberio died in December 1565. Stone tablets flanking the entrance to the chapel (Thode 1908–13) record on one the foundation of the chapel and the bequest left by the cardinal with which he charged his heirs to complete the work, and on the other the conclusion of the work in 1573 under Alessandro Sforza, brother of Ascanio, who was also buried in the chapel (his funerary monument was completed in 1582). The name of the architect who continued the work according to Michelangelo's plan after 1565 is not documented, but scholars unanimously agree that it was probably Giacomo della Porta.

The Sforza Chapel is spatially autonomous in relation to the Early Christian basilica-plan church, as is the adjacent Cesi Chapel built in the mid-sixteenth century by Guidetto Guidetti. The original chapel front in a bay of the left side aisle was removed in the eighteenth-century renovation work on the church done under Ferdinando Fuga. It is not clear whether the chapel front was destroyed, as Bottari lamented in two letters to Anton Francesco Gori in the summer of 1748 (Fanfani 1876), or was sold to Cardinal Alessandro Albani for his villa outside the Salaria Gate, as Pier Filippo Strozzi wrote in an unpublished manuscript (Biblioteca Vallicelliana, Bianchini estate, ms. 74; see Anselmi 1990). The appearance of the chapel front has been handed down in prints by Paolo De Angelis (1621), Johann Jakob von Sandrart (1694), and Giovanni Giacomo de Rossi (1713), as well as in an anonymous eighteenth-century watercolor view now in Paris (fig. 483; see Tolnay 1951). A depiction in the *Zibaldone* by A. Paglierini (fig. 482), dat-

able around 1582, was preserved in the Sforza Castle until it was lost in the 1930s (see Heydenreich-Lotz 1974).

Serious doubts about the attribution of the chapel front to Michelangelo were expressed by Ackerman (1961), who saw incongruencies not only in the execution, which certainly took place after Michelangelo's death, but also in the ideation of the work. Portoghesi-Zevi (1964), however, considered Ackerman's strong reservations to be excessive, and Schiavo (1953) and Tolnay (1963) saw analogies between the design of the Sforza Chapel front and that of the courtyard aedicula of the Chapel of Saints Cosmas and Damian for Leo X in Castel Sant'Angelo (see fig. 64). Certainly owed to Michelangelo was the concept of the internal space, and a number of sketches have been related to this. The theme of the formal research for the chapel is similar, or at least analogous, to that of the project for San Giovanni dei Fiorentini, and some of these drawings have been connected alternately to the Sforza Chapel and to San Giovanni. Definitely related to the Sforza project is the ground plan in fig. 479, which shows a small vestibule at the entrance, three alcoves—the lateral ones probably for tombs and the other for the altar, and a square crossing (or a dome, according to Ackerman 1961) supported by four columns embedded at the corners. As an afterthought, Michelangelo added a second column at the corner of the left niche (at the top of the plan), thus reducing the sharp angle formed by the meeting of the vertical elements. This experimental change then became the basis of the final plan. The other sketches on this sheet (the verso is blank, contrary to what Wilde 1953 stated) appear to develop in elevation and ground plan three other solutions independent of the one actually carried out, if they are indeed connected with the chapel.

Probably related to the Sforza Chapel is a sheet of studies for central-plan structures (fig. 481) just slightly earlier than the plan in fig. 479. These seem to indicate a passage from the dynamic complexity of the ground plans for San Giovanni dei Fiorentini to a concentration of space "as a kind of fluid sub-

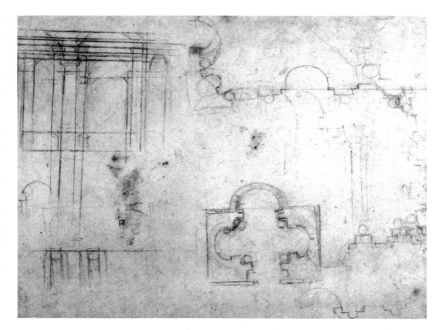

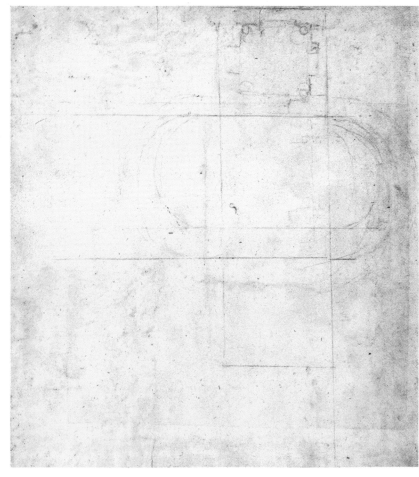

481. *(above left) Michelangelo. Four plans of central-plan building, and architectural details. Casa Buonarroti, Florence, A 109 (C. 625r)*

482. *(below) A. Paglierino (attrib.). Entrance façade of Sforza Chapel, Santa Maria Maggiore, Rome. Formerly, Castello Sforzesco, Milan, Cod. Trivulziano 179 (disappeared between 1935 and 1936)*

483. *(right) Anonymous, 16th c. (previously attrib. to Pier Leone Ghezzi). Entrance façade of Sforza Chapel, Santa Maria Maggiore, Rome. Bibliothèque Nationale, Paris, Dept. of Prints, vol. V b, 69, Topog. Roma*

stance [which] swells in the middle and penetrates from the center into the apses, out of which it flows again to the center" (*Corpus*). This is indeed a characteristic of the Sforza Chapel and, as often noted by scholars, one of the great legacies of Michelangelo to the architecture of the seventeenth century, in particular that of Borromini. The elevation shown in the bottom left corner of fig. 481 could be a first idea for the chapel front inside the church, articulated with three zones separated by giant-order columns.

A sheet in the British Museum (fig. 480), unconvincingly identified by the *Corpus* as a preparatory study for Santa Maria degli Angeli, is very likely connected with the Sforza Chapel, although this is not certain. On the other hand, there is no reason at all to relate to the chapel the sketches of a central-plan building on two sheets in the Ashmolean Museum (figs. 366, 455).

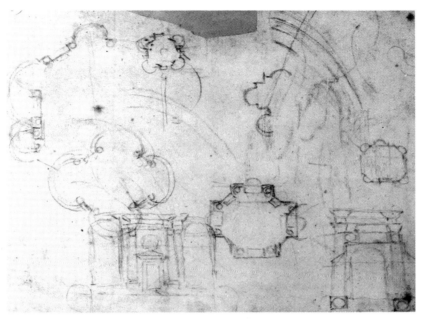

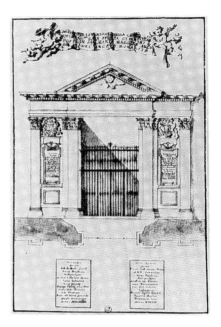

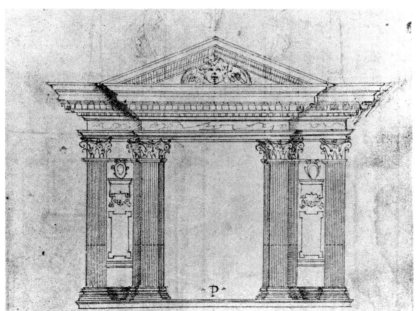

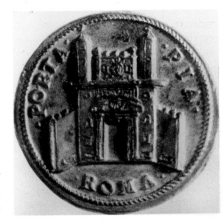

On January 18, 1561, according to a letter from the ambassador of the duke of Mantua in Rome, "[Pius IV] went to the gardens of the former Very Reverend Bellai [Jean du Bellay] to see a roadway called by his name, Pius, for which houses had been torn down and vineyards destroyed, and it begins at Monte Cavallo, and it will end at the city wall between the Sellara [Salaria] Gate and the S. Agnese Gate, between·which two gates will be· constructed, [and] at the meeting point of that road a new gate, which will be called the Pius Gate [Porta Pia]." Just at the beginning of 1561, an urban project was being concretized by Pius IV, who intended to run a wide road straight from the Quirinal up to the Church of Sant'Agnese, more than a kilometer outside the Aurelian Wall, which would join with the straightened Via Nomentana. On January 22, Nanni di Baccio Bigio was paid "for his part of the surveying of the ground taken by said road" (Schwager 1973). On March 24, the monks of San Pietro in Vincoli were compensated for the loss of revenue from tolls caused by the changes in the city wall, which included closing up the Nomentana Gate. The Medici pope appears to have renewed a project already laid out by Paul IV, who, as documented in a letter of the Tuscan ambassador in Rome to Cosimo I de' Medici on September 28, 1558, had asked Michelangelo to design a triple staircase which would join the Quirinal to the Piazza Venezia, "leaving from Santo Salvestro by making three flights of stairs one behind the other, and the first and last of which would be covered, and that of the middle uncovered, and after that would be made a straightaway which would end at Santo Marco" (Ancel 1908).

Even in the absence of sure documentation, the hypothesis advanced by Ackerman (1961) is sufficiently probable that Michelangelo was involved in the planning by Pius IV (see Ferrucci in Fulvio 1588), which would also explain the contemporaneous interest of the artist in the project for Santa Maria degli Angeli. For pertinent observations about the urban context, see Zanghieri (1953), Ackerman (1961), Schwager (1973), and Pietrangeli-Di Gioia-Valeri-Quaglia (1977). For an addition to the general program of Pius IV, see Fagiolo-Madonna (1972 and 1973), and for documents still indispensable for the work, see Bertolotti (1875) and Lanciani (1902–12).

As for the gate, for which the demolition of the old opening was begun in May 1561, we know that on June 18 "Our Holy Lordship [Pius IV] . . . accompanied by many cardinals went through the road made by him named Pia, which today is a very beautiful road, having nearly all that they made nearby most beautiful and high walls with most graceful gates, which lead to these villas, and other decorations, and that was extended up to the city walls, where the Pius gate was made and there the customary ceremony was performed and the first stones laid with different medals inside" (letter from the ambassador of the duke of Mantua, published in Pastor; for the "merriments" on the occasion of laying the cornerstone of the Porta Pia, see Bertolotti 1875).

A few days later, on July 2, the contracts for the construction of the Porta Pia were drawn up between the dean and president for the streets and the masters for the roads, on one side, and the construction superintendents Allegrante Fontana and Alberto da Locarno on the other. Although the main body of the contract did not name the architect, an appended clause established that "master Michelangelo" would be given, in case of full satisfaction, a gratuity of forty to fifty ducats (Gotti 1875). That Michelangelo was the architect responsible for the design of the new gate is also documented by payments received in his name by Pier Luigi Gaeta, "his agent," in 1563–64 (Podestà 1875). Vasari (1568) also recorded that, "sought out . . . by the pope for a design of the Pius gate, Michelangelo made three of them totally extravagant and most beautiful, from which the pope chose to have the least expensive one made, as it can be seen today built with much praise to him. And seeing the mood of the pope, because he wanted to renovate the other gates of Rome, he made many other designs for him."

Other documents refer to the work being carried out for the Porta Pia. In 1561, Gaeta was paid as the "superintendent for said gate" (Gotti 1975). On May 15, 1562, "Jacomo Siciliano [Jacopo del Duca] and Luca, sculptors, [received] twenty ducats on account for the arms in marble for the outside of said gate." Again on November 15, Jacopo del Duca received fifteen ducats "on account for work done and being done" (Gotti 1875). In 1565, Nardo de' Rossi was paid for two angels in travertine to replace two existing *ignudi*, which were taken to be installed on the façade of the Church of San Luigi dei Francesi (Schwager 1973). No more payments were recorded for the gate after the summer of 1565.

The many doubts expressed by scholars aside, it is fairly certain that the attic level, although probably unfinished at Michelangelo's death, was completed in 1565, because the plans of Rome by Mario Cartaro of 1576 and Dupérac of 1577 show the gate with its top section. Only in the fresco view of the Via Pia in the Lateran Palace (fig. 494), painted by Cesare Nebbia after 1587, does the gate appear without the crowning section, which may have been destroyed by an earthquake. The top of the gate was reconstructed in 1853 in an arbitrary manner, but faithful in its intentions to Michelangelo's design, by Virginio Vespignani, who also executed the gate face on the outside of the wall.

A large number of autograph sheets are preserved, which can be related in some way to the project for the Porta Pia or, remembering Vasari's account, to the many designs Michelangelo presented to Pius IV for renovating the other city gates. Also providing evidence to reconstruct Michelangelo's intentions with regard to the Porta Pia is the founding medal by Federico Bonzagni (fig. 484), made before April 1561, as well as a print depiction dated 1568 (fig. 485). The medal represents an idea, sufficiently defined, of Michelangelo's initial design—that is, the least financially burdensome one selected by the pope. Because this image differs in many details from the actual structure, it has been theorized that it was taken either from the design for another gate (inserted into rather than projecting from the wall) or from the design for the exte-

485. *Anonymous. Michelangelo's design for Porta Pia, Rome. Plate dated 1568; published by Faleti, 1568*

486. *Michelangelo. Sketch of portal for Porta Pia, Rome. Casa Buonarroti, Florence, A 99 (C. 617r)*

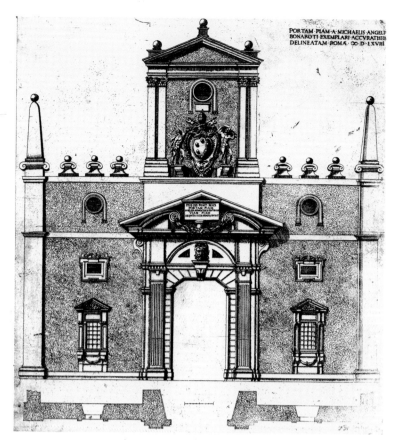

487. *Michelangelo. Study of portal for Porta Pia, Rome. Casa Buonarroti, Florence, A 102r (C. 618r)*

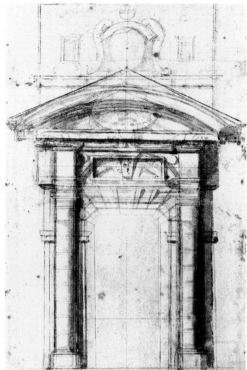

rior face of the Porta Pia. Carefully considered, the first possibility rests only on the inept perspective foreshortening of the side walls, as noted by Schwager (1973). The second, which was supported by Millon-Smyth (1975), is contradicted by a letter of August 1561, in which Tiberio Calcagni mentions to Michelangelo's nephew, Leonardo Buonarroti, that the artist was involved in the "designs for the gate of the part on the outside which has not been made" (Papini 1949).

Schwager (1973) convincingly argued that the print published by Faleti in 1568 represented a study by Michelangelo previous to the definitive one. With regard to the differences in the top section of the existing gate compared to the print view (cf. figs. 415 and 485), Ackerman (1961) considered these to have come about from the ideas of Michelangelo's "successors." Of the autograph drawings, only fig. 486 shows the entire gate, and it should be considered as an early summary study, especially in view of the definition of the dimensional relationships between the bottom zone with the gate opening and the top section, as well as between the gate and the side walls. Due to the similarity of the proportions of the lower and upper sections to those shown in Bonzagni's medal, this drawing can be dated in absolute terms prior to April 1561.

Two more studies for the gate (figs. 414, 487), erroneously assigned to an assistant, are of the highest formal quality and absolutely autograph. On the verso of fig. 414 are sketches of a horse's head and hoof and a human hand (see fig. 517), probably related to the equestrian monument of Henry of France, commissioned from Michelangelo by Catherine de' Medici in 1559–60 (Hartt 1971). Accompanying these are studies of windows and cornices which may relate to the Porta Pia itself (Mac Dougall 1960).

A series of sheets (figs. 488–491, 519, 520; and Uffizi A 108 [C. 622]) have been connected more or less closely with the Porta Pia project, but considering the similarities, some might be connected instead with the designs for the other city gates prepared by Michelangelo for Pius IV. Not autograph,

but certainly assignable to the circle of the artist, is a drawing showing the "kneeling" window of the Porta Pia (fig. 493; Schwager 1973). A sketch of this window is preserved in the Scholz Scrapbook (The Metropolitan Museum of Art, New York, 49.92.56v; illustrated in the *Corpus*, IV, with a reference to the sheet in fig. 517).

The definitive design, except for minor details, was copied in a drawing in the Uffizi, with small corrections and additions of measurements in pencil (fig. 492). Attributed to Giovanni Antonio Dosio by Mac Dougall (1960), it is more likely by Tiberio Calcagni and therefore an operational drawing for the work (Schwager 1973; and Ackerman 1986).

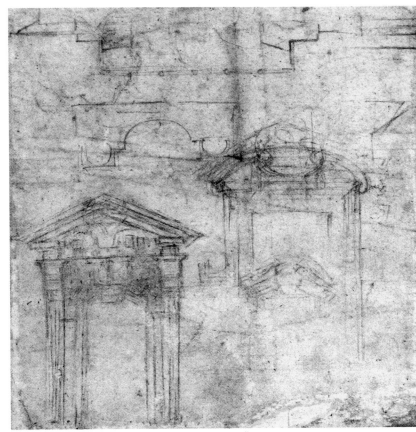

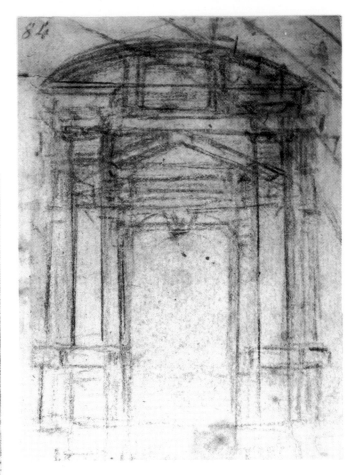

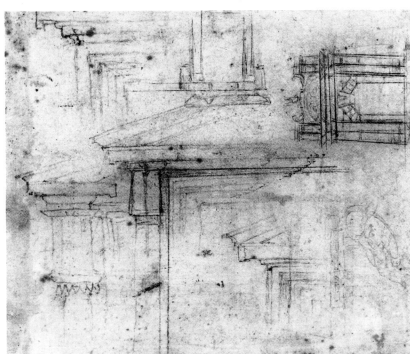

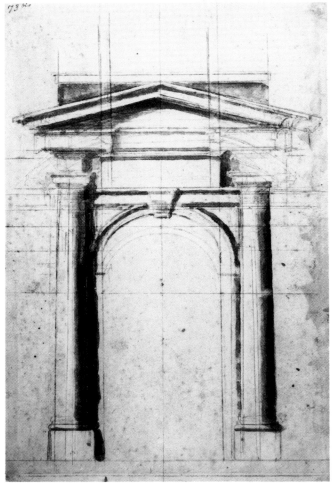

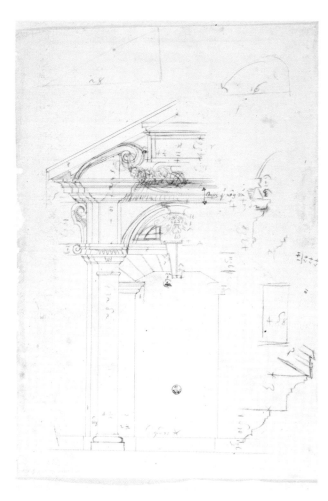

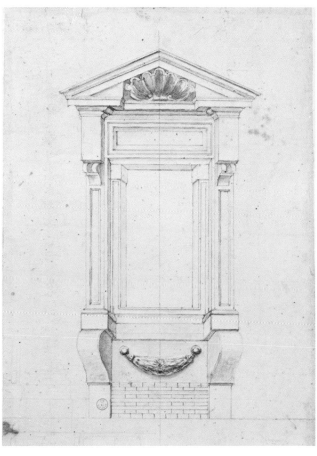

492. *Tiberio Calcagni. Copy after Michelangelo's design for Porta Pia, Rome. Uffizi, Florence, Drawings and Prints Dept., A 2148*

493. *Assistant of Michelangelo. "Kneeling" window of Porta Pia, Rome. Uffizi, Florence, Drawings and Prints Dept., A 2737r*

494. *Cesare Nebbia.* La Via Pia *(fresco). Sala della Conciliazione, Lateran Palace, Rome*

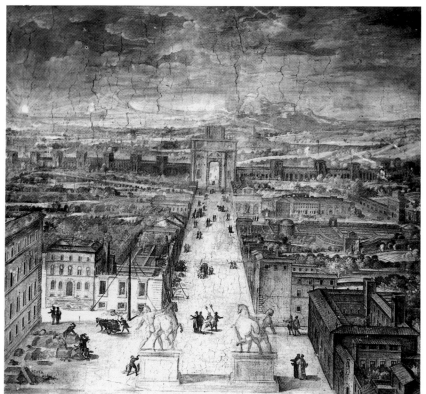

SANTA MARIA DEGLI ANGELI, ROME, 1561–64

Situated at the edge of Rome, almost at the boundary of the Aurelian Wall outside the inhabited area of the city at that time, the gigantic Baths of Diocletian were practically whole and in relatively good condition in the mid-sixteenth century. A ground plan of the complex (fig. 495) with elevations and details on the recto by Antonio da Sangallo the Elder accurately documents this monument of antique architecture. Other graphic records of the Baths are preserved: an ideal reconstruction of a wall of the *tepidarium* (Uffizi, Florence, Drawings and Prints Dept., A 131), also by Antonio the Elder rather than by Giuliano da Sangallo as proposed by Borsi (1985), among others; a drawing by Baldassare Peruzzi (Uffizi, Florence, Drawings and Prints Dept., A 161), usually interpreted as a proposal for the restoration of the Baths in anticipation of a religious use; and a drawing probably by Giovanni Battista da Sangallo called Gobbo (Uffizi, Florence, Drawings and Prints Dept., A 2162).

According to a pious tradition, the Baths were believed to have been built with the labor and blood of Christian martyrs condemned during the last Roman persecutions. The idea for an ecclesiastical reuse of the great hall of the Baths was conceived in 1541 by a Sicilian priest, Antonio Lo Duca, who claimed to have had a vision suggesting the conversion of the pagan edifice into a church dedicated to the angels and consecrating the site of the martyrdom of so many saints (for Lo Duca, see Salvetti 1965). Various problems intervened, as recorded in a chronicle from the end of the sixteenth century kept by a witness to the events, Mattia Catalani (Vatican Apostolic Library, Rome, Vat. Lat. 8735; published in part in Pasquinelli 1925). On August 10, 1550, Julius III issued a bull officially designating the Baths as a Christian temple, and its walls were consecrated five days later. The Classical edifice did not undergo any physical changes; Father Lo Duca was limited to having an entrance opened at the northwest end of the hall and installing some provisional altars (Schiavo 1953). The consecration of an area which the Roman nobility used to "play at ball and hammers, and handle

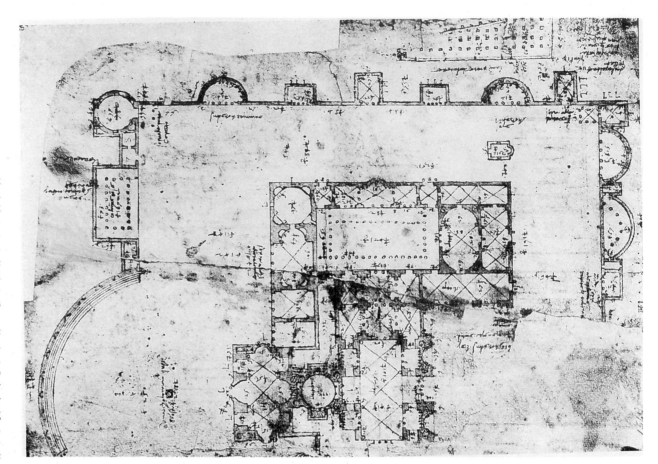

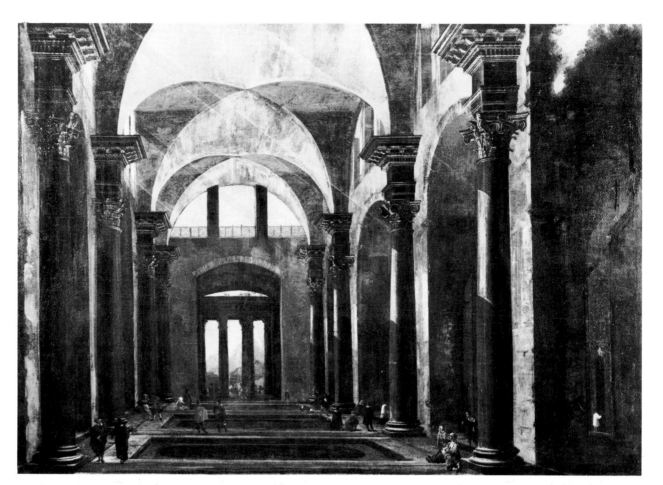

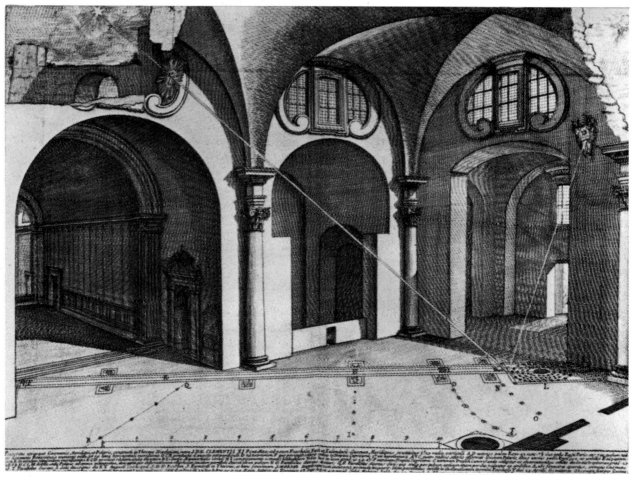

499. (above) Gerolamo Franzini. View of main altar of Santa Maria degli Angeli, Rome. Illustration in Franzini (1588)

500. (below) Anonymous, 17th c. View of choir of Santa Maria degli Angeli, Rome. Illustration in Martinelli (1644)

horses in these surroundings," as Catalani wrote, and on which stood numerous villas, provoked differences with powerful individuals and with the Capitoline administration as well, which had jurisdiction over the Roman antiquities (Siebenhüner 1955). Thus, Lo Duca fell into disgrace and was forced to give up on the Baths.

The project was resumed at the beginning of the pontificate of Pius IV, who, at the same time, began the creation of the contiguous road which led from the Quirinal to the Nomentana, and of the related Porta Pia. According to Vasari (1568), Michelangelo's design for the new church prevailed over "many other matters for the excellent architect." More probable is Catalani's description in which the pope "sent for Michelangilo Bonaroti, and, having told him about his wish to make a church of the most interior part of the Baths, he directed that he go to see and consider the site, and judge the cost that it would be to restore it." Interesting also is Catalani's testimony about the discussion on the orientation of the church structure. The priest Lo Duca, reproposing the previous arrangement of 1550, "had wanted the church to be made longitudinal. . . . Michelangilo appeared to design it in a Cross, and making it smaller and raising the low chapels, he broke through the roof, and thus came about the highest part inside the vault of the antique ceiling which was supported by eight columns. . . . And he designed there three doors, one to the West, another to the North, and the third to the South, as seen placed, and that the main altar was towards the East."

After complex negotiations, and the donation of the land by the cardinals Carlo Borromeo and Alessandro Farnese to construct the convent, Pius IV issued a bull on July 27, 1561 ceding the new church to the Order of Carthusians of the Rome Church of Santa Croce in Gerusalemme and pledging to provide them with sufficient funds to transform the central hall of the Baths. The work was to be directed also "towards the preservation of such a venerated monument of antiquity." The Order itself was obliged to stand the expenses

for the construction of the cloister and the cells for the monks. On August 5, the cornerstone was laid and the *Instrumentum concessionis et conservationis Thermarum Caesaris Diocletianj et illarum adeptae possessionis*, or document of cession, was signed, which was then ratified by the Capitoline administration on August 14. The construction, which had resumed in April 1563 after a short suspension, was described by Catalani: "[Michelangelo] first covered the main vault with large boards. From the foundations he made the great chapel with the tribune, [and] he opened the door towards the west and enclosed the body of the church by two walls. In one, he made the door towards the north, [and] in the other he built the door towards the south, and he began to plaster the ceilings."

At Michelangelo's death, the church was on the verge of completion. In January 1565, Jacopo del Duca, a nephew of the Sicilian priest, and Jacopo Rocchetto were commissioned to make a bronze ciborium for the main altar after a design by Michelangelo (fig. 502; now in the Carthusian monastery at Padula). In May, the first mass was celebrated in the nearly completed Church of Santa Maria degli Angeli, which Pius had established as a titular church with his nephew, Cardinal Giovanni Antonio Serbelloni, at its head.

The pope's death in December 1565 brought the construction to a temporary halt due to the lack of assured funding. Nevertheless, the work on the body of the church was completed by June 1566, and the reckoning of overall costs came to only 17,492 ducats (Lanciani 1902–12). The cloister, whose construction was the responsibility of the Carthusians, was just barely under way, however. The minimal total cost of the conversion for the church, which was equal to only about twice what was paid for the construction of the Porta Pia (Ackerman 1961), demonstrated that Michelangelo's intervention had in effect involved very little work. This comprised the construction of simple "pluggings" to create the two vestibules on the larger axis from northwest to southeast (fig. 418, labeled E and F), while the main vestibule at the entrance

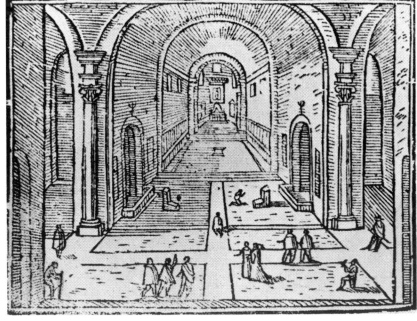

501. *Complex of Baths of Diocletian and Church of Santa Maria degli Angeli, Rome (aerial view, bottom half)*

502. *Jacopo del Duca. Tabernacle, formerly in Santa Maria degli Angeli, Rome. Bronze, Carthusian Monastery, Padula*

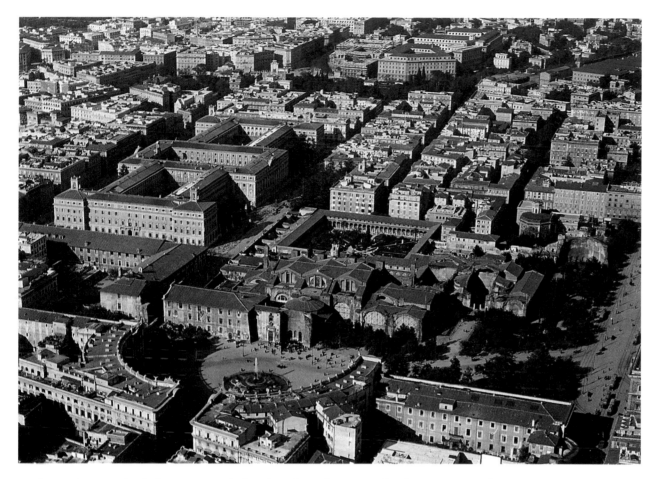

on the southwest utilized the existing rotunda between the great hall and the ruins of the *calidarium*. On new foundations, he built the apse to contain a deep choir for the monks, which was necessary for liturgical reasons.

In the large central space, Michelangelo's concept required minimal work, probably limited to covering the vaulted ceilings with new roofs and applying new plaster and whitewash (see fig. 419). He also replaced a missing capital on one of the eight colossal antique columns (the bases belong probably to the time of Gregory XIII, when the church floor was repaved in 1570). The large windows were divided vertically by two plain struts, as seen in Gerolamo Franzini's illustration for his 1588 book on the sights of Rome (fig. 499). The curious volute frames shown in the interior view of the church published by Bianchini in 1703 (fig. 498) were added

before the eighteenth century. The choir designed by Michelangelo was eventually torn down and rebuilt in a larger form on the design of Vanvitelli between 1763 and 1794 (Schiavo 1954). Therefore, an idea of Michelangelo's original design can only be interpolated from these book illustrations of 1588 and 1703, and a woodcut illustration in the guide to Rome of 1644 by Fioravante Martinelli (fig. 500). The latter shows a long, barrel-vaulted choir beyond an initial bay, created in the former corridor from the great hall to the *frigidarium*. The earliest illustration (fig. 499) shows a single altar (made of wood up to 1596), not at the back of the choir but at the front, at the entrance to the deep apse framed by two columns supporting a cornice. This is probably the original arrangement, modified later on perhaps due to the opening up of two side chapels off the nave (see fig. 500).

From the beginning, the two side entrances to the church had very plain portals, as seen in the earliest known depiction, Giovanni Dosio's view of the southeast entrance (fig. 496), which shows no style characteristics typical of Michelangelo (Ackerman 1961). No evidence exists to define Michelangelo's design for the main vestibule, which Vasari (1568) called "an entrance beyond the belief of all the architects." In 1577 the vestibule rotunda had a lantern, shown in Dupérac's plan of Rome published that year, but there is insufficient data to determine if this was owed to Michelangelo. Nor do we know anything about the concave façade, and it is possible that the death of the artist, or of Pius IV, deprived the "continuers" of the opportunity to solve the problem, if it had ever been posed. Finally, it is not known how much was changed in the major transformation carried out in the

eighteenth century by Vanvitelli, who rendered unrecognizable the last "architecture" of Michelangelo (for appraisals of Vanvitelli's intervention, see Bottari 1754, and Milizia 1768 and 1781).

Confirming how deeply misunderstood this final, original, creative "gesture" of Michelangelo was, his patron Pius IV, before his death, already had the intention of decorating the "nakedness" of the church (Meliù 1950). As a result of renovations at the end of the sixteenth century and at the beginning of the seventeenth, with the enclosure of the two lateral arms to make two large chapels, as well as in the mid-eighteenth century with the addition of abundant and ostentatious "ornamentation," the scenographic effect of Michelangelo's austere, not-finished design for the Church of Santa Maria degli Angeli was changed entirely.

THE ARCHITECTURAL LEGACY

"My soul which speaks with death." Poems, 22

What were the effects of the architecture of Michelangelo on the history of art? His work created neither a "school" nor a theory, and its immediate impact was minimal and digressive. Only in the seventeenth century, with Bernini and Borromini, was it recognized as a problem demanding a clear knowledge of its range on the part of a culture defining itself as modern, even at the risk of arriving at a scarcely mitigated condemnation, as did Francesco Milizia.

In the unitary concept of art which Michelangelo had, architecture was not a ramification but a necessary component. In a life where every instant was vigorously lived, no single experience was stronger than the others and all were desired. Those contemporaries and later critics were in error who believed that his architecture and poetry were marginal activities, one a duty and the other a soothing diversion. In terms of the art that he loved and made as a result of an internal imperative, it is very likely that Michelangelo himself preferred sculpture, and maybe also painting. Architecture was not his profession, but what mattered to him were intellectual and religious undertakings, and, when he was old, he felt compelled to leave everything else and make only architecture. The "fables of the world" had deprived him of the time to contemplate God, and the building of Saint Peter's, in his mind, was contemplation of God. While he was involved with this, he was unable to execute both naturalistic metaphor and pure conceptualism, and, as a result, there was a meditated, suffered transition from representational art to architecture. Architecture was the final shaping of his concept of art, even though it was achieved through many renunciations. Yet what could the legacy of a great believer be except the call to renunciation?

He was by nature brilliant and wise, and he never did anything that he didn't want to do, even when, later, what he had promised to do constrained what he chose to do. Close to dying, he decided to renounce making architecture, just as earlier he had renounced making sculpture and painting. His abstention from the active construction of the Church of Santa Maria degli Angeli was not "not-doing" but doing in a nonmaterial, invisible way—an act or gesture between magical and baptismal, which changed pagan into Christian. With that gesture he finished everything: "No one has the whole garment before the very end of art and life."

Renunciation was the final word of his legacy. With it, as with the *Rondanini Pietà*, he consciously, almost voluntarily, made his entrance into nothingness. What was the outcome of that gesture? A great deal—a rigorous process of intellectual and religious ascent and the liberation of art from materiality and "manuality." But of greatest importance, it established the expiration and sanctioned the end of what was judged to be the golden age of art and the triumph of creativity—the Renaissance. In his youth, Michelangelo had been one of the most acclaimed, although the most independent, of the protagonists of that cultural manifestation. And it was he who determined, already with the Biblical vision of the Sistine Ceiling, the radical revolution (not Copernican, but the contrary) from Renaissance to Mannerism, for which the history of the building of the new Saint Peter's

was practically a diagram. The first design by Bramante was an image of the perfect equilibrium and the unshakable stability of the religious and political values which the Church represented. The church-as-edifice would be the image of the Church-as-institution for Michelangelo as well, but the historical circumstances had changed dramatically. The Church of Rome was under attack and had to be defended. The Saint Peter's of Michelangelo was the image of the doctrinal unity of Christians and, at the same time, of the implored, then exalted, and finally satisfied longing for God. Bernini later changed this image of struggle into one of victory.

Michelangelo's greatest polemical focus was not the authoritarian classicism of the Rome school of architecture. His anti-Leonardoism had not stopped with the death of Leonardo, and it continued as the radical refutation of a conception of art, of the world, and of moral life which was contrary to and, in terms of declared progressism, apparently more open and permissive than his own. The difference was moral, because Michelangelo was a deeply believing laic, and Leonardo was nonreligious. It was also cultural, because Leonardo was not interested in the antique, which, for Michelangelo, was an unavoidable problem. But the major antagonism was of a theoretical nature. For Leonardo, there were no disciplinary boundaries. Everything was knowledge, and art itself was a means and a method for the analysis and description of natural phenomena. Moreover, the phenomenal area was in continuous expansion, as if the universe were continuously and spontaneously in the process of being created. Michelangelo opposed Leonardo's unbounded gnoseologism with a strict ontologism. The problem of "being" preceded that of "knowing," and "subject" preceded "object." A religious postulate was implicit—God gave humanity existence and the capacity to know the world, but there was no claim that knowledge of God could be attained through knowledge of the world.

Everything in the work of Michelangelo was coherent within that ontological premise. Through the vision (the Sistine Ceiling), God gave the world certain enigmatic signs of his own Being. The idea of existence was not achieved without the idea of death (the dominant theme of his sculpture), and God would be revealed at the end of humanity in the role of judge (*The Last Judgment*). The necessary consequence of that ontologism was the identification of intellectual life with religious life (the Pauline Chapel frescoes), which led to the renunciation of worldly appearances. As a result, Michelangelo separated himself forever from the contemplation of representation and devoted his art, as well as his existence, to the service of God—that is to say, to the service of the Church. He ceased doing sculpture and painting, which were constitutionally allegorical discourses, and limited himself to making almost nothing but architecture—then, at the end, making only Saint Peter's. All of the architecture he designed was directly or indirectly in the orbit of that theological obligation.

Thinking of art as existence meant confronting the problem of Self and Other, of the genesis and destiny of humanity, and of its past, present, and future. In his search for the form of the greatest temple of Christianity, how could this deeply religious artist not have asked himself which would be, then and later on, the winning card—his wholly vertical ontologism, or Leonardo's wholly horizontal gnoseologism? Nothing could be more progressist and progressive than Leonardo's binomial of art and science. Unified with that artist's unprejudiced experimentalism were an enlightened secularism, an inexhaustible curiosity about the world, a penetrating spirit of research, and an identification of Self with Other. One could not imagine a mentality more open towards a modernity in which the hegemony would be science. But was this futuristic approach not a scientism which had its roots in medieval mechanics? Was it true modernity to avoid confrontation with the antique? Only much later, with Galileo, did science define its true contours, declare its own disciplinary autonomy, and establish its own methodology. And it didn't require the connivance of art, which it saw as the protagonist of a preceding, surpassed culture.

In the sixteenth century, the major problem was in fact not that of the science of the future, but the religious conflict in progress. And in that dangerous diverging of the two concepts of the divine and the human, it was certainly not Leonardo's skepticism but the tenacious, even though troubled, fideism of Michelangelo which was more useful. The new Saint Peter's was, objectively speaking, the strongest doctrinal response to the Lutheran protest. The ideologically charged art of Michelangelo was understood and promptly put to use by Paul III. Moreover, in that emergency state of affairs, the pope used it for its neoplatonic roots, because neoplatonism was actually, through the Pauline and Augustinian tradition, the philosophy of the Reform. To accept as orthodox doctrine the neoplatonic ontologism of Michelangelo was to carry the dispute onto the adversary's own ground.

Also, the importance of the antique with regard to the present entered into the religious problem, because the Reformist philosophy had a humanistic foundation. Leonardo had impartially taken away the authority of history, because memory mitigated the vividness of physical perceptions. Antiquity was an organic problem for Rome, because it was a modern city superimposed upon an ancient one, yet it obviously had other needs with regard to its urban life and development. The relationship between antique and modern was, in objective terms, a difficulty which had to be resolved. Michelangelo did not consider himself to be modern as the result of a tradition which progressed and matured in his work, but rather because he put himself in opposition to the antique. Even though the antique obviously fascinated him, he did not make it a model by imitation. Consequently, he rejected the theory of *renovatio urbis* and conceived of the city as an assemblage of places invested with potential significance. The generative nucleus remained Saint Peter's, but it was echoed in the city; the church-Church would not be a prototype but a characterizing element. Given the stratified and diffused sacredness of Rome, it would not be a matter of physical connections but of the association of ideas.

The Church of San Giovanni dei Fiorentini was the daughter of the Vatican edifice. The site, which was already fixed, seemed to Michelangelo

503. *Michelangelo. Study of architectural pediment, and poem drafts. Archivio Buonarroti, Florence, XIII, f. 160r (C. 366r)*

504. *Michelangelo. Two sketches of tabernacles (perhaps for San Silvestro in Capite), and profile of a sarcophagus. Casa Buonarroti, Florence, A 110r (C. 175r)*

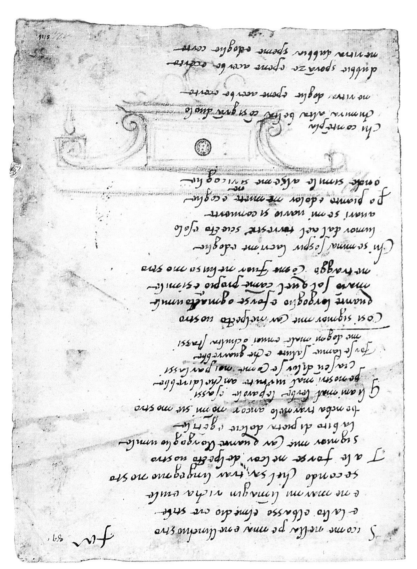

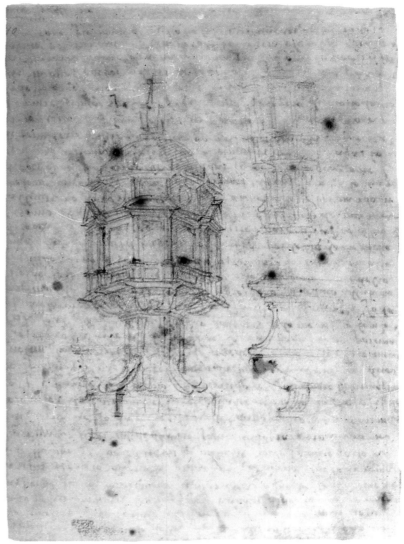

to have been predestined. He liked the idea of inflecting there, in terms of the community of the city, the doctrinal themes which he had developed in Saint Peter's with regard to the Christian ecumene. San Giovanni would be both church and crossroads. Its assonant relationship with the rounded volumes of Castel Sant'Angelo on the other bank of the Tiber and with Saint Peter's at the apex of the triangle would thus reaffirm his intention to make the Vatican church the pivotal point of an urban composition.

The circumstance of the Sforza Chapel in the Church of Santa Maria Maggiore was different, but it demonstrated with equal force the reduction of art to a purely intellectual act in the mind of the elderly artist. It showed that making art could be thought, and, inversely, thinking could be making, with all its inherent responsibilities. The original design, of which the constructed chapel was a "copy," was undoubtedly only a ground plan, but resolved and conclusive like those for the Church of San Giovanni dei Fiorentini. Those scholars who often labor and search in vain to reconstruct from Michelangelo's ground plans their nonexistent elevations ought to pursue the reverse path in this case. They should, if it is possible, reconstruct from the existing but mediocre elevation the highest architectonic concept of the aged Michelangelo, who was satisfied by the design of the ground plan and went no further. Perhaps no architectural design could ever be as cogent or as potentially structural and plastic as that which was lost.

Michelangelo naturally could not foresee the circumstances in which the interpretation of his architectural design would result in mediocrity, but it is clear that he wanted the design to be self-sufficient. Like a musical composition, it would be complete within itself but susceptible to different interpretations. Nevertheless, the more the architecture was reduced to pure design, the more the design disclosed its own intrinsic representationalism, in spite of the absence of any apparent verisimilitude. Even in the constructed copy, it can be seen that the juncture between the gentle curve of the chapel wall and the projecting pilaster is like a deep armpit between the chest and the muscular arm of a human figure. Thus, all that remains to be asked is whether the chapel was figural architecture or de-figured sculpture. Even that doesn't really matter, given the fact that Michelangelo no longer thought about the dialectical synthesis of the arts. No longer was it a combining, but rather it was a sedimenting out of indelible experiences which resurfaced, perhaps unrecognizable, in the mind of the old master for whom the past was something voluntarily both renounced and proffered. He wanted nothing more than to finish his art and his life together.

With the Sforza Chapel, this modest copy of a great original, was brought to an end the most heroic of Michelangelo's intellectual virtues—the design. That this was the point in the planning process common to all three arts was generally accepted, but Michelangelo made it the theoretical principle of the conceptual unity of art. He was a religious man, and he had been mandated by the pope to make the Visible Church a visual reality. He embarked on this fearing that the salvation of his soul depended on the completion of the

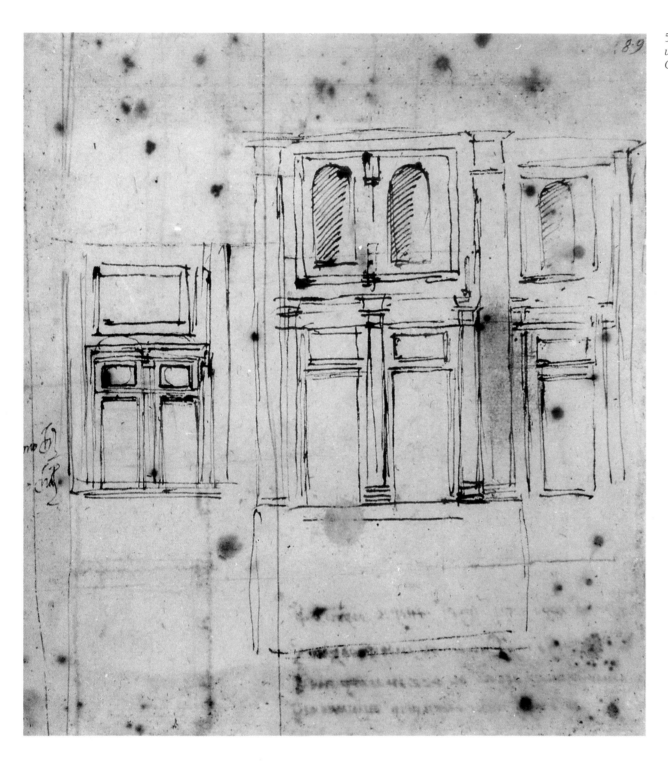

506. *Michelangelo. Elevation of wall of vestibule of Laurentian Library, Florence. Casa Buonarroti, Florence, A 89r (C. 524r)*

507. *Michelangelo. Profile of column base for double tomb of the Magnificents in New Sacristy, San Lorenzo, Florence. Casa Buonarroti, Florence, A 59r (C. 204r)*

508. *Michelangelo. Profile of cornice for vestibule of Laurentian Library, Florence. Casa Buonarroti, Florence, A 62 (C. 532r)*

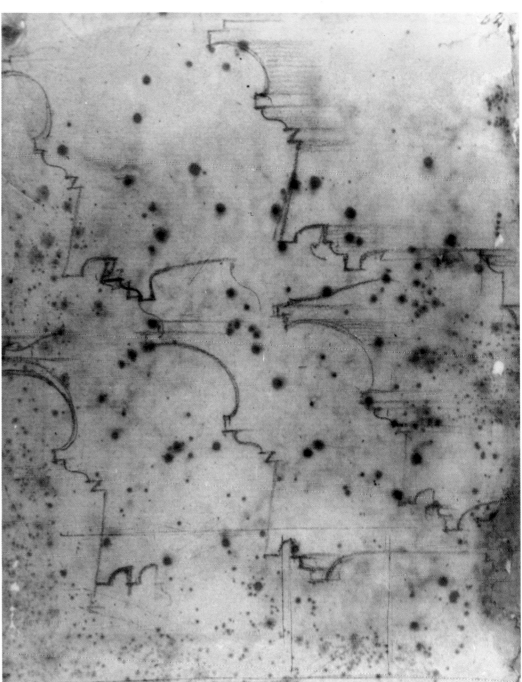

work, and he identified his whole past, present, and future self with the undertaking. Whatever else he did or planned would be a sin (even though this was objectively impossible), unless it were closely connected with the problem of Saint Peter's. And yet the last two works on which he meditated, the Porta Pia and the Church of Santa Maria degli Angeli, were not connected to it. But were these really new works, or only the final thoughts of the artist about the essence of art?

The Porta Pia was a city gate, which was a simulated fortification and a charming urban decoration. Represented there were not really structures but rhymed symmetries. The portals, windows, cartouches, and battlements were nothing but insignia, and, lacking conceptual content, the gate was a frivolous, spaced-out construction where symbol was everything, yet symbol was emblem—the distinctive emblem of ceremonial protocol. Why did Michelangelo, who had made of Saint Peter's a *summa theologica*, offer his services in his old age on this bagatelle? Was it perhaps a kind of blessing bestowed by an indulgent patriarch on all future architectonic license? Or was it to show that in art even a light-hearted theme demanded the rigor of design? Austere classicistic formalism also had its moderately extravagant counterpart legitimated by the Roman *grottesche*, but this did not serve Michelangelo, for whom the antique was a problem and not a patron saint. The Via Pia was the most modern road in Rome, so his gate would be modern—and modern was simply the opposite of the antique. He didn't alter the icons of the antique lexicon, he deconstructed them, destroying their meaning. There was also a contradiction in the theme, which involved images of force without real force. The two, or maybe three, portals embedded one in the other were repeated without being summarized, and the drawings show how much he studied that transition by exaggeration from the constructed to the ornamented. Deconstruction de-signified the forms, but, at the same time, it intensified their visual clarity.

In his *Poems*, de-signification accompanied by phonetic intensification was frequent. In the following passages, the rhythm was created by the colliding of the "r"-sounds: "*Di fior sopra ' crin d'or d'una grillanda* (Of the flowers over the golden locks, of a garland)"; and "*El passo dier libero ai fier dardi* (The pass of yesterday set free the fierce arrows)." And in these examples, the slipperiness of the "s"-sounds was the controlling factor: "*E sai ch'io so che tu sa' ch'i' son desso* (And you know that I know that you know that I am he)"; and "*Non so se s'è la desiata luce* (I do not know if there is the desired light)." Both the visual quality and the phonetic intensification signified strong, immediate perception. For Michelangelo this was the absolute present, which was the necessary counterpart of concept. The antique was concept, therefore associating it with intensified perception was a *coincidentia oppositorum*, a coincidence of opposites.

The modern was light, voluble, and changing, while the antique was profound and immutable. The Porta Pia and Santa Maria degli Angeli were works contiguous in time and space, thus they were complementaries in the mind and in the legacy of Michelangelo *in limine vita*. Michelangelo designed

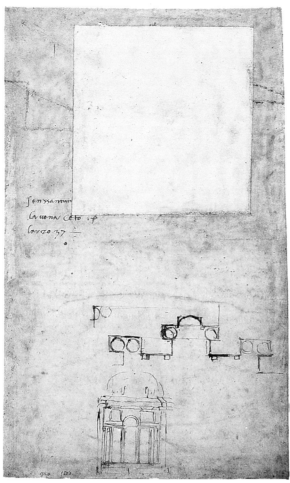

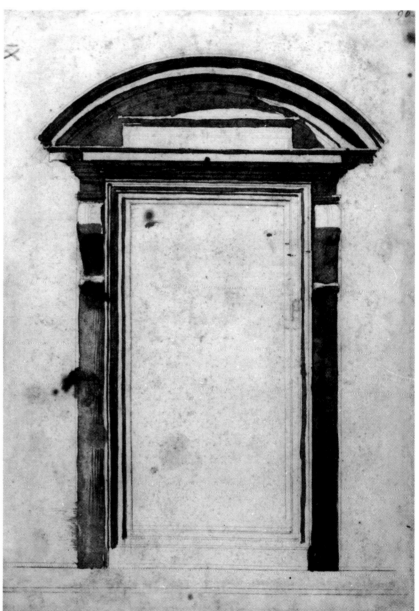

510. *Michelangelo. Design for wall of vestibule, or of chapel, for Laurentian Library, Florence. British Museum, London, 1946–7–13–33r (C. 561r)*

511. *Michelangelo. Profile of desk for Laurentian Library, Florence. Archivio Buonarroti, Florence, I, 80, f. 218 (C. 556r)*

512. *Michelangelo. Study for door from vestibule into reading room of Laurentian Library, Florence. Casa Buonarroti, Florence, A 96r (C. 551r)*

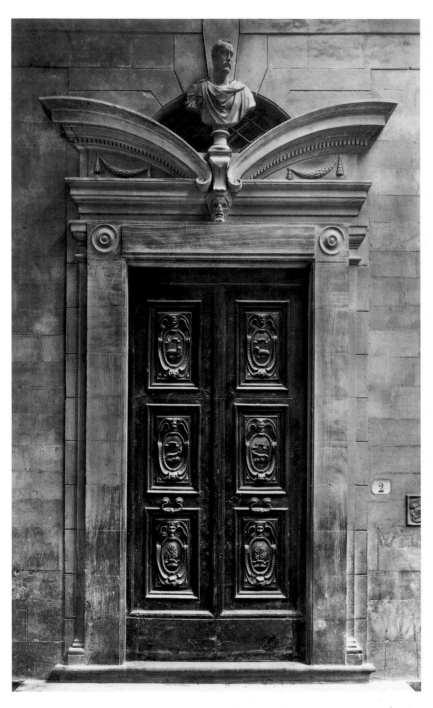

the church in the Baths of Diocletian without planning, thus leaving the ancient structure intact but rethought. Earlier, in other situations, he had demonstrated a strict respect for the antique, which might seem and in a certain sense was a modern manner of behavior. He rejected the ideology of the "rebirth" of the antique in terms of making it modern. The antique was what it was, and it could not be changed except by miraculous intervention. In that case, the Lord would entrust it to the artist as one of his representatives on earth, and its character would therefore not be that of cultivated skill—less humanistic and more human, as Leonardo would have it—but of inspired genius. From that time to ours, in fact, making art has been a kind of priesthood, sometimes rebellious or heretical and for that reason condemned, and then rehabilitated as a different but authentic sign of the Divine—just as it happened with Michelangelo and *The Last Judgment*.

With the extravagant design of the Porta Pia, Michelangelo declared that art was by its very nature irrational. The opposite of rationality was fantasy, which did not have a rule according to nature but had its own internal rigor—design. This was not verisimilitude according to the Ciceronian rhetoric of classicism, but it was thinkable, and that was enough. In Santa Maria degli Angeli, he did not abstain because of archaeological scruples. Instead, he proclaimed that, from this moment on, making art was no longer making objects, it was making ideas. This allowed for the renunciation of action, or rather the action of renunciation. What was modern or romantic art if not an exception to the bourgeois ethic of acquisition and profit?

Transferring art from the gnoseological to the ontological sphere, Michelangelo tied it to existence, but there was no thought of existence which was not also a thought of death—that was the end and the aim. There was no sonnet or madrigal from his poetry-diary in which, directly or indirectly, death did not appear: "Everything arrives at death"; "my soul which speaks with death"; "dying to myself, I live"; "in me death, in you my life"; "death and sorrow for which I long and search"; "already being nearly in the number of the dead"; "he who lives by death never dies"; and "you yourself in dying made dead and divine." These are only a few citations from among many possibilities; life and death were coinciding opposites.

There was no idea conceived by him, he said, in which death was not carved. This was a sculptor who said this, for whom sculpture was a making and a wanting to make. Sculpture was made by way of removing, and Michelangelo, as he said many times, loved the material which he sacrificed to the spirituality of his art. For him, sculpture was the first—no, the model—of all the arts, consequently there was a profound connection in his mind between art and death. Thus, the ontological and monistic bond between art and death was the conception of art as a renunciation of the world and a surpassing of existence in life.

This was the idea left by Michelangelo to the modern world by that final gesture which was the synthesis of the whole of his life. As Schopenhauer will say, "Death is the inspiring genius of philosophy." But the great artist's legacy was not received by the architects who came immediately after him.

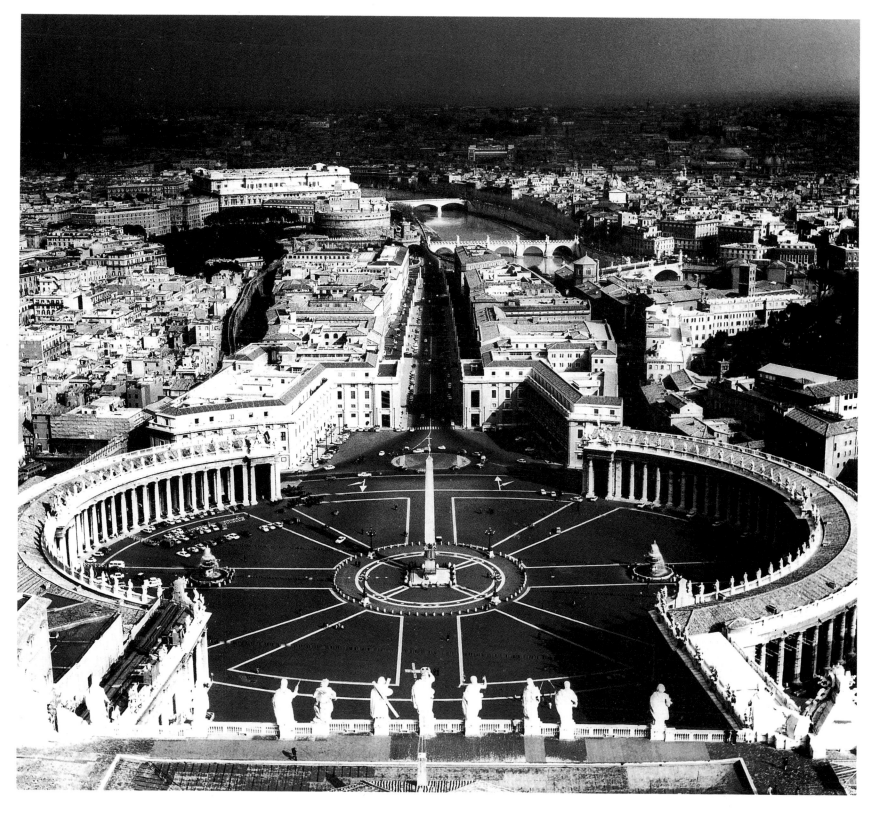

514. *Saint Peter's in the Vatican, piazza and colonnade by Gianlorenzo Bernini*

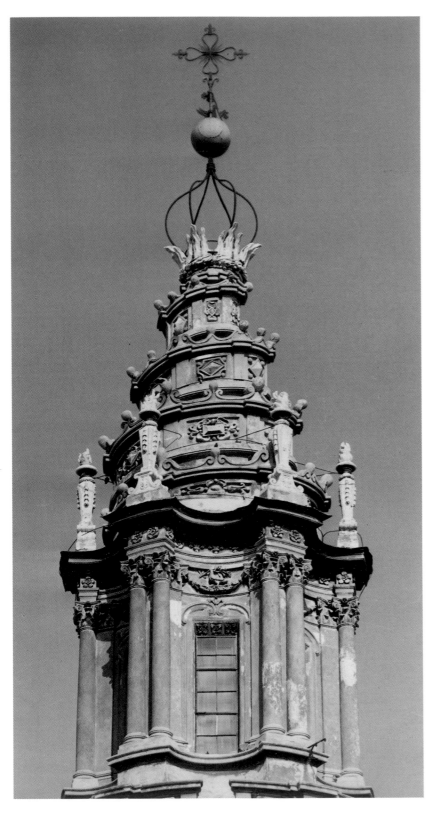

515. Sant'Ivo alla Sapienza, Rome, by
Francesco Borromini, detail of dome and
lantern

They instead quickly resigned themselves to a utilitarian mediocrity which
discounted the genius of this "divinity." It is true that Buontalenti, the
extremist of Mannerism, surpassed them, but he was only able to derive
from that inaccessible genius a useful inventiveness. Thus, the hypocritical
legend was born of Michelangelo as the uncorrupted father of corrupted
sons—a great artist but a bad and dangerous master. In actuality, he left no
resolved problems to posterity; on the contrary, he himself posed a very
difficult problem, which had to be resolutely confronted in order to go
forward. Confronting it, of course, meant clearly distinguishing between
Michelangelo and Michelangeloism.

He was not a classicist, and he did not impart dogmas or precepts. His
neoplatonic thinking about the coincidence of opposites in reality only
caused him to translate the desperate uncertainty which was the human
soul into philosophy. He left neither an apodictic conception of art nor a
liberal openness towards individual choices. Art was necessarily a choice
between contraries which would ultimately be integrated, as it was in the
second half of the sixteenth century between the Romans and the
Venetians—between drawing and color. But Michelangelo himself was a
genius who could be interpreted in different or even contrary ways. Had he
been the great creator, or the prime destroyer, of the "rebirth" which seemed
to have brought modern art to the perfection of the antique? His work—the
architecture more than the painting and sculpture—was not given as a
theoretical certainty but as a problem. He imposed decisive choices tied to
the problematic aspect of existence, something which required either
acceptance or rejection. These very difficulties, contradictions, and self-
criticisms of Michelangelo impeded all scholastic Michelangeloism.

The only architect of the second half of the sixteenth century on a level to
compete ideally with him was Palladio. At the time when Palladio lived in
Rome, he was particularly close to the classicism descended from Bramante.
He would have seen practically nothing of Michelangelo's constructed
architecture, but he could not have been unaware of this master's plans for
the Campidoglio and Saint Peter's. Palladio's contrary position was clear; he
subordinated architecture to a prearranged urban order, aimed it towards a
dominant social class, and formulated it in completely different terms,
although with the same awareness of the necessity for clarity in the relation-
ship of antique and modern. His treatise of 1570 was the contrary of
Vignola's architectural manual. The antique for him was not a rule but an
active factor in the planning process. But, intentionally or not, his insistent
quotation of it was the contrary, certainly not casual, of the deliberate
nonintervention of Michelangelo in Santa Maria degli Angeli, which was an
act of respect for the antique document but also an admission of the
irreconcilability of the antique source with modern planning. Palladio's
philologism was anticlassical because it was functional and not normative,
but it was an anticlassicism of an opposite sign compared to that of
Michelangelo. Less than ten years separated the untouched antiquity of
Santa Maria degli Angeli from the total absorption of the antique and the

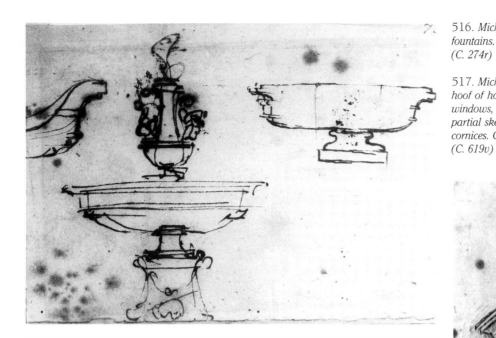

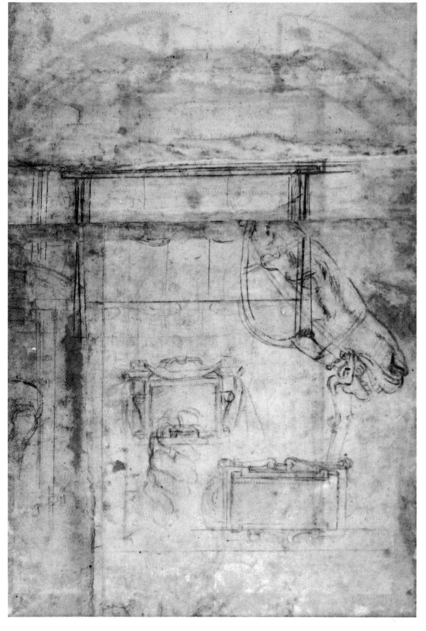

516. *Michelangelo. Three designs of fountains. Casa Buonarroti, Florence, A 73 (C. 274r)*

517. *Michelangelo. Sketches of head and hoof of horse; two sketches of small windows, probably for Porta Pia, Rome; partial sketch of door; and two outlines of cornices. Casa Buonarroti, Florence, A 106v (C. 619v)*

518. *Michelangelo. Study of window for Laurentian Library, Florence. Casa Buonarroti, Florence, A 65r (C. 548r)*

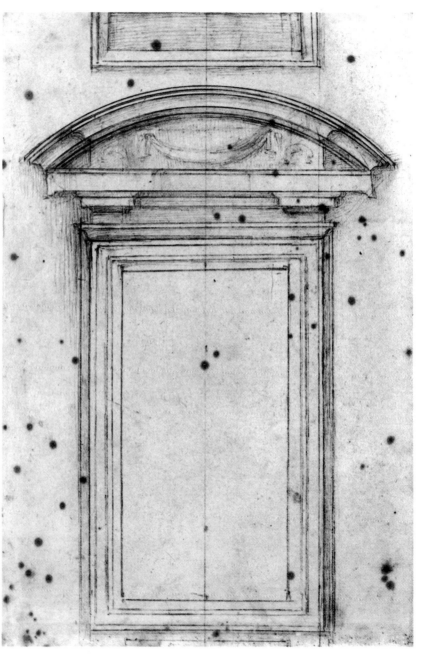

519. *Michelangelo. Sketch of window,
probably for windows on lower level of
Porta Pia, Rome. Casa Buonarroti,
Florence, A 85r (C. 620r)*

modern in Palladio's Teatro Olimpico in Vicenza. Yet, undoubtedly there was a connection between the two in some of the more audacious architectonic solutions, such as the unique order of large pilasters or the trabeated porticoes which made the empty space support the filled. Finally, the Michelangelesque rupture of the orders was without doubt a premise underlying Palladio's overturning of a structurality based on quantified graduations in preference for clear, qualitative juxtapositions. It was this relationship between Michelangelo and Palladio, at a distance and practically antinomic, which was one of the most vital tangencies between Roman and Venetian Mannerism.

The thesis of an exuberant Baroque which displaced an enervated Mannerism was dropped long ago, but there is no doubt that the general tendency to reduce the importance of Michelangelo's architectural innovation (not just the architecture) was succeeded in the seventeenth century by the recognition of his unavoidable problematic quality. The different interpretations of Michelangelo arrived at by Annibale Carracci and Caravaggio were not a matter of similarity to or divergence from his style. For Annibale, Michelangelo was an outstanding but integrated personage; for Caravaggio, he was a contrary artist who had finally destroyed the dogma of the teachers of nature and history.

A few decades later, different interpretations were also presented in larger, more precise terms of architecture by Gianlorenzo Bernini and Francesco Borromini. The crux of the matter was Rome, the urban reform begun by Domenico Fontana for Sixtus V, and the necessity for moving from the structure to the image of the city. Its apostolic and political function had been extended across the seas and to the Church State, for which architectural decorum was no longer sufficient. An eloquent architecture was needed, whose visible present would also be the memory of the past and the view to the future.

The new layout of roads brought the ancient churches into prominence, and daily devotional practice had economic returns, but it also rendered concrete Michelangelo's conception of the city as a constellation of sacred sites. Bernini adhered to this; unable to make Saint Peter's a center, he made it a vertex. He doubled the size of the piazza and theoretically opened it wide to the whole ecumene. He also repeated its luminous space in other municipal piazzas from the Navona to the Pantheon and Montecitorio, which were the scenery of his urban theater. This was superimposed on the structure planned by Michelangelo like a magnifying glass, enlarging it and at the same time distancing it. Having been conceived for a religious war now vanquished, it necessarily had to change. And who but Michelangelo himself conceived architecture by re-signifying or re-semanticizing something which already existed? He had done it respectfully with regard to Brunelleschi and scornfully with Antonio da Sangallo the Younger. He made architecture the visual communication of ideas about value, which inevitably changed. Maderno transformed Saint Peter's because devotional custom had changed, and Bernini altered it because the ideological dimension of

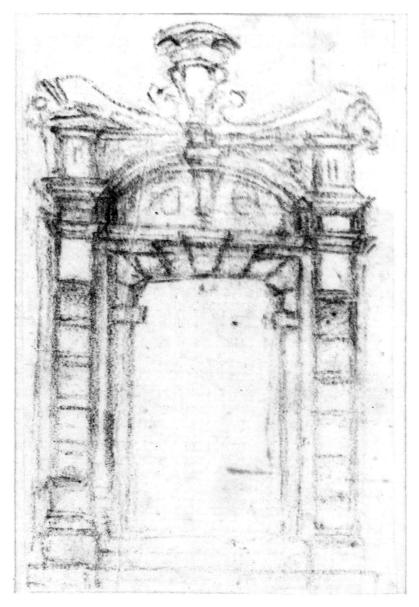

the Church had expanded. Later, Vanvitelli changed Santa Maria degli Angeli because the relationship between the antique and the modern had changed. Michelangelo substituted art-transcendence for art-imitation, and Bernini defined the transcendence of reality as imagination. Art was not the product but the process of the imagination. The aesthetic foundation of art in the seventeenth century was Aristotle's *Poetica*, and the only constraint to the imagination was verisimilitude, verified either by resemblance to nature or by a precedent or analogous occurrence. Michelangelo's transcendence was therefore the precedent which expanded the horizon of possibilities for Bernini. His was a rhetorically correct interpretation, which not only absolved Michelangelo of all his licenses but also relocated him, reluctant though he himself would have been, among the great spirits of the Renaissance. He became, in spite of himself, a classicist, and he remained so. Even Milizia's strict academic neoclassicism could not eject him.

Rome was viewed as a collection of consecrated sites by Borromini also, not due to the protocol of the Curia but to the charitable action of the religious orders. He abhorred the logic of imitation as well as the passage from real to simulated reality. The space of his architecture was not imagination but fantasy. Fantasy did not have prescribed limits, therefore he could impose on it a moral discipline. The morality of Borromini did not have precepts but was instead an internal tension or anxiety for the Divine. And he feared neither a lack of verisimilitude nor oddness, which were expressions of the *docta ignorantia*. Bernini had criticized him for this in speaking with Paul Fréart de Chantelou, saying that he created chimera. Like Michelangelo, Borromini was religious almost to the point of asceticism, but it was dangerous to imagine without a limit to the possibilities. This could reach the point of despair of salvation, and in fact he did despair, dying a suicide. He did not imitate Michelangelo's architecture, it was his creed, and

certainly he did not approve of Bernini's bombastic intrusions. He understood the most secret meanings of Michelangelo's mysterious legacy—a building was not a large box with an inside and an outside placed in an urban space; it was a refined, nonnatural body whose vibrating lines of force, generated from tension, culminated in song—that is, in ornamentation, or more precisely, in a kind of prayer.

In working voluntarily for the religious orders, whose presence was an essential compensation for the officiality of the Curia, he expressed what he knew of the torment, as well as of the free exultation, of religious practice. He did not seek resemblances in his works, but he made the disquieted, anxious, impatient, not-finished manner of Michelangelo's planning process his own, utilizing many nervous drawings and models sculpted in clay and also intervening personally on the scaffolds. Like Michelangelo, he was a religious fanatic, and similarly his architecture did not make doctrine but devotion—not the image of God but the love of God. Like sacred music, it accompanied communal prayer and ended in individual ecstasies. If a line of union can be drawn between the liturgical chorality of Michelangelo and the sophisticated asceticism of Borromini, I could mention only one name—El Greco. As with logic, the absurd also had its rigor. Borromini's interpretation, which isolated Michelangelo's architecture, was contrary to that of Bernini's, which officialized and popularized it. Bernini's triumphal tonalities sang of the beauty of life, while Borromini's accents of despair spoke of the greater beauty of death. Which of the two was correct? Michelangelo left nothing of certainty to art and to the world except a longing and anxiety for a beauty or a truth which was the same for life as it was for death. "O tell me, please Love, whether my eyes / see the truth of the beauty to which I aspire / or whether I have it within when, wherever I gaze, / I see carved the face of that woman."

373

BIBLIOGRAPHY

For a complete bibliography on Michelangelo up to 1970, see: STEINMANN, E., and WITTKOWER, R. "Michelangelo Bibliographia, 1510–1926." *Römische Forschungen der Bibliotheca Hertziana* 1. Leipzig, 1927; and DÜSSLER, L. *Michelangelo Bibliographia, 1927–1970*. Wiesbaden, 1974. For the texts of the quotations in their original languages, see: ARGAN, G., and CONTARDI, B., *Michelangelo architetto*, Milan, 1991.

(Note: Roman numerals only in the text refer to *Il Carteggio di Michelangelo* listed alphabetically below.)

ACIDINI, C., and SPINI, G.
1980 "I tre primi libri sopra l'instituzioni de' Greci et Latini architettori intorno agl'ornamenti che convengono a tutte le fabbriche che l'architetture compone." In *Il disegno interrotto: Trattati medicei d'architettura*, ed. by F. Borsi, *et al.*, 11–201. Florence

ACKERMAN, J. S.
1954 *The Cortile del Belvedere*. Rome
1961 *The Architecture of Michelangelo*. London
1964 *The Architecture of Michelangelo*.
-66 London
1968 *L'architettura di Michelangelo*. Turin
1986 *The Architecture of Michelangelo*. With catalogue of works ed. by J. S. Ackerman and J. Newman. Chicago

ADAMS, N.
1978 "Baldassarre Peruzzi and the Siege of Florence: Archival Notes and Undated Drawings." *Art Bulletin* LX, 3:475–82

AGOSTI, G., and FARINELLA, V.
1987 *Michelangelo: Studi di antichità dal Codice Coner*. Turin

ALIBERTI, F., and GAUDIOSO, E. (eds.)
1981 *Gli affreschi di Paolo III a Castel Sant'Angelo: Progetto ed esecuzione 1543–1548*. Exhibition catalogue. Rome

ALKER, H. R.
1922 "Das Michelangelo-modell zur Kuppel von St. Peter in Rom." *Repertorium für Kunstwissenschaft* XLIII:98–99

ALVAREZ, G. B.
1964 "Gli interventi architettonici cinque-
-65 centeschi nella ricostruzione del duomo di Padova." *Atti e Memorie dell'Accademia Patavina di Scienze, Lettere e Arti* LXXVII, 3:605–24
1980 "Alvise Cornaro e la fabbrica del duomo di Padova." In *Alvise Cornaro e il suo tempo*, ed. by L. Puppi, 58–62. Exhibition catalogue. Padua

AMASEO, R.
1563 *Oratio habita in funere Pauli III Pont. Max.* Bologna

ANCEL, R.
1908 "Le Vatican sous Paul IV: Contribution à l'histoire du Palais Pontifical." *Revue Bénédictine* XXV:48–71

ANSELMI, A.
"La decorazione scultorea della facciata di Santa Maria Maggiore a Roma: Un inedito manoscritto con memoria del programma iconografico." *Ricerche di Storia dell'Arte* (In press)

ARGAN, G. C.
1964 "La tomba di Giulio II." In *Michelangelo architetto*, ed. by P. Portoghesi and B. Zevi, 61–94. Turin

ASHBY, T.
1904 "Sixteenth-Century Drawings of Roman Buildings Attributed to Andreas Coner." *Papers of the British School at Rome* II:1–96
1916 *Topographical Study in Rome in 1581*. London

BAROCCHI, P.
1962 *Michelangelo e la sua scuola: Disegni di Casa Buonarroti e degli Uffizi*. Florence
1964 *I disegni dell'Archivio Buonarroti*. Florence

BATTISTI, E.
1961 "Disegni cinquecenteschi per San Giovanni dei Fiorentini." *Quaderni dell'Istituto di Storia dell'Architettura dell'Università di Roma* 31–48:185–94
1976 *Filippo Brunelleschi*. Milan

BELLINATI, C., *et al.*
1977 *Il duomo di Padova e il suo battistero*. Padua

BENEDETTI, S.
1986 "Il modello per il San Pietro Vaticano di Antonio da Sangallo il Giovane." In "Antonio da Sangallo il Giovane: La vita e l'opera." *Atti del XXII Congresso di Storia dell'Architettura, Roma 19–21 febbraio 1986*, 157–74. Rome

BENTIVOGLIO, E.
1972 "Un palazzo 'barocco' nella Roma di Leone X: Il progetto per palazzo Medici in piazza Navona di Giuliano da Sangallo." *L'Architettura*, XVIII, 3:196–204

BERTOCCI, C., and DAVIS, C.
1977 "A Leaf from the Scholz Scrapbook,"
-78 *The Metropolitan Museum Journal* XII:93–100

BERTOLOTTI, A.
1875 "Documenti intorno a Michelangelo Buonarroti trovati ed esistenti in Roma." *Archivio Storico-Artistico, Archeologico e Letterario della Città e Provincia di Roma* I:13–22; 161–66

BIANCHINI, F.
1703 *De Kalendario e cyclo Caesaris ... dissertationes duae ... his accessit enarratio ... de nummo et gnomone Clementino*. Rome

BINNI, W.
1965 *Michelangelo scrittore*. Rome

BLUNT, A.
1958 *Philibert de L'Orme*. London
BOCCHI, F. (added to by CINELLI, G.)
1677 *Le bellezze della città di Firenze, dove a piano di pittura, di scultura, di sacri tempii, di palazzi i più notabili artifizii e più preziosi si contengono*. Florence
BORSI, F.
1989 *Bramante*. With catalogue by S. Borsi. Milan
BORSI, S.
1985 *Giuliano da Sangallo: I disegni di architettura e dell'antico*. Rome
BÖSEL, R.
1985 *Jesuitenarchitektur in Italien (1540–1773)*. I: *Die Baudenkmäler der römischen und der neapolitanischen Ordensprovinz*. Vienna
BOTTARI, G. G.
1754 *Raccolta di lettere sulla pittura, scul-*
–73 *tura ed architettura scritte da' più celebri professori che in dette arti fiorirono dal secolo XV al XVII*. Rome
BRANDI, C.
1968 "La curva della cupola di San Pietro." *Accademia Nazionale dei Lincei. Problemi Attuali di Scienza e Cultura* 123 (Rome)
BRINCKMANN, A. E.
1922 "Das Kuppelmodell für San Pietro in Rom." *Repertorium für Kunstwissenschaft* XLIII:92–97
BRUSCHI, A.
1969 *Bramante architetto*. Bari
1979 "Michelangelo in Campidoglio e 'l'invenzione' dell'ordine gigante." *Storia Architettura* IV, 1:7–28
BUCCI, M., and BENCINI, R.
1974 *Palazzi di Firenze*. II: *Il quartiere della SS. Annunziata*, Florence
BUDDENSIEG, T.
1969 "Zum Statuenprogramm im Kapitolsplan Pauls III." *Zeitschrift für Kunstgeschichte* XXXII, 2:177–238
1975 "Bernardo della Volpaia und Giovanni Francesco da Sangallo: Der Autor des Codex Coner und seine Stellung im Sangallo-Kreis." *Römisches Jahrbuch für Kunstgeschichte* XV:89–108
BURNS, H.
1979 "San Lorenzo in Florence Before the Building of the New Sacristy, An Early Plan." *Mitteilungen des Kunsthistorisches Institutes in Florenz.* XXIII, 1–2:145–54
BURNS, H., and PAGLIARA, P. N.
1989 "La cappella Castiglioni." In *Giulio Romano*, 532–34. Milan
CALABI, D., and MORACHIELLO, P.
1984 "Rialto 1514–1538: gli anni della ricostruzione." In *"Renovatio Urbis": Venezia nell'età di Andrea Gritti (1528–1538)*, ed. by M. Tafuri, 291–334. Rome
1987 *Rialto: le fabbriche e il ponte 1514–91*. Turin
CALÌ, M.
1980 *Da Michelangelo all'Escorial: Momenti del dibattito religioso nell'arte del Cinquecento*. Turin
CALVESI, M.
1980 "Il programma della cappella Sistina." In Maurizio Calvesi, *Le arti in Vaticano*, 53–86. Milan
CARPEGGIANI, P., ed.
1975 *Michelangelo Buonarroti e il Veneto*. Exhibition catalogue. Padua
CARPICECI, A. C.
1987 "La Basilica Vaticana vista da Martin van Heemskerck." *Bollettino d'Arte* LXXII, 44–45:67–128
Il Carteggio di Michelangelo, ed. by G. Poggi. Posthumous edition, ed. by P. Barocchi and R. Ristori. Florence, 1965–83. [CITED by Roman numeral only]
Il Carteggio indiretto di Michelangelo, ed. by P. Barocchi, K. Loach Bramanti, and R. Ristori. I. Florence, 1988
CIULICH, L. BARDESCHI.
1977 "Documenti inediti su Michelangelo e
–78 l'incarico di San Pietro." *Rinascimento* XVII:235–375
1983 "Nuovi documenti su Michelangelo architetto maggiore di San Pietro." *Rinascimento* XXIII:173–86
CLEMENTS, R. J.
1965 *The Poetry of Michelangelo*. New York
CONDIVI, A.
1553 *Vita di Michelangelo Buonarroti*. Rome
CONTARDI, B.
1984 "Il bagno di Clemente VII in Castel Sant'Angelo." In *Quando gli dei si spogliano: Il bagno di Clement VII a Castel Sant'Angelo e le altre stufe romane del primo Cinquecento*, ed. by B. Contardi and H. Lilius. Rome
COOLIDGE, J. P.
1945 "The Arched Loggie on the Cam-
–47 pidoglio." *Marsyas* IV:69–79
Corpus dei disegni di Michelangelo, ed. by Charles de Tolnay. I–IV. Novara, 1975–80 [CITED as *Corpus*]
CORTI, G., and PARRONCHI, A.
1964 "Michelangelo al tempo dei lavori di San Lorenzo in una 'ricordanza' del Figiovanni." *Paragone* 175:9–31
CRUCIANI, F.
1969 *Il teatro del Campidoglio e le feste romane del 1513*. Milan
DAL POGGETTO, P.
1979 *I disegni murali di Michelangelo e la sua scuola nella Sagrestia Nuova di San Lorenzo*. Florence
DAVIS, C.
1975 "Cosimo Bartoli and the Portal of Sant'Apollonia by Michelangelo." *Mitteilungen des Kunsthistorisches Institutes in Florenz* XIX, 2:261–76
DEGENHART, B.
1955 "Dante, Leonardo und Sangallo: Danteillustrationen Giuliano da Sangallos in ihrem Verhältnis zu Leonardo da Vinci und zu den Figurenzeichnungen der Sangallo," *Römisches Jahrbuch für Kunstgeschichte* VII:105–292
DE GRASSI, A.
1947 *Inscriptiones Italiae*. XIII: *Fasti e elogia* (fasc. 1). Rome
DE MAIO, R.
1977 "Michelangelo e il cantiere di San Pietro." *Civiltà delle Macchine* XXV, 1–2:115–20
1978 *Michelangelo e la Controriforma*. Bari
DI MAURO, L.
1987 "Il cantiere di Palazzo Farnese a Roma in un disegno inedito." *Architettura: Storia e Documenti* 1:113–23
1988 "'Domus Farnesia amplificata est atque exornata.'" *Palladio* I, 1:27–44
Disegni di fabbriche brunelleschiane. Florence, 1977
Disegni italiani del Teylers Museum Haarlem provenienti dalle collezioni di Cristina di Svezia e dei principi Odescalchi, ed. by B. W. Meijer and C. van Tuyll. Florence, 1983
D'ONOFRIO, C.
1973 *Renovatio Romae: Storia e urbanistica dal Campidoglio all'EUR*. Rome
D'OSSAT, G. DE ANGELIS
1966 "Uno sconosciuto modello di Michelangelo per Santa Maria del Fiore." In *Arte in Europa: Scritti di storia dell'arte in onore di E. Arslan*, 1, 501–4. Milan
1989 "Il Marco Aurelio sulla piazza del Campidoglio." In *Marco Aurelio: Storia di un monumento e del suo restauro*, ed. by A. M. Vaccaro and A. M. Sommella, 157–68. Milan
D'OSSAT, G. DE ANGELIS, and PIETRANGELI, C.
1965 *Il Campidoglio di Michelangelo*. Rome
DÜSSLER, L.
1959 *Die Zeichnungen des Michelangelo: Kritischer Katalog*. Berlin
EGGER, H.
1906 *Codex Escurialensis: Ein Skizzenbuch aus der Werkstatt Domenico Ghirlandaios*. Vienna
EICHE, S.
1989 "July 1547 in Palazzo Farnese." *Mitteilungen der Kunsthistorischen Institutes in Florenz* XXXIII, 2–3:395–401
EINEM, H. VON
1951 "Michelangelos Juliusgrab im Entwurf von 1505 und die Frage seiner ursprünglichen Bestimmung." In *Festschrift für Hans Jantzen*, 152–68. Berlin
1959 *Michelangelo*. Stuttgart
1973 *Michelangelo*. London
ELAM, C.
1979 "The Site and Early Building History of Michelangelo's New Sacristy." *Mitteilungen des Kunsthistorischen Institutes in Florenz* XXIII, 1–2:155–86
1981 "Michelangelo, His Later Roman Architecture." *Architectural Association Files* 1:68–76
1984 "Rome and Florence: The Raphael Exhibitions, Architecture." *Burlington Magazine* CXXVI, 976:456–57
ELIA, M. MANIERI
1986 "La loggia Squarcialupi in Campidoglio (e un'ipotesi sulla Scala Senatoria)." *Architettura: Storia e Documenti* II, 2:79–86
ETTLINGER, L. D.
1978 "The Liturgical Function of Michelangelo's Medici Chapel." *Mitteilungen des Kunsthistorischen Institutes in Florenz* XXII, 3:287–304
FAGIOLO, M.
1986 "La basilica vaticana come tempio-mausoleo 'inter duas metas': Le idee e i progetti di Alberti, Filarete, Bramante, Peruzzi, Sangallo, Michelangelo." In *Antonio da Sangallo il Giovane: La vita e l'opera*, *Atti del XXII Congresso di Storia dell'Architettura, Roma 19–21 febbraio 1986*, 187–209 (with a note by P. SILVAN, 209–16). Rome
FAGIOLO, M., and MADONNA, M. L.
1972 "La Roma di Pio IV. Pt. 1: La 'Civitas Pia,' la 'Salus Medica,' la 'Custodia Angelica.'" *Arte Illustrata* V, 51:383–402
1973 "La Roma di Pio IV. Pt. 2: Il sis-

tema dei centri direzionali e la ri-fondazione della città." *Arte Illustrata* VI, 54:186–212

FANFANI, P.
1876 *Spigolatura michelangiolesca*. Pistoia

FERRI, P. N., and JACOBSEN, E.
1904 "Nuovi disegni sconosciuti di Michelangelo." *Rivista d'Arte* II:25–37
1905 *Neuentdeckte Michelangelo-Zeichnungen in den Uffizien zu Florenz*. Leipzig

FERRONI, A., and SACCO, F.
1989 "Il basamento di Marco Aurelio: Una lettura archeologica." In *Marco Aurelio: Storia di un monumento e del suo restauro*, ed. by A. M. Vaccaro and A. M. Sommella, 195–204. Milan

FINCH, M.
1990 "The Sistine Chapel as a Temenos. An Interpretation Suggested by the Restored Visibility of the Lunettes." *Gazette des Beaux-Arts* CXV, 2:53–70

FIORE, F. P.
1978 *Città e macchine del Quattrocento nei disegni di Francesco di Giorgio Martini*. Florence
1986 "Episodi salienti e fasi dell'architettura militare di Antonio da Sangallo." In "Antonio da Sangallo il Giovane: La vita e l'opera." *Atti del XXII Congresso di Storia dell'Architettura, Roma 19–21 Febbraio 1986*, 331–47. Rome

FOSCARI, A., and TAFURI, M.
1983 *L'armonia e i conflitti: La chiesa di San Francesco della Vigna nella Venezia del Cinquecento*. Turin

FOSSI, M.
1970 *Bartolomeo Ammannati: La città, appunti per un trattato*. Rome

FRANZINI, G.
1588 *Le cose maravigliose dell'alma città di Roma, dove si veggono il movimento delle guglie, e gli acquedotti per condurre l'Acqua Felice, e ample e commode strade ... e si tratta delle chiese, rappresentate in disegno da Gieronimo Francino*. Venice

FRAZER, A.
1975 "A Numismatic Source for Michelangelo's First Design for the Tomb of Julius II." *Art Bulletin* LVII, 1:53–57

FREY, D.
1920 *Michelangelo-Studien*. Vienna

FREY, H. W.
1951 "Zur Entstehungsgeschichte des Statuenschmuckes der Medici Kapelle in Florenz: Eine Erläuterung

des Briefes Michelagniolos vom 17. Juni 1526." *Zeitschrift für Kunstgeschichte* XIV:40–96

FREY, K.
1907 *Michelagniolo Buonarroti: Quellen und Forschungen zu seiner Geschichte und Kunst. I: Michelagniolo Jugendjahre*. Berlin
1909 "Studien zu Michelagniolo Buonarroti und zur Kunst seiner Zeit." *Jahrbuch der Königlichen Preussischen Kunstsammlungen* XXX supp.:103–80
1909 *Die Handzeichnungen Michelagniolos*
–11 *Buonarroti*. Berlin
1911 "Zur Baugeschichte des St. Peter: Mitteilungen aus der Reverendissima Fabbrica di San Pietro." *Jahrbuch der Königlichen Preussischen Kunstsammlungen* XXXI supp.
1913 "Zur Baugeschichte des St. Peter: Mitteilungen aus der Reverendissima Fabbrica di San Pietro." *Jahrbuch der Königlichen Preussischen Kunstsammlungen* XXXII supp.
1916 "Zur Baugeschichte des St. Peter: Mitteilungen aus der Reverendissima Fabbrica di San Pietro." *Jahrbuch der Königlichen Preussischen Kunstsammlungen* XXXVII supp.

FROMMEL, C. L.
1967 "S. Eligio und die Kuppel der Cappella Medici." In "Stil und Überlieferung in der Kunst des Abendlandes." *Akten des 21. Internationalen Kongresses für Kunstgeschichte in Bonn 1964*, II:41–54. Berlin
1973 *Der römische Palastbau der Hochrenaissance*. Tubingen
1976 "Die Peterskirche unter Papst Julius II im Licht neuer Dokumente." *Römisches Jahrbuch für Kunstgeschichte* XVI:57–136
1977 "'Cappella Julia': Die Grabkapelle Papst Julius II in Neu-St. Peter." *Zeitschrift für Kunstgeschichte* XL, 1:26–62
1979 *Michelangelo und Tommaso dei Cavalieri: Mit der Übertragung von Francesco Diaccetos 'Panegirico all'amore'*. Amsterdam
1981 "Sangallo et Michel-Ange (1513–1550)." In *Le Palais Farnèse*, I, 1:127–224. Rome
1984 "San Pietro: Storia della sua costruzione." In *Raffaello architetto*, ed. by C. L. Frommel, S. Ray, and M. Tafuri, 241–310. Milan
1986 "Raffael und Antonio da Sangallo der Jüngere." In "Raffaello a

Roma." *Atti del Convegno del 1983, Roma*, 261–304. Rome
1990 Communication to Vatican conference related to exhibition, *Michelangelo e la Sistina. La tecnica, il restauro, il mito*. Rome (*Atti* in press)

FULVIO, A.
1588 *L'antichità di Roma*. With revisions, additions, and annotations by G. FERRUCCI. Venice

GAUDIOSO, E.
1976ᵃ *Michelangelo e l'edicola di Leone X*. Rome
1976ᵇ "I lavori farnesiani a Castel Sant'Angelo: Precisazioni ed ipotesi." *Bollettino d'Arte* LXI, 1–2:21–42 and 3–4:228–62

GAURICO, L.
1552 *Tractatus astrologicus*. Venice

GAYE, J. W.
1839 *Carteggio inedito d'artisti dei secoli*
–40 *XIV, XV, XVI*. Florence

GEYMÜLLER, H. VON
1885 "Documents inédits sur les manuscrits et les oeuvres d'architecture de la famille des San Gallo ainsi que sur plusieurs monuments de l'Italie." *Mémoires de la Société Nationale des Antiquaires de France* XLV:1–31
1901 "Alcune osservazioni sopra recenti studi su Bramante e Michelangelo." *Rassegna d'Arte* I:184–86
1904 *Michelagnolo Buonarroti als Architekt nach neuen Quellen*. Munich

GIESS, H.
1978 "Die Stadt Castro und die Pläne von Antonio da Sangallo dem Jüngeren (Pt. 1)." *Römisches Jahrbuch für Kunstgeschichte* XVII:47–88
1981 "Die Stadt Castro und die Pläne von Antonio da Sangallo dem Jüngeren (Pt. 2)." *Römisches Jahrbuch für Kunstgeschichte* XIX:85–140

GINER GUERRI, J.
1975 "Juan Bautista de Toledo y Miguel Angel en el Vaticano." *Goya* 126:351–59

GIOVANNONI, G.
1959 *Antonio da Sangallo il Giovane*. Rome

GNOLI, U.
1886 "Un disegno di Michelangiolo per la Colonna Traiana." *Nuova Antologia* XL:542–47

GOLZIO, V.
1936 *Raffaello nei documenti, nelle testimonianze dei contemporanei e nella letteratura del suo secolo*. Rome

GOTTI, A.
1875 *Vita di Michelangelo Buonarroti nar-*

rata con l'aiuto di nuovi documenti. Florence

GRONAU, G.
1911 "Dokumente zur Entstehungsgeschichte der neuen Sakrestei und der Bibliothek von San Lorenzo in Florenz." *Jahrbuch der Königlichen Preussischen Kunstsammlungen* XXXII supp.:62–81
1918 "Über zwei Skizzenbücher des Guglielmo della Porta in der Düsseldorfer Kunstakademie." *Jahrbuch der Königlichen Preussischen Kunstsammlungen* XXXIX:171–200

GUGLIELMOTTI, A.
1887 *Storia delle fortificazioni nella spiaggia romana risarcite e accresciute dal 1560 al 1570*. Rome

GÜNTHER, H.
1984ᵃ "Il prisma stradale davanti al ponte di Sant'Angelo." In *Raffaello architetto*, ed. by C. L. Frommel, S. Ray, and M. Tafuri, 231–34. Milan
1984ᵇ "Das Trivium vor Ponte S. Angelo: Ein Beitrag zur Urbanistik der Renaissance in Rom." *Römisches Jahrbuch für Kunstgeschichte* XXI:165–251
1985 "Die Strassenplanung unter den Medici-Päpsten in Rom (1513–1534)." *Jahrbuch des Zentralinstituts für Kunstgeschichte* I:237–93

GÜTHLEIN, K.
1985 "Der 'Palazzo Nuovo' des Kapitols." *Römisches Jahrbuch für Kunstgeschichte* XXII:83–190

HALE, J. R.
1965 "The Early Development of the Bastion: An Italian Chronology in Europe." In *The Late Middle Ages*, ed. by J. R. Hale, J. R. L. Highfield, and B. Smalley. London, 1965

HARTT, F.
1969 *Michelangelo, The Complete Sculpture*. London
1971 *The Drawings of Michelangelo*. London
1982 "The Evidence for the Scaffolding of the Sistine Ceiling." *Art History* V, 3:273–86

HEDBURG, G.
1970 "The Farnese Courtyard Windows and
–71 the Porta Pia: Michelangelo's Creative Process." *Marsyas* XV:63–72

HEIKAMP, D., ED.
1975 *Il Tesoro di Lorenzo il Magnifico*. II: *I vasi*. Florence

HERSEY, G. L.
1989 "Greek Elements in Some Renaissance Vitruvians." In *Roma centro*

ideale della cultura dell'Antico nei secoli XV e XVI, ed. by S. D. Squarzina, 435–41. Milan

HESS, J.
1961 "Die päpstliche Villa bei Aracoeli: Ein Beitrag zur Geschichte der kapitolinischen Bauten." In *Miscellanea Bibliothecae Hertzianae zu Ehren von L. Bruhns, F. G. W. Metternich, L. Schudt (Römische Forschungen der Bibliotheca Hertziana XVI)*, 239–54

HEYDENREICH, L. H., and LOTZ, W.
1974 *Architecture in Italy 1400 to 1600.* Harmondsworth

HIRST, M.
1972 "Addenda Sansoviniana." *Burlington Magazine* CXIV, 828:162–65
1974 "A Note on Michelangelo and the Attic of St. Peter's" *Burlington Magazine* CXVI, 860:662–65
1976 "A Project of Michelangelo's for the Tomb of Julius II." *Master Drawings* XIV, 4:375–82
1983 Review of C. de Tolnay, *Corpus dei disegni di Michelangelo. Burlington Magazine* CXXV, 966:552–56
1986 "A Note on Michelangelo and the San Lorenzo Façade." *Art Bulletin* LXVII:323–26
1988 *Michelangelo and His Drawings.* New Haven
1989 *Michel-Ange dessinateur.* Paris

HÜLSEN, C., and EGGER, H.
1913 *Die römischen Skizzenbücher von Marten van Heemskerck.* Berlin

HYMAN, I.
1977 *Fifteenth-Century Florentine Studies: The Palazzo Medici and a Ledger for the Church of San Lorenzo.* New York

JOANNIDES, P.
1972 "Michelangelo's Medici Chapel: Some New Suggestions." *Burlington Magazine* CXIV, 833:541–51
1978 Review of C. de Tolnay, *Disegni di Michelangelo nelle collezioni italiane. Art Bulletin* LVIII, 1:174–77
1981 Review of R. Wittkower, *Idea and Image*, and review of J. Wilde, *Michelangelo, Six Lectures. Burlington Magazine* CXXIII, 943:620–22
1982 "Two Bronze Statuettes and Their Relation to Michelangelo." *Burlington Magazine* CXXIV, 946:3–8

KELLER, F.-E.
1976 "Zur Planung am Bau der römischen Peterskirche im Jahre 1564–1565." *Jahrbuch der Berliner Museen* XVIII:24–56

KLAPISCH-ZUBER, C.
1969 *Les maîtres du marbre: Carrara 1300–1600.* Paris

KÖRTE, W.
1932 "Zur Peterskuppel des Michelangelo." *Jahrbuch der Preussischen Kunstsammlungen* LIII:90–112

KRIEGBAUM, F.
1933 "Der Ponte Trinità in Florenz und Michelangelo." In *Festschrift für Walter Friedländer zum 60. Geburtstag am 10. März 1933*, 260–70
1941 "Michelangelo e il ponte a Santa Trinità." *Rivista d'Arte* XXIII:137–44

KRUFT, H.-W.
1975 "Antonello Gagini as Co-Author with Michelangelo on the Tomb of Pope Julius II." *Burlington Magazine* CXVII, 870:598–99

KÜNZLE, P.
1961 "Die Aufstellung des Reiters vom Lateran durch Michelangelo." In *Miscellanea Bibliothecae Hertzianae zu Ehren von L. Bruhns, F. G. W. Metternich, und L. Schudt (Römische Forschungen der Bibliotheca Hertziana XVI)*, 255–70

KURZ, O.
1953 Review of J. Wilde, *Italian Drawings in the Department of Prints and Drawings in the British Museum: Michelangelo and his Studio. Burlington Magazine* XCV:310

LANCIANI, R.
1902 "La via del Corso dirizzata e abbellita nel 1538 da Paolo III." *Bollettino della Commissione Archeologica Comunale di Roma* XXX:229–55
1902 *Storia degli scavi e notizie intorno le collezione romane di antichità.* Rome
–12

LETAROUILLY, P. M.
1849 *Edifices de Rome moderne ou Recueil des palais, maisons, églises, couvents et autres monuments publics et particuliers les plus remarquables de la ville de Rome.* Liège
–66

LEY, JOHANNES
15th *Tractatus De visione beata.* Rome, c. 1963

LISCI, I. GINORI
1972 *I palazzi di Firenze nella storia e nell'arte.* Florence

LOTZ, W.
1967 "Zu Michelangelos Kopien nach dem Codex Coner." In "Stil und Überlieferung in der Kunst des Abendlandes." *Akten des 21. Internationales Kongresses für Kunstgeschichte in Bonn 1964*, II:12–19. Berlin
1981 "Vignole et Giacomo della Porta (1559–1589)." In *Le Palais Farnèse*, I, 1:225–41. Rome

LUPORINI, E.
1957 "Un libro di disegni di Giovanni Antonio Dosio (Pt. 1)." *Critica d'Arte* IV:442–67
1958 "Un libro di disegni di Giovanni Antonio Dosio (Pt. 2)." *Critica d'Arte* V:43–72

MAC DOUGALL, E. B.
1960 "Michelangelo and the Porta Pia." *Journal of the Society of Architectural Historians* XXIX:97–108

MANCINELLI, F.
1982 "Il ponte di Michelangelo per la Cappella Sistina." *Rassegna dell'Accademia Nazionale di San Luca* 1–2:2–9
1986 "Michelangelo all'opera: tecnica e colore." In *La Cappella Sistina: I primi restauri, la scoperta del colore*, 218–59. Novara

MANETTI, R.
1980 *Michelangelo: le fortificazioni per l'assedio di Firenze.* Florence

MARANI, P. C., ED.
1984 *Disegni di fortificazioni da Leonardo a Michelangelo.* Exhibition catalogue. Florence
1985 "Gli ultimi disegni di fortificazioni di Michelangelo." In *Renaissance Studies in Honor of Craig Hugh Smyth*, II:597–612. Florence

MARCHINI, G.
1976a "Le finestre 'inginocchiate.'" *Antichità Viva* XV, 1:24–31
1976b "Postilla alle 'finestre inginocchiate.'" *Antichità Viva* XV, 5:27–28
1977 "Il ballatoio della cupola di Santa Maria del Fiore." *Antichità Viva* XVI, 6:36–48

MARCONI, P.
1966 "Contributo alla storia delle fortificazioni di Roma nel Cinquecento e nel Seicento." *Quaderni dell'Istituto di Storia dell'Architettura* XIII:73–78; 109–30

MARIANI, G. M.
1983 "Il palazzo Medici a piazza Navona: un'utopia urbana di Giuliano da Sangallo." In *Firenze e la Toscana dei Medici nell'Europa del Cinquecento*, III:977–93. Florence

MARLIANO, B.
1549 *Consulum, dictatorum censorumque Romanorum series.* Rome

MARTINELLI, F.
1644 *Roma ricercata nel suo sito, e nella scuola di tutti gli antiquarj.* Rome

MAZZUCATO, O.
1985 *I pavimenti pontifici di Castel Sant'Angelo.* Rome

MELIÙ, A.
1950 *Santa Maria degli Angeli alle Terme di Diocleziano.* Rome

METTERNICH, F. WOLFF
1963 "Le premier projet pour St. Pierre de Rome, Bramante et Michel-Ange." In "The Renaissance and Mannerism: Studies in Western Art." *Acts of the XX International Congress of the History of Art, New York, 1961*, II:70–81. Princeton
1975 *Bramante und St. Peter.* Munich
1987 *Die Frühen St.-Peter-Entwürfe 1505–1514.* Published posthumously, organized and edited by C. THOENES. Tubingen

MIGLIO, M.
1982 "Il leone e la lupa: Dal simbolo al pasticcio alla francese." *Studi Romani.* XXX, 2:177–86

MILANESI, G.
1875 *Le lettere di Michelangelo Buonarroti pubblicate coi ricordi ed i contratti artistici.*

MILIZIA, F.
1768 *Le vite dei più celebri architetti d'ogni nazione e d'ogni tempo.* Rome
1781 *Dell'arte di vedere nelle Belle Arti del disegno, secondo i principii di Sultzer e di Mengs.* Venice
1787 *Roma delle Belle Arti del disegno, I: Dell'Architettura civile.* Bassano

MILLON, H. A.
1979 "A Note on Michelangelo's Façade for a Palace for Julius III in Rome: New Documents for the Model." *Burlington Magazine* CXXI, 921:770–77

MILLON, H. A., and SMYTH, C. H.
1969 "Michelangelo and St. Peter's. I: Notes on a Plan of the Attic as Originally Built in the South Hemicycle." *Burlington Magazine* CXI, 797:484–501
1975 "A Design by Michelangelo for a City Gate: Further Notes on the Lille Sketch." *Burlington Magazine.* CXVII, 864:162–66
1976 "Michelangelo and St. Peter's: Observations on the Interior of the Apses, a Model of the Apse Vault, and Related Drawings." *Römisches Jahrbuch für Kunstgeschichte* XVI:137–206
1988 (eds.) *Michelangelo architetto: La facciata di San Lorenzo e la cupola di San Pietro.* Milan

MORSELLI, P.
1981 "A Project by Michelangelo for the Ambo(s) of Santa Maria del Fiore, Florence." *Journal of the Society of*

Architectural Historians XL, 2:122–29

NAVA, A.
1935 "Sui disegni architettonici per San
–36 Giovanni dei Fiorentini in Roma."
Critica d'Arte I:102–8
1936 "La storia della chiesa di San Giovanni dei Fiorentini nei documenti del suo archivio." *Archivio della R. Deputazione Romana di Storia Patria* LIX:337–62

NESSELRATH, A.
1983 "Das Liller 'Michelangelo-Skizzenbuch.'" *Kunstchronik* XXXVI, 1:46–47
1986 "I libri di disegni di antichità: Tentativo di una tipologia." In *Memorie dell'arte italiana*, III:87–147. Turin

NOEHLES, K.
1969 *La chiesa dei Santi Luca e Martina nell'opera di Pietro da Cortona*. Rome

NOVA, A.
1983 "Bartolomeo Ammannati e Prospero Fontana a Palazzo Firenze: Architettura e emblemi per Giulio III Del Monte." *Ricerche di Storia dell'Arte* 21:53–76
1984a *Michelangelo architetto*. Milan
1984b "The Chronology of the Del Monte Chapel in San Pietro in Montorio in Rome." *Art Bulletin* LXVI, 1:150–54

OBERHUBER, K., and BURNS, H.
1984 "La citazione dell'antico: Il progetto per il monumento funebre al marchese Francesco Gonzaga." In *Raffaello architetto*, ed. by C. L. Frommel, S. Ray, and M. Tafuri, 410–12. Milan

OLIVATO, L.
1980 "Filippo Brunelleschi e Mauro Codussi." In *Filippo Brunelleschi: La sua opera e il suo tempo*, II:804–6. Florence

ORBAAN, J. A. F.
1917 "Zur Baugeschichte des Peterskuppel." *Jahrbuch der Königlichen Preussischen Kunstsammlungen* XXXVIII supp.:189–207

PAGLIARA, P. N.
1982 "Alcune minute autografe di Giovan Battista da Sangallo: Parti della traduzione di Vitruvio e la lettera a Paolo III contro il cornicione michelangiolesco di palazzo Farnese." *Architettura Archivi* I:25–50
1990 Communication to Vatican conference related to exhibition, *Michelangelo e la Sistina: La tecnica, il restauro, il mito*. Rome (*Atti* in press)

PAGLIUCCHI, P.
1906 *I castellani del Castel Sant'Angelo*.
–9 Rome *Le Palais Farnèse*. Rome, 1981

PANOFSKY, E.
1920 "Bermerkungen zu D. Frey, *Michelangelo-Studien*." *Archiv für Geschichte und Asthetik der Architekture als Anhang zu Wasmuths Monatshefte für Baukunst* V:35–45
1922 "Die Treppe der Libreria di San Lorenzo." *Monatshefte für Kunstwissenschaft* XV:262–74
1937 "The First Two Projects of Michelangelo's Tomb of Julius II." *Art Bulletin* XIX:561–79

PANVINIO, O.
1558 *Fastorum libri V*. Venice

PAPINI, G.
1949 *Vita di Michelangelo nella vita del suo tempo*. Milan

PASQUINELLI, A.
1925 "Ricerche edilizie su Santa Maria degli Angeli." *Roma* III:349–56; 395–407

PASTOR, L. VON
1923 *History of the Popes*. London (or
–53 other editions)

PATETTA, L., ED.
1980 *I Longhi. Una famiglia di architetti tra manierismo e barocco*. Exhibition catalogue. Milan

PECCHIAI, P.
1950 *Il Campidoglio nel Cinquecento sulla scorta dei documenti*. Rome

PEDRETTI, C.
1972 *Leonardo da Vinci: The Royal Palace at Romorantin*. Cambridge, Mass.
1978 *Leonardo architetto*. Milan

PEPPER, S., and ADAMS, N.
1986 *Firearms and Fortifications: Military Architecture and Siege Warfare in Sixteenth-Century Siena*. Chicago

PERRIG, A.
1981 "Die Konzeption der Wandgrabmäler der Medici-Kapelle." *Städel-Jahrbuch* VIII:247–75

PERTILE, F., and CAMESASCA, E., eds.
1957 *Lettere sull'arte di Pietro Aretino*. With
–60 commentary by F. Pertile and revisions by C. Cordié. Milan

PETRUCCI, A.
1986 *La scrittura: Ideologia e rappresentazione*. Turin

PIETRANGELI, C., DI GIOIA, V., VALERI, M., and QUAGLIA, L.
1977 *Il nodo di San Bernardo: Una struttura urbana tra il centro antico e la Roma moderna*. Milan

PIRRI, P.
1941 "La topografia del Gesù di Roma e le vertenze tra Muzio Muti e S. Ignazio." *Archivum Historicum Societatis Iesu* X:177–217

PODESTÀ, B.
1875 "Documenti inediti relativi a Michelangelo Buonarroti." *Il Buonarroti* X:128–37

POLLAK, O.
1915 "Ausgewählte Akten zur Geschichte der römischen Peterskirche (1515–1621)." *Jahrbuch der Königlichen Preussischen Kunstsammlungen* XXXVI supp.:21–117

POPP, A. E.
1922 *Die Medici-Kapelle Michelangelos*. Munich
1927 "Unbeachtete Projekte Michelangelos." *Münchner Jahrbuch der bildenden Kunst* IV:389–477

PORTOGHESI, P., and ZEVI, B.
1964 *Michelangelo architetto*. With catalogue of works by F. Barbieri and L. Puppi. Turin

PUPPI, L., ED.
1980 *Architettura e Utopia nella Venezia del Cinquecento*. Milan

RAMSDEN, E. H.
1963 *The Letters of Michelangelo*. Stanford

RICHA, G.
1754 *Notizie historiche delle chiese fiorentine*
–62 *divise ne' suoi quartieri*. Florence

I ricordi di Michelangelo, edited by L. B. Ciulich and P. Barocchi. Florence, 1970 [CITED as *Ricordi* with Roman numeral]

ROCCHI, E.
1902 *Le piante iconografiche e prospettiche di Roma del secolo XVI*. Turin

SAALMAN, H.
1975 "Michelangelo: S. Maria del Fiore and St. Peter's." *Art Bulletin* LVII, 3:374–409
1977 "Michelangelo at Santa Maria del Fiore, an Addendum." *Burlington Magazine* CXIX, 897:852–53
1978 "Michelangelo at St. Peter's: The Arberino Correspondence." *Art Bulletin* LX, 3:483–93
1985 "The New Sacristy of San Lorenzo before Michelangelo." *Art Bulletin* LXVII, 2:199–228

SALVETTI, C. BERNARDI
1965 *Santa Maria degli Angeli alle Terme e Antonio Lo Duca*. Rome

SCHIAVO, A.
1949 *Michelangelo architetto*. Rome
1953 *La vita e le opere architettoniche di Michelangelo*. Rome

SCHMARSOW, A.
1884 "Ein Entwurf Michelangelo's zum Grabmal Julius II." *Jahrbuch der Königlichen Preussischen Kunstsammlungen* V:63–77

SCHWAGER, K.
1973 "Die Porta Pia in Rom: Untersuchungen zu einem 'verrufenen Gebäude.'" *Münchner Jahrbuch der bildenden Kunst* XXIV:33–96
1975a "Ein Ovalkirchen-Entwurf Vignolas für San Giovanni dei Fiorentini." In *Festschrift für Georg Scheja*, 151–78. Sigmaringen
1975b "Giacomo Della Porta Herkunft und Anfänge in Rom." *Römisches Jahrbuch für Kunstgeschichte* XV:109–41

SHAW, J. B.
1976 *Drawings by Old Masters at Christ Church, Oxford*. Oxford

SHEARMAN, J.
1975 "The Florentine 'Entrata' of Leo X, 1515." *Journal of the Warburg and Courtauld Institutes* XXXVIII:136–54
1986 "La costruzione della Cappella e la prima decorazione al tempo di Sisto IV." In *La Cappella Sistina: I primi restauri, la scoperta del colore*, 22–87. Novara

SIEBENHÜNER, H.
1954 *Das Kapitol in Rom: Idee und Gestalt*. Munich
1955 "Santa Maria degli Angeli in Rom." *Münchner Jahrbuch der bildenden Kunst* VI:176–206
1956 "San Giovanni dei Fiorentini in Rom." In *Kunstgeschichtliche Studien für Hans Kauffmann*, 172–91. Berlin

SIMMEL, G.
1985 *Il volto e il ritratto: Saggi sull'arte*, 111–36. Trans. by Perucchi. Bologna

SINDING-LARSEN, S.
1978 "The Laurentiana Vestibule as a Functional Solution." *Acta ad Archeologiam et Artium Historiam Pertinentia* VIII:213–22

SMYTH, C. H.
1970 "Once More the Dyson Perrins Codex and St. Peter's." In "Abstracts of Papers Presented at the Twenty-third Annual Meeting of the Society of Architectural Historians, Washington, January 29–February 1, 1970." *Journal of the Society of Architectural Historians* XXXIX:265

SOMMELLA, A. MURA
1989 "Il monumento di Marco Aurelio in Campidoglio e la trasformazione del palazzo Senatorio alla

metà del Cinquecento." In *Marco Aurelio: Storia di un monumento e del suo restauro*, ed. by A. M. Vaccaro and A. M. Sommella, 177–94. Milan

SPEZZAFERRO, L.
1981 "Place Farnèse: urbanisme et politique." In *Le Palais Farnèse*, I, 1:85–123. Rome

STEINMANN, E.
1901 *Die Sixtinische Kapelle*. Munich –5

TAFURI, M.
1973 "San Giovanni dei Fiorentini." In L. Salerno, L. Spezzaferro, and M. Tafuri, *Via Giulia: Una utopia urbanistica del Cinquecento*, 201–54. Rome
1975 "Michelangelo architetto." *Civiltà delle Macchine* XXIII, 3–6:49–60
1984a "'Roma instaurata': Strategie urbane e politiche pontificie nella Roma del primo Cinquecento." In *Raffaello architetto*, ed. by C. L. Frommel, S. Ray, and M. Tafuri, 59–106. Milan
1984b "Progetto per la facciata della chiesa di San Lorenzo, Firenze 1515–1516." In *Raffaello architetto*, ed. by C. L. Frommel, S. Ray, and M. Tafuri, 165–70. Milan
1985 "Un progetto 'raffaellesco' per la chiesa di San Giovanni dei Fiorentini a Roma." *Prospettiva* 42:38–47
1986 "Antonio da Sangallo il Giovane e Jacobo Sansovino: un conflitto professionale nella Roma medicea." In "Antonio da Sangallo il Giovane: La vita e l'opera." *Atti del XXII Congresso di Storia dell'Architettura, Roma 19–21 febbraio 1986*, 157–74. Rome
1987 "Due progetti di Antonio da Sangallo il Giovane per la chiesa dei Fiorentini a Roma." *Architettura: Storia e Documenti* I:35–52
1989 "Disegni architettonici." In *Giulio Romano*, 302. Milan

THIES, H.
1982 *Michelangelo: Das Kapitol*. Munich

THODE, H.
1902 *Michelangelo und das Ende der Re-* –12 *naissance*. Berlin
1908 *Michelangelo. Kritische Unter-* –13 *suchungen über seine Werke*. Berlin

THOENES, C.
1968 "Bemerkungen zur St. Peter-Fassade Michelangelo." In *Minuscula Discipulorum Kunsthistorische Studien Hans Kauffmann zum 70. Geburtstag*, 331–41. Berlin

TITI, F.
1763 *Studio di pittura, scoltura et architettura nelle chiese di Roma (1674–1763)*, ed. by B. Contardi and S. Romano. Florence, 1987

TOLNAY, C. de
1928 "Die Handzeichnungen Michelangelos im Archivio Buonarroti." *Münchner Jahrbuch der bildenden Kunst* IV:377–476
1930 "Zu den späten architektonischen Projekten Michelangelos (Pt. I)." *Jahrbuch der Preussischen Kunstsammlungen* Ll:1–48
1932 "Zu den späten architektonischen Projekten Michelangelos (Pt. II)." *Jahrbuch der Preussischen Kunstsammlungen* LIII:231–53
1935 "La Bibliothèque Laurentienne de Michel-Ange." *Gazette des Beaux-Arts* VI/XIV:95–105
1940 "Michelangelo Studies." *Art Bulletin* XXII:127–37
1945 *Michelangelo II: The Sixtine Ceiling*. Princeton
1948 *Michelangelo III: The Medici Chapel*. Princeton
1951 *Michelangelo*. Florence
1954 *Michelangelo IV: The Tomb of Julius II*. Princeton
1955 "Un 'pensiero' nuovo di Michelangelo per il soffitto della Libreria Laurenziana." *Critica d'Arte* II:237–43
1956 "Unknown Sketches by Michelangelo: Projects for St. Peter's and the Palazzo dei Conservatori." *Burlington Magazine* XCVIII, 643:379–80
1963 "Michelangelo Buonarroti." In *Enciclopedia Universale dell'Arte*, IX, cols. 263–306. Venice
1965 "A Forgotten Architectural Project by Michelangelo: The Choir of the Cathedral of Padua." In *Festschrift für Herbert von Einem zu 16. Februar 1965*, 247–51. Berlin
1966 "Nuove ricerche riguardanti la casa di Michelangelo in via Ghibellina." In *Accademia Nazionale dei Lincei: Quaderno 93*
1967 "Newly Discovered Drawings Related to Michelangelo, The Scholz Scrapbook in the Metropolitan Museum of Art." In "Stil und Überlieferung in der Kunst des Abendlandes." *Akten des 21. Internationalen Kongresses für Kunstgeschichte in Bonn 1964*, II:64–68. Berlin
1972 "I progetti di Michelangelo per la facciata di San Lorenzo a Firenze: Nuove ricerche." *Commentari* XXIII, 1–2:53–71
1975 (ed.) *I disegni di Michelangelo nelle collezioni italiane*. Florence

TUTTLE, R. J.
1982 "Against Fortifications: The Defense of Renaissance Bologna." *Journal of the Society of Architectural Historians* XLI, 3:189–201

UGINET, F. C.
1980 *Le Palais Farnèse à travers les documents financiers, 1535–1612*. Rome

VASARI, G.
1550 *Le vite de' più eccellenti architetti, pittori et scultori italiani*. Florence
1568 *Le vite de' più eccelenti pittori, scultori ed architettori*, ed. by G. Milanesi. Florence, 1878–81 (Reprint Florence, 1971)

VICUNA, C.
1966 "Juan Bautista de Toledo, arquitecto segundo de la Fabrica de San Pedro de Roma." *Archivo Español de Arte* XXXIX:1–8

VODOZ, E.
1941 "Studien zum architektonischen Werk des Bartolomeo Ammannati." *Mitteilungen des Kunsthistorischen Institutes in Florenz* VI, 3–4:1–141

WACHLER, L.
1940 "Giovannantonio Dosio, ein Architekt des späten Cinquecento." *Römisches Jahrbuch für Kunstgeschichte* IV:143–251

WALLACE, W. E.
1987a "Two Presentation Drawings for Michelangelo's Medici Chapel." *Master Drawings* XXV, 3:242–60
1987b "Michelangelo's Project for a Reliquary Tribune in San Lorenzo." *Architectura* XVII, 1:45–57
1987c "'Dal disegno allo spazio': Michelangelo's Drawings for the Fortifications of Florence." *Journal of the Society of Architectural Historians* XLVI, 2:119–34
1989 "The Lantern of Michelangelo's Medici Chapel." *Mitteilungen des Kunsthistorischen Institutes in Florenz* XXXIII, 1:17–36

WEINBERGER, M.
1967 *Michelangelo the Sculptor*. London

WILDE, J.
1953 *Italian Drawings at the Department of Prints and Drawings in the British Museum: Michelangelo and His Studio*. London
1954 *Michelangelo's "Victory"*. London
1955 "Michelangelo's Design for the Medici Tomb." *Journal of the Warburg and Courtauld Institutes* XVIII:55–66
1978 *Michelangelo: Six Lectures*, ed. by J. Shearman and M. Hirst. Oxford

WINNER, M.
1967 *Zeichner sehen die Antike*. Exhibition catalogue. Berlin

WITTKOWER, R.
1933 "Zur Peterskuppel Michelangelos." *Zeitschrift für Kunstgeschichte* II:348–70
1934 "Michelangelo's Biblioteca Laurenziana." *Art Bulletin* XVI:123–218
1978 "Michelangelo's Dome of Saint Peter's" (conference paper, Wellesley College, 1970). In *Idea and Image: Studies in the Italian Renaissance*, 73–89. London

ZANDER, G.
1986 "Il colore della basilica di San Pietro secondo il probabile pensiero di Antonio da Sangallo" (appendix by N. GABRIELLI). In "Antonio da Sangallo il Giovane: La vita e l'opere." *Atti del XXII Congresso di Storia dell'Architettura, Roma 19–21 febbraio 1986*, 175–86. Rome

ZANGHIERI, G.
1953 *Il Castello di Porta Pia da Michelangelo (1564) al Vespignani (1864) e ad oggi*. Rome

INDEX

385

Roman Catholic Church, 8, 17, 25, 29, 38, 39, 42, 80, 117, 210, 213, 215, 272, 273, 274, 276, 359; *see also* Counter Reformation

Roman Curia, 17, 25, 36, 210, 211, 272, 340, 372

Roman monuments, studies after Coner Codex, 154; *154, 158, 159* [161, 169–76]

Romano, Giulio (Pippi), 54, 322, 342

Rome, 17, 29, 30, 33–35, 211, 277, 370, 372; and Florence, 29, 35, 80, 277; fortifications for, 264, 336; restoration of, 8–9, 13, 33, 272–73, 281, 359; Sack of (1527), 74, 181, 184, 195, 198, 210, 272, 322, 336

Rome school, 9, 21, 33, 35, 47, 85, 211, 217, 359

Rondanini Pietà, The, 281, 301, 358; *285* [393]

Rosselli, Cosimo, 60

Rosselli, Domenico, 174

Rosselli, Pietro, 60, 61, 173–74

Rossellino, Bernardo, 273, 322

Rossi, Giovanni Giacomo de, 348

Rossi, Nardo de', 265, 350

Rovere, Bartolomeo della, 73

Rovere, Francesco della, *see* Sixtus IV

Rovere, Francesco Maria della, duke of Urbino, 67, 70, 73, 75, 76, 252

Rovere, Guidobaldo della, 76, 77

Rovere, Giuliano della, *see* Julius II

Rovere, Leonardo Grosso della, cardinal, 67, 70, 72, 73

Rovere family, 63, 67, 73, 76

S

Saalman, Howard, 56, 172, 175, 322, 325, 329, 330

S. Agnese, Rome, 350

S. Andrea, Mantua, 81, 341

S. Anna Gate, Rome, 336

S. Antonino, summit of, Rome, 336

S. Apollonia, Monastery of, Florence, portal of, 201; *201* [284]; elevation and details (Dosio), 201; *201* [282–83]

SS. Celso and Giuliano, Chapter of, 342

SS. Cosmas and Damian, Chapel of, Castel Sant'Angelo: courtyard aedicula, 21, 64–66, 80, 255; before early 20th c. restoration, 21, 64, 66, 348; *64* [64]; after early 20th c. restoration, 66; *64* [65]; after 1988 restoration, *82, 83, 84* [93–95]; plan perhaps for, 66; *66* [70]; study for modifying (Montelupo), 64, 66; *65* [67]; copy of (anon.), 66; *65* [68]; study for chapel (Antonio da Sangallo the Younger), 64; *65* [66]

S. Costanza, Rome, 33, 297

S. Croce in Gerusalemme, Rome, 356

S. Fiore, cardinal of, 348

S. Giorgio quarter, Florence, 202

S. Giovanni dei Fiorentini, Rome, 33, 284–300, 341, 342–47, 348, 359–61; plans for, 26, 33, 145, 151, 153, 297, 344–47; *298, 299, 302, 343, 344, 345* [405–7, 465–71]; copy after (Biringucci), 297, 300, 347; *346* [473]; ground plan after (Casale), 347; *347* [477]; polished version (Calcagni), 297, 300, 343, 347; *346* [475]; sketches for (?), *335* [455]; wood model, 297, 343, 347; copies after (anon.), 347; *346* [474]; (Dosio), 297, 347; *347* [478]; copy after section of (Le Mercier), 297, 347; *347* [476]; ground plan after (attrib. Montano), 347; *346* [472]

S. Giovannino degli Scolopi, Florence, 184

S. Ivo alla Sapienza, Rome (Borromini), detail of dome and lantern, *368* [515]

St. John Lateran, Rome, 252

S. Lorenzo complex, Florence, 38, 175, 186; *187* [246]; piazza, 169, 186; *see also* S. Lorenzo, Church of; Laurentian Library

S. Lorenzo, Church of (Brunelleschi), 80, 94, 175; baldachin for relics, *see* Tribune of the Relics; plan to locate tombs of Medici popes in, 181–84, 185, 187; *see also* Medici popes, tombs of; plan of church (attrib. Jacopo Sansovino), 175; *176* [220]; in plan of complex, *187* [246]; sacristies, *see* New Sacristy (Medici chapel); Old Sacristy; unfinished façade, 37, 80, 161; *86* [96]; *see also* S. Lorenzo façade project

S. Lorenzo façade project, 25, 37–38, 66, 70, 71, 72, 73, 80–82, 85, 161–69, 186, 218

—designs prior to Michelangelo commission: Giuliano da Sangallo, 37, 81, 162, 167; *164, 165* [182–84]; Raphael, 37, 81, 161, 162, 163, 167; copy of (attrib. Aristotile da Sangallo), 81, 161, 167; *86* [97]

—preliminary designs, 37, 82, 166, 167; *87* [98]; copies of (Montelupo), 166; *166* [187–88]

—"first design," 164–66, 167; *89, 166* [102/186]; copy of (Montelupo), 164; *165* [185]; wood model (Baccio d'Agnolo, after Michelangelo) 37, 81, 82, 164, 169; *88* [101]

—"second design," 37, 71, 82, 166–67; *87, 167* [99, 189]; section of, 167; *167* [190]

—"final design," 37, 38, 82, 169; *88* [100]; copies of studies (Antonio Sangallo the Younger), 169; *168* [196]; (Giovanni Battista da San-

gallo), 169; *168* [195]; reconstruction (Ackerman), 164, 169; *169* [197]; sketches of marble blocks, *169, 170, 171* [198–210]; studies for, 167; *167* [191–92]; bay, *10* [3]; sections, 154, 169; *155, 168* [165, 193–94]

S. Lorenzo, Monastery of, plan of, with proposed location of Laurentian Library, 29, 186; *188* [247–48]

S. Lorenzo quarter, defense of, 202

S. Luigi dei Francesi, Rome, 350

S. Marco, Library of, Florence (Michelozzo), 117; interior, *117* [128]

S. Marco, Library of, Venice (Sansovino), 35, 218

S. Marco, Palazzetto of, 252

S. Marco, Rome, 350

S. Maria bridge, Rome, 153, 337

S. Maria d'Aracoeli, Rome, 215, 252, 253

S. Maria degli Angeli, Rome, 6, 29, 297, 281, 301, 303–9, 349, 350, 354–57, 358, 364–66, 368, 372; aerial view, *357* [501]; crossings, *319, 321,* [425, 427]; details, *316, 318, 320* [422, 424, 426]; great hall, 33, 357; *312–13* [419]; groin vaults, *314, 317* [420, 423]; left transept, *315* [421]; drawings: choir (anon.), 357; *356* [500]; choir and southeast vestibule (anon.), 357; *355* [498]; interior (Hulst), 355 [497]; main altar (Franzini), 357; *356* [499]; vestibule at southeast entrance (Dosio), 357; *354* [496]; plans: of complex (Antonio da Sangallo the Elder), 303, 354; *354* [495]; with indications of Michelangelo's additions, 309, 356; *312* [418]; tabernacle (Duca), 356; *357* [502]

S. Maria del Fiore (Florence Cathedral), 172, 203, 261; dome (Brunelleschi), 87, 277, 280, 300, 325–27; detail of, with gallery executed by Baccio d'Agnolo, *56* [50]; studies for drum, 56; *58, 59* [55–58]; wood models for drum, 56; *56, 57* [51, 53]; (Cronaca, Giuliano da Sangallo, and Baccio d'Agnolo), 56; *57* [52]; façade, 81, 161; sculpture, 14; sketch of apostle, *14* [7]; *see also Deposition of Christ*

S. Maria delle Grazie, Mantua, Tomb of Baldasarre Castiglione, 54

S. Maria delle Grazie, Milan, 37

S. Maria del Popolo, Rome, 63, 264

S. Maria di Loreto, design for façade (Giuliano da Sangallo), *165* [183]

S. Maria Maggiore, Rome, 66, 163, 184, 185, 348; *see also* Sforza Chapel

S. Maria sopra Minerva, Rome, 184

S. Miniato al Monte, Florence, fortifications, 202, 205, 207, 336

S. Onofrio di Foligno, Florence, 201

Saint Paul, for Tomb of Julius II, 49; study for, 52; *53* [42]

St. Peter's, Vatican (New St. Peter's; *see also* Old St. Peter's), 7, 17, 24, 29, 30, 33, 35, 49, 53, 80, 150, 153, 163, 172, 213, 216, 239, 264, 265, 272–84, 300, 322–33, 339, 343, 358–59, 361, 364, 368; architectural sketches for, *335* [455]; Bramante's plan, 29, 52, 53, 324, 359; *54* [44]; exterior view and elevation (Dupérac, according to Michelangelo's design), 280, 329, 330, 333; *275* [385–86]; Michelangelo's goal, 30, 240, 272, 273–74, 280, 284, 324, 358, 359; plans (Dupérac, after plan of Michelangelo), 29, 273, 280, 325, 333; *274* [384]; (Pellegrino), *54* [45]; Sangallo's design, 30–33, 272, 273, 280, 322, 324, 325, 327; wood model after (Labacco), 273, 322, 324, 327, 328; *324* [431]; section of elevation (Dupérac, according to Michelangelo's design), 280, 329, 330; *275* [385]; 16th c. views (anon.; in Notebook of Heemskerck), 327, 329; *323* [428–29]; (circle of Dupérac), 333; *333* [449]; statues for, 281; successive constructions of Sangallo and Michelangelo, 324; *276* [387]

—apse hemicycles, 280; *290, 291* [398–400]; elevations (anon.), 329; *328* [438]; (Orlandi), 328–29; *328* [437]; plan (anon.), 329; *328* [439]

—Chapel of the King of France, 281, 324, 327–28; vault, 328; *326, 327* [433–36]; wood model of (Labacco), 327; *324* [431]; *Pietà*, 281

—choir, perhaps after Bramante's wood model (anon.), *55* [47]; plan of, after Bramante's plan (Antonio da Sangallo the Younger), *54* [46]

—dome, drum, and lantern, 17, 26, 33, 121, 213, 273, 274, 276–280, 284, 325–27, 329–33; *292–96* [401–4]; changes by Giacomo della Porta, 33, 277, 333; elevations (Lille sheet), 277, 329, 330; *279, 331* [389, 444]; load-bearing piers, 273, 276, 280; plans: dome, 330; *279, 331, 332* [389, 446, 448]; sections, 330; *329, 332* [440, 447]; (Dosio, from Michelangelo's model), 333; *334* [450–52]; studies, sketches, and designs: dome, 330; *331* [445]; (Haarlem drawing), 277, 330; *278, 332* [388/447]; window with pediment for drum, 347; *335* [453]

lantern, 173, 277, 333; *286, 287* [394–95]; elevations, *279, 331* [389, 444]; oculus (circle of Dupérac); *330*

PHOTOGRAPHIC SOURCES

Sergio Anelli, Milan; Alinari Archive, Florence; Buonarroti Archive, Florence; Electa Archive, Milan; Ashmolean Museum, Oxford; Bruno Balestrini, Milan; photographic archive, Vatican Apostolic Library, Rome; Bibliotheca Hertziana, Rome; British Museum, London; photographic documentation, Réunion des Musées Nationaux, Paris; Works of Saint Peter's, Rome; Foto Gualdoni, Arezzo; Foto Saporetti, Milan; Fotostudio Moreno, Florence; Photographic Department, Superintendency of Artistic and Historical Properties, Florence; Francesco Lazzeri, Florence; Pepi Merisio, Bergamo; photographic service, Musée des Beaux-Arts, Chambéry; photographic service, Musée Condé, Chantilly; Musée d'Art et d'Histoire, Lille; photographic archive, Vatican Museums, Rome; photographic archive, Museo Nazionale di Castel Sant'Angelo, Rome; photographic archive, Museo Poldi Pezzoli, Milan; Toni Nicolini, Milan; Takashi Okamura, Rome; Pedicini, Naples; Donato Pineider, Florence; Mario Quattrone, Florence; Scala, Florence; photographic archive, Staatliche Kunstsammlungen, Dresden; photographic services, The Metropolitan Museum, New York; Teylers Museum, Haarlem; photo library, Italian Touring Club, Milan; and Massimo Velo, Naples.